WORLDS OF ART

Cover Artist An artist of extraordinary versatility, Sonia Delaunay (1885–1979) ranged over worlds of art, from avant-garde painting to innovative fashion and textile design. Delaunay's wide-ranging creativity eclipsed the customary boundaries between fine and applied art, high art and commercial decorative design. The large abstract painting of 1914, *Electric Prisms,* employs the same brilliant color and interwoven, loosely geometric surface design that characterize her dresses, fabrics, tapestries, and set designs. Of her painting, her husband, the French painter Robert Delaunay commented, "The colors are dazzling. They have the look of enamels or ceramics, or carpets—that is, there is already a sense of surfaces that are being combined, one might say, successively on the canvas." More specifically, *Electric Prisms* embodies Sonia Delaunay's excited aesthetic response to the electric lamps newly installed on Paris's boulevards. In abstract translation, circles and rainbows of light blossom forth in vibrant, interactive planes of color. The light moves and pulsates, fields of energy filling the sky. It is a springtime vision of wonder and optimism in an urban industrial society on the brink of world war.

For her remarkable artistic achievement, Sonia Delaunay was honored in 1964 with a major exhibition at the Louvre museum in Paris, the first woman to receive such a show during her lifetime. (Sonia Delaunay. *Prismes électrique.* Oil on canvas. 250 × 250 cm. Musée Nationale d'Art Moderne, Paris.)

WORLDS OF ART

Robert Bersson

JAMES MADISON UNIVERSITY

MAYFIELD PUBLISHING COMPANY

MOUNTAIN VIEW, CALIFORNIA
LONDON • TORONTO

In memory of my father, Abraham Bersson
In honor of my mother, Edith Bersson

Copyright 1991 by Mayfield Publishing Company

Library of Congress Cataloging-in-Publication Data

Bersson, Robert.
 Worlds of art / Robert Bersson.
 p. cm.
 Includes bibliographical references and index.
 ISBN 0-87484-797-4
 1. Arts. I. Title.
NX620.B47 1991
700—dc20 90-13467
 CIP

Manufactured in the United States of America
10 9 8 7 6 5 4 3 2

Mayfield Publishing Company
1240 Villa Street
Mountain View, California

Sponsoring editor, C. Lansing Hays; managing ed-
itor, Linda Toy; copy editor, Antonio Padial; text
and cover designer, Anna George; photo researcher,
Stephen Forsling. The text was set in 10/12 Galliard
by Waldman Graphics and printed on 60# Litho
Gloss by Kingsport Press.

*(Text and photo credits appear on a continuation of the copy-
right page, p. 591.)*

Preface

Worlds of art surround us. If we take the trouble to look, we see the artist's hand in the architectural design of the rooms we sit in as well as the product design of the chairs we sit on. Paintings, prints, posters, photographs, video, and computer images fill our fields of vision. Artistic masterpieces from other times and cultures come to us through museum exhibitions and through films, television programs, textbooks, and even magazine advertisements. All of these art forms, in subtle or overt ways, influence our lives. Wherever we look—or don't look—in a world dominated by the eye, thousands of visual experiences affect us. To an extent that most of us would be hesitant to acknowledge, we *are* what we see.

Worlds of Art does not attempt to explore the entirety of visual experience—that would be an impossibility—but instead focuses on important elements in our visual fields: both the "ordinary" objects of functional and mass media art that crowd our everyday lives and the "extra-ordinary" creations of painters, sculptors, craftspersons, and designers whose

work has earned the prestigious label of fine art. Like most art appreciation texts, *Worlds of Art,* focuses principally on fine art but treats it in a more "real life" way than is the custom. Fine art is viewed both as a distinct category of art *and* as it relates to the applied and mass media arts. Instead of being segregated in a separate enclave, cordoned off in museums and galleries, fine art is seen as a living force that influences, and is influenced by, all other types of art. The form and content of twentieth century advertising, for example, are viewed in *Worlds of Art* as directly related to the five-hundred-year-old European tradition of oil painting; at the same time, the influence of advertising and commercial culture is noted in the work of contemporary pop and new realist artists.

In addition to emphasizing the interaction between fine, applied, and mass-media art, *Worlds of Art* explores these art forms across time and cultures. In Chapter 3, for instance, we observe how images of nature—in paintings, relief sculptures, drawings, photographs, and postcards—change from the medieval pe-

riod to the present and from the Western to the Eastern traditions.

But introducing the reader to the diverse worlds of art that exist across artistic categories, cultures, and historical periods is only the starting point. Such breadth of coverage is balanced in the text by the in-depth examination of art objects. Because works of art are richly complex phenomena, possessing multiple levels of meaning, a "comprehensive" approach to art appreciation has been applied throughout the book. Emphasizing breadth of thinking and depth of looking, this global approach employs two time-honored ways of viewing art, formalism and contextualism. The formalistic way of seeing emphasizes the formal or intrinsic visual qualities—the line, color, composition, and subject matter—of a given work. The contextual perspective, in complementary relationship, sees art in terms of its sociocultural background: as the creation of a particular artist, culture, and society. Works of art are experienced as both visual form *and* sociocultural meaning, as befits their rich complexity. Laying down a solid foundation on which to build, the book's first two chapters are devoted to learning the process of appreciation and becoming aware of form and meaning in the everyday world.

After becoming acquainted in Part One with the process of art appreciation, the reader is introduced to the "worlds of art" that are the subject of Part Two. Putting into practice a time-tested educational principle, the book first presents subject matter and art forms with which the reader is relatively familiar: graphic art (Chapter 4), product design (Chapter 5), architecture and community design (Chapter 6), and photography and moving pictures (Chapter 7). The text then moves in Part Three to an examination of fine art, an area generally less familiar to students. This part spans subjects ranging from the paintings and sculptures of the Renaissance to the boundary-breaking mixed-media and new media works of the present. The systematic progression in the book's first nine chapters from familiar to unfamiliar content is meant to foster interest and confidence before more complex and challenging topics are introduced.

In Parts Two and Three, historical and thematic approaches are used together to provide a comprehensive art appreciation experience. Interwoven chronological and thematic treatments broaden and deepen the reader's understanding of each work of art. For example, the nineteenth-century art movements, naturalism and impressionism, are considered in respect to their historical and stylistic relationships and, thematically, as the products of the industrial age. Seeing naturalist and impressionist paintings both in terms of art historical and stylistic development and in relationship to their sociocultural context deepens the viewer's appreciation.

In its overall content, *Worlds of Art* emphasizes the Western tradition but reflects the fact that the art world has become increasingly international and intercultural over the centuries. Committed to a multicultural perspective, the book honors the contributions of women and artists of diverse cultures.

In its approach, *Worlds of Art* seeks to be lively and challenging. It informs, but it also provokes; its goal is to foster perceptive, thoughtful, "active" viewing. To this end, first-person commentaries by artists, historians, critics, and sensitive laypersons appear throughout the text. These highly personal testimonies are meant to stimulate readers' own looking and thinking, and engage them more actively in the process of appreciation. In this same vein, the book contains thirty-seven "appreciation features." In each, an art expert responds to one or more works of art. Incorporated into the book's twelve chapters, these appreciations help the reader both to focus in depth on the given work and, perhaps even more importantly, to experience voices and ways of responding different from those of the author. This, too, is meant to encourage readers to develop their own ways of experiencing art. Among the respondents are women and men whose writing styles, critical perspectives, and cultural backgrounds—including African-American, Asian-American, Hispanic-American, and native American—are bound to expand the reader's art appreciation experience.

As an introductory text, *Worlds of Art* strives for balance: between breadth of coverage and in-depth analysis; between the visual form and sociocultural meaning of works; between masterpieces of the fine art tradition and

masterworks from everyday life; between the author's perspective and those of artists, historians, critics, and laypersons of diverse backgrounds. Everything in this book has been written to motivate the reader to active interest and involvement: to the appreciation of art in its remarkable diversity and complexity.

Acknowledgments

Worlds of Art is the collaborative product of hundreds of individuals, all of whom deserve abundant praise. Without their substantial contributions this book would not have been possible. First thanks go to the twenty-seven writers whose original "appreciation essays" are featured in the book. Their names along with a brief biographical sketch accompany their essays. Special appreciation likewise goes to eight writers of prominence—Josephine Withers, Lucy Lippard and Renate Hinz, Wendy Slatkin, Frima Fox Hofrichter, Betty LaDuke, Sun Bear, and Wabun—who permitted me to fashion appreciation essays from previously published materials. These women and men, thirty-five in all, are truly co-authors of *Worlds of Art*.

The unsung heroes of this book, the people behind the scenes, are the Mayfield staff who worked so hard day in and day out to make this a text of the highest quality: my sponsoring editor Lansing Hays, managing editor Linda Toy, copy editor Antonio Padial, photo researcher Steven Forsling, and designer Anna George. Together we worked with the friendship of a family and the solidarity of a winning team.

Then there are the reviewers whose thoughtful criticism served to consistently improve the conceptual, factual, and literary dimensions of the text. My sincerest appreciation extends to: Susan Delaney, San Diego State University; Sally Hagaman, Purdue University; Cheryl Hayes, University of New Orleans, Lakefront Campus; Jack Hobbs, Illinois State University; Melinda Lorenz, California State University, Northridge; Mery Lynn McCorkle, formerly with Lane Community College; Joanne Morrison Peterson, Southwestern College; Donna von Mizener, University of California, Fullerton; Michael Murray, North Texas State University; Edward Pope, University of Wisconsin; David Raizman, Western Illinois University; Bernard Schultz, West Virginia University; David Sharp, Eastern Michigan University; Joel Smith, Western Illinois University; Laura Young, Montclair State College.

I wish I could recognize in print the hundreds of friends and colleagues whose contributions, large and small, over the years proved to be invaluable. You know who you are. Let me simply conclude by offering heartfelt thanks to three members of my inner circle: my cousin, Stanley Marcus, for his expert editorial assistance in the crucial early stages of the book; and my mother, Edith Bersson, and my wife, Dolores Shoup, for their ongoing moral support.

Worlds of people made *Worlds of Art* a reality.

Contents

PART TWO: WORLDS OF ART 59

PART THREE: FINE ART: FORM & CONTENT *271*

WORLDS OF ART

THE PROCESS OF APPRECIATION

C h a p t e r 1

The Process of Appreciation

Is there one correct way of looking at art? We have often been encouraged to think so. Proponents of one or another school of art appreciation have consistently tried to tell us that we, too, should adopt a specific vantage point. But isn't art itself too complex and varied to allow for a single approach to appreciation? And aren't we, the viewers and consumers of this diverse world of art, too different in our responsive capacities to be channeled into a single way of seeing? As citizens, we refuse to tolerate that kind of regimentation in our political life. To submit to it in our aesthetic life is equally unacceptable.

Does this mean that art appreciation is unteachable and that no organized effort should be made to develop it? Certainly not. We can formulate many useful statements about art appreciation, provided those statements limit themselves to general principles and do not presume to dictate individual experience. From them we can learn an enormous amount about the infinitely complex relationship between art and the world it both mirrors and creates. With this as our underlying assump-

tion, we present in the following pages two general but time-honored approaches to art, and the reader is encouraged to use them as springboards into his or her far more subtle, far more idiosyncratic personal adventures in seeing.

As the title *Worlds of Art* implies, we will explore a wide range of art forms and engage in a variety of appreciative experiences. Some of these experiences are primarily emotional; others, intellectual. Some interlace emotions, intellect, and senses in a holistic weave. Certain experiences point toward spirituality, whereas others take us into the raucous forum of politics. Art appreciation cannot be neatly pigeonholed or summed up in a convenient formula, because appreciation is an encounter filled with human variability. It brings together in sensitive dialogue a work of art, the product of a particular time and place, and a viewer, unique in background, values, and personality.

As a first example of what such an encounter might be like, let us look at the reactions of one person to one painting. An undergraduate

student taking an introduction to art course wrote the following about her experience of *On the Cliffs, Dieppe* (1.1) by Claude Monet (1840–1926):

> When my glance fell upon the painting, I was suddenly transformed into the mist and coolness and silent secret that is the sea. The ocean is calm—blue and green with touches of pink and purple. The sky is pale, paler than the ocean, and there is a hint of pink and yellow on the horizon. Perhaps in an hour the sky will be ablaze with sunset.
>
> There is a oneness, a unity among sky, rocks, and ocean. It all flows with the same rhythm; the strokes are even, graceful, and free. The cliffs in the background have almost merged with the ocean. Only at their summit is a contrast between earth and sky discernable. In the foreground are cliffs of more distinctive purple and green hues, and on the ocean side, there is an outcropping of clay-colored rock or sand.
>
> The artist has transported us to a world devoid of people or their influence. All we see is water, earth, and sky. And even these seem to want to merge with each other, share each other's identity, tease the eye of the beholder of the light that suffuses land, sea, and air.
>
> There are so many different colors that they cannot always be separated or distinguished. Similarly, there are so many tiny, tiny strokes that the water is smooth and flawless. Just as drops of water make the sea, and grains of sand form the shore, so each tiny stroke of color forms this limitless painting, which is only a glance. When I come close to the painting, I unravel some of its mystery, but its peace and serenity speak more clearly from afar. Besides, my eye does not want to toil and linger. It wants to go away and come back again for a fresh glance, which each time beholds the mystery anew.

Through the sunlit art of the French painter Monet, this student was transported and

1.1 • CLAUDE MONET. *On the Cliffs, Dieppe.* 1897. Oil on canvas. 25⅝ × 39⅜." The Phillips Collection, Washington, D.C.

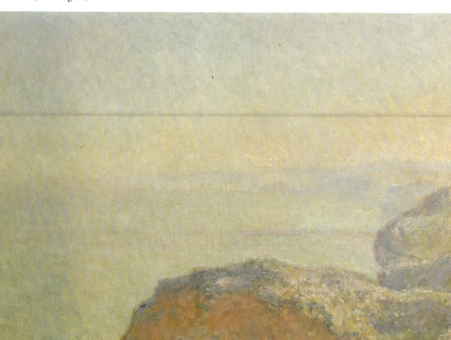

1.2 • PETER REISS. *Untitled.* 1982. Chromogenic color print, type C process. 14½ × 14½". © Peter Reiss.

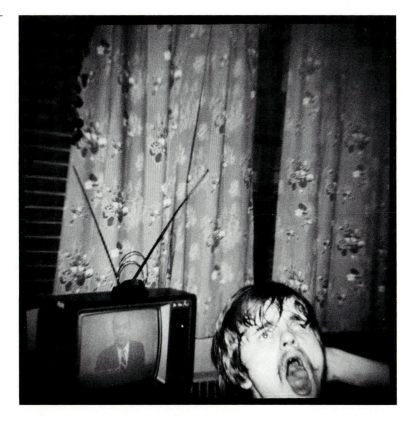

transformed. Drawn into a world distant in time and place, yet as vibrant as the day the artist painted it, the young woman experienced the seemingly timeless power of great art to move us. Her aesthetic experience of *On the Cliffs, Dieppe,* a heightened blend of sense, emotion, and thought, awakened in her a more vital sense of nature and herself. Through her interaction with the painting, she became, for a significant moment, more fully and vividly alive. Such experiences of art invariably become part of us, enriching our lives well into the future.

In another undergraduate essay, a student wrote about the works of Peter Reiss (born 1953). An award-winning artist, Reiss is also an epileptic who suffered a stroke that paralyzed his right side. People who are severely retarded and physically malformed, so often hidden from our view, are his subjects (1.2). In the conclusion of her paper, a deeply affected student wrote these words:

> Imagine a toothpaste commercial showing a child with overcrowded teeth and a hydrocephalic head, as Reiss has done unabashedly.

Imagine an advertisement with something other than beautiful, comfortable, or "normal" people. The kind of human beings Reiss celebrates will rarely be celebrated in pictures. It is easy to forget them as they spend their lives in beds or in institutions. Reiss is not repelled by their features or fragility; rather, he is attracted by their strength. Perhaps we should follow his example.

The photographs of Peter Reiss belong to a noble artistic tradition that has sought to make visible the lives of those who are normally invisible: the "abnormal," the poor, the oppressed. Witness *The Night of the Poor* (1.3), a mural by Mexican artist Diego Rivera (1886–1957). Painted with a loving brush, Rivera's poor are penniless but noble, tired yet not without hope. Assuredly, art has the power to make the invisible visible.

Realms of experience or cultural perspectives little known to the majority of the population can reach the public consciousness through the forceful images of art. Artists, for example, working from an ethnic or feminist perspective make us deeply aware of the diverse cultures that make up our world. Con-

1.3 • DIEGO RIVERA. *The Night of the Poor.* 1923–1928. Mural from top floor, Secretariat of Education Building, Mexico City.

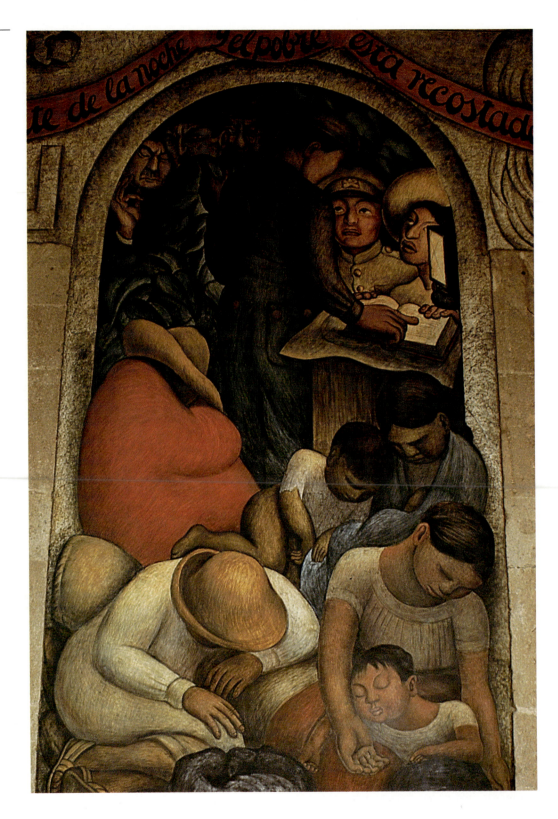

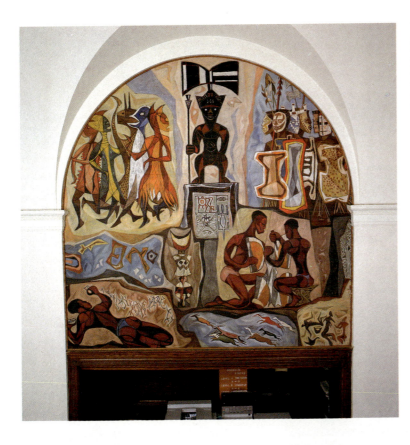

1.4 • HALE WOODRUFF. *Native Forms,* mural, panel one from *The Art of the Negro,* 1950–1951. Oil on canvas. 144 × 144″. Courtesy Clark Atlanta University, Atlanta, Ga.

sider the majestic mural series, *The Art of the Negro* (1.4, Appreciation 1) by Hale Woodruff (born 1900) or the epic environmental construction, *The Dinner Party* (Appreciation 32) by Judy Chicago (born 1934). *The Dinner Party* includes a table, settings, and individualized ceramic plates in praise of great, often underacknowledged women of the past. The plate (1.5) dedicated to Sojourner Truth (1797–1883), the courageous African-American abolitionist and feminist, emphasizes Sojourner's proud African heritage and her painful life in slavery. Central to both Woodruff's and Chicago's work is the theme of recovering one's cultural past to affirm and build one's present identity.

The experience of art can teach us that the act of looking intensely, of opening our sensibilities to the world, yields a humanizing reward in the process of living. In a period when the need for sensitive, open-minded beings is greater than ever, art experiences that expand our consciousness and deepen our humanity are essential.

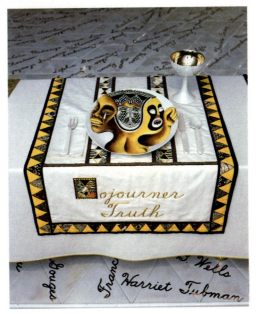

1.5 • JUDY CHICAGO. *Sojourner Truth,* plate and place setting from *The Dinner Party.* 1979. Multimedia, china painting on porcelain, needlework. 48 × 48 × 48′ installed. © Judy Chicago.

1.6 • LENI RIEFENSTAHL. *Triumph of the Will.* (Hitler, Himmler, and Lutze traverse the stadium.) 1934. Transit-Film-Gesellschaft MBH. The Museum of Modern Art/Film Stills Archive.

1.7 • D. W. GRIFFITH. *The Birth of a Nation.* (The Klan rides to the rescue of endangered white womanhood.) 1915. Epoch Producing Corporation. The Museum of Modern Art/Film Stills Archive.

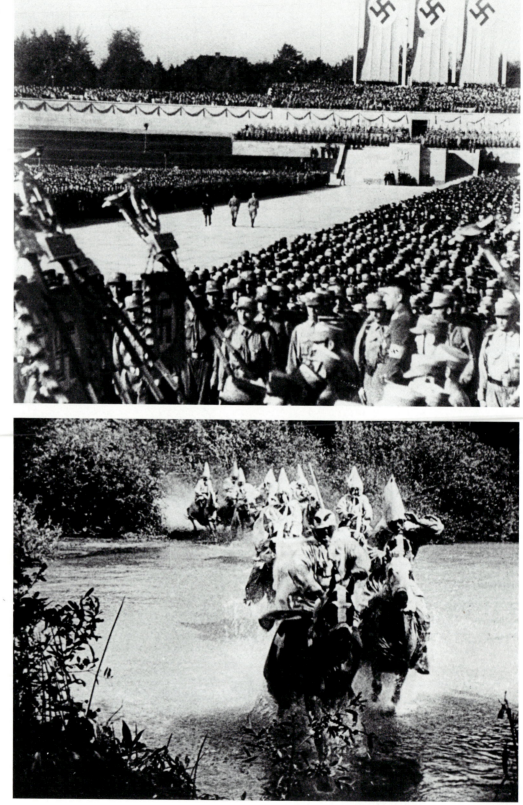

Unfortunately, not all works of art enlarge our horizons and sensibilities. Some masterful works of art can restrict our awareness and debase our humanity. An art appreciation concerned with seeing only the good, true, or beautiful in works of art is incomplete. The world of art is far too complex and multidimensional for such an orientation. We must also learn to analyze and understand those works of functional, mass-media, and fine art that limit or even enslave the human spirit. Two "classic" art films by directors of genius serve as telling examples. *Triumph of the Will* (1.6), directed by Leni Riefenstahl (born 1902) is supposedly a cinematic "document" of the 1934 Nuremburg rally, a spectacular political event organized by Hitler and the Nazi party to sway the German people to their side. Filled with dramatic camera compositions and exhilarating editing sequences that juxtapose shots of a godlike Hitler with scenes of majestic Nuremburg and adoring crowds, *Triumph of the Will* is an artistic masterpiece and can be appreciated as such. Yet it is also a powerful piece of fascist propaganda. Lavishly produced by and for the Nazi party, it glorifies Hitler and nazism while hiding from view the virulent racism and violent imperial intentions of the Third Reich. As a stirring part of a highly effective propaganda campaign, the film helped to bring to power one of the most murderous regimes in history. As art, it retains the power to inspire fascists of the present and future while aesthetically seducing the rest of us into enjoying its artistic form at the expense of forgetting the horror it both masked and made possible. In this regard, *Triumph of the Will* must also be appreciated "contextually"; that is, in the context of actual life. If we appreciate this film only for its artistic form, we forget some of the most heartrending lessons of history.

Another example of art's transformative power is the silent classic, *The Birth of a Nation* (1.7), directed by D. W. Griffith (1875–1948). This film seems ever capable of swaying audience members to cheer the exploits of the Ku Klux Klan, a group that has practiced racial bigotry and lynch mob terrorism for more than a century. At such unsettling moments, it is apparent how completely art, especially great art, can carry us away, convince us of its reality, however distorted, and transform us for better or worse and sometimes both.

Through experiences like these, thoughtful viewers have come to understand that art appreciation is not simply a matter of aesthetic enjoyment. Surely *Triumph of the Will* and *The Birth of a Nation* are to be appreciated for their enduring artistic qualities, irrespective of their repressive political content. But they must also be appreciated contextually for what their form and content can teach us, both good and bad, about ourselves and our history.

WAYS OF SEEING: FORMALISM & CONTEXTUALISM

Because art is so multifaceted and can move us in so many ways, one-sided or narrow methods of art appreciation are insufficient. We need an approach that is at once more general and comprehensive. Such an art appreciation might be achieved by combining two traditionally distinct ways of seeing: formalism and contextualism. In the formalist way of seeing, art is appreciated for the enlivening aesthetic experience its visual form can provide. The name **formalism** stems from the primary focus on the artistic form of the work: its line, shape, color, texture, composition, and so forth. For the formalist, art is to be valued for its artistic qualities ("art for art's sake"), separate from its connections to the larger world. In the case of a film like *Triumph of the Will*, the viewer would concentrate on the work's formal qualities (for instance, camera compositions, editing rhythms, settings, lighting effects, dialogue and sound track, facial expressions and gestures) while ignoring the film's contextual relationships to Hitler, nazism, propaganda, and so on. Such "nonartistic" considerations, the formalist would argue, only detract from the vivifying aesthetic experience the work's artistic form can provide. Although the formalist approach pares away history, morality, and virtually everything other than color, shape, technique, and composition, this approach does get the viewer to look closely and respond with feeling to the sensuous qualities of the art object. As

such, the formalist way of seeing seems a good starting point for the appreciation of art.

In contrast to formalism, **contextualism** is concerned with the appreciation of art "in context"; that is, in relation to the rest of life. Like a wide-angle camera shot, contextualism takes in the big picture. Of relevance is everything that surrounds and relates to the work of art: the viewer; the artist; the physical setting of the work; the art, culture, and society that gave birth to it. For the contextualist, a full appreciation of *Triumph of the Will* is impossible without information about its director and her creative process, as well as knowledge about Hitler, nazism, propaganda, and Germany in the 1930s. The strong point of the contextualist approach is its ability to expand our understanding of the work in relationship to the larger world. Contributing to this understanding are the research and ideas of art critics and historians, psychologists, sociologists, the viewer, and significant others. In contrast to the reductive focus of formalism, contextualism offers the viewer many ways of looking at and giving meaning to the work of art. Its major limitation, the formalist would argue, stems from its primary concern with facts and theories. In their intellectual enthusiasms, contextualists can often emphasize fact-finding and theorizing to the exclusion of any sensuous response to the work of art.

TOWARD A COMPREHENSIVE APPRECIATION OF ART

Rather than considering formalism and contextualism as mutually exclusive ways of seeing, as incompatible as fire and water, we can recognize that both have a good deal to contribute to a holistic or comprehensive approach to art appreciation. A primarily formal response, akin to the undergraduate student's experience of Monet's *On the Cliffs, Dieppe* (1.1), would appear to be a natural starting place for the appreciation process. With little or no knowledge of Monet or his impressionist style of painting, the student was able to achieve a deeply personal experience of the work based on her own perceptions, thoughts, and feelings. A broader contextual understanding of the work, based on commentary

by the artist, art historians, and social scientists, would build on that initial personal experience, making for an increasingly rich and complex appreciation.

We can apply the formal and contextual ways of seeing to Vincent van Gogh's *The Night Cafe* (1.8) to demonstrate how a combination of these two approaches can bring about a more comprehensive appreciation of art. Although our particular experience of *The Night Cafe* begins with the formalist approach, there is no rule dictating that everyone need employ the two ways of seeing in sequential order. We separate them into such clearly distinct entities and apply them in sequence mainly for the sake of introducing the two modes of appreciation. After mastering the formal and contextual approaches, readers will probably find that they, like the majority of experienced viewers, interweave the two, mixing feeling with fact, sensuous response with intellectual insight and understanding. Ultimately, personal temperament and purpose, cultural background, and the specific work of art determine the nature of each art appreciation experience.

VAN GOGH'S *NIGHT CAFE:* AN APPRECIATION

A Formalist Response. "From a formalist point of view," artist Jerry Coulter (born 1936) explains, "all that is necessary is that we look at the work of art. Knowing who did it or where it came from might be interesting, but it is not necessary to our responding to the work." What is necessary, he insists, is to allow ourselves to respond directly to the formal properties of the artwork, because it is in the line, shape and space, texture, color, and composition that the feeling of the work is contained. What follows is Coulter's own response, in true formalist fashion, to *The Night Cafe*.

The most powerful element in this small painting is color. The color is acidic. It has a strength and intensity that's unpleasant. The light and color that emanate from the room convey tension and unease. One doesn't have to know about van Gogh's personal life or his artistic intentions to feel these emotions. They are embodied in the color relationships [1.9]. The

THE PROCESS OF APPRECIATION

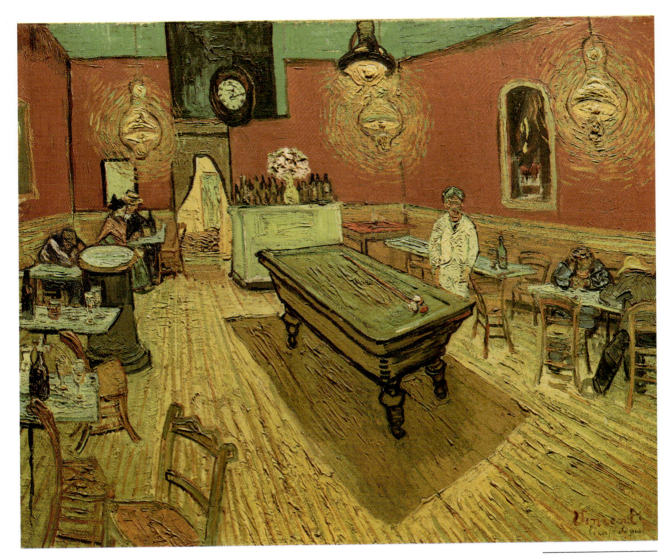

value [light-dark] contrasts in *The Night Café*—from light yellows to dark reds and blue-greens—are very strong although it's not a value-oriented painting in the traditional sense. Then there are the discordant contrasts of the reds against the greens. All of these contrasts create a tension and excitement.

When one looks at the material itself—the way the paint is put on in rough, heavy textures [1.10]—there's a kind of anxiety in it. There's a scratching, almost flailing in some places as opposed to a fluid, tender touching of brush to canvas. And although there is control, there seems to be a psychotic intensity behind it. It's all put down so excitably, scratched into or thrust onto the picture surface.

Animated by the intense, unpleasant color, the space in the painting feels almost claustrophobic. The perspective of the interior leads the eye to a little yellow opening in the back of the room which appears to be electrically hot. It's not the kind of place one would enter to calm down. It has an electric anxiety. The cool blue-green vibrating against that blistering, hot yellow in the opening; they're just incompatible. And that yellow is the brightest, hottest spot in the entire picture. It moves toward the eye although, in terms of a realistic spatial representation, it's supposed to be the area most distant from us. Yet another incompatibility and source of tension.

In keeping with these distortions of space and color, the lines in the back of the painting are as thick and strong as the lines in the foreground [1.11]. That doesn't make sense. So again one gets the feeling that the space is not right. There's something wrong with the space, and although the discrepancies are relatively subtle from a realistic point of view, one feels a tension in it.

1.8 • Vincent van Gogh. *The Night Café*. 1888. Oil on canvas. 28½ × 36¼". Yale University Art Gallery. Bequest of Stephen Carlton Clark, B.A. 1903.

1.9 · Color wheel and
color relationships.

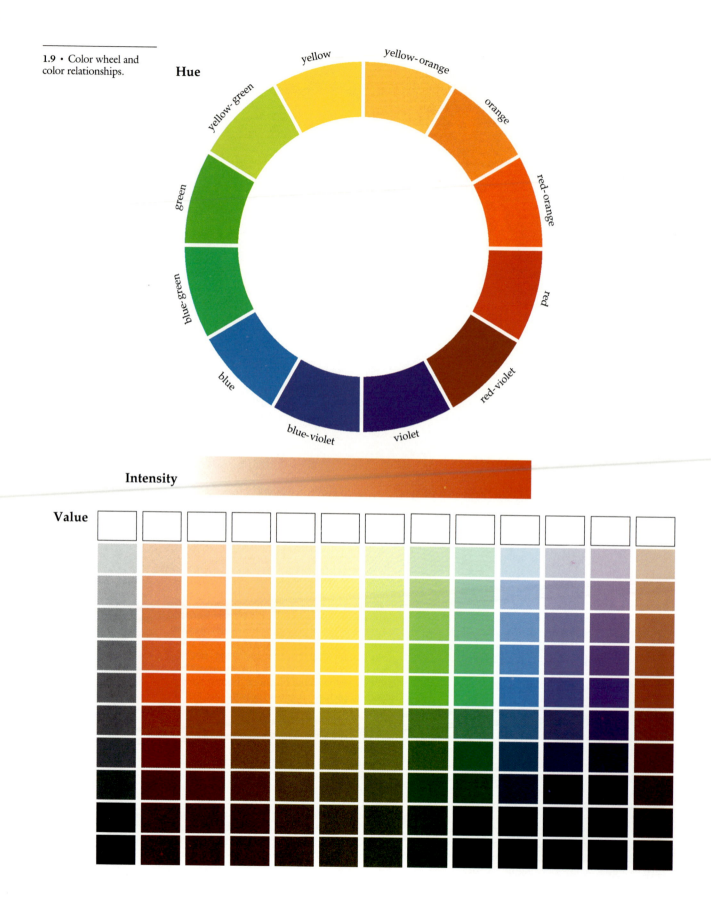

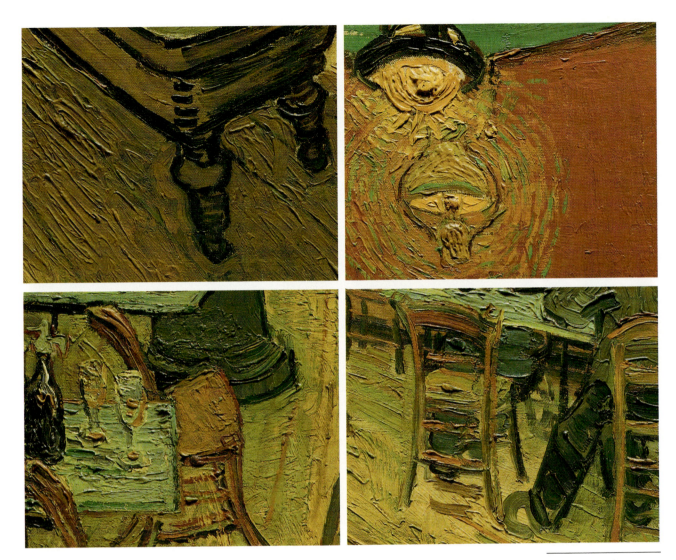

1.10 • Texture in
The Night Cafe.

1.11 • Line in the
The Night Cafe.

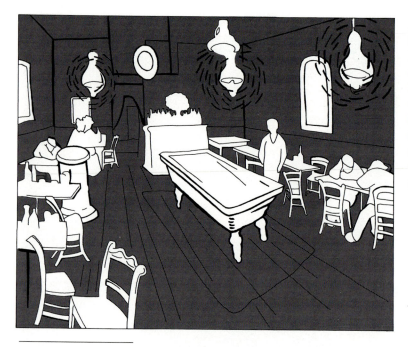

1.12 • Shape in *The Night Cafe*.

Sloping downward at an impossibly sharp angle, the pitch of the floor makes our sense of balance precarious. The shadow under the pool table extends this feeling of unease. It's an oozing, weighty kind of thing. Van Gogh is clearly not trying to depict the actual space of *The Night Cafe*. He's trying to convey the feeling of the cafe, the kind of tension and remoteness human beings can actually feel even when in close proximity to each other.

The shapes [1.12] of the figures displayed in the cafe convey a weightiness; the stiff vertical figure; the hunched drinkers; the lumps of humanity sitting at the tables. They all seem immobilized but filled with tension. Their gestures are not friendly but rather standoffish ones. They lack in ease and naturalness.

The painting's overall composition, characterized as it is by contrast, variety, and a dynamic asymmetrical balance, strengthens the feeling generated by the individual elements [that is, the line, color, texture, space, and shape].

What is really so interesting about *The Night Cafe* is that it is so small [28½ by 36¼ inches] and yet so powerful. I think that's one of the charms of van Gogh's paintings. They're so small and intimate, yet when one is drawn into them, their intensity sends you reeling. That's the kind of tension and psychological power that characterizes van Gogh's art.

A Contextualist Response. Lonely and isolated from his fellow human beings, Vincent van Gogh (1853–1890) (1.13) poured out his most intimate thoughts and feelings in hundreds of letters to a small group of family members and friends. In a September 1888

letter to Theo, his brother and ever-supportive friend, Vincent van Gogh tells of his financial hardship and of a new painting he has recently completed. It is called *The Night Cafe*, and he hopes that his landlord, who is also the cafe's owner and the central figure in the work, will buy it, thereby easing his financial burden. In the excerpt that follows, van Gogh relates the circumstances surrounding the creation of the work, describes the painting in formal detail, and touches on his artistic intentions.

> Then to the great joy of the landlord, of the postman whom I had already painted, of the visiting night prowlers and of myself, for three nights running I sat up to paint and went to bed during the day. I often think that the night is more alive and more richly colored than the day.
>
> Now, as for getting back the money I have paid to the landlord by means of my painting, I do not dwell on that, for the picture is one of the ugliest I have done. It is the equivalent, though different, of the "Potato Eaters" [a dark, powerfully expressive portrayal, painted by van Gogh several years earlier, of poor peasants eating a meal] (9.29).
>
> I have tried to express the terrible passions of humanity by means of red and green.
>
> The room is blood red and dark yellow with a green billiard table in the middle; there are four citron-yellow lamps with a glow of orange and green. Everywhere there is the clash and contrast of the most disparate reds and greens in the figures of little sleeping hooligans, in the empty, dreary room, in violet and blue. The blood-red and the yellow-green of the billiard table, for instance, contrast with the soft tender Louis XV green of the counter, on which there is a pink nosegay. The white coat of the landlord, awake in a corner of that furnace, turns citron-yellow, or pale luminous green.[2]

Through van Gogh's words, the painting takes on additional levels of meaning. As we learn more about the painting, the artist, and his world—the context of the work—our appreciation of *The Night Cafe* grows. It is very much like a relationship with another person. The more we learn about someone else, the better we understand and appreciate that person. Our appreciation of *The Night Cafe* likewise grows as we learn more about van Gogh's artistic intentions:

> In my picture of the "Night Cafe" I have tried to express the idea that the cafe is a place where one can ruin oneself, go mad or commit a crime. So I have tried to express, as it were, the powers of darkness in a low public house, by soft Louis XV green and malachite, contrasting with

yellow-green and harsh blue-greens, and all this in an atmosphere like a devil's furnace, of pale sulfur.[3]

Locating the artist and work in a larger social and historical context, art historian Werner Haftmann increases our intellectual and emotional intimacy with van Gogh and *The Night Cafe*. Haftmann writes:

> In February, 1886, Vincent van Gogh came to his brother Theo's shop [a Paris art dealership]. Gaunt, awkward, red-headed, highly-strung, he took everyone but himself for a genius. Given to dreams of universal brotherhood and love he met with indifference everywhere.
>
> What brought him to painting in the first place was his overflowing love of things and his fellow men. He had been an unsuccessful sales-man in an art gallery, and then a lay preacher in the Belgian coal mining region. He had always been drawn to men. He was a great Christian; though a religious dilettante, he was one of the "poor in spirit" mentioned in the Gospels. Throwing himself wholeheartedly into his mis-sion, he had lived with the wretched miners of the Borinage as one of them. For that reason, the religious authorities had forbidden him to preach. But a man of his stamp had to do some-thing to express his love. And so van Gogh took up drawing.[4]

By 1886 his journey into art had brought him to Paris and put him in contact, through Theo, with the most advanced artists and ar-tistic approaches of the day. There he took on the free, bright palette of the impressionists, individuals such as Monet, painter of *On the Cliffs, Dieppe* (1.1). But his nature forced him to go deeper than the impressionists. His struggle was to get beyond the surface ap-pearance of things to a second, artistic reality that extended deep into the soul. A slight dis-tortion of visual appearance, he discovered, could reveal human depths and bring forth spiritual realities. Through the expressive use of color and line, he learned to convey a broad range of spiritual states. In *The Night Cafe*, for example, he was able to express "the terrible human passions" that previously were repre-sented only by facial expression and bodily gesture. "In painting the cafe at Arles at night," Haftmann writes, "Vincent again en-hanced and modified the colours, 'in order to show that this is a place where a man can lose his mind and commit crimes . . . an atmos-phere of a glowing inferno, pale suffering, the dark powers that rule over sleep.' Colour and

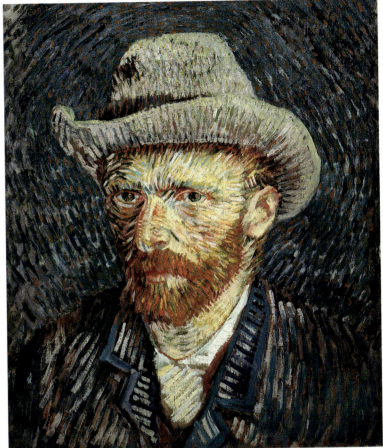

1.13 • VINCENT VAN GOGH. *Self-portrait with Gray Hat*. 1887. Oil on canvas. 17¼ × 14¾″. Vincent van Gogh Foundation/National Museum Vincent van Gogh, Amsterdam.

line became for van Gogh a bridge to the realm where objects are signs, conveying messages from man's inner world."

Much more could be learned about Vincent van Gogh and *The Night Cafe*. Psychologists, sociologists, and others might add their per-spectives. The appreciative experience can al-ways be enlarged. But the point is this: We enhance appreciation of works of art by using the formal and contextual modes of seeing in a complementary manner. The resulting ex-perience is richer and more complex. If the two are artificially kept apart, as they some-times are, then we, the viewers, are the losers. In the chapters that follow, we place a con-sistent emphasis on the formal and the con-textual, the visual form and the cultural mean-ing of works of art. We begin our journey with those "worlds of art" with which we are most familiar: Chapter 2 introduces fashion and al-bum cover design, whose visual forms and cultural meanings are very close to all of us.

APPRECIATION 1

Hale Woodruff, *Interchange* and *Dissipation* from the mural series, *The Art of the Negro*

EUGENE GRIGSBY, JR.

Hale Woodruff, although not widely known to the general public, was recognized by colleagues as a major artist, by students as a master teacher, and by friends and associates as a warm, friendly person with a ready smile and a willing handshake. Born in Cairo, Illinois, in 1900, Woodruff overcame poverty and racial discrimination to become a prominent figure in America's artistic and intellectual communities. The initial support of his mother, a domestic servant, and his own hard work and desire to become an artist boosted him in his climb to success as a painter and professor at Atlanta University and at New York University.

A man with a deep sense of humanity, Woodruff was one of those rare individuals everyone seems to like. Yet in spite of his calm, easy-going manner, he was an intense person, and this intensity is reflected in the dynamic quality of his work.

One of the best examples of his work is the six-panel mural, *The Art of the Negro*, created between 1950 and 1952 for Atlanta Univer-

Eugene Grigsby, Jr., is professor emeritus of art and art education at Arizona State University and a founder of the Committee on Minority Concerns of the National Art Education Association. He is also a professional artist and author of Art and Ethnics, *published in 1977 by the William C. Brown Company.*

sity's Trevor Arnette Library. Painted in oil on canvas, two of the panels, *Interchange* (Fig. A) and *Dissipation* (Fig. B), show the range of design and feeling in Woodruff's work: from the cool, solid, and classically structured, to the hot, frenzied, and rhythmically dynamic. They also show his concern for understanding cultures and his particular love for African art. *Interchange* depicts the sharing of knowledge between Greek, African, Roman, and Egyptian scholars in ancient times. In contrast, *Dissipation* shows Europeans attempting to destroy African culture by destroying its sculpture. Author Gylbert Coker makes this comparison:

> *Interchange* offers Woodruff's feelings about the exchange . . . that has taken place over the centuries between . . . culture[s]. In the center top area of this panel, Woodruff has created a symbolic image of what he considers to be the four major cultural influences on Western art . . . — Greek, Roman, Nigerian, and Egyptian. . . . [Note the symbolic architectural columns of the four different cultures and related sculptural forms.] Around this symbol he places all the artisans of antiquity exchanging new concepts and ideas.
>
> *Dissipation* . . . begins the attack on the culture of Africa. By dramatically using the burning of Benin, the capital of Nigeria, by the British, Woodruff . . . focus[es] on the waste and loss of a people's culture through the blind looting and destruction of their art.

In *Interchange* the artist plays contrasting shapes and colors against one another to make a telling visual and symbolic statement: Dif-

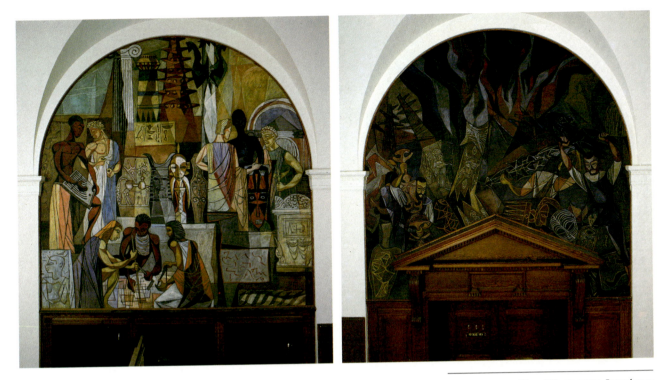

Appreciation 1 • HALE WOODRUFF. *Interchange* and *Dissipation*, mural panels two (left) and three (right) from *The Art of the Negro.* 1950–1951. Oil on canvas. 144 × 144″, respectively. Courtesy Clark Atlanta University, Atlanta, Ga.

ferent people and cultures (like different colors and shapes) might contrast but still interact harmoniously. Woodruff conveys a sense of solidity and harmony by the balancing of straight lines, strong verticals and horizontals. Adding to the sense of orderly interchange between peoples, colors, and shapes, Woodruff uses the composition of the painting to lead the eye, step by step, through the three groups of artisans and scholars to the African masks and Greek horse in the center and then to the columns above. The overall composition is pyramidal; the eye moves upward and inward from the broad base to a point just above the center columns. Adding to the quiet dynamism of the picture, the gentle curve of the architecture that forms the top of each panel contrasts with the straight lines and square shapes of the modules that overlap and intersect in the painting.

Visually, *Dissipation* gains strength and tension from dynamic diagonals, rippling with rhythmic movements. African masks and sculptures crisscross in and above the hands of the European destroyers. Rich colors animate the patterns of design. Whereas the quiet and composure of *Interchange* evoke calm reflection, the composition and content of *Dissipation* angrily admonish the Europeans for trying to destroy a culture, suggesting that the masks and sculpture of Africa will survive the looting and outlive the flames. ∎

Chapter 2

Form & Meaning in the Everyday World

It's a great misfortune that the majority of people do not recognize artistic form and meaning in their everyday surroundings, for example, in fashion, commercial art, the built environment. It is also a testament to the effectiveness of an art education system that defines art in the narrowest of terms. According to the definition of art that predominates in our culture, only those objects housed in art museums or belonging to the elite category known as "fine art" qualify as worthy of serious viewing. In reality, the dividing line between fine art and other forms of art (for example, applied, popular, or folk art) is far from distinct. What was folk art or a functional object centuries ago might now qualify as fine art and be housed in the most exclusive collections. To believe that only those works of art exhibited in major museums or reproduced in art history texts are worthy of serious attention is a clear sign of either tunnel vision or faulty reasoning. We need more unprejudiced looking and open-minded reflection. There is a vast range of aesthetically and humanly important art in the contemporary world. If we give it

our careful consideration, it will offer us significant experiences in return.

FASHION DESIGN: THE PRESENTATION OF SELF

The Aesthetics of Punk: The United States 1983. Hand in hand, they walk across campus in tough military attire, spiked bracelets, and severe hairstyles that evoke stares and sneers.

Some people have the ability to capture attention. Punk-rock couple Joe and Kathy (2.1) do just that. Other students, intrigued with the couple's appearance, display several reactions. The most common is "surprise and shock," according to 21-year-old Kathy. "Another is curiosity," says her partner Joe, also 21. "They would like to know what our deal is. They say, 'How can they dress that way?'"

The answer: "We like punk rock. We like the music, the attitude, the clothes, and we dress up." And their image has given them widespread recognition. "I was just another faceless person. Now they definitely know

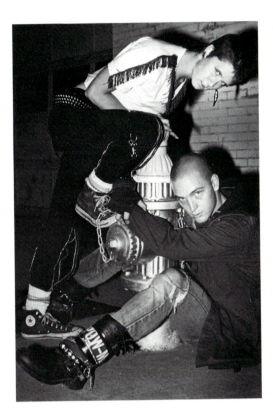

2.1 • YO NAGAYA. *Untitled.* 1983. Black and white photograph.

expression of alienation, a source of new personal identity, or a way to capture attention. One middle-class punk stylist put it this way: "Everyone is such a clone of everyone else, dressing the same, acting the same. I wanted to be unique. I had to break out, be expressive, different." As the style, with its look of danger and excitement, penetrated outward, even the world of high fashion took note (2.2).

The punk image is certainly compelling. It demands attention. Sharp metal objects are pinned to or laid over rough, torn fabrics and black leather. Chains and metal-studded leather belts, bracelets, and collars wrap around waists, wrists, ankles, necks. Knifelike earrings and safety pins pierce the ears. The hair is often cut severely short or worked up into a "spiked" style.

Extreme value contrasts of white against dominant black characterize the look. The metallic glint of silver stands out against pale skin or black leather. Color is minimal but glaring. Phosphorescent orange, purple, or red used in hair, makeup, or accessories send out jolts of color from the surrounding darkness. These are the colors of rock concert lighting and urban neon in the night.

The lines and shapes of punk are angular and irregular, disrupted by pieces torn off or

who I am," Kathy explains. Although they are not about to assault anyone, their image is aggressive, ominous. "We do dress pretty nasty sometimes," admits Joe. "I think we frighten people. They don't know what we're gonna do."

Fashion design may be a multibillion dollar industry, but, as Kathy and Joe demonstrate, it is also an intimate form of self-expression. Encompassing clothing, accessories, hairstyling, and body language, the style in which we dress tells the world at large who we think we are—or at least who we would like to become. The visual images that we present in public, designed by ourselves in living color, texture, and shape, express the most eloquent of personal and social messages, from "Please accept me" to "Steer clear." As a form of moving sculpture, fashion is truly our second skin.

Born in working class England in the mid-1970s, the punk fashion style was a second skin for young people in many parts of the world. Its hard, defiant look, born of the grim realities of unemployment and low-income life-styles, became for more affluent youth an

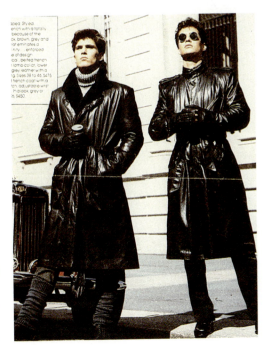

2.2 • Menswear advertisement, 1982. Courtesy Macy's, New York.

2.3 • Donovan. 1969.
Black and white
photograph.

2.4 • "The Conservative
Student." 1985.

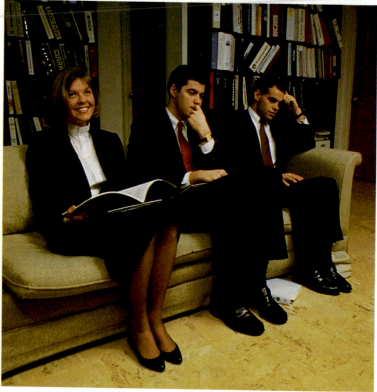

objects added on. The exciting diagonal holds sway over more stable horizontals and verticals. Asymmetry is the compositional rule. One sleeve is cut higher than the other. Buttons, pins, tufts of hair are arranged in conscious disregard for classical order and balance. Completing the image, a specifically punk facial expression and body language—taut, bound up, coldly explosive—accompany the clothing style.

What is so surprising is how utterly different this countercultural appearance is from the one that preceded it. Both the hippie style of the 1960s and the punk style of the 1970s are defiant statements of alienation from the dominant culture, yet the two are worlds apart in the values they communicate. Whereas hippie dress (2.3) reflects naturalness, celebration, and the flow of human feeling, streetwise punk sneers at such romantic ideals. Peace? Love? No chance. In the concrete jungle, wisdom takes the form of a razor blade. Punk magnifies in its forbidding motifs the violence, emotional estrangement, and physical harshness of the urban landscape. The countercultural image of the 1960s embodied a springtime vision of a budding cosmos, in which enlightened souls were claiming their heritage of freedom, transcendence, and harmony with nature. Punk grew out of and reflected the agonizing despair of an economic and social prison. For the young working-class people who created the style, reality was a hell in which the ruling class, according to punk songs, had "Complete Control," where the young searched in vain for "Career Opportunities," where the final report card said "No Feelings." They, and others who adopted the style, were making a bid for existence.

Business Dress: Classicism versus Romanticism. Business dress (2.4) certainly embodies everything that punk and hippie are not. The latter are **romantic** styles suffused with feeling, imagination, and sensuousness; by contrast, the business style is dignified and restrained, with a tradition-bound **classical** line befitting the commercial middle class that has led Western society for over two centuries. In the perennial confrontation between **romanticism** and **classicism,** the business world has consciously identified itself with the classical

tendency and its principles of formality and order. This choice was moral as well as aesthetic in that all visual designs embody and express a particular world view, a specific system of values and beliefs. In the case of today's business outfit, image and ideology, form and content are perfectly matched.

Clean, crisp lines and an unambiguous contour dominate the business suit. Stable horizontals and commanding verticals communicate firmness and calm. The ever-present rectangle and its triangular counterpart emphasize the precision and purity of geometric forms. Ever idealistic, classical art concentrates on form rather than texture, on line rather than color. The classical approach, writes art historian Hugh Honour, is "cerebral," derived from a belief that art should appeal to the mind rather than the senses, that artistic problems should be solved not by emotional inspiration but by intellectual analysis. Classical art of all periods, Honour affirms, has eschewed coloristic and textural effects not only because of their superficiality but also because they could be apprehended only through the senses, the most imprecise of our body's receptors.

According to art historian Walter Friedlaender, the real battle between classicism and romanticism was between discipline and morality on one side and amoral slackening of rules and subjective irrationality on the other. For the orthodox classicist, Friedlaender writes, "line and linear abstraction embodied something moral, lawful, and universal, and every descent into the coloristic and irrational was a heresy and a moral aberration that had to be strenuously combatted." The French artist, Jean Ingres (1780–1867), the nineteenth century's self-proclaimed protector of classical line and moral order, fulminated that the colorful, boldly brushed painting of his romantic rival, Eugène Delacroix (1798–1863), was the work of the devil himself. "It smells of brimstone," he said. Their respective portraits of the violinist Paganini, both admirable works of art, elucidate some of the basic differences between the two tendencies. Ingres's classical portrait (2.5) is characterized by clarity of line and form, a stately pose, and emotional restraint, the same qualities that characterize business dress. Delacroix's romantic portrait (2.6), in comparison, is a painterly rendering

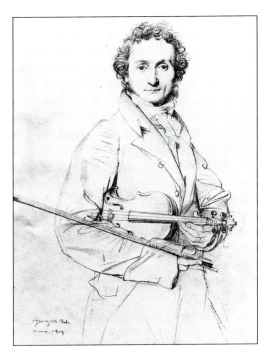

2.5 • JEAN-AUGUSTE-DOMINIQUE INGRES. *Paganini*, 1819. Drawing. 12 × 8½". The Louvre. Paris.

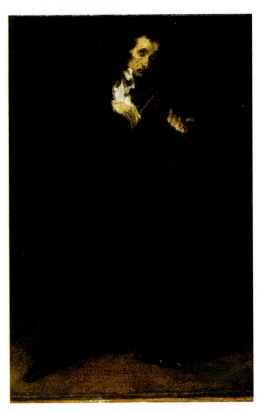

2.6 • EUGÈNE DELACROIX. *Paganini*, 1831. Oil on cardboard. 17⅝ × 11⅞". The Phillips Collection, Washington, D.C.

filled with motion and unrestrained emotion. Unposed, the violinist is depicted in the passionate act of musical creation. Contemporaries considered Paganini to be a performer of almost magical ability, and Delacroix shows him in this vein: mysterious, spectral, emerging from the darkness, face and hands aglow in hues of whitish yellow. In keeping with his romantic persona, Paganini's hair is tousled and his clothing loose-fitting. The fashion look is one of flowing freedom: lines meander and blur; irregular shapes meld together. Each fashion style, and each style of portrait painting, reflects a different moral and aesthetic outlook.

The severely classical dress of the rising European middle classes of the seventeenth and eighteenth centuries—the English Puritans, Dutch burghers (2.7), revolutionary French bourgeoisie (2.8)—shows us how fit-

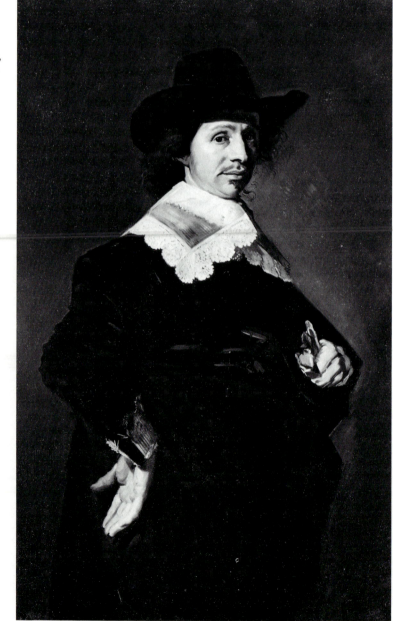

2.7 • Frans Hals. *Portrait of a Man (Paulus Verschuur).* 1643. Oil on canvas. 46¾ × 37″. The Metropolitan Museum of Art, New York. Gift of Archer M. Huntington in memory of his father, Collis Potter Huntington, 1926.

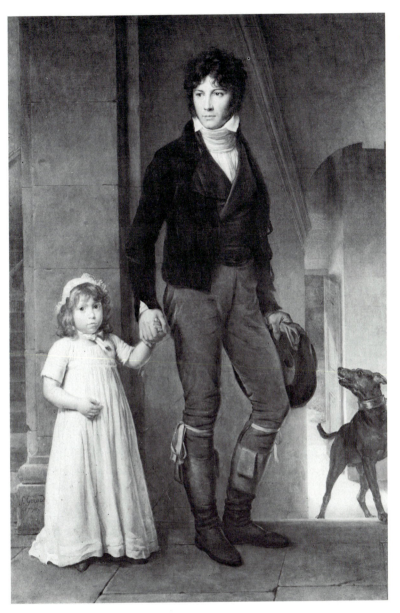

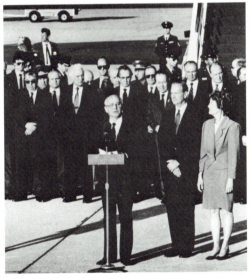

2.8 • FRANÇOIS GÉRARD. *Jean-Baptiste Isabey and His Daughter.* 1795. Oil on canvas. 77 × 51¼". The Louvre, Paris.

2.9 • Mikhail Gorbachev, President of the Soviet Union, and James Baker, U.S. Secretary of State. 1990.

ting was the wedding of classicist aesthetics and middle-class morality. For over two centuries, the business dress of our economic and political leaders has reflected the stoic side of classicism. Today's business outfit (2.9) remains an idealized expression of smoothly functioning technocratic operation: rational, impersonal, rule-laden. No surprises or distractions are welcome in the way of bold colors, eye-catching shapes, sensuous textures, or dynamic asymmetrical balances. In the service of aesthetic and organizational unity, strong contrasts are proscribed in favor of close or matching relationships. Covering up the entire body with the exception of the hands, neck, and head, the business image transmits a nonsensual look of cool, "masculine" intelligence.

Informed by the middle-class work ethic and spirit of technocracy, the classic business look has conquered the world. The leaders and white-collar followers of capitalism and socialism, dictatorship and democracy, embrace its style with equal fervor. Masking individual, class, and ideological differences, the look is recognized worldwide as a symbol of power.

The French Revolution in Fashion

PAM SCHUELKE JOHNSON & ROBERT BERSSON

As a decorative and functional art form, fashion expresses who we are, what we believe in, and where we stand in the social scheme of things. An article of clothing can give us a glimpse into the structure, technological accomplishment, and spirit of a society. Even more can be revealed through a study of the fashion styles of the day. A dramatic example is the fashion styles in the decades prior to the bloody French Revolution. These fashions reflect a sharply stratified society smoldering with class conflict. A small aristocratic minority, extravagantly attired from head to toe, held sway over a rising middle class and a vast, impoverished working class. Threatened by the growing economic and political power of the bourgeoisie, worker discontent, and the cultural challenges of liberal European Enlightenment thinkers, many French aristocrats deepened their commitment to fashion as a clear display of their social superiority. The excessive decoration and frivolity of aristocratic costume (Fig. A) spoke volumes about hereditary wealth, conspicuous consumption, and privileged leisure. Splendidly at odds with the demands of workshop and field, aristocratic fashion asserted that its wearers could hire others to toil for them.

Women of noble birth (Fig. B) were willing to pursue monstrous extremes, especially for court occasions, to keep up with the latest styles and to distinguish themselves from their affluent middle-class counterparts. Powdered hair, sculpted into a cornucopia of forms, rose to heights of up to three feet. Dresses, supported on elaborate metal frames called *paniers,* ballooned outward. Upon them were festooned every form of ruffle, pleat, button, and bow. While the dresses billowed outward, corsets brutally pinched in the waist and breasts to achieve the "perfect" silhouette. In what one contemporary costume designer called "an almost demented preoccupation with the sporting of wealth," ladies "of quality" came to look like oversized wedding cakes with all the pastry-tube trimmings.

With the violent overthrow of the old order, aristocratic fashion was radically exorcised. Rallying to the cry of "liberty, equality, and fraternity," the new society sought to integrate its revolutionary values into every sphere of activity, especially those in the public eye. Clothing, hair styles, and even bodily movement in the Directory Period (1795–1799) would convey the spirit of the new order, bourgeois governed, worker supported, and modeled on the liberating cultural ideals of the European Enlightenment and the classical world of ancient Greece and Rome. (The visual style that grew from these Enlightenment and ancient classical ideals would come to be known as **neo-classical** or "new classical" and would manifest itself in architecture [6.34, 6.35], product design, sculpture [6.30], and painting [8.41] as well as the decorative art of fashion.)

Revolutionary ideology had declared war

Pam Schuelke Johnson is a teacher and resident costume designer in the Theater Department of James Madison University, Harrisonburg, Virginia. She is also a fiber artist and creator of wearable art.

on the fetters and chains imposed by the tyranny of aristocratic costume: corsets, *paniers,* wigs, high heels, powder, beauty spots, and ribbons. These stood as hated symbols of the *ancien régime* and had to be expunged at all costs. A more uniform dress was adopted that, in accordance with the ideals of equality and fraternity, would draw little distinction between the classes: for the men, the sober bourgeois fashion; for women of means (Fig. C), extreme simplicity influenced by the naturalness of ancient Greek and contemporary English fashions. Enlightenment ideals of simplicity, industry, and rational seriousness were widely embraced in the culture and conveyed in the dress.

(continued)

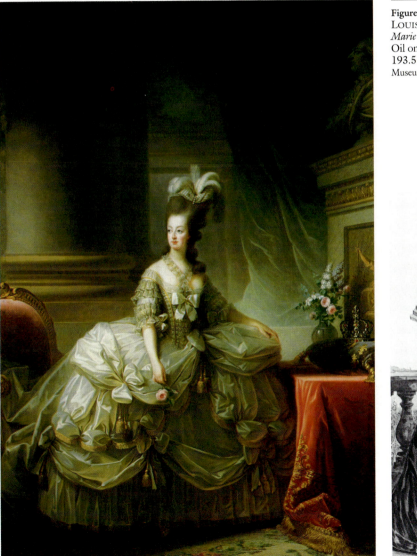

Figure A • ELISABETH-LOUISE VIGÉE-LEBRUN. *Marie Antoinette.* 1778. Oil on canvas. 273 × 193.5 cm. Kunsthistorisches Museum, Vienna.

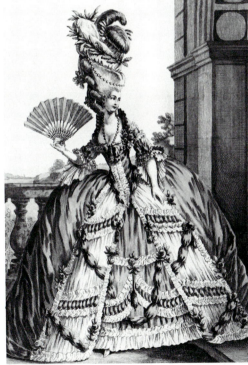

Figure B • ETIENNE CLAUDE VOYSARD, after Desrais. *Young Woman of Quality Wearing Victory Headdress.* From Nicholas Dupin, *Les Costumes François . . .* , Paris. 1776. Etching. Print Collection. Miriam & Ira D. Wallach Division of Art, Prints and Photographs, The New York Public Library, Astor, Lenox, and Tilden Foundations.

Male clothing of the Directory Period [2.8] settled into the convention of dark coat, light waistcoat, and skin-tight breeches or stockinette pantaloons, not very unlike the modern business outfit of dark suit, vest, light shirt, and tie. Just as feminine dress displayed the natural figure and ease of movement for the first time in almost four hundred years, so too did masculine dress. In keeping with the ideal of naturalness, hair styles were contrived which were shorter and simpler, with locks falling over the ears.

Interestingly, a key article of the evolving bourgeois business outfit came from working class "fashion." The dress of the revolutionary French workers (Fig. D), highly functional but filled with patriotic colors, made itself felt in the Directory Period in several ways, one of the most lasting being the adoption by a wider public of proletarian trousers or *sansculottes.* For certain bourgeois intellectuals, the wearing of this obviously utilitarian garment stood as a bold, style-conscious symbol of identification with the oppressed, as well as a statement against the old feudal order and its exploitive life of leisure. ∎

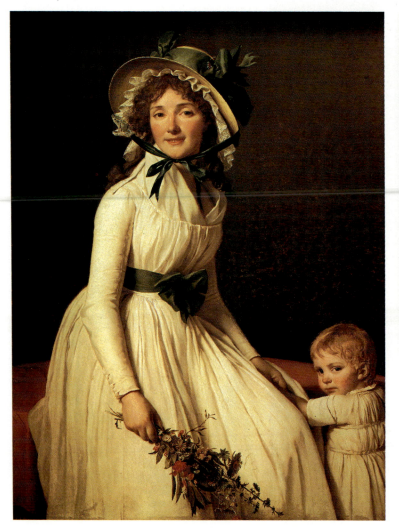

Figure C • JACQUES-LOUIS DAVID. *Madame Sériziat.* 1795. Oil on wood. 51 × 38″. The Louvre, Paris.

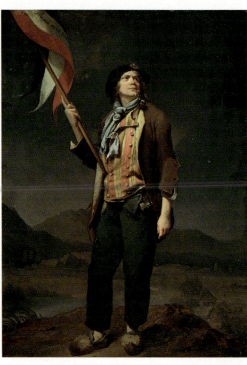

Figure D • LOUIS-LÉOPOLD BOILLY. *The Actor Chenard as a Sans-Culotte.* 1792. Musée Carnavalet, Paris.

ALBUM COVER DESIGN: AN ARTISTIC MELTING POT

Cutting across age, class, and cultural lines, music albums are collected by vast numbers of people in both the industrial and third-world nations. Many own scores, if not hundreds of albums, making record, stereo cassette, and compact disc covers perhaps the most collected art forms in history. Every possible subject is represented in these album covers, which include the widest range of popular, folk, and fine-art imagery. Images and styles derived from fashion photography or comic books interweave freely with those from the world of fine art. Whether considered commercial art, popular art, folk art, or even fine art, the album cover is a fascinating hybrid, a true melting pot of images, styles, and functions.

At root, album covers are promotional packages designed to protect and sell the music inside. Yet the product they sell makes them very different from cigarette packs, cereal containers, or detergent boxes. Designers began to understand this shortly after the first 33⅓ RPM long-playing records rolled off the presses in 1949. Designing the new promotional package was a more complex problem than giving credibility to the super-duper car, thirst-killer soda pop, or never-ending tube of lipstick. The challenge was to package the personal creations of living artists who were highly concerned about their own image and their own message on their own product. Conveying the wonders of a sparkling cola was one thing; capturing the individuality of the musicians and their music was quite another. What was clearly needed, and what was first seen in the jazz albums of the 1950s and rock albums of the 1960s, was the beginning of a new consciousness about the dialogue that had to exist between the designer and the music maker.

The Jazz Album Pioneers. The pioneering jazz covers of the 1950s and 1960s exemplified this dialogue between cover designer and music maker. The results, at their best, were covers that communicated a great deal about the musicians and their music, pioneered graphic design breakthroughs, and set artistic standards that would influence the industry for years to come. The designers of these covers, often freelance artists working for small, independent companies, aspired to conscious artistic statement rather than advertising appeal.

Unlike the major record corporations, the smaller companies were more concerned with making high-quality jazz recordings available than with generating huge profits. Album cover designers Roger Dean and David Howells note that "there is a certain serious quality about jazz, as if the artists involved were very genuine, full of integrity, and thus unwilling to indulge in meaningless razzmataz or outrageous hype. Jazz was (and still is) untainted by commerciality or crass salesmanship." Jazz covers, in general, reflect these values. Commercial exploitation of sex, violence, glamour, and glitter, the common currency of many pop music covers, is largely absent from jazz album design. Moreover, the early designers of jazz albums set themselves some dauntingly ambitious artistic challenges, probably the most difficult of which was the explicit representation of music in visual imagery.

Most album covers, whatever the category, do not attempt a visual representation of the music inside the sleeve. Instead, they show portraits of the music makers. These portraits reflect the widest range of artistic interpretation and, at their most successful, are very penetrating (2.10). Almost as numerous as the portrait covers are those that build a design

2.10 • Gustav Mahler. *Symphony No. 9.* 1980. James Cook, designer. © Columbia Records. Courtesy Sony Classical U.S.A.

2.15 • ROY
LICHTENSTEIN. *Whaam!*
1963. Acrylic on canvas.
1727 × 4064 mm. The
Tate Gallery, London.

phy, and illustration with a form of music and a musical audience that was self-consciously "progressive." The racially mixed jazz audience, primarily intellectuals, artists, and bohemians, wanted information from the covers, but they also wanted style. They got both, as avant-garde sounds were transformed into avant-garde imagery. The quality and invention of these pioneering covers were not to be matched until rock music gained a sense of its own relevance in the 1960s.

The Pop Music Explosion. "A pop explosion," writes music critic Greil Marcus, "is an irresistible cultural upheaval that cuts across lines of class and race (in terms of sources, if not allegiances), and, most crucially, divides society itself by age."

> The surface of daily life (walk, talk, dress, symbolism, heroes, family affairs) is affected with such force that deep and substantive changes in the way large numbers of people think and act take place. . . .
> Enormous energy—the energy of frustration, desire, repression, adolescence, sex, ambition—finds an object in a pop explosion, and that energy is focused on, organized by and released by a single, holistic cultural entity.[1]

In America in 1964 "the entity" was rock and roll, and the Beatles were its first principle and shining exemplar. The rock music explo-

sion of the mid-1960s galvanized individuals into groups, fans into audiences, and young people into a generation. Rock music pulled into itself, reflected, and affirmed with surging power the idealistic and rebellious yearnings of 1960s youth.

Calling for love, peace, and freedom in an America torn by presidential assassination, civil rights struggle, and escalating war in Vietnam, rock music tapped a wellspring of youthful passions. Inspired by the pop explosion, young people began to act with an irrepressible conviction that they could change themselves and the world. Growing rebellion, led mostly by people under thirty, swelled on the sexual, psychedelic, and political fronts. In a decade of confrontations with "the system," rock musicians became the poet-heroes and messengers of a generation, the central nervous system and communications center of the insurrection.

With young people buying long-playing records in the millions, record company executives were compelled to give rock musicians free rein over their sounds, lyrics, and packaging of their albums. Pop stars worked closely with album designers of their own choosing to convey the musician's unique look and message to an audience hungry for both music and imagery. The traditional, celebrity-style pop star portrait (2.16), a formulaic

straitjacket, was scrapped and rapidly replaced by the most personal and idiosyncratic of visual imagery. Album designers needed new styles, subject matter, techniques, and a whole new spirit of freedom and experimentation to keep up with the musicians and the times. To survive in the rock record design field, wrote one graphic artist, the designer had to be "fast, eclectic, flexible, and original" with "a broad vocabulary of popular [and, we could add, fine-art] forms of the past and present."

If the new rock or pop album cover was any one thing, it was eclectic, a potpourri of form and content. As with their music, the Beatles led the way. Moving quickly beyond the straightforward portraiture of the 1963 album *Please Please Me,*, unusual camera angle notwithstanding, covers of Beatles albums beginning with the 1964 *A Hard Days Night* (2.17) quickly became unique artistic events. Formal influences came from diverse sources: from psychedelic and pop culture, fine art, and the dramatic fashion photography of Robert Freeman. Techniques for creating the images ranged from drawing, collage, sculpture, and assemblage to all manner of photographic manipulation. Subject matter was similarly encompassing, from the maximal pop theater of *Sgt. Pepper's Lonely Hearts Club Band* (2.18) to the minimal all white cover of the *White Album*. Walls of convention came crashing down. After 1963 the pop album became an increasingly dynamic hybrid. The liberating effects would be felt in every musical category of album cover design.

Pop Album Covers and Fine Art. That fine art came to play a substantial role in a form of popular culture may at first seem surprising. However, when one considers the eclectic, all-encompassing nature of pop music, the art school connections of many pop musicians, and the fine-art backgrounds of most commercial designers, the fine-art influence in the design of album covers becomes comprehensible. Certain pop album covers are the work of established fine artists. Covers by Peter Blake, Richard Hamilton, and Andy Warhol, for example, for the Beatles (2.17, 2.18) and Rolling Stones (2.19) have become familiar to pop fans throughout the world. Robert Rauschenberg, a master of juxtaposition and

2.16 • Johnny Mathis. *More: Johnny's Greatest Hits.* Photo: Wallace Seawell of Paul Hesse Studio. © Columbia Records/CBS, Inc.

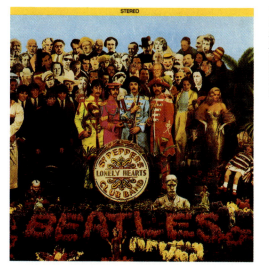

2.17 • The Beatles. *A Hard Day's Night.* 1964. Robert Freeman, designer. Parlophone. © Apple Records, Inc.

2.18 • The Beatles. *Sgt. Pepper's Lonely Hearts Club Band.* 1967. Peter Blake/ Jann Haworth, designers. Photo: Michael Cooper. Parlophone. © Apple Records, Inc.

2.19 • The Rolling Stones. *Sticky Fingers.* 1971. Andy Warhol, designer. Courtesy and © Musidor BV/RZO, Inc.

collagelike combination, has combined both record and cover into a multilayered work of art (2.20). Covers by musicians with art school backgrounds include those by Joni Mitchell, David Byrne, and Brian Eno. Like her music, Mitchell's visual style ranges widely; the surreal fantasy vision of *Hejira* (2.21) is but one compelling example. Byrne's *More Songs about Buildings and Food* (2.22) is an expressionistic portrait of urban unease, the band members locked into and fractured by an imprisoning grid. An early leader of "art rock," Brian Eno creates an interplay of evocative shapes and indeterminate spaces in *My Life in the Bush of Ghosts* (2.23). Its forms and colors are the re-

2.20 • Talking Heads. *Speaking in Tongues.* 1983. Robert Rauschenberg, designer. Original printed illustration art (left) and one of three color layers (right) used for album package. © Sire/Warner Brothers Records.

2.21 • Joni Mitchell. *Hejira.* 1976. Joni Mitchell, designer. © 1977 by Elektra Entertainment.

2.22 • Talking Heads. *More Songs about Buildings and Food.* David Byrne, designer. © Sire/Warner Brothers Records. 1978.

2.23 • Brian Eno/David Byrne. *My Life in the Bush of Ghosts.* 1981. Brian Eno, designer. © E.G.

2.24 • G. F. Handel. *Messiah Highlights.* 1962. Sir Adrian Boult conducting the London Symphony Orchestra and Chorus. © Decca/The London Recording Company.

2.25 • SANDRO BOTTICELLI. *The Birth of Venus. ca* 1480. Tempera on canvas. 5′ 8″ × 9′ 1″. Galleria degli Uffizi, Florence.

2.26 • The Grateful Dead. *Skeletons from the Closet.* 1974. John van Hamersfeld and Bob Seidemann, designers. © Warner Brothers Records.

sult of video manipulation, a growing source of imagery for both album covers and music videos.

Works of fine art such as Michelangelo's *Pietà*, reproduced with straightforward distinction on many classical music covers (2.24), are rarely seen on pop albums. However, pop album designers do not hesitate to quote from, spoof, or transform fine-art styles and masterpieces when it suits their purposes. The goddess Venus—from Botticelli's famous Renaissance painting (2.25)—makes an appearance with the Grateful Dead's *Skeletons from the Closet* (2.26). Meanwhile, Pablo Picasso's *Three Musicians* (2.27) is resurrected in a jazzy,

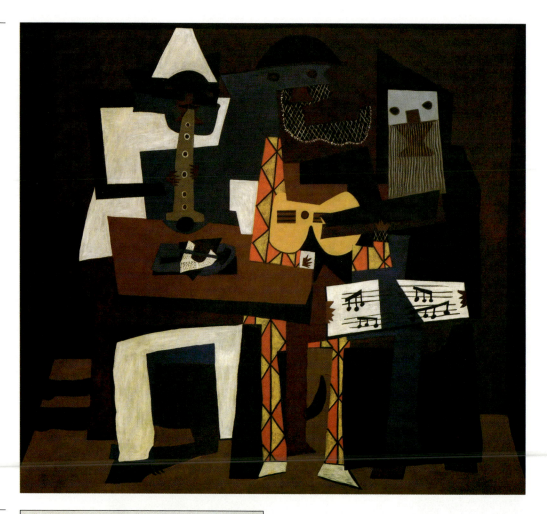

hyped-up style in *Me and Mr. Sanchez* (2.28) by Blue Rondo a la Turk.

The influence of almost every major modern art movement, artist, and style can be seen in the kaleidoscopic world of the pop cover. Underlying many a punk cover (2.29) is the anarchic spirit and aggressive collage technique of the early twentieth-century art movement known as **dada** (2.30). Russian **constructivist** design from the Revolutionary period (2.31) provides a fitting aesthetic framework for *A Different Kind of Tension* (2.32), an album by the Buzzcocks, a left-oriented British band. *Compass Points* (2.33), by Jamaican reggae artist Desmond Dekker, honors the warm, organic vitality of the abstract designs made from cut paper (2.34) by the French master Henri Matisse.

In this age of information and mass-market consumerism, all images and styles seem fair

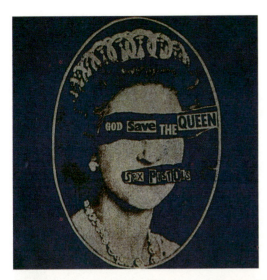

2.29 • Sex Pistols. *God Save the Queen*. 1977. Jamie Reed, designer. © Virgin Records.

2.30 • RAOUL HAUSMANN. *Head (ABCD)*. 1923. Collage. 15⅜ × 10½″. Musée National d'Art Moderne, Paris.

2.31 • EL LISSITZKY. *Beat the Whites with the Red Wedge.* 1919. Colored lithograph/ poster. 63 × 52 cm. The Lenin Library, Moscow.

2.32 • Buzzcocks. *A Different Kind of Tension.* 1979. Malcolm Garret & Accompanying Images, designers. Courtesy and © EMI Records Ltd.

game for the pop album designer. Past and present, elite and popular, noble and ignoble, all find a home on the pop music cover. In its record, cassette, and compact disc formats, the album cover has, in fact, become a "museum without walls," a busy transit station for fine-art transmissions to the larger world. In an age in which ideas change hands as effortlessly as stocks, it is possible for fine-art techniques, images, and styles to be almost immediately appropriated by album designers and trans-lated with originality and effect into mass-produced popular art forms. Millions of indi-viduals who have never been inside an art mu-seum have, unbeknownst to them, been in intimate contact with fine art. Anyone whose album collection encompasses classical, jazz, and popular music can probably find the entire history of Western art, from ancient Greece to the present, within easy reach.

Like all the art forms we will study in this book, pop music covers possess multiple

2.33 • Desmond Dekker.
Compass Points. 1981.
Barney Bubbles, designer.
© 1981 Stiff Records Ltd.

2.34 • HENRI MATISSE.
*The Thousand and One
Nights.* 1950. Gouache on
cut and pasted paper.
54¾ × 147¼". The
Carnegie Museum of Art,
Pittsburgh. Acquired
through the generosity of the
Sarah Mellon Scaife family,
1971.

levels of meaning. For the music industry, they
are packages that are designed to protect and
sell a product. For the people who collect
them, they are valued sources of personal and
cultural identity. For individuals whose inter-
est lies in art history or the study of culture,
they are artifacts filled with stylistic variety and
iconographic complexity. And finally, for the
growing numbers of people who are receptive
to aesthetic experiences outside of the mu-
seum's walls, these music covers are objects of
artistic power—works of art in their own
right.

Chapter 3

Different Ways of Seeing

How each artist and each person sees a forest or city street is clearly a phenomenon of extraordinary complexity: Many variables shape our vision and the process of art appreciation. The works of art in these first three chapters represent richly complex ways of seeing made visible. By looking closely at these works, we gain access to individual outlooks and cultural world views different from our own. If we open our minds to these messages from across the oceans and centuries, and across town, we will gain insights that will make us more reflective travelers through history and more respectful citizens at home and abroad. These insights can only deepen our appreciation.

VIEWS OF NATURE ACROSS TIME & CULTURE

Seeing, which comes before both art and art appreciation, is never a neutral act. In any society, seeing is colored by personality, shaped by education, and directed by individual interest and purpose. Consequently, no two people see the world in exactly the same way. For example, a scientist viewing an oak tree may register a complex of biological facts: the tree's botanical classification, characteristic markings, and patterns of growth. The timber company executive who stands before the same tree may view it in terms of the lumber and profit it might produce. An artist might contemplate the oak from a pictorial perspective: as an interplay of line, color, shape, and texture, a worthy subject for a painting or photograph. The poet, young child, or ecologist would see the oak in yet other ways.

Differences in ways of seeing—what we choose to look at and how we think and feel about what we see—become even more pronounced when the comparison extends beyond individuals of the same culture to persons of highly distinct cultures; for example, Australian Aborigines before the coming of Western civilization, eleventh-century Sung dynasty Chinese, twentieth-century North Americans. Each culture sees the world differently; each has a "world view" of its own, based on a commonly held system of values

and beliefs. To reverse a popular saying, we might say that "believing is seeing." What we believe and value, the result of our socio-cultural conditioning, becomes the basis of what and how we see. Focusing on the single theme of nature, we will soon come to appreciate how differently people from different cultures and historical periods have seen and represented the natural world.

The world view of the Druids of ancient Britain, for instance, was based on animism, the belief that all objects—trees, rocks, the wind—have souls and the capacity to intervene willfully in human affairs. A Druid viewing an imposing oak might well have perceived in it the presence of the Goddess, the Universal Mother of all things. He or she would have addressed the tree with reverence. Two thousand years later, a Briton conditioned to the world view of science would hardly view an oak, however beautiful or prepossessing, as a conscious being with a soul and will of its own. What, in fact, has changed in the intervening two thousand years is not the biological faculties of the viewers but their belief systems.

WAYS OF SEEING NATURE: THE MIDDLE AGES & THE RENAISSANCE

Because of cultural conditioning, people from different societies have seen mountains, trees, and streams differently. Rather than one Nature, there have been and continue to be many natures, each the cultural product of divergent ways of seeing. Most men and women in early medieval Europe, for example, showed little aesthetic interest in the natural world around them. Images of nature are not prominent in their art or literature. A primary reason was the pervasive Christian belief that this life was but a wretched interlude on the road to eternal bliss. On an earthly journey fraught with physical temptations, one's surroundings must not become the object of too much attention. If the soul is divine and the body prone to sin, if ideas are godlike and sensations debased, then absorption in nature, which we perceive through the senses, is sinful. Such would have been the strict monastic view prior to the year 1000. Its influence on the general populace

3.1 • *Adam and Eve Reproached by the Lord,* from the bronze doors of Bishop Bernward for Saint Michael's, *ca* 1015. 23 × 43″. Hildesheim Cathedral.

and artists in particular, most of whom were either monks or under contract to the church, was considerable. When we do find nature portrayed by artists of the early Middle Ages, it is almost always at a nonsensuous distance, in the form of stereotypic symbols or abstract ornamentation, expressions of the intellect more than the flesh (3.1, 3.2).

Reinforcing this cultural bias was the perception of nature as a disquieting and frightening place: one thousand years ago, seacoasts represented violent storms, perilous currents,

3.2 • Mosaic, *ca* 1100, Palermo, Sicily, Cappella Palatina.

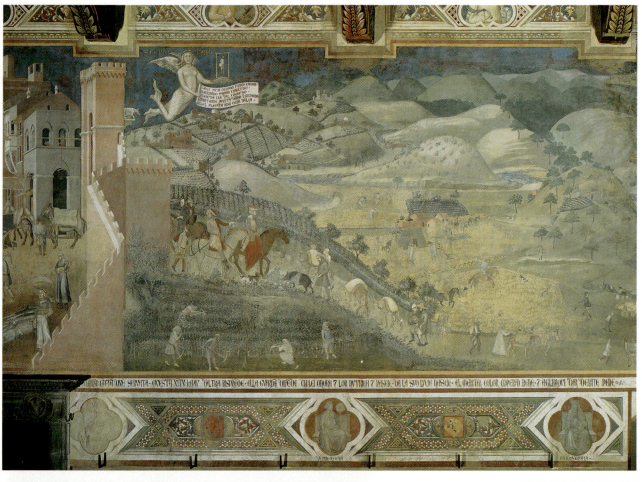

3.3 • AMBROGIO
LORENZETTI. *The Effects
of Good Government on the
Countryside* from *The
Allegory of Good
Government.* 1338–1339.
Fresco, Palazzo Pubblico,
Siena, Italy.

3.4 • LORENZETTI. *The
Effects of Good Government
on the Countryside.* Detail.

and bloodthirsty invaders; the hinterlands comprised dark forests and primeval swamps. Beyond the walls of the city lurked wild animals and outlaws. Serfdom, for its brutalizing part, demanded the backbreaking labor of millions upon the land. In such a context, the vast majority of the population could hardly have viewed nature as a source of refreshment and delight.

It was not until the early monastic view of nature had lost some of its cultural grip and a rising secular society of market towns (3.3, 6.20) had begun to regulate and safeguard the countryside—"civilizing" nature in the process—that land, sea, and sky became objects of wide-ranging economic and scientific interest and down-to-earth enjoyment (3.4). This gradually developing interest began to show itself in the art and literature of the later Middle Ages, approximately between 1100 and 1400, but it was not until the fifteenth century that the more secular, more humanistic way of seeing became dominant. This new mode of seeing resulted in paintings and sculptures that strove to be lifelike and factual as opposed to imaginatively symbolic and stereotypic. The works created in this dawning Age of Humanism, in which man, not God, becomes "the measure of all things," are increasingly the product of direct observation, empirical knowledge, and common sense, hallmark values of the rising merchant classes. Businessmen, who along with the nobility would soon eclipse the church as the major source of artistic patronage, were enjoined to view reality with a pragmatic, exacting realism; otherwise they would not be successful in their economic and political affairs. The artists who fulfilled the commissions of these bankers and merchant princes most certainly had to take their employer's secular, worldly way of seeing into strict account. If the artists did not satisfy the aesthetic wishes of their powerful patrons, there was a very good chance they would not be paid.

With the rise of humanist values, spurred by a rebirth or "renaissance" of interest in the literary, scientific, and artistic achievements of the non-Christian Mediterranean world—especially ancient Greece and Rome—the flat, beautifully stylized, "other-worldly" images

3.5 • Genesis scenes from the *Moutier-Grandval Bible:* God creates Adam and Eve; the Fall; the expulsion from the Garden of Eden. Tours, France. 834–843. 20 × 14¾". By permission of the British Library, London.

(3.5) that had communicated church doctrine for centuries began to give way to late medieval images that were more full-bodied, weighty, and lifelike (3.6). Space, likewise, became more realistic. By the fifteenth century, artists were utilizing scientific knowledge, recently developed **fresco** and **oil painting** materials, and innovative techniques of **perspective** to create convincing illusions of depth and distance. Depictions of such subjects as mountains and trees, which previously had been rendered in abstract symbolic form, began to resemble physical reality, the nature we have come to know through our twentieth-century scientific eyes.

3.6 • GIOTTO. *Joachim Takes Refuge in the Wilderness.* After 1305. Fresco. Arena Chapel, Padua, Italy.

Two Views of the Wilderness. A comparison of two fifteenth-century Italian paintings, *The Young Saint John Going out into the Wilderness* (3.7) by Giovanni di Paolo (1403–1482/83) and *Saint Francis in the Wilderness* (3.8) by Giovanni Bellini (*ca* 1430–1516) clearly illustrates the differences between the two ways of seeing and representing: the former, imaginative, abstract, other-worldly; the latter, more humanistic, scientific, realistic.

Although di Paolo's elegant little work was created around 1450, a date customarily associated with the Italian Renaissance, it represents a continuation of a late medieval tradition often called the late or international **Gothic.** The artist, working with oil-based pigment paint on a wooden panel, presents a symbolic retelling of a familiar New Testament story. As in spoken or written narrative, the action unfolds sequentially from beginning to end; two consecutive scenes are shown side by side, much as in a contemporary cartoon strip. Knowing the symbols and stories by heart, a

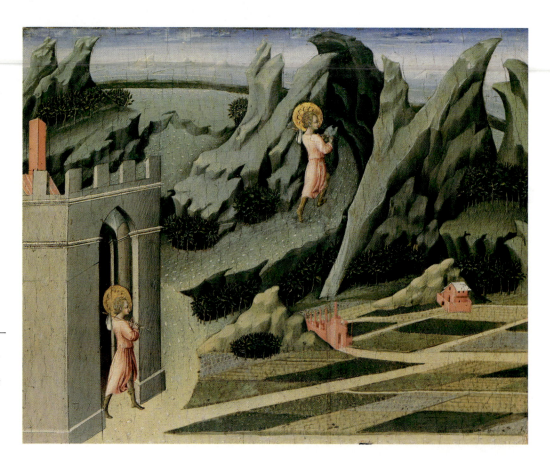

3.7 • GIOVANNI DI PAOLO. *The Young Saint John Going out into the Wilderness (Saint John the Baptist Retiring to the Desert). ca* 1450. Oil on wood. 31.1 × 38.8 cm. The National Gallery, London.

3.8 • GIOVANNI BELLINI. *Saint Francis in the Wilderness (Saint Francis in Ecstasy). ca* 1485. Panel. 48½ × 55″. The Frick Collection, New York.

largely illiterate public could "read" such visual narratives as easily as twentieth-century people read wordless traffic signals and signs. Just as we know that a red light means stop and a green one go, medieval and Renaissance viewers knew instantly that a person with a halo was a saint and that a saint with a rough coat, usually of animal skin, was John the Baptist. Such religious paintings were indeed worth a thousand words.

In the first scene of the di Paolo painting, the young Saint John, knapsack in hand, is leaving the protection of a walled building symbolizing the town. In front of him lies a cultivated fifteenth-century countryside of orchards and fields. For church viewers, it was not necessary for artists like di Paolo to represent this landscape realistically; abstract images communicated to them with equal power. They would immediately comprehend Saint John's whereabouts through schematic suggestions of walls, roads, and fields.

In the second scene, we observe Saint John climbing a rough path into untamed mountain highlands symbolic of the wilderness. Space and time, size and shape, are not rendered accurately according to our modern scientific view of things. Rather, nature and humanity are presented symbolically, the artist's concern being a persuasive retelling of a familiar story and the revelation of a metaphysical, as opposed to physical, truth. We must realize, from our vantage point in history, that such "nonrealistic" imagery would have nonetheless been exceedingly "real" to a community of devout Christian believers.

In contrast, the oil painting on canvas of *Saint Francis in the Wilderness* by Giovanni Bellini epitomizes the later, more humanistic, scientific way of seeing and representing. This is not to say that Christianity had substantially declined as a force or that it had been largely replaced by the world view of secular humanism. Most paintings and sculpture of the fifteenth and sixteenth centuries depicted religious subjects and were still housed in churches—the political, economic, and cultural influence of the church would remain

3.9 • JACOPO BELLINI. Flower study from the sketchbook of the artist. Mid-fifteenth century. The Louvre, Paris.

foxglove blooms by Saint Francis's side, and ivy crawls over the face of the rock. Even though Bellini is a man of religious belief, he manifests a profound sensuous as well as spiritual love for nature's sunlight, colors, and textures. (Such a love of nature likewise pervaded the world view of Saint Francis, whose preaching and hymns contributed greatly to Christianity's ultimate acceptance of nature.) Although *Saint Francis in the Wilderness* was painted indoors and the scene combines imaginary and realistic motifs, it is obvious that the artist studied nature firsthand, probably making preparatory drawings, much like the flower study (3.9) by his father, the artist Jacopo Bellini (*ca* 1400–1470/71). Making life studies was far from the typical medieval approach to painting a landscape background. The medieval artist would employ traditional landscape symbols established by earlier artists or use rocks to represent mountains and a few branches to simulate a forest.

In the new age of Renaissance humanism, even the wilderness (literally, "wild animal land") has been humanized. With a pleasant arbor of vines above and a comfortable chair and desk below, Bellini's Saint Francis lives in congenial harmony with nature. The stark, untamed wilderness of earlier medieval representations is gone. The birds, animals, stones, and caverns of formerly wild nature have been domesticated. The cultivation and regulation of the countryside, already evident in the late Middle Ages, were greatly advanced in the Europe of the fifteenth century.

Many wealthy persons in both Renaissance Italy and northern Europe now owned both a country and city home. We know, for example, that country villas surrounded many an Italian city from as early as the thirteenth century. For people of affluence, "the country" had already become a source of peace, quiet, psychological solace, and spiritual renewal. This view of the countryside was expressed by no less a figure than Lorenzo di Medici (1449–1492), the merchant prince who was an influential political and cultural leader of the Florentine Renaissance. In a poem entitled "Town or Country?", Lorenzo writes longingly of forsaking the complicated demands of city life for the simpler, purer pleasures of nature.

very powerful for several centuries to come— but religious art was now reinterpreted according to humanistic science, literature, and philosophy.

We note that Saint Francis (1182–1226) and his natural environs are not presented symbolically, but realistically. The saint is no longer an abstract symbol but a human individual of flesh and blood. Rocks, trees, and plants are likewise individualized. They are no longer stereotypes but rather particularized entities recognizable to us by common and scientific names. On the arbor we see grapevines and in the sky cumulus clouds. A

Let him who wills seek pomp and honours, public squares, temples and great buildings, pleasures and rewards which bring with them a thousand distracting thoughts, a thousand troubles. A green meadow full of lovely flowers, a stream which washes the grass on its banks, a little bird that makes its plaint of love, these soothe our restlessness far better.[1]

The nature of the early medieval period, which travelers found menacing and monks sin-provoking, had long since receded into the past. Nature would henceforth serve human needs, whether as a pastoral retreat from urban life or as an earthly source of aesthetic pleasure and spiritual inspiration.

SEEING NATURE AS PICTURESQUE

We see the natural world through the selective filter of our sociocultural conditioning, as Jane Austen (1775–1817) proves with instructive humor in her early nineteenth-century novel, *Northanger Abbey*. The setting is the English countryside. In one episode, Catherine, a beautiful, rather naive girl of modest origins, is given instruction by two highborn friends, a young gentleman and his sister, in the cultivated way of seeing nature.

> They were viewing the countryside with the eyes of persons accustomed to drawing, and decided on its capability of being formed into pictures, with all the eagerness of real taste. Here Catherine was quite lost. She knew nothing of drawing, nothing of taste.... The little she could understand, however, appeared to contradict the very notions she had entertained in the matter before. It seemed as if a good view were no longer to be taken from the top of a high hill and that a clear blue sky was no longer proof of a fine day.[2]

Ashamed of her ignorance, Catherine declares that she would give anything to see the world as they do. The young gentleman immediately gives Catherine a lecture on the picturesque, in which his directions are so clear that she soon begins to see beauty in everything he admires.

> He talked of foregrounds, distances, and second distances—sidescreens and perspectives—lights and shades; and Catherine was so hopeful a scholar that when they gained the top of Beechen Cliff, she voluntarily rejected the whole city of Bath as unworthy to make part of a landscape.[3]

The **picturesque** vision that characterized much of cultivated English seeing, landscape design, and art in the eighteenth and nineteenth centuries was the sociocultural product of a privileged upbringing. In the broadest sense, it meant seeing nature as if it were a picture; hence picturesque or "picturelike." More specifically, it denoted an aesthetic vision that relished such qualities in landscape and landscape art as variety, irregularity, contrast, and surprise. Prior to her lessons in seeing nature with the eyes of persons schooled in the landscape drawing and painting of the day, Catherine had no inkling that reality could be so artful, so aesthetically engaging. Unacquainted with the fine art that hung almost exclusively in the homes of the wealthy, she could hardly have appreciated nature as if it were a picturesque landscape (3.10) by Paul Sandby (1730/31–1809).

Woodsmen and agricultural workers laboring in those same "scenic" forests and fields—and often appearing in the artworks themselves—would have found the notion of seeing nature as if it were a beautiful artistic composition even more baffling. Long hours of arduous work, a rustic education, and scant leisure time were not conducive to an aesthetic response to nature. Their peasant eyes saw nature bluntly and directly. For them, as for the medieval serfs before them, nature was a demanding mistress, not a picture gallery in

3.10 • PAUL SANDBY. *Landscape with a Waterfall.* 1791. Watercolor. 37.2 × 52.7 cm. Dundee Art Galleries and Museums, Dundee, Scotland.

the open air. This is not to demean the picturesque way of seeing but rather to point out that it was, at one time, the exclusive cultural property of a small, privileged elite. In our own more democratic society, many ways of seeing—embodied in the arts of past and present—have become available to increasing numbers of people through museums, art reproductions, public school art education, films, and television. The picturesque, as a generalized way of seeing has, in fact, become a fixture in our world. Most people in industrial nations look to nature for lovely "scenery," charming "views," and captivating "landscapes," terms and concepts that derive originally from the world of art.

Images of picturesque nature are everywhere: on calendars and picture postcards (3.11), in magazine and television advertisements, in feature films. Even our own yards or grounds bear the stamp of the picturesque. On the estates of the wealthy and in more modest homes in middle- and lower-income neighborhoods, lawns are mowed, hedges shaped, trees pruned, flowers planted; all for the sake of making our surroundings into a pleasing picture, a picturelike image. The aesthetic pleasure we derive from nature—the enjoyment of its colors, shapes, and compositions—is a legacy of centuries-old ways of seeing, like the picturesque.

Two Views of the English Countryside. The influence of culture on ways of seeing as well as modes of artistic representation has been a central concern of various art and cultural historians, among them Ernst Gombrich. In his book, *Art and Illusion*, he includes two views of Derwentwater in the English Lake District. One is a typical picturesque rendering from the early nineteenth century (3.12). It is an idealized, prettified version of the actual scene. The second is by Chiang Yee (1903–1977), a writer and artist who wants the viewer to see the English countryside "through Chinese eyes" (3.13). Chiang Yee's way of seeing, combined with his schooling in a thousand-year-old Oriental tradition of landscape painting, has resulted in the selection and representation of those features for which his background has prepared him. Scanning the landscape, Chiang emphasizes the sights that are valued in his native culture and that can be subsequently matched with the techniques and conventions of a deeply rooted artistic tradition. The scene may be the English Lake District, but the stylized trees and mist-shrouded mountains make a Western viewer with only minimal exposure to Chinese art think more of the Orient than the British Isles. Does this mean that Chiang Yee actually saw the English Lake District differently from his Western counterpart? It certainly does. As the artist himself notes, he viewed the English countryside "through Chinese eyes," bringing a very different set of values, beliefs, and artistic conventions to that experience.

Nature through Asian Eyes. "For thousands of years," says twenty-nine-year-old Kao Pao Tang, "China has been an agricultural society. We have lived very close to nature. Ours is a feeling of respect toward nature."

Kao Pao Tang came to the United States in the early 1980s from his native Taipei, the commercial and political center of Nationalist China. He subsequently completed a master's degree in civil engineering at an American university and settled in the United States. He is convinced that Asian and European people view nature differently. "In the West," he asserts, "people think that man is number one." In contrast, in Chinese culture, nature is seen as vast and man as insignificant in comparison. "To us," Kao Pao affirms, "man is just very small compared to the earth. That's a very different philosophy." The visual evidence of Chinese landscape art seems to bear him out. People, houses, boats, and animals are almost always represented as infinitesimal in compar-

3.12 • Anonymous.
*Derwentwater, Looking
toward Borrowdale,* from
*Ten Lithographic Drawings
of Scenery.* 1826.
Lithograph. Victoria and
Albert Museum, London.

3.13 • CHIANG YEE.
Cows in Derwentwater
from *The Silent Traveller*.
1937. Brush and ink.
Courtesy Country Life, Ltd.,
London.

ison with the rather grand proportions of nature (3.14).

In contrast to its preeminent position in Chinese culture and art, nature has been assigned a rather ambivalent, secondary status in the Western world. Since the later Middle Ages and Renaissance, Western civilization has become evermore "anthropocentric": humanity-centered as opposed to God-centered or nature-centered. Because in the Western world view the individual is the measure of all things, nature is viewed almost strictly in terms of fulfilling human needs. On the one hand, nature is revered as a source of serenity, beauty, and poetic inspiration. On the other, it is looked upon as an "inhuman" domain to be commercially exploited for every drop of oil or linear foot of lumber it can produce. This latter mindset, in which nature is thought of as territory to be conquered, causes most Westerners to experience nature as a thing separate and disconnected from ourselves, something external, "out there." In this view, so pervasive in Western science and econom-

ics, nature is perceived as an alien force or soulless object to be analyzed and manipulated for human progress and material gain—and sometimes the cost is ecological disaster.

This mentality differs sharply from both the reverential Asian view expressed by Kao Pao Tang and the pantheistic view of native peoples of the world—such as Australian Aborigines, African tribal peoples, and American Indians (Appreciation 3)—who worship nature as divine and attempt to live in spiritual and ecological harmony with what they perceive to be natural laws. A sacred "I-Thou" notion might aptly describe the relationship between these non-Western persons and nature; a more one-sided, combatively anthropocentric "I-it" relationship is inherent in the West.

Images of nature in Eastern and Western art reflect these differences. Whereas the Chinese artist assumes the beholder is *in* the painted landscape, the Western artist employs a way of representing and seeing in which the viewer is looking *at* the scene from a vantage point outside, from a visual and psychological

distance. Nature has been central in the art of non-Western peoples for well over a thousand years; by contrast, it did not move to the center stage of Western art—with a few notable exceptions—until the nineteenth century, our golden age of landscape art. Nature, it is true, had for centuries served as background or setting for many a portrait or historical, mythological, or religious work. But in this role, it almost always occupied a position of secondary importance to some primary human drama. The central focus was on human protagonists, or on pagan deities or Christian divinities who, not surprisingly, were of distinctly human appearance.

Fan Kuan's Travelers amid Mountains and Streams. In Chinese art, for well over a thousand years, nature has rarely been portrayed as mere background. Instead, it is presented as the very "ground" of existence, a cosmic tapestry in which the human species is but one of innumerable strands. In the words of the philosopher Confucius (551–479 B.C.), "Nature is vast and deep, high, intelligent, infinite, and eternal." In later forms of Confucianism, and in other dominant Asian philosophies such as Buddhism and especially Taoism, nature is revered. In such a world view, the act of painting a landscape or observing one, real or painted, can be a path to spiritual enlightenment.

Looking at a reproduction of Fan Kuan's masterpiece, *Travelers amid Mountains and Streams* (3.15), created a thousand years ago, Kao Pao Tang, who has seen the original in the National Palace Museum in Taiwan, makes several observations. He notes that the artist, Fan Kuan (active *ca* 990–1030 A.D.), is sensitive to nature's physical appearance but has idealized and beautified the scene. "For Chinese people," Kao Pao Tang explains, "God lives in this kind of mountain, high, with huge pine trees and lots of clouds around. It's utopia. Our goal. Peaceful, calm. Perfect." The ever-changing terrain and atmosphere of external nature has been transformed in Fan Kuan's painting into a timeless ideal landscape, an embodiment of the one, unchanging moral and metaphysical heart of things, what neo-Confucians call "the Supreme Ultimate" and Taoists "the Way."

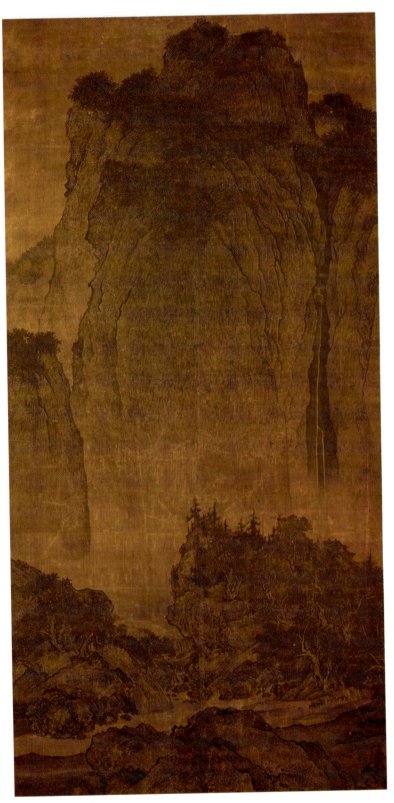

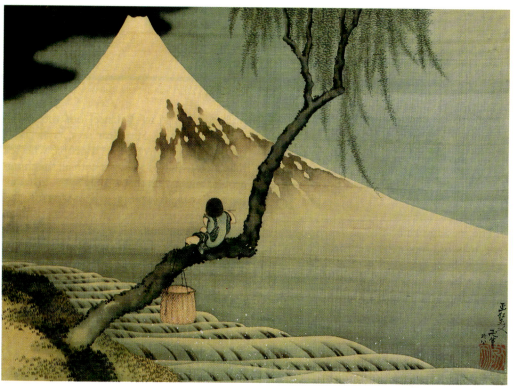

3.16 • KATSUSHIKA HOKUSAI. *Boy Viewing Mount Fuji.* Edo period, early nineteenth century. Ink and color on silk. 14¼ × 20 1/16″. The Freer Gallery of Art, Smithsonian Institution, Washington, D.C.

Travelers amid Mountains and Streams shows us the "vast and deep, high, intelligent, infinite and eternal" nature perceived by Confucius. The human travelers are barely visible, no larger than ants, as they walk with their animals across an open cut of land in the lower right corner of the painting. Several temples are nestled among the conifers and deciduous trees on the cliff immediately above the travelers. Nature is immense; people and the products of civilization, minuscule. But the relationship between nature and humanity is one of serene harmony; the travelers and temples blend peacefully into their surroundings. Mortal humanity and immortal nature meld in a perfect union. Kao Pao Tang estimates that as many as half the living or dining rooms in his native Taiwan have a hand-made, traditional-style landscape painting like Fan Kuan's. Such works are painted on silk or paper by contemporary Chinese artists working within the conventions of the thousand-year-old tradition of landscape painting. Even in modern China, these images retain spiritual associations and stir deep feelings of cultural pride.

Hokusai's Boy Viewing Mount Fuji. Westerners, conditioned to constant change, must be surprised by the relative stability of the Eastern view of nature over many centuries. The same physical immensity and spiritual serenity that characterize Fan Kuan's Chinese landscape painting from around the year 1000 are evident in *Boy Viewing Mount Fuji* (3.16), a work created eight hundred years later by the Japanese master, Katsushika Hokusai (1760–1849). A small boy sits on the trunk of a solitary tree, contemplating the revered Mount Fuji as he plays on a wooden flute. One imagines the sounds to be as serene and noble as the mountain, a holy site for many Japanese. One can also imagine the meditative notes wafting over the vast space and subtly fading from hearing just as the mountain fades in the most delicate gradations of color from the solid whites and tans of the snow-capped summit to the almost transparent bluish tans below. It is as if the solid matter above has dematerialized into vaporous ether as the eye descends. A similarly subtle progression of tone and substance occurs in Fan Kuan's much earlier painting, in which the darkness and opacity of the mountain's core lighten in value and weight as the eye moves upward to the airy peaks and downward toward the mist-shrouded base. Although the color scheme of the nineteenth-century Japanese work is far more varied than the restrained palette—limited in color but rich in values—of the Chinese painting, an extraordinarily fine modulation

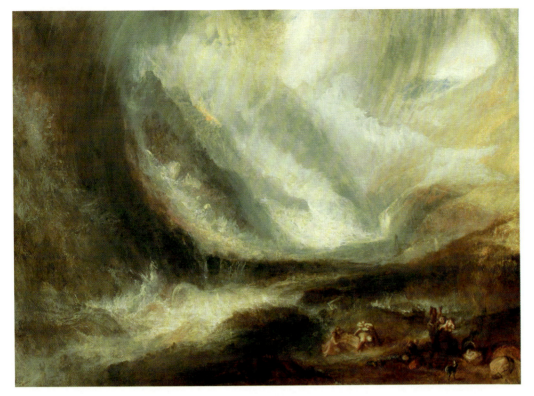

3.17 • Joseph Mallord William Turner. *Snowstorm, Avalanche, and Inundation—A Scene in the Upper Part of the Val d'Aosta.* 1837. Oil on canvas. 92.2 × 123 cm. The Art Institute of Chicago, Frederick T. Haskell Collection.

of tonal effects is common to both. These effects, in turn, create the most sensitive transitions between opacity, translucency, and transparency, qualities especially evident in the depiction of the mountains. Nature is revealed as simultaneously substantial and insubstantial, as solid matter and ethereal void. Form flows into formlessness, interweaving physical fact and metaphysical essence.

THE WESTERN VIEW OF THE SUBLIME

It is interesting to compare the Eastern conception of nature as sublime—vast and imposing, yet peaceful and intelligent—with a Western way of seeing nature specifically called **Sublime.** This latter conception, which rose to prominence in Europe and North America in the nineteenth century, had strong connections with the cultural movement known as romanticism (2.6). Emphasizing feeling, imagination, and individualism in both life and art, romantics sought out nature at its most passionate, dramatic, and seemingly irrational. Tempestuous storms, soaring heights, and crashing waves were the faces of nature that the romantic mind found thrill-

ingly Sublime. Here is the German philosopher Immanuel Kant (1724–1804) writing in 1790:

Bold, overhanging, and, as it were, threatening rocks, thunderclouds piled up to the vault of heaven, borne along with flashes and peals, volcanoes in all their violence of destruction, hurricanes leaving desolation in their track, the boundless ocean rising with rebellious force, the high waterfall of some mighty river, and the like, make our power of resistance of trifling moment in comparison with their might. But, provided our position is secure, their aspect is all the more attractive for its fearfulness; and we readily call these objects sublime, because they raise the forces of the soul above the height of vulgar commonplace, and discover within us a power of resistance of quite another kind, which gives us courage to be able to measure ourselves against the seeming omnipotence of nature.[4]

Kant's words find awe-inspiring visual correspondence in *Snowstorm, Avalanche, and Inundation—A Scene in the Upper Part of the Val d'Aosta* (3.17), a painting by the English artist J. M. W. Turner (1775–1851). In Turner's picture, the superhuman size and power of nature receive full expression. Nature in such an earthshaking guise—like earlier images of the Greek god Zeus with his thunderbolts or Christ at the Last Judgment—retained the power to terrify and overawe. "Sublimity"

3.18 • Katsushika Hokusai. *The Waterfall at Ono* from *Famous Waterfalls in Various Provinces.* Edo period, early nineteenth century. Colored inks on paper. 14⅝ × 9⅞" The Freer Gallery of Art, Smithsonian Institution, Washington, D.C. Gift of Eugene and Agnes E. Meyer.

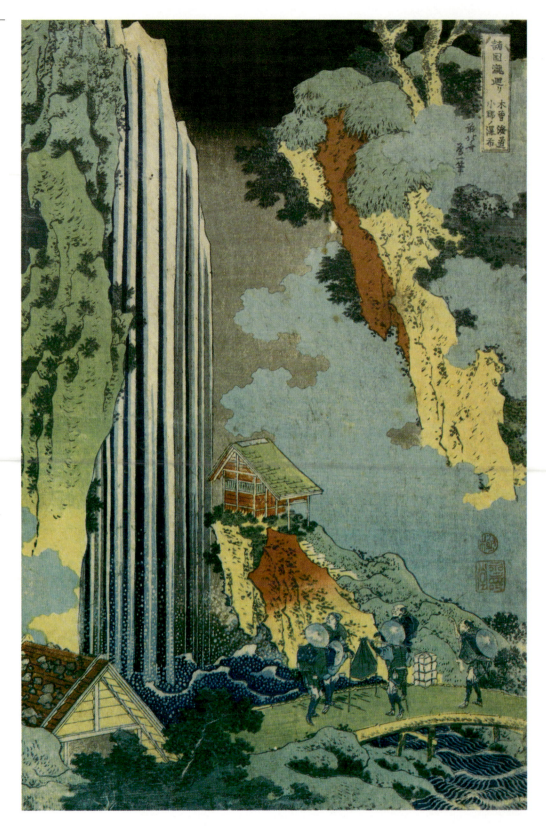

3.19 • FREDERIC EDWIN CHURCH. *Niagara*. 1857. Oil on canvas. 42¼ × 90½″. The Corcoran Gallery of Art, Washington, D.C. Museum purchase.

here, frightening and exhilarating, is certainly of a very different cast from that sublimity represented in the Oriental landscape.

A comparison of two waterfall scenes, one by the Japanese master Hokusai and the other by the North American romantic Frederick Edwin Church (1826–1900), elucidates the enormous difference between the two conceptions of sublimity (3.18, 3.19). In his woodblock print, from a series entitled "Famous Waterfalls in Various Provinces," Hokusai depicts the waterfall as immense and the onlookers as minute, but there is no sense of threat to either the tiny figures or ourselves, the viewers. Rather, nature is imposing but friendly, and the figures blend harmoniously with their surroundings. In addition, we see the great falls at a substantial distance. Like the artist, we look at them from a secure, comfortable position on high ground.

In contrast to Hokusai's small print, Church's huge oil painting, *Niagara*, thrusts the viewer up very close to the gigantic cataract, in perilous proximity to the churning waters. Many nineteenth-century viewers were initially unnerved by the convincing illusionism of this wall-sized painting, feeling as if they were about to be swept away over the falls. Inspiring reverential wonder and awe, Church's canvas is a tour de force of the romantic Sublime.

The social context that gave birth to the romantic Sublime was the Industrial Revolution and, in one sense, the romantic rebels and industrialists were of like mind: both sought to challenge and even conquer the forces of nature. But more than simply an offshoot or variant of the technological mindset, the Sublime was a reactive response, an intuitive attempt to reunite with nature in those places where it was still most "natural," most untouched by humanity. Through contact with nature's unbridled power, romantic poets and painters sought an emotional and spiritual rebirth beyond the rational rules and mechanical rhythms, and a refuge from the soot and ugliness of the rapidly emerging urban, industrial society. The wilderness, the wild places where prophets and saints once ventured for divine illumination, would become, in the nineteenth and twentieth centuries, havens from technocratic civilization, preserves of organic life—often protected by government legislation—where individuals might experience something of the Sublime in both nature and themselves (Appreciation 4).

Ansel Adams: Photographer of the Landscape

ELIOT COHEN

In the foreword to one of his most important books, *Yosemite and the Range of Light,* the twentieth-century photographer Ansel Adams writes that his photographs of nature served not as factual reproduction but as "equivalents of my experiences." There were, Adams notes, many fine books on Yosemite if scientific analysis or the history of the region is your interest. The goal of his book, in contrast, was "to present visual evidences of memories and mysteries at a personal level of experience." "Most such experiences," Adams writes, "cannot be photographed directly but are distilled as a synthesis of total personal significance; perhaps their spirit is captured by images visualized through the obedient eye of the camera."

Although he began his photography career working in the soft-focus mode of picturesque turn-of-the-century **pictorialism,** Adams quickly converted to the so-called straight approach that emerged during the 1920s. This approach was well suited to Adams's reverence for the natural qualities of wilderness and the forces of nature that could be observed there. In *Mount Williamson—Clearing Storm* (Fig. A), one can observe Adams's interest in the mysteries of nature as well as the concept of equivalence, a symbolic or metaphorical approach to subject matter articulated by the pioneering modernist photographer, Alfred Stieglitz. The drama created by the rays of light descending on a vast plain of huge boulders suggests an equivalent epic of creation

Eliot Cohen is a professor of photography at the Loudon campus of Northern Virginia Community College.

from a biblical or scientific perspective. By backlighting the clouds, Adams creates an aura of energy opposed by the dark mountain forms beneath them. The power of this light can be seen in the foreground, where it directs us to several prominent boulders that presumably have broken off from the mountains in the background.

Like his predecessors in the nineteenth century (among them photographers such as Carleton Watkins, Eadward Muybridge, and Timothy O'Sullivan), Adams invokes a Sublime sense of the landscape. The image creates feelings of intimidation and respect. In the sense of the word as used by Emerson, Thoreau, and other nineteenth-century New England transcendentalists, the image is also transcendent. We see it not only for what it is but also for the spirit associated with it.

To achieve his dramatic results, Ansel Adams made certain decisions about formal elements in the organization of his picture. First is the choice of a large-format camera, which, although bulky and slow, provides a negative whose size (4″ × 5″ or 8″ × 10″) allows much more detail than negatives obtained with conventional cameras do. He also used the large-format camera for *Tenaya Creek, Dogwood, Rain, Yosemite Valley* (Fig. B). The great clarity and wealth of detail give the sense of being present in the environment.

A second decision is the placement of the camera. In the *Mount Williamson—Clearing Storm,* Adams chose a position close to the rocks in the foreground to exaggerate their size relative to the mountains in the background, making them seem perhaps even

larger than they are. Another question is framing. The boundaries of this picture imply a vast plain of rocks. Although this may be the case in fact, it may also be that Adams has selected a point of view that creates this impression. Light is also very important to Adams's photography. He uses it both dramatically (Fig. A) and descriptively (Fig. B). Light becomes a force leading one's eye through the picture and a means of varying the value scale within a picture.

Before deciding on a life in photography, Adams had been a performing pianist. He maintained his interest in music throughout his life and often spoke of its relationship to his photography. Just as a symphony can be an exciting arrangement of audible tones, so can black-and-white photography depict an evocative arrangement of visual tones. By making the landscape abstract through the use of black and white, he achieves highs (lights)

(continued on next page)

$$Chapter\ \ \ 4$$

Graphic Art: From Illustration to Advertising

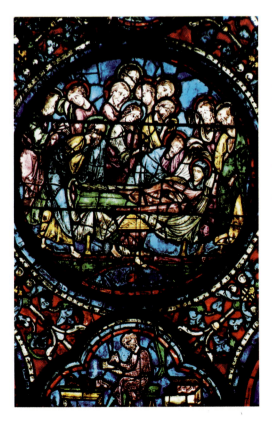

Many of the great works of art of the past have been illustrative, their purpose being to make visible a story, a series of connected events. Illustration, in this respect, might be thought of as the art of visual storytelling. The stories that are made visible might be true or fictitious, written or spoken, long or short. They might be mythological, historical, or otherwise informative. Their purpose might be to educate, persuade, or entertain. They might be told through pictures alone or through a combination of words and pictures. The luminous stained glass in the Gothic cathedrals, for example, told the stories of the New Testament to a nonliterate public in strictly visual terms that all could understand (4.1). In contrast, the romance of the Persian Prince Humay and the Chinese Princess Humayun, created around 1450, interweaves delicate pictures with panels of golden Persian writing to tell the story of the royal lovers, their gaze upon each other, their hearts held in their hands (4.2). Only a tiny elite of wealthy, educated persons would have had access to this aristocratic fable.

4.1 • *Death of the Virgin.* Thirteenth century. Stained glass. Chartres Cathedral, Chartres, France.

61

4.2 • *The Persian Prince
Humay Meets the Chinese
Princess Humayun in Her
Garden.* From the Persian
manuscript of a romance.
ca 1450. Musée des Arts
Décoratifs. Paris.

In our own century, illustrative art is every-where, from the "success stories" of magazine advertisements and television commercials to illustrated books of every kind. Beginning with the simulations, imbued with magic powers, of animal hunts painted on cave walls seventeen thousand years ago, and continuing to contemporary books and films that use computer-generated pictures and effects, visual imagery that tells stories has been central to all cultures and historical periods.

ILLUSTRATION THROUGH THE AGES

The Ancient World. In the millenia before the birth of Christ, innumerable works of art illustrated mythical or historical stories. Some of these works, like commercial graphic design today, employed written language along with visual imagery to tell their tales more explicitly. In fact, "graphic," in the original Greek and Latin, meant "of or pertaining to drawing or writing," the two visual languages through which people described their lives and world. Much of the art found in the pyramid tombs of the Egyptian pharaohs combines painted or carved pictures with hieroglyphics, the pictographic writing of ancient Egypt. In the scene of *Tutankhamen Hunting* (4.3), from a painted chest found in the young king's tomb, we observe the boy pharaoh riding forward boldly on his chariot, bow drawn. His arrows rain down on the wild animals he and his dogs pursue. A retinue of servants follows. They are represented as tiny in comparison with their king because he is a semidivine ruler and they are lowly subjects. Blending harmoniously with the overall composition, hieroglyphics behind the horse and king relate and add details to the visual story.

The works of art of ancient Greece and Rome can also be highly illustrative in the portrayal of mythological or historical stories. In such works, the written accompaniment is most often implicit rather than explicit, the art being based on preexisting stories. For example, Greek ceramic jars from the fifth and sixth centuries B.C. were often decorated with scenes from mythology. On one famous black-figure amphora style jar (4.4), the Greek

4.3 • *Tutankhamen Hunting.* From a painted chest found in the king's tomb, Thebes. *ca.* 1350 B.C. Length of scene 20″. Photography by Egyptian expedition, the Metropolitan Museum of Art, New York.

4.4 • EXEKIAS. *Black-Figure Amphora. ca* 530 B.C. 80.5 cm high. Museo Gregoriano Etrusco, Vatican City, Rome.

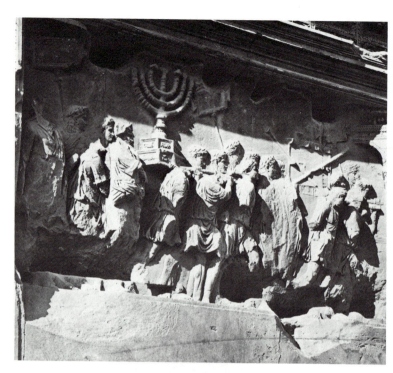

4.5 • *Spoils from the Temple in Jerusalem.* Relief on the Arch of Titus. 81 A.D., Rome. Marble. Height, 7′10″.

4.6 • *Scenes from Genesis. ca* 1200. Mosaic on ceiling. Saint Mark's Basilica, Venice.

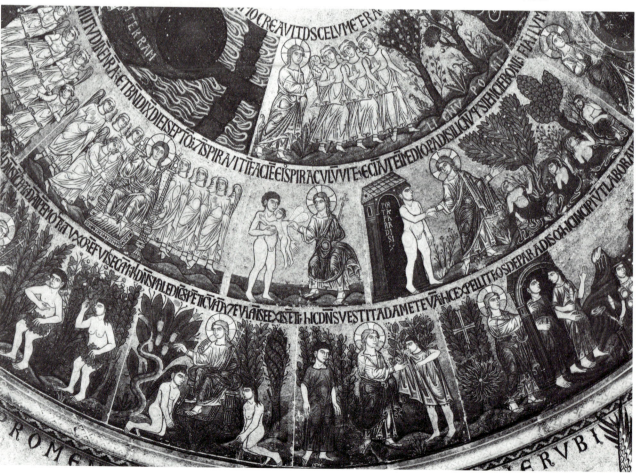

heroes Achilles and Ajax, fully armed, are so engrossed in a board game that they miss a crucial battle with their Trojan foes. Functioning in a related way are the large narrative panels on the triumphal arch of the Roman emperor Titus. As a visualization of history, a supposedly true story, the carved panels illustrate and trumpet the victory of Rome over the Jewish insurrection in Judea in the first century A.D. One panel (4.5) shows us part of the triumphal procession celebrating the conquest of Jerusalem. The spoils include a seven-branched candelabra and other sacred Jewish objects. Situated in a busy public place in the ancient Roman forum, this sculptural frieze served as both graphic narrative and political propaganda, memorializing and glorifying the event for the citizenry.

The Middle Ages. Like the ancient Greeks and Romans, the early Christians depended on visual imagery to illustrate and communicate their most important stories. Along with the language of words, visual stories served to educate and inspire both the learned men and women of the church and the vast illiterate populace. The mosaic cycle (4.6) on the ceiling of Saint Mark's, the famed church in Venice, unfolds like a giant picture book complete with captions and text. It illustrates a sequence of stories from Genesis—note the story of Adam and Eve—and was probably based on an early **illuminated** (that is, illustrated) **manuscript**. Such manuscripts (4.7), which were the pride of the learned clergy, nobility, and bourgeoisie, are the direct ancestors of our modern books. Their subject matter ranged from Bible stories and Greek philosophy to contemporary medieval life; their functions from religious instruction and aids to scholarship to literary entertainment. They were written and illuminated by hand, often by monks, and could take months or years to complete. On many pages, **calligraphy**, or beautiful writing, interweaves in organic unity with illustrative pictures and decorative effects. In addition to being masterworks of graphic art, some of these manuscripts were of monumental importance to Western civilization, preserving, during the turbulent period after the fall of Rome, the literary, religious, philosophical, and scientific achieve-

4.7 • *Illuminated Initial to the Book of Jeremiah* from the Winchester Bible. *ca* 1150–1200. The Warburg Institute and the Dean and Chapter of Winchester, England.

ments of the diverse peoples of the Mediterranean world: Greek, Roman, Hebrew, Arab, and African.

Other illuminated manuscripts, from the medieval period through the Renaissance, focused on the life and legends of Europe. In one exquisite French Burgundian manuscript from the early 1400s, *The Very Rich Hours of the Duke of Berry*, an illustrated calendar provides detailed insights, month by month, into the lives of the peasants and nobles. We witness the nobles engaged in pursuits of pleasure: hunting, courting, and feasting (4.8). Larger than life and luxuriously robed, the Duke of Berry commands attention. His chamberlain's words ring out, telling a suitor to "approche, approche." Meanwhile the joy-

4.8 • THE LIMBOURG BROTHERS. "The Duke at Dinner," *January* detail from *The Very Rich Hours of the Duke of Berry. ca* 1413–1416. Approx. 8½ × 5½". Musée Condé, Chantilly, France.

less peasants, portayed with an exacting realism, labor to make all this possible. According to apologists for the church and nobility, it was the God-given calling of the peasants to serve their masters faithfully, who, in turn, would protect and provide for them always. (Several centuries later, plantation owners in the Americas would give much the same defense of slavery.) In the illumination for the month of October (4.9), one serf on a horse plows the field while another, worn and melancholy, sows the winter wheat. A scarecrow with bow and arrow poised stands guard. An impressive white castle, figurative head of the medieval "body social," looms over the peasantry, the innumerable "feet" who, according to the twelfth-century writer John of Salisbury, "raise, sustain, and move forward the weight of the entire body." Above, and encompassing all of nature and humanity, are the heavenly bodies and zodiacal constellations, the divine presence made manifest, in their eternal progression through the days, months, and years.

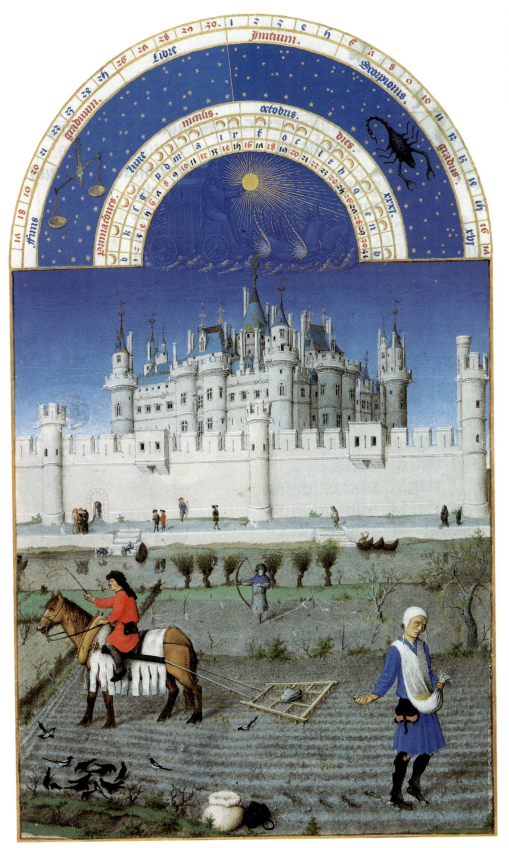

4.9 • THE LIMBOURG BROTHERS. *October* from *The Very Rich Hours of the Duke of Berry. ca* 1413–1416. Approx. 8½ × 5½″. Musée Condé, Chantilly, France.

4.10 • HUBERT AND JAN
VAN EYCK. *Adam and
Eve,* left and right wing
details from *The Ghent
Altarpiece.* Completed
1432. Oil on panel. Saint
Bavo, Ghent.

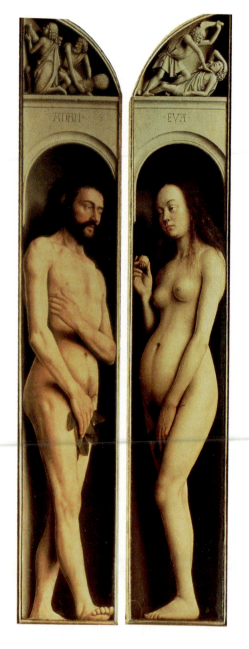

implicit to the work. In the tall, narrow panels at each end of the altarpiece, we see Adam and Eve (4.10). They are succinctly introduced by name above and caption below, and their sin is foretold by the expressive stories of Cain and Abel above their heads.

Biblical stories were the basis for many Renaissance masterworks. Numerous painted versions of *The Last Supper,* including the famous one (4.11) by Leonardo da Vinci (1452–1519), are based on a passage from the New Testament in which Jesus says, " One of you will betray me"; his shocked disciples responding, "Lord, is it I?" The traditional literary drama of the story is here heightened enormously by the visual drama created by Leonardo. All the formal compositional elements rivet our attention on Christ, the work's central figure. Leonardo not only situates Christ in the center of the painting, framing him in the center window, he also locates the Savior at the geometrical **vanishing point** of the **one-point perspective** system (4.12), around which the composition is organized. To see how this perspective system guides our way of seeing, note how the sight lines formed by the table ends, walls, and ceiling beams angle our vision toward the central figure of the drama. Leonardo's use of formal and emotional contrasts also pulls us into the drama. Having revealed to his disciples that one of them will betray Him, Christ sits apart in physical and psychological stillness. His gaze has turned inward. In contrast, the disciples gesture animatedly and stare in amazement at their leader. Compared to Christ's triangular form and pose, which are stable and peaceful, his followers are a jumble of agitated, interlocking forms. They recoil in disbelief, rise from their seats, move forward and back, right and left. In every way, the painting communicates that Christ is the controlling center of this unfolding epic tragedy.

Paintings and sculptures illustrative of Greek and Roman mythology, such as Sandro Botticelli's (1445–1510) *Birth of Venus* (4.13), are also common in this period, which sees a renascence or rebirth of the culture and humanistic values of the classical Greco-Roman world. Inspired by the literature of the ancients, Renaissance patrons enlisted artists

The Renaissance. Following in the illustrative traditions of the ancient and medieval worlds, many masterpieces of Renaissance art are visual portrayals of religious, historical, and mythological stories. As before, the imagery is based on words. In a masterwork of the early Renaissance in northern Europe, the *Ghent Altarpiece* by the Flemish brothers Hubert (died 1426) and Jan van Eyck (1390–1441), language is experienced as both explicit and

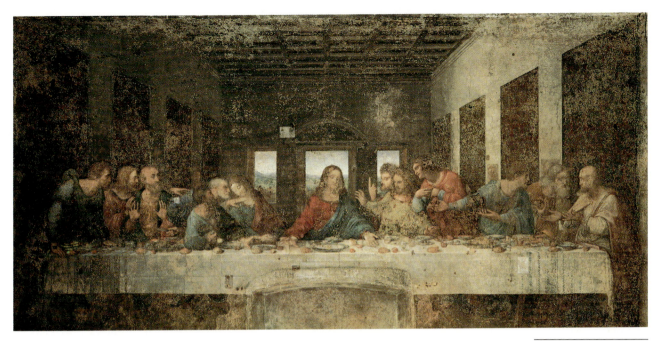

4.11 • LEONARDO DA VINCI. *The Last Supper.* *ca* 1495–1498. Oil-tempera on wall. 13′ 10″ × 29′ 7½″. Santa Maria delle Grazie, Milan.

4.12 • Perspective drawing of *The Last Supper.*

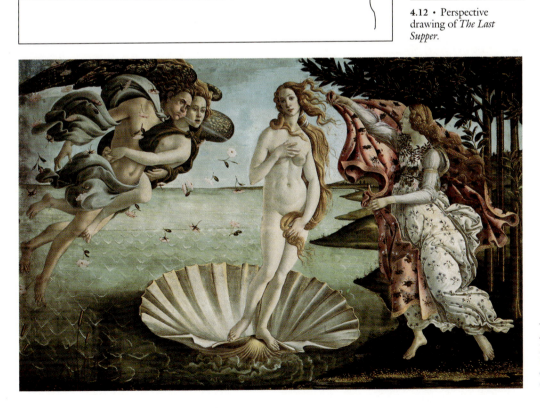

4.13 • SANDRO BOTTICELLI. *The Birth of Venus. ca* 1480. Tempera on canvas. 5′ 8″ × 9′ 1″. Galleria degli Uffizi, Florence.

to portray classical myths almost as frequently as they hired artists to represent Christian stories and legends.

Relative to artistic treatment, a more empirical, scientific way of seeing, already evident in the art of the later Middle Ages (4.8, 4.9), results in an increasingly realistic portrayal of people and their lives here on earth. Even spiritual entities such as Christ, God the Father, and the heavenly host, represented by schematic symbols in earlier medieval art (4.6, 4.7), become increasingly human in their appearance. To the medieval Christian worldview with God at its center is grafted the humanistic credo—"man is the measure of all things"—of the ancient Greek philosopher Protagoras.

4.14 • ALBRECHT DÜRER. Adam and Eve. 1504. Engraving. 251 × 192 mm. The Fogg Art Museum, Harvard University. Gift of William Gray from the Collection of Francis Calley Gray.

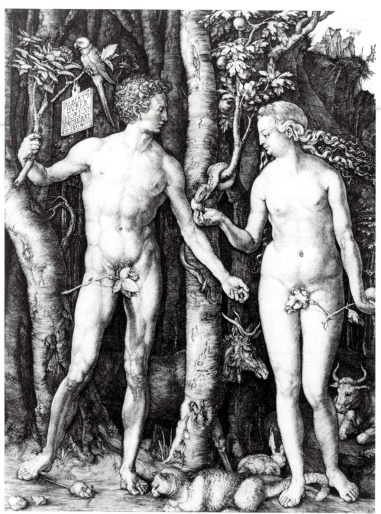

Albrecht Dürer: A Genius of Graphic Art. The graphic works of the German artist, Albrecht Dürer (1471–1528), epitomize this Renaissance union of Christianity and humanism. In Dürer's art, Christian stories are seen in the light of the most advanced literary, scientific, and artistic developments of the day. In this way, Dürer, like Leonardo, is a true "renaissance man." All the world is his stage. A pious Christian, he counts international humanists, like Erasmus of Rotterdam (*ca* 1466–1536), as friends or colleagues. A northern European artist, he draws inspiration from the achievements of the Italian masters: from their development of scientific perspective and knowledge of anatomy, which made possible a more perfect rendering of nature and the beautiful human body. His *Adam and Eve* (4.14), for example, combines the northern European artist's love of descriptive detail with the Italian artist's love of anatomy and search for ideal human proportions. Compare, for instance, his treatment of the Adam and Eve figures with the detailed realism of the Van Eycks' Adam and Eve and the more generalized, idealized treatment the figures receive in the Italian Botticelli's *The Birth of Venus*. In the Dürer work, the two great traditions have been synthesized.

Although Dürer created original, one-of-a-kind paintings and altarpieces as other eminent artists did, he is most famous for his **woodblock prints** and his **engravings**. Through these, he would become the first great artist of mass communications. With the advent in fifteenth-century Germany of a printing press with movable type, inexpensive paper, and artistic print media such as the woodblock and engraving, illustrated pamphlets, books, and religious stories became, for the first time, widely available and affordable. Printing, as we know it in the West, had been born, resulting in a far more democratic distribution of knowledge, opinion, and imagery. This was a truly revolutionary development. The entrance of rudimentary "mass media" into the everyday world resulted in the formation of reading and viewing publics, made up of individuals who read the same information and viewed the same images. Individuals in England, Spain, or Germany, reading the humanist Erasmus's *Praise of Folly*

(1509)—which took to task popes, kings, monks, scholars, war, and religion—might think critical new thoughts completely at odds with the laws and teachings of the local religious and political authorities. This encouraged not only the rise of humanist thought but also reflective, individualistic thought in general. In a related way, the wide distribution of the printed tracts of Luther and other "protestant" theologians, combined with expanding ownership of the Bible itself, spurred on the Reformation in Northern Europe and the subsequent development of Protestant religions of individual conscience. In short, the impact of printed words and images on European civilization was rapid and enormous.

Dürer was a master of woodblock prints and copperplate engravings, and his mechanically reproduced imagery reached both rich and poor across Europe, selling at fairs for as little as "one penny plain, two penny colored"; that is, one penny for the print in black and white, or two pennies if color were added. The fifteen prints of his woodblock series, *The Apocalypse*, illustrating the revelation of Saint John, were among his most famous. The series was created in 1498. These woodblocks, heralding the coming of a cosmic holocaust that would consume all evil, represented tumultuous themes and a fervent spirit that reflected a troubled period of war, plague, and unrest among the exploited lower classes and presaged the stormy Protestant Reformation to come. Stirred by such visions, many people believed that the world would come to an end in the year 1500. In the fourth print of the series (4.15), *The Four Horsemen of the Apocalypse,* four figures ride roughshod over Europe. Under the approving eyes of an angel, Famine, Pestilence, and War trample on the sinful, while Death's bony nag treads on a corrupt bishop who falls into the gaping jaws of the dragon of hell. Fifteen years later, Dürer would create a somber but hopeful response to *The Four Horsemen*. His engraving, *Knight, Death, and Devil* (4.16), based on Erasmus's *Manual of the Christian Soldier,* expresses the belief that a pious humanity can forge its way past mortal temptation to everlasting salvation. Humankind, with puritan determination, must follow the lead of the incorruptible knight of Christ.

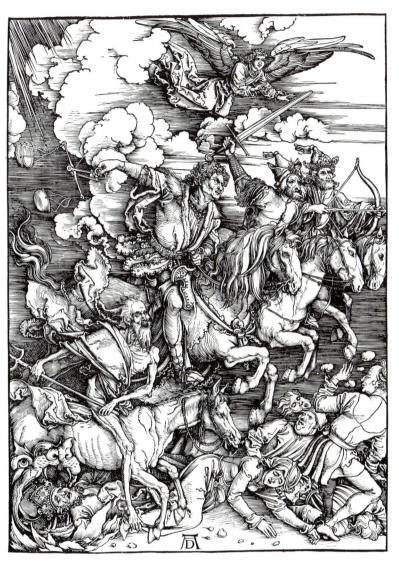

4.15 • ALBRECHT DÜRER. *The Four Horsemen of the Apocalypse.* 1497–1498. Woodcut. 390 × 281 mm (trimmed). The Fogg Art Museum, Harvard University. Gift of Paul J. Sachs.

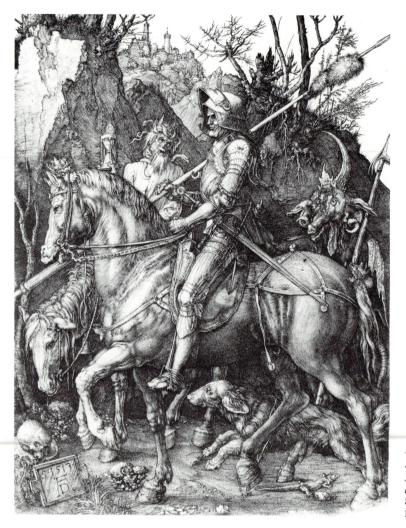

4.16 • ALBRECHT DÜRER. *Knight, Death, and the Devil.* 1513. Engraving. 250 × 192 mm. The Fogg Art Museum, Harvard University. Gift of William Gray from the Collection of Francis Calley Gray.

4.17 • REMBRANDT. *The Return of the Prodigal Son. ca* 1665. Oil on canvas. 8′ 8″ × 6′ 7¾″. The Hermitage, Leningrad.

From Renaissance to Modern: "The Graphic Arts" in Transition. In the five hundred years from the Renaissance to the twentieth century, the most important art remained proudly illustrative. According to the influential art academies that rose to prominence in the 1600s and 1700s and exerted substantial influence well into the nineteenth century, the most prestigious art portrayed stories from history, mythology, and religion; this art had a literary and intellectual basis. Portraits, still lifes, and landscapes, categories of art less rooted in literature and intellectual discourse, were judged of lesser cultural consequence and therefore of lower artistic merit.

At this historical juncture, when an illustrative, literary art was so highly prized, the **graphic arts** also achieved their broadest and highest status. In the centuries following the Renaissance, the graphic arts were considered to be any form of visual representation, and especially such two-dimensional media as drawing, painting, **etching**, and engraving. In this general sense, both an etching, such as *Christ Healing the Sick* (Appreciation 5), and a narrative oil painting, such as *The Return of the Prodigal Son* (4.17) by the seventeenth-century Dutch master, Rembrandt van Rijn (1606-1669), might be considered works of graphic art. Both Rembrandt's prints and his paintings, especially those that tell stories from the Old Testament and the New Testament, are magnificent visual representations that illuminate their subjects with intimate warmth in compelling values of both dark and light.

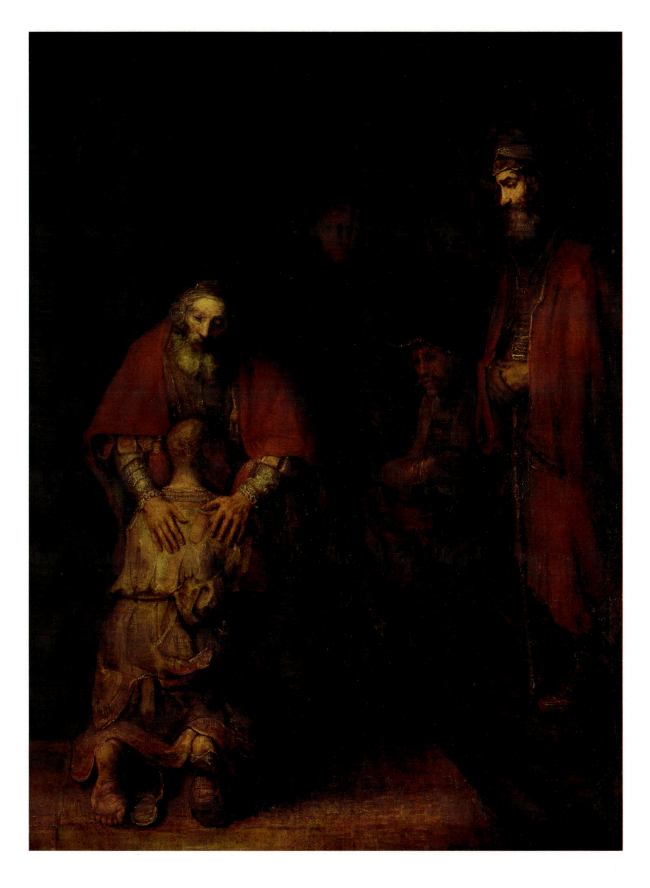

Rembrandt van Rijn. *Christ Healing the Sick*

SCOTT MILLER

Rembrandt has always been one of my favorite artists. I admire him because, in his work, I experience a visual drama, an excitement brought about by the artist's use of **chiaroscuro**, or dramatic light and dark. Although Rembrandt's use of light and shadow is evident in all of his work, I find it nowhere more exciting than in his black-and-white prints. The artist's ability to tell a story simply with light and dark is sometimes awe inspiring.

Take, for instance, *Christ Healing the Sick*, an etching from around 1650. First, look at the overall composition. Is this the source of the visual excitement? The main group in the foreground is composed of the central figure of Christ, located at the apex of a pyramidal group of followers and onlookers. The pyramid is one of the most stable of geometric forms, and it is used here to create a sense of balance and equilibrium while, at the same time, focusing our attention on Christ. The primary source of drama in the piece is not to be found here.

Next, look at the figures closest to Christ. Emotion is conveyed by some of the gestures and facial expressions on various faces, but these alone do not do the trick; they must be coupled with some other element, and the element that Rembrandt chooses is dynamic light and shadow, or *chiaroscuro*.

This masterful use of light and shade is the source of the print's power. Note that the light does not come from above or from the side, as is customary, but from Christ. The central group of figures is bathed in this light, seemingly as bright as day. The background, especially on the right, is cloaked in a murky darkness from which pious newcomers emerge and timidly approach the main group. Dark, looming shapes complete the backdrop for the spotlit central group. This juxtaposition of virtual daylight with deep shadow is startling until one realizes its significance to the story being told.

Rembrandt's purpose is not merely to dazzle the viewer with his mastery of light and dark but rather to relate a Bible story visually. Through the bold use of chiaroscuro, the artist directs the eye to the part of the print that holds the most meaning. Look again at the central group of figures. The artist meant for the viewer to notice that the source of the light is not the sun in the sky, but Christ, the son of God; otherwise he would not have made it so obvious. Rembrandt's visual message is that Christ enlightens all those who listen to him and heal all those who accept him as Lord.

The shadows can also be seen as having allegorical significance. They represent the everyday mortal world that one must leave to "see the light." The figures on the left fringe

Scott Miller is a graphic artist and designer in northern Virginia. As an undergraduate, he wrote an honors thesis, "Graphic Design versus Fine Art."

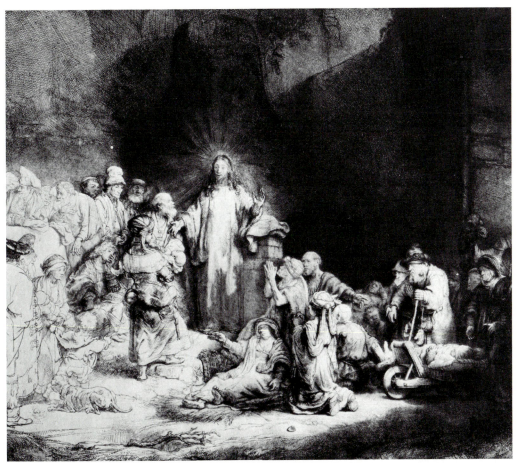

Appreciation 5 •
REMBRANDT. *Christ Healing the Sick* ("The Hundred Guilder Print"). *ca* 1642–1649. Etching, drypoint, and burin. 11 × 15⅝". The Metropolitan Museum of Art, New York. Bequest of Mrs. H. O. Havemeyer, 1929. The H. O. Havemeyer Collection.

of the crowd are not as brightly lit or sharply drawn; perhaps they are the ones who ignore or dispute Christ's capacity to enlighten. They are incapable of shedding their "mortal coil." Those closest to Christ, bathed in his radiance, are most attentive, thus less of this world and more of the next.

None of this is done by chance; this is the message Rembrandt wants to convey. He was a deeply religious man, and works of this kind were meant to bring the Bible to life for his fellows, to illustrate subtly some of the more metaphorical passages of the Bible. Judging from the popularity of the print—it was called the "Hundred-Guilder Print" for the price it reportedly fetched—it succeeded well, from the very beginning, in telling its story.

The modern viewer may not believe that Christ healed the sick and brought those in the darkness to the light, but it cannot be disputed that Rembrandt told these New Testament stories, through his dramatic use of light and dark, with visual and human power. ∎

This broad, expansive definition of "the graphic arts" held sway right up to our own century, when defiantly antiliterary, anti-illustrative "abstract" artists and their adherents, marching to the formalist anthem of "art for art's sake," hurled the related terms *graphic art*, *literary art*, and *illustration* out of the mainstream of the fine arts vocabulary. Serious "modern art" of the twentieth century (2.13) demanded the new title "visual art," emphasizing its nonillustrative, optical orientation. This revolutionary change in the direction of painting, sculpture, and printmaking did not mean that the art of illustration, which has been at the heart of culture for millenia, had come to an end. But as many painters, sculptors, and printmakers abdicated their time-honored role of visual storyteller, others, such as pictorial journalists, advertising designers, television producers, and film directors, took it up. Life's most important stories—once illustrated by painters and sculptors in the fine arts—would, in the twentieth century, be told primarily by the men and women of the mass media.

The Modern Period: The Rise of the Mass Media.
Many of us assume that the modern period starts with the twentieth century. Convincing arguments, however, place the birth of the modern world in the late eighteenth and early nineteenth centuries, with the Industrial Revolution and the revolutions for political democracy in both Europe and America. Along with the quest for life, liberty, and property came the equally revolutionary rise of capitalist free-market economics, sweeping away the last vestiges of its more restrictive predecessors, feudalism and mercantilism. Through capitalist enterprise, the commercial middle class of merchants and industrialists rose forcefully to the head of modern society. The source of power of the triumphant bourgeoisie was not divine right or aristocratic title, but wealth. Through its ownership of the institutions of production, transportation, and finance, the dynamic middle class ushered in an age of technological progress and unrestrained materialism. Factories proliferated, and cities swelled. For the privileged classes, a libertarian individualism in economics, politics, and culture became the order of the day. The new

industrial laboring class rallied behind the cry for decent living and working conditions, along with adequate wages. For them, socialist working-class ideals became the order of the day.

Honoré Daumier and His Public Easel.
Inspired by the new spirit of freedom and individualism, and compelled by the free-market economy to fend for themselves, certain artists began to portray life with an unprecedented subjectivity and criticality. During the period of the bourgeois-dominated monarchy in France from 1830 to 1848, Honoré Daumier (1808–1879), a political cartoonist, illustrator, and ardent supporter of democracy, took advantage of the picture magazine and newspaper, his "public easel," to address the new urban middle classes and industrial working-class proletariat.

The second quarter of the nineteenth century marks the beginning of the modern mass media as we know it, in terms of style and format (for instance, newspapers, magazines, leaflets), substantive content, and the impact on an increasingly large and mobile urban population. Albrecht Dürer's woodblock prints and copperplate engravings of the Renaissance period might have found their way to a few thousand people across Europe over the course of months or years. By contrast, graphic illustrations in nineteenth-century newspapers and magazines, executed in the rapid new print medium of **lithography**, were reaching tens of thousands in a single city daily or weekly.

Firing barbs at the alliance of royalty and bourgeoisie that ruled mid-century France—a rogue's gallery of arrogant lawyers, avaricious entrepeneurs, and pompous administrators (4.18)—Daumier's lithographic drawings are little stories packed with information and invective. Far more sober in tone than these biting caricatures, but just as passionate, is Daumier's pictorial journalism. His *Rue Transnonain, 15 April, 1834* (4.19) is based on the true story of the murder by government troops of an innocent worker, his family, and proletarian neighbors. Daumier made all of Paris witness to the gruesome event through the graphic severity of his lithograph. In the drawing, as the contemporary poet Baudelaire

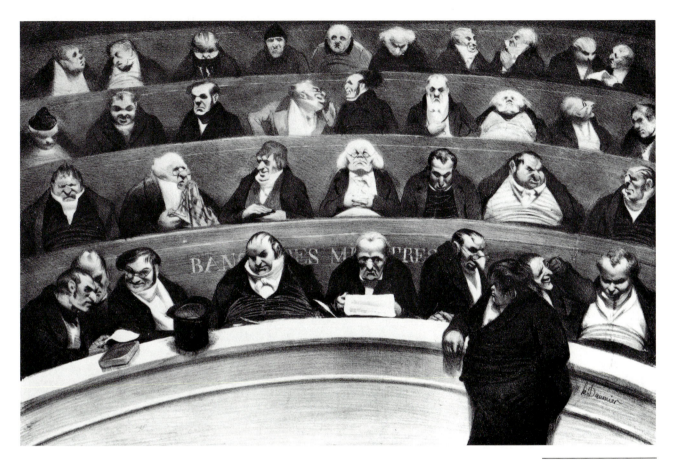

4.18 • HONORÉ DAUMIER. *The Legislative Paunch.* 1834. Lithograph. 431 × 280 mm. Museum of Fine Arts, Boston. Bequest of William P. Babcock.

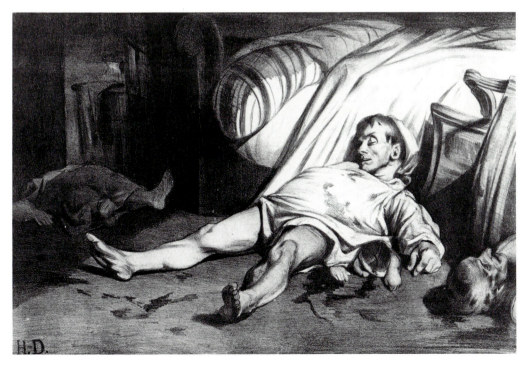

4.19 • HONORÉ DAUMIER. *Rue Transnonain.* 1834. Lithograph. 290 × 445 mm. Boston Public Library, Print Department.

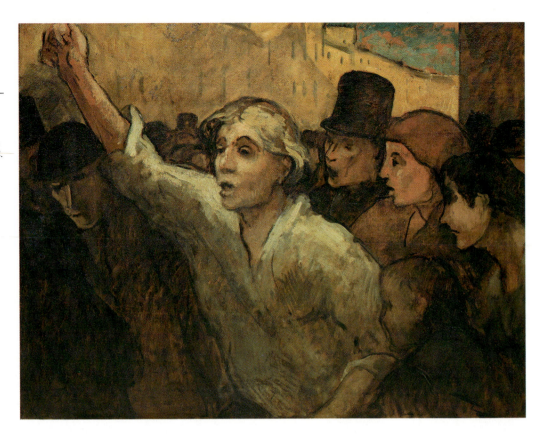

4.20 • HONORÉ DAUMIER. *The Uprising.* Undated. Oil on canvas. 34½ × 44½". The Phillips Collection, Washington, D.C.

observed, only silence and death reign. The troops of law and order have withdrawn, and the corpses sprawl where they have fallen. The drawing, which took three months to create, drew excited crowds to the publisher's shop window. Individual copies were sold until the government confiscated the original lithographic stone and all remaining copies. Previously imprisoned for his trenchant caricatures of the state, Daumier represented a new breed of artist who was willing to issue a public challenge to the authorities rather than simply do their bidding.

A later unfinished oil painting, *The Uprising* (4.20), shows the common people rising up in subsequent rebellion for their rights. Its journalistic slice-of-life **realism**, giving the impression that the action is taking place right before our eyes, differentiated it from earlier portrayals of revolutionary uprisings, such as the wall-sized painting, *Liberty Leading the People* (4.21), by his compatriot Eugène Delacroix (1798–1863). Delacroix's romantic masterpiece features an allegorical figure of Liberty and universalized character types representing the segments of French society who, in 1830, rose up against a tyrannical monarchy and oppressive social conditions. We see the liberal bourgeois intellectual in his top hat, the

prayerful working-class woman roughly clad in the colors of the revolution, the Negro second-class citizen from the colonies, and the pistol-wielding street urchin. In the tradition of European academic art, the figures are heroically posed in carefully choreographed groupings, more an inspiring theatrical tableau than an actual scene from life. Adding to the theatricality of the composition, Delacroix has built his composition around the colors of the French flag, the red, white, and blue of the tricolor. Some realism is thus exchanged for amplified patriotic expression.

In contrast, Daumier's painting seems like a straightforward snapshot, observed and recorded in an instant. In its muted colors, one feels the dust and murk of the troubled street. The sun of late afternoon strikes the blond insurgent, who, with arm and fist flung upward, urges the crowd forward. Behind this painting stand a pictorial journalist's photographic memory and a draftsman's ability to get it all down quickly. (Note how the heads of the anonymous crowd members retain the bold outlines with which the artist first defined them.) The same thirst for factual truth that documents the tragedy at the Rue Transnonian animates the surging crowd in *The Uprising*. In the person of Daumier, the popular,

commercial artist of the mass media and the fine artist working for a smaller, more elite art public meld into one, a "crossover" phenomenon common to many exceptional artists of the last two centuries.

By Daumier's time, further meanings had come to be attached to the term *graphic*. These connotations persist to the present day. In addition to the perennial association of graphic art with illustration and two-dimensional media (including drawing and painting), works reproduced by printing processes (such as engravings, woodblocks, and lithographs) came to be identified as "graphic works." In this media-based use of the term, graphic work might encompass the creation of popular or fine artists, so long as it is executed in one of the reproducible "print" media. In another usage, given impetus by the illustration styles of the past, the adjective *graphic* joins the fray. Meaning "vividly described" or "sharply defined," this broadly descriptive usage of the term emphasizes the descriptive detail and the linear style of much (but not all) of the popular illustration from Dürer's time to the twentieth century. All of Daumier's previously cited work, in these respects, qualifies as graphic art, embodying some or all of these characteristics. The same might be said of much of the work of Daumier's younger contemporary, the American artist and illustrator, Winslow Homer (1836–1910).

4.21 • EUGÈNE DELACROIX. *Liberty Leading the People*. 1830. Oil on canvas. 102⅜ × 128″. The Louvre, Paris.

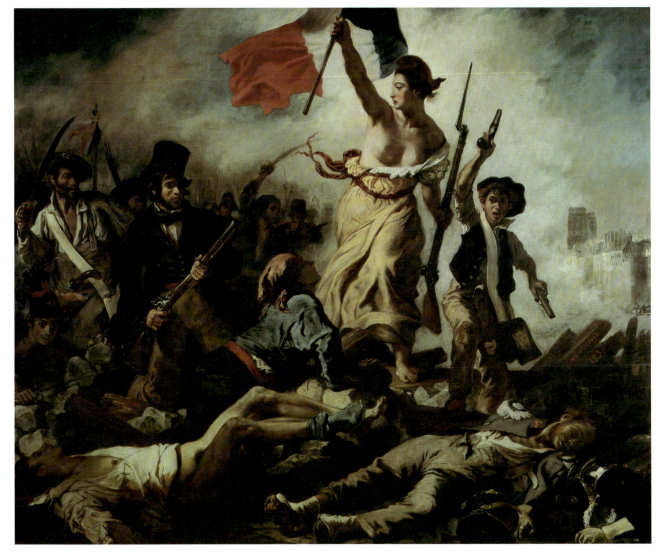

Winslow Homer: Visual Reporter. As a young illustrator and visual reporter for *Harper's*, the greatest pictorial weekly newspaper of nineteenth-century America, Winslow Homer was a first-rate popular artist. In his assignments as a visual reporter, Homer drew or painted the news as he witnessed it. His coverage of the Civil War provided the raw material for both realistic drawings (4.22), which were later executed as woodblock engravings for newspaper reproduction, and oil paintings, which he exhibited to a more select fine art audience. As with Daumier and others who created both popular and fine art, Homer's work as a commercial artist influenced the style of his "free," self-determined art. His best paintings, many of which depict the life of the ocean (4.23) or inland waterways, have the inspired freshness of a scene observed directly and composed on the spot or from vivid memory, special skills he cultivated as a top-flight visual journalist. From Dürer, creating woodblock prints for a popular audience, to Rembrandt, whose etchings hung in modest Dutch

4.22 • WINSLOW HOMER. *The Sharpshooter.* 1862. From a drawing in *Harper's Weekly.* The Smithsonian Institution, Washington, D.C.

4.23 • WINSLOW HOMER. *The Fog Warning.* 1885. Oil on canvas. 30 × 48″. Museum of Fine Arts, Boston. Otis Norcross Fund.

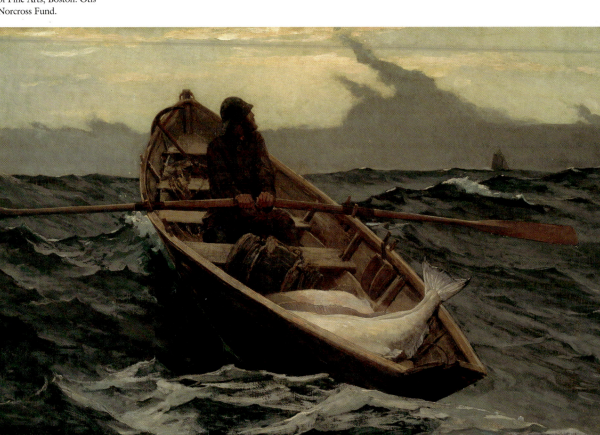

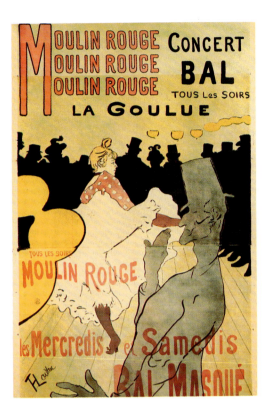

homes, to Daumier, Homer, and twentieth-century pop artists such as Lichtenstein (2.15) and Warhol (2.19), the line between the best popular art and fine art has been blurry indeed. In terms of enduring impact, there really has been no line at all. The only thing that ultimately counts is the rich, complex quality of the work itself.

Posters and Publications: "The Gallery in the Street." By the second half of the nineteenth century, the range of mass-produced graphic illustration had expanded to include posters, literary journals, soft-cover books, advertisements, and political leaflets. The posters of Henri de Toulouse-Lautrec (1864–1901), which today hang in museums, were used on Paris street corners as commercial advertisements for cafe nightlife (4.24). In the 1890s, avant-garde artists such as Toulouse-Lautrec and Pierre Bonnard were excited by the possibility of having their fine art seen by a large public. They consequently pursued and helped to establish the new genre of poster art. Not surprisingly, turn-of-the-century cultural observers would call the poster "the art gallery in

the street." In literary illustration, the sinuously linear **art nouveau** ("new art") fantasies (4.25) of Aubrey Beardsley (1872–1898) were bringing to visual life characters and scenes from the works of Shakespeare, Omar Khayyám, and Beardsley's own controversial friend, Oscar Wilde (1854–1900). In Beardsley's illustration for Wilde's 1894 play, *Salomé*, we see the princess Salomé triumphantly raise the bloody head of the prophet Jokanaan (John the Baptist) before her vengeful eyes; it is through her wiles, and those of her mother, that the holy man has been executed. These literary illustrations, with their deliciously sinister perfume of eroticism and decadence, made Beardsley the most famous graphic artist in Victorian England in the last decade of the century. Far different in purpose and tone,

4.24 • HENRI DE TOULOUSE-LAUTREC. *La Goulue au Moulin Rouge.* 1891. Lithographic poster. 191 × 117 cm. The Art Institute of Chicago. The Mr. and Mrs. Carter H. Harrison Collection.

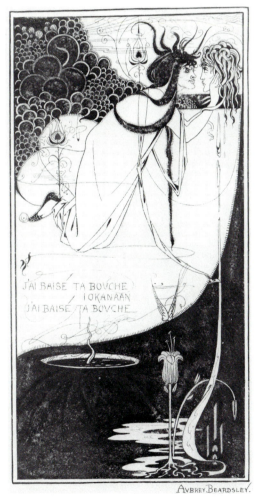

4.25 • AUBREY BEARDSLEY. *Salomé.* 1892. Pen drawing. 10⅞ × 5¾". Princeton University Library, Princeton, N.J.

4.26 • KÄTHE
KOLLWITZ. *The
Survivors—Make War on
War!* 1923. Lithographic
poster. 22⅛ × 27″. The
National Gallery of Art.
Rosenwald Collection.

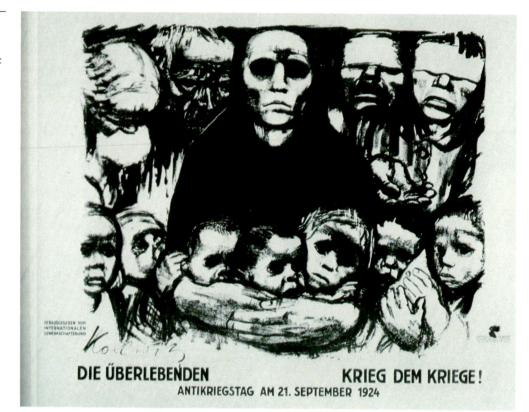

4.27 • HANS ERNI.
*Atomkrieg Nein (Atom
War No).* 1954. Offset
lithograph, printed in
black. 50 × 35″.
Collection, The Museum of
Modern Art, New York. Gift
of the designer.

4.28 • LEONARD BASKIN. Watercolor from *A Passover Haggadah*. Viking Press, 1982.

Käthe Kollwitz's emotionally gripping images of the poor and the oppressed (4.26) were seen by her fellow German citizens between 1890 and 1930 in political leaflets handed out in the street, posters on building walls, or drawings in a weekly newspaper (Appreciation 6). Only later would they, too, find their way into art museums for permanent preservation and appreciation.

In our age of mechanical reproduction, the world has literally become a "museum without walls"; hundreds of images of every artistic category and cultural lineage rise daily before our eyes. This is not to say that very much of this mass-reproduced imagery is of enduring artistic quality. The vast majority of it, espe-cially of the crassly commercial variety, is not. But amidst the glut of printed graphics are works of distinction by artists from around the world. These include the *Atomkreig Nein* ("Atomic War No") poster (4.27) by the Swiss artist Hans Erni (born 1909), the book illustrations (4.28) of the North American Leonard Baskin (born 1922), and the posters (Appreciation 7) of Korean designer Sang Yoon (born 1958). These graphic works, in their captivating form and significant content, have a human and aesthetic significance that will affect viewers centuries from now. In the jungle of publicity images that surround and accost us each day, such art is waiting to be discovered and appreciated.

Käthe Kollwitz. *Hamm*

RENATE HINZ & LUCY R. LIPPARD,
COMPILED BY ROBERT BERSSON*

In the years 1908 to 1911 Kollwitz's drawings appeared in *Simplicissimus*, a satirical [Berlin] weekly newspaper with a liberal political orientation. That *Simplicissimus* published her drawings—works of social criticism that stood in sharp contrast to the satirical and humorous illustrations that dominated the weekly—for four years attests to the reputation Kollwitz had attained. . . . Kollwitz made fourteen drawings for *Simplicissimus* [including *Hamm*], all illustrating "the many sung and unsung tragedies of urban life." Eight of these drawings depict general aspects of the urban proletariat's social situation, e.g., widowhood, unemployment, hunger and despair, anti-sociality, unwanted pregnancy. The series *Scenes of Poverty* shows [in Kollwitz's words] the "typical misfortunes of working-class families. If a man drinks or is sick or unemployed, the same things always happen. Either he is a dead weight on his family and lets them support him . . . or he kills himself. And the fate of the wife is always the same. She is left with children she has to support. . . ."

Unlike many contemporary illustrators of the urban environment, Kollwitz largely avoided any sentimental, pamphleteering elements. Her protest is truly effective because it

"so convincingly links social comment to the reality depicted."

Kollwitz's work for *Simplicissimus* forced her to conceptualize key themes quickly and to express them in a pictorial language that was accessible to a broad public. This brought about a major change in her mode of work. In the past she had carefully developed her pictorial ideas using live models, painstakingly working out every movement and detail. Now she shifted to a freer drafting style, dispensing with detail in order to focus on essential elements. The result was a compressed pictorial idiom. . . . Her earlier prints and drawings had either suggested or concretely depicted the worker's world. Now she focused exclusively on the human figure, using it alone to convey the social problems she envisioned. In this phase of her artistic development, she had such a large store of studies on hand and was so practiced in her draftsmanship that she could work without models. [From the Introduction by Renate Hinz, p. xxi.]

[Her] politics [and art] emerged from her social life, her gut, her heart, her historical awareness, and merged with the forms of the human bodies that were the vehicles for her beliefs. She dealt with tragedy, not pathos, though [the heroic notion of] tragedy was not usually associated with the lives of working-class people. . . . Her formal strategies were integrated with her content. There are no weak spots in her shapes or compositions; like her figures, they are compact and earth-bound, held together by a suggested solidity/solidarity. In the person of each weary woman,

*Compiled with the authors' permission from their book, Käthe Kollwitz: Graphics, Posters, Drawings, New York: Pantheon Books, 1981.

Renate Hinz of Germany and Lucy R. Lippard of the United States are internationally known writers on art. Each has a special interest in twentieth-century art that is socially responsive.

bowed under oppression she is helpless to affect directly, is the hidden courage and endurance that permits her to survive and will eventually permit her to fight back.

There was also an evangelical component to Kollwitz's responses that can be traced to her attachment to her father, a committed social democrat, and her grandfather, a reform preacher. She often mentioned "a duty to serve" through her art. As a child she was fascinated by the bodies and faces of waterfront laborers in her hometown, by their "native rugged simplicity . . . a grandness of manner, a breadth to their lives." . . . In addition, she felt a level of intolerance for her own class that these days would probably be chalked up to "middle-class guilt." "Middle-class people held no appeal for me at all," she recalled. "Bourgeois life as a whole seemed to me pedantic." And as for the "upper-class educated person," "he's not natural or true; he's not honest, and he's not a human being in every sense of the word."

With age, however, Kollwitz learned to become more tolerant. Living with her doctor husband in Berlin's poorest district, she was "gripped by the full force of the proletarian's fate. Unsolved problems such as prostitution and unemployment grieved and tormented me, and contributed to my feeling that I must keep on with my studies of the lower classes. And portraying them again and again opened a safety valve for me; it made life bearable." Life in Berlin offered the practice to fuse with the theories of her Konigsberg girlhood. One of the most moving aspects of Kollwitz's biography is the evolution of her intimate and utterly natural relationships with the women whose lives and sorrows she came to share, depict, objectify into searing symbols of injustice. . . .

"The working-class woman," she wrote, "shows me much more than the ladies who are totally limited by conventional behavior. The working-class woman shows me her hands, her feet, and her hair. She lets me see the shape and form of her body through her clothes. She presents herself and the expres-

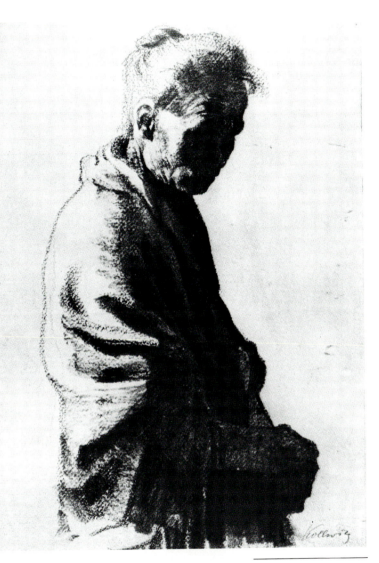

sion of her feelings openly, without disguises."

. . . Kollwitz had stated in the early 1920s her desire to "exert influence in these times when human beings are so perplexed and in need of help," and to "be the direct mediator between people and something they are not conscious of, something transcendent, primal." She succeeded then, and her art continues to succeed as an example for those who care enough about their art to want it to function in society. [From the foreword by Lucy R. Lippard, pp. viii–xi.] ■

Appreciation 6 • KÄTHE KOLLWITZ. *Hamm (Standing Working-Class Woman).* From *Simplicissimus,* November 30, 1908. Kunstbibliothek, Staatliche Museen Preussischer Kulturbesitz, Berlin.

FROM THE ART OF ILLUSTRATION TO THE DESIGN OF INFORMATION: THE EVOLUTION OF MODERN ADVERTISING

Advertising, as a pervasive and powerful art form, is less than one hundred years old. Small shop signs that advertised services or products existed even in ancient Rome, but modern advertising is a beast of an entirely different nature. Mass-market advertising as we know it is the product of our modern period of mass-produced products and mechanically reproduced images. It did not get into high gear until the Industrial Revolution, driven by capitalist economics, had reached an advanced stage.

Late Nineteenth- and Early Twentieth-Century Advertising Graphics. To meet the needs of rapidly expanding capitalist commerce, increasing numbers of artists from the end of the nineteenth century to the present were enlisted to create advertising publicity for consumer goods, services, and institutions. At first, some of the resulting advertisement graphics followed the fine art styles of the day. This stylistic connection to fine art—a successful strategy that continues to the present—added a sense of sophistication to turn-of-the-century ads plugging everything from Job cigarettes (4.29) to AEG electric lamps (4.30) to Victor bicycles (4.31). A Victor bicycle advertising poster created in 1899 by Will Bradley (1868–1962) echoes the curvilinear fantasies of Aubrey Beardsley and the flat patterning of the art nouveau style. Like such well-known European colleagues as Mucha and Behrens, the American Bradley thought of himself as an artist, was responsible for the overall creation and execution of the advertisement, and was proud of the fact that the public could discern a Bradley ad from others. Some of these turn-of-the-century advertising posters were even signed by the artists, as if they were paintings or sculpture. Although most of today's advertisements are no longer the creation of individual artists bent on creating fine art for the masses, the relationship between mass-market advertisements and fine art remains substantial, and we will return to this relationship shortly.

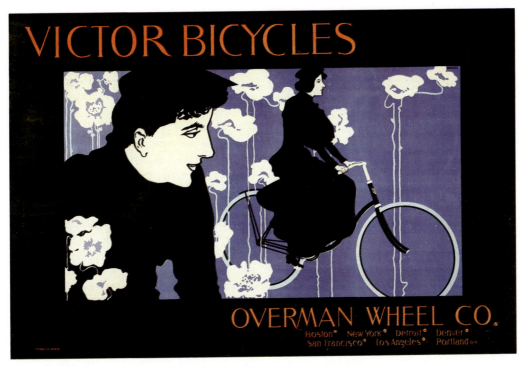

4.31 • WILL BRADLEY. *Victor Bicycles.* 1895. Lithograph, printed in color. 27 × 40⅝″. Collection, The Museum of Modern Art, New York. Gift of The Metropolitan Museum of Art in honor of Leonard A. Lauder.

The Necessity of Advertising. As the twentieth century progressed and capitalist industry in Europe and America grew to vast proportions, it became essential to stimulate the needs and desires of the masses for the endless array of products coming off the assembly lines. Need and desire had to keep up with industrial output. How could this be accomplished? The answer was advertising. As President Calvin Coolidge (1872–1933) stated in a major address of 1926, it was advertising's role to educate the people of the United States to "new thoughts, new desires, new actions." Coolidge argued that the desire for more and better things is the crucial element separating a civilized from an uncivilized people.

> The uncivilized make little progress because they have few desires. The inhabitants of our country are stimulated to new wants in all directions. In order to satisfy their constantly increasing desires they necessarily expand their productive powers. They create more wealth because it is only by that method that they can satisfy their wants. It is this constantly enlarging circle that represents the increasing circle of civilization.[1]

Advertising, Coolidge correctly observed, was the crucial linchpin in the production-consumption cycle at the heart of capitalist enterprise. Without advertising, the president declared, new desires could not be created, worker productivity would remain static, and little "civilizing" progress would take place. The uniquely North American belief in an ever-productive, upwardly mobile individual free to choose from an ever-expanding range of goods and services soon came to be associated with democratic as well as capitalist ideals. Personal freedom, private property, and the pursuit of happiness, the most cherished ideals of American political democracy, would become increasingly identified with consumerism. Consumers, President Coolidge and industrial leaders emphasized, had the democratic right to choose from a wide range of commodities; in democratic political language, they could "vote for," "cast their ballot for" the products of their choice.

By the early twentieth century, advertising had indeed become a great leader, a "captain of consciousness" capable of motivating the new worker-consumers, winning their allegiance and shaping their desires. Impressed by its power to persuade, the major corporations quickly began to employ advertising to un-

4.32 • *The Psychology of the Automobile.* 1924. General Motors advertisement. Courtesy Chevrolet/General Motors, Inc.

dercut the appeal of communism and socialism, especially to industrial workers. Advertising's success stories could convince the masses that the good life was available to all citizens in capitalist society. No Russian battleship during the twenties and thirties could match the firepower of the ads in repulsing the threat of communism in America. In his critique of capitalism, Karl Marx had certainly not figured on the dream-making capacity of advertising to socialize entire populations. While virtually all commercial advertising is, at root, pro-capitalist and anti-communist, the text of a 1924 Chevrolet advertisement (4.32) asserts this dialectic in the most explicit of terms:

Every [automobile] owner is in effect a railroad president. . . .

The once poor laborer and mechanic now drives to the building operation or construction job in his own car. He is now a capitalist. . . .

He has become *somebody*. . . . How can Bolshevism [communism] flourish in a motorized country . . . ?[2]

The advertisement has indeed become the capitalist art form par excellence. (In communist countries the chief art form is propaganda art, political advertising selling party ideology rather than products.) In nations where private enterprise reigns, advertising saturates the environment, calling out from newspapers, magazines, posters, billboards, radios, televisions, and films.

Toward the Scientific Art of Graphic Design. By the middle of the twentieth century, the ads had become increasingly scientific. To capture the minds and pocketbooks of a fast-moving public in a complex world, "effective information packages" were being prepared in accordance with experimental studies of perception and social scientific research into human behavior. Drawing from the most advanced knowledge bases of science and art, the production of advertisements now required an entire team: market research analysts, copy-writers, illustrators, photographers, printers, and artistic directors. This focus on the systematic organization of visual information would bring forth the new concept and field of **graphic design**. The day of the singular advertising artist like Will Bradley and Alphonse Mucha was over. The ads had become scientific, advertising had become an industry, and the individual artist had been replaced by a design team.

Did the change from art to design and from individualistic expression to the collective organization of information signify, as many might assume, an automatic reduction in aesthetic quality or cultural importance? Eminent graphic designers like Milton Glaser (born 1929) answer with a resounding "No!" Glaser argues that the design of information (4.33) is basic to many masterpieces of art. He asserts, for example, that the magnificent Gothic cathedrals of the Middle Ages were the creations of teams of anonymous artisans (that is, designers), and that their stained glass (4.1), sculptural programs (6.42), and architectural designs (6.41, 6.43) organized objective information (that is, church liturgy and law) for the instruction of the entire populace. Like contemporary advertising, Christian religious art was "designed" to provide information and propagate particular ideas, beliefs, and practices; its dual purpose was to inform and persuade. Although one might argue that Christianity and consumer materialism have little in common, it is clear that the production process, purposes, and even subject matter and style of commercial graphic design have precedents in some of the great art of the past.

Advertising and the Oil Painting Tradition. It may come as a surprise to discover that the style and the subject matter of much contemporary advertising originate in the realm of oil painting, a centuries-old art form. The critic John Berger argues that many twentieth-century advertisements are really an extension of the oil painting tradition, a distinctive way of seeing and representing that arose during the Renaissance and continued through the nineteenth century. It is a way of seeing that attempts to render reality as it appears to the senses, the artist making physical objects look so real that one gets the sense of actually being able to touch and possess them. In this way of seeing (Berger argues), rooted as it is in the experience of acquisition and being the natural outgrowth of a commercial, consumer-oriented society, the possession of material things has become a dominant value. Oil paint, better than any other medium, could create convincing illusions of the texture,

color, and weight of material objects. As the anthropologist Claude Lévi-Strauss (born 1908) observes, "It is this avid and ambitious desire to take possession of the object for the benefit of the owner or even of the spectator which seems to me to constitute one of the outstandingly original features of the art of Western civilization." For Renaissance artists such as Jan van Eyck and Leonardo da Vinci who helped to originate the oil painting tradition, painting might well have been an instrument of knowledge, but it was also an instrument of possession in which rich patrons looked on the painters as agents who could confirm for them, by their masterful illusions, all that was beautiful and desirable in the world. The pictures in the homes of wealthy patrons represented a microcosm in which the owners, thanks to the artists, could recreate within easy reach, and in as real a form as possible, all those features of the world to which they were attached.

4.33 • MILTON GLASER. *New York* magazine cover illustration and design. April 6, 1970. Courtesy *New York* magazine.

Jan van Eyck's oil painting *Giovanni Arnolfini and His Bride* (4.34) is a case in point. Painted in 1434, it is a visual marriage certificate for Arnolfini, a wealthy young Italian businessman in the international wool trade. Weaving together Christian symbolism (for example, the single candle, burning in broad daylight, standing for the all-seeing Christ) and scientific realism in true Renaissance fashion, the painting was revolutionary in its illusionism, creating an extraordinary likeness of the couple, their belongings, and the interior of their home. A simple corner of the world had suddenly been captured on a panel as if by magic. Here it all was in living color and texture: the carpet and the slippers, the chandelier, the mirror and the chain of beads on the wall, a world of cherished objects and activities. The basic language of much of twentieth-century product advertising had been introduced.

A comparison of a seventeenth-century Dutch oil painting (4.35) by Willem Kalf (1619–1693) and a 1979 magazine advertisement (4.36) brings the argument home. Each work is a highly realistic still life featuring food and drink. Each work employs the medium that in its time best created the illusion of reality. In this sense, the extreme verisimilitude of the color photograph is simply an extension of the painstaking realism of the oil painting. Both media bring out similar, highly tactile qualities—reflections, textures, subtle gradations of value—convincing the viewer that he or she can actually touch and possess the real thing shown in the image. Each work also features objects, warmly lit and carefully composed, making both the painting and magazine advertisement a visual eulogy. What is being praised is a life-style of material abundance, one characterized by the proud, pleasureful possession of physical things.

4.34 • JAN VAN EYCK. *Giovanni Arnolfini and His Bride*. 1434. Panel Painting. 33 × 22½". The National Gallery, London.

4.36 • *Courvoisier, the Brandy of Napoleon*. 1979. Cognac advertisement. Courtesy W. A. Taylor & Co./Courvoisier S.A.

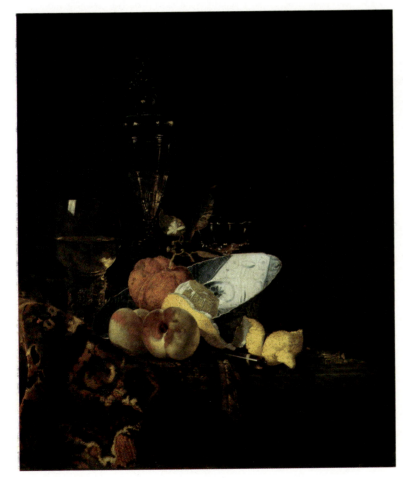

4.35 • WILLEM KALF. *Still Life*. Oil on canvas. 1665. 25⅜ × 21¼". National Gallery of Art, Washington, D.C.

Yet despite the continuity of language between the two works, the function of advertisements is decidedly different from that of oil paintings. The spectator-buyer viewing an advertisement stands in a very different relationship to the world than does the spectator-owner who commissioned the painting or bought it on the open market. Most often, the spectator-owner actually owned the contents—or facsimiles of them—represented in the purchased paintings. Such contents and possessions might include prize animals (a bull, horse, or dog) or expensive objects of art: beautifully crafted furnishings, plates, vessels, and so forth. The oil painting might even show the collector's home or lands, as does the portrait *Mr. and Mrs. Andrews* (4.37) by the English painter Thomas Gainsborough (1727–1788). An oil painting generally showed the possessions or way of life its owners were already enjoying. It confirmed their sense of their own value. It enhanced their view of themselves as they already were. Oil paintings began with facts and hung proudly in the homes in which their owners actually lived.

The purpose of the advertisement, in contrast, was to make the spectators somewhat dissatisfied with their present life-style; not with the materialism of consumer society but with their own lives in it. It suggests that life will become better if the consumer buys what the advertisement is offering. Buy me, says the ad, and you will become more beautiful, more lovable, more esteemed.

The oil painting was primarily addressed to those who led society, the aristocrats and wealthy middle class. It represented the objects, values, and life-style they already possessed. Whereas the advertisement is an insubstantial promise, beckoning the spectator-buyer to future fulfillment ("drink Courvoisier cognac and you will enjoy a sophisticated, upper-class life-style"), the oil painting is a permanent record. One of the pleasures a painting gave its owners was the thought that it would convey the image of their existence to their descendants. Thus, the oil painting was strongly oriented to the present and permanence. The advertisement, in contrast, is future-oriented. An impermanent image, the

4.37 • THOMAS GAINSBOROUGH. *Mr. & Mrs. Andrews.* 1748. Oil on canvas. 27½ × 47". The National Gallery, London.

advertisement is as fleeting as the latest fashions. Looking askance at the present, it promises a future life of radiant success and abundance, a fantasy largely unattainable.

Toward a Critical Appreciation of Advertising Design. Like all works of art, advertisements can be appreciated from a formal or contextual perspective, or both. From a formal point of view, certain product advertisements and corporate posters, album and book covers, television and film commercials possess an aesthetic power that move viewers of the present and will move those of the future. When their original purpose of plugging products, services, or events has faded, the best twentieth-century advertisements will be perceived as works of fine art, just as turn-of-the-century posters like those of Bradley and Mucha currently are. As with all categories of art, whether fine, folk, or popular, time will gradually separate the wheat from the chaff. Inferior popular art, like bad fine art, will ultimately vanish from view.

Yet advertisements, because of their power to effect social conditioning, must be appreciated from more than a formal standpoint. They must also be understood contextually. Relative to our own culture, we must look closely at what advertisements are saying to us and doing to us. Their messages unfortunately are not always laudable: social climbing is good, young is better, smoking makes one sexually attractive, drinking brings success and sophistication. That effectiveness of these ads in shaping our attitudes, values, and behavior, all of which influence our buying patterns, is proved by the billions of dollars paid annually to the international advertising industry. Although we might appreciate the alluring artistry of the ads, we must also learn to understand their meanings.

A "take-off" of a 1979 cigarette ad (4.38)— text excluded—offers an instructive example. The focus of this "advertising image" is the young man in the foreground. He is a stereotypic icon: tall, dark, and handsome. Absorbed in his own activity, he exudes a feeling of masculine independence. Because of his physical size and placement in the extreme foreground, the man is a giant compared to the attractive young women who gaze admir-ingly at him from afar. The central position of the two women, despite their diminutive stature, affirms their central importance to the advertisement. The bright yellows, reds, and whites of their clothing, combined with their bare legs, further attract the male consumer's attention. The man literally wears the pants in this social group. Further differentiating the sexes, the man's clothing and skin tones are darker than the women's.

The women's gazes and a host of exciting diagonal lines and forms—the paddles, cigarette, the canoe, the edge of the mountain— lead the eye to the man. The cigarette in his mouth is supported and pointed to by the strong equilateral triangle of his interlocked arms and hands. Smoking a cigarette is associated with a constellation of stereotypically masculine traits: strength, independence, emotional control, sexual attractiveness. In keeping with this macho man fantasy, the backpack of the standing woman caresses the man's arm, while her feet connect with the diagonal paddle that leads right into his body.

4.38 • After a 1979 cigarette advertisement.

Is too much being read into this advertising image? Could it really be so masterfully manipulative on so many levels? Let the buyer beware! With thousands or possibly millions of dollars of profit on the line, every mass-market advertising design decision is carefully calculated by a team of specialists. Every device of art and science is shrewdly employed to manipulate the target audience.

We have seen how subject matter (the tall, independent man; the smaller, admiring women) and formal means (lines, colors, composition) are employed to manipulate the viewer's conscious and unconscious responses. Let us conclude with a look at how nature, as subject matter, form, and symbol, is put to use in this ad. Many cigarette ads exploit certain kinds of natural settings—verdant woodlands and cooling waters, never hot, dry deserts—to counteract the perception that smoking is unpleasant to the senses and dangerous to the health. This advertisement is no exception. The greens of the trees, the blue of the water, and the bluish gray of the sky are cool and soothing. The viewer is encouraged to associate cigarettes not with hot and dry smoke but with the healthy sensuousness of crystal waters and grassy meadowlands. The large lake the man has just paddled across interjects a romantic note of passion—nature as powerful but now tamed by the cigarette smoker.

SOCIETY'S MIRROR

To sell their products or services, businesses gear their advertising messages to the accepted values and beliefs of the majority of citizen-consumers. In this way, advertising is a revealing social mirror, an accurate reflection of the status quo. Although commercials are often daring in a formal artistic sense, their content is usually conservative, representing and affirming mainstream attitudes and beliefs. When American society, for example, was racially segregated, blacks, Hispanics, and Asians never appeared in ads, except perhaps as servants or cooks. After the legal and social integration of eating places, schools, and neighborhoods, these same minorities gradually entered the ads on an equal footing with

white Americans. Very quickly, they, too, became a valued market to be reached.

The way men and women are portrayed in commercial advertisements likewise reflects their status in society. Our cigarette advertising image is a good example in this regard. In Western society, as a rule, men have been brought up to act, lead, make the major decisions and play the dominant roles. Women, in turn, have been conditioned to react to and support the principal activities of men. Right up to the 1990s, in most ads that feature both men and women, women usually appear somewhat in the background, at a lower level in the picture plane, or in roles of lesser power or social status than men. Women are often portrayed in dependent or supporting roles, and men are frequently portrayed as independent or in leading roles. Our cigarette advertising image is typical in this regard: the man totally absorbed in his own activities, the women admiring and affirming his independence and authority.

Twentieth-century advertisements have not been the first visual art form to portray men and women in these ways. In paintings and sculptures men and women, often in the guise of gods and goddesses, have for centuries been portrayed in accordance with the idea of a male-centered social order. An obvious example is *Jupiter and Thetis* (4.39), a large oil painting done in 1811 by the French master Ingres (1780–1867). In the painting, the powerful, independent male is being entreated by a smaller, weaker, and dependent female. Representing a passage from Homer's *Iliad*, this painting shows the sea nymph Thetis pleading her case to Jupiter, king of the gods. Jupiter will then make a crucial decision. It will be his actions that move the world, alter history, change society. Virtually powerless, all Thetis can do is use her feminine wiles to plead her case.

Such social criticism is not intended to diminish the viewer's formal enjoyment of this highly accomplished painting but rather to make the contextual point that a patriarchal definition of male and female roles has characterized Western society and much of its art for centuries. As new roles for men and women take root—and the liberation movements of recent decades promise expanded

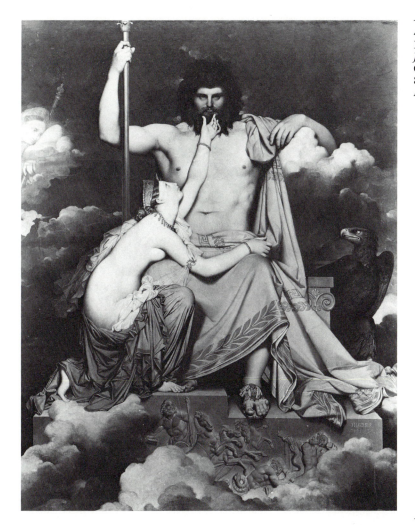

4.39 • JEAN-AUGUSTE-DOMINIQUE INGRES. *Jupiter and Thetis.* 1811. Oil on canvas. 11′ 4⅝″ × 8′ 5¼″. Musée Granet, Aix-en-Provence.

4.40 • After a 1982 cigarette advertisement.

possibilities as well as greater equality and power—both fine art and commercial advertising (4.40) will come to reflect these historical developments. Art, both elite and popular, ultimately mirrors society.

As the nineteenth-century critic John Ruskin (1819–1900) observed, "Great nations write their autobiographies in three manuscripts, the book of their deeds, the book of their words and the book of their art." Of these, he concluded, the book of art is the most trustworthy. From ancient illustrators to contemporary advertising designers, graphic artists have been the visual storytellers of society. They have told the stories that chronicle and comment, that persuade and entertain. Taken together, these stories reflect and shape the biographies of nations.

Sang Yoon's "Water Waters Life."

JAE YOON

Sang Yoon's poster series "Water Waters Life" was created for the Third International Design Competition held in Osaka, Japan, in 1987. This biannual competition, in which visual designers from many nations participate, provides a forum for international exchange. The third competition, whose theme was "water," emphasized social and cultural significance as well as design quality.

For visual designers, the competition's theme of water, general and abstract as it is, must have presented problems. The theme is also too familiar, since water is too great a part of our ordinary lives for us to appreciate it truly or give it true meaning. So many directions seemed to be relevant. The problem for Yoon was to offer a unique view on the importance of water.

Two aspects of Yoon's approach to the theme of water stand out: a global perspective and a positive approach. First, she emphasized the global perspective to express concern for the future of humankind and nature as a whole. She attempted to depict the necessary harmony between nature and human beings wherever they are living. Growing up and training as an artist in Korea gave Yoon a culturally unique viewpoint for the visualization of a global perspective. Second, she adopted a positive approach that emphasizes the ecological importance of water. A positive approach operates by sympathy and consensus, whereas a negative one functions mostly by fear and repression. Stressing the positive

Jae Yoon is a specialist in information technology and mass-media culture. He lives in Harrisonburg, Virginia, with his wife Sang Yoon.

over the negative, Yoon emphasizes the relationship of harmony and peace rather than the struggle to find and preserve the water supply.

Water, the source of all life, is an integral part of every aspect of the human experience: existence itself, daily life, industry, culture, environment. Yoon focuses on the indispensability of water to the existence of the planet. Within the single drop of water in her series of posters, all organisms come to life beautifully and peacefully. Outside of the water drop, each organism turns into a lifeless silhouette—the strongly symbolic "dance of death" in her work. The slogan "water waters life," the single line of text in her posters, further expresses the idea that water is the essential source of all organisms.

The constant in Yoon's series of six posters is a single drop of water. A goldfish, a giraffe, a butterfly, a lotus blossom, a peacock and human hand, representing natural realms, appear inside each of the six single drops. She shows that a single drop of water represents and corresponds to both the specific and the typical in nature. The single drop of water in Yoon's work is a microcosm in which the animal and vegetable kingdoms live peacefully and harmoniously.

Among the six living things that Yoon chose for her poster series, the goldfish and the lotus blossom in particular reflect her cultural heritage. Her choice of a goldfish is natural because these colorful creatures are much used as pond fish in Korea. The lotus blossom symbolizes the teachings of Buddhism.

The last but indispensable life form that Yoon pictures is humankind, represented by a hand. The part of the human hand outside the

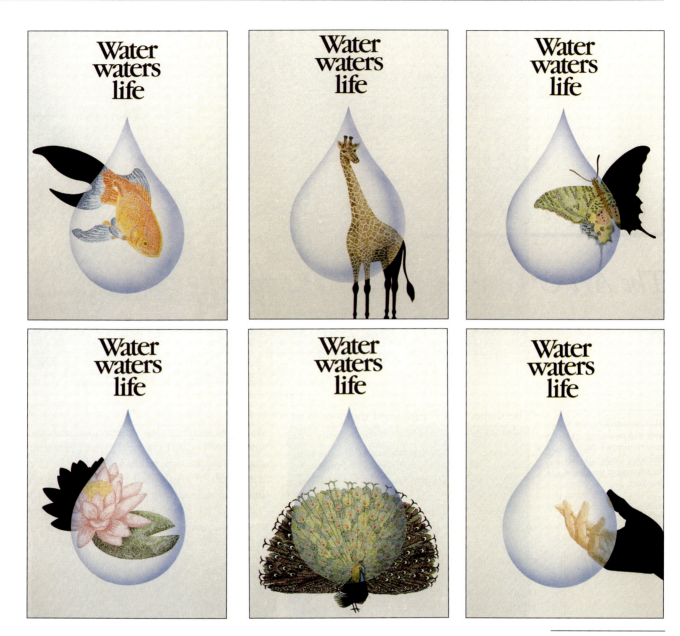

water drop is a solid black silhouette, whereas the part of the hand inside the water drop is seen as animate. This human hand symbolizes the idea that humankind can either bring harmony and peace between nature and human beings or it can bring disharmony and destruction.

As for her artistic approach, Yoon used watercolor and a pointillist technique instead of solid brushstrokes to portray the living creatures. The sharp contrast between the animated mixture of numerous dots of vibrant color—the living forms are literally made of drops of watercolor—and the bold, solid black silhouette is an evocative visual technique for depicting an organic view of the world. In Yoon's "Water Waters Life," visual form and content relate harmoniously, much as living forms and water must relate harmoniously if life is to continue on our planet. ■

Appreciation 7 • SANG YOON. *Water Waters Life.* Poster series. 22 × 15½″ each. 1986.

5.4 • CLAUDE MONET.
The Gare St-Lazare. 1877.
Oil on canvas. 83.1 ×
101.5 cm. The Fogg Art
Museum, Harvard University.
Bequest of Maurice
Wertheim, class of 1906.

and engineering? With visionary enthusiasm, and with the familiarly modern requirements of completing the building quickly and at relatively modest cost, Paxton proposed a plan that called for the most advanced industrial methods and materials. The first part of the plan called for factory prefabrication of all parts: 1,073,760 square feet of prefabricated modular glass frames, each 49 inches long; 6024 iron columns, each 15 feet long; 1245 wrought-iron girders, and 45 miles of standard-length sash bars. With these ready-made parts, a contemporary design journal noted, the putting together should work as with "a perfect piece of machinery." Prefabrication did, in fact, speed construction time and limited on-site labor to the mere assembly of parts. The job was carried out by a small army of unskilled workers. By reducing construction time and eliminating the need for costly,

highly skilled artisans, Paxton reduced expenses. He completed the huge structure within budget in a miraculous seven months after the plan had been approved. Nothing like this had ever happened in the history of building. No structure so large had ever been created so quickly and at such moderate cost.

Impressive though the Crystal Palace was as a triumph of engineering and industry, it nonetheless appeared "styleless" to many persons of cultivated taste, lacking as it did the customary artistic ornamentation and historical elements, such as Greek columns or Gothic arches, that clothed all important buildings. Most sophisticated art lovers couldn't begin to consider such a structure as architecture or art; ingenious industrial engineering, yes; elevated architectural art, no. The eminent critic John Ruskin (1819–1900), while applauding the "bodily industry" that went into the con-

struction of the building, derided the final result as little more than "a greenhouse larger than ever greenhouse was built before." In terms of the traditional nineteenth-century way of seeing, the grand pavilion seemed all too plain, too straightforwardly functional, to be appreciated as a work of art.

Yet unbeknownst to critics and public, the great engineering achievements of the nineteenth century—bridges, exposition halls, railway stations (5.4)—would turn out to be the harbingers of the "modern" functionalist architecture and product design of the next century. Years ahead of their time, the formal qualities of these supposedly styleless giants would gradually enter the consciousness of the world's people. Ever so slowly, the public would become aware, as poets like Whitman already had, that a unique new style was arising. Giving visual form to the values, materials, and processes of the Industrial Revolution, the new **functionalist** or **machine style** would, within the next century, come to dominate all areas of design, from engineering to architecture to everyday products. This new aesthetic, which onlookers today readily identify as modern, is now seen everywhere: in our home furnishings and kitchenware; in our airplanes, trains, and automobiles; in our stadiums, museums, and skyscrapers, those towering crystal palaces of glass and steel that dominate the urban landscape. Conquering the world, the machine look would become a truly international style and the most dominant aesthetic in the history of humankind. Yet through much of the nineteenth century, almost amazingly, it went totally unrecognized as art and style.

Although a number of factors—new industrial materials, new modes of production (prefabrication, division of labor, the assembly line), and designers unrestricted by traditional artistic or architectural training—played a part in the development of the modern machine style, the most important factor was that of function. In the nineteenth century, exhibition halls, bridges, and railway stations had to function effectively, both for commercial success and human safety. The appearance or form of the structure was consequently determined primarily by its specific function and engineering requirements. In contrast, artistic

5.5 • JOHN BELL. Hours clock. 1851. Made by Elkington's.

concerns prevailed over practical ones in the profusely decorated furniture, kitchen implements, and clocks (5.5) exhibited at the Great Exhibition of 1851. In these works, as in so many of the products designed for affluent Victorians, the artistic components of figurative ornamentation or historical styling disguised or overpowered the functional purpose.

By the early twentieth century, however, the tables had turned. Function became the first principle in determining the appearance of almost all designed forms, from buildings to mass-produced products. The most famous design principle of the twentieth century, best summed up by North American architect Louis Sullivan (1856–1924), was "form follows function." Large-scale engineering projects led the way. The functionalist design of architecture and everyday commodities gradually followed.

Because of our present profound conditioning to the world view of functionalism, it is not surprising that the nineteenth-century structures that seem most forward-looking to us are those, such as exposition halls, suspen-

5.6 • G. G. ADAMS.
Gothic clock in imitation
oak. 1851.

sion bridges, and railway stations, that derived
their visual form primarily from their utilitar-
ian purpose. Such structures are characterized
by an aesthetic we now know all too well:
simple geometric shapes, precise and standard-
ized, with a minimum of historical styling and
ornamentation, a line or contour that is direct
and unbroken ("streamlined," to use our
twentieth-century word), and surfaces of uni-
form texture. But whereas these nineteenth
century shapes of bridges, vast frameworks,
and girders looked confidently toward the fu-
ture, much of the product design of the Vic-
torian era looked nostalgically to the past, and
not always with the best artistic results.

Product Design at the Crystal Palace. Al-
though the Crystal Palace embodied in its
grand pavilion of metal and glass the confident
optimism of science and industry, the "man-
ufactures" housed within its halls seemed to
flounder for identity. Soon after the world's
fair opened, the *Times* of London commented:
"The absence of any fixed principles in orna-
mental design is apparent in the Exhibition—
it seems to us that the art manufacturers of the
whole of Europe are thoroughly demoral-
ized." Writing a century later, Miss Yvonne
ffrench would criticize the contents of the
Great Exhibition in much the same way, find-
ing all too many "examples of the hideous and
the debased . . . of a bastardization of taste
without parallel in the whole recorded history
of aesthetics." Well before the exhibition
opened, the lack of design standards in
machine-based industry had alarmed civil
servants like Sir Henry Cole (1808–1882). It
was Cole who helped launch the Great Exhi-
bition by persuading Prince Albert, the pres-
ident of the Society of Arts, to back it. One
motive for holding the Great Exhibition
was, in fact, to dramatize the abysmal design
standards of British industry. The exhibition
proved the point that Cole wished to make:
that the new machine-made goods were infe-
rior to the handcrafted ones. Upgrading these
products, Cole argued, would require legisla-
tion and the education of designers with a
sensitivity to art and craft.

Less diplomatic than Cole, the harsher crit-
ics at the exhibition used words such as *bas-*

tardization and *debasement* to describe the
manufactured goods. Why such indignation?
What was being bastardized or debased? The
principal answer was historical styling. Fur-
niture, kitchenware, even machines, were
being decorated in a potpourri of historical
styles—Egyptian, Gothic, Renaissance, ba-
roque, rococo—little of which bore an au-
thentic relationship to the originals. The result
of these freewheeling evocations of earlier
styles were products (5.6) that hostile critics
like Ruskin called "sham" or "imposture."
Such words are comparable perhaps to such
recent derogatory terms as *phoney* or *kitsch,*
the latter defined as something gaudy, preten-
tious, shallow, and calculated to have popular
appeal.

In addition to being disturbed by the deg-
radation of historical styles, critics such as
Ruskin, for whom art and morality were in-
separable, disliked the "deceptive" substitu-
tion of new industrial materials—iron, brass,
zinc, molded paper pulp—for the authentic
wood, stone, or marble of the original period
furnishings. For Ruskin and many other Vic-
torian critics, ethics infused aesthetics, and
they perceived such substitutions of materials
as deceptive and "dishonest." In the fabrica-
tion of Victorian kitchenware, for example,

rative content, in the fashion of the European academic paintings of the day (4.39). The catalogue accompanying the "daydreamer" chair, like the long captions of explanation that frequently accompanied Victorian paintings, explains the content and form of this art manufacture:

> The chair is decorated at the top with two winged thoughts—the one with bird-like pinions, and crowned with roses, representing happy and joyous dreams, the other with leather bat-like wings—unpleasant and troubled ones. Behind is displayed Hope, under the figure of the rising sun. The twisted supports of the back are ornamented with poppy, heartsease, convolvulus and snowdrop, all emblematic of the subject. In front of the seat is a shell . . . and on either side of it, pleasant and troubled dreams are represented by figures. At the side is seen a figure of Puck, lying asleep in a labyrinth of foliage. . . . The style of the ornament is Italian.[3]

For a Victorian public that equated painting—"a novel in a rectangle"—with literature, the incorporation of allegories, stories, and human subjects into its art manufactures was not at all uncommon. The Victorians loved the literary as much as they loved historical styling and ornamentation. In their objects of art, ornamental effects, historical decoration, and literary associations could actually overwhelm the humble factor of function. This love of elaboration was in utter contrast to the Crystal Palace—of unadorned surface, transparent lightness, and functionalist geometry—which housed art manufactures like the "daydreamer" chair for all the world to see.

VICTORIAN DESIGN & MIDDLE-CLASS TASTE

The type of product design represented by the "daydreamer" chair appealed to the increasingly prosperous and powerful middle class. The political and industrial revolutions of the eighteenth and nineteenth centuries had made the bourgeoisie the leaders of society, raising them above their former rulers, the clergy and nobility. **Victorian design**, in large part, reflected their taste. It was the taste of a "nouveau riche," a growing class of newly rich people. To a cultivated Victorian aristocrat or aesthete, most machine-made art manufac-

real silver might be simulated by electroplating, lowering costs for an eager buying public. The initial shock of such material simulations to more sensitive systems might have been much like that of persons in the mid-twentieth century, who, despite an addiction to technological innovation, were at first aghast at the simulations, in plastic, of natural materials (wood, leather, stone), and even flowers and houseplants.

Furniture at the Crystal Palace: The "Daydreamer" Chair. A display model at the exhibition much admired by the general public, though undoubtedly scorned by Ruskin and other critics, was the "daydreamer" easy chair, an "art manufacture" by H. Fitz Cook (5.7). Created in the popular new material of papier-mâché, the short-lived plastic of its day, the "daydreamer" chair was characterized by curving lines and shapes, a great deal of ornamental detail, and the illusion of bulk and weightiness, belying its actual weight. Its overall style was reputed to be "Italian." Six full-length figures, clothed, semiclothed, and nude, adorn the surfaces. In sleeping and reclining positions, the "dreaming" figures and the chair's name endow this utilitarian object with a nar-

tures represented a tasteless display: forms that were illiterate distortions of earlier styles, materials that were falsifications, ornamentation that was verbose. A simple, unsavory rule seemed to be operative among these nouveau riche: more wealth, more show. Wealthy churchmen, aristocrats, and merchant princes of previous centuries had, of course, engaged in displays of conspicuous consumption: from the extraordinary costumes of Queen Marie Antoinette (Appreciation 2, Fig. A) to the grandiose feasts of the avaricious Duke of Berry, immortalized in his own medieval manuscript illuminations (4.8), to the exhibition of luxurious dinnerware and foodstuffs in certain seventeenth-century Dutch still-life paintings (4.35). But to cultural aristocrats who sought to uphold Victorian aesthetic standards, the issue was not so much wealth as taste, and the taste displayed by the nineteenth-century's newly rich seemed to them particularly low.

As design historian Nikolaus Pevsner explains it, the hard-driving men of commerce put their energies into money making and empire building, leaving relatively little time for cultural development and the acquisition of the more subtle, discriminating tastes of their gentlemenly predecessors. The overall feeling of bourgeois interior design and furnishings is therefore not one of sophisticated discernment but of heavy-handed show (5.8). It is the taste of a class that is forging ahead vigorously on the economic and political fronts but is not entirely knowledgable or sure of itself in the cultural sphere. Proof of this lack of distinct cultural identity in the middle class, was their enthusiastic embrace of a freewheeling mix of styles of earlier ruling elites, from ancient Egyptian to the eighteenth-century French rococo style of Louis XV's reign; styles that were too often exaggerated mimicries of the originals.

For their part, self-styled Victorian gentlemen, whether of noble or common birth, looked in other directions. In the 1840s and 1850s, various members of the cultural elite looked to the medieval period and a rigorously authentic **Gothic revival style** (5.9) for national as well as moral and artistic identity. (The famous Houses of Parliament [6.49] in London, Gothic in their styling, were built during this time.) From the 1860s and 1870s, many among the aesthetically sophisticated looked to the fine handcrafted work of Morris and Company, inspired by medieval art-craft ideals, and also to Japanese art and design, with its aesthetic of elegant simplicity and decorative restraint. The Japanese aesthetic was imaginatively adopted in the furniture (5.10)

5.8 • SOLOMON JOSEPH SOLOMON. *A Conversation Piece.* 1884. Oil on canvas. 40 × 50″. By permission of Kensington and Chelsea Borough Council, Leighton House, London.

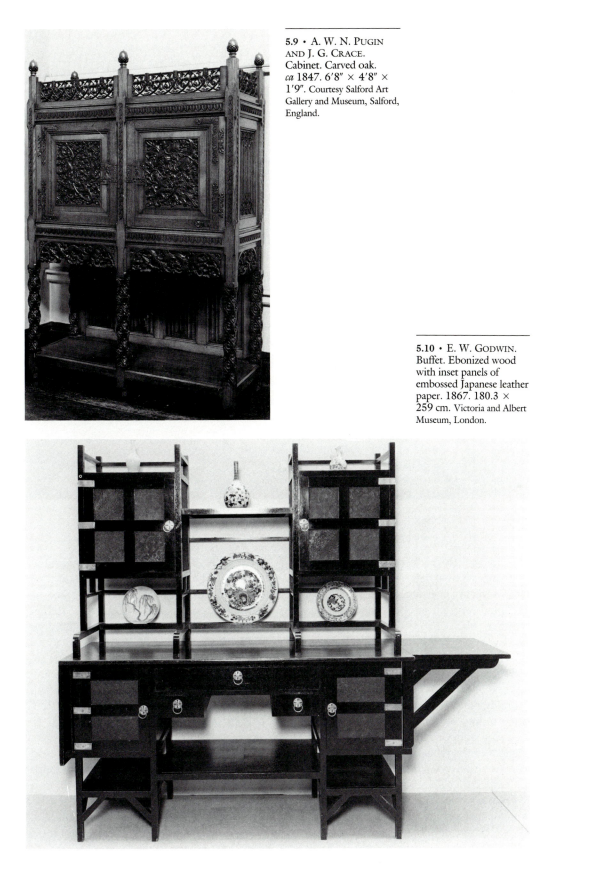

5.9 • A. W. N. PUGIN AND J. G. CRACE. Cabinet. Carved oak. *ca* 1847. 6'8" × 4'8" × 1'9". Courtesy Salford Art Gallery and Museum, Salford, England.

5.10 • E. W. GODWIN. Buffet. Ebonized wood with inset panels of embossed Japanese leather paper. 1867. 180.3 × 259 cm. Victoria and Albert Museum, London.

5.11 • THOMAS JECKYLL
AND J. M. WHISTLER.
The Peacock Room.
1876–1877. Oil color and
gold on leather and wood.
14′ × 33′ ⅛″ × 20′.
The Freer Gallery of Art,
Smithsonian Institution,
Washington, D.C.

and interior designs of the architects E. W. Godwin (1833–1886) and Thomas Jeckyll (1827–1881). Jeckyll also collaborated with the American expatriate painter, James McNeill Whistler (1834–1903) in the creation of the famous Peacock Room, an Anglo-Japanese hybrid of remarkable originality (5.11). Whistler's peacock figures adorn the wall. Whistler was one of the first to integrate Japanese subject matter and aesthetic principles into Western painting; note, for our immediate purpose, the simplicity, lightness, and abstract elegance of the Japanese furniture in the right corner of his 1864 painting, *Caprice in Purple and Gold, No.2: The Golden Screen* (5.12).

Entering western Europe in forms ranging from Japanese furniture and woodblock prints to porcelain "chinaware" (all observed in Whistler's *Golden Screen* painting), the aes-

thetics of the Far East was a substantial stimulus to the development of modernist art and design. Both designers in the applied arts (product, interior, and architectural designers) and creators of paintings and posters (vanguard artists such as Whistler, Monet, van Gogh, Toulouse-Lautrec, and Cassatt) responded to the Japanese influence and found it liberating. The painters, printmakers, and poster artists were much drawn to the abstract qualities of Japanese art, in particular to the simple, stylized shapes, areas of flat color, and asymmetrical compositions in the woodblock prints of such masters as Utamaro, Hiroshige, and Hokusai (3.18). The artifacts of non-Western cultures, especially those of the Far East, Africa, and the Pacific Ocean islands, all contributed significantly to the birth of modern design and art.

During this period of forward-looking scientific and technological progress and major social change, all classes in British society seemed to be searching for an identity. For cultural identity, individuals and groups looked romantically to the great European styles of the past—Gothic, Renaissance, baroque, rococo—and to Japan and other faraway cultures. At the same time, an industrial transformation of society, a revolution of the most profound effects, was, in its struggle to be born, shattering the old world. At some level, almost all Englishmen and women must have felt a certain cultural instability and sense of anticipation. As the essayist Thomas Carlyle (1795–1881) wrote in the 1830s, ". . . the Old has passed away; but alas, the New appears not in its stead." In a similar sentiment expressed twenty-five years later, the poet Matthew Arnold (1822–1888) described, "Two worlds, one dead or dying, one struggling, but powerless to be born."

THE INDUSTRIAL REVOLUTION: THE DARK SIDE

Echoing the insights of Carlyle and Arnold, the socially critical novels of Charles Dickens (1812–1870) offered the view that it was the best of times and the worst of times. The giant new mills and factories of the Industrial Revolution were successfully producing an abundance of goods at lower cost. The profits from industry and commerce had greatly expanded the size and power of the middle class. Scientific discoveries and technological inventions were on the rise. Yet not all were satisfied with these results. Critics lambasted the ugliness and tastelessness of many of the machine-made goods. Those concerned with the natural environment were enraged by the ravaging of agricultural field and picturesque landscape, and the industrial pollution of water, earth, and sky.

Even more powerful outcries were directed at the traumatic changes industrialization had brought to the laboring masses. Displaced from town and countryside by the emerging urban-industrial society, artisans, craftspersons, and independent farmers were forced into an entirely unfamiliar mode of productiv-

5.12 • J. M. WHISTLER. *Caprice in Purple and Gold: The Golden Screen.* 1864. Oil on wood panel. 19¾ × 27". The Freer Gallery of Art, Smithsonian Institution, Washington, D.C.

ity. Persons who had previously handcrafted whole products or executed entire agricultural processes were suddenly compelled to labor at simple, repetitive, highly specialized jobs. It might be their lot to assemble a single part, dig holes, or unload coal twelve to fourteen hours a day, six days a week, fifty-two weeks a year.

In Monet's 1875 painting, *Unloading Coal* (5.13), lines of faceless workers trudge forward and back, machinelike, against a background of smoking factory chimneys and the domineering presence of an iron bridge. Given this drastic change in working conditions, it is not surprising that many workers from craft workshop or farm could not adjust and even rebelled against the dehumanizing conditions they experienced. The early industrial laborers had been accustomed to nontechnocratic modes of productivity based on a sense of time that was human or natural, that is, rooted in the cycles of day and night, the seasons, and the directives of their own bodies and personalities. They were furthermore used to controlling tools or machines at their own pace, rather than having the machines and tools control them. The technocratic workworld thrust on them was unrecognizable and incomprehensible. For the first generations of factory workers, the new technocratic mode of production (fragmented, impersonal, and me-

5.13 • CLAUDE MONET. *Unloading Coal.* 1875. Oil on canvas. 21¼ × 25½". Collection Durand-Ruel, Paris.

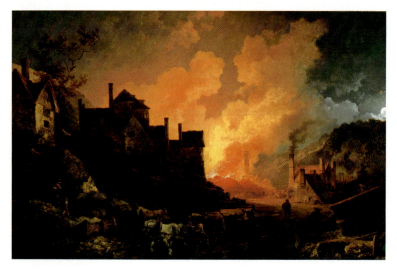

5.14 • PHILIPPE JACQUES DE LOUTHERBOURG. *Coalbrookdale by Night.* 1801. Oil on canvas. 26¾ × 42". The Science Museum, London.

chanical) and sense of time (mechanical, unnatural, and seasonless) was horrific. Critics such as the poets William Blake (1757–1827) and William Wordsworth (1770–1850) used images of Satan and the inferno as metaphorical equivalents of the first heavy industries, billowing with smoke and fire and suggestive of underworld imprisonment and torture (5.14). The first mine, mill, and factory workers felt themselves to be literally in hell, chained to their machines and ruled by the

unfeeling ticks of the clock that told them when they had to work and when they could stop. Decades before Carlyle and Ruskin or Marx and Engels, in fact, around 1810, Wordsworth despaired over the arrival of a night shift:

> Disgorged are now the ministers of day;
> And, as they issue from the illumined pile,
> A fresh band meets them, at the crowded door—
> And in the courts—and where the rumbling stream,
> That turns the multitude of dizzy wheels,
> Glares, like a troubled spirit, in its bed
> Among the rocks below. Men, maidens, youths,
> Mother and little children, boys and girls,
> Enter, and each the wonted task resumes
> Within this temple, where is offered up
> To Gain, the master idol of the realm,
> Perpetual sacrifice.[4]

From the standpoint of economics, the goals of most nineteenth-century captains of commerce were quite simple: having freedom from governmental regulation—touted as economic liberalism—and making the maximum profit. For the most part, the leaders of the bourgeois revolution got their way and ruthlessly made their fortunes. Disgusted critics would come to denounce the resulting free market system as "commercialism" or "mammonism," after the Biblical term for money. These "latter-day mammons" would work their production line laborers for long hours at low wages. Critics ranging the political spectrum from conservative to communist saw such workers as merely slaves who were paid wages, or "wage slaves." In the 1830s, the young women working in the textile mills of Lowell, Massachusetts, a supposedly enlightened factory system, labored thirteen to fourteen hours six days per week, a condition that worsened after the women went on strike for better working conditions and were gradually replaced by lower-paid immigrant laborers. No paintings or photographs of the Lowell strike exist, but the British artist Eyre Crowe (1824–1910) did paint a picture, unique in Victorian art, showing a group of factory girls taking their dinner break outside a Wigan cotton mill (5.15). "Crowe," art historian Christopher Wood writes, "must have tried to idealize the scene a little—the girls are pretty,

5.15 • EYRE CROWE. *The Dinner Hour, Wigan.* 1874. Oil on canvas. 30 × 42½". Manchester City Art Gallery, Manchester, England.

5.16 • THÉODORE GÉRICAULT. *Pity the Sorrows of a Poor Old Man.* Number two from *Various Subjects Drawn from Life and on Stone* (English series). 1821. Lithograph. 12¼ × 14¾". Stanford University Museum of Art. Alice Meyer Buck Fund.

neat and cheerful, and there is no hint of any exploitation or misery—yet he was attacked by most critics for painting the subject at all." Factory women and men might labor hard for the captains of industry, but they should never, according to most contemporary middle- and upper-class art critics and gallery goers, be seen in public as subjects of works of art.

Compounding the plight of the worker class inside the factories was their social situation outside. Housing, health, and sanitary conditions for the vast majority of American and European laborers were abysmal. The incisive novels of Dickens and the forceful drawings of two prominent French artists, Théodore Géricault (1791–1824) and Gustave Doré (1832–1883), done almost fifty years apart, gave grim aesthetic life to these conditions (5.16, 5.17). In an uncanny way, these drawings remind us of the contemporary plight of our own poor and homeless in the postindustrial society of the late twentieth century. Such visual reportage corresponded to the 1842 governmental *Report on an Inquiry Into the Sanitary Conditions of the Labouring Population of Great Britain,* which described

"*Pity the sorrows of a poor old Man!*"

5.17 • GUSTAVE DORÉ.
*Scripture Read in a Night
Shelter.* 1872. Wood
engraving.

with scientific objectivity the new system of
social relations and the abject living conditions
created by the revolution of industry and the
bourgeoisie.

> The great towns are chiefly inhabited by
> working-people, since in the last case there is
> one bourgeois for two workers, often for three,
> here and there for four; these workers have no
> property whatsoever of their own, and live
> wholly upon wages, which usually go from hand
> to mouth. Society, composed wholly of atoms,
> does not trouble itself about them; leaves them
> to care for themselves and their families, yet
> supplies them no means of doing this in an
> efficient and permanent manner. Every working
> man, even the best, is therefore constantly ex-
> posed to loss of work and food, that is to death
> by starvation, and many finish in this way. The
> dwellings of the workers are everywhere badly
> planned, badly built, and kept in the worst con-
> dition, badly ventilated, damp, and unwhole-
> some.[5]

RUSKIN'S ARGUMENT FOR
HANDCRAFTSMANSHIP:
A CRITIQUE OF THE INDUSTRIAL
MODE OF PRODUCTION

Although the oppressive living conditions of
the laboring classes disturbed many, the critics
Carlyle and Ruskin were particularly angered
by the transformation of the work process it-

self. For these two widely read writers, work
was the most sacred of activities, the chief
source of human fulfillment. In Carlyle's
words, "work is worship" and "labor is life."
Such a view of work was given visual expres-
sion at the time by an artist who completely
sympathized with Carlyle's views. In his large
painting, *Work,* begun in 1852, Ford Madox
Brown (1821–1893) portrayed blue-collar
workers as the most noble contributors to
society's well-being (5.18). All social classes,
the painter implies, should honor the honest
laborer.

As the critics saw it, the factory system, by
its conversion of work into mindless drudgery,
robbed humanity of its most noble satisfac-
tion. The industrialization of work, they be-
lieved, was an incalculable sin against God,
humankind, and nature. In preindustrial
times, Ruskin pointed out, people's work was
their "art," meaning their skill or craft in a
particular discipline or trade. The "arts" in
medieval times, the period with which he had
the greatest sympathy, referred not to painting
or sculpture alone, but proudly to all the trades
and professions. In medieval society, Ruskin
argued, skill, pride, and love went into one's
art, whether it was the tanning of hides, carv-
ing of stone, or making of furniture. Art, craft,
and skilled labor in the Middle Ages were one
and the same thing, and all "the arts" were
esteemed equally. The same, he believed,
should hold true for modern-day England.

The captains of the Industrial Revolution,
Ruskin lamented, had debased the status of
the practical arts by employing masses of un-
skilled laborers and unfeeling machines at the
expense of skilled artisans and craftspeople.
Goods produced by skilled individuals, he ob-
served, could not compete in price with the
mass-produced goods coming off the assembly
lines, and many had been forced to give up
their trades, even seeking work in the hated
mills and factories. Skilled creators of high-
quality products, attractive in appearance, well
made, and effective in function, were being
steadily lost, while "cheap and nasty" machine
manufactures, to use Carlyle's phrase, were
flooding the market. For Ruskin, the most
influential cultural and social critic of the pe-
riod, the process of work and the resultant
products should aspire to the level of art; that

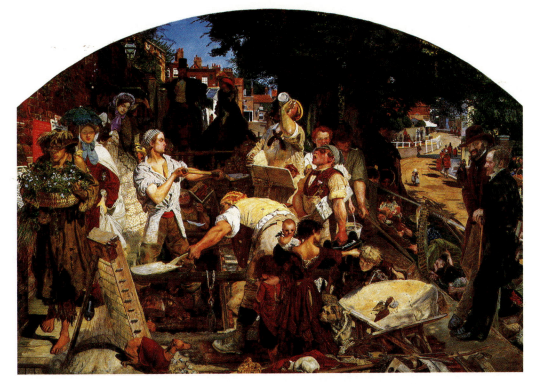

5.18 • FORD MADOX BROWN. *Work.* 1852–1865. Oil on canvas. 54½ × 77⅛″. Manchester City Art Gallery, Manchester, England.

is, they should embody the mind, character, and skillful hand of its creator. In a passionate argument for the continuation of the handicrafts in the face of increasing machine production, he argued that

> . . . hand-work might always be known from machine-work; observing, however, at the same time, that it was possible for men to turn their lives into machines, and to reduce their labor to the machine level; but so long as men work *as* men, putting their heart into what they do, and doing their best, . . . there will be that in the handling which is above all price; it will be plainly seen that some places have been delighted in more than others—that there have been a pause and a care about them; and then there will come careless bits, and fast bits; and here the chisel will have struck hard, and here lightly, and anon timidly; and if the man's mind as well as his heart went with the work, all this will be in the right places, and each part will set off the other; and the effect of the whole, as compared with the same design cut by a machine or a lifeless hand, will be like that of poetry well read and deeply felt to that of the same verses jangled by rote.[6]

In comparison to such handcrafted work, the shapes, surfaces, finish, and ornament produced by the machine, Ruskin felt, were "cold" and "deadly," with a chill "look of equal trouble everywhere," an inhuman appearance of "smooth, diffused tranquillity." Such a point of view would help to explain his lukewarm reaction to the Crystal Palace, that "greenhouse larger than a greenhouse was ever built before," with all of its standardized parts prefabricated by machine and assembled by unskilled workers. The best of the nineteenth-century's mass-produced furniture, classics such as the cafe chair and rocker (5.19, 5.20) by the Austrian designer Michael Thonet (1796–1871), would, for these same reasons, probably have left him "cold." How our aesthetic orientation has changed! We now live in, completely accept, and even prefer our machine-made products of smooth, tranquil surfaces, with their "look of equal trouble everywhere."

Along with the rise of machine production, Ruskin saw industry's extreme division of labor as the principal cause of the degradation of worker and product. Divided labor made workers into mechanisms, limited them to a single set of faculties, and dissociated them from the completed product, a condition later critics called "alienated labor." For Ruskin, the division of work transformed laborer and labor into "mere segments and crumbs of life." The consumer, Ruskin added, suffered as well because production, though increased in quantity, was lessened in quality, and the true

factures. Wrestling with many of the same problems, most developing industrial nations would follow the British example.

WILLIAM MORRIS & THE ARTS & CRAFTS MOVEMENT

It was into this historical situation that William Morris (1834–1896) and other English **Arts and Crafts** reformers stepped. Looking for furniture for his own lodgings, Morris, the son of a successful businessman, could find no good designs and was utterly disheartened by the ugliness and vulgarity of the products available. Believing with Carlyle and Ruskin that the combination of divided labor, machine production, and competitive commercialism was impoverishing products and work process alike, he determined to set an alternative example. In 1861, at the age of 27, he opened a seven-member firm, Morris and Company, whose goal was to produce finely designed, handcrafted products (5.21) at reasonable cost. Among the seven members were the painters Ford Madox Brown, Dante Gabriel Rossetti (1828–1882), and Edward Burne-Jones (1833–1898); the architect Philip Webb (1831–1915); and Morris himself, an artist-craftsperson in diverse media. Master artisans, some of them recruits from the Workingmen's College, assisted on the projects. Within the scope of Morris's medieval-style guild-workshop ideal, artists and craftspersons would cooperate to create decorative and functional art, well made and beautiful, for private homes and public places. An equality of the arts and crafts would preside, fine and applied artists working side by side for the greater good of art and society. In this setting, the work process would be pleasurable and gratifying, enabling all the artist-workers to give fully of themselves in the creation of decorative and practical art of the highest quality. The pride of the artist-craftsperson would be manifested in each work.

The range of work of decorative and useful art produced by Morris and Company was extraordinary: mural decoration, stained glass, decorative tiles, architectural carving, metalwork including jewelry, ceramics, weaving and embroidered textiles, wallpaper and fabric de-

value of the goods, whatever their retail price, was correspondingly lowered.

In respect to the issue of product quality, Ruskin and Carlyle were not alone in crying out. Many participated in the critical chorus. The government reports on design and industry of 1836, the Great Exhibition of 1851 and subsequent trade expositions, and reformist legislation that imposed standards and set up design schools were all attempts to improve the poor quality of British industrial manu-

sign, furniture, and, by the 1890s, the printing of artistic books. Though they advocated no single style, they adhered to general moral-aesthetic imperatives such as "fitness for purpose," handcraftsmanship, respect for materials, simplicity, and restraint. Within these broad parameters, the artist-craftsperson was encouraged to bring personal expression to the medium: Rossetti and Burne-Jones, for example, in stained glass; Webb in furniture; Morris in wallpaper, weaving, fabric, and tile design (5.22). In this stimulating community of master artists, even more ambitiously varied in the range of arts they practiced than their medieval guild-workshop forebears, the individual, guided by personal integrity, was the ultimate arbiter of style.

Building upon the idea of the equality of the arts and the cooperative interplay of diverse artist-craftspersons, Morris urged the

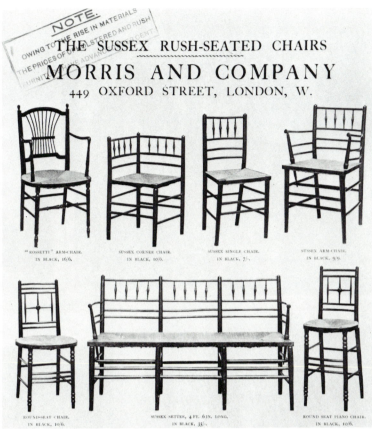

5.21 • WILLIAM MORRIS AND COMPANY. The Sussex rush-seated chairs. Page from a 1910 catalogue. The William Morris Gallery, Walthamstow, London.

5.22 • WILLIAM MORRIS. Tile panel. Made by William De Morgan for Membland Hall, Devon. 1876. 167.6 × 91.4 cm. The William Morris Gallery, Walthamstow, London.

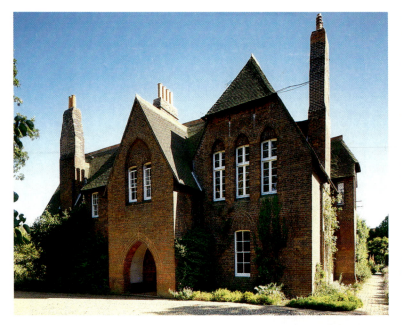

5.23 • PHILIP WEBB.
Red House. 1859.
Bexleyheath, England.

coming together of the various arts in a higher synthesis in private homes and public buildings, on the street and in the workplace. Practicing what he preached, Morris made his own Red House (5.23), designed by his friend Philip Webb, a total work of art, a complete aesthetic environment. On the outskirts of London, Red House, as an early biographer put it, evoked feelings of the medieval but in a modern way. Adhering to Morris's values of simplicity and fitness for purpose, its design, wrote the biographer, was "externally . . . plain, almost to the point of severity, and depended for its effect on its solidity and fine proportion. The decorative features it possessed were constructional, not of the nature of applied ornament," the latter being characteristic of contemporary Victorian taste. Nearly every aspect of Red House, from the

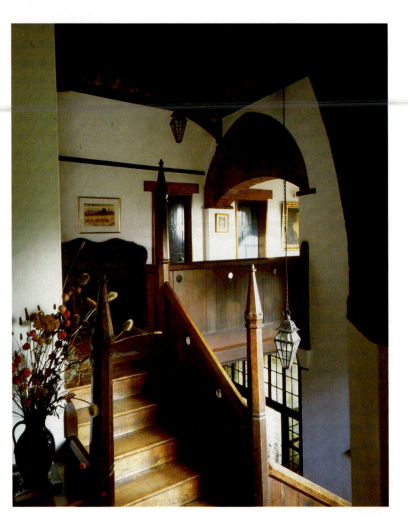

5.24 • PHILIP WEBB.
Staircase at Red House.
Bexleyheath, England.

landscape gardening to the wall and floor coverings, furniture, and woodwork (5.24), was designed, decorated, and handcrafted by Morris and his friends.

A man of means and cultivated taste could create such a total domestic environment of beauty and function and receive pleasure in doing so, but could modest working people, as the Arts and Crafts reformers hoped, achieve the same for their homes and communities? The general answer seems to be no, though the example of America's Shakers, or Shaking Quakers, says otherwise. Separating themselves from the urban industrial world, this idealistic Protestant sect established a handful of small rural communities in the United States in the late eighteenth and early nineteenth century. Of modest means but totally devoted to their religious beliefs, the

Shakers preached pacifism, sexual and racial equality, spiritual purity, and honest craftsmanship in everything they made (5.25). In 1852, the Shakers founded a highly successful chair factory to make furniture for outside sale; their ideals were "regularity is beauty" and "beauty rests on utility," an aesthetic morality very much akin to that of Morris and Ruskin and a far cry from the bourgeois aesthetic embodied in the highly decorated, historicist furniture that dominated the Crystal Palace Exhibition of the previous year. In 1845, the socialist author and manufacturer Friedrich Engels (1820–1895) went so far as to cite the Shakers as proof of the possibility and practicality of communism, noting that their productions emphasized the conviction that the utility, simplicity, and perfection of their environment constituted a moral obligation

5.25 • Reconstruction of a Shaker room. The American Museum in Britain, Bath, England.

within their communities, reflecting their ethical system. This perfect integration by the Shakers of art, ethics, and communal living was a total model that Morris and the Arts and Crafts movement could applaud but not equal.

In their small, self-contained communities, the Shakers achieved, in microcosm, the Arts and Crafts ideal: nameless craftsperson-citizens sharing their wealth and talents for the moral, aesthetic, and material good of society. By contrast, longstanding Arts and Crafts commercial firms, such as Morris and Company (established in 1861) and the more socialistic Art Workers, Craftsmen, and Handicraft Guilds that arose from 1880s onward, could not succeed in a comparable way. In a competitive free-market economy, their products, designed and handcrafted by a master and skilled assistants, proved too expensive or too unusual in style for a middle-class public whose preference was for historical revival styles and profuse ornamentation. For these reasons, the products of Arts and Crafts practitioners tended to be commissioned or purchased by a small elite of wealthy, sophisticated people.

But although their initial commercial market may not have been large (though it grew steadily over time), the passionate idealism of the Arts and Crafts movement spread almost immediately. From personal contact and exhibits at various international expositions, through speeches, pamphlets, books, and magazines (such as, the Century Guild's *Hobby Horse,* established in 1884; *The Studio* and *International Studio,* in 1893; *House Beautiful,* in 1896; *The Craftsman,* in 1901; and *Handicraft,* in 1902), movement ideals spread across national boundaries, with art works taking on the aesthetic character of their country, locality, and individual creator. The movement's enthusiatic vision, coupled with the fine work of original Arts and Crafts practitioners such as Morris, inspired and influenced several generations of artists, architects, product designers, and aesthetes in both Europe and America.

Among the aesthetes was the flamboyant writer Oscar Wilde (1854–1900), an early supporter of Arts and Crafts principles. For all his supposed decadence and elitist poses,

Wilde was ardently concerned for individualism in art and took an interest in Morris's social ideals, undertaking a wildly successful eighteen-month tour of America in 1882 to spread the gospel of aesthetic enlightenment. Artistic considerations, Wilde believed, should enter into every arena of life.

Arts and Crafts ideals would strike a still deeper chord with the vanguard artist-designer practitioners of the 1890s and early twentieth century: members of Scotland's Glasgow School of Art, Germany's Jugend (Youth) Movement, Vienna's Secession, Belgium's L'Association Pour L'Art (Association for Art), and North America's various Arts and Crafts societies, including the one in Chicago, founded in 1897, in which the young architect, Frank Lloyd Wright, was a charter member. All of these organizations or movements promoted the equality of fine and applied arts, the ideal of the artist-craftsperson as designer, and the goal of creating fine decorative and useful art for the larger public: "art for all," as Morris would say.

ART NOUVEAU: THE NEW ART OF THE TURN OF THE CENTURY

The "new art" movements of the 1890s and early years of the twentieth century had much in common but were initially differentiated by name and national traditions. Although the movement quickly took on an international character—artists and writers from across Europe and America exhibited and published in each other's home countries—the "new art" was originally described by a host of separate (but interrelated) names: **art nouveau** in England and France; Studio-stil (Studio style) in Belgium (after the English publication, *Studio,* which reflected the work of the Arts and Crafts Exhibition Society); Jugendstil (young style) in Germany and Austria; modernismo (modernism) in Spain; English or Liberty style in Italy (after London's Liberty store, which sold Arts and Crafts and Oriental items). Mild differences in name and certain regional differences notwithstanding, the new art movements had a great deal in common both ideologically and stylistically.

The forward-looking art and craft of the *fin-de-siècle* (turn of the century) tended to unite, as an American critic wrote in 1902, in its "underlying character of protest against the traditional and the commonplace." To many, the new art seemed an anti-movement, consciously discarding the old, outworn conventions for the new and experimental. Decrying the backward-looking historicism still so prevalent in the last years of the century, self-conscious modernists joined with the international art dealer Siegfried Bing (1838–1905) in his complaint that amidst the scientific progress of the day, so much art and decoration "continued to be copied from what was in vogue in previous centuries, when different habits and different masters were current. . . . What an astonishing anachronism!" he exclaimed.

It was the German-born Bing who gave the movement its most popular title. Bing named his Paris shop "Maison de l'Art Nouveau" because it was "the name of an establishment opened as a meeting ground for all ardent young artists anxious to manifest the modernness of their tendencies." For his first Salon de l'Art Nouveau, which opened in 1895, Bing commissioned such avant-garde artists as Toulouse-Lautrec and Bonnard to make designs for stained glass to be executed by Louis Comfort Tiffany (1848–1933) in the United States. The exhibition included vanguard paintings, Japanese woodblock prints, and innovative sculpture by the individualistic French master, Auguste Rodin (1840–1917) (7.24, Appreciation 20). Placing the applied arts on an equal basis with the fine arts, the salon featured glassware by Tiffany (5.26) and Frenchman Émile Gallé (1846–1904), jewelry by Frenchman René Lalique (1860–1945), book illustrations by the English graphic artist Aubrey Beardsley (4.25) and Arts and Crafts artist Walter Crane (1845–1915), and posters by the likes of Toulouse-Lautrec (4.24) and Bradley (4.31). In 1896, Bing presented the first Paris exhibition of Edvard Munch (1863–1944), a controversial young Norwegian painter and graphic artist (10.5, 10.6). He also introduced the Belgian Henri van de Velde (1863–1957) to Paris by inviting him to send four completely designed rooms to the Maison de l'Art Nouveau. Less

5.26 • LOUIS COMFORT TIFFANY. Four pieces of favrile glassware in the art nouveau style. *ca* 1900. Left to right, 2⅞" high; 15½" high; 18¹¹⁄₁₆" high; 4¹⁄₁₆" high. The Metropolitan Museum of Art, New York.

than two years later, Bing had van de Velde invited to Germany to participate in the large international art exhibition of 1897 in Dresden, which was acclaimed as "the trumpet call inaugurating a new time."

This emphasis on the modern and new was to be as much an earmark of art nouveau as was its striving toward an equality and synthesis of the fine and applied arts. As early as 1885, the American architect, Louis Sullivan, whose swirling decorative work on otherwise highly functionalist buildings predicted so many stylistic characteristics of art nouveau, proclaimed: "Our art is for the day, is suited

APPRECIATION 8

Victor Horta. Staircase in the Tassel House, Brussels, 1892–1893.

GEORGE HILLOW

5.27 • HECTO
GUIMARD. De
ca 1889, remo
1909. Olive w
ash panels. 28
8′5″ × 47¾″.
The Museum of
New York. Gift
Hector Guimard

Victor Horta's staircase in the Tassel House in Brussels will, for me, forever be linked with a project I was working on a number of years ago. I'm a theatrical set designer, and I'm continually poring over books, researching styles and looking for ideas. I was designing the scenery for one of the Dracula plays, and Horta's staircase struck me as having a wonderfully macabre quality for the vampire's castle. The exotic and fertile line here is more than fluid. It is convoluted and twisted, with a serpentine beauty that seems spun by a spider rather than crafted by human hands. Its organicism is total. The energy from the wrought-iron railing flows into the column, across the ceiling and down the wall. It is more sculpture than architecture. How could you hang a picture on this wall—it would be like hanging a picture on a tree. The total effect is both insidious and seductive—perfect for Dracula.

Since the first viewing, I've stumbled across pictures of this staircase countless times, and my thoughts about it have deepened beyond those very subjective initial reactions. I will always think it gorgeous. I suspect I'll remain in awe of it as an artifact of a social upper crust devoted to itself to the point of decadence. I think of the era of its creation and remember the great robber barons, the lack of child-labor laws, the incredible extremes of wealth and

poverty that caused so many to emigrate from Europe. Looking at this staircase I'm reminded of Horta's poster-painting peers, Aubrey Beardsley [4.25] Maxfield Parrish, and Mucha [4.29] who created mythical realms and dreamy enchantments. They provided an escapism that, I can't help but muse, underlay Horta's design process.

But when taken off the two-dimensional poster and thrust into our tangible, three-dimensional world, such escapism becomes a bit jarring, possibly even perverse to the modern sensibility. It's comparable to trying to live in a stage set, in a Disney environment. Where's the wicked queen? Nor can I look at this staircase and not think of Louis Sullivan's later dictum "form follows function." Here we see form winding around function, strangling it, vinelike. Horta's form is the product of a culture where extremes were fashionable, where excess was the norm. It's *La Belle Époque,* the good old days of peace, prosperity, and dissension at the turn of the century. Such a staircase was made for grand, sweeping entrances, not for simply going downstairs. It remains a fabulous example of the high-water mark of art nouveau, the most emblematic decorative style associated with La Belle Époque.

Scene designers love art nouveau. If you work backstage long enough, one day you will have to fabricate an art nouveau prop, say a table lamp. You'll find a picture of one in a book with a beautiful Tiffany lampshade, dripping stained glass, on a base of swirling ten-

George Hillow is a free-lance designer working in theater, television, film, and commercial art. He is based in Norfolk, Virginia.

Appreciation 8 • VICTOR HORTA. Tassel House. Interior with staircase. *ca* 1892–1893. Brussels, Belgium.

drils entwining with the hair of a nymph. Then you think, "How am I going to make *this*?" Such a reaction takes you to the heart of the art nouveau movement: defiance of the machine-produced commodity. The Industrial Revolution of the mid-nineteenth century streamlined production of consumer goods, but it did so by streamlining the goods themselves so that they could be manufactured more easily. As the value of repetition and simplicity in product design rose, the role of the artisan diminished, and objects became notably ugly, if cheap and sturdy. Mass production brought the artisan to the brink of extinction. As the obvious need for aesthetic quality asserted itself, an ethic arose that was antithetical to the machined processes. "If it doesn't look like a machine made it, good. If it looks like the product of nature, better." Art nouveau was the last gasp of the artist-craftsperson before the onslaught of the machine age. Some art nouveau objects were, of course, machine made and mass produced, but the intention was to make them appear to be the inspirations of nature. Horta's staircase embodies this ethic. It was the culmination of a style, one which began perhaps with the "daydreamer" chair [5.7]. The "daydreamer" chair, however, is an awkward, earthbound attempt to answer the growing desire for "art manufactures." Decades later, art nouveau culminated in an elegant, thoroughly self-infatuated style of which Horta's staircase is a prime example. ■

5.31 • ANNI ALBERS. Wall hanging. 1964 (after an earlier design). Cotton and silk. 58 × 48″. Guntha Sharon-Stolzl workshop, manufacturers. Collection, The Museum of Modern Art, New York. Gift of the designer in memory of Greta Daniel.

5.32. • MARIANNE BRANDT. Coffee and teapots designed for mass production, 1926. Photograph courtesy The Museum of Modern Art, New York.

Wassily Kandinsky (1866–1944) (10.12); from Switzerland, the abstractionist of intimate fantasy, Paul Klee (1879–1940) (10.14); from Hungary, Laszlo Moholy-Nagy (1895–1946), an original designer in many areas; and from Germany itself such luminaries in art and design as Lyonel Feininger (1871–1956) and Oskar Schlemmer (1888–1943). Within a few years, the graphic artist and photographer (7.37), Herbert Bayer (born 1900), the Hungarian-born furniture designer Marcel Breuer (1902–1981), the designer of metal kitchenware Marianne Brandt (1893–1983), the pioneering textile artist Gunta Stolzl, and the geometric abstractionist in painting and stained glass, Joseph Albers (1888–1977), joined the ranks of master teachers. By the mid-1920s, Anni Albers (born 1899), the young wife of Joseph Albers, had become a powerful innovator in the weaving and textile area. In its final years, before the Bauhaus was shut down by the nazis in 1933 as too progressive, iconoclastic, and "Jewish," the prominent German architect-designer Ludwig Mies van der Rohe (1886–1969) (6.54) took over the school's directorship.

The cross-fertilization of ideas and activities between artists, craftspersons, architects, and designers produced an explosion of creativity, much of it geared to the production of useful objects that might serve as prototypes for industrial mass production. Committed to social as well as artistic goals, the Bauhaus sought to make its shining vision into reality in the design of low- and moderate-income housing; in the creation of prototypic rugs, draperies, and wall hangings (5.31) for the enhancement of home and office; in the fabrication of furniture that was light, mobile, and capable of multiple uses; and in the production of ceramic vessels and kitchenware (5.32) that were functional and of abstract beauty. There probably never has been a more dynamic and successful center for the creation of models, prototypes, and actual artworks—ever practical and original—for the purpose of infusing everyday life with art.

Although individual creativity was always promoted at the Bauhaus, just as it was in the earlier Arts and Crafts movement, a recognizable Bauhaus style did emerge. It might be characterized as tending toward the nonrepre-

by industry inspired formal-functional breakthroughs. The result was mass-produced articles that were practical, affordable, and beautiful.

Breuer's choice of material and his design considerations, both practical and aesthetic, were guided by the overarching goal of mass production at moderate cost. In many ways, Breuer's furniture design embodies the same engineering, social, and entrepeneurial concerns that gave rise to the Crystal Palace and the Thonet chairs the century before. His design decisions were obviously for a successful integration of form, function, and affordability, because numerous "take-offs" on his chairs and tables are still found in homes, schools, and offices over sixty years later.

Although Breuer thought of his furniture as more functional than stylish, the aesthetics of these chairs and tables epitomizes the best of the functionalist machine style: clean ("streamlined") in line, simple and abstract but appealing in sculptural form, smooth and uniform in texture but with an enriching mixture of cooler industrial materials and warmer natural materials. Simultaneously light and strong, designed for comfort, convenience, and multiple use, they meet the designer's requirement that furniture fit the diverse needs of the modern person. This utilitarian orientation is made clear in the designer's statement: "This metal furniture is intended to be nothing but a necessary apparatus for contemporary life." For the functionalist Breuer, contemporary life dictated the shape of art and design. His own furniture is therefore no arbitrary composition, "but rather the outward expression of our everyday needs; it must be able to serve both those needs which remain constant and those which vary. "This flexibility in the furniture is possible, he continues, "only if the very *simplest* and most *staightforward* pieces are used; otherwise changing will mean buying new pieces."

Simple, straightforward, flexible, practical, and economical, Breuer's furniture reflects the archetypically functionalist formula for furniture in our ever-changing modern world. "And so," the designer states, "we have furnishings, rooms and buildings allowing as much change and as many transpositions and different combinations as possible" (5.34).

5.33 • MARCEL BREUER. B32 "Cesea" side chair. 1928. Chrome-plated tubular steel, wood, and cane. 31½ × 17½ × 18¾". Collection, The Museum of Modern Art, New York, Purchase.

sentational, toward simple geometric lines and shapes, but also toward an irrepressible variety in composition. It was as if the functionalist geometry of the machine style had been rearranged in a freely improvisational way. Form still followed function—utility was emphasized—but the originality of the individual artistic mind rearranged shapes and materials into unique yet practical compositions.

In this wedding of art and industry, the most recent technological developments were ever welcome, making Bauhaus product design look "hi-tech" then as now. An example is the tubular metal furniture of Breuer and the school's final director, Mies van der Rohe. The chairs Breuer created between 1925 and 1928—his tubular chairs and tables, folding and swivel chairs, and cantilever chairs (5.33)—represent a minor revolution in furniture. Tubular metal posts, smooth and gleaming, are used together with natural materials, such as fabric, leather, wood, or cane, to create lightweight chairs that are portable and comfortable. These were the first chairs to use tubular metal, an innovation supposedly inspired by Breuer's meditations on the handlebars of his own bicycle. For true artists like Breuer (and Thonet [5.19, 5.20] before him), the materials and processes developed

The pieces of furniture and even the walls of the modern interior, Breuer writes, "have ceased to be massive and monumental, apparently immovable and built for eternity." Recall how heavy, immobile, dark, enclosed, and densely packed most Victorian interiors (5.8) were. Bauhaus design, in contrast, was to be in synchrony with the dynamism of twentieth-century society, ever mobile, temporary, and boundary-breaking.

Following the closing of the Bauhaus in 1933, many of its most prominent members immigrated to the United States. Germany's loss was America's great gain. Gropius and Breuer took up teaching posts in Harvard University's Department of Architecture, the former becoming its chairman in 1938. Mies van der Rohe went to the Architecture Department of the Illinois Institute of Technology. Moholy-Nagy took up the directorship of the New Bauhaus (later known as the Institute of Design) in Chicago; Joseph Albers taught at North Carolina's experimental Black Mountain College before chairing the Department of Design of Yale University. Her-
bert Bayer became a design consultant and later chairman of the Design Department of the Container Corporation of America.

The influence of these and other Bauhaus expatriates on North American architects, designers, and artists was substantial, and a largely Bauhaus-inspired functionalist or machine style—also known as **international style** or simply **modern style**—rose to worldwide renown in the 1940s. The cool, refined minimalism of Gropius, Breuer, Mies van der Rohe, and their colleagues, as well as the best work of several generations of students, epitomizes the functionalist machine aesthetic at its best. The furniture and interior design of Florence Knoll (born 1917), one of Mies van der Rohe's students, have had a worldwide influence on the form and function of the modern office building (5.35). To the present day, her firm, Knoll Associates, remains one of the foremost interior design firms and furniture manufacturers in the world. Expanding its base from a tiny avant-garde of appreciators in the 1920s to the most widespread public acceptance today, the Bauhaus, together with

5.35 • FLORENCE KNOLL. Dr. Frank Stanton's office, CBS building, New York. 1965.

its integrated approach to art and industry, has achieved a central place in the product, interior, and architectural design of the twentieth century.

FINE PRODUCT DESIGN FOR THE MASSES: THE FURNITURE OF SAARINEN AND EAMES

In the 1930s, a most important community and school arose at Cranbrook in the Michigan countryside near Detroit. The ideals of the Cranbrook Academy grew from the Arts and Crafts movement, and its purpose paralleled that of the Bauhaus. Founded by a Michigan businessman and aesthete, George Booth, and the internationally prominent Finnish architect, Eliel Saarinen (1870–1950), who served as its first director, Cranbrook became a North American version of Gropius's "Building House" and one of the principal launch sites for fine product design in America. Relative to product design, Cranbrook designers took the cool, clear geometry of the

Bauhaus and warmed and softened it. In the area of furniture design, biomorphic forms derived from nature replaced the abstract machine geometry of Breuer and Mies van der Rohe. Eero Saarinen (1910–1961), son of the director, began his illustrious career as a product designer and architect at Cranbrook and collaborated with the multitalented Charles Eames (1907–1978) in the creation of a new generation of well-designed furniture that was geared from the start for mass production.

With Saarinen and Eames, the Arts and Crafts and Bauhaus ideal of art for the masses began to be fully realized. Some of the most popular chairs of the second half of the twentieth century are the result of their collaboration at Cranbrook and subsequent individual work. The development of new materials and techniques (for instance, molded plywood and plastics) for furniture design, some of them pioneered by the two men, opened the way for an expansion beyond the geometric Bauhaus styles. As Saarinen was the first to admit, "New materials and techniques have given us great opportunities with structural shells of

5.36 • EERO SAARINEN
AND CHARLES EAMES,
designers, and Haskelite
Manufacturing
Corporation, Chicago.
Armchair for "Organic
Design in Home
Furnishings
Competition." *ca* 1940.
Molded plywood, fabric,
sponge-rubber padding,
four maple legs. 42½ ×
32¾ × 31¾". Eames
Office, Los Angeles.

plywood, plastic and metal." The problem, he added, then became "a sculptural one, not the cubist, constructivist one" that the Bauhaus designers wrestled with and solved in the 1920s.

In 1940, Saarinen and Eames won two first prizes at the Organic Design in Home Furnishings Competition held at New York City's Museum of Modern Art for their design of a series of chairs, modular storage units, sectional sofa, and tables. The pair's armchair (5.36), looking a bit like a flower opening outward, is a molded plywood shell with maple legs and wool upholstery. If the 1920s had been the decade of breakthroughs in metal furniture, the 1940s and 1950s were certainly decades committed to the exploration of molded plywood and plexiglass, which were often used in combination with metal, wood, and various upholstery fabrics. In the skillful hands of North American designers excited by the structural possibilities of the new materials, flat cubist-constructivist planes of metal became more gently rounded and "organic." The machine aesthetic became more "naturalized." Eames's molded plywood chairs reached out to welcome the sitter. Inexpensive to moderate in cost, light and practical, Eames' chairs became ubiquitous in homes, classrooms, and meeting rooms from the late 1940s onward. In 1948, Saarinen's "womb chair" with ottoman (5.37), renowned for its comfort and its softly rounded volumes, was put into mass production by Knoll Associates. It has a molded, reinforced plastic shell with foam-rubber padding and fabric cover; a seat and back cushion are added for extra comfort. The base is a chrome rod or metal rod with chrome or painted finish. The no. 71 armchair (5.38), a follow-up to the womb chair and stylistically a direct descendant of the earlier molded plywood chair (5.36), was introduced around 1950 and has become one of the twentieth-century's most widely used office chairs. As one writer observes, "The soft sculptural forms [of the no. 71 armchair] belie their simplicity: a close examination of the detailing of the base, shell, and upholstery reveals a masterful design."

One of Saarinen's crowning achievements is certainly his pedestal series, designed between 1955 and 1957. These tables and chairs

5.37 • EERO SAARINEN,
designer, and Knoll
Associates, manufacturer.
No. 73 settee ("womb
chair"). *ca* 1946. Molded
plastic shell, foam
cushion, steel rod base.
35½ × 40 × 34".
Courtesy Knoll International,
New York.

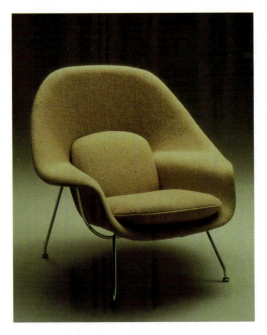

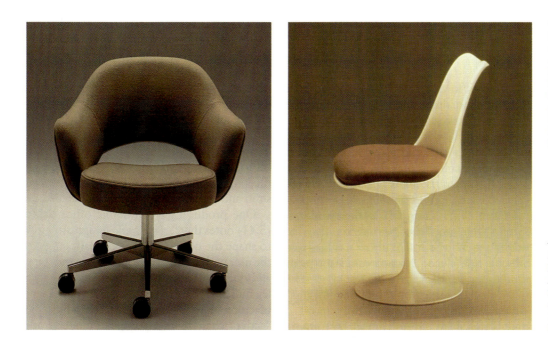

5.38 • EERO SAARINEN, designer, and Knoll Associates, manufacturer. No. 71 armchair. 1957. Molded fiberglass shell, latex cushion, cast aluminum base. 31¼ × 25¼ × 25¼″. Courtesy Knoll International, New York.

5.39 • EERO SAARINEN. Pedestal chair. 1957. Molded fiberglass shell, foam cushion, cast aluminum base. 32 × 20 × 21¼″. Courtesy Knoll International, New York.

(5.39), and "knock-off" variations of them, can be seen in airport and bus terminals and college classrooms worldwide. One of the designer's intentions had been to get rid of "the slum of legs" in a room, and he achieved a most successful visual transition between a plastic shell and its base. Nicknamed the "tulip chair," the pedestal chair rises out of the floor on a single stem to a sculptural shell of soft folds, almost flowerlike. To many, these pedestal chairs and tables have a space age look, perhaps because of their flowing line, sense of lightness, and suggestion of movement. With only one leg or support connecting them to the floor, these pieces of furniture seem less restricted by gravity, more airborne: fitting images for the interiors of airports.

Furniture Design of the Future: Three Possibilities. Given the evolution of the chair over the last one hundred and fifty years, let us pose a tantalizing question: In what direction will chair design move in the twenty-first century? One possibility is toward chairs (5.40) designed by post-modernists, who reject the principle that form follows function and don't share the modernists' commitment to abstract, generally machinelike shapes. **Post-modern** designers, like the post-modern architects we

5.40 • ROBERT VENTURI. *The Venturi Collection.* 1984. Courtesy Knoll International, New York.

5.43 • Peter Blake.
Hackensack River Valley.
From *God's Own
Junkyard.* 1964.

Richard Latham, a one-time member of the prestigious industrial design firm of Raymond Lowey Associates, notes that the design of most products has been "falsified" by status, marketing, and fashion considerations. Sadly, Latham observes a "debasement" in the intrinsic qualities of many an everyday product, as evidenced by "the way the materials that compose it are used and the quality of the materials themselves; by lack of detail, the absence of patient care expressed in the way two materials are joined; by the finish, both inside and out; and finally by the aesthetics of the object expressed in relation to its function."

Who, Latham asks, is to blame for this compromise in design standards, this falsification and debasement? His answer: the manufacturers, their designers, and marketing strategists. Those who plan, produce, and advertise substandard goods are primarily responsible. But, he adds, the buying public must share some of the responsibility. Citizens do not demand enough from manufacturers and product designers. They could shun poorly designed products, casting their ballots in the market place for products of good design. But, Latham notes, most of the contemporary public no longer looks to products for beauty, excellence of craft, or lifelong use. Rather we buy cleverly packaged commodities that are "here today and gone tomorrow." We have succumbed to the mentality of a "temporary" society and its principle of planned obsolescence, in which products are thrown out as soon as they are used up, fall apart, or go out of style.

As Blake and Latham see it, most people in contemporary North America and Europe, unlike our pre-industrial ancestors, do not feel an emotional reverence or love for the implements of everyday life. If anything, we feel emotionally disconnected or alienated from our artifacts. We are thus less whole, less fully human than our ancestors. In contrast, Latham argues, "The artifacts of our original settlers, the art of the Indians who populated our country [Appreciation 9], and later the everyday objects our pioneer stock evolved, all share a high level of intrinsic quality and craftsmanship. Most important, they reflect the regard which the people who made and used them felt for the objects themselves." Indian pottery, basketry, and clothing, Shaker furniture (5.25), early American kitchenware, and farm family quilts (Appreciation 10) are only a few of the many beautifully conceived and executed artifacts designed, made, and used by Americans living outside the commercial and industrial mainstream.

The result of the onslaught of commercialized industrialism, Latham laments, "was a general movement away from aesthetically sound craftsmanship, and the loving know-how built into well-designed objects, to a superficial, confused, frivolous, ugly 'art-of-artifact' that was aesthetically retrogressive." In the process, we lost not only our emotional connection to our everyday products but also our sense of beauty and our capacity to see and reject ugliness. We have become callous and insensitive, anaesthetized rather than "aesthetized" in our responses. "We as design-

ers," Latham admits, in a statement that sounds like pure Ruskin, "are born and grow up in this environment, and our senses and motor functions are also crippled—our work is an accurate reflection of our actual ability." As designers, he concludes, we are only as good as the society into which we are born.

So, what can be done about "God's own junkyard"? Perhaps the simplest and most effective prescription is the creation of products that are beautiful and well crafted, designed in form and function to last a lifetime or longer. Products that are genuine works of art do not go out of style. Finely crafted products, whether made by hand or machine, last virtually forever. Limiting production to products that are socially necessary, safe, and aesthetically satisfying would result in less glut, waste, pollution, and sensory overload. The result would be a world in far better ecological balance, one in which nature, humanity, and machines coexist in a more healthful harmony.

DESIGNING FOR THE PEOPLE

Could such a harmonious world be brought about? Who would see to it that the essential conditions for improvement were met? We live in a free-market society, not a centrally planned one, and only pressure—political, economic, intellectual, and artistic—not force, can be brought to bear on the titans of commerce to convince them to change their ways. In Britain in the early industrial age, critics like Ruskin and artist-craftsmen like Morris prompted change by word and deed. At the same time, reformers like Henry Cole pushed through legislative measures for higher manufacturing standards, design education, and ongoing industrial expositions, such as the Great Exhibition at the Crystal Palace, whose purposes were to reward the best work and stimulate the interchange of ideas and critical opinion. Now, as then, the idealism and actions of designers, critics, consumers, government officials, and socially minded manufacturers are necessary to improve the sorry conditions.

The mid-twentieth-century industrial designer Henry Dreyfuss (1904–1972), creator

5.44 • HENRY DREYFUSS. 500 desk set telephone. 1949. Molded phenol plastic. 4¾ × 5 × 8¾". AT&T Archives, Warren, N.J.

of the classic Bell telephone (5.44), provides a praiseworthy model for all of us. Working within the system, Dreyfuss insisted on the design of products that were first-rate inside and out. For him, form truly followed function, and he adhered ethically to this principle. He refused to accept lucrative "commercial art" jobs in which he would simply restyle old products in a fashionable new look for increased saleability. To socially minded designers like Dreyfuss, the planning of products is never simply a matter of packaging and surface cosmetics. Each product represents a complex problem with moral, practical, aesthetic, social, and economic facets. In his book, *Designing for People*, Dreyfuss describes the highest model of his profession as follows:

The industrial designer began by eliminating excess decoration, but his real job began when he insisted on dissecting the product, seeing what made it tick, and devising means of making it tick better—then making it look better. He never forgets that beauty is only skin deep. For years in our office we have kept before us the concept that *what we are working on is going to be ridden in, sat upon, looked at, talked into, activated, operated, or in some way used by people individually or en masse. If the point of contact between the product and the people becomes a point of friction, then the industrial designer has failed. If, on the other hand, people are made safer, more comfortable, more eager to purchase, more efficient—or just plain happier—the designer has succeeded.* He brings to his task a detached, analytical point of view. He consults closely with the manufacturer, the manufacturer's engineers, production men, and sales staff, keeping in mind whatever peculiar problems the firm may have in the business or industrial world. He will compromise up to a point but he refuses to budge on design principles he knows to be sound. Occasionally he may lose a client, but he rarely loses the client's respect.[8]

APPRECIATION 9

An Anasazi Indian "Kayenta Olla."

MOLLY F. WHITE

As I look at this pot today, I think "what a strikingly handsome design!" And yet I know that it is almost one thousand years old and was made in the region of the southwestern United States where I now live.

This "olla" (the Spanish word for water jar) was found at Betatakin near Kayenta, Arizona, and is a product of the Anasazi culture. In this type of container the Anasazi stored water or grain. There is no reason to assume that it was made for ceremonial purposes. Rather, given all the many archaeological finds of similar objects throughout the Four Corners area, I assume that it was made for ordinary, everyday use.

The Anasazi lived either in apartmentlike cliff dwellings, as at Betatakin, or in pueblolike multistoried units, as at Chaco Canyon. At the height of their culture, pottery was developed technically to a high level of skill and craft. Women shaped the pots by hand, building clay coil upon clay coil and then fusing the coils together into smooth walls. In the case of this Kayenta olla, the shaping had to be gauged carefully to build out diagonally to the wide shoulder and then tapered back to the small mouth.

Today the women at Zuni, Acoma, San Ildefonso, and other pueblos still build their pots by hand, using the same coil method. Mother teaches daughter, and the special pol-

ishing stones for smoothing the final surface are carefully passed down from generation to generation. The pot is set in the sun to dry before the design is added. The mineral black paint is applied with a brush cut from yucca roots. The brush is trimmed and then softened to the desired state of flexibility by chewing.

I am astounded by the skill of application of paint to create the dynamic black-on-white geometric design on this ancient olla. In this design the strong diagonals of the heavy black and white lines accentuate and complement the slanting contour lines of the body of the pot. Within these strong diagonal lines we find the more delicate shapes of triangles, stepped pyramids, and spirals. The narrow-patterned diagonal lines set up a complementary rhythm to the solid black shapes. The graceful curving line of the exterior shape of the olla is enhanced and made vibrant by the striking abstract design within.

We don't know exactly why this water jar for everyday use was decorated with its dynamically beautiful design. Perhaps it showed the high regard of its makers for its function, the storing of grain or water, precious commodities in the arid Southwest. What we can assume is that the design of the olla brought aesthetic pleasure to the one who made it and the ones who used it.

Viewing this Kayenta olla today creates in me a sense of wonder and excitement to realize the artistry of the people of this ancient civilization that flourished in the Southwest some five hundred years before the arrival of the white man. ■

Molly F. White works as an artist. She is Chairperson, Division of Communications, Humanities, and Fine Arts, Navajo Community College, Shiprock Campus, Shiprock, New Mexico.

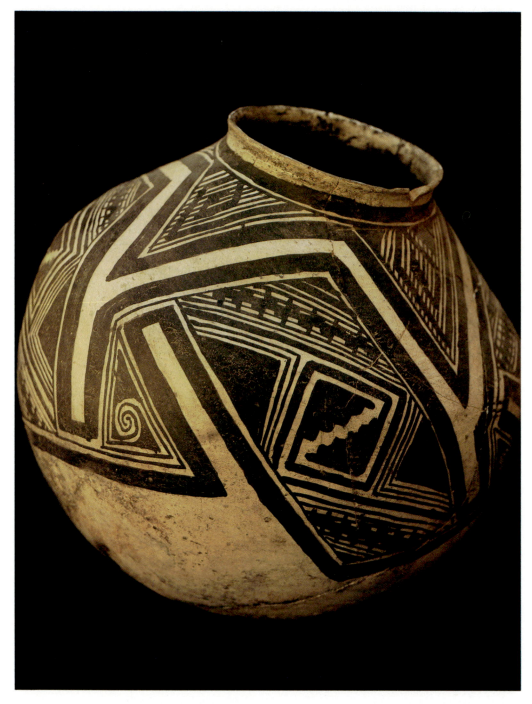

An Illinois Farm Quilt Top.

CATHY MULLEN

I bought this quilt top several years ago, when I lived in Champaign, Illinois. I spotted it in an antique dealer's display in the concourse of my local shopping mall. The soft, faded blues, the neat lines, and the corners of the pattern caught my eye. The dealer told me that she had acquired the piece in a nearby farm town. She probably bought it at an estate auction.

Although it was meant to become the top layer of a useful bedcover, this unfinished patchwork now hangs on my bedroom wall. Displayed this way, it disengages from its identity as a practical object and becomes an image that I contemplate as I would a painting or drawing. In this way it tells me something important about the character of a place, of a farming way of life, and of a woman's domestic work.

The pattern reminds me of the farmland of east-central Illinois. The colors are the sky colors one sees during the growing season—harmonies of clear or cloudy blues and twilight mauves interjected with the muddy grays and greenish browns of thunderstorms and tornadoes.

Under that unpredictable sky, the flat, treeless earth is sectioned into precise rectangles and parallel rows for efficient agricultural production. It is a landscape of orderly, mind-numbing repetitions. The striped and checkered cloth shapes meet at straight edges and precise corners, much as the fields of corn and soybeans meet along roads and railroad tracks that run dead-straight to the horizon.

The stitches, both those sewed by hand and those done by machine, set a cadence of measured, steady repetitions. Stitch by stitch, piece by piece, a row forms and extends for as long as it needs to. Then a second row and a third are added, until a field of pattern grows to bed size. The pattern has no center; just edges and expanses, starts and stops.

This is also the rhythm of a farm woman's work: the back-and-forth cadence of housework—scrubbing, sweeping, ironing. Progress comes in measured steps. In due time she reaches the end of the row, turns, and begins the next one—equally considered, tidy, precisely constructed. The procession continues until the garden is weeded, the lawn is mowed, the floor is cleaned.

In this patchwork image I see one woman's skills and aesthetic sensibilities coming together in work sparked by purposefulness, endurance, adaptability—in a word, *gumption*. She worked carefully, meticulously, patiently. She got satisfaction in using her skills and knowledge to make something useful and pretty.

I imagine how she went about her work. She transformed worn-out clothing into a stock of fabric shapes. She selected colors that harmonize. She arranged the pieces according to her own design. She fitted and sewed each piece into the evolving pattern. She had to work piecemeal, interrupting this project with countless chores and distractions.

Cathy Mullen teaches in the Department of Art Education at Concordia University in Montreal, Quebec, Canada. She is an active teacher and researcher specializing in sociocultural aspects of participation and learning in the visual arts.

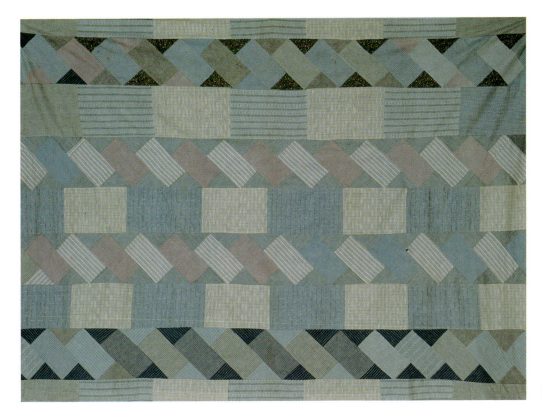

Appreciation 10 •
Anonymous. Illinois farm
family quilt top. *ca* 1940.
Mixed fabric. 60 × 80″.

In the world of women's work, creative projects such as this are often casualties to the competing demands on a woman's abilities, energies, and time. Perhaps that explains why this patchwork top was not completed. It is easy for me to speculate that its maker was drawn away from this project by any number of competing obligations and demands for her attention. Concentration dissipates, time passes, and a temporary interruption becomes permanent.

Although its intended use has not been fulfilled, this piece of patchwork gives valuable service in my daily life. From its place on the wall in my apartment, in a city hundreds of miles from those Illinois farmlands, it helps me to remember a place and way of life, and to acknowledge an unknown woman's work. Above all, it gives me a means to consider my own work and the rhythms of the life-pattern I am continually creating. ■

PRODUCTS IN THE IMMEDIATE ENVIRONMENT: A CASE STUDY

The conclusion of this chapter urges a closer look at our own everyday surroundings. Let's break through the normal rush of daily life and spend some time looking, perceptively, thoughtfully, "aesthetically," at the products around us. Let us probe our rooms, our homes, our schools, our workplaces. Which objects of practical function or decoration in our living or working environments are hand-crafted or machine-made? Which are well de-signed and crafted? Which are ugly or junk? It is one thing to look at applied art in museums, books, films, or slide reproductions and to have experts tell us about them. It is another to examine the products that surround us. The lessons we learn about ourselves and our world from such real life investigations can be most revealing.

What follows is a brief case study of the work area of a professional writer in her early forties. We decided to focus on Sharon's work area (5.45) because she spends most of her time in that part of the house. Her writing area is quite small, really a nook in the corner of a second-story white-walled bedroom. At the rear of the house, the bedroom has large windows and a view of neighboring houses on two sides. This room is worlds apart from the darker, more fortresslike middle-class in-

teriors of the Victorian era in which inside and outside, living quarters and working areas, were sharply demarcated or compartmental-ized. In contrast, Sharon's bedroom-study is a modernist interior where the indoors and out-doors interface and living and working spaces flow together fluidly and flexibly.

The bedroom portion of the room, com-pared to its Victorian counterpart, is spare in furnishing and decoration—only four small landscape paintings animate the plain white walls—but the work corner of the room is filled with products, almost all of them within arm's reach and made within the last twenty years. (In our kitchens, bathrooms, and work areas, most of us inhabit an especially up-to-date, product-intensive environment.) On Sharon's small wooden desk sits a word processing system—compact desktop com-puter, external disk drive, keyboard, and printer. As a professional writer, she spends thousands of hours each year working on her word processor, yet she admits never having taken a really close look at it. (Have we, even the writers and artists among us, lost interest in the appearance of the products we use every day, valuing them only for their function? Or are the products themselves unworthy of our attention?)

The four components of Sharon's word processing system, the manual tells us, were designed and mass produced in the United States. We learn that a team of over forty peo-ple combined their talents to design this sys-tem from the inside out, in the best Dreyfuss tradition. Product design in the contemporary world has indeed become a large-scale collab-orative activity. Building a fine automobile, rocket, or computer system requires an army of nameless workers, craftspersons, designers, engineers, and sponsors, much in the fashion of the coordinated crews of laborers and spe-cialists who raised the medieval cathedrals.

What are formal qualities of Sharon's word processing system? The plastic outer shells of the four components are characterized by a subtle, closely matched range of colors, from light tan to antique white; these hues straddle the tonal range between warm and cool, tech-nological and natural color. The surfaces of the components are uniformly smooth, with the slightest textural hint of crackling, proba-

5.45 • Professional work area (1990). Word-processing system by Macintosh (1986); drafting lamp by Underwriters Laboratories, Inc. (1983); ceramic mug by David Kreider (1982); glass mug by National Park craftspeople, Jamestown, Va. (1986).

bly added to make the system more inviting, physically and psychologically, to the touch. As for shape, geometric forms have been streamlined, with all right angles and edges softened by gentle curves or indentations. All of these forms follow their functions. The overall shape of the computer is dictated by its viewing screen. The shape of the external disk drive reflects the shape of the computer disk that goes inside. With the exception of the corporation's logo, directional labels, and graphic symbols, there is no ornament. Any lines that we observe on these surfaces are constructional rather than decorative: lines that are implied where two surfaces meet as opposed to painted or etched on. In effect, each component is an unadorned functionalist sculpture, our favorite being the printer, with its lighter, more enlivening color and greater complexity of forms. The others we find, from a formal-aesthetic point of view, a bit too plain and uninteresting.

Attached to the desk is a metal draftsman's lamp, solid brown in color. We note that it is mass produced, made in Taiwan, and very moderate in price. With a long, thin, two-part

stand that bends in the center, it is a lamp of maximum flexibility. It turns in every direction, and moves up and down to work to meet any need. (An early example of ergonomic "human factor" design?) The metal of the lamp is paper thin and very light in weight. The lamp also folds up for easy portability. Once again, the visual appeal is modernist, coming not from decoration but from the sculptural form itself. Even though the lamp is inexpensive, it is far from "cheap and nasty." The design, we discover, is something of a classic, based on a prototype put into mass production in the 1930s. This lamp is just another example that good design has staying power and doesn't have to be expensive. Sharon notes that she still enjoys the look of this lamp and that it has served her well for many years.

Next to Sharon's simple, mass-produced wooden desk of warm blond and brown hues, natural grain, and spare functionalist design stands a small, portable electric radiator (5.46). Moderate in price, its logo indicates that it is made by DeLonghi of Italy. The radiator is adjustable in its electrical requirements, highly effective as a heater, and very portable with its handle and four-wheeled base. In our mobile society, almost all products, including Sharon's personal computer, seem to be designed for portability.

The shell of the radiator is made of thin metal, antique white in color. Heat-conducting filaments are housed in six vertical plates that are proportionally tall and of exceeding thinness; the lines of the radiator carry the eye upward, much as the soaring arches of a Gothic cathedral do. This moderately priced radiator is indeed an elegant sculptural object, one befitting Mies van der Rohe's minimalist aesthetic dictum "less is more."

Although mass-produced products are the rule in Sharon's work area, two items are of more human, idiosyncratic personality. Next to the drafting lamp are two mugs, one ceramic and the other of transparent green glass. Broken by accident years ago, the ceramic mug serves a new purpose as a holder of pens and pencils. It was made by hand—a rarity in product design these days—by a man who throws pots for a living. It is signed "D. Kreider" and dated 1982. The mug is certainly an exception

5.46 • DēLonghi, Inc. Electric radiator. Model 3107. *ca* 1980. Steel, plastic wheels, pure diathermic oil. 25½ × 16 × 6¼".

in this era of mass production and divided labor: a product made from start to finish by a single person. (To be sure, we are experiencing something of a worldwide crafts renaissance, with increasing numbers of craftspersons creating and a growing public of consumers buying fine handmade products.) Selling his wares at craft fairs and galleries, this production potter made many mugs of this general shape, size, and coloration, though each, being made by hand, is somewhat different. Shaped on a potter's wheel, the mug shows the circular striations and slight unevenness of surface and edge caused by the craftsperson's fingers—a human presence—as he raised the clay from a moist unshaped mass to its present form. A personal touch is also seen in the glaze; the ceramic surface is enlivened by a painterly wash of warm brown tones. But although handmade, this mug still belongs to the modernist industrial age. Its dappled coloration is abstract, not figurative or narrative like many ceramic pieces of old. And its shape is one of pure, simple geometry, embodying the functionalist principle that form follows function.

The second mug of transparent green glass, by contrast, has a quite different personality, and with good reason. It is a recreation of the glass mugs made and used in Jamestown, Virginia, the first permanent English settlement in North America. It was created by a glassblower employing the same materials and techniques as were used in the earliest colonial times. The vessel has a simple functional beauty, but one enriched by a handle that swirls and tapers to a curlicue base. A small protuberance at the handle's top adds further aesthetic interest and also a comfortable place to put one's thumb. A slightly lopsided shape, speckled imperfections in the glass, and walls of varying thickness engage our senses and communicate to us that this is an object of the pre-industrial age, an engaging "antique" sitting next to computer components of modernist perfection and uniformity. Are we still sensitive enough, Sharon wonders, to appreciate this artifact and mirror of a long-lost world?

Each of us has different products in our homes and places of work. Some may be of functionalist modern design; others of premodern or post-modern design. Some we choose for ourselves, and others are thrust on us by circumstance or work requirements. Yet, in all cases, our products are an accurate reflection of ourselves: our socioeconomic status, our mode of work, our values and lifestyle. They reflect our taste for contemporary or historical styles, our orientation to permanence or mobility, and much more. They mirror our inclination for the forms, materials, and values of nature, the machine, or individualist fantasy. Ever in active relationship with us, our products mirror and affirm our personalities and influence our lives. The shapes of functional art forms, the poet Whitman exclaimed in the 1860s, were rising up around him. As we near the end of the twentieth century, we can report that a vast world of products now surround us, and these products are helping to shape our lives.

Art on an Environmental Scale: Architecture & Community Design

Stand on any college campus in America and look at the buildings. You are likely to see examples of one of three architectural styles: the classical, the Gothic, or the modern. If the college buildings were built in the nineteenth or early twentieth century, the predominant styles will probably be classical, as at the University of Delaware (6.1); Gothic, as at West Virginia's Bethany College (6.2); or a mix of the two. In consciously progressive institutions of higher education built after World War I, beginning with Gropius's Bauhaus (6.3), the preeminent style is invariably modern—"art suited to the day," as the pioneering modernist architect Louis Sullivan put it.

Although perhaps more easily identifiable on an architecturally integrated college campus, these three major styles spread far beyond the borders of academe. Buildings created in the classical, Gothic, and modern styles pervade Western society. Look at our homes, our municipal, commercial, and religious buildings or at our centers of transportation, recreation, and culture. All of these structures, in some way, incorporate one or more of the three styles. Why have we embraced these styles? What aesthetic, moral, political, cultural values do they communicate to us? Why is a given style used for a particular type of building? So many of our government buildings, libraries, and metropolitan art museums have been built in the classical style; so many of our churches, universities, and Victorian homes are Gothic in feeling. In so many of our corporate headquarters, office buildings, and research centers the modern style is employed. Why is this?

To begin to understand buildings as both style and expression, we must begin with the fact that architecture is one of the most social of the arts. This is how Louis Sullivan (1856–1924) put it in an 1899 speech to the Chicago Architectural Club:

> Architecture is not merely an art more or less well or more or less badly done; it is a social manifestation. If we would know why certain things are as they are in our architecture, we must look to the people; for our buildings as a whole are an image of our people as a whole, although specifically they are the individual images of those to whom, as a class, the public has

6.1 • Old College, University of Delaware. Newark. Central section erected 1834; side wings added 1902.

6.2 • "Old Main," Bethany College. Bethany, W. Va. 1858.

6.3 • WALTER GROPIUS. The Bauhaus. Dessau, Germany, 1925–1926.

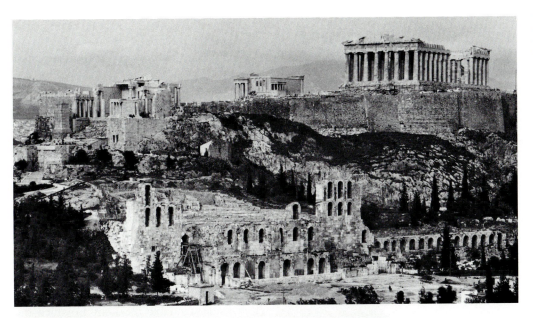

6.4 • The Acropolis. Athens, Greece. Distant view from the southwest.

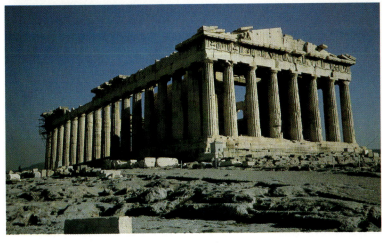

6.5 • ICTINUS AND CALLICRATES. The Parthenon. Athens, Greece. *ca* 447–438 B.C. View from the northwest.

delegated and entrusted its power to build. Therefore by this light, the critical study of architecture becomes . . . in reality, a study of the social conditions producing it.[1]

THE CLASSICAL STYLE: THEME *&* VARIATIONS

We begin our study of architecture as artistic form and expression of sociocultural content in ancient Greece, one of the fountainheads of Western civilization and the birthplace of the classical style.

Classical Greece: The Parthenon. On the **Acropolis,** the fortified hill on which Athens built its spiritual center in the fifth century B.C., stand the remains of buildings (6.4) that hold the key to the **classical style** and ideal. Chief among them is the Parthenon (6.5), the temple of Athena Parthenos (Athena the Virgin), mythical founder and patron goddess of the city.

The approach to the Parthenon is ever upward, from the crowded, bustling lower city of Athens—in ancient times, an extraordinarily large city of 200,000—up through the gateways and courts of the Acropolis, to the

6.6 • Le Corbusier *The Parthenon Seen through the Propylaia.* Sketch.

6.7 • Le Corbusier. *The Acropolis. Distant view.* Sketch.

sculpture and the Attic mountain chain on the horizon which echoes its mass."

Something essential about the Parthenon and the classical ideal is revealed by this imposing setting. Crowning the heights of the city, approached from a dramatic angle, communing with mountains, sea, and sky, the Parthenon evokes conscious or subliminal associations with higher things: uplifting moral values; transcendent spiritual beliefs; exalted activities, such the ancient procession of the city's populace every four years up to the Acropolis to honor Athena in her temples.

The relationship of a building to its surroundings, in terms of height, centrality, and style, always carries a symbolic charge. For Athenians, the placement of the Parthenon on the crest of the Acropolis set up an immediately understandable hierarchy in which the assigned roles of humanity and the gods were clear. To the Greeks of the fifth century, the summit of a city was, literally and symbolically, higher ground. It was reserved for the immortal gods. Mortal humanity, for its part, was assigned to the flatlands below. To this hierarchical division between gods and human beings a further political meaning was added. The fourth-century philosopher Aristotle (384–322 B.C.) recognized this symbolic order when he observed, "An Akropolis is suitable for oligarchy and monarchy, level ground for democracy." Put another way, no human should aspire to be a god reigning tyranically over fellow citizens from on high.

In the context of fifth-century Athenian democracy, the Acropolis, with the Parthenon at its crest, fulfilled a dual religious-political function, inspiring the democratic freemen of Athens with both civic pride and spiritual devotion, all for the greater good of the *polis*. Built under the leadership of the great statesman Pericles (*ca* 500–429 B.C.), the Parthenon was a beacon proclaiming the glory of Athens. Larger than the surrounding buildings and constructed of gleaming white marble, the most expensive of materials, it could be seen by travelers on land and sea from many miles away. Directionally, the structure expands both outward and upward, up a platform of steps, ever a physical-symbolic indicator of "elevated" function, and up soaring vertical columns toward a triangular roof whose final

physical and spiritual top (*akros*) of the city (*polis*). At the crest, the temple rises still higher toward the sky. Viewing the Parthenon with the sea and mountains in the distance and the teeming metropolis below, one realizes how crucial the setting of a building is to its overall meaning. Two pencil sketches (6.6, 6.7) by the famous twentieth-century architect Le Corbusier shed light on the relationship of the Parthenon to both its natural and architectural surroundings. According to architectural historian Spiro Kostof, Le Corbusier viewed the great Temple "climbing toward it up the steep west slope of this natural citadel, and catching sight of it at a dynamic angle through the inner colonnade of the Propylaia, the ceremonial gate of the Akropolis." Le Corbusier's long view, Kostof continues, "shows the building in relation to the larger shapes of nature that complement its form: the pedestal of the Akropolis spur that lifts it up like a piece of

crest points toward the heavens. But while the Parthenon is a giant, it is one whose power is ordered and controlled. It is power made reasonable. The opposites of horizontality and verticality have been balanced in careful proportion. A serene regularity presides in the repetitive spacing between the fluted columns that taper subtly toward their simple Doric capitals. (Among the three primary Greek **columnar styles** or **orders** [6.8], the **Doric** was both the oldest and most simple.) The Parthenon's symmetrical balance gives a feeling of stability and permanence. The result of the design is a beauty that is at once dignified and potent, a fitting image for Athens herself, ruler of a tribute-paying confederacy of over three hundred Greek cities.

The lines and shapes of Athen's Parthenon are those of geometry: pure, simple, and precise. These are the forms of reason and intellect befitting a city famous for its philosophers, scientists, and mathematicians. We see positive shapes and negative spaces of rectangular variety, cylindrical columns with square Doric capitals, and two climactic triangular **pediments**: the one on the east at one time showing the birth of Athena; the one on the west (6.9) originally filled with a vast sculptural program representing the triumph of Athena

over the rival god Poseidon in their battle for the rule of the city. A rational ordering, balance, and a harmony of parts tie all the separate architectural and sculptural pieces together in a profound unity. One thinks of the geometrically ordered universe of the Athenian philosopher Plato (427–347 B.C.) with its perfect spiritual essences of Truth, Knowledge, and Beauty.

In the Parthenon, visual, emotional, and moral qualities are inseparable. Visual simplicity, harmony, and symmetry produce feelings and thoughts of order, calm, and restraint. As in our earlier discussion of classicism in the modern period (for instance, the "neoclassical" draftsmanship of Ingres [2.5] and the "classic" styling of business dress [2.4]), an aesthetic of rationality and idealized decorum reigns in the Parthenon and in Greek architecture and art of the fifth century.

The ancients themselves described what would later become known as the classical ideal with such phrases as "beauty without extravagance" and all things "arranged with sense and symmetry." All the individual elements, says a character in an essay by Xenophon, appear "more beautiful when placed in order," and when so ordered, according to reason, "will then seem to form a choir; the center which they unite to form will create a beauty that will be enhanced by the distance of the other objects in the group." Rational

6.8 • The three Greek orders: Doric (top), Ionic (center), and Corinthian (bottom).

6.9 • The Parthenon. Reconstruction drawing. View from the northwest.

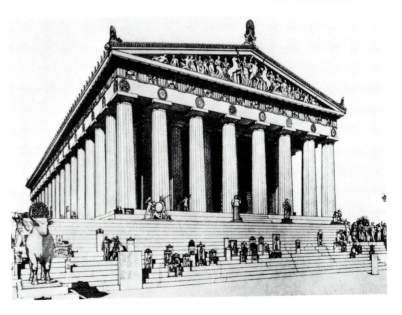

6.10 • Pont du Gard. Nîmes, France. Late first century B.C.

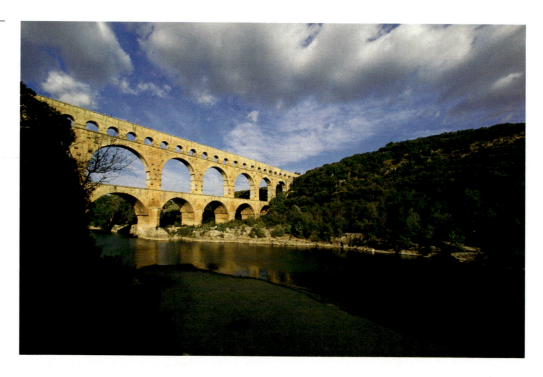

order, symmetrical balance, unification of the individual parts for the greater good and beauty of the whole: these are basic attributes of the classical ideal. Twenty-five hundred years later, the reason, modesty, and potency of the classical form still speak to us. The Parthenon, as a primary exemplar, continues to breathe with an immense, timeless vitality.

It is no wonder that the Romans, who rose to power over the Greeks and whose empire, at its height, stretched from England to Persia, came to embrace many of the elements of Greek classicism as their own.

Roman Innovation: The Arch, the Vault, and the Dome. Whereas straight lines and right angles—vertical columns (posts) and horizontal cross beams (lintels)—are the predominant features of Greek architecture, Roman building features the **arch** and its variations. As perfected by the Romans, arches, **vaults**, and domes became an integral part of the classical vocabulary. Built by the Romans in the late first century B.C., the Pont du Gard (6.10) was an aqueduct that carried water some thirty miles across the French plain and valley of the Gardon River to the city of Nîmes. Structurally, the aqueduct shows the arch in a single

plane stacked up in three stories. Not meant primarily as a work of art, this triumph of engineering nonetheless possesses a functionalist beauty that takes one's breath away. From the Pont du Gard to the Crystal Palace (5.2), the most outstanding achievements of engineering seem to transcend their immediate function and inspire viewers with the power of their aesthetic form.

In the impressive Basilica of Maxentius (6.11), the Royal Hall of Justice of the Emperor Maxentius, we see the arch stretched out in a straight line, thereby becoming a barrel vault. (Notice the multistoried arches of the Colosseum, that most famous of ancient buildings, in the distance.) Nearby, were the Markets of Trajan (*ca* 100–112 A.D.), a kind of three-story supermall that had more than one hundred and fifty shops and offices. The centerpiece of this complex was a covered market (6.12) composed of two sets of intersecting barrel vaults. This innovative application of vaulting produced a broad commercial space, well lit and ventilated; a most suitable creation for a populace primarily engaged in working for, buying from, and selling to each other. This proliferation of arches and vaults of multiple forms was made possible by the devel-

6.11 • The Basilica of Maxentius and the Colosseum. Rome. 307–312 A.D. and 72–80 A.D.

6.12 • APOLLODORUS OF DAMASCUS. The Markets of Trajan. Rome. 100–112 A.D.

opment of a slow-drying cement, just one of the many technological advancements made by ingenious Roman builders. The earlier architecture of the ancient Near East and Greece had been essentially an art of mass; space was simply what was left over or left between massive horizontals and verticals. By contrast, Roman building became an architecture of space, the structure being conceived as a flexible shell molding space into whatever form was desired.

The Pantheon: Symbol of Cosmos and Empire

All of the technical innovations that had gone into the creation of this new architecture of space were put to use in Rome's Pantheon (*ca* 120–127 A.D.), whose interior remains one of the wonders of the world. On the outside, this Roman temple dedicated to all (the "pantheon") of gods, combines a traditional Greek temple **portico** front with an enormous domed rotunda (6.13). One hundred forty-four feet in both height and diameter, the rotunda was made possible by the earlier innovations in vaulting and the development of slow-drying cement.

Passing from a Greek world of clear, confining angular forms, one enters a space of spherical boundlessness, in which the darkness is penetrated by a column of light pouring through a circular eye, or *oculus,* twenty-six feet wide, at the top of the dome (6.14). Within, one is compelled to look up. On a sunlit day, the broad beam of light is so concentrated that even the sky itself is blocked out by its brilliance. The onlooker experiences a magical light coming from some infinite place above, setting up a dramatic contrast as it revolves around the dark circular interior. In keeping with the movement of the earth and the passage of the sun, the beam of light shines in turn on or above each of the gods, including those of the planets. Note the placement of the statues of the gods in tabernacles or "temple fronts" that ring the interior.

An association is set up. The Pantheon's boundless hemispheric dome with its illuminating shaft of light becomes the visual equivalent of the vault of heaven. And so it was to the Romans of the time. The historian Dio Cassius (*ca* 135–*ca* 325) pondering its significance, remarked that the building was perhaps called the Pantheon because "it received among the images which decorate it the statues of many deities, including Mars and Venus; but my opinion of the name is that, because of its vaulted roof, it resembles the heavens." Earlier domes had been decorated to symbolize the heavens, but no single building embodied this idea more effectively or on a grander scale than the Pantheon.

Like the Parthenon in Athens, Rome's Pantheon also expresses a political content. There were images of the Emperor Augustus in the entrance vestibule and of a deified Julius Caesar within. Hadrian, the emperor who had the Pantheon built, held judicial court in the rotunda. And there were other imperial meanings. The Pantheon was built from materials supplied from the subject lands. From Egypt came granite; from Africa, colored marbles; from Greece, white marbles. The Pantheon, as Rome personified, was, in effect, the integrated sum of its parts.

No ancient buildings have had a greater influence on religious and municipal architecture in the West than the Parthenon and Pantheon. The Greek temple and the Roman dome, in all their permutations, are an architectural language spoken across the centuries. From the temple-dome composition of Saint Peter's in the Vatican to the nineteenth-century temple-dome composition of the Capitol of the United States, the Greco-Roman legacy has, over a period of two thousand years, given birth to a host of extraordinary offspring.

The Early Renaissance in Italy: Translating the Greco-Roman Legacy.

Following the sack of Rome in 410 A.D. by Alaric and his Goths, much of the ancient culture of Greece and Rome was temporarily lost to the Western world. In the turbulent centuries that ensued, it was Christian monks and Germanic Christian rulers—notably Charlemagne (771–814) and Otto I (936–973)—along with Arab and Hebrew scholars who saved the precious manuscripts of antiquity. As order returned to Europe and the later medieval period took shape, beginning approximately in the eleventh century, interest in the history and culture of the classical world (4.4, 4.5) grew steadily. This interest would reach full flower at the

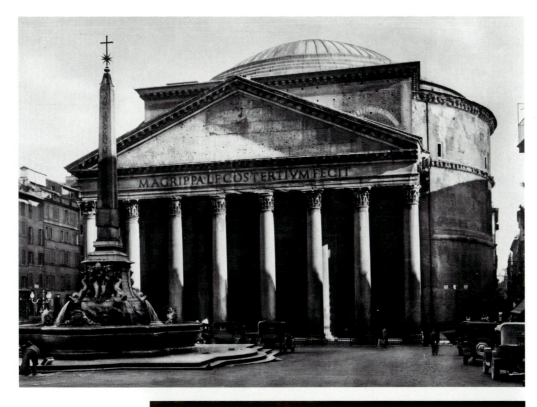

6.13 • The Pantheon. Rome. *ca* 120–127 A.D. View from the north.

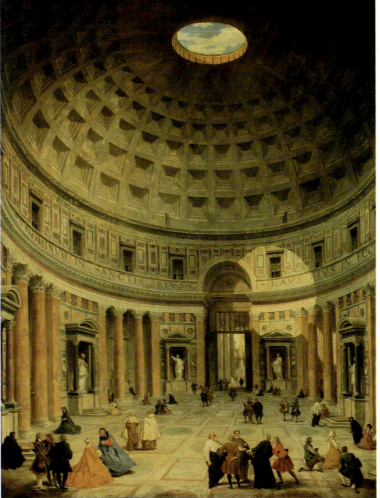

6.14 • GIOVANNI PAOLO PANNINI. *The Interior of the Pantheon. ca* 1740. Oil on canvas. 50½ × 39″. The National Gallery of Art, Washington, D.C. Samuel H. Kress Collection.

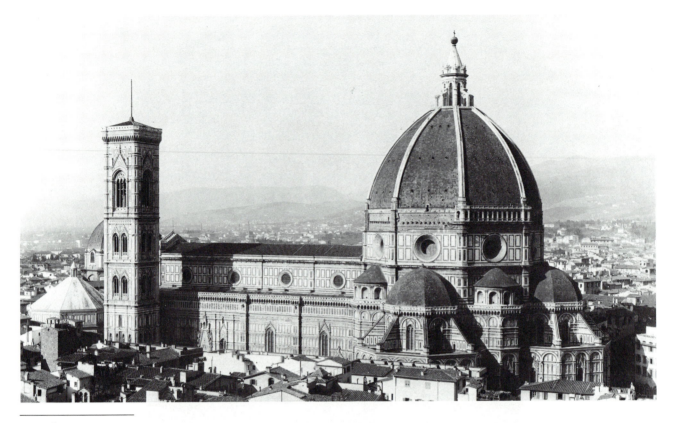

6.15 • ARNOLFO DI
CAMBIO AND FILIPPO
BRUNELLESCHI. Florence
Cathedral. Florence, Italy.
Begun 1296; dome
1420–1436.

beginning of the fifteenth century in Florence, just a few hundred miles north of Rome. From the soil of the Middle Ages, so rich in antiquarian learning, a full-scale revival of Greco-Roman culture grew. While humanist scholars in Florence studied and translated the classical texts of "the ancients," artists and architects began to investigate the technical and aesthetic achievements of their forefathers. Florentine sculptors like Lorenzo Ghiberti (1378–1455) and Donatello (*ca* 1386–1466) closely examined Roman statuary, much of it in ruins or fragments, to simulate and translate its beauty. Filippo Brunelleschi (1377–1446), architect, sculptor, and friend of both Donatello and Ghiberti, traveled south to Rome to study the ancient ruins and, in particular, the Pantheon in his ambitious quest to raise the immense dome of Florence's unfinished Gothic-style cathedral (or **duomo**), an undertaking many believed to be technically impossible. He had gone to the imperial capital, his biographer Vasari tells us, to study "the way the ancients built and their proportions" and to observe "closely the supports and thrusts of the build-

ings, their forms, arches, and inventions … as also their ornamental detail." This close observation, combined with his own ingenious engineering discoveries, finally enabled him to raise the huge dome (6.15), a process that required thousands of skilled artisans and seventeen years of Brunelleschi's tireless direction.

It is a magnificent achievement indeed, with its red brick panels, its eight ribs of shining white marble, and its crowning lantern: a miniature cathedral with arch-shaped windows that ties the whole design together. With a Greek cross rising from its top, the lantern's conical roof points reverently toward the heavens, while its windows, like the Pantheon's *oculus,* admit light that penetrates the dark interior far below. From its base to its crest, Brunelleschi's design was a most effective compromise between the older medieval style of the cathedral (begun in 1296) and the emerging classical style of the early Renaissance. A true sculpture in the round, the huge dome, visible from near and far, became a proud symbol for Florence and its country-

6.16 • Filippo Brunelleschi. Portico (left) and Loggia and Courtyard (below) of the Foundling Hospital. Florence. 1419–1426.

side. For the city and its visitors, all roads, and all lines of sight, seem to lead to and radiate from the Duomo, center of a brilliant new Rome in the hills and valleys of Tuscany.

Remarkable as the achievement of the cathedral dome may have been, the classical legacy of Greece and Rome is seen in more thorough translation in Brunelleschi's Pazzi Chapel and Foundling Hospital. The latter, known in Italian as the *Loggia dello Spedale degli Innocenti* (6.16), is considered by many to be the first truly Renaissance-style building. In the graceful columned **arcade** (or *loggia*) of

this public foundling home (*spedale*) for abandoned children (*innocenti*), the dark, complex medieval styles of the preceding centuries are nowhere to be found. Instead there is a new, "modern" architecture, classical in inspiration, consisting of Greek **Corinthian** columns rising into circular Roman arches that glide gracefully along under their straight **entablature** (6.8); the **cornice,** somewhat lifted, is the base of a row of "pedimented" windows, an evocation, in shape, of the triangular **pediments** of Greek temples such as the Parthenon. The vaulted arcade of the Foundling Hospital cre-

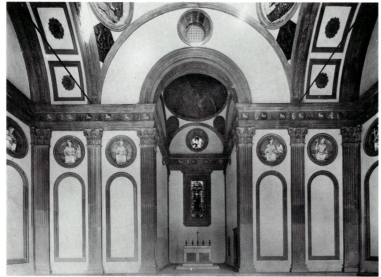

6.17 • FILIPPO
BRUNELLESCHI. Pazzi
Chapel. Santa Croce,
Florence. Begun 1440.

ates a welcoming space that is open, light-filled, and airy. The antique classical attributes of simplicity, clarity, and order are manifested here in a building that does not merely copy but extends the achievements of the Greco-Roman past. Beauty without extravagance, a pleasing harmony among the parts, and a symmetrical rhythmic arrangement greet the viewer. This, as art historian Kenneth Clark points out, is an architecture of humanism. Unlike the soaring God-centered Gothic cathedrals of the preceding centuries, such early Renaissance architecture is proportioned to the scale of humanity. One feels at home, not awed, walking under the loggia's gentle

6.18 • KONRAD
HEINZELMANN AND
KONRAD RORICZER.
Choir of Saint Lorenz.
Nuremberg Cathedral.
Begun 1439.

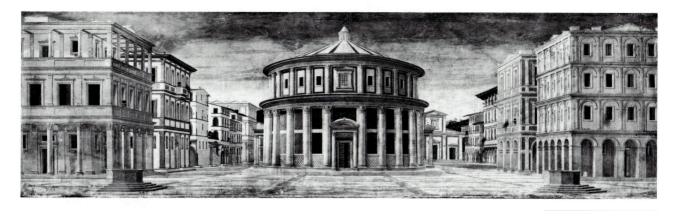

6.19 • CIRCLE OF PIERO DELLA FRANCESCA. *View of an Ideal City.* Oil. 79 × 23½". *ca* 1475.

vaulted roof or resting on the steps in front of the building.

Much the same feeling is generated by the interior of the Pazzi Chapel (6.17), designed by Brunelleschi for one of the powerful bourgeois families of Florence. Begun in 1440, the building was completed by others after the architect's death. Compared to the inner sanctum of the late Gothic cathedral of Saint Lorenz in Nuremburg (6.18), built at almost the same time, the Pazzi Chapel appears plain and unassuming; some would say unimpressive. It is certainly worlds apart from the Gothic. It does not overwhelm so much as make one feel at peace. Simplicity, clarity, and gentle curves replace Gothic complexity, pointed arches, and upward thrust. In Brunelleschi's design, medieval mystery and aspiration toward the otherworldly are replaced by a more down-to-earth equilibrium of horizontals and verticals, a harmonious relationship of the parts to one another, and a humanistic orientation in which "man is the measure of all things."

In the Pazzi Chapel, Brunelleschi once again drew on the principles and elements of the Greco-Roman legacy—arches, vaults, domes, flattened **pilaster** columns with Corinthian capitals—but he forged them into an architectural beauty and meaning completely new, one that spoke the language of the clear-headed, bright-minded Florentines—scholars, crafts- and businesspeople, artists—who made their city and Italy the birthplace of the Renaissance. To paraphrase Shakespeare, Florentine humanists saw the individual as potentially godlike: noble in reason, infinite in faculties, in form expressive and admirable, in action like an angel, in apprehension like a god. "A man can do all things if he wills" insisted the architect, poet, athlete, and thoroughgoing "renaissance man" Leon Battista Alberti (1404–1472). Through their learning and skill, money and power, individuals like Brunelleschi and Alberti sought to bring the beauty and perfection previously assigned to heaven down to earth.

A painting of an ideal town (6.19), executed in the second half of the fifteenth century, gives expression to these classical-humanist aspirations. A circular building, probably a kind of temple-church, stands in the center of a marble-paved public square, or piazza, surrounded by buildings of geometrical shape, in the classical style of the early Renaissance. Order here is not so much imposed as accepted, permitting architectural and human individuality so long as they are within the bounds of propriety and reason. The airy lightness and planned spaciousness of this environmental plan, which differentiate it from that of the labyrinthine accumulated parts of a medieval city (6.20), provide the perfect Renaissance setting: an aesthetic place of variety within unity, a human place that promotes harmonious community relations. For the architect and theorist Alberti, the public square in such a city was simultaneously an artistic and social necessity "where young men may be diverted from the mischievousness and folly natural to their age; and, under handsome porticos, old men may spend the heat of the day, and be mutually serviceable to one another." According to the classical ideal of fifteenth-century Italy, every individual and

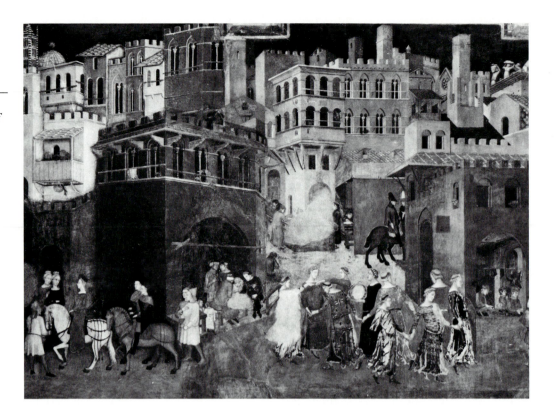

6.20 • AMBROGIO
LORENZETTI. *Allegory of
Peace* (detail). 1339.
Fresco. Palazzo Pubblico,
Siena, Italy.

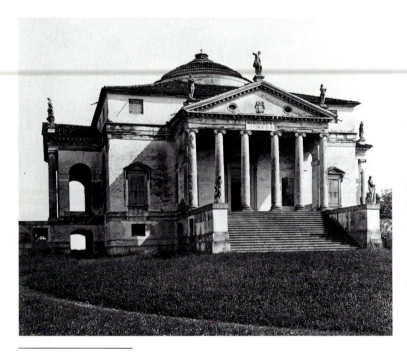

6.21 • ANDREA
PALLADIO. Villa
Rotonda. Vicenza, Italy.
Begun *ca* 1550.

part had its place and worked in concert for
the harmony and beauty of the whole.

***Stretching the Classical Ideal: From the High
Renaissance to the Baroque.*** In the sixteenth
century, architects either adhered to the clas-
sicism of Brunelleschi, or bent and sometimes
broke the early Renaissance classical mold.
Palladio's Villa Rotonda (domed house)
(6.21), in Vicenza, for example, still holds
strongly to Renaissance principles. Four tem-
ple portico fronts, approached by long series
of steps, lead into a square central structure
from which rises a hemispheric dome.

Begun about 1550, the Villa Rotonda is an
appropriate country home for a wealthy
gentleman versed in the classics. All is balanced
and ordered. Here is a beauty, modest and
clear, symmetrical and harmonious. To An-
drea Palladio (1508–1580) and many of his
contemporaries, classical phrases such as "har-
moniously proportioned" were not mere fig-
ures of speech. Simple mathematical ratios,
such as 1:2, 2:3, and 3:4, when applied to the
measured relationships of spaces and solids,
were adjudged to be the most visually satisfy-
ing. Indeed, these simple ratios were so often
used that they came to inform our Western
sense of proportion and Western idea of a well-

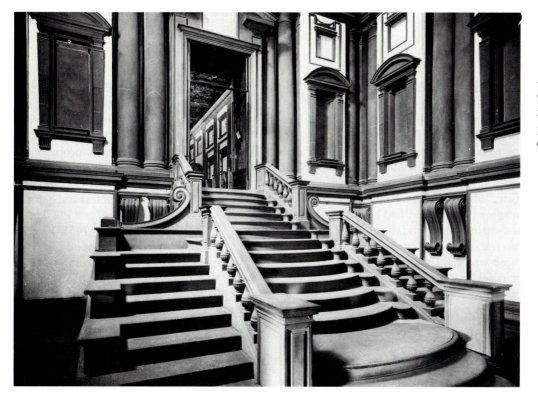

6.22 • MICHELANGELO. Laurentian Library Vestibule. Florence. Begun 1554; stairway designed 1558–1559.

proportioned building. "Such harmonies," wrote Palladio, "usually please very much without anyone knowing why, apart from those who study their causes." Observance of the laws of harmony, it was believed, attuned all aspects of life on earth to higher spiritual laws. In Palladio's palaces and villas in Vicenza and the Venetian mainland, the classical-humanist optimism of the early Renaissance continues to be affirmed.

But in other works of the Italian sixteenth century, the laws of classical harmony were being bent and even broken. The tormented spirit of Michelangelo (1475–1564) filled works like the Laurentian Library of Florence's Medici family (6.22) with a restless energy alien to the classical ideal. Although Michelangelo employed recognizable classical elements (Doric-style columns, pilasters, and niches) in the vestibule of the library, he distorted them into disruptive new shapes. No longer was all regular, predictable, and serene. A feeling of compression rather than spaciousness, of tension rather than calm, animates this interior space. The cause of these unclassical sensations is to be found in the clash of the light-dark values, the **broken pediment** above the main door, and the contrasting of curved and triangular pediments over the empty

niches. In addition, the outer frames of the niches, being wider and deeper at the top than at the bottom, create an unstable forward-leaning effect. The tall, darkly ominous **Tuscan Doric** (6.8) columns stand close together and are recessed into the wall, fostering a slightly claustrophobic effect. The scroll-like console brackets below the columns support nothing, a symptom of irrationality to a classicist. And the stairs, built according to Michelangelo's design after his death, seem to rush downward and outward at high velocity. A taut dynamism, an energy strange to traditional classicism, is evoked.

All of these innovations are expressive of Michelangelo's indomitable individual style or "manner," and it is not surprising that the art history term **mannerism** is now often used in reference to the work of those artists of the middle and late sixteenth century, many of whom were inspired by the troubled genius, who painted, sculpted, or designed buildings in idiosyncratic or emotional styles that willfully deviated from the classical norm.

In his architectural designs in the 1520s for the Laurentian Library Vestibule and the New Sacristy in the adjacent Church of San Lorenzo, Michelangelo had defiantly broken with the precepts and spirit of Renaissance

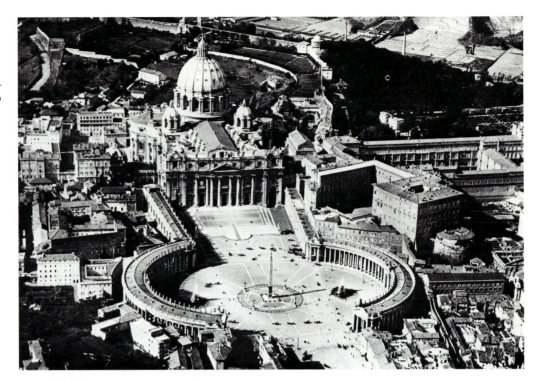

6.24 • Carlo Maderno and Gianlorenzo Bernini. Saint Peter's. Rome. Facade (1602–1612) and colonnade (begun 1656).

vertical emphasis recalls both Brunelleschi's Duomo, one of the inspirations for the design, and the soaring effect of a Gothic cathedral, but Michelangelo's design interrupts this insistent upward thrust with strong horizontals above which the dome, with its energetic arc, seems to float. Some commentators have attached a metaphorical significance to these horizontals and the visual distinction they create between the body of the church below and the dome above. They interpret this to mean that heaven, symbolized by the dome, is no longer attainable here on earth, as earlier Renaissance humanists had argued, but can be attained only through the intercession of the church and its ministers, a central precept of the Catholic Counter-Reformation. Whether we accept this interpretation or not, the dome is an awesome presence, communicating grandeur and inspiring obedience.

In the church's facade by Maderno, following the pattern set by Michelangelo for the exterior of the church, another drama unfolds. A colossal order of columns and pilasters two stories in height interrelates dynamically to focus the viewer's attention on the entrance portals and the central temple-front form. We experience a crescendo of energy gathering from the corners toward the center: the supports are more closely spaced, flat pilasters metamorphose into full-bodied columns, and all architectural elements of the facade project forward toward the viewer step by step in a quickening rhythm. The onlooker is pulled, almost magnetically, to the central entranceways.

Extending outward from the church's entrance portals and the main facade toward the elliptical piazza are the two enormous **colonnades** designed by Gianlorenzo Bernini, the greatest sculptor-architect of the seventeenth century. Visually and figuratively, the colonnades open their arms to embrace the spectator. Bernini actually thought of them as the motherly arms of the church "embracing Catholics in order to reinforce their belief, heretics to reunite them with [her], and agnostics to reveal to them the true faith."

Such **baroque** spaces, writes the architectural historian Vincent Scully, create an active but totally controlled environment; one in which the viewer experiences a sense of freedom within a secure order.

> They are spacious and swelling and present an open invitation to the drama of movement. At the same time, their spaces, which seem so free, are in fact symmetrically focused. . . . All movement is around fixed points. It is a union of the opposites of order and freedom. The order is absolutely firm, but against it an illusion of freedom is played. . . . It is therefore an architecture that is intended to enclose and shelter human

beings in a psychic sense, to order them absolutely so that they can always find a known conclusion at the end of any journey, but finally to let them play at freedom and action all the while. . . . It is a paternal or, perhaps better, maternal architecture, and creates a world with which, today, only children, if they are lucky, could identify.[3]

Making one's way across Bernini's vast enclosed piazza, climbing the steps of the Basilica and passing under the enormous facade, the viewer enters a nave (6.25), immense in height and breadth, and over two football fields (695 feet) in length. All of the decoration of this colossal interior owes some debt to Bernini, because the sculptures, mosaics, and ornamental details created by innumerable artists over the centuries were largely based on his original plans. It is here, within, that the theater of baroque illusion truly begins. There are billowing bishops, weightless angels, and trembling cherubs. Gold leaf glitters, and the floor is alive with a patterned array of multicolored stone. Walking toward the central crossing point of the church under the great dome, the

onlooker approaches Bernini's giant *baldacchino* (6.26) or canopy for the main altar of the church; it is situated above the tomb believed to contain the remains of Saint Peter and Saint Paul. The baldacchino is gigantic, 95 feet high, of bronze embellished with gilding. It rises majestically, like an irresistible force, to reaffirm the centrality of the spot not only for this church but for all of Christendom. Many of the elements, it should be noted, even the unusual twisted columns, had their roots in antiquity, but they are here recomposed and animated by a baroque dynamism and cinematic flourish that speak of the missionary grandeur and emotionalism of the Counter-Reformation.

It is all *un bel composto,* a beautiful whole, in which architecture, sculpture, and mosaics combine to carry one away on a magical journey, as an exhilarated art teacher testified:

> Saint Peter's Basilica is one of the most amazing structures I have ever seen, almost beyond human comprehension, and even when you are standing inside, it is still too much! I kept read-

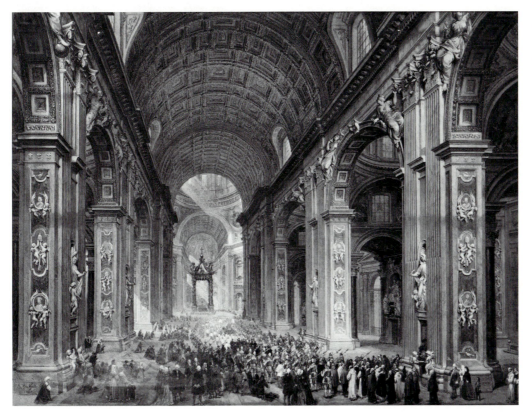

6.25 • LOUIS HAGHE. *Interior view of Saint Peter's.* 1867. Victoria and Albert Museum, London.

6.26 • GIANLORENZO
BERNINI. The
Baldacchino. Saint Peter's.
Rome. 1624–1633.
Approximately 100′ high.

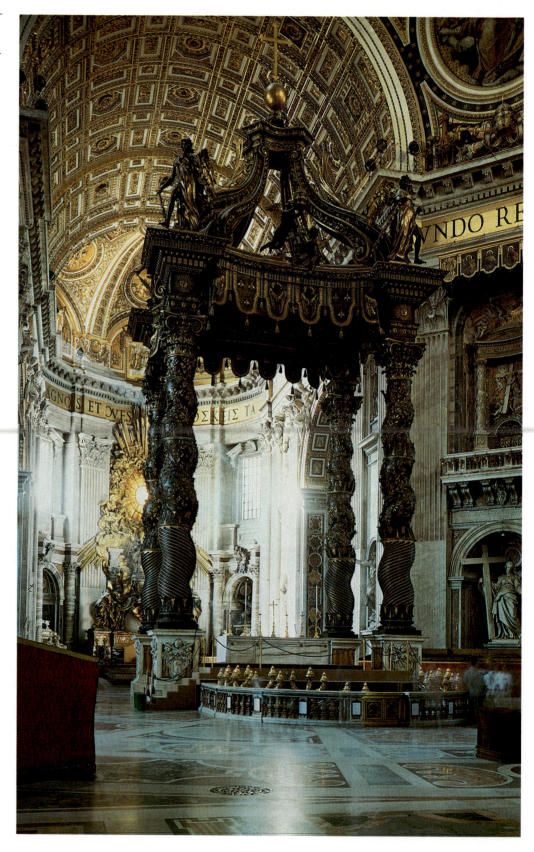

justing to its size, believing in its hugeness, yet not believing. Every statue, column, painting or mosaic is actually gigantic, as is the building itself, but because of perfect proportions, it all falls into place and does not appear to be as big as it is. Every inch of the floors, walls, ceilings is covered with an enduring precious metal, marble, or mosaic. The large mosaics were almost unbelievable, for they looked like huge oil paintings, but were actually small pieces of tile put together in endless values and shades of colors. . . . It was truly beautiful and very moving. . . . Some of the world's finest works of art, by Bernini, Michelangelo, Donatello, and others, were constantly before my eyes. I guess it is trite to say I was overwhelmed, but I was.

Compared to much of the art of the Renaissance, arrived at through intellectual means—geometry, perspective, knowledge of antiquity—and subsequently appreciated by a small group of learned humanists, baroque art appealed to the masses and was as popular then as prime-time television or the commercial Broadway stage is today. Present-day commentators, in fact, often compare the interior design of baroque churches to the performing arts of ballet, theater, or film in their dramatic capacity to simulate movement, create spatial illusions, and pull the viewer into the action. The baroque ceiling (6.27) of *Il Gesù* ("The Jesus"), the main church of the Jesuits, confirms the analogy. Indeed, a built environment of today that might compare to the total baroque compositional effect of *Il Gesù* or Saint Peter's is the Disneyland entertainment park. In accordance with the Roman baroque ideal, Disneyland functions as a joyously instructive and immensely popular fantasyland in which the senses are stimulated at every corner, and a giddy illusion of freedom exists within a carefully planned system of total control.

Baroque Classicism: The Louvre of Louis the XIV. The period of baroque exuberance, Roman style, was limited. It was neither long-lived in relative historical time (lasting at most one hundred and fifty years) nor truly international in scope. Although it captured the imagination of the rulers of Catholic Germany and Austria, and Spain and its colonies, in certain countries—England, France, Holland and their colonies—it never fully took root or was tempered by a more puritanical classicism. The east front of the Louvre (6.28), the palace

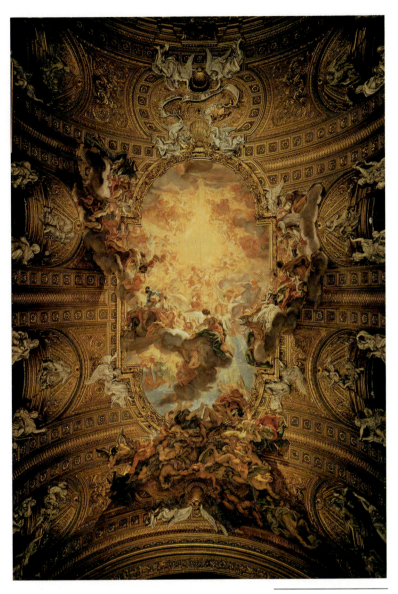

6.27 • GIOVANNI BATTISTA GAULLI. *The Adoration of the Name of Jesus.* 1669–1683. Fresco. Il Gesù, Rome.

6.28 • CHARLES LEBRUN, LOUIS LE VAU, AND CLAUDE PERRAULT. The Louvre. Paris. 1667–1670. East front.

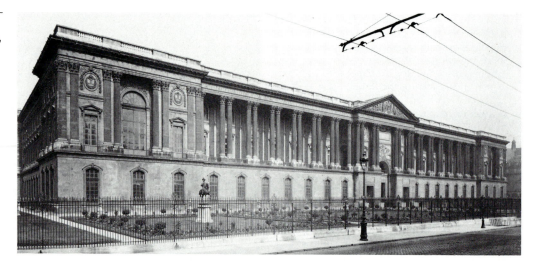

of the French kings, is an example of this far more sober baroque style, called **baroque classicism** by various historians.

Designed by Claude Perrault (1613–1688) and others, the east front of the Louvre is baroque in its grandiose scale but moderated by a severely classical order. Its decoration is restrained, its symmetry absolute; any Roman baroque sense of playfulness or freedom is suppressed. It is a superbly controlled design, like the reasoned policies of the bureaucracy of King Louis XIV (1638–1715) or a rationalist argument by the contemporary French philosopher René Descartes (1596–1650). As the earthly home of the divinely consecrated "Sun King," the Louvre embodied the authoritarian ideals of the French monarchy, serving also as a fitting symbol of national unity and international power. As the king's minister, Colbert, said, "nothing is so well able to show the greatness and spirit of princes than buildings; and all posterity will judge them by the measure of those superb habitations which they have built during their lives." A French bishop, emphasizing this power of architecture to aggrandize, proclaimed, "May the glorious dignity and the majesty of the palace blaze out, for all to see, the splendid grandeur of the royal power, so that, as a stroke of lightning, it sheds light in every direction." Expressive of superhuman authority and severe but rational order, the east front of the Louvre served well as the social face of oligarchy: absolute, centralized power made visible.

A Classical Revival in the New World: Neoclassicism in America. A century later in the New World, Thomas Jefferson (1743–1826), was challenged by a far different problem: how to create the architecture of democracy. Acutely aware of how architecture could symbolize political ideology, Jefferson sought to create buildings that reflected democratic and republican ideals. In addition, he desired to create buildings that emphasized rationality, learning, and moral dignity, primary principles of the eighteenth-century European philosophical movement known as the Enlightenment, a movement whose leading figures included the English liberal political theorist John Locke (1632–1704), the French encyclopedist Denis Diderot (1713–1784) (8.40), and Jefferson himself. Shunning the prevailing British style in the colonies, Jefferson sought a building style independent of "King George's Tyranny." After the bloody War of Independence, an American style was needed; the British Georgian style would not do.

Where might an architecture appropriate for the young democratic republic be found? Jefferson and his compatriots, like the architect Benjamin Latrobe (1764–1820), looked to classical Greece and republican Rome. Latrobe asserted that a new Greece was growing "in the woods of America." Like the United States, he noted, "Greece was free; in Greece every citizen felt himself an important . . . part of his republic." Classical Greek architecture, he concluded, was therefore well-suited for

America. Jefferson, for his part, had the architecture and culture of republican Rome in mind, as had those Frenchmen who would lead the first phase of their country's bourgeois revolution. The leaders of the American War of Independence drew their moral inspiration from those self-denying Roman heroes who, like the patriotic brothers in the Frenchman David's *Oath of the Horatii* (8.41), loved country above all else and valued liberty more than their lives. Their planned senate on the Potomac would be a reincarnation of the Roman senate, a patrician precursor of American representative democracy. It is therefore not surprising that a full-fledged classical revival, resulting in an architecture we now call **neoclassical** (new classical), came to dominate the Federal Period, from approximately 1790 to 1830.

To Jefferson, the first order of business in bringing forth a national architecture was the transport of the Roman architectural style to America. The designs he sent from France for the new state capitol of Virginia reproduced, on a larger scale, a Roman temple, the so-called Maison Carrée that he had seen in Nîmes, France. He wrote that he had gazed on the small temple for hours, "like a lover at his mistress." "It is very simple," he observed, "but it is noble beyond expression, and would have done honor to our country, as presenting to travellers a specimen of taste in our infancy, promising much for our maturer age." In Richmond, legislative, executive, and judicial functions were to be carried on within the walls of this sober, harmonious structure (6.29). The moral and aesthetic qualities communicated by the exterior extended to both the building's interior design and a featured statue within: a standing portrait of George Washington (6.30), slightly larger than life, by the Frenchman Jean-Antoine Houdon (1741–1828), the supreme neoclassical sculptor of the Enlightenment. According to art historian Kenneth Clark, "Houdon saw his subject as that favorite Roman republican hero, the decent country gentleman, called away from his farm to defend his neighbors' liberties; and, in moments of optimism, one may feel that, through all the vulgarity and corruption of American politics, some vestige of this first ideal has survived." In the fine and

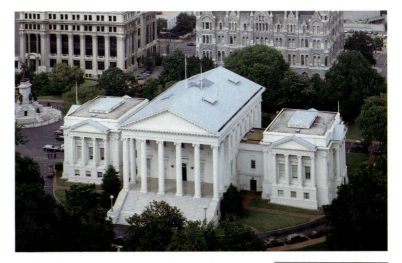

6.29 • THOMAS JEFFERSON. State Capitol. Richmond, Va. 1780–1785.

6.30 • JEAN-ANTOINE HOUDON. *George Washington.* State Capitol. Richmond, Va. 1788–1792. Marble. Height, 6′ 2″.

applied arts, in architecture and in fashion (2.8), the neoclassical aesthetic would become synonymous with the political ideals of the revolutionary new republics in both the United States and France.

A strong believer in publicly funded education, Jefferson took great pride in founding the University of Virginia. For its library (6.31), the core of his "academical village," Jefferson built a version of Rome's Pantheon (6.13), at two-thirds its scale. At the head of a gently rising mall, this pantheon of knowledge was flanked by ten pavilions for profes-

sors and between them, behind a colonnade, the rooms of the students, all linked to the whole, yet all individual. The symbolism of this design should not be overlooked. The library, not the administration building, as in so many recent universities, is the largest, most centrally located building on campus. In Jefferson's plan (6.32), the faculty and students, architecturally and factually, are at the core of the academic enterprise, physically linked to all the knowledge of the past. The fact that the original campus of the University of Virginia was open at one end, looking out on and

thereby linking the campus with the mountains and larger world beyond, reflects Jefferson's desire that academe be integrally related to nature (and natural law) and to evolving human civilization as well. The academical village was not to be an ivory tower, walled in and cloistered from the rest of life.

Some ten miles from the University of Virginia stands Jefferson's own home, Monticello (6.33), crowning the small mount for which it is named. At Monticello, the Pantheon finds yet another application. Here it is domesticated in the illustrious residential tradition that began with Palladio's Villa Rotonda (6.21). Stylistically, similarities between the two residences are apparent: central domes on a cross-axial plan; temple portico fronts; classical composition emphasizing simple geometric shapes, symmetry, and decorative restraint. But differences are also evident. An important one is Monticello's greater horizontality. Compared to its predecessor, the dome of Jefferson's home (6.34) is smaller and gentler in its curve, less vertically prominent, and its side wings spread out over the land, making the thrust of the building more outward than upward. Interpreting this more expansive horizontality in terms of the American experience, Vincent Scully writes that much of Jefferson's work, including Monticello and the University

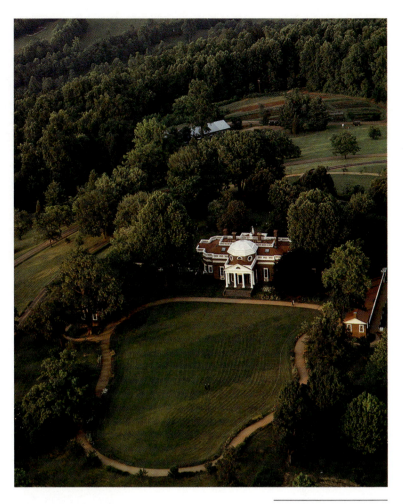

6.33 • THOMAS JEFFERSON. Monticello. Charlottesville, Va. 1770–1784; remodeled 1796–1806. Aerial view.

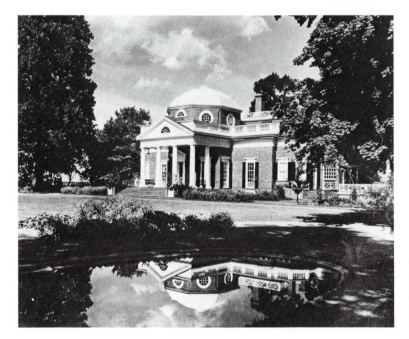

6.34 • THOMAS JEFFERSON. Monticello. Charlottesville, Va. 1770–1784; remodeled 1796–1806.

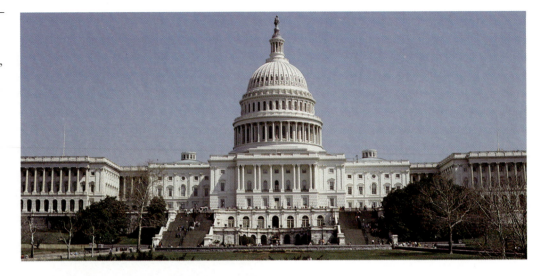

of Virginia, should be seen in metaphorical terms as "a struggle between the fixed European past and the mobile American future, between Palladio and Frank Lloyd Wright, between a desire for contained, classical geometry and an instinct to spread out horizontally along the surface of the land." In this light, Monticello is a hero's house, a "place where the decisive stance was taken on the continent, when all of European memory and civilization that a single brain could encompass were shaped to provide the foothold for the step to the western sea." A prototypic American committed to individual liberties and open horizons, it was Jefferson who finalized the vast Louisiana Purchase and who advocated a spacious America in which the majority of the citizenry would thrive as noble self-sufficient farmers owning their own houses and tilling their own land.

Washington, D.C.: In the Image of Greece and Rome.

The classical architectural ideal of Jefferson, Latrobe, and others would have a very substantial influence on the style of public buildings in the United States, from federal buildings in cities and towns across America to those in Washington, D.C., the nation's capital. The Capitol (6.35) and the White House, the two most prominent government buildings constructed in the nineteenth century, led the way. They represented the classical revival in its purest American form. However, by the first half of the twentieth century,

not one but two strains of classicism had become evident along the Potomac. The first was the "full-dress" classicism conveyed by the Capitol and White House, the Jefferson and Lincoln memorials, the Commerce and Supreme Court buildings, and the National Gallery of Art. The second strain, typical of the office buildings that house the bureaucracy in the Federal Triangle area, was constructed in a synthetic classical-modern style criticized by some as "starved classicism." Classical styling in most of these Federal Triangle buildings (6.36), built primarily in the 1930s, was concentrated at entranceways and focal points, while the bulk of the giant structures were given over to large expanses of blank walls and rows of shallow unframed window openings. Many federal office buildings around the country have taken their lead from these classical-modern designs.

Only since World War II has the architecture built or sanctioned by the federal government moved completely beyond the neoclassical and classical-modern styles to a full-fledged modernism. The result has been a mixed bag of architecture, good, bad, and controversial. Among the most distinguished (although it has been criticized as too nontraditional for the classicist Mall area of Washington, D.C.) is the East Wing of the National Gallery of Art (6.37), a razor-edged modern sculpture of dramatic angles and exciting interior spaces by I. M. Pei (born 1917). Among the most unsettling examples is the so-called

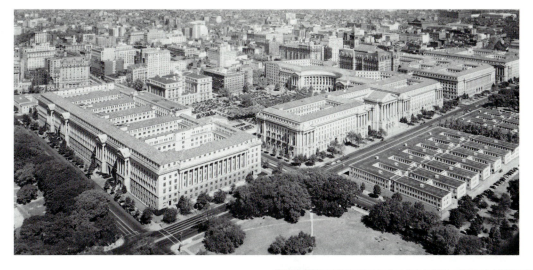

6.36 • The Federal Triangle. Washington, D.C. View *ca* 1940.

6.37 • I. M. PEI. East Wing, National Gallery of Art. Washington, D.C. 1978.

6.38 • CHARLES F. MURPHY AND ASSOCIATES. J. Edgar Hoover building (Federal Bureau of Investigation). Washington, D.C. 1974.

brutalist architecture of the Federal Bureau of Investigation Building (6.38), a structure so hostile and overbearing in appearance as to make one fearful of the nation's criminal investigators. Certain critics go so far as to maintain that the chilling modernism of the F.B.I Building conjures up inhuman images that are more closely associated with fascism than with democracy.

If the National Gallery's East Wing appears too nonrepresentational and nonsymbolic, if the brutalist modernism of the F.B.I. Building conjures up fear among the citizenry, and if the "starved classicism" of the Federal Triangle buildings communicates a feeling of oversized, insensitive bureaucracy, might not a return to the more comforting, "full-dress" classical style be in order? Both traditionalists and certain **post-modern** critics argue for a return to a more thoroughly classical style of architecture with all its symbolic associations for the American public. Isn't the classical style, they argue, really more appropriate for our government buildings as the style of democracy? Given the historical context of the United States, the answer would seem to be yes. The neoclassical buildings of Jefferson, Latrobe, and others are still strongly associated with Athenian democracy, Roman republicanism, and the founding of our nation.

Yet in other societal contexts, the classical style has not stood for democracy or republicanism. In fascist Italy, Spain, and Germany in the 1930s and 1940s (1.6), not to mention

absolutist France under Louis XIV (6.28), the classical style was invested with very different meanings. Under these regimes, classicism was the architectural face of authoritarianism. It symbolized, for example, the imperial greatness of the Roman Empire of the Caesars, or the slave-holding Greek empires of Athens and Sparta. For Hitler and Mussolini and their followers, those parts of the Greco-Roman legacy that were committed to democracy and republicanism were simply overlooked. Often superhuman in scale, fascist classicist architecture communicated messages about obedience and the primacy of the state over the individual.

As with professional business dress, likewise "classic" in its styling (2.4, 2.9), classically styled architecture of the twentieth century has been an open book in which leaders of diverse political ideologies have inscribed their specific meanings. And like classic business dress, whether worn by an American president or Soviet premier, much of classical architecture, when put to use in public buildings, has communicated a message of power. Classical architecture, harking back to the golden ages of Greece, Rome, and the Renaissance, has become for democrats and autocrats, capitalists and communists, a visual projection of the stability, order, and strength of their respective systems.

It remains to be seen whether, after twenty-five hundred years, governments and private citizens will relinquish the language of classicism in their most important buildings. In much of the twentieth century, modernism, with its negative attitude toward the past, has attempted to root out the classical vocabulary in government and commercial buildings worldwide. The Doric, Ionic, and Corinthian orders are rarely seen in our streamlined steel and glass skyscrapers or "high-tech" industrial parks. (The post-modern architectural direction of the 1980s and 1990s, it should be noted, has been much friendlier to building styles of the past and the legacy of Greece and Rome.) Yet, in spite of modernism's fierce assault, the old classical style buildings remain; over twenty-five centuries worth of them. And for many people, their meanings, in all their diversity, still ring loud and clear.

THE GOTHIC IDEAL & MEDIEVAL REVIVAL STYLES

If the classical is the most familiar and enduring of all the Western architectural styles, then the second most recognizable and lasting is the **Gothic.** The classical style was a product of the Greco-Roman world of the Mediterranean; the Gothic, in contrast, arose in northern Europe as an expression of the Christian culture of medieval Germany, England, and especially France. Catholic churchmen, representatives of the most powerful political and cultural institution of the period, were the principal creators of the style. Prominent among them was the French Abbot Suger (1081–1151). Small in physical stature, like many of the movers and shakers of history, Suger possessed the high position and exceptional abilities to realize his vision in words and deeds.

Suger was the right man at the right time. At the beginning of the twelfth century, the church was at a high point of power and wealth. It was clearly capable of creating a magnificent new architecture for the glory of God and itself. Suger, for his part, was a lover of precious and beautiful things, an aesthete who appreciated art and architecture for their sensuous appeal as well as their power to inspire and teach. A most persuasive speaker and writer, he was able to convince the churchmen of the *Ile de France*, the royal province surrounding Paris, of the essential role that beauty must play in the service of God. He argued that man could come to understand absolute beauty, which is a direct manifestation of God, only through the effect of precious and beautiful things on the senses. He wrote, "The dull mind rises to truth through that which is material."

For Suger and others to propose such a sensory-based "aesthetic" approach to religion was, for the time, revolutionary. In the preceding centuries, the prevailing view was that the physical body and the five senses were most prone to sin. Only the mind, the least "material" of the body's receptors, might transport fallible humanity to the life of the spirit. For this reason, many churchmen and women had sought holiness in the isolation of monasteries

or convents, far from the temptations of court or town. For the various orders of monks and nuns, ascetic self-denial was the way to transcend the temptations of the flesh and, with the help of prayer and meditation, achieve spiritual union with the Almighty. To such men and women, the concept of finding God through the senses must have seemed all too blasphemous. Affirming the monastic point of view, Saint Anselm (died 1109), writing at the beginning of the twelfth century, maintained that material things were harmful in proportion to the number of senses that they delighted. He therefore rated it as dangerous to sit in a garden where there were roses to satisfy the senses of sight and smell, and songs and stories to please the ear.

In utter opposition to the monastic view, Suger argued for total sensory immersion in the service of God. Suger's position was to win out and become the public policy of the church, persisting through the Renaissance and achieving climactic expression in the multisensory baroque extravaganzas of the Counter-Reformation. Suger believed that through an interplay of the sight, sound, smell, and touch, the Church mass might come to be celebrated "so festively, so solemnly, so diversely and yet so concordantly, and so joyfully" that it would render the service "delightful by its consonance and unified harmony." The church service might rise to become "a symphony angelic rather than human. . . ." Through the arts, and their effect on the various senses, the mind might be lifted upward to experiences of joy, solemnity, consonance and harmony—that is, to experiences of the eternal. Suger's proposals for the aestheticization of religion were apparently popular among most sectors of society, including among churchmen whose worldly flocks consisted of persons, of all classes, the great majority of whom could neither read nor write. Such "dull minds," these practical churchmen insisted, might indeed "rise to the contemplation of the Divine through the senses." The theoretical justification for the Catholic Church's full-fledged integration of art and religion, aesthetic and spiritual experience evolved from such arguments by Suger and others.

6.39 • Abbey church of Saint Denis. Near Paris. 1140–1144. Interior view of Suger's choir.

Building on his revolutionary theory, Suger put into practice at the abbey church of Saint Denis (6.39) on the outskirts of Paris what we have come to know as the Gothic style. Saint Denis had not only the characteristic pointed Gothic arches but also light-giving high windows known as the **clerestory**. "Bright," Suger says, "is the noble edifice that is pervaded by new light." In a synthesis of Christian philosophy and Greek-inspired Neo-Platonic thought, with its emphasis on the possibility of mystical union between the individual soul and the universal One, Suger derived the idea of God as the "superessential light" reflected in "harmony and radiance" here on earth. Characteristic of Suger's new, modern work on the church, his "opus modernum," the renovated choir and sanctuary at Saint Denis were

6.42 • Chartres Cathedral. Chartres, France. West front, main portal.

6.43 • Chartres Cathedral. Chartres, France. View of the nave toward the rose window on the west front.

rope had been destroyed during times of war. They had burnt down and been rebuilt. Their construction had been held up while huge sums of money were gathered to hire and pay the armies of guild artisans and traveling lodges of stonemasons who built them. For this reason, very few cathedrals exhibit a total stylistic unity. But Chartres, in spite of the stylistic differences of its towers and sculptures, does possess a great deal of unity, especially spiritually. And it was the overarching spirit of the place that spoke to me most strongly.

Chartres, for me, is the spirit of medieval Christianity in physical form. Everything about it, inside and out, speaks of the exaltation of Christ and His church. It is the Bible made visible. The stone sculptures on its exterior recite the whole history of the Church, from the Old Testament predecessors of Christ, to Jesus Himself, to His emissaries here on earth—the saints, kings, and secular ministers of His divine plan. Over the main portal on the west is a scene of Christ in Majesty [6.42]. As I near the main door, I see that Christ is surrounded by symbols of the four apostles, and I become aware of the great rose window rising above the Son of God. Through visual experiences such as these, the Church must have impressed upon medieval man the gravity of his earthly journey. It is under this scene of Christ, surrounded by His apostles, that I enter.

As impressive as the cathedral is from the outside, with its central hilltop location, soaring height, and encyclopedic sculptural program, the real mystery lies within. In the vast space of the nave [6.43], one feels like a tiny atom in the mysterious darkness. My immediate instinct is to look up. And with good reason. The entire focus of the interior is upward. Beams of colored

light—red, blue, purple—filter through the darkness from the high stained glass windows on the north clerestory wall [6.44]. The holy light leaves touches of color on the floor and wall and even dapples the tourists who sit or stand or walk slowly about. Moreover, it moves as the sun moves and changes as the sky changes. Truly sent from the heavens, it seems to live and breathe: material and yet immaterial, body and spirit. The stained glass windows [4.1] are filled with figures and scenes, but most are too high up to be well seen or understood. No, it is the light itself, the magical light, animating the darkness from on high, that inspires a reverence.

I look up also because the ceiling itself is so high, with bundles of thin columns shooting skyward and coming to a point in the ribbed vaults of the ceiling. Everything points to the heavens: the arches, the vaulting, the high stained glass windows which allow entry of the heavenly light.

The message of the cathedral is clear: glory to God in the highest. The direction of one's life must be ever upward, to the eternal realm above. Chartres leads the believer confidently. It is to be a successful journey. The threat of eternal damnation and hellfire, so prevalent in earlier medieval churches I saw on my trip, are not present here.

From its foundation in the shape of a Latin cross to its arches and vaults pointing heavenward, Chartres is the body of the church and its congregants rising ever upward, inspiring belief and carrying the faithful on their journey toward the Almighty.

International Gothic versus Italian Classicism.

For more than three centuries, from approximately 1200 to 1500, the Gothic style and ideal led the way in most of Western Europe. For over three hundred years, the Gothic dominated religious and secular buildings to such an extent that it could legitimately be called an "international style." Not since the Roman Empire had administered the land from England to Germany, populating it with classical structures, had one style found its way across the length and breadth of Europe. There were, of course, national and local variants on the Gothic, but these were essentially variations on the original theme.

Even Italy, filled with architectural reminders of the Roman Empire, succumbed, to a certain extent, to this cultural invasion from the Gothic north. Yet, Italy would eventually reassert its Greco-Roman legacy with the achievements of Brunelleschi and Alberti

in the first three quarters of the fifteenth century. The classical style of Greece and Rome was to be reborn, first in Florence, and then all over the Italian peninsula. By the sixteenth century, partisans of the new Italian style would decry the dominant Gothic as they sought to dethrone and replace it. In his seminal art historical treatise of 1550, *The Lives of the Most Eminent Painters, Sculptors, and Architects*, the Florentine architect and painter Vasari condemned the architecture of "the Goths, these barbarians, untutored in the true classics." These northerners, lamented Vasari, "have evolved a style of their own which is a mere hodgepodge of spires and pinnacles and grotesque decoration and unnecessary details

6.44 • Chartres Cathedral. Chartres, France. Rose and lancet windows. Stained glass. 42′ 8″, diameter of rose. North transept.

which are completely lacking in the simple beauty of the classical world."

It was indeed true that the northern Europeans had evolved a style of their own (6.18), one very distinct in form and intent from the classical style of the early Renaissance (6.17). But Vasari, as a radical proponent of the Italian classical tradition, as well as its mannerist variations, had unfairly maligned the Gothic. The churches of Brunelleschi and Michelangelo are certainly not superior to the Cathedral of Chartres as works of art. All are masterpieces of religious architecture and wondrous expressions of their time. The finest art is never better or worse; it is simply different. Each of us will ultimately form a personal preference, but we should strive, at least initially, to be receptive to ways of seeing and representing that are different from our own. Vasari, as a

passionate proponent of Italian art and architecture, never really gave the Gothic style a chance. His passion for the classical and its Renaissance offshoots turned into a belligerent insensitivity to the Gothic. Although radically committed ways of seeing, such as Vasari's, may be necessary for making revolutionary changes in society and culture, they can be dangerous indeed when applied to the process of appreciation; too often, they breed intolerance and blindness to all types of art but one.

Palatial Houses in the Gothic and Renaissance Styles: An Appreciation. In the spirit of open-mindedness, it is instructive to view the palatial homes of two fifteenth-century merchants of wealth and power—one Italian, the other French. Created within a year of each other,

6.45 • House of Jacques Coeur. Bourges, France. 1443–1451. View of courtyard from southeast.

6.46 • MICHELOZZO. Palazzo Medici. Florence. 1444–1460.

the houses of Jacques Coeur in Bourges (6.45) and Cosimo di Medici in Florence (6.46) were built in the late Gothic style and in the new Renaissance style, respectively.

Jacques Coeur, a merchant and member of the guild of silversmiths, was a financier of the king and one of the wealthiest men in France. Cosimo di Medici, a man of comparable wealth, was the de facto ruler of Florence. Each man's house is a carefully calculated public expression, a political-cultural statement by its owner. Both houses are large and have spacious courtyards, but there the similarity ends. The house of Jacques Coeur is made up of a complex variety of shapes. Each section of roof, tower, turret, and entranceway is different. Diversity and asymmetry reign. In the words of Vasari, there is "no end of pinnacles and points and leaves." The height of the roof line surrounding the interior courtyard varies as well. Decorative imagery and ornamental effects abound. The exterior of the house exhibits numerous carvings alluding to the owner's name, statues crowning the heights, and illusionistic figures leaning out of simulated windows. In keeping with the traditional vertical thrust of the Gothic, gently pointed arches, spiky spires, and long, slender columns and pilasters move the eye upward. A sharply inclined roof, and sharp triangular gables and window frames further emphasize the vertical.

A "bourgeois aristocrat," a man of the middle class who communed regularly with king and his court, Coeur naturally looked to the French national style when building his home. Palaces of the nobility, such as the white turreted castle portrayed in the Duke of Berry's *Book of Hours* (4.9), would most likely have been his models. The rich merchant clearly desired to be looked on as a noble. To this end, Coeur's house seeks to embody the chivalric values of the nobility: the fanciful romance, extravagant flourish, and conspicuous display (4.8). Courtly games, lavish ceremony, and adventurous quests, including the fabled Crusades, had for centuries been central to the life of the French nobility. Chivalry rivaled faith, and wealth, as the dominant social force of the age. In the literature of the time, as in Sir Thomas Malory's fifteenth-century romance of King Arthur and the Knights of the Round Table, imaginary journeys and fantastical quests are plentiful. In this regard, the shape and decorative trappings of Coeur's house appear to bear a chivalric stamp. This is a high-spirited architecture, extroverted and fanciful, a fitting expression of Coeur's climb to the pinnacle of French society.

In utter contrast, the Palazzo Medici greets us with a heavy handshake and a sober look. No gallant kissing of the hand or graceful bows here. If this building could be trans-

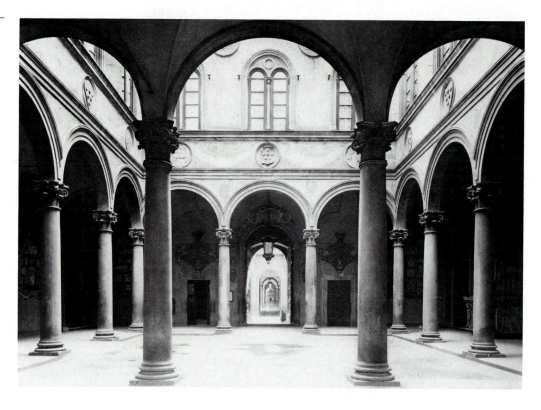

formed into a person, it would not be a chiv-
alrous knight but a pragmatic man of affairs,
an austere individual of weight and gravity.
Everything about the palazzo is clear, simple,
and symmetrical; the classical ideal in the form
of a fortress. It is an architecture of order and
stability, the qualities that Cosimo di Medici,
Florence's ruler from 1434–1464, wanted the
people of the city to associate with him. Co-
simo, "Father of His Country," made the pa-
lazzo his public face: rational, restrained, and
strong. Though, like Coeur, Cosimo was a
bourgeois noble, his building's social front is
purposely modest, "of the people." In Palazzo
Medici, Cosimo's own enormous wealth, ac-
crued through an international banking em-
pire, and his privileged life-style are kept under
wraps. Only in the inner courtyard (6.47) does
the building's restrained formality soften a bit
as a symmetical colonnade of arches evokes a
flowing but stately rhythm. The resemblance
of this courtyard colonnade to Brunelleschi's
Loggia dello Spedale degli Innocenti (6.16) is no
mere coincidence. Michelozzo di Bartolom-
meo (1396–1472), the architect of the Pa-
lazzo Medici, was Brunelleschi's student.

Gothic Revival Styles. With the rebirth in fif-
teenth-century Italy of a classical style of ar-
chitecture, the Gothic style went into a period
of relative dormancy in Europe. But it never
completely left the architectural stage and a
partial and then a full-fledged **Gothic revival**
was never far off. In church architecture, both
Catholic and Protestant, one of the central
ideals of the Gothic, verticality, persisted as a
fixture. In the manner of the soaring cathedrals
of the medieval Age of Faith, Christian
churches for eight hundred years have aspired
heavenward, whether through pointed arches,
high windows, the sharp angles of their roofs,
or tall bell towers or spires. Furthermore, the
magical light that shone through medieval
stained glass has continued to animate Catho-
lic churches and many Protestant ones right
up to the present.

Enduring in its appeal, the Gothic even
joined in oddly harmonious matrimony with
the classical in a substantial number of
churches in England and America. A proto-
type is the Church of Saint Martin in the Fields
in London, completed in 1726; it has a Greek
temple below and a Gothic bell tower and

spire above (6.48). Eight centuries after the rising of the first Gothic cathedrals, the Gothic style remains so powerful that a contemporary Christian architecture is almost inconceivable without it.

A full-scale revival of interest in the Middle Ages and Gothic art and architecture arose in England in the first half of the nineteenth century, right in the middle of the Industrial Revolution. A host of factors fueled the English medieval revival. These included a desire for renewed spirituality in a period of unbridled materialism and a longing for a Christian moral code in an age of unscrupulous speculation and exploitation. The designer A.W.N. Pugin (1812–1852) looked to the Gothic style in particular for an uplifting national style of product design and architecture. In addition to his design work on England's Houses of Parliament (6.49), Pugin created a **neo-Gothic** furniture (5.9), sensitive in its historical details, that was highly applauded at the 1851 Crystal Palace Exhibition. Mid-century painters such as Dante Gabriel Rossetti and Edward Burne-Jones, along with the critic

6.48 • JAMES GIBBS. Saint Martin-in-the-Fields. London. 1721–1726.

6.49 • SIR CHARLES BARRY AND A. W. N. PUGIN. The Houses of Parliament. London. Begun 1836.

6.52 • ADLER AND SULLIVAN. Guaranty Building. Buffalo, N.Y. 1895.

palazzo is made even more assertively vertical. Far taller than it is wide, with vertically unbroken lines leading the eye rapidly upward from the third story to the roof, the Guaranty would serve as a prototype for the soaring "cathedrals of commerce" of the twentieth century. The younger Sullivan had once referred admiringly to Richardson's 1885 Marshall Field Warehouse as a heroic "man on two legs." In the Guaranty Building, Sullivan himself had created a vertical body stretching and swelling with muscular force. For architectural historian Vincent Scully, Sullivan's early skyscraper is a "new kind of giant [standing] . . . high on his legs: mass man with steel muscles, tensile and springy." For Scully, the volume of the Guaranty Building, as a whole, "has a classic integrity, but it is stretched into the scale of a new urbanism beyond classical boundaries."

This new superhuman scale, "beyond classical boundaries," was one of Gothic hyperverticality. It was brought about in part by skyrocketing real estate prices and made possible by the invention of the power elevator. Office and commercial buildings now leapt skyward, not for the glory of God, but for corporate enterprise. Although the Gothic style would be employed in a number of prominent skyscrapers (6.53) of the early twentieth century, the new **international style** of modernism, rooted in the machine aesthetic of the Bauhaus (5.31–5.34, 6.3), was rapidly becoming the dominant style of the day. One of the finest high-rise achievements of the international style was New York City's Seagram Building (6.54) built in 1956–1958 by onetime Bauhaus director Ludwig Mies van der Rohe (1886–1969) and his former student, Philip Johnson (born 1906), an internationally influential architect in his own right. A monument to form and function, and an exemplar of Mies van der Rohe's motto, "less is more," the Seagram Building stands heroically, according to Scully's anthropomorphic imagery, "as a body on its legs much like Sullivan's Guaranty Building," albeit with thinner metal sections supporting its seemingly weightless skin of glass. But now, the being who stands so straight and tall is increasingly technological: "simplified, pure, clean, generalized, reasonable, abstract . . . the ideal flesh-

may have served as a model, we see that the proportions and the thrust of the warehouse push the classical structure upward as well as outward. Note how the tall arched windows gradually diminish in size as they move upward, setting up a vertical imperative we associate with the Gothic and the medieval styles that preceded it.

In fact, the early and later skyscrapers that evolved from the work of such innovative architects as Henry Hobson Richardson (1838–1886) and Louis Sullivan (1856–1924) drew on both the classical and Gothic styles, while simultaneously finding inspiration in the modern functionalist ideal associated with the machine. In the Guaranty Building (6.52) in Buffalo, New York, created by the firm of Adler and Sullivan in 1894–1895, the Renaissance

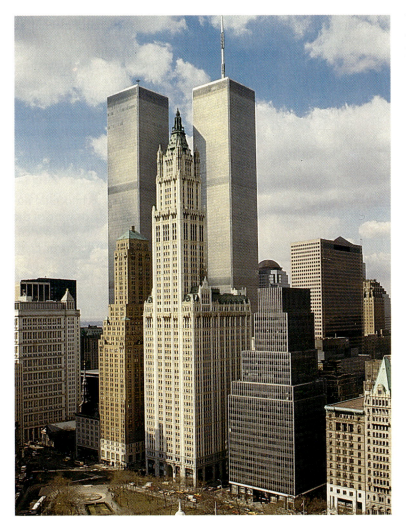

6.53 • CASS GILBERT. Woolworth Building. New York City. 1911–1913.

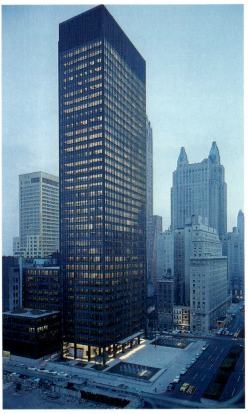

6.54 • LUDWIG MIES VAN DER ROHE AND PHILIP JOHNSON. Seagram Building. New York City. 1958.

less skeleton of ringing steel." This thirty-eight-story structure is sheathed from top to bottom in gray-tinted glass and architectural bronze, making it one of the most richly textured skyscrapers ever built. Vertical I-beams are welded to the exterior, where they separate the windows and give a lively vertical pattern, moderated by horizontals, to the outer form. Carried out in the most luxurious of materials, the tall tower is a study in precision and restraint, clarity and dignity, qualities that link Mies's work to the original classical ideal.

Setting off the handsome structure is its own plaza, ninety feet long, paved with pink granite, and set with twin pools and weeping beech trees. The pool and the trees, human in their scale, are complemented by the harmonious placement of plaza and building at right

Inside of Mies's buildings, the same basic principles hold true. The interior of Crown Hall is a completely open, unobstructed space: absolute simplicity. Some charge that Mies was interested only in the exterior form of his buildings and not their specific functions, thus leaving the interiors of his structures spatially empty. But he himself argued, like his Bauhaus colleagues, that open space was democratic space, the arena in which the users of the building might decide individually and communally how to arrange their working or domestic lives. "Closed" space was necessarily more directive and authoritarian in its influence on the users. The trend in interior design since the 1970s toward evermore mobile "open plans" for the workplace—employing movable dividers, light portable furniture, flexible configurations—seems to bear out Mies's original conception. If such an open plan is not the interior design of democracy, then it is certainly the spatial conception best attuned to the future-oriented dynamism of advanced capitalist society.

In his interior and exterior design, Mies sought one ideal image of timeless consistency and refinement. But the enterprising builders of commercial strips and shopping centers who took up Mies's principles and forms had different goals in mind. In their designs, they opted for variety and fashion. Their muse was not Plato but profit, and they milked Mies's solutions for all they were worth. The retail spirit thrives not on permanence or idealism but on novelty, trendiness, and the advertising potential of the package. A society that changes cars and appliances every few years, whether they are in working condition or not, is not likely to be enamored of the eternal

building. So, an unholy union took place: Miesian reductivism married entrepreneurial expansionism. On Mies's geometrical steel frame skeletons, the building industry, especially in the United States, threw up countless shopping centers, industrial complexes, and commercial facilities—all open containers waiting to be filled as the users saw fit. Some good buildings have resulted, but all too many, especially the commercial buildings that cram our suburban shopping centers and roadside strips (6.57), are poorly designed and cheaply made. The latter structures, strangled by advertisements, are the worst of the lot: all function with little redeeming form. Critics refer to them as "junk architecture," put up as quickly and inexpensively as possible and not built to last very long. They hardly deserve the name architecture, being stamped out like fast food restaurants and chain stores, built for a few decades worth of profit, no more. Typical of the ethic of disposability, such structures will be torn down as soon as they are used up. In effect, they are not architecture but "anti-architecture," buildings that were never meant to be of any lasting value.

Le Corbusier. If we were to compare the great architectural form givers to Greek mythological figures, Mies van der Rohe might be likened to Apollo, "the shining one," because of Mies's orientation to lightness and clarity and his drive for order and perfection. Le Corbusier (1887–1965), while not without Apollonian qualities, might better be likened to Prometheus, powerful, defiant, lonely and creative, battling the gods to bring his gift of fire to the earth. In Le Corbusier's buildings two attributes, sometimes separate, often

6.57 • PETER BLAKE. *John's Bargain Store, Long Island,* New York. From *God's Own Junkyard.* 1964.

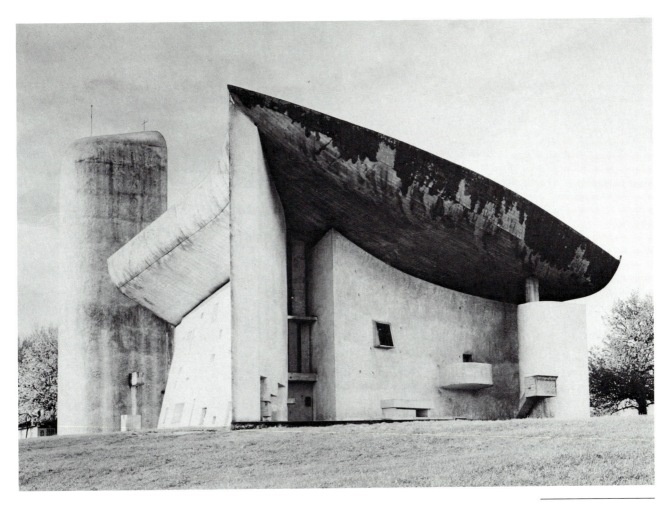

6.58 • LE CORBUSIER.
Ronchamp, the
pilgrimage church of
Notre-Dame-du-Haut.
Near Belfort, France.
1950–1955.

combined, stand out: their monumentality and their sculptural quality. Some of his last and best buildings, the Chapel at Ronchamps in France (1950–1955) and the Carpenter Center at Harvard University (1961–1964), are truly sculptures in the round, molded and formed in the pliable medium of poured concrete. In his description of the Chapel at Ronchamps (6.58), architectural historian Spiro Kostof seems to be writing of a sculpture rather than a building. For Kostof, much about Ronchamps recalls organic forms from nature: "caves and creatures and violent contrasts." Heroic tensions pulse in the body of this modern pilgrimage church. The image of a ship joins with that of the sea caves and ocean creatures. The dark slab roof, Kostof observes, simultaneously bears "down on the stippled whitewashed walls of rough masonry" yet lifts "prowlike at the southeast corner of the church where two curving walls meet in a taut, razor-sharp" intersection. "The side chapels," he continues, ". . . send hooded funnels upward to catch the light, and the random pockmark fenestration of the oblique south wall empha-

sizes thickness, plasticity. The building both engulfs and resonates, draws us into its hollows, and makes us go around it as we would around powerfully molded sculpture."

Both Ronchamps and Harvard's Carpenter Center (6.59) have a solidity and weight, as well as an organic plasticity and asymmetry, that differentiate them from the pristine boxes of Mies. Whereas Mies's buildings reveal themselves with an orderly directness, Le Corbusier's late buildings are mysterious and filled with surprise. A building like the Carpenter Center requires a walk around the entirety, a journey up and down ramps, an ongoing adventure to new vistas, whether one is looking from the outside in or from the inside out. It is a most fitting image for a building that is a visual studies center, concerned with creative expression and original solutions to contemporary design problems. But it is also consciously heroic, some would say vainglorious, in its modernist defiance of the past; a quality equally evident in the work of Mies and Wright. Except for its height, the Carpenter Center makes little attempt to relate to its sur-

6.59 • LE CORBUSIER. Carpenter Center for the Visual Arts, Harvard University. Cambridge, Mass. 1961–1964.

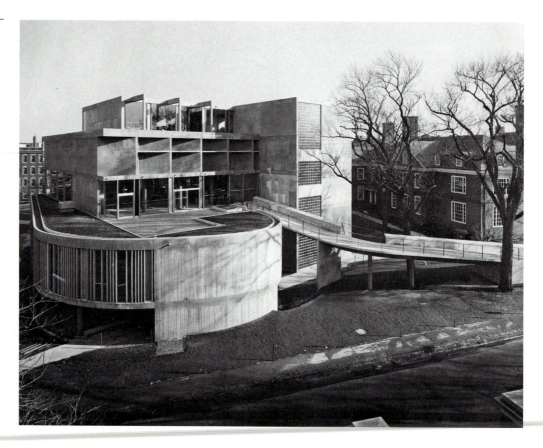

roundings, university buildings designed in styles of the eighteenth and nineteenth centuries. It stands powerful and alone, an apt expression of the modern condition: men and women, and the architecture and art that expresses them, as individualistic atoms in a free-wheeling, ever-changing world. Like the building, we are free and independent but estranged in our separateness; yet, at the same time, we strive with a heroic will to make our mark in the world.

Le Corbusier's buildings rise up and seem to stand on the earth, making their existential mark. Many of his most monumental structures stand on *pilotis*, free-standing columns, posts, or piles that support the building and raise it above the ground. Rooted with certainty in the earth but rising above it, the building becomes, in Le Corbusier's term, a "machine for living." But these are not elegant steel-and-glass machines in the style of Mies. Le Corbusier's "machine-buildings" have an earthy ruggedness, beginning with their very

substance. The surfaces of the poured concrete sections that compose many of them are rough-hewn and irregular, picking up the textural imprint of the wooden molds in which they were formed. Even the great apartment block called the Unité d'Habitation (6.60, 6.61), far more regular and cubic in shape than his later works, has this sculptural physicality. Notice the *pilotis*, or posts, on which the building straddles the earth and the twisting form of the outside staircase. As one writer puts it, the Unité d'Habitation embodies Le Corbusier's achievement of an "active monumentality" and "an articulated, unified sculptural body." Looking out toward the mountains and the sea, and rising from its massive *pilotis* above the earth, this apartment building asserts itself as an elemental presence in its own right, a machine-made equal of nature itself, "a new mid-twentieth-century image of embattled humanity in the world."

Living at the Unité, however, was not supposed to be a battle but a stimulating com-

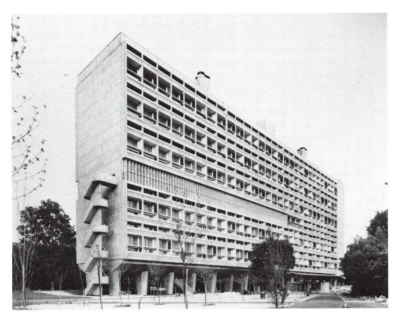

6.60 • LE CORBUSIER.
Unité d'Habitation.
Marseilles, France.
1946–1952.

6.61 • LE CORBUSIER.
Unité d'Habitation.
Marseilles, France. Detail
of exterior stairwell and
pilotis.

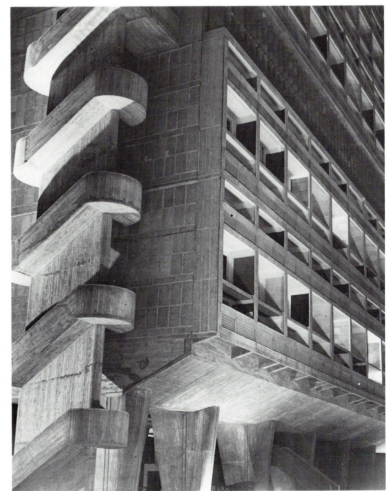

munal experience made possible by rational planning. Aiming for social interaction and self-sufficiency, Le Corbusier incorporated shopping, recreation, and service facilities within the huge nine-story structure (185 feet high, 420 feet long, 60 feet wide). The top floor contains a kindergarten and nursery. On the roof are playful sculptural forms, a children's swimming pool, playground, snack bar, gymnasium, and track. There were "interior streets," corridors that run the length of the building on every third floor and a broad shopping arcade halfway up the building. Designed to house 1600 people, the Unité contained 337 independent living units of a wide variety of sizes and shapes, from single rooms to large family apartments opening onto both the front and rear of the slab. The idea was to ensure a good social mix; Le Corbusier thought of the Unité as "unity" as well as "units," a complete neighborhood community. Multiplied in kind, structures such as the Unité might ultimately make up a "radiant city," a metropolis of spatially ordered mega-structures "bathed in light and air." His own "Voison Plan" of 1925 (6.62) for the urban renewal of Paris gives one a sense of this vision. The plan called for the demolition of a very historic section of Paris that he saw as "particularly unhealthy and antiquated" and its replacement by a rational, modern city of high

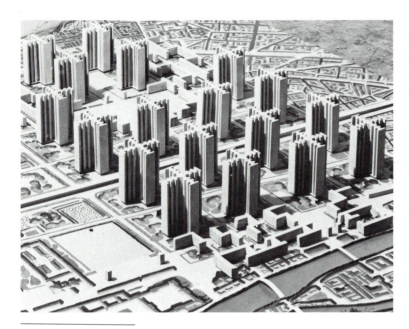

6.62 • LE CORBUSIER.
Voisin plan for rebuilding
Paris. 1925. Model.
Photograph courtesy The
Museum of Modern Art,
New York.

rise Unité-type megastructures with super-highways running between them. In a city as historically minded as Paris, the plan naturally provoked fierce debate and was never executed.

Le Corbusier hoped the French government, which financed the Unité d'Habitation as an experimental project, would adopt it as a prototype to alleviate the national housing shortage after World War II. He spoke of such residential construction as his highest goal, of having been inspired by the "single preoccupation" of introducing into the home "the sense of the sacred" and making the home "the temple of the family."

The Unité d'Habitation was intended to be his temple of urban living. Unfortunately for Le Corbusier, the French government decided against using it as its prototype. Considered too difficult and expensive to become a standard housing formula, it nonetheless became, as a "high-rise slab block," a principal worldwide alternative to the skyscraper tower for both apartment and office buildings (6.63) from South America to Japan. In Britain and Switzerland, the high-rise block became a model, as the architect had hoped, for social housing in the welfare state.

In the United States, in urban renewal projects, it was used similarly. Its success in the sphere of public housing, however, was mixed. One highly instructive disaster, the Pruitt-Igoe housing project in Saint Louis, employed Le Corbusier's basic scheme. A mini-city complex consisting of high rise Unité-type structures, Pruitt-Igoe was a housing project built by the city of Saint Louis according to the designs of Minuro Yamasaki (born 1912), an esteemed international style architect best known for his two World Trade Center towers at the base of Manhattan Island. The Pruitt-Igoe housing project was entirely inhabited by low-income inner city residents. The buildings themselves received high marks for their design and won a variety of architectural awards. But living in these high-rise structures proved terrifying. The buildings became breeding grounds for drug abuse and crime. Residents were afraid to use the common stairwells or elevators or "interior street" corridors that led to their apartments. Forced

6.63 • KENZO TANGE.
City Hall, Okayama
Prefecture, Kurashiki,
Japan. 1958–1960.

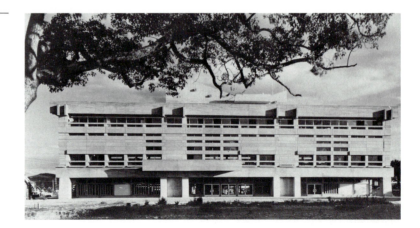

6.64 • Dynamiting Pruitt-Igoe apartment complex, Saint Louis, Mo. 1972.

to use these public passages because there were no private outdoor entrances to their apartments, the residents felt endangered by criminal elements that were lurking inside. The building became a trap rather than a shelter. Communal morale declined, and the building itself deteriorated badly. Policing the huge structures proved to be virtually impossible. What had been intended as a progressive solution to the housing problem turned into a nightmare. Completed in 1955, the low-income project was demolished in part by the city of Saint Louis in 1972 (6.64). The megastructures had simply become too crime-ridden, garbage-strewn, and run-down to be workable as public rental housing.

Although Pruitt-Igoe lacked good management and the fundamental social mix that Le Corbusier so strongly recommended for urban living, factors which may have saved the community and the buildings, this tragedy and others like it taught idealistic architects a number of hard lessons. To begin, problems of housing are very complex, involving such factors as class, cultural background, employment and educational opportunities, social services, crime, and so forth. Such problems, architects came to realize, are not amenable to architectural solutions alone, especially ones that are not sufficiently sensitive to the complicated living-working patterns of the future occu-

pants. From experiences such as Pruitt-Igoe, architects and city planners learned greater humility and realism. They learned that they could not create visionary designs in the isolation of their offices but instead had to work more closely with a difficult mix of government officials, social scientists, social welfare professionals, as well as the future occupants, the last being the most important group to consult and often the most easily forgotten. As the ancient Greek philosopher Aristotle might have put it, the architects and the planners needed to come down from the Acropolis heights and work in the gritty flatlands below.

Living architecture, in contrast to museum pieces that are no longer used but only admired, has to be successful both in function and form. Unfortunately, the buildings of some of the century's greatest form givers were, at times, less than masterly from a practical and social standpoint. Some argue that even Le Corbusier's Unité apartment building in Marseilles receives far better marks for form than function. Although Le Corbusier designed the Unité in a heartfelt attempt to improve people's lives, his harsher critics have judged the revolutionary building to be insensitive to the actual desires of the occupants. The critic Robert Hughes describes the result with acerbic wit:

There is little privacy in this nobly articulated beehive of raw concrete; the children's rooms are hardly more than cupboards (Corbusier had no children of his own and apparently disliked them); and the ideal of communal self-sufficiency left its fossil in the form of a "shopping mall" on the fifth floor so that, in theory, nobody would need to leave the building to go to market. As everyone in France except Le Corbusier knew, the French like to shop in their street markets. So, the "shopping mall" remained deserted; later, it was turned into a spartan and equally empty hotel, the Hotel Le Corbusier, where the sleepless guest may listen to the spectral whining of the mistral [wind] *inside* the building. Finally, none of the Marseillais who lived there could stand Corbusier's plain, morally elevating interiors, so they soon restored the *machine à habiter* [machine for living] to the true style of suburban France. The flats of the *Unité* are crammed with plastic chandeliers, imitation Louis XVI *bergères*, and Monoprix ormolu—just the furniture Corbusier struggled against all his life. The man who wanted to assassinate Paris [demolishing whole sections and replacing them with a "Radiant City" of mega-Unités] could not, in the end, ensure that a single concierge would buy the right rug.[5]

Le Corbusier may have been the most inventive of architectural form givers, but he was probably too utopian in his hopes of transforming people's tastes and life-styles through architecture. He was not, however, alone in his passionate conviction that the architect could initiate progressive change in society. Many of his generation, men and women of humanist, democratic, or socialist ideals, believed that architecture could dramatically improve the world. At times, such a heroic attitude caused pioneering architects to lose sight of the actual users of the buildings, the "little people" whose preferred life-styles were often quite different from those of the master-builders. Too often an "I-know-what's-best" elitism crept into the designs—as at the Unité, or Pruitt-Igoe, whose occupants were round balls refusing to fit neatly into the square boxes prepared for them.

Learning from the successes and failures of their predecessors, architects who design public and private housing projects have become more modest and realistic in their goals. New York City's moderate-income Riverbend Houses (6.65), a creative adaptation of Le Corbusier's Unité, is an example of such architecture. Thoughtfully based on it occupants' specific life-styles and preferences, it is housing on a far smaller, more manageable, user-sensitive scale than Pruitt-Igoe or the Unité. Each duplex apartment, for example, has its own private outdoor entrance and front porch, improving safety and giving the tenants a valued sense of personal ownership. As one young architect put it, "If you are going to design effective housing for senior citizens, or people of low or moderate income, you've got to think small and conservative. Most importantly, you've got to plan with the needs of the actual users of the buildings in mind."

6.65 • DAVIS, BRODY & ASSOCIATES. Riverbend Houses, New York City. 1968. General view and section perspective drawing of interior.

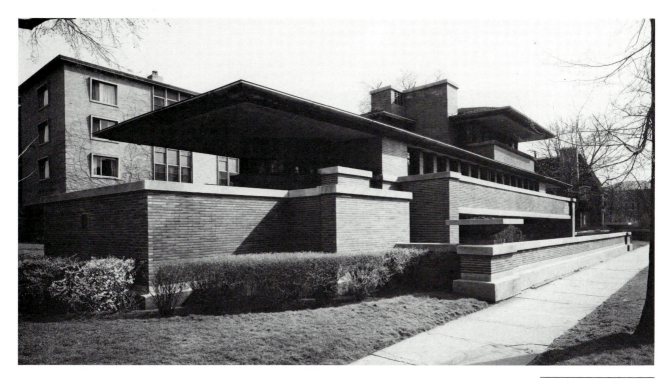

6.66 • FRANK LLOYD WRIGHT. Robie House. Chicago. 1908–1909.

Though projects like Riverbend do not revolutionize society, they do improve the lives of individual persons, families, and communities. In a society as complex as our own, that is a large contribution indeed.

Frank Lloyd Wright. One visionary architect-planner of the twentieth century who felt the pulse of the American masses was Frank Lloyd Wright. His low, sprawling "prairie houses" (for instance, the famous Robie House [6.66]), built in the Midwest from the onset of the twentieth century, became a primary model for the now ubiquitous suburban ranch houses. Designed for affluent single families, the prairie houses are detached homes that spread horizontally across their own rectangular plots of land. Here was the ideal model for American suburban living. In contrast with Le Corbusier's preference for urban living and his emphasis on centralization and communal interaction, Wright's houses and community plans emphasized decidedly anti-urban qualities: spaciousness, decentralization, and personal privacy. Ideally, all families would own their own houses—of varying sizes according to income level—separated from neighbors' houses by the borders of shrubs or fences that defined their own yards.

Much of Wright's vision and work was directly in harmony with the American dream: from his prairie houses in the first decade of the century to his later plans for "American System Ready-Cut" residences (6.67), modestly priced, prefabricated cottages, duplexes, and quadruple (four-unit) housing. All of these housing types would become constituent parts of his prophetically suburban "Broadacre City" plan (6.68), a prototype of today's planned communities, such as Columbia, Maryland, and Reston, Virginia (6.69). It was the American dream come true, Jeffersonian style, in which all citizens owned their own houses (or apartments) and private land for their lifetimes. Like Jefferson's noble and self-reliant farmers, the citizens of Broadacre City (and Columbia and Reston) could cultivate their plots, gardening, mowing, and caring for trees and flowers. They could thus stay in touch with nature, an experience both Jefferson and Wright, who was born in rural Wisconsin, considered spiritually elevating. The citizens of Wright's ideal society would live in a spacious countrified city of broad acreage away from the crowds, exorbitant rents, and centralized corruption he associated with the "big city." Commuting to the city, the bane of most contemporary suburbanites, would be reduced to a minimum because Broadacre City would be largely self-sufficient economically, with enough industrial, agricultural, and service work for its citizens.

6.67 • FRANK LLOYD
WRIGHT. American
System Ready-Cut
Houses. 1913–1915.
Drawings.

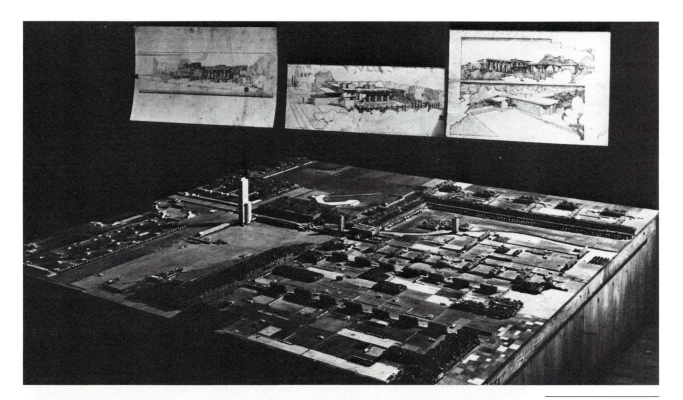

6.68 • FRANK LLOYD WRIGHT. Broadacre City Model. 1933–1940.

6.69 • CONKLIN AND WITTLESEY. Reston, Va. Aerial view. Late 1960s.

6.70 • FRANK LLOYD WRIGHT. Thomas House. Oak Park, Ill. 1901.

It was a North American dream that combined planning with maximum freedom and independence to lead one's life according to personal preferences. It was also a dream supported by democratic social values: complete equality of opportunity and lifetime ownership of one's own home or apartment. This was coupled with fine, reasonably priced design of all private and public facilities produced for the good of the entire community. Such a Wrightian living condition stands in complete contrast to the unregulated sprawl of most late twentieth-century suburban areas, where one-sided commercial values, denounced by the architect as "insensate business greed," prevail over the "human" values Wright believed essential to true democracy. In contrast with the increasingly dense, commercially motivated sprawl of the present, Wright's Broadacre City plan is the logical extension of the Jeffersonian dream for wholesome living in the New World.

Returning to the level of home design, let us look once more at Wright's prototypic prairie house. In these sprawling residences for the wealthy, we observe the shape of suburban homes to come. Take, for example, the Thomas House (6.70), built in 1901 in what were then the outskirts of Chicago. Here we find the basic form of many post–World War II suburban homes: long, rectilinear, horizontally sprawling, and low to the ground. The design of these prairie houses is characterized by a simple, unadorned geometry. It is the streamlined machine aesthetic manifesting itself in the American single-family house. This aesthetic is in sharp contrast to the eclectic variety and complexity of Victorian exteriors of the period, which Wright contemptuously described as "Gables, dormers, minarets, bays, porches, oodles of jiggered woodwork ruthlessly painted, poking in or peeking out of piles of fancified stonework and playing idiotic tricks with each other. . . ." In comparison to

6.71 • FRANK LLOYD WRIGHT. D. D. Martin House. Buffalo, N.Y. 1904. Living room.

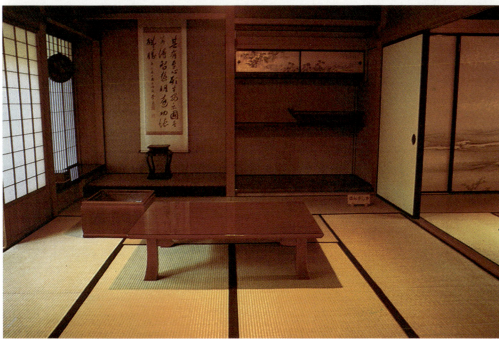

6.72 • Yoshijima House. Takayama, Japan. *ca* 1900. Reception room.

such picturesque Victoriana, Wright's prairie houses must have truly looked like "machines for living," albeit ones that sought an integration between themselves and nature. We see this feeling for nature in the use of natural materials (wood, stone, concrete, glass), in built-in window boxes and plant-filled urns, in the emphasis on grassy plots of land with trees and shrubs around the houses.

The interior (6.71) of such houses exhibited a spacious horizontality, with an open, continuous plan allowing the living, dining, and other common rooms on the first floor to flow into each other. This concept was inspired, in part, by the spatial fluidity of traditional Japanese homes (6.72). Wright's design of flexible, open interior spaces, in turn, inspired the architectural and interior design of

6.73 • FRANK LLOYD
WRIGHT. "Falling Water"
(Kaufmann House).
Near Connellsville, Pa.
1936–1938.

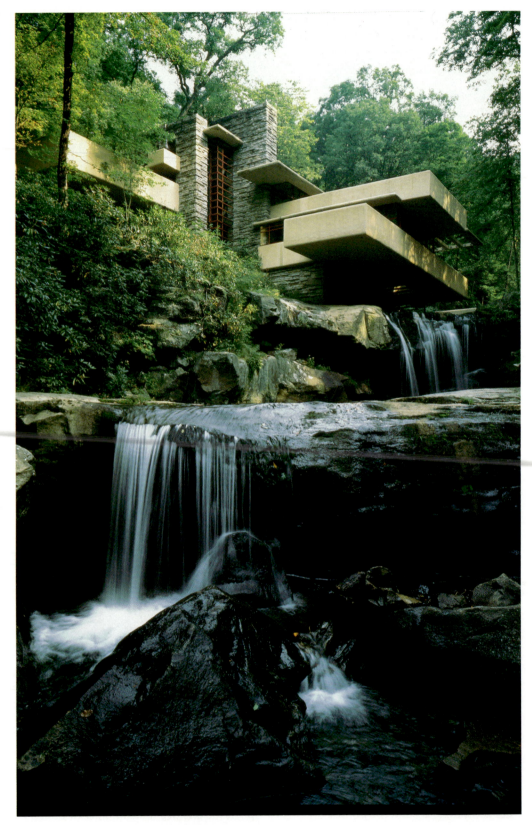

Mies, Gropius (5.34), and their followers (5.35). As a basic component of the modernist international style, such open space design would subsequently influence the living and working patterns of millions of people around the world.

The interior openness of the prairie houses was not as evident on the outside of the homes, where a sense of enclosure and protectiveness prevailed. Contributing to this sense of enclosure are the overhanging eaves of the roof, the narrow window bands, and the elimination of the publicly oriented front porch. This was in keeping with the ideals of familial privacy so strongly valued by Wright and his affluent suburban clients. Frederick C. Robie said of the well-known house Wright designed for him in 1906 that it enabled him to "look out and down the street to my neighbors without having them invade my privacy." "Shelter," Wright later affirmed, was "the essential look" he sought to promote in these dwellings.

The prairie houses had a substantial influence on the shape of the American suburban house as well as the modernist architectural design of the Bauhaus and Dutch De Stijl (The Style) pioneers of the 1910s and 1920s. The house for which Wright is best known, however, has become an icon that stands alone. Popularly known as "Falling Water" (6.73) for the rural Pennsylvania waterfall over which it is built, it is perhaps Wright's crowning artistic achievement. Yet it is a house that is unique and unrepeatable; therefore, its influence on later architecture was not nearly so overt as that of the prairie houses or prefabricated "Ready-Cut" residences. Built as the weekend home of the wealthy Kaufmann family, who lived and worked in Pittsburgh, "the House on the Falls" would be a place that perfectly balanced the family's desires and Wright's ideals. Leaving the hustle of the big city behind, the Kaufmanns desired a country home that maximized the pleasures of the outdoors. On their rural Pennsylvania property, they had loved to spend time by the falls, enjoying the rush of the water, the rocks, sunlight, and plant life. Wright took all this into account in his design. The result was a great work of art and the clearest expression of Wright's ideal of "organic architecture," in

which the building embodies the human desires and values of its users and relates harmoniously to its natural surroundings. As the architect put it, "the term 'organic' in architecture applies to a concept of intrinsic living and of building intrinsic and natural," a "great altogether" in which "features and parts, congenial in form and substance, are applied to purpose" in a thoroughly integrated way.

Whereas the machines for living of Le Corbusier and Mies maintain a distinct separateness from their immediate natural surroundings, even rising on *pilotis* above the ground in the case of the Unité, "Falling Water" merges thoroughly with its natural surroundings. Actually placed in the rushing stream, the cantilevered concrete slabs of "Falling Water" echo the rock shelves beneath. The stone of its walls, floors, and chimney was quarried from the surrounding area. Within, the boulder on which the house is built functions as the base of the central fireplace. Like an anchor, the boulder connects the interior of the house to bedrock beneath. The house is situated to allow a maximum of sunlight to enter all the rooms. At the same time, the rectilinear bands of upstairs windows are located so as to frame surrounding nature as a picture frame might. As the client's son, Edgar Kaufmann, Jr., observed: "'Falling Water' had a special function for my parents: to give their lives a balance; to give these urbanites an immediate relation with nature . . . a relationship in which nature was given clarity, rhythm . . . and human scale." "The House on the Falls" promoted an ecological relationship in which nature and humanity were in balance; nature was humanized and human beings naturalized.

POST-MODERNISM: TOWARD A NEW PHILOSOPHY OF ARCHITECTURE

In retrospect, it appears that "Falling Water" contained a seed of the multifaceted architecture that since the 1970s has been referred to as **post-modern.** One major value associated with post-modernism is alternately referred to as the "ecological" or "contextual"; the emphasis is on buildings that relate sensitively to

their natural or built surroundings. "Falling Water" certainly made the case for architecture that was well integrated with its natural surroundings. Post-modernism builds on this legacy, extending it, as modernism did not, to the built environment. Post-modernists consciously seek to relate a building to its neighbors; this in contrast to most modernist buildings, such as those of Mies, Corbusier, and Wright himself, which reflect little or no concession to the built environment around them.

An analogy for this difference in approach is the difference in behavior of two groups of Western persons arriving in an Asian or African country. The "post-modern" group begins to learn the language and customs of the host culture, retaining their identity but respecting and seeking dialogue with the larger culture. By contrast, the "modern" group takes the attitude that their Euro-American way is best, that there is little to be gained from interchange with the foreigners around them, and that they will thus speak only their language, dress and act as they like, even if they thus defy the country's centuries' old customs. From the respectful perspective of cultural pluralism, the second approach represents a prideful ethnocentrism and isolating individualism that has led to disharmony between cultures as well as buildings.

Contextually sensitive post-modern architects, much as Western visitors who attune themselves to the language and who respect the ways of their host culture, seek to design buildings that are in an ecological harmony with their environs, accepting that the buildings are an interdependent part of a larger whole and not islands unto themselves. For this reason, ecologically oriented post-modern structures, although clearly creations of the machine age, also represent an attempt to relate to the neighboring buildings and to the larger neighborhood. This tie might be achieved through their scale, materials, shapes, symbolism, or historical styling. They do not stand out individualistically, heroic "fragments" out of synch with their surroundings. Cooperation and harmony, not competition and defiance, are their way. Their humble goals are communion and "completion," not revolutionary upheaval. Such an ecological attitude is summed up by the post-modern theorist and designer, Leon Krier (born 1946). "Cities and landscapes," he observes, "are the tangible realisation of our material and spiritual worth, for good or for ill." Krier puts it this way:

6.74 • RAWLINGS AND WILSON. Baptist Student Center. Harrisonburg, Va. 1985.

Each image we draw, each structure we build is an integral statement on how we want or don't want the entire world to be. We either work on its construction or on its destruction. We complete or we fragment it. The first rule of ecology is that we cannot do one thing alone.[6]

Examples of ecological and nonecological attitudes toward architecture and environmental design are everywhere, but, for our purposes, a single city block in a small city in western Virginia will do. Built in 1985, Harrisonburg's Baptist Student Center (6.74) is an exemplar of the post-modern orientation at its ecological best, seeking as it does a harmonious relationship with the older buildings adjacent to it. Its clean lines and clear-cut, unadorned geometry, combined with its use of advanced building techniques and materials, communicate its origins in the late twentieth century, yet its overall scale, shape, color, and composition show a respect for its neighbors and their turn-of-the-century appearance. "We wanted to be good neighbors," confirms the center's director, "and we wanted the building to communicate that fact."

In utter contrast, a three-story rental apartment building at the other end of the block shows the most disturbing disregard for its surroundings. A prefabricated structure put up virtually overnight, the Duke Garden Apartments (6.75) was erected at almost the same time but with far less concern for aesthetics or ecological ethics. In no way an example of good architecture in the modern style, it nonetheless points out several of the shortcomings of the modernist attitude. First, the emphasis in the Duke Garden Apartments is on functionality, that core principle of modernist architecture, yet here the modernist dictum of "form follows function" is taken to its negative extreme. Functionally, the apartments provide effective short-term rental space for university students as well as substantial profits for its owner. One could therefore claim that the building successfully fulfills its primary functions. (A close look, however, reveals that the structure is shoddily constructed, and its life as a rental property is probably limited to a few decades.)

By paying excessive attention to short-term profit, the builders of the Duke Garden Apartment House have disregarded both art and ecology. From an artistic standpoint, it is "nonarchitecture," a building with few redeeming aesthetic qualities. From an ecological perspective, it is an individualistic fragment that sticks out like a sore thumb in relation to the carefully crafted beauty of its longstanding

6.75 • Duke Garden Apartments. Harrisonburg, Va. 1985.

6.76 • LeRoy Troyer
and Associates.
Campus Center, Eastern
Mennonite College.
Harrisonburg, Va. 1985.

neighbors. The apartment house relates to its neighbors only in that it is of similar height and width, which were mandated by zoning requirements. This is a short-sighted, crassly commercial approach to architecture and community design that pushes to a negative extreme the modernist attitudes of functionality, individuality, and defiance of the past.

But there is more to post-modernism than its ecological orientation. What observers often note first about such architecture is its eclectic historical character. In post-modern buildings, the forms and symbolism of past styles of architectural and community design are welcome (Appreciation 11). We see columns and pediments, proportions and compositions from earlier decades or centuries, all redolent with memory and meaning communicated to us in a familiar language. Looking toward a superior future, modernists cast off the past and its language and values. Post-modernists accept the past and the imperfect present and agree to work with them. The architect Robert A. M. Stern (born 1939) describes the difference as follows:

> Modernism in architecture was premised on a dialectic between things as they are and things as they ought to be; post-modernism seeks a resolution between—or at least a recognition of—things as they were and as they are. Mod-

ernism imagined architecture to be the product of purely rational and scientific process; post-modernism sees it as a resolution of social and technological processes with cultural concerns.

Post-modernism seeks to regain the public role that modernism denied architecture. The post-modern struggle is the struggle for cultural coherence, a coherence that is not falsely monolithic, as was attempted in the International Style in architecture or National Socialism [nazism] in the politics of the 1920s and 1930s, but one whose coherence is based on the heterogeneous substance and nature of modern society: post-modernism takes as its basis things as they are, *and* things as they were. Architecture is no longer an image of the world as architects wish it to be or as it will be, but as it is.[7]

Another building in the small city of Harrisonburg, Virginia, might be noted as an example of the post-modern valuation of the present and past, its respect for cultural heterogeneity, and its related ecological/contextual concerns. Together with the Baptist Student Center (6.74) the award-winning Campus Center of Eastern Mennonite College (6.76) is the finest example of post-modern architecture in this city of 30,000. The campus center fulfills all of Stern's and Krier's criteria. It relates well to its architectural context, the older styles of the adjacent red brick chapel and campus buildings. It achieves a successful resolution, as Stern emphasized, between things as

they were and as they are. Its shapes or materials evoke memories and meanings from the past: of an earlier administration building destroyed by fire, of the nearby chapel, and of Mennonite country churches in general. At the same time, the campus center expresses the technological capabilities and geometric forms of the late twentieth century. As a harmonious blending of the traditional and the contemporary, the subjective vision of the architect with the collective vision of the community, the Eastern Mennonite College Campus Center represents a satisfying post-modernist synthesis between progress and permanence, and between the individual and the group.

Perhaps a major shift is taking place in our society, one more firmly grounded in multiculturalism and the honoring of past traditions and characterized by an impulse to harmonize the public with the private. We hear that "small is beautiful," that we now live in "post-industrial" society, and that, if we are to survive, as individuals and nations, "the me generation" must be replaced by the "we generation." In such a post-modern world, the role of the architect would naturally change. Robert Stern puts it this way:

> The fundamental shift to post-modernism has to do with the reawakening of artists in every field to the public responsibilities of art. Once again art is being regarded as an act of communication as opposed to one of production or revelation (of the artist's ego and/or of his intentions for the building or his process of design). . . . To the extent that contemporary artists care about the public life of art, they are post-modernists.[8]

Whether we are currently in the process of creating a post-modern art and society remains to be seen. Whatever happens, architecture, that most social of the arts, will invariably reflect and help to shape our lives in the years to come.

APPRECIATION 11

From Modernism to Post-Modernism: Louis Kahn, Robert Venturi, & Charles Moore.

MARK SIMON

The great Philadelphia architect Louis Kahn (1902–1974), through his thoughtful invention, made way for the development of post-modernism. On the one hand, as a modernist, he struggled to make buildings that reflected an "honest use" of their materials (asking his

Mark Simon is an architect and partner, Centerbrook Architects, Essex, Connecticut. He has won numerous national design awards, and his work is reviewed frequently in the international press.

famous question "What does a brick want to be?"). On the other hand, Kahn suggested that people are happier in spaces that they can understand than in the abstract, free-flowing space of modernism (found in Frank Lloyd Wright's Martin House interior [6.71] or in the undifferentiated space between the high-rise towers of Le Corbusier's "Radiant City" plan [6.62]). Searching for "the place of well-being," he discovered that contained space, such as a room or urban street lined with

Figure A • LOUIS KAHN. Jonas B. Salk Institute for Biological Studies. La Jolla, Calif. 1962–1966.

buildings, pleases the human psyche. Kahn also had an inkling that buildings speak to people, that they tell stories and convey meaning through their shapes, spaces, and elements. This is contrary to the modernist notion that buildings are machines for living, whose only content is their function and structure.

The Jonas B. Salk Center for Biological Research (Fig. A) in La Jolla, California, (1962–1966) is a good example of Kahn's work. Here he used carefully detailed concrete walls, left exposed to be appreciated for the pattern left by the molds in which they were formed. They create a series of towers of offices and stair halls in two buildings that face one another to form a courtyard looking out on the Pacific Ocean. With wooden walls and shutters in their openings, the building's towers are reminiscent of a small European village. Even though a modern material (concrete) is used, the building forms proclaim human habitation and reinforce a sense of community. The courtyard—a great, open-ended outdoor room—offers protection from winds and frames the sea, the mist, and the sunset. A man-made stream flows down the center to the sea, creating a magical link to the eternal ocean beyond. This is not just a "machine for living," even though it is carefully machined. It offers shelter and physical comfort the way a modern building might, but it also offers a theatrical experience and the beginning of psychological comfort. It welcomes human use. That welcome, however, is somewhat ambivalent; the building's gestures are so heroic that it is a timeless place. It is a nice place to visit, but you might not want to live there.

Kahn was a noted teacher and had many students who furthered his ideas. Two, Charles Moore (born 1925) and Robert Venturi (born 1925), moved beyond to pioneer post-modernism. Venturi, in his important book of the mid-1960s, *Complexity and Contradiction,* suggests that buildings should not aspire to perfection, for instance, the clean seamlessness of Mies van der Rohe's Seagram Building [6.54] or the suggestion of eternity in Louis Kahn's buildings. Instead, imperfec-

Figure B • ROBERT VENTURI AND ASSOCIATES. Gordon Wu Hall, Princeton University. Princeton, N.J. 1982–1984.

tion, which is necessary to meet human needs, can be artfully handled by making reference to other times and places. Such imperfection might be far more humane (and interesting). For Moore, it is important to know where we are to know who we are. Moore holds a notion of a "sense of place" similar to Kahn's "place of well-being," but he emphasizes connections to the recognizable, such as the remembered past.

Both Venturi and Moore also see the good sense of fitting architecture into its surroundings, and many of their buildings (Figs. B, C) draw from regional styles. (Venturi holds that Main Street is "almost" OK, and Moore states that "a popular architecture in which people feel comfortable is by no means at odds with an architecture of mysterious depths and poetry.") Then, too, both believe that buildings communicate in more ways than Kahn suggested. Venturi and his partner even studied Las Vegas and Levittown [the prototypic post–World War II suburban community] to understand popular symbolism and to learn from commercial and "tract" architecture.

Moore, in particular, proposes that the way an architect works with clients might change. Earlier in the twentieth century, in the mold of Frank Lloyd Wright, Le Corbusier, or Mies

Figure C · CHARLES MOORE AND ASSOCIATES. Sea Ranch. Northern California. 1966.

van der Rohe, the architect was a master who would tell clients what they needed and what they should like. Moore, working with associated offices—most notably Centerbrook Architects in Essex, Connecticut—has developed methods to engage the participation of users or owners of buildings in the design process. In this way, the dreams and visions of the owners and users become the inspiration for the resulting building.

In this regard, the Hood Museum at Dartmouth College (Fig. D), by Charles Moore and Chad Floyd of Centerbrook Architects, is a new kind of masterwork designed with the participation of the Dartmouth community. Moore and Floyd had the difficult task of bridging two existing college buildings of very different ilk. To the right was the modern Hopkins Center; to the left, the medieval revival style Wilson Hall. The Hood name was required to be seen from the front of the new building facing the Hanover village green.

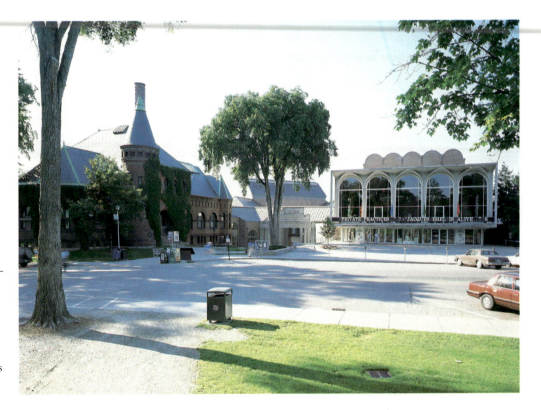

Figure D · CHARLES MOORE AND CHAD FLOYD of Centerbrook Architects. Hood Museum, Dartmouth College, Hanover, N.H. 1985. Wilson Hall (left) completed 1884; Hopkins Center (right) completed 1962.

204

Despite this need to call attention to itself, the museum presents an unpresuming face—only an entry arch that ties Wilson Hall to Hopkins Center. The bulk of the building (Fig. E) is behind this entry and curves to create a series of courtyards between itself and Hopkins Center. In this way, like the Salk Institute, it creates outdoor spaces, places for human activity. Here, however, there is no grandiose, symbolic element—the stream to the ocean—but a pathway for the stream of students who must get from the center of the campus to a shopping street beyond. The Hood Museum has subtle ambitions. It fits into its site gently. Indeed, the materials used here—brick and a copper roof—mimic those of other buildings on the campus, participating in an agreement among the buildings that they all belong to the same place. From its south side, the building is also reminiscent of New England factories nearby.

(*continued*)

Despite its deference to its neighbors, the Hood Museum is not a "wallflower." It has a sense of wit; the windows rhythmically bounce up and down its walls, and its various pavilions crash into each other. These carefully studied collisions suggest a relaxed, humane attitude and at the same time create an exciting aesthetic experience (Fig. F). The roof lines also slope up and down, coming together at one point in a hipped roof pavilion opposite the entry arch to mark the entrance of the building. This again reminds us of another hallmark of the best of post-modern architecture: the celebration of real human activity, whether it is the act of entering the building or residing within.

The Hood Museum doesn't suggest an imagined future, as a modern building might, project us into a Kahnian eternal never-never land, or return us to some carefully recreated historical composition, as certain post-modern buildings do. Rather, it suggests that the visitor is indeed in Hanover, New Hampshire, on the Dartmouth campus, and welcome to enter and enjoy in the here and now. This building unites all tenses—present, past, future, and eternal—thereby uniting our activities, our memories, our aspirations, and our dreams.

■

<div align="right">

C h a p t e r 7

</div>

Art & the New Media: Photography & Moving Pictures

The photographic way of seeing was born long before the invention of the photograph. Its roots are traceable to the ancient Greek aesthetic principle of **mimesis,** defined as the imitation of reality. An early instance of extreme *mimesis* is the legendary story of Apelles, court painter to Alexander the Great. Apelles painted a portrait of the conqueror's horse, Bucephalus, so accurately that Bucephalus whinnied at the portrait as if it were a real horse. A striving for mimesis and capacity to capture the world of people and things in an exact likeness are evident in certain Roman paintings and sculptures, beginning from the fourth century B.C., the time of Alexander. The bust of *Philippus the Arab* (7.1) seems a veritable photograph of the man in stone, so particularized and accurate is the portrayal.

After the medieval Age of Faith, with its more symbolic, abstract art (3.1, 3.2), the quest to reproduce objective reality returns with full force during the Italian Renaissance. Early in the fifteenth century, Filippo Brunelleschi, innovator of the Renaissance style of architecture, had articulated the system of

7.1 • *Philippus the Arab.* 224–249 A.D. Marble. Lifesize. Vatican Museums, Rome.

207

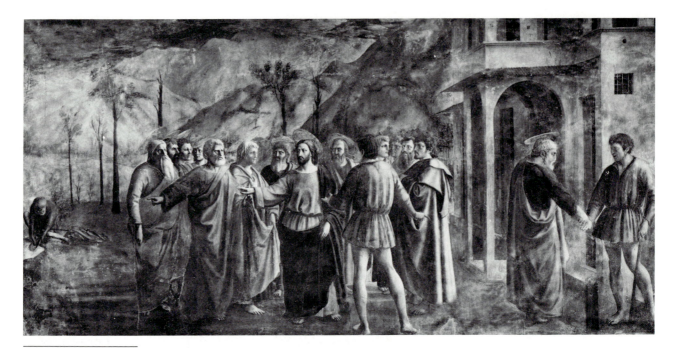

7.2 • MASACCIO. *The Tribute Money.* 1427. Fresco. 8′ 2⅜″ × 19′ 8¼″. Brancacci Chapel, Santa Maria del Carmine, Florence.

one-point perspective, by which draftspersons, painters, and sculptors working in relief could create the illusion of deep, three-dimensional space on a flat, two-dimensional surface. Henceforth, painted or drawn figures seemed to move and converse in a remarkably lifelike illusionistic space. In both *The Tribute Money* (7.2) by Brunelleschi's friend Masaccio (1401–1428) and Leonardo da Vinci's *Last Supper* (4.11, 4.12), the system of linear one-point perspective is put to masterful use. In both works, the **vanishing point** is behind Christ's head, creating a convincing illusion of space while at the same time focusing attention on the most important person in the picture. All of the geometrical sight lines lead the eye inward toward Christ, turning a flat surface into a miraculously lifelike window on reality. (Leonardo, with a genius encompassing science and art, also aided painters who sought a convincing portayal of external reality through his refinement of **aerial perspective,** a technique that creates the illusion of depth. This illusion is achieved by using muted colors and blurring contours to represent objects in the distance; this in accordance with the way the eye actually sees distant objects.)

The impact of one-point perspective on the visual arts and the entire culture of the Renaissance was indeed substantial, some would even claim revolutionary. In addition to helping to bring about a more convincing illusion of the physical world, it affirmed a change in world view that helped fifteenth-century painters and their publics to move beyond the medieval conception of God and eternity as the center of reality. Henceforth, the individual self and human perception increasingly became the pivot points of reality. The art historian Elton Davies puts it this way:

> Medieval art . . . had its center in the images of God, the saints, and the devil. These were fixed, changeless beings [4.1, 4.6] to be viewed by spectators who were moving about. But for Brunelleschi's painting [demonstrating the principle of one-point perspective] the human spectator was the motionless center, and so was the spot on the earth's surface where he sat [or stood].[1]

In the majority of paintings created in the West during and after the Renaissance, the individual viewer, whether artist or spectator, becomes the center of the universe and "the measure of all things." This artistic-cultural shift from a God-centered to an individual-centered world is reflected in van Eyck's fifteenth-century oil portrait of *Giovanni Arnolfini and His Bride* (4.34), in which the perspectival sight lines lead the eye deep into the space of the room and toward the vanishing point in the convex mirror on the rear wall

7.3 • JAN VAN EYCK. Detail from *Giovanni Arnolfini and His Bride*. 1434. The National Gallery, London.

(7.3). In the reflection of the mirror, we observe four figures. One is the painter van Eyck, witnessing the marriage vows of the Italian Arnolfini and his Flemish bride. We behold the scene from van Eyck's particular vantage point, his individualistic point of view. After a medieval period that defined itself in terms of collective faith and suprapersonal imagery, Western culture, spurred by humanism, science, and capitalism, turned increasingly toward a secular and individualistic orientation in all areas of life. The enthusiastic reception at this time of perspectival systems, scientific study (of anatomy, aerial effects), and the medium of oil paint (which could simulate real-life colors and textures better than any previous medium) shows how ready these cultures were for the rebirth of a more mimetic way of seeing and representing.

SCIENCE, ART, & THE CAMERA OBSCURA

During the age in which a science based on objectivity and reproduceable proofs was rising to a leading position in Western civilization, new mechanical "contrivances" were used along with perspectival systems for the purpose of charting and reproducing physical reality. By the sixteenth century, one such device, the **camera obscura** (literally "dark room"), was in common use in Italy. Born of the imperatives of scientific study, it was initially used by astronomers to observe solar eclipses and sun spots. In a print from an astronomy book from 1630 (7.4), we see both linear perspective and the camera obscura in action, the one reproducing sun spots, the other creating an illusion of the physical space of the astronomers' laboratory. This partnership is fitting in that both were an expression of the same scientific desire for reproductive exactitude. To this day, the way of seeing and representing embodied in this print—a combination of individualistic perception and an objectivist science based on mathematical certainty—still dominates the way most persons relate to and understand the world. (Only in the twentieth century has a multiperspective, interdependent, "relativist" view of the universe, one embodied in the theory of relativity of physicist Albert Einstein [1879–1955], come forward to challenge the supremacy of the older scientific and cultural vision.)

In keeping with the commitment of post-Renaissance science to physical observation and verification, various artists from the sixteenth century onward used the camera obscura to authenticate their individualistic

7.4 • CHRISTOPHER
SCHEINER. Camera
obscura used for
observing sunspots, from
Rosa Ursina Sive Sol.
1630. Engraving. 3⅞ ×
8⅛″. Special Collections, The
Stanford University Libraries,
Stanford, Calif.

views of reality. As one noted writer on art and science subsequently recommended, "Painters should make the same use of the Camera Obscura, which Naturalists and Astronomers make of the microscope and telescope; for all these instruments equally contribute to make known, and represent Nature." The camera obscura allowed images from the natural world to be recorded on a ground corresponding to a retina. From these images, exact drawings or even paintings could be made. By the seventeenth century, through the use of improved lenses and mirrors, the camera obscura had become like a modern photographic camera in every major respect except that it did not use film. Books for artists and architects on how to operate this helpful "machine for drawing" became available, and the device began to be used, to varying degrees, by painters. Among the distinguished ones were Vermeer, the Dutch painter of interiors; Canaletto, the Italian painter of views of Venice; and Sandby, the British landscapist (3.10). Seeking greater scientific naturalism, Sandby, according to his son, "aimed at giving his drawings the appearance of nature as seen in the *camera obscura* with truth in the reflected lights, clearness in shadows and aerial tint and keeping in the distances and skies."

Many painters from the seventeenth century onward learned from the camera obscura greater justness of contours and exactness of perspective, value, and color, but no artist learned to see more "photographically" or render reality more accurately than the seventeenth-century Dutchman, Jan Vermeer (1632–1675). During his own period, in which he achieved a moderate degree of fame, and for two centuries thereafter, during which his work and reputation sank into relative obscurity, Vermeer was often criticized as being "too objective." Yet today, conditioned as we are to a photographic way of seeing, we appreciate his interiors (7.5) as exalted marriages of scientific objectivity, individualistic intimacy, and artistic genius. Two of his interiors even show scientists, an astronomer and a geographer, at work. The geographical map on the wall in *Young Woman with a Water Jug* is but another example of the Dutch preoccupation with science, in this case, the accurate charting of the physical world.

Just as the camera obscura, and then photography, froze light, space, and time within a picture frame, so did Vermeer capture a fleeting moment in all its subtle color and form, immortalizing it forever. In his interiors, writes art historian Marcel Brion, material things take on a poetic spiritual life. Light and time, Brion observes, envelops "beings and things in a transparent film. It makes them immobile, transforms them into pearls, so that what is transient becomes eternal, and time itself now becomes a permanent and immortal factor."

7.5 • JAN VERMEER. *Young Woman with a Water Jug. ca* 1664–1665. Oil on canvas. 18 × 16″. The Metropolitan Museum of Art, New York. Gift of Henry G. Marquand, 1889. The Marquand Collection.

NATURALISM & THE BIRTH OF PHOTOGRAPHY

The same desire to record reality objectively that is evident in the art of Vermeer and other Dutch painters of his time is expressed in the first half of the nineteenth century by the "natural" landscape painting (7.6) of the Englishman John Constable (1776–1837). Though he probably did not use the camera obscura in his work, Constable firmly believed that painting should be looked on as a pursuit "scientific and mechanical." So strong was his desire to record nature precisely that he believed that painting was "a science and should be pursued as an inquiry into the laws of nature." For this reason, Constable concluded, "landscape painting [should] be considered as a branch of natural philosophy, of which pictures are but the experiments." As in Vermeer's work, a gentle vitality animates Constable's subject matter: in this case, scenes of land, water, and sky. Though their respective visions were rooted in a scientific way of seeing, theirs was ever a soulful art, a marriage of objectivity and feeling.

The English "natural painting" of Constable and the camera obscura–aided landscapes of his compatriot Sandby were precursors of a full-fledged **naturalist** art movement that arose in mid-nineteenth century France and had its analogue in the detailed realistic style of certain English painters as well (5.18). It was in this most fitting cultural context of artistic and scientific naturalism, during the rise of the Industrial Revolution, that two Frenchmen, Joseph Niepce (1765–1833) and Louis Daguerre (1789–1851), and an Englishman, William Talbot (1800–1877), almost simultaneously invented photography as we know it today. Their crucial innovation was the development of film surfaces that reproduced and fixed the images taken by the cameras of the day. Because photography is a

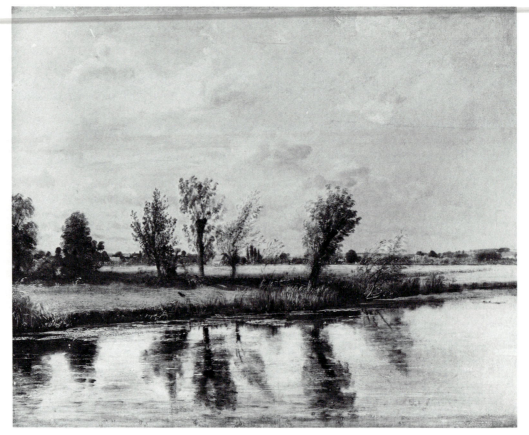

7.6 • JOHN CONSTABLE. *Water Meadows near Salisbury.* 1829. Oil on canvas. 18 × 21¾". Victoria and Albert Museum, London.

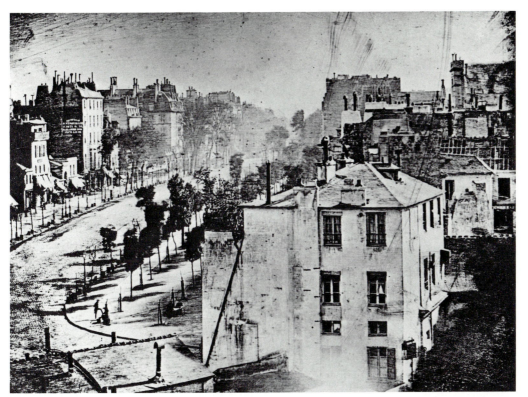

7.7 • LOUIS-JACQUES-MANDÉ DAGUERRE. *Boulevard du Temple, Paris. ca* 1838. Daguerreotype. Bayerisches Nationalmuseum, Munich.

way of seeing and picturing that marries science and art, it is not surprising that all three men had been actively involved in the visual arts: Niepce attempted to improve the reproductive printing process of lithography, Daguerre was a realistic painter and inventor of illusionistic **trompe l'oeil** (fool the eye) theater effects and dioramas, and Talbot was an amateur artist who had used the camera obscura as an aid in his landscape drawings. In fact, generations of visual artists, with their intense desire for accurate reproduction, paved the way for the invention of photography. As the cultural critic Jose Arguelles asserts, the tradition of mimetic painting in the West, from the Renaissance onward, proved to be the decisive "prehistory of photography."

> The true culmination of the mechanistic mode of visual perception and mental ordering was the perfection of *drawing with light,* the literal meaning of photography. . . . Just as a mechanistic mode of consciousness had to precede full-scale industrialization, so a naturalistic mode of visual perception had to precede the invention of photography. The grid of the photographic perceptual field was perfected by Dürer, Leonardo, and Raphael in the early sixteenth century; the technique for achieving exact naturalistic modeling, tonality, and luminosity was perfected by Vermeer in the mid-seventeenth century.[2]

By the first half of the nineteenth century, Arguelles adds, artists such as Constable had gone so far as to speak of painting as a mechanical and scientific activity, equivalent to the pursuit of natural philosophy and scientific experimentation. With all of the necessary "prehistory" in place, it was only a matter of time before reproductive photography itself was invented.

THE NEW MACHINE ART: TRIUMPHS AND TRIALS

Formally and fittingly introduced to the world in 1839 by the French Academy of Science, the photographs of Daguerre (called **daguerreotypes**) made the mechanistic mode of visual perception and representation a physical reality. Talbot's photographs, called calotypes, produced by a different chemical process and characterized by a softer, grainier appearance, were made public the same year. A multitude of photographic images, from portraits to panoramic city views (7.7), were soon made available for purchase by an eager public. Photography's instant popularity spurred rapid technical developments. Improvements in chemical processing steadily reduced the time needed to take a photograph, and increasingly

7.8 • NADAR (GASPARD-FÉLIX TOURNACHON). *Satire on a Battle Painting Shown in the Salon of 1861.* Lithograph. Bibliothèque Nationale, Paris.

7.9 • HONORÉ DAUMIER. *Nadar Raising Photography to the Height of Art.* 1862. Lithograph. The International Museum of Photography at George Eastman House, Rochester, N.Y.

"instantaneous" reproductions were made possible by the 1850s.

The response to the revolutionary invention was almost universally enthusiastic. No image-making procedure had ever received such widespread public acclaim. Scientists, from anthropologists to biologists, were excited by photography's documentary capabilities. Certain artists likewise saw photography as a valuable aid to drawing or painting. No group, however, was more excited by the introduction of photography than the general public. It is claimed that in 1849—a scant ten years after the introduction of Daguerre's invention by the Academy of Science—one hundred thousand daguerreotype portraits were taken in Paris alone. As a method of mechanical documentation, photography had clearly won over the scientific community and the masses.

By the 1850s, excited by photography's mimetic capabilities, increasing numbers of painters were striving to simulate the detailed accuracy of the new "drawings with light," to such an extent that a cartoon of the period shows paintings of battle scenes so realistic that smoke billows from the canvas (7.8). At the same time, artistically minded photographers, many with backgrounds in painting or printmaking, were battling to have the authorities judge their daguerreotype or calotype portraits, still lifes, and landscapes on an equal footing with painting and sculpture.

In France, the more audacious photographers even sought to have their pictures exhibited in the prestigious annual Salon, the government-sponsored exhibition, in the very same building previously reserved for the fine arts of painting and sculpture. These photographers claimed that theirs was not merely a mechanical skill, as various fine artists and critics contended, but an artistic activity involving thought, feeling, and individuality. The heated debate between the upstart photographers and the protectors of traditional fine art spawned a great number of caricatures. The pioneering photographer Nadar (1820–1910), who took the first aerial shots of Paris from a hot air balloon, subsequently found himself lampooned by Daumier in an amusing caricature of double meaning (7.9) for attempting "to raise photography to the height

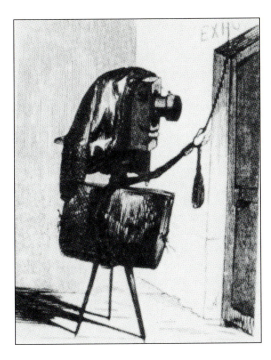

7.10 • NADAR. *Photography Asking for Just a Little Place in the Exhibition of Fine Arts.* 1855. Engraving from *Petit Journal pour Rire.* (left). Bibliothèque Nationale, Paris.

7.11 • NADAR. *The Ingratitude of Painting, Refusing the Smallest Place in Its Exhibition, to Photography to Whom It Owes So Much.* 1857. Engraving from *Le Journal Amusant.* Bibliothèque Nationale, Paris.

7.12 • NADAR. *Painting Offering Photography a Place in the Exhibition of Fine Arts.* 1859. Engraving. Bibliothèque Nationale, Paris.

of art." A caricaturist himself, Nadar summarized the topsy-turvy relationship between fine art and photography in three cartoons (7.10–7.12) executed between 1855 and 1859, the year in which photography was officially granted space in the prestigious Salon.

BAUDELAIRE: THE CASE AGAINST PHOTOGRAPHY

Among those artists and critics in France who viewed the rise of photography as something harmful and malignant, none was more hot-blooded in his attacks than the poet and critic Charles Baudelaire (1821–1867). In his review of the Salon of 1859, Baudelaire thundered like an Old Testament prophet. The popular "new industry," warned the poet, was a cancer that had infected the broad public and was wreaking havoc on art as well.

> In these lamentable days, a new industry has arisen, which contributes not a little to confirming stupidity in its faith and to ruining what might have remained of the divine in the French genius. This idolatrous crowd [infatuated with photography's mimetic power] postulates an ideal worthy of itself and appropriate to its nature, that is perfectly understandable. As far as painting and sculpture are concerned the current credo of the sophisticated public, above all in

France . . . is this: "I believe in nature and I believe only in nature. . . . I believe that art is and cannot be other than the exact reproduction of nature. . . . Thus the industry that could give us a result identical with nature would be the absolute form of art." A vengeful God has granted the wishes of this multitude. Daguerre was his messiah. And now the public says to itself: "Since photography gives us all the guarantees of exactitude that we could wish (they believe that, the idiots!), then photography and art are the same thing." From that moment squalid society, like a single Narcissus, hurled itself upon the metal, to contemplate its trivial image. . . .

If photography is allowed to stand in for art in some of its functions it will soon supplant or corrupt it completely thanks to the natural support it will find in the stupidity of the multitude. It must return to its real task, which is to be the servant of the sciences and of the arts, but the very humble servant, like printing and shorthand which have neither created nor supplanted literature. . . .[3]

Photography, Baudelaire concluded, might serve the various professions as a humble copying machine, a mechanical "secretary and clerk. But if it be allowed to encroach upon the domain of the impalpable and the imaginary, upon anything whose value depends solely upon the addition of something of a man's soul, then it will be so much the worse for us!"

Baudelaire's greatest fear was that painters, "by bowing down before external reality," would lose their most precious gifts: their imagination and capacity to dream. Influenced by photography, he asserts, "the painter becomes more and more given to painting not what he dreams but what he sees." Baudelaire was a giant of poetry and isolated individualist who stood between the romantic individualism of the first quarter of the nineteenth century and the subjectivist symbolism of the last. For him, art was not an objective mirror of life, but an imaginative interpretation of it. Art, he thought, should be suffused with feelings and filled with dreams. The allure of photography's naturalism was great. If the imagination of the artist were to wither away and the cult of individualistic artistic genius challenged, then art itself, Baudelaire feared, would be dead.

7.13 • Jean-Francois Millet. *The Gleaners.* *ca* 1857. Oil on canvas. 33 × 44". The Louvre, Paris.

PAINTING AS A MIRROR OF REALITY: THE PHOTOGRAPHIC VISION

Baudelaire's "antinaturalist" fears were to be borne out, but art itself was not to die. To a substantial degree, the next decades saw the rise of naturalistic art, pursued under the banners of realism, naturalism, and impressionism. In 1863, the writer Castagnary announced that a full-blown movement of naturalist art was under way, a pronouncement that must have certainly angered and dismayed those of Baudelaire's persuasion. Condemning all types of non-naturalistic art, Jules-Antoine Castagnary (1830–1888) criticized the then dominant "classical" and "romantic" schools—epitomized respectively by the works of the towering figures of Ingres and Delacroix (2.5, 2.6)—for their different distortions of reality. The classicists, he maintained, distorted reality by idealizing it; the romantics, by subjectively interpreting it beyond recognition. He then praised the younger naturalist painters for their faithfulness to nature, a fidelity completely in harmony with the aims of science and the documentary truthfulness of photography. "The naturalist school," wrote Castagnary, "asserts that art is the expression of life in all forms and on all levels, and that its sole aim is to reproduce nature by bringing it to its maximum strength and intensity: it is truth in equilibrium with science." The naturalist school of art, he contended, would "mirror" the modern era, both "country life, which it already interprets with such rustic power [7.13], and . . . city life, which still holds in reserve this [school's] greatest triumphs. . . ."

It was in the context of these debates for and against naturalism and photography that the group of youthful painters soon to be called impressionists struggled to maturity. They grew up in an urban industrial culture strongly influenced by photography. Born in the 1830s and 1840s, they were really the first generation brought up in a world rapidly filling with photographs, and they were all powerfully affected by the pervasive new medium, whether or not they knew or admitted it. The future impressionists quite understandably chose older naturalist and realist painters as

7.14 • HILAIRE-GERMAIN-EDGAR DEGAS. *The Ironers.* 1882. Oil on canvas. 32⅜ × 29¾″. The Norton Simon Art Foundation, Pasadena, Calif.

teachers and heroes. Among these were Millet (7.13), Courbet (9.13), Manet (9.14), and Daubigny (9.23), and like them the impressionists sought to capture, with a scientific honesty, their generalized "impressions" of both country and city life.

Edgar Degas (1834–1917) became impressionism's most penetrating chronicler of the life of the metropolis (7.14). Observing and portraying city life as if "through a keyhole," Degas, like an invisible photographer, captured Parisians in spontaneous moments: washing clothes, bathing, dressing, trying on hats, performing at the theater, ballet, or orchestra, practicing for performances, walking on the boulevard, sitting in the cafes. In his works, those by Mary Cassatt (9.27) and Gustave Caillebotte, and some by Renoir (9.24), Monet (9.25), and Morisot (9.26) as well, the triumphs of the urban naturalist art predicted by Castagnary were realized.

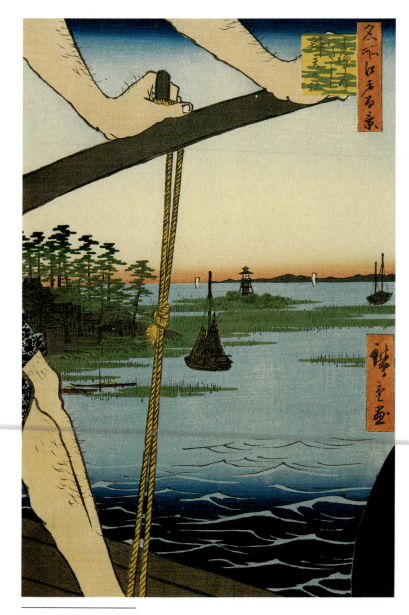

7.15 • ANDO
HIROSHIGE. *The Haneda
Ferry and Benten Shrine.*
1858–1859. Woodblock
print from *One Hundred
Views of Edo.* The Trustees
of the British Museum,
London.

DEGAS, IMPRESSIONISM, & PHOTOGRAPHY

In addition to photography, and the naturalism and realism of their immediate predecessors, the influences upon the impressionists were diverse yet in the final analysis mutually reinforcing. These influences included Japanese prints such as those of Katsushika Hokusai (1760–1849) (3.18) and especially Ando Hiroshige (1797–1858) (7.15). The impressionists were attracted to the formal qualities of these prints: they were colorful, generalized, and abstract, featuring informal slice-of-life framing and asymmetrical compositions. Known in Japan as *Ukiyo-e* (literally "floating world"), the prints focused on the passing world of contemporary and commonplace life; the "modern" and democratically expansive subject matter the impressionists liked so well. Closer to home, influences on the impressionists included scientific discoveries about the interactive effects of complementary colors, which the artists then put to use in evoking vivid impressions of their fast-moving, everchanging urban industrial world.

Among all the diverse influences on the impressionists, however, photography, with its extraordinary sensitivity to light and ability to capture fleeting moments of country and city living, brought unity to all the rest. And of all the impressionists, Degas was most influenced by the new mechanical medium. He drew inspiration from the language of the new instantaneous "snapshot" and transformed it, through arduous artistic labor, into drawings and paintings that seem to sing the song of city life, capturing the ephemeral truth of its light, color, people, poses, and rhythms. Other art forms—caricature, theater, Japanese prints—certainly influenced Degas's work. But there is little doubt that the photographic vision, and specifically the way of seeing embodied in instantaneous photography, played a central role in synthesizing these many influences.

In 1858, when Degas was 24 years old, rapid-exposure (up to 1/50th of a second) photography made its sensational debut. (In photographic terms, the human eye records motion at a normal speed of 1/12th of a second.) The desire of the public for these instan-

7.16 • FERRIER AND SULIER. *Paris Boulevard.* 1860. Instantaneous photograph. The International Museum of Photography at George Eastman House, Rochester, N.Y.

taneous views was boundless. Sales in Paris alone totaled in the millions. Stirred by the precision in detail of instantaneous views taken in Paris in 1861, the American writer Oliver Wendell Holmes (1809–1894) wondered at the "walking figures, running figures, falling figures, equestrian figures and vehicles, all caught in their acts without the slightest appearance of movement or imperfect definition. . . ."

Like the general public, artists were naturally influenced by the new way of seeing and picturing. Rapid-exposure photographs, which were immensely popular throughout Europe and North America (7.16), exhibited characteristics—arbitrary framing, asymmetrical composition, unusual angles of vision, real-life variety and unexpectedness—that increasingly appeared in the works of Degas and the impressionists. (They also corresponded, in mutually reinforcing fashion, to the poses, gestures, and framing found in Japanese prints such as those of Hiroshige.) In these photo-graphs, figures, horses, and carriages are "cut off" at the edges. In his views of the city's bridges and boulevards, taken from the high viewpoints subsequently employed in impressionist paintings of the same subjects (9.25), one also sees the inevitable severing of pedestrians and vehicles at the edges of the photograph. Mocking the "ridiculous" cut-off forms and figures in these "instantaneous" views, the caricaturist Cham shows us an omnibus slashed in half, the passengers, legs severed at the kneecaps, riding on top (7.17). Yet what was initially perceived as odd and looked on as hilarious soon became second nature. Such was the influence of the new industry and its millions of documentary images on the way we, the public, see.

Degas's **Place de la Concorde.** Knowledge of these early instantaneous photographs enhances our appreciation of Degas's painting *Place de la Concorde (Vicomte Lepic and His Daughters)* (7.18). The viscount strolls along

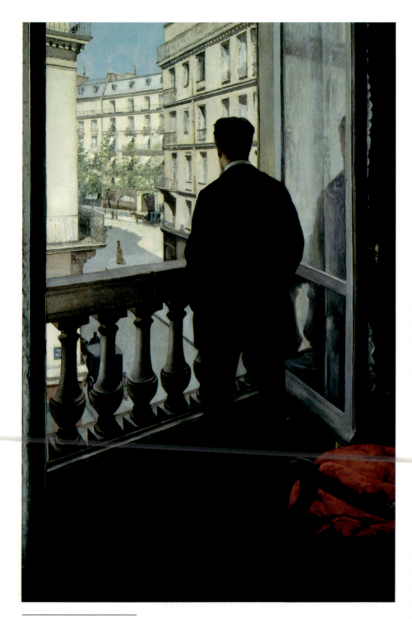

7.19 • GUSTAVE
CAILLEBOTTE. *Young
Man at a Window*. 1876.
Oil on canvas. 46 ×
32½″. Private collection.
Courtesy Wildenstein & Co.,
New York.

directly to a painting by Gustave Caillebotte (1848–1894), *Young Man at a Window* (7.19):

> Views of people and things have a thousand ways of being unexpected in reality. Our point of view is not always [as in the traditional perspective of many academic paintings] in the center of the room with two lateral walls receding toward that of the rear; it does not always gather together the line and angles of cornices with a mathematical regularity and symmetry. Nor is it always free to suppress the great swellings of the ground and of the floor in the foreground; it [one's viewpoint] is sometimes very high, sometimes very low, missing the ceiling, getting at objects from their undersides, unexpectedly cutting off the furniture. . . .[5]

After thus dismissing fixed systems of academic linear perspective in favor of the mobile, relativistic perspective of the camera—proof that a more relativistic world view was entering modern consciousness?—Duranty continues with a passage that describes more specifically Caillebotte's work and the photographic qualities for which other critics derided it:

> From within, we communicate with the outside through a window; and the window is the frame that ceaselessly accompanies us. . . . The window frame, depending upon whether we are near or far, seated or standing, cuts off the external view in the most unexpected, most changeable way, obtaining for us that external variety and unexpectedness which is one of the great delights of reality.[6]

It is almost impossible not to rethink Duranty's imagery in terms of the camera. Meaning "room" in Italian, the camera is an enclosed interior from which one looks out on an everchanging world through the arbitrary frame of a rectangular lens window. But unlike a stationary window in a room, the camera window moves, it is a mobile frame ever ready to freeze a moment in time.

Although Degas, Caillebotte, and their colleagues actually based some of their works on specific photographs, the influence on their art of a generalized photographic way of seeing is far more important. The poet Paul Valéry (1871–1945), a friend of Degas in his later years, wrote that the artist tried "to combine the [quality of] the snapshot with the endless labor of the studio . . . the instantaneous giving enduring quality by the patience of intense meditation." On the avenues, at the dance stu-

7.20 • EADWEARD MUYBRIDGE. *Annie G. in Canter,* from *Animal Locomotion.* 1887. The International Museum of Photography at George Eastman House, Rochester, N.Y.

dios, in the theater, Degas would observe, occasionally taking notes or making studies, relying on memory for the works he planned. His mind became a dark room in which scenes he had observed were brought to light by long exposure to memory and thought. Increasingly, his tendency from the late 1860s was to observe without actually painting and to paint without observing. The instantaneous photograph that had helped to shape his impressionist vision also helped him recall those subtleties of movement, light, and composition that the eye might forget, miss, or not reveal. But the finished work would always be pure Degas, never a mere translation of a photograph. The artist's mind and hand were ever the final arbiters. Degas, wrote his friend Valéry, "loved and appreciated photography at a time when artists despised it or did not dare admit that they made use of it." "He was among the first artists," continued the poet, "to see what photography could teach the painter—and what the painter must be careful not to learn from it."

Toward Complete Mimesis: From Still Photography to Moving Pictures. One of the lessons Degas learned from instantaneous photography was how horses really galloped. Eadweard

Muybridge's famous sequential photographs of galloping horses (7.20), circulated in France from 1878, taught artists to correct previous errors in drawings and paintings of racing horses. The modern desire to reproduce life evermore completely made inevitable the progression from the single still photograph to sequential photographs to a sequence of shots that, when projected, simulated the movement of life itself. The sequential instantaneous photographs of United States citizen Muybridge (1830–1904) were logically succeeded by the "chronophotographs" of Frenchman Etienne-Jules Marey (1830–1904). Invented in the 1880s, Marey's chronophotographs (7.21) showed each minute phase of a movement in its correct spatial position.

7.21 • ETIENNE-JULES MAREY. *Man in Black Suit with White Stripes Down Arms and Legs, Walking in Front of a Black Wall.* 1883. Chronophotograph. Musée Marey, Beaune, France.

7.22 • AUGUSTE AND
LOUIS LUMIÈRE. *The
Arrival of a Train*. 1895.
The Museum of Modern Art/
Film Stills Archive.

From Marey's static simulation of motion, it was but a stone's throw to "cinematography," the art of making pictures that actually moved. The mid-1890s brought the public release of "motion picture" shorts by the American inventor Thomas Alva Edison (1847–1931) and the French Lumière brothers, Auguste (1862–1954) and Louis (1864–1948). The age of film was under way. Audiences screamed and recoiled with fear when they saw the train hurtling toward them in the Lumières' minute-long *The Arrival of a Train* (7.22). From the turn of the century onward, the technical evolution of photography and the cinema proceeded rapidly toward evermore complete verisimilitude (true or real appearance). By the late 1920s, sound was added to the previously silent films, and "living color" entered the realms of motion pictures and photographs shortly thereafter. The public appetite for increasingly convincing illusions of reality, soon to include the televised images of electronic video and laser-generated holography, was seemingly insatiable.

MODERN ART: AGAINST THE NATURALISM OF THE CAMERA

Although extreme naturalism was the dominant direction in the new mechanical media, one that influenced many mainstream painters as well, avant-garde artists would have none of it. Vanguard artists initially influenced by impressionism who reached maturity in the 1880s and 1890s—individuals now referred to as the **post-impressionists**—rejected the camera's precise reproduction of reality in favor of their own highly personal interpretations. Akin to Baudelaire's attack on the "new industry" decades earlier, their reaction against photography and optical realism stemmed from their belief that the mere imitation of reality revealed only the most superficial or shallow truths.

Backing Baudelaire's arguments with his own antinaturalistic art and forceful personality, French artist Paul Gauguin (1848–1903) called for a **symbolist** art, a spiritual antidote to the material reality captured in

photographic images. In his *Symbolist Self-Portrait with Halo* (7.23) of 1890, Gauguin presents himself as a contemporary Adam struggling with a fateful decision that will determine his destiny. Formally, the figures— snake, plant, apples, person—are simplified, flattened, and generally abstracted. The intention is to convey spiritual (that is, symbolic) as opposed to physical truths. The evocation of elusive ideas, mysterious dreams, and enigmatic sensations, that which transcends physical reality and its mechanical reproduction, was the concern of symbolist art. Such art emphasizes individualism, feeling, and the imagination, and was, Gauguin asserted, "a new departure which inevitably diverges from anything that is mechanical, such as photography, etc." In the context of an evermore materialistic, mechanized society, Gauguin protested, "The machines have come in, art has gone out. . . . I am far from thinking that photography can be favourable to us."

In 1888, Vincent van Gogh described to his brother Theo this "new departure" of Gauguin, himself (1.8), and their colleagues. The expression of feeling and individuality, he insisted, must take precedence over the barren perfection of photographic imitation.

> You must boldly exaggerate the effects of either harmony or discord which colours produce. It is the same as in drawing—accurate drawing, accurate colour, is perhaps not the essential thing to aim at, because the reflection of reality in a mirror, if it could be caught, colour and all, would not be a picture at all, no more than a photograph.[7]

For the post-impressionists, the camera was a cold-blooded machine, a popular mass killer of personal expression and imagination, just as Baudelaire had predicted. Photographic naturalism and academic naturalism in painting, the painter Maurice Denis (1870–1943) cynically observed, were really the same deplorable thing, "worthy of an epoch of science and democracy." In contrast, he insisted, modern art, is

> . . . no longer simply a visual sensation which we receive, a photograph, however refined it may be of nature. No, it is a creation of our spirit for which nature is only a starting-point. Instead of "working around the eye, we look to the mysterious centre of thought" as Gauguin said. Imagination has thus become, as Baudelaire wished, the Queen of the Faculties.[8]

7.23 • PAUL GAUGUIN. *Symbolist Self-Portrait with Halo.* 1889. Oil on wood. 31¼ × 20¼". The National Gallery of Art, Washington, D.C. Chester Dale Collection.

A half century later, in 1942, the pioneering modernist painter Henri Matisse (1869–1954) would still criticize the camera for much the same shortcomings. Matisse summarized his own artistic goal in this way: "To translate my emotions, my feelings, and the reactions of my sensibility into color and design [2.34], something that neither the most perfect camera, even in colors, nor the cinema can do."

7.24 • EDWARD STEICHEN. *Rodin— The Thinker.* 1902. Gravure print. 15⅞ × 19¹³⁄₁₆″. The Gilman Paper Company, New York.

NEW MEDIA IN A NEW CENTURY: FROM INFORMATION TO ART

The criticisms of certain avant-garde fine artists notwithstanding, photography and film—soon to be joined by television after World War II—rapidly became the twentieth century's most influential visual media in terms of information, persuasion, and entertainment. Social historian Arnold Hauser goes so far as to describe the period between World War I and the 1950s as "the film age." Communications theorist Marshall McLuhan declared that the influence of television in the second half of the century was so enormous that it had transformed the world into "a global village." Correlatively, the average person after World War II saw millions, if not billions of photographic images in a lifetime: in magazines, on products, in snapshot albums, in the daily newspapers. It was the age of photog-

raphy as well as television and film. The new media had become "mass media," and their impact was nothing less than incredible in all areas of life. "But," an avant-garde painter or sculptor might have reported, "is there anything in this vast forest of media worthy of being called 'art'?"

At the turn of the twentieth century, only a small minority, led by the artistically minded "pictorialist" photographers, would have claimed that the new mechanical media were capable of producing fine art. (In the early years of the century, the medium of film was still looked down on by the cultural elite as mere movie house entertainment for the laboring classes.) But modernist fine art did become the steadfast goal of select groups of men and women equipped with cameras. At the Gallery 291 in New York City, photographer Alfred Stieglitz (1864–1946) exhibited both the work of avant-garde painters and sculptors

such as Rodin, Matisse, Cézanne, and Picasso and vanguard pictorialist photographers who were attuned to the aesthetic and symbolist concerns of the day. Called **photo-secession-ists** because they chose to secede from traditional academic and commercial photography, the photographers included Stieglitz himself, Gertrude Kasebier (1852–1934), and Edward Steichen (1879–1973).

Steichen's *Rodin—The Thinker* (7.24) exemplifies this union of vanguard art and photography that Stieglitz's Gallery 291 espoused. In the photograph, the great sculptor Rodin is shown with two of his famous works. Across from the sculptor is *The Thinker* and, in the background, his statue of the romantic writer Victor Hugo. Light flickers moodily on the dark silhouetted foreground figures and floods the whitened sculpture behind. The gestures of the figures and the overall symbolist quality suggest deep meditation or thought. Steichen was most happily surprised to find that such photographic works, with their pronounced aesthetic and symbolist qualities, were well received. From Paris in 1901, Steichen wrote to his friend Stieglitz in America that "even big painters and artists here . . . up to Rodin himself" praised his creations as "remarkable works of art."

"Art photography" seemed to be making headway, with the tireless Stieglitz leading the charge. In addition to running Gallery 291, Stieglitz was the editor of *Camera Work,* the influential photo-secessionist journal published between 1903 and 1917. Among its more famous contributors were the contemporary modernist writers Gertude Stein, Maurice Maeterlink, H. G. Wells, and George Bernard Shaw. Their general opinion was that the camera and dark room were but tools that, like the painter's brush or sculptor's chisel, might be employed to convey the sensibility of the individual photographer. Observing photography's evolution from a medium of mechanical imitation to one of human art, Maeterlink (1862–1949) wrote glowingly of its possibilities.

It is already many years since the sun [through photography] revealed to us its power to portray objects and beings more quickly and more accurately than can pencil or crayon. It seemed [as a mechanical process] to work only its own way

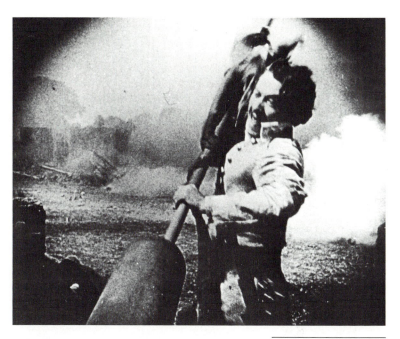

7.25 • D. W. GRIFFITH. *The Birth of a Nation.* Storming the Union Line. 1915. Epoch Producing Corporation. The Museum of Modern Art/Film Stills Archive.

and at its own pleasure. At first man was restricted to making permanent that which the impersonal and unsympathetic light had registered. He had not yet been permitted to imbue it with thought. But today it seems that thought has found a fissure through which to penetrate the mystery of this anonymous force, invade it, subjugate it, animate it, and compel it to say such things as have not yet been said in all the realm of chiaroscuro, of grace, of beauty and of truth.[9]

As a still younger medium, cinematography had to wait until the second and third decades of the century before anyone saw it as capable of creating great art. With the films of Griffith and von Stroheim in America, Eisenstein and Pudovkin in Russia, and Murnau and Riefenstahl in Germany, directors of artistic power (or *auteurs,* "authors," as the French called them) began to be recognized for their personal vision and indelible style. In the hands of such creative artists, even films based on historical facts or actual events, supposed objective reality, were transformed into artistic tour de forces of personal interpretation and imagination.

In the silent film classic, *Birth of a Nation,* D. W. Griffith (1875–1948) recreated the Civil War and Reconstruction from a white southern gentleman's point of view (7.25, 1.7). Premiered in 1915, Griffith's epic

7.26 • EMANUEL
LEUTZE. *Washington
Crossing the Delaware*.
1851. Oil on canvas.
12′ 5″ × 21′ 3″. The
Metropolitan Museum of Art,
New York. Gift of John S.
Kennedy, 1897.

production brought the Civil War and its aftermath to heart-throbbing life; "history written in lightning," marveled President Woodrow Wilson. As a convincing "historical facsimile," Griffith's film appropriated for the cinema one of the most revered traditions in Western art, that of history painting. With its basis in literature, its realistic settings and style, and its larger-than-life tableaux, *Birth of a Nation* seems a natural outgrowth of the grand-scale history paintings, such as *Washington Crossing the Delaware* (7.26), that were immensely popular in nineteenth-century Europe and North America.

In a related way, *Triumph of the Will* by Leni Riefenstahl (born 1902), the so-called document that transformed the Nuremburg Rally of 1934 into a mythically brilliant glorification of Hitler and the Nazi party, bears comparison to certain history paintings. A production of superhuman scale, staged and filmed for propaganda purposes (to inspire the loyalty and faith of all Aryan segments of German society), Riefenstahl's film (7.27, 1.6) has specific precedents in pre-twentieth-century

paintings whose purpose was to glorify autocratic rulers and perpetuate their reigns. In David's great propaganda painting for a more enlightened despot, *The Coronation of Napoleon and Josephine* (7.28), the French First Consul, like Hitler in *Triumph of the Will,* is symbolically deified. In David's painting, we witness the moment when Napoleon, having just been crowned emperor by the pope, crowns his wife Josephine empress. The crownings take place amidst the greatest pomp and pageantry and before the most important personages of the day. In the twentieth century, film directors have taken over the role once performed by history painters. With roots that stretch deep into the most elevated fine art traditions of the past, *Birth of a Nation* and *Triumph of the Will* are clearly masterpieces, although socially dangerous ones.

Relative to their status as fine art, photography and film have come a very long way; so far that it appears that these youthful media, along with video, have equaled or even surpassed painting and sculpture as the most pervasive and influential artistic media of the cen-

tury. That is a remarkable achievement indeed when one realizes that painting and sculpture had dominated the visual arts for over five hundred years. If Baudelaire, Gauguin, and van Gogh were alive today, they would probably be impressed by the imagination, expressiveness, and individuality that twentieth-century artists have conveyed through the new media. And much to their surprise, they would have discovered that many of the finest photographs, films, and video works are shown in museums of modern art previously reserved for avant-garde painting and sculpture.

PHOTOGRAPHY & MOVING PICTURES: SELECTIVE VIEWS

Throughout the twentieth century, the relationship between fine art and photography, film, and video has been dynamic. To help us chart and gain a foothold in this vast and varied artistic landscape, we will use four broad interpretive categories, expressionism, surrealism, formalism, and social realism. These four categories are part aesthetic (concerned with artistic intention) and part historical (referring to official art movements). Used appropriately, they can guide our initial steps toward greater understanding. At the same time, we must be aware that the best art, particularly in the modern era, often defies, traverses, or transcends categories. Many twentieth-century artists dislike the stereotypical

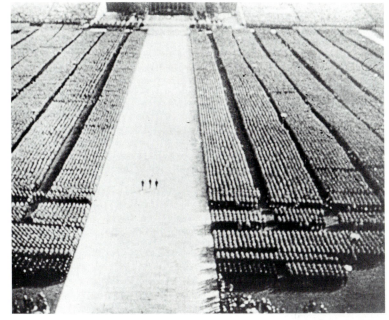

7.27 • LENI RIEFENSTAHL. *Triumph of the Will.* Hitler, Himmler, and Lutze traverse the stadium. 1934. Transit-Film-Gesellschaft MBH. The Museum of Modern Art/Film Stills Archive.

7.28 • JACQUES-LOUIS DAVID. *The Coronation of Napoleon and Josephine.* 1805–1807. Oil on canvas. 20′ × 30′ 6½″. The Louvre, Paris.

7.29 • ERNST LUDWIG KIRCHNER. *The Red Cocotte.* 1914. Pastel. 41 × 30.3 cm. Graphische Sammlung, Staatsgalerie, Stuttgart.

expression. In the sphere of subjective expression, the influence of van Gogh and Gauguin (7.23) on the upcoming generation of young European artists was indeed profound.

In the first decades of the twentieth century, the new goal of self-expression reached deeply into the souls of diverse Germanic artists who collectively came to be grouped under the historical banner **German expressionism.** One of the earliest German expressionist groups, *Die Brucke* (the Bridge), originated in Dresden in 1905. Its leader, Ernst Ludwig Kirchner (1880–1938), conveyed his inner apprehension of life, as opposed to his optical perception of it, in paintings set in the studio and out in the urban streets. Believing in Die Brucke as a liberating "bridge to the future," Kirchner wrote in the group's manifesto, "He who renders his inner convictions as he knows he must, and does so with sincerity and spontaneity, is one of us." These artists pursued honesty of personal expression, especially in respect to life's darker and repressed sides, with missionary zeal. The optical imitation of the physical world was declared insufficient in capturing the "internal" truth of reality. In Kirchner's *The Red Cocotte* (7.29), begun in the first bloody year of World War I, a sexually promiscuous woman in glaring red is surrounded by faceless men in evening attire. Like a vortex, they whirl around her. But the form of the work, even more than the subject matter, conveys its "inner expression": a feeling of jittery glamour. We observe an unnatural mix of sharply angular shapes and shrill colors dashed, in anxious strokes, onto a flattened space that feels positively claustrophobic.

The social context from which such works grew was big city life, increasingly anonymous, nervous, and morally unrestrained, an unsettling world denounced by its critics as "a devourer of souls." As if to address the modern problem of unsettled souls, psychology also emerged during this period. Largely a Germanic invention, it was the science of the inner being. The work of diverse northern European artists would soon be influenced by the theories of Sigmund Freud (1856–1939), Carl Gustav Jung (1875–1961), and other psychoanalytic practitioners. Works of expressionistic art representing the artists' internal perception of reality grew naturally in such soil.

labels applied to them by critics or historians. This being said, the viewer is urged to use the aforementioned categories not as straitjackets but as aids to more complex appreciations.

Expressionism: Unleashing the Emotions. **Expressionism,** as a way of seeing and representing, is as prevalent in photography and film as it is in painting and sculpture. Arguably, Vincent van Gogh is a primary founder of this major direction in the visual arts of the modern period. In his passionate art work, he interprets objective reality (people, interiors, nature) to express his personal feelings. *The Night Cafe* (1.8) and other works (1.13) exaggerate or distort color, shape, or perspective for the purpose of emotional or psychological

7.30 • ROBERT WIENE. *The Cabinet of Dr. Caligari.* Dr. Caligari and his sleepwalking assistant, Cesare. 1919. Deda-Bioskop/Erich Pommer. The Museum of Modern Art/Film Stills Archive.

The goals and methods of the *Die Brucke* painters, printmakers, sculptors, and their colleagues were readily translated by expressionists who used film and photography as their media. The most notorious masterpiece of the German expressionist cinema, *The Cabinet of Dr. Caligari* (7.30), looks like a Kirchner painting come to life. (Many consider it the first "art film.") Hermann Warm (born 1889), its designer, actually conceived of the film as "a drawing brought to life," the sets, lighting, costumes, and makeup adhering to the conventions of Die Brucke expressionism. The film's plot is as distorted and disturbing as the appearances of its characters and settings. Dr. Caligari is an evil man who uses his hypnotic powers to impel his innocent sleepwalking assistant, Cesare, to commit a series of brutal murders.

Knifelike shapes pierce or cover walls. Windows are asymmetric openings leading nowhere. Dramatic, artificial lighting creates shrill, dark-light contrasts and ominous shadows. Diagonal lines and zigzag patterns foster disequilibrium. Space is alternately compressed or elongated, boxed in or elliptically stretched out. It is a design that causes the eye to be ever moving and restless. The cinematography reinforces the nightmarish quality of set and story through the use of tilted camera angles, off-center circular "iris shots," and continuous movement. The editing style is jumpy; scenes crash into each other without smooth transition. One is made to feel that everything is askew, out of balance, insane.

Originally, the writers intended *The Cabinet of Dr. Caligari* as a metaphor for Germany itself, a country in which power-mad leaders had cast spells over the unsuspecting masses, leading them into the horrors of war and the doing of society's dirty work. In keeping with leftist political theory and the cultural radicalism of the German expressionist art movement, the scriptwriters wanted to show poor Cesare, the sleepwalker, forced to commit criminal acts under the influence of the demonic and corrupt figure of authority. Although the story was ultimately changed by the movie's profit-minded producer to eliminate any political sting, the style of the film nonetheless conveys the feeling of a world gone mad.

7.33 • DIANE ARBUS. *Burlesque Comedienne in Her Dressing Room, Atlantic City, New Jersey.* 1963. Copyright © Estate of Diane Arbus 1972. Courtesy Robert Miller Gallery, New York.

They get narrower and more particular in it. Invention has a lot to do with a certain kind of light some people have and with the print quality and the choice of subject. It's a million choices you make. . . . I mean it comes from your nature, your identity. We've all got identity. You can't avoid it.[10]

As a revealer of souls, both her own and those of her subjects, Arbus was a pioneer in her medium. "Diane's pictures," emphasized photographer Jerry Uelsmann, "appealed to the mind, not the eye, which is one of the reasons she broke new ground for photographers. Diane explored the psychological."

Surrealism: Visualizing Dreams and Fantasies. **Surrealism,** which coalesced as an art movement in the 1920s, was committed to realizing in literature and the visual arts the irrational world of the unconscious mind as manifested in dreams, hallucinations, and fantasies. (In its exploration of the psychological dimension, surrealism bears a kinship with expressionism, but its focus is more emphatically on the imagery that arises from the unconscious mind as opposed to the expressionist artist's emotional response to the "waking reality" of the external world.) For two decades, the surrealists formed an identifiable group that often published and exhibited together. The range of their visual work was wide, encompassing diverse media and styles. In the realm of painting, these included the enigmatic fantasies of the Belgian painter René Magritte (1898–1967)—his *Castle of the Pyrenees* (7.34) is a surrealistic contrast to Arbus's more expressionistic *Castle in Disneyland*—and the painted dreamscapes by the Spaniard Salvador Dalí (1904–1989), which he called "hand-colored photographs" of the unconscious (10.35). The photographers and filmmakers, for their part, made equally important contributions to the surrealist movement.

Surrealist Photography. Born in New York but living much of his life in Paris, the painter and photographer Man Ray (1890–1976) became the primary American in the surrealists' inner circle. His association with the avant-garde was lifelong, from his close friendship with photographer Alfred Stieglitz and frequent visits to Stieglitz's Gallery 291 in the

expressionist art, she cut her subjects off from everything but their immediate surroundings and probed with microscopic intensity for their idiosyncrasies, "the flaws" that defined them. A square picture format, a predominance of frontal poses, snapshot candor, and bold light-dark flashbulb contrasts, at times harsh, further serve to rivet our attention.

But, Arbus warns us, the photographic process is not so easily analyzed. Her way of working, she insists, is more intuitive and inner-directed than it is conscious and rational. Arbus writes of her technique as coming "from some mysterious deep place." Technique, she believes, comes not from the paper or the developer that photographers use, but "mostly from some very deep choices somebody made that take a long time and keep haunting them." "Invention," she writes, "is mostly this kind of subtle, inevitable thing." The longer photographers work with a subject, the closer they get to the beauty of their invention.

7.34 • RENÉ MAGRITTE. *The Castle of the Pyrenees.* 1959. Oil on canvas. 200 × 145 cm. The Israel Museum, Jerusalem. Gift of Harry Torczyner, New York.

7.35 • MAN RAY.
Le Violon d'Ingres. 1924.
Courtesy Rosalind and
Melvin Jacobs, New York.

early teens to his active participation in Europe, from the 1920s onward, with the iconoclastic dadaists (2.30) and surrealists. His **photomontages,** essentially collages created from disparate or manipulated photographic images, evoke flights of surrealist fantasy. In *Le Violon d'Ingres* (The Violin of Ingres) (7.35) of 1924, a nude woman, beautiful and exotically attired, is turned into a violin. The impossible in reality becomes possible in surreality: in the world of dreams, fantasy, and the imagination. Like dreams and fantasies themselves, this visual representation is pregnant with multiple meanings. Exotic and sexually alluring, the woman maintains a degree of distance. Her back is turned, and she gazes slightly away from the viewer, yet she appears seductively aware of our viewing her. She is indeed a sensual woman, but she is more. She is a violin, and the violin of Ingres if we go by the title. An enigma within a mystery?

The work's title refers to the nineteenth-century artist Ingres, renowned as a painter of exotic courtesans and sensual bathers. These paintings were much enjoyed by the bourgeois male public of his day. Is the woman in Man Ray's montage seen then as an instrument, like the sweet-toned violin, to be played upon by men of affairs? It would seem so. The turban that the woman wears and the pose she assumes are certainly references to paintings by Ingres, such as the *Bather of Valpincon* (7.36)

7.36 • JEAN-AUGUSTE-
DOMINIQUE INGRES.
The Bather of Valpinçon.
1808. Oil on canvas, 56¾
× 38¼″. The Louvre, Paris.

and his more overtly seductive *Turkish Bath* and *Grande Odalisque*. As a curious footnote, Ingres, a rather proper gentleman in the public domain, was reputed to be a good classical violinist. Ever irreverent, *Le Violin d'Ingres* pokes fun at Ingres, his music, and his art.

A second meaning of the work relates to Man Ray himself. The model for the work was the celebrated Kiki de Montparnasse, Ray's mistress in Paris for six tempestuous years. Was Kiki also Man Ray's violin, the instrument of his own life's song and art? Or was the exotic image conveyed by Kiki an unattainable fantasy, realizable only in art or dreams?

7.37 • HERBERT BAYER. *Lonely Metropolitan*. 1932. Gelatin silver print. 13⅜ × 10½". Museum Folkwang, Essen, Germany.

Surrealist images can rarely be pinned down completely, although, like dreams and fantasies, they inspire and are open to interpretation. *Lonely Metropolitan* (7.37) is such an enigmatic image. It is a photomontage by Herbert Bayer (born 1900), an Austrian who was a principal instructor at the Bauhaus during the 1920s. Fleeing the nazis, Bayer later became a famous graphic designer in the United States. In this work of 1932, two eyes, one light and one dark, with eyebrowlike forms above them, are superimposed on the palms of a pair of hands, one of which is dark and the other light. The sleeve beneath the lighter hand (containing the darker eye) is darker than its mate, one more irrational relationship in an image that nonetheless has an unsettling unity. Proportionally larger than the windows of the building on which they cast their shadows ("proof" of their reality), the hands reach upward with their palms facing the picture plane. As we look at the image for a while, the hands become a face, a startling "double image" whose precise meaning eludes us.

The title refers to the general condition of urban loneliness, but the photo may also convey some of Bayer's own sense of alienation and foreboding following the closing of the Bauhaus in Dessau by pro-nazi authorities, resulting in the gradual breakup and scattering of a close-knit artistic community. The setting is desolate: two adjacent apartment buildings with no people in sight. The "lonely inhabitant" floats disconnected and rootless in space. It seems to stare with a look that is hard and cold. And while no one rational meaning is possible, the image haunts the viewer. The static singular viewpoint of reproductive photography has here given way to a dynamic multiplicity of views and meanings. The medium of montage, the artist notes, "makes images of a surreal character, of the impossible and the invisible, possible." The photomontage, Bayer says, "has been compared to a conquest of the irrational, it can express the hallucinations of dreams." The great power of the photomontage to connect with the subliminal self has not gone unexploited. We now see it everywhere, in attention-grabbing advertisements, evocative album covers (2.21), and the like.

7.38 • JERRY
UELSMANN. *Untitled
(Cloud Room).* 1975.
Toned gelatin silver print.
Courtesy the artist.

Influenced by surrealism, Jerry Uelsmann (born 1934) is one of a group of photographers who since the 1960s has employed montage to create poetic fantasies. Pieced together from an array of his own negatives, Uelsmann's works achieve a seamless transition between real and imagined space and events. *Untitled (Cloud Room)* (7.38) is a wondrous interweaving of an enclosed room and nocturnal sky, both seemingly illuminated by the central table lamp. In such a work, as in dreams, the impossible and contradictory fit together in a baffling unity. None of the mechanical or mimetic qualities customarily associated with photography remain in this astonishing landscape of the imagination.

Surreal Cinema. In 1929, painter Salvador Dalí and Spanish film director Luis Buñuel (born 1900), premiered the most famous of

istence. As painters, photographers, filmmakers, and creators of documentaries for television, artists of social realist motivation share the broad humanistic goal of helping humanity and society to see itself, but with a political twist: they side with the underdogs and underrepresented of society. In this sense, social realism has always had an ideological orientation, being associated with the goals of the political left. Its goal is to document the trials and triumphs of "common people," the underprivileged, and the oppressed.

In the noncommunist world, the imagery of social realists has tended to honor working-class people and expose social injustice to promote political reform. It comes as no surprise, therefore, that social realism in the United States evolved into a full-scale art movement during the catastrophic years of the Depression. Socially concerned artists, working in a variety of styles—note how Ben Shahn's poster, *Dust* (7.41), combines realism and expressionism—sought to bear witness to unemployment, drought, hunger, and homelessness and were often supported by the federal government to do so. In the most extensive social welfare program in American history, the Roosevelt administration's New Deal, hundreds of thousands of unemployed men and women were put back to work on much-needed projects, ranging from the building of hydroelectric dams to farm relief. The federal government also employed artists to create socially meaningful paintings, photographs, films, prints, posters, and sculpture.

The purpose of such art ranged from inspiring a sense of pride and participation in one's work, community, cultural background, and the democratic political system to critically documenting harsh Depression period conditions so as to promote progressive reform. Of the many thousands of art works produced for the American government and people, hundreds have been preserved. The most public of these works are probably the murals celebrating the work of farmers or factory workers. Such murals cover the walls of post offices and government buildings in small towns and large cities throughout the United States.

It was in this context that the Historical Section of the Farm Securities Administration, known popularly as the F.S.A. project, got under way. Headed by Roy Stryker (1893–1976), a former teacher of economics at Columbia University, the project brought together a gifted group of photographers, including Dorothea Lange (1895–1965), Arthur Rothstein (born 1915), and Ben Shahn (1898–1969). Their immediate job was to document the working and living conditions of displaced farmers who had suffered the double disaster of economic depression and drought, and, when possible, to portray the more positive aspects of rural life. Their pho-

7.41 • BEN SHAHN. *Years of Dust.* 1936. Offset lithograph. 38 × 25″. New Jersey State Museum. Gift of the New Jersey Federation of Women's Clubs, Junior Membership Department. Courtesy Mrs. Ben Shahn.

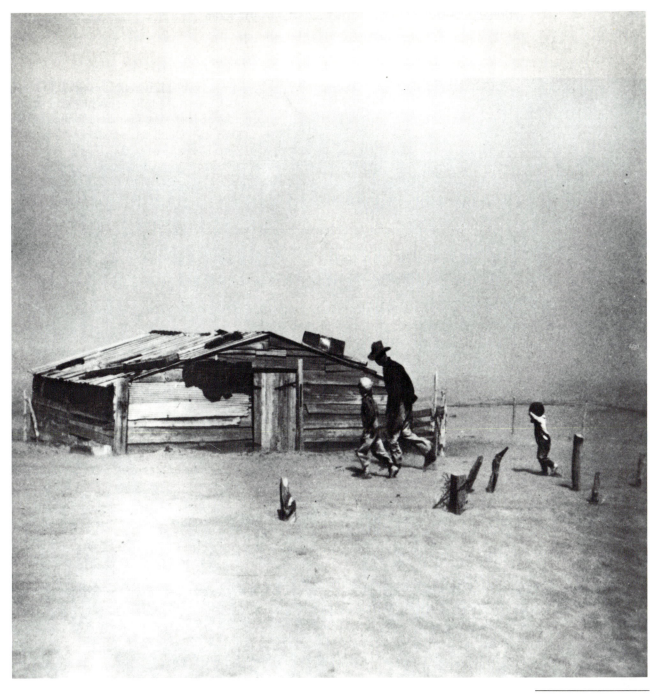

7.42 • ARTHUR
ROTHSTEIN. *Fleeing a
Dust Storm, Cimarron
County, Oklahoma*. 1937.
Gelatin silver print. Library
of Congress, Washington,
D.C.

tographs, and those of masterful photo-journalists such as *Life* magazine's Margaret Bourke-White (1904–1971), gave to subsequent generations a lasting "picture" of the Great Depression and its great underclass. The photographers more than any other group of artists, made visible the suffering and injustice experienced by the displaced and unemployed so that legislators and the more affluent public might be stirred to relieve their plight.

Although the F.S.A. photographers used different approaches to produce their portraits of the period, all the diverse images, in the end, shared one crucial quality: documentary truthfulness. Some of the portraits were posed—"fakery in the service of truth" as a documentary filmmaker put it—while others, particularly those of Shahn, were candid snapshots of unposed immediacy. Of all the many compelling images taken, some 270,000 in all, probably the two most famous are Arthur Rothstein's *Dust Storm* (7.42) and Dorothea Lange's *Migrant Mother* (7.43). They have become icons of the Depression.

7.47 • VITTORIO DE SICA. *The Bicycle Thief.* Father and son search in vain for the family's stolen, and badly needed, bicycle. 1948. PDS-Enic/ Umberto Scarparelli. The Museum of Modern Art/Film Stills Archive.

us the good ones and the bad ones of this world—in actuality, giving us close-ups of those who make their neighbours' bread too bitter, and of their victims, if the censor allowed it." Zavattini and the directors he worked with did not provide the Italian masses with escapist entertainment. Socially concerned realists, they mirrored in their films the little joys and large sorrows of a scarred and struggling nation in the post–World War II years. Committed to objective truthfulness, they shot their films on location in working-class neighborhoods, employed neighborhood people along with professional actors, and told their stories in a straightforward, naturalistic style. The Italian neorealist cinematographers were to Italy what the Farm Securities Administration photographers had been

to North America during the Depression: they captured an era, touched the national conscience, and helped to foster much-needed social reform.

Formalism: Emphasis upon Visual Form. All photographs, films, and video works are really "formalist" to a substantial degree in that, above and beyond the choice of subject matter, each work requires innumerable formal decisions: about lighting (natural, artificial, high or low contrast); definition ("soft" or "sharp" focus); texture ("smooth" or "grainy"); framing (close-up, medium shot, wide angle); editing (fast-paced; leisurely or accelerating rhythms), and so forth. A great film classic like *Citizen Kane,* for example, is the product of innumerable formal decisions made by a host

7.48 • ALFRED
STIEGLITZ. *The Steerage.*
1907. Photogravure.
18⅛ × 12½″. The Los
Angeles County Museum of
Art. Museum Library
Purchase, 1965.

of individuals working on their own and in collaboration (Appreciation 12). Most of the finest media creations of social realism, expressionism, and surrealism are expressive, evocative, or communicative because they are effective from a formal standpoint. Only through articulate use of the language of visual form does the artist's content (for instance, an every-day event, emotional state, or fantasy) come alive.

Alfred Stieglitz's **The Steerage.** This inter-weaving of artistic form and content is evident in Alfred Stieglitz's famous 1907 photograph, *The Steerage* (7.48). At first glance, many might judge the primary concern of *The*

punctuates Kane's blindly ambitious political campaign? What would the movie be like without the imposing sets for Kane's gargantuan pleasure palace, Xanadu? How much credit for the music and sets belongs to Welles? How much to Hermann and Polglase?

All this commentary is not meant to take away from Welles's genius as a filmmaker. But it does dispute the *auteur* theory: that movies are made by one person, the director. Movie making is a group effort. Everyone contributes. *Jaws* may be a Steven Spielberg movie, but Peter Benchley wrote the story, and John Williams, the composer, gave us the unforgettable music that we hear in our heads every time we swim in the ocean. *Fanny and Alexander* may be Ingmar Bergman's most beautiful film, but would it even have been "Bergman" without the cinematography of Sven Nykvist?

When the credits roll, let's give credit where credit is due. ∎

F • Kane's symbolic walk into solitude. Xanadu has become his prison.

H • Kane with Teddy Roosevelt in the realistic "newsreel" footage.

G • The camera's low angle emphasizes Kane's obsession with power.

I • The opera set—an overblown spectacle that matches Kane's career.

Steerage to be social realist documentation, and to a significant degree that judgment is correct. Yet the formal structure of this photograph is what makes the subject matter so compelling and the image so enduring, and this, too, should be appreciated. *The Steerage* is a good example of what artist Ben Shahn called "the shape of content," the indissoluble synthesis of form, subject matter, and personal vision in successful works of art.

Stieglitz's own account of the genesis of *The Steerage* sheds light on this interrelationship of form and content. On a trip to Europe aboard a luxurious ocean liner, Stieglitz found himself surrounded by newly rich people he did not like. He hated the atmosphere of the fashionable first-class section. On the third day out, longing to escape, he went as far forward on the ship as he could and came upon the steerage section reserved for the poorest passengers. What met his eyes was remarkable: a ready-made work of art, waiting to be photographed. His words convey the excitement he felt before the scene.

> A round straw hat, the funnel leaning left, the stairway leaning right, the white draw-bridge with its railings made of circular chains—white suspenders crossing on the back of a man in the steerage below, round shapes of iron machinery, a mast cutting into the sky, making a triangular shape. I stood spellbound for a while, looking and looking. Could I photograph what I felt, looking and looking and still looking? I saw the shapes related to each other. I saw a picture of shapes and underlying that the feeling I had about life. And as I was deciding, should I try to put down this seemingly new vision that held me—people, the common people, the feeling of ship and ocean and sky and the feeling of release that I was away from the mob called the rich—Rembrandt came into my mind and I wondered would he have felt as I was feeling.[14]

Stieglitz ran to his cabin for his camera. Racing back again all out of breath, he discovered that his passionate hope had been miraculously fulfilled. "Seemingly no one had moved." Had anyone substantially changed position, Stieglitz wrote, "The relationship of shapes as I wanted them would have been disturbed and the picture lost." Amazed and with heart thumping, he snapped the photograph, a masterpiece "based on related shapes and on the deepest human feeling."

7.49 • PAUL CÉZANNE. *Turning Road at Montgeroult.* 1898. Oil on canvas. 32 × 25⅝". Courtesy Mrs. John Hay Whitney, New York.

Most often in works of art, a balance is struck between the concerns of form and content. However, in certain works, especially in the modern period, one becomes aware that formal concerns outweigh or even eclipse social or psychological ones. An artist of strong formalist persuasion does not view or portray a subject—a person, factory, or flower—in terms of its social or psychological meanings but rather for its abstract visual qualities. In 1890, the post-impressionist painter Maurice Denis stressed, "It is well to remember that a picture—before being a battle horse, a nude woman, or some anecdote—is essentially a plane surface covered with colors assembled in a certain order." This formalist rationale has informed much of the abstract art of the twentieth century. In the post-impressionist work (7.49) of the French painter Paul Cézanne

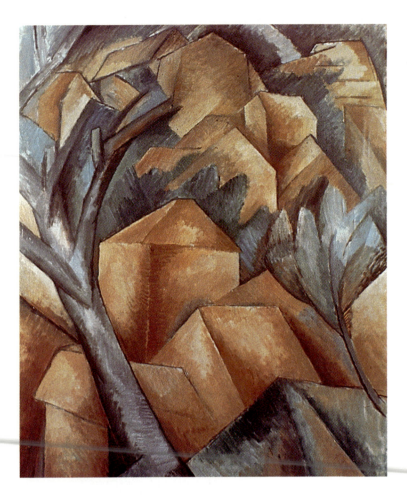

7.50 • GEORGES BRAQUE. *Houses at L'Estaque.* 1908. Oil on canvas. 28½ × 23". Kunstmuseum, Berne. Hermann and Margrit Rupf Foundation.

(1839–1906), for example, **cubist** artists like Georges Braque (1882–1963) found a precedent for their increasingly abstract visions of the physical world (7.50). The cubists and fellow **formalist abstractionists** pursued and valued light, shape, color, and composition for their own sake. The noted English art critic Clive Bell (1881–1964) perhaps summed it up best in a 1913 essay. The transcendent goal of art, Bell wrote, was the creation of "significant form." Significant form alone—"lines and colors combined in a particular way, certain forms and relations of forms"—could transport the viewer to the highest spiritual states of human experience, which the critic equated with "esthetic" feeling. For Bell, everyday subject matter was commonplace and troublesome; it got in the way of the far more exalted perception of pure form. For this modernist critic, only significant form possessed the power to "stir our esthetic emotions."

Drawing on the formalist sensibility pioneered by the early modernist painters and critics, photographers like Edward Weston (1886–1958), Charles Sheeler (1883–1965), and Aaron Siskind (born 1903) came to love and look for significant form in the world around them. In Weston's photographs, all forms of physical reality—the California seacoast, a nude, a vegetable—take on a highly abstract, extraordinary quality. Commonplace subject matter undergoes an aesthetic or formalist transformation. A halved artichoke ceases to be an artichoke (7.51) but becomes a fascinating play of light, texture, and shape. A nude woman ceases to be an individualized human being and becomes a sculptural object of detached, impersonal beauty (Appreciation 13). The same holds true for the extreme closeups of Aaron Siskind, in which sections of walls become wondrous abstract compositions (7.52). On a far larger scale, Charles Sheeler's

7.51 • EDWARD
WESTON. *Artichoke,*
Halved. 1930. Gelatin
silver print. © 1981 Arizona
Board of Regents. Center for
Creative Photography,
Tucson.

7.52 • AARON SISKIND.
Untitled. Chicago, 1948.
Gelatin silver print.
Courtesy the artist.

paintings and photographs (7.53) strip from industrial architecture and design their usual economic, social, and psychological associations. In his industrial landscapes, Sheeler emphasizes the artistic interplay of smooth surfaces, clean lines, and geometric shapes.

Such an abstract, formalist vision of industry stands in sharp contrast to that of a social realist, expressionist, or surrealist artist dealing with the same subject. In *Smoky City* (7.54), for instance, photo-journalist W. Eugene Smith (1918–1978) makes his message of

7.53 • CHARLES SHEELER. *Untitled.* 1928. Gelatin silver print. Gilman Paper Company, New York.

7.54 • W. EUGENE SMITH. *Smoky City* (*Untitled*, from "Pittsburgh" series). 1955–1956. © The Heirs of W. Eugene Smith/Black Star.

7.55 • MICHELANGELO
ANTONIONI. *The Red
Desert*. Mother and child
dwarfed by the industrial
landscape. 1964. Film
Duemila/Cinematografica
Federiz (Rome)/Francoriz
(Paris). The British Film
Institute, London.

harmful industrial pollution loud and clear.
Here the form is effective but understated,
serving the picture's reason for being: its social
content. In the cinematic images of *The Red
Desert* (7.55), a film by Italy's Michelangelo
Antonioni (born 1912), the view of the in-
dustrial landscape is more multidimensional,
the director's formalist, realist, and expression-
ist inclinations blending inextricably. Anto-
nioni's vision of industry is formally beautiful
but also psychologically and socially unset-
tling. The world of industry is presented as
fascinating in its artistic form and technolog-
ical achievement yet ominous in its capacity to
dehumanize all who are enmeshed in it.

ART, NEW MEDIA, & MASS MEDIA: RELATIONSHIPS IN FORM & CONTENT

The relationship between traditional art me-
dia, such as painting and sculpture, and the
newer media of photography, film, and video
continues to be dynamic. As we advance to-
ward the twenty-first century, it is apparent
that the newer media are having an increasing
impact on traditional fine art, both in its crea-
tion and appreciation. An obvious example of
the influence of the newer media on the older
media is the uncanny **photorealism** of artists
such as Richard Estes (born 1936) and Chuck

7.56 • RICHARD ESTES. *Supreme Hardware.* 1973. Oil and acrylic on canvas. 40 × 66¼″. High Museum of Art, Atlanta. Gift of Virginia Carroll Crawford, 1978.

Close (born 1940). Their paintings are based directly on photographs: Estes makes cool, detailed portraits of peopleless urban landscapes (7.56), and Close paints huge (nine feet high by seven feet wide) meticulous close-ups of people's faces (11.39). The **superrealistic** sculptures of Duane Hanson (born 1925) and John Andrea (born 1944) have a kinship with the absolute mimesis made possible by photography, film, and video. When placed in real-life settings, Hanson's sculptures (7.57) have actually fooled onlookers, who walk up to these mute beings to ask questions or make requests. Starting with a plastic body cast made from plaster body molds of actual people, the artist proceeds to paint his figures in lifelike fleshtones. He then adds human hair, and real clothing and accessories. The results are superreal sculptures that take the already extreme realism of ancient Rome's *Phillipus the Arab* (7.1) a giant step further.

In the realm of **pop art,** many of best known images (2.19, 11.35) of Andy Warhol (1928–1987) have been made from mass-media photographic images transferred to paper or canvas by photoprinting processes.

7.57 • DUANE HANSON. *Self-Portrait with Model.* 1979. Polyvinyl, polychromed in oil. Lifesize. Courtesy O. K. Harris Gallery, New York.

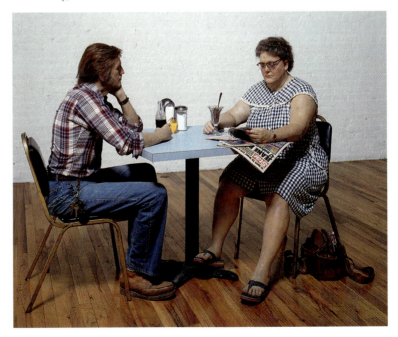

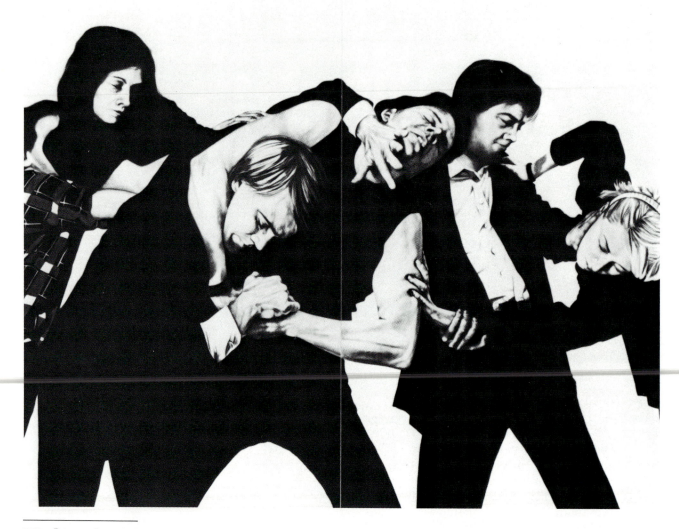

7.58 • ROBERT LONGO. *Untitled (White Riot Series)*. 1982. Charcoal, graphite, and ink on paper. 8 × 10′. Courtesy Eli and Edythe L. Broad, Santa Monica, Calif.

Robert Longo (born 1953), likewise, has based his **neoexpressionist** works on photographs. To create his 1982 *Untitled (White Riot Series)* (7.58), he projected photographic slides of middle-class men and women locked in struggle onto a huge sheet of paper, eight feet by ten feet. Longo and an assistant then executed the finished picture in charcoal, pencil, and ink. Art historian H. H. Arnason makes this connection:

> As a resident of a loft district near New York's Wall Street [financial district], Longo has been a regular witness to "the pressures of modern life," in which upscaling men and women, like those in glossy ads, engage in never-ending "corporate wars." The artist has made their *Toten-*

tanz [dance of death]—the energy, aggression, and hostility that seethe behind bland, buttoned-down exteriors—still more explicit in the White Riot series, where middle-class types, dressed in nine-to-five wear, join in an orgy of pushing and pulling, not unlike that seen every day on the floor of the New York Stock Exchange.[15]

A mixed media innovator, Robert Rauschenberg (born 1925) has incorporated photographic imagery from newspapers and magazines in collagelike "works of art" (2.20, 11.27) that interweave the form and content of the mass media with a traditional **abstract expressionist** painting style. Also employing a collage approach, photographer Barbara Kruger (born 1945) appropriates images from

newspapers and magazines. She then takes apart and transforms—deconstructs and reconstructs—the original meaning of the images, adding text, in order to make forceful comments on media and cultural stereotypes. On a strictly visual level, Kruger's large black-and-white photomontage, *We Won't Play Nature to Your Culture* (7.59), is startling and surreal. It grabs one's attention just as successful mass-media advertisements do. The head of an attractive young woman, her eyes covered by leaves, fills three quarters of the picture frame. Behind her appears to be a blurred natural landscape. The woman's head

is upside down and tilted diagonally. We, the viewers, tower above her in a dominating position of power. Dramatically posed and lit, this image works somewhat as an exotic perfume advertisement or traditional painting of an alluring nude (9.18, 9.19) does, one that employs the stereotype of a beautiful, mysterious, sensual woman who attracts and then fulfills a man's desires. Adding text, the meaning of the work becomes more specific as a telling feminist critique. Women are stereotypically associated with nature (for instance, fertility, sensuality, the irrational, mystery), whereas men are stereotypically associated

7.59 • BARBARA KRUGER. Photomontage from *We Won't Play Nature to Your Culture.* 1983. 6′ 1″ × 4′ 1″. Courtesy the Institute of Contemporary Arts, London; the Kunsthalle, Basel; and the Mary Boone Gallery, New York.

From Renaissance to Revolution:
The Fine Arts of Painting & Sculpture

THE RENAISSANCE:
THE BIRTH OF FINE ART
& "THE ARTIST"

Our modern notion of "fine art" as an exalted pursuit has its roots in the Italian Renaissance. It did not exist in the ancient world, where painting and sculpture were considered mere "mechanical arts" of the same lowly status as the manual labor of carpenters or stone masons. Nor did the concept of fine art exist in the European Middle Ages or early Renaissance, during which the ancient association of painting and sculpture with the mechanical arts persisted. In this context, those who possessed such skill (that is, "art" or "craft") in a manual trade became known as "artisans" or "craftspersons"; and it was to this class of skilled workers, from carpenters to shoemakers, that painters and sculptors initially belonged (8.1). (Paradoxically, the work of these artisans and craftspersons was often accorded a relatively high sociocultural status, but the creators themselves were not.)

Our contemporary concepts of fine art and "the artist" (that is, the fine artist) did not begin to develop until the late Middle Ages and early Renaissance, when sculptors and painters such as Lorenzo Ghiberti (1378–1455) and Leonardo da Vinci (1452–1519) began seeking a higher sociocultural status for their professions. The ensuing struggle for status of the more eminent painters and sculptors was accompanied by a steady loss in power and prestige of the craft guilds, the protective trade associations to which painters of altarpieces or church walls and sculptors of religious statuary or pulpits had belonged for centuries. Influential throughout the Middle Ages, the craft guilds had protected local workers from foreign competition, provided social support, set standards of workmanship, and determined wage scales and rates. But now their power was in decline, steadily reduced by the rising commercial class of bankers, merchants, and factory owners, opponents of the "minor" guilds' restrictions on the free flow of capital and labor.

The result, by the end of the fifteenth century, was an economy in which individual painters and sculptors, increasingly free from guild protection and restraints, had begun to

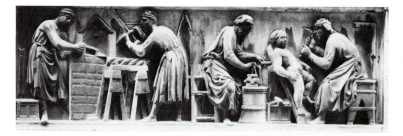

8.1 • Nanni di Banco. *Sculptor's Workshop.* 1408–1414. Marble. San Michele, Florence.

8.2 • Leonardo da Vinci. Architectural perspective and background figures for *The Adoration of the Magi.* *ca* 1481. Pen and ink. 6½ × 11½″. Gabinetto dei Disegni e Stampe, Galleria degli Uffizi, Florence.

compete for artistic commissions. This development might be described as the beginning, however rudimentary, of an "art market." Private patronage from the middle class and aristocracy came to rival the public patronage of church and state. The growth of artistic commissions subsequently enabled the most talented, ambitious painters and sculptors to attain a fame and fortune previously unimaginable.

Wanting to end what they now considered a demeaning relationship with the handicraft guilds, and desiring to terminate their cultural association with skilled artisans such as carpenters and stone masons, the most presti-

gious painters and sculptors of the fifteenth and sixteenth centuries took up the argument that their arts required substantial intellectual knowledge, not technical skill alone. In the early Renaissance, as early as 1440, the idea of the intellectual artist was promoted by the prominent Florentine goldsmith, painter, and sculptor Ghiberti, who wrote that sculptors and painters "should be trained in all these liberal arts: Grammar, Geometry, Philosophy, Medicine, Astronomy, Perspective, History, Anatomy, Theory of Design, and Arithmetic." Ghiberti indeed needed knowledge of such liberal disciplines as perspective (8.2), anatomy, and history (of religion) to create the sculptural relief depicting Jacob and Esau (8.3), one of the panels of his famous cast bronze doors of Florence's baptistery in the city center. Because of these artists' broad intellectual background and their technical expertise in several areas, later centuries would praise the multitalented geniuses of the early Renaissance—Ghiberti, Brunelleschi, Alberti—and the giants of the later "high" Renaissance—Leonardo, Michelangelo, Raphael, Titian—as "universal" or "Renaissance

8.3 • LORENZO GHIBERTI. *Jacob and Esau.* Panel of *The Gates of Paradise* from the Baptistery doors, Florence. *ca* 1435. Gilt bronze. 31¼" square.

men." Yet in their own time, these aspiring male artist-intellectuals had to lead the struggle, through their arguments and their art, for greater respect from the leading classes.

Linking painting and sculpture with the esteemed liberal arts—the "liberal" arts were those intellectual disciplines freely pursued by the "free man" of the clergy, aristocracy, and bourgeoisie—seemed the best strategy. Gaining this status for their art would enable male painters and sculptors to break from their past working-class affiliation and establish a new identity as part of the educated elite. In their struggle for greater prestige and recognition, they had to sever this old association with the "mechanical arts."

A genius in science and engineering as well as painting, Leonardo da Vinci (8.4) made the boldest case for the painter's art. He went so far as to claim that painting was equal and even superior to the various scientific disciplines, all acknowledged from ancient times as respected liberal arts. To begin, Leonardo asserted, painting encompasses many sciences. It requires knowledge of anatomy, optics, and mathematics. Perspective in painting, the artist insisted, is simply the application of mathematics to spatial configuration. Furthermore, painting combines these scientific disciplines in "an act of creation," thus making painting superior to science. Leonardo then proceeded to poetry, another long acknowledged liberal art. Painting, he argued, was superior to poetry as well. Although both disciplines are based on the imitation of nature and are concerned with ethical instruction, painting is the more effective of the two. It can better instill a moral lesson because of its immediate visual

8.4 • LEONARDO DA
VINCI. *Self-Portrait.*
ca 1512. Red chalk.
33.3 × 21.4 cm. Biblioteca
Reale, Turin, Italy.

impact and ability to make these moral situations more real. A fine painting of Christ's last supper (8.5), Leonardo might have contended, would affect the beholder more profoundly than a poem on the same subject. As he put it, "Write up the name of God [Christ] in some spot and set up His image opposite and you will see which will be most reverenced. Painting comprehends in itself all the forms of nature, while you [poets] have nothing but words, which are not universal, as form is. . . ." Painting was no mere "mechanical" art, but an exalted activity in which "the painter strives and competes with nature" itself.

Raphael: The Artist as Intellectual and Gentleman. In the large wall painting *The School of Athens* (8.6) by Raphael Sanzio (1483–1520), the painters, sculptors, and architects have scaled the heights of the liberal arts. They stand beside the most learned philosophers, scientists, and poets of ancient times. Moreover, it is believed that several of the great artist-intellectuals of the high Renaissance—Leonardo, Michelangelo, the architect Bramante, and Raphael himself—were models for four of the learned personages portrayed in the work. This was certainly a bold symbolic

8.5 • LEONARDO DA
VINCI. *The Last Supper.*
ca 1495–1498. Oil-tempera on wall. 13′ 10″
× 29′ 7½″. Santa Maria
delle Grazie, Milan.

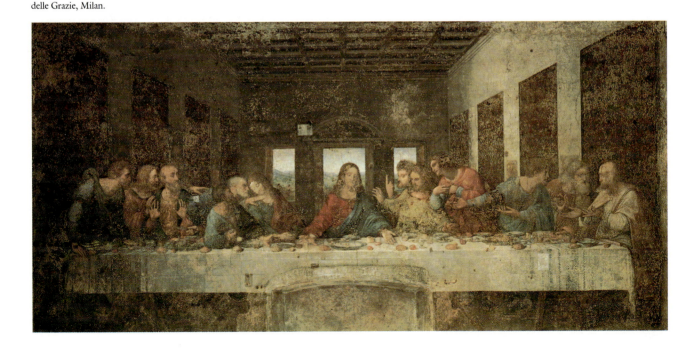

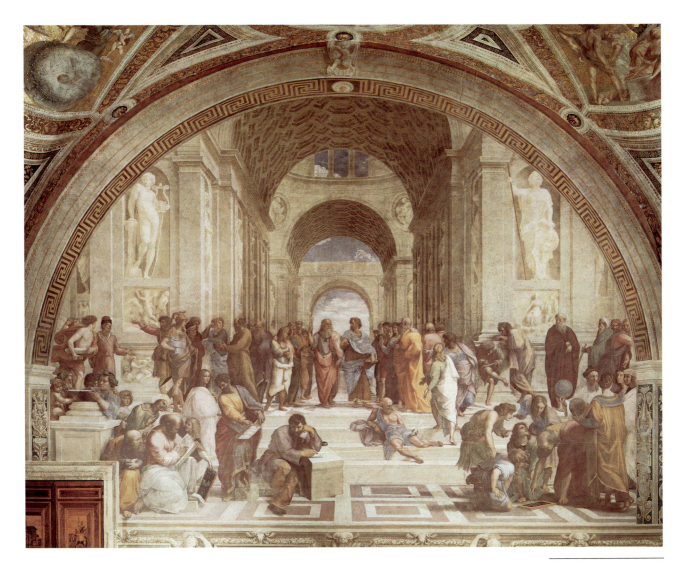

8.6 • RAPHAEL. *The School of Athens*. Fresco. 18 × 26'. 1510–1511. Stanza della Segnatura, Papal Apartments, the Vatican, Rome.

assertion of the rising sociocultural status of these men.

In the center of the painting stand the two foremost philosophers of antiquity, Plato and Aristotle. They are situated within a grand classical structure thought to be derived from Bramante's contemporary plans for the rebuilding of Saint Peter's and reminiscent of the ancient Roman Basilica of Maxentius (6.11). Plato, the idealist, points upward to the realm of spirit, the source of metaphysical ideas and divine inspiration. In a niche above him and to his right is the commanding statue of Apollo, the god of high places, associated with poetry and transcendent thought. To Plato's right we find the famous poets and philosophers of ancient times: the garlanded Epicurus, reading a book, and Pythagoras, writing about and demonstrating his theory of proportion. Other philosophers look on, among them the turbaned Moorish mathe-

matician Averroes. Many have proposed that the figure of Plato is an idealized portrait of Leonardo da Vinci whose art and views on art Raphael clearly admired. Indeed, the younger painter may have drawn inspiration for his more complicated *School of Athens* from Leonardo's own wall painting, *The Last Supper*. There certainly are some basic similarities: the placement of figures within an overarching architectural setting, the employment of a one-point perspective system that focuses attention on the central figures, the representation of the protagonists in expressive poses and gestures that convey their innermost thoughts, the intertwining of participants and groups to produce a unified dramatic whole.

Walking beside Plato and sharing center stage in *The School of Athens* is Aristotle. Thirty years younger than his teacher, Aristotle is more interested in the practical functioning of the natural and political world. He holds out

8.7 • RAPHAEL. Detail of
Ptolemy, Euclid, Raphael,
and Sodoma from
The School of Athens.

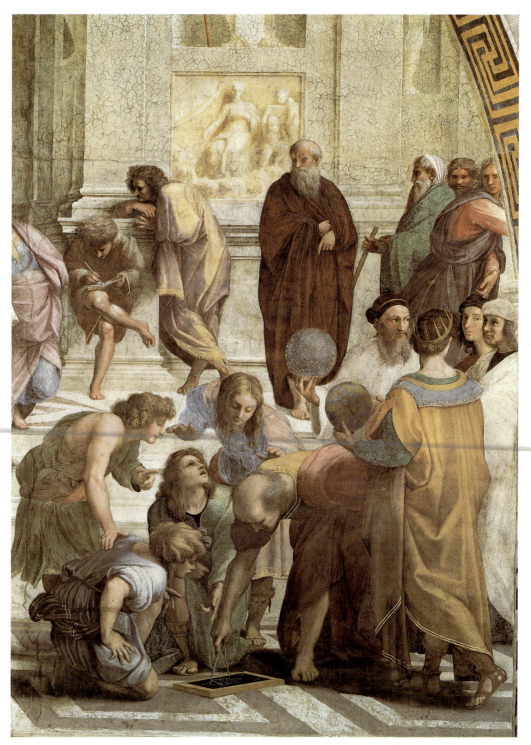

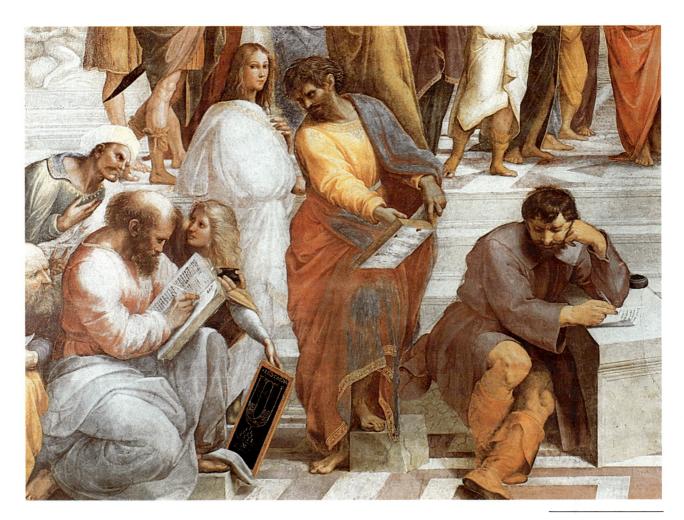

8.8 • RAPHAEL. Detail of Pythagoras, Averroes, and Heraclitus (Michelangelo) from *The School of Athens.*

his hand with the palm facing downward, perhaps to bring his master's soaring idealism back to the earth and the realm of the possible. The statue to Aristotle's left represents Athena, goddess of reason. In keeping with this emphasis on reasoning, physical scientists—men who apply reason to worldly activity—occupy this half of the painting: the astronomer Ptolemy, holding his celestial sphere, and the geometer Euclid, holding a compass and bending over a problem in geometry (8.7). The model for Euclid is Raphael's friend, the architect Bramante (*ca* 1444–1514), for whom the science of geometry would have been essential. Behind Bramante, on the extreme right, the handsome face of the twenty-six-year-old Raphael looks out at us. Next to him is another friend, the painter Sodoma (1477–1549). In front and just to the left of center on the steps is another artist: a large,

brooding, and solitary presence. Reputed to be the ancient philosopher Heraclitus, this figure is a melancholic portrait of Michelangelo. Fittingly, he wears the short, hooded smock and soft boots of a sixteenth-century stonecutter (8.8). The greater bulk and tension embodied in this figure and its last-minute integration into the work are said to have been inspired by Raphael's visit to the nearby Sistine Chapel, where the moody and secretive Michelangelo was in the second year of labor on his vast ceiling fresco. There Raphael must have been moved by the giant painted figures, superhuman in size and power. The inspiration for the Michelangelo figure may have come directly from Michelangelo's sibyls, prophetesses of Greek mythology, and his Old Testament prophets. Forerunners of Christianity, the sibyls and prophets are the fresco's largest figures. They ring the seven central

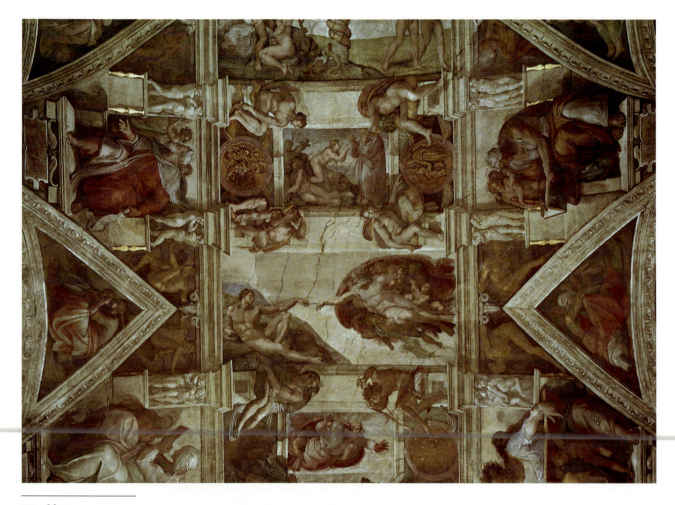

8.9 • MICHELANGELO. Ceiling fresco from the Sistine Chapel. 1511. Detail of the "Creation of Adam" and surrounding Sibyls (Persica and Cumaea) and Prophets (Daniel and Ezekiel). The Vatican, Rome.

8.10 • RAPHAEL. *Baldassare Castiglione.* *ca* 1515. Oil on canvas. 32¼ × 26½". The Louvre, Paris.

scenes of the ceiling, including the one in which God the Father electrifies heaven and earth in *The Creation of Adam* (8.9).

On the walls of the papal apartments, Raphael placed several of the finest contemporary painters, sculptors, and architects alongside the most revered ancient practitioners of the liberal arts. The symbolic message is clear: painters, sculptors, and architects are worthy of the same high status that scientists, philosophers, and writers had long been accorded. In the real world of sixteenth-century Italy, this was, in fact, proving to be the case: the most celebrated artists were joining the elite of society. Already working for popes and princes, certain painters, sculptors, and architects were beginning to live and travel in the highest social circles. Among Raphael's closest friends in Rome was the Count Baldassare Castiglione (1478–1529) (8.10), a noted diplomat and man of letters. Castiglione wrote the famous

book, *The Courtier* (1528), which prescribed correct behavior for the noble Renaissance gentleman and furthered the idea that upper-class women should be educated and trained in the arts.

In much of Raphael's art, including his portrait of the count, the values later preached in *The Courtier* found visual form. The art historian Frederick Hartt writes that the count's cool composure exemplifies the inner calm essential to the gentleman's character. "The black, white, and soft gray of the costume," he writes, "embody the elegant sobriety and restraint successfully preached by Castiglione. . . ." This integration of classical order and harmony with coloristic resonance and human depth, manifested in both *The School of Athens* and the Castiglione portrait, won for Raphael centuries of praise as the supreme painter and gentleman-artist of the high Renaissance. A supreme compliment was paid to the Castiglione portrait in the next century by the great Dutch painter Rembrandt. Perhaps the finest portraitist ever, Rembrandt tried unsuccessfully to buy the work at auction and, never forgetting it, did two portraits of himself in the pose of the count and in the general style of Raphael's portrait.

Michelangelo: The Artist as Heroic Genius. Unlike the sociable Raphael, whom he saw as a rival, Michelangelo Buonarroti (1475–1564) was far from a graceful cavalier. A loner who lived in shabby quarters and dressed like the poorest of workmen, Michelangelo possessed a volcanic pride and most ungentlemanly temper. On occasion, he rebuked the popes themselves. Once he combatively broke off a papal commission from the warlike Julius II and went into hiding, risking the possibility of torture or imprisonment. The next pope, Leo X, was an art lover who showered commissions on the genial Raphael but protested of Michelangelo, "He is too intense; there is no getting on with him." But Michelangelo's genius was so universally acknowledged that commissions from society's rulers—from Roman popes to Florentine merchant-princes—poured in, chaining the artist to scaffold or stone for years.

In this role as the executor of the projects of others, Michelangelo was not entirely the self-directed artist, free to determine a personal course of action, as contemporary fine artists do. Although the Renaissance artist's individual genius or style might be valued, and the genius of Michelangelo was valued exceedingly, it was the patron who usually determined the general subject matter, message, medium, material, and size of the work. A legal contract was drawn up relative to these matters, and the bill was paid only when the contractual conditions were met.

Over the course of his long life, Michelangelo worked mainly for the popes, but secular authorities also commissioned the artist. One of the most famous works of his young manhood was created for his home city of Florence. There he carved the huge statue of *David* (8.11), about fourteen feet high, at the request

8.11 • MICHELANGELO. *David.* 1501–1504. Marble. Height of figure, 13′ 5″. Galleria dell'Accademia, Florence.

282

8.12 • MICHELANGELO.
Pietà. ca 1499. Marble.
Height, 5′ 8½″. Saint
Peter's, the Vatican, Rome.

of the city government. As a public outdoor sculpture, it represented the proud independence of the Florentine republic, free from the control of local tyrants or foreign imperialists like the French or Milanese. His friend and biographer Vasari, probably paraphrasing Michelangelo, describes the political intent of the sculpture this way: "As David defended his people and governed with justice, so should this city be defended with courage and governed with justice."

Outwardly, the nude body of the *David* is of a classical beauty and calm grandeur. Yet within, inside the torso, arms, and legs, and in the young man's expression, a vigorous energy swells. Tension awaits release. David's brow is knit. His eyes glare; an early instance of the titanic power, called *terribilità* in Italian,

that filled Michelangelo's subsequent works. This "terribleness" is already evident in David's glowering expression of fierce confidence. The eyes seem to emit thunderbolts, shot out defiantly at any oncoming Goliath who might dare threaten the republic. In its original setting on the square outside of the Palazzo Signoria, the palace of the city's governors (*signorie*), the *David* for centuries served as political art to stir the Florentine public. Only in the nineteenth century, for reasons of preservation, was it moved to a specially designed Renaissance-style interior in the gallery of Florence's Academy of Fine Arts.

In the *David*, Michelangelo's *terribilità* is tempered by his passion for the beauty of the nude male body. The same holds true of his powerful figures of God and Adam in the fa-

mous *Creation of Adam* (8.9) from the Sistine ceiling. Adam, in fact, recalls a slumbering David just rising to life. Inspired by a mixture of classical, humanist, and Christian values, the artist had a lifelong love affair with human beauty. An early work, the *Pietà* (8.12), commissioned in 1498 by Cardinal Villiers, the French ambassador to the Vatican, shows this love of physical beauty minus the *terribilità*. For the young Michelangelo, beauty is the Neo-Platonic reflection of the divine in the physical world. A gifted poet, Michelangelo wrote these verses at the dawn of the new century:

> He who made the whole [universe] made
> every part;
> Then from the whole chose what was most
> beautiful,
> To reveal on earth, as He has done here and
> now,
> His own sublime perfection.[1]

Completed around 1499, when Michelangelo was only 24 years old, the Vatican *Pietà* achieved that "sublime perfection." In the best classical sense, order, harmony, and a calm grandeur prevail. The basic pyramidal shape of the design, almost a trademark of Renaissance composition, weds the figures in a formal and symbolic oneness. Slightly larger than life, a chaste, youthful Mary tenderly cradles her child, a slender, delicate youth. He seems to sleep, at peace, in her arms. Mary holds up her dead son without effort. His weight is not that of a dead man; he is so light in her arms that one of his legs rests almost weightlessly on a small tree stump. Unclassical exhibitions of strain, disorder, or anguish, so typical of northern sculptors' wooden pietàs from the medieval period, are absent. In Michelangelo's *Pietà,* the human and spiritual realms confidently conjoin: Christian piety with a classical sense of human beauty, Catholic faith with humanist values.

But a half century later, a great heaviness and tiredness had come over the artist and man. The aging Michelangelo was dejected by the Protestant Reformation and the subsequent turn of Papal Catholicism away from a more humanistic spirituality to a practice far more dogmatic and puritanical. He hoped for release from his earthly bonds to gain the realm of the spirit and the peaceful rest of eternal life. His *Pietà* (also referred to as *The Deposition*) in the Cathedral of Florence (8.13), executed between 1550–1555, expressed much about this later state of mind. Carved for his own tomb, this work is one of Michelangelo's most autobiographical statements. The earlier graceful and radiant Jesus, cradled tenderly in His mother's arms, has given way to a more tortured Christ who reflects the artist's own spiritual torment. The immense weight of this Christ, as he is taken from the cross, pulls the Son of God down toward the grave. The Virgin Mary, Mary

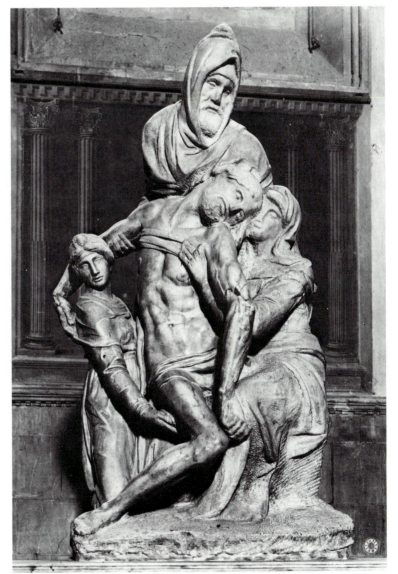

8.13 • MICHELANGELO. *Pietà. ca* 1555. Marble. Height, 7' 8". Florence Cathedral.

Magdalen, and Joseph of Arimathea are powerless to hold him up. None of the sensuous classical beauty of the early *Pietà,* so radiant and confident that it overcomes the tragedy of the event, is evident here. But all is not lost. Hope glimmers. In the rough-hewn, unbeautiful face of the elder Joseph of Arimathea, a likeness of Michelangelo himself, we see sadness and resignation but also a stoic calm. In the face and figure of Joseph, it is possible to sense Michelangelo's unbroken loyalty and hopeful belief. The autobiographical content of the sculpture implies that devotion to Christ will bring the artist, in the guise of Joseph, ultimate redemption in the arms of his Savior.

A poem written by Michelangelo during this period elucidates the profound conflicts the aged artist must have been experiencing as he struggled with both his sculpture and his own mortality, salvation ever on his mind. In anguished moments of doubt, Michelangelo laments his obsessive love of art and human beauty, so passionately evident in the early *Pietà.* In such moments, he sees his love of

8.14 • PARMIGIANINO. *Self-Portrait in a Convex Mirror.* 1524. Oil on panel. Diameter, 9⅝″. Kunsthistorisches Museum, Vienna.

beauty and gift for art not as a joint blessing but as a twofold curse, one that threatens, he fears, his very access to the eternal life. Has he not, he moans, spent too much time in vain human pursuits and too little in pursuit of prayer and spiritual contemplation? In the last decade of his life, around 1555, he writes:

I have let the vanities of the world rob me of the time I had for the contemplation of God. Not alone have these vanities caused me to forget His blessings, but God's very blessings have turned me into sinful paths. . . . Hope fails me, yet my desire grows that by Thee I may be freed from the love [for earthly things] that possesses me. Dear Lord, halve for me the road that mounts to Heaven, and if I am to climb even this shortened road, my need of Thy help is great. Take from me all liking for what the world holds dear and for such of its fair things as I esteem and prize, so that, before death, I may have some earnest of eternal life.[2]

The late *Pietà* and poem embody Michelangelo's urgent hope and doubt. In both marble and word one feels the torment of spiritual-artistic conflict and an ardent longing for God-given redemption. The result is a tragic drama of immense weight, one that can be resolved only through the mercy and intervention of Christ, "for by Thee," prays Michelangelo, "I may be freed."

Intense feelings and conflicts like these were so powerful in Michelangelo that they came to infuse, in a modern self-expressive way, almost all of his works in spite of the fact that the patronage system largely determined the general subject matter and form of his art. Nonetheless, Michelangelo's genius was so respected and his *terribilità* so accepted that patrons did not reject and even sought after works demonstrating his deeply expressive "manner." In a society of growing individualism, the cultural elite enthusiastically embraced individualistic genius, however troubled.

The powerful tensions that marked much of Michelangelo's later life and art were an alternative to the Renaissance vision of confident humanism, ideal beauty, and perfect order. In Italian painting, sculpture, and architecture after about 1520—recall Michelangelo's Laurentian Library Vestibule (6.22)—a variety of often unsettling and idiosyncratic **mannerist** styles (8.14) vied or in-

terweaved with classical high Renaissance tendencies, just as they did in Michelangelo's own career. The once-dominant Renaissance classicism of Florence and Rome was in decline. Divergent styles of art rose to prominence in other cities; for example, in Venice painters such as Bellini (3.8), Giorgione (9.16), Titian (9.18), and Tintoretto made "Venetian color" world-famous. Regional and individualistic tendencies extinguished any sense of a unified sixteenth-century Italian style. What historians call a "period style" did not rise again in Italy until the end of the 1500s, when the style known today as baroque emerged.

THE ARTIST & THE PUBLIC: THE CHANGING RELATIONSHIP

Fine Art and the Masses. Arnold Hauser, a social historian of art, observes that the newly elevated social position of painters and sculptors during and after the Renaissance brought with it a fundamental change in the relationship between art and the general public. For the five hundred years preceding the Renaissance, most people considered painters and sculptors members of the skilled working class, or, if they owned small workshops, members of the lower middle class (8.1). Because they did physical labor, both workshop owners or journeymen belonged to the "minor" or "lesser" craft guilds, not to the "major" and more politically influential guilds made up of wealthy bankers, merchants, and white-collar professionals such as judges and lawyers. A great deal of medieval painting and sculpture was commissioned for practical use or didactic display in town halls or churches. Its orientation was public and popular. Ranging from wall paintings, altarpieces, and paintings on wooden panels to carved pulpits and church statuary (8.15, 6.42), such art, by and large, was accessible to and understood by the masses.

However, as artist-intellectuals such as Leonardo, Raphael, and Michelangelo were gradually integrated into the social elite, painting and sculpture began to move into a more sophisticated and private realm, that of "high culture." "High art" began to separate itself

8.15 • Jamb statues. *ca* 1215–1220. South transept portals, Chartres Cathedral. Chartres, France.

from "low art," and the gulf between "artist" and "artisan" widened. Painters and sculptors who aspired to a loftier status created with an elite, educated audience in mind. The content and form of their work reflected this aspiration. Inspired by advanced philosophical theories, filled with complex literary content, and characterized by personal artistic styles, much high Renaissance and post-Renaissance art became "difficult," just as today's modern art is difficult. Then as now, a great deal of art became incomprehensible to those uneducated in the high culture of the times. In the sixteenth century, a cultural wall was thrown up between the uneducated masses and art in the "true" or "fine" style.

Physical walls were raised as well. Largely commissioned by the social elite for their personal quarters, many of the most renowned works of the sixteenth century were not meant to be viewed by the multitudes. Raphael's *Count Baldassare Castiglione* went into a nobleman's palace; his *School of Athens*, to the pope's private apartments. Michelangelo's Sistine ceiling covered the pope's personal chapel. Arnold Hauser describes the situation this way:

> The art of the early Renaissance could still be understood by the broad masses; even the poor and uneducated could find some points of contact with it, although they were on the periphery of its real artistic influence; the masses have no contact at all with the new art. What possible meaning could Raphael's *School of Athens* and Michelangelo's Sybils [his Greek prophetesses on the Sistine ceiling] have for them, even if they had ever been able to see these works?[3]

8.16 • PIETER BRUEGEL THE ELDER. *The Painter and the Connoisseur. ca* 1565. Brown ink on paper. 9⅞ × 8½″. The Albertina Museum, Vienna.

In contrast to the art of the Middle Ages and early Renaissance, during which most of the painting and sculpture had been public, practical, and popular, much of the art of the high Renaissance and sixteenth century was socially and culturally exclusive. It was esteemed as an expression of beauty and individual genius and valued not for its practical utility but for its own sake. In the preceding centuries, the majority of viewers had been able to see and comprehend paintings and sculptures for themselves. Now writers and lecturers were necessary to help a well-educated minority better appreciate the new, more demanding art. Literary men like Castiglione and Giorgio Vasari, whose *Lives of the Most Excellent Painters, Sculptors, and Architects* of 1550 qualifies as the first Western art history book, were called upon to analyze, interpret, and judge contemporary works and those of the recent past. In so doing, such men became the first critics, art historians, connoisseurs, and art educators. Their job was to help the educated public of art lovers and "connoisseur-collectors" (8.16) to understand the finer points of the challenging new works of "liberal art."

Art Academies and the Education of Artist-Intellectuals. The new sophistication and prestige of late fifteenth- and early sixteenth-century art raised painting and sculpture to the highest levels of culture, along with philosophy and poetry. Painters and sculptors of the time sought to affirm its new exalted status. By the middle of the sixteenth century, artists and writers like Vasari had joined the newly crowned liberal arts of painting, sculpture, and architecture in symbolic union under the honorary title "the arts of design" (*arti di disegno*). This phrase distinguished these three "higher" arts from the "lesser" arts and crafts, the so-called mechanical arts of artisans and craftspeople. The honorary title "the arts of design" was applied to painting, sculpture, and architecture well into the nineteenth century. Thereafter, the synonymous term *fine art* gradually took its place. The word *disegno*, alternately defined in Italian as drawing, draftsmanship, invention, or composition, was acknowledged by Vasari and other sixteenth-century commentators as the common

basis of the three higher arts. In its broadest meaning, *disegno* was the means by which the creative genius of the individual artist-intellectual brought forth visual ideas.

In 1561, Vasari founded the first "Academy of Design" in Florence. The next academy was founded in Rome in 1593. Others soon opened throughout the Italian peninsula and, thereafter, in France. The academies opened their doors to talented men of diverse social background but for centuries denied women, even of the upper classes, entry or full participation in classes and meetings. The supposed reason was the impropriety of women beholding nude male models. Even in the northern Italian city of Bologna, where women taught and studied with men at the ancient university and actively participated in the various arts and crafts guilds, entry was denied into the new art academy founded in the 1580s.

The initial purpose of the art academies was to teach the true and fine style, the "manner of the modern age." According to Vasari, this manner (later called the **grand manner**) originated with Leonardo and reached perfection with Raphael and Michelangelo. Practical *and*

theoretical, academic training elevated the artist above the artisan in technical capability and intellectual knowledge. The academies helped bring respect to the profession of artist. The goals of the academies were thus social and cultural as well as educational. One learned to be an artist and also an intellectual and gentleman. Through academic education, painters and sculptors in Europe and the New World could gain acceptance as gentlemen and intellectuals. As academies gained in cultural status and power in the seventeenth and eighteenth centuries, study at or honorary membership in these institutions was often the artist's surest path to fame and financial reward.

For its part, "academic art" ever aspired to be high art, seeking its home among the cultural and social elite. In fact, the first academies in France and England were directly sanctioned and supported by the crown and consequently called by the name "Royal Academy." Zoffany's portrait (dated 1771–1772) of England's Royal Academy (8.17) shows these gentlemen-artists in intellectual discussion of issues pertaining to the life-drawing class, the core of the curriculum. Two female

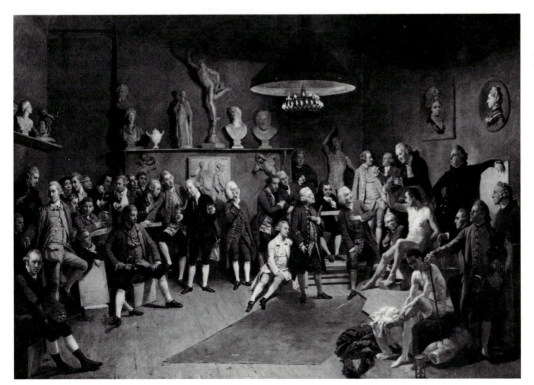

8.17 • JOHANN ZOFFANY. *The Academicians of the Royal Academy.* Oil on canvas. 100.7 × 147.3 cm. Royal Collection, Windsor, England.

8.23 • GIANLORENZO
BERNINI. *The Ecstasy of
Saint Theresa.*
1645–1652. Marble.
Lifesize. Santa Maria della
Vittoria, Rome.

most venerated of emotional states, religious ectasy.

> He has illustrated exactly the passage in the saint's autobiography in which she describes the supreme moment of her life: how an angel with a flaming golden arrow pierced her heart repeatedly. "The pain [Saint Theresa wrote] was so great that I screamed aloud, but simultaneously felt such infinite sweetness that I wished the pain to last eternally. It was the sweetest caressing of the soul of God."[4]

Casting aside all restraint, writes art historian Ernst Gombrich, Bernini carries us to a pitch of emotion that previous artists had shunned. The intensity of feeling in the saint's facial expression and pose had never before been attempted, at least not in Italian art. "Even Bernini's handling of the draperies," Gombrich notes, "was at the time completely new. Instead of letting them fall in dignified folds in the approved classical manner, he made them writhe and whirl to add to the effect of excitement and movement." In its time, and still today, the sculpture touches viewers "body and soul." This is the purpose of almost all Catholic religious art from the Middle Ages to the present.

Yet not all recent commentary on the *Ecstasy of Saint Theresa* has been so complimentary. Art historian Clark, for example, voices reservations about this and other Catholic baroque works. Although he finds *The Ecstasy of Saint Theresa* "one of the most deeply moving works in western art," he admits that such Catholic baroque art is suspect as a civilizing force. By Clark's estimation, it is just too illusionistic and exploitive. Even a masterpiece as artistically great as *The Ecstasy of Saint Theresa* is ethically troublesome. In the sculpture, Clark tells us, Bernini has turned the humble Theresa of Avila, a nun with a plain and sensible face, into a swooning, sensuous beauty. As she floats on the clouds, her swirling robes flow over a slender, graceful body. Is such extreme distortion of the historical truth acceptable? Is it, as documentary filmmakers might say, "fakery in the service of truth" or is it sensationalism? "One can't help but thinking," Clark notes, "that the affluent Baroque, in its escape from the severities of the earlier fight against Protestantism, ended by escaping from reality into a world of illusion," one in which art, propelled by its own giddy

momentum, fabricated insubstantial fantasy worlds with little basis in reality. The art historian takes special aim at "the aerial ballets" painted on the ceilings of Catholic churches such as the *Gesù* in Rome (6.27). For Clark, works such as these, tremendously popular then and now, just go too far. He sees such virtuoso ceiling performances, with their grandiose casts of thousands, dizzying illusionistic perspective, and whirling melodrama as baroque art at its most excessive and superficial.

In addition to such artistic exploitation, Clark cites the material exploitation inherent in so much baroque art. Clark laments that "the colossal palaces of the Papal families were simply expressions of private greed and vanity," the result of competing ambitions "as to who should build the largest and most ornate salons." All but forgotten in these grandiose displays were the untold numbers of Indians in Mexico and blacks in Puerto Rico who had slaved for their Spanish lords to keep the papal families and international Catholic aristocracy in cash and power. This foreign wealth, combined with harsh taxes at home, made possible the fame and fortune of artists such as Bernini and that other most esteemed of Catholic baroque artists, the Flemish painter Peter Paul Rubens. This was the dark, unseen side of much baroque art.

Painting as Courtly Drama: The Art of Peter Paul Rubens. Like Bernini, Peter Paul Rubens (1577–1640) achieved high social stature as an artist. (The vast majority of artists, it must be emphasized, never became rich or famous.) Of privileged birth, Rubens was the son of an Antwerp lawyer and alderman. He subsequently received much of his education, both in diplomacy and art, in the Catholic courts of Europe. Vigorous and learned, this handsome northerner became a painter-courtier in the mold of Raphael, as well as an esteemed diplomat who carried state secrets and performed international negotiations at the highest level. His organizational abilities, in fact, carried over to his painting commissions. Coming from the courts and churches of Catholic Europe, his commissions were so numerous that Rubens had to develop a finely tuned "studio-factory" of talented painters to help him execute his projects.

8.24 • PETER PAUL
RUBENS. *The Arrival of
Marie de' Medici in
Marseilles.* 1622–1625.
Oil on canvas. 12′ 11″ ×
9′ 8¼″. The Louvre, Paris.

To some contemporary viewers, Rubens's style may seem too energetic, overblown, and melodramatic. To the Catholic nobility and the Jesuit church leaders of his own day, it was dazzling. Again, the comparison might be made to twentieth-century cinematic spectaculars. At their most extravagant, Rubens's grand-scale paintings are peopled by multitudes. Covering enormous walls, they are sometimes as large as movie screens. And what a show they provided. "I have never lacked courage to undertake any design, however vast in size or diversified in subject matter," the artist wrote in 1621. "I am by natural instinct better fitted to execute very large works than little curiosities." In keeping with such statements, Rubens painted twenty-one twelve-

foot-high canvases illustrating scenes from the life of the powerful and controversial Marie de' Medici (1573–1642), queen of France. In these scenes, Rubens portrayed his patron with a grandeur and heroic flourish usually reserved for male rulers and heroes. Executed for the royal palace between 1621 and 1625, the large paintings currently hang in the galleries of the Louvre in Paris. In *The Arrival of Marie de' Medici in Marseilles* (8.24), the sea god Neptune rises from the waters, dancing mermaids sing praises, and angelic "Fame" sounds his trumpets, all in joy over the mighty queen's safe arrival. On the earthly plane, a man in a Greco-Roman helmet greets her majesty, a true "hero heroine," while a knight of Christ looks on. Mythology and allegory intertwine with history, and heaven and earth rejoice in a unifying swirl of color and movement. The continuous motion, dynamic action, shifting lights, and dissolves that the cinema would appropriate three centuries later are foreshadowed in baroque works such as this one.

In the context of such painterly spectacles, *The Garden of Love* (8.25) appears to be one of Rubens's more restrained works, yet it, too, is pure baroque theater. Over six feet high and more than nine feet long (of moderate size by this artist's standards), the oil painting contains not one but ten small cupids. The cherubic love gods dance busily about seventeen attractive ladies and gallant gentlemen engaged in pleasureful discourse. All the ladies and gentlemen wear sumptuous contemporary dress. The setting is a courtly garden park with fantastic fountains spewing water in passionate streams. The winged cupid on the far left pushes a gowned lady into the embrace of a bearded gentleman (said to be Rubens and his new bride). A musician plays on a lute, and a little dog walks down the steps under the tread of a gallant cavalier. Playful diversity reigns in this action-packed scene. The activity spills asymmetrically and dynamically in various directions, in great contrast to the central focus, classical symmetry, and comparatively frozen poses of so many Renaissance paintings, among them Leonardo's *Last Supper* (8.5) and Raphael's *School of Athens* (8.6).

And yet, a high Renaissance painting, *The Bacchanal,* by the great Venetian Renaissance

8.25 • PETER PAUL RUBENS. *The Garden of Love. ca* 1632–1634. Oil on canvas. 6′ 6″ × 9′ 3½″. The Prado, Madrid.

painter Titian may have been the model for Rubens's work. In Titian's *Bacchanal,* the young men and women of ancient Greece cavort festively and riotously with mythological woodland creatures. Such riotous behavior is absent from Rubens's *Garden of Love.* Now social propriety reigns, and the faces and dress of the main figures are strictly contemporary. The inspiration for the blond, buxom, fair-skinned ladies was probably Rubens's young Flemish bride, Helene Fourment. *The Garden of Love* is a garden of healthy pleasures, one sanctified by marital rite, from which both sin and tragedy have been banished. With lute music playing in the background, beautiful people pursue amorous activities in a poetically idealized setting.

Furthering the sense of delight, *The Garden of Love* is painted in luscious "living color," executed in vivid hues and with flourishing brushwork. The painting is playful in form as well as content. The eye is led in numerous directions. We follow, in the darting manner of a game of hide-and-seek, the divergent sight lines of the architecture or the eyes or gestures of the protagonists. The gaze glides to those points of attraction set up by the bold reds, yellows, and blues that pulsate in the dresses and capes of the festive band. To the privileged audiences of the day who had the access to such works, Rubens's painterly tour de forces must have been irresistible, just as his religious works in Catholic churches must have enchanted the broader public.

Italian Baroque Painting: The Triumph of Artemisia Gentileschi. The fame of Rubens notwithstanding, the art most eagerly sought by European collectors remained Italian. One of the great practitioners of Italian baroque easel painting during the first half of the seventeenth century was Artemisia Gentileschi (1593–1652) (8.26). Gentileschi was that rare Italian woman who possessed both immense artistic talent and the possibility of realizing it. Her father, Orazio (1563–1639), was an accomplished painter who willingly taught her everything he could about the medium of oil painting. Growing up in Rome,

8.27 • ARTEMISIA GENTILESCHI. *Judith and Her Maidservant with the Head of Holofernes. ca* 1625. Oil on canvas. 6′ ½″ × 5′ 7¾″. The Detroit Institute of Arts. Gift of Mr. Leslie H. Green.

she was moreover in perfect position to absorb the pictorial language of early baroque painting, especially as embodied in the stirring religious scenes of Michelangelo Merisi da Caravaggio (1571–1610). Building on the dramatically lit, emotionally charged realism of the innovative Caravaggio, Artemisia quickly became a titan in her own right.

Gentileschi's *Judith and Her Maidservant with the Head of Holofernes* (8.27) proves that she learned her lessons well and quickly moved on to the creation of original masterpieces.

Based on the bibical story of Judith, *Judith and Her Maidservant* is set in the tent of King Holofernes, the Assyrian general who was about to attack and conquer the Hebrew people. Determined to save her people, Judith offered her sexual favors to the general. After their third night of lovemaking, Judith, with the help of her serving woman Abra, cut off the sleeping general's head. In the painting, the maidservant is gathering up the severed head from the floor. Awaking to find their leader decapitated, the shocked Assyrians retreated, and the Hebrew people were saved.

In Gentileschi's visualization of the story, a windblown candle burns in the darkened tent, casting dramatic shadows on the face and arms of the two protagonists. Light flickers on the ruby red drapery and green tablecloth, and on the gold and purple dresses; these complementary colors sing in deep, vibrant tones. Judith motions for Abra to be quiet as if she hears a noise outside the tent. She holds her sword in readiness. The deed has been done, but the two women must still escape through the Assyrian camp. This is wonderfully suspenseful theater; our attention is riveted on the interlocked figures of Judith and Abra as they prepare for action. But it is far more. It is a revolutionary pictorial drama that portrays women as powerful, active leaders in a world dominated by men. Most Italian paintings up until this time had portrayed women stereotypically as softly beautiful and idealized, whether as chaste virgin, mythological love goddess, or dignified portrait likeness. Here was a far bolder, more realistic, down-to-earth image of woman by a strong-willed female painter who had suffered much in her youth, including rape by a male artist.

Gentileschi's numerous paintings of courageous biblical heroines, such as Judith, are indeed rare images in the history of art. They present the viewer with emotionally complex, multidimensional female characters who are heroic in the elevated classical sense customarily reserved for male characters. Gentileschi's "strong women" embody male as well as female qualities, an androgynous ideal. They are breakthrough images, not to be seen again until artists like Kathe Kollwitz at the turn of the twentieth century reintroduced forceful images of women as heroic liberators (10.7).

SEVENTEENTH-CENTURY ART IN PROTESTANT HOLLAND: FROM REMBRANDT TO VERMEER

Certain Dutch painters of the seventeenth century were influenced by Catholic baroque art, such as that of Gentileschi, Caravaggio, Rubens, and Bernini. But in general, Dutch Protestant art of the 1600s differed substantially from its counterpart in Catholic Italy and Flanders. To begin, it was shaped by different religious, political, and social traditions and reflected the dissimilar economic conditions under which artists worked. Unlike Catholicism, with its emphasis on the miraculous and mystical and on the primacy of the church in guiding the human flock to salvation, Protestantism was committed to the notion that the individual, and not the church hierarchy, was primarily responsible for his or her salvation. The eternal life was to be gained largely through personal prayer, bible study, and "good works."

Interpreted broadly, such good works might include working industriously and profiting financially from one's commercial activity. Material achievement in life, some believed, was a sign that the successful person was among the blessed, the "elect" destined for salvation. The modern German sociologist Max Weber (1864–1920) made much of this notion in his classic study, *The Protestant Ethic and the Spirit of Capitalism*. Weber claimed that the youthful Protestant religion provided the spiritual base for the vigorous development of capitalism in northern Europe and colonial America. Whatever we might think of Weber's theory, the Protestant commitment to individualism of conscience and "the Protestant work ethic" certainly served to support Holland's rudimentary forms of capitalism and democracy. All of these factors, in turn, influenced the character of Dutch art.

Having recently liberated themselves from the autocratic rule of Catholic Spain, the Dutch "United Netherlands" had built up a vibrant middle-class commercial society with a thriving international trade in goods ranging from pictures to spices. (In the seventeenth century, Dutch colonies and imperialistic spheres of influence, all exploited for immense profits, ranged from North and South Amer-

8.28 • DAVID VINCKBOOMS. Detail from *A Fair*. 1608. Oil on wood. 115 × 141 cm. Herzog Anton Ulrich-Museum, Braunschweig, Germany.

ica to Asia and Africa.) In such a dynamic capitalistic society, the painters of the Dutch Netherlands came to be the first nation of artists to participate fully in what we have come to know as the "art market." Whereas Bernini and Rubens responded primarily to commissions for specific works, producing particular religious, mythological, or historical paintings and sculptures for specific courtly or ecclesiastic patrons, Dutch artists began to create pictures increasingly for an anonymous art market. Producing in quantity at relatively low prices, many Dutch artists tended to specialize in portraits, seascapes, landscapes, still lifes (4.35), interiors (7.5), devotional pictures, or "genre" scenes of everyday life (Appreciation 14). Such works might be marketed through art dealers who had previously purchased the work or who received a commission for the sale; or the pictures might be sold directly by the artist at markets or fairs (8.28).

The buying public encompassed all classes of society. It ranged from upper-middle-class "burghers"—bankers, shippers, manufacturers, and government officials captured brilliantly (2.7) by the portraitist Frans Hals (1581/5–1666)—to lower-middle-class artisans. It extended to shopkeepers and enterprising peasants. In the form of small, portable oil paintings, these many and varied pictures might be bought for either investment or for decoration of one's house or workplace. It was a situation very much like our own today. An English traveler to Amsterdam in 1640 wrote of the singular affection of the Dutch people for pictures, "all in general striving to adorn their houses, especially the outer or street rooms, with costly pieces—butchers and bakers not much inferior in their shops, which are fairly set forth, yea many times blacksmiths, cobblers, etc. will have some picture or other in their forge and in their stalls."

Judith Leyster. *The Proposition.*

FRIMA FOX HOFRICHTER

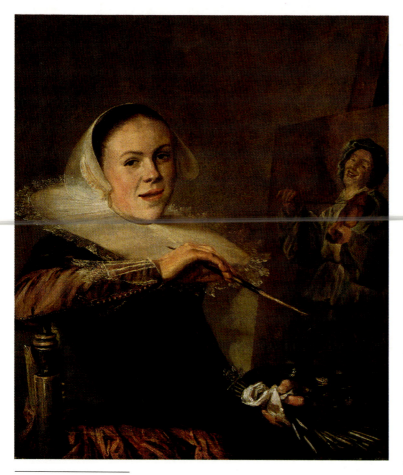

Figure A • JUDITH LEYSTER. *Self-Portrait. ca* 1635. Oil on canvas. 29⅜ × 25⅝″. The National Gallery of Art, Washington, D.C. Gift of Mr. and Mrs. Robert Woods Bliss.

Frima Fox Hofrichter is an art historian specializing in seventeenth-century Dutch art. She is the author of Judith Leyster: A Woman Painter in Holland's Golden Age *(Davaco, 1989), and she organized the exhibition* Haarlem: The Seventeenth Century *at the Zimmerli Art Museum of Rutgers University.*

It has been three centuries since the death of the versatile Dutch genre, portrait, and still life painter Judith Leyster (1609–1660) [Fig. A], but it was only during the last women's movement that the pioneer study [in 1927] of her works was finally made. . . .

Yet during her own lifetime, Leyster had been praised twice in the histories of the city of Haarlem (where she was born), once in 1627 by Samuel Ampzing . . . when she was only eighteen, and again in 1648 by Theodore Shrevel, who, punning on her last name, called Leyster a "leading star in art." She was admitted to the St. Luke's Guild in Haarlem in 1633, and is known to have had several students (documents concerning at least three students exist). She married another Haarlem painter, Jan Miense Molenaer, in 1636, bore five children, and died in Heemstede, near Haarlem, in 1660.

During her fifty-one years, Judith Leyster worked in Haarlem, Utrecht, and Amsterdam; presumably she knew the master of each school, including Hals, Honthorst and Ter-brugghen, and Rembrandt, respectively. Her familiarity with the subjects and with the lighting and compositional techniques of each school is evident in her works. Indeed, her work was often attributed to the other masters because of certain similarities and was praised for this affinity; on the other hand, however, Leyster was condemned for this same reason—and more severely so for those works which show Frans Hals's influence [2.7]. Even in current art historical literature on Dutch art, she is often quickly dismissed as a "clever" imitator of his. However, because of Leyster's

training in Utrecht [where the influence of the Italian baroque painter Caravaggio was substantial], as well as in Haarlem, many of her paintings actually owe little to Hals.

The Proposition [Fig. B] in the Mauritshuis, The Hague, confirms this view. This small panel painting is 12.2 inches high by 9.5 inches wide, bears her monogram, and is dated 1631. In the choice of subject, and the dark setting, lit only by an oil lamp, the influence of the Utrecht *Caravaggisti* [followers of Caravaggio] is clear. [Recall that Leyster's Italian contemporary, Artemisia Gentileschi (8.26, 8.27), was also much influenced by the pictorial innovations and subject matter of Caravaggio.]

The proposition is initiated by the man as he leans over the woman's shoulder, with one hand on her upper arm and his other extended forward full of coins. She, without noticeable reaction, or perhaps with determined disinterest, sits in a chair with her feet propped on a footwarmer, concentrating on the sewing which she holds in her lap. Leyster is openly and clearly depicting a sexual proposition (the man is not offering the woman payment for the sewing!). However, it is not the subject, but rather Leyster's attitude toward this popular theme, which is our main concern in this painting.

The theme of propositions, prostitution, procuresses, and brothels, including seventeenth-century scenes of the Prodigal Son, was common in Northern art. Pigler, in his 1956 *Barockthemen* (*Baroque Themes*), cites seventy-two scenes of ill-matched lovers and twenty-five others of love gardens, and this listing could easily be expanded. The popularity of the theme may be explained in part because the subject was common enough in life in seventeenth-century Holland. Despite the influence of Calvinism in the latter half of the sixteenth century, or perhaps because of it, there was a resurgence of brothels in the seventeenth century. Such paintings were probably appealing both as depictions of forbidden, but commonplace, pleasures and as works with moralizing intent.

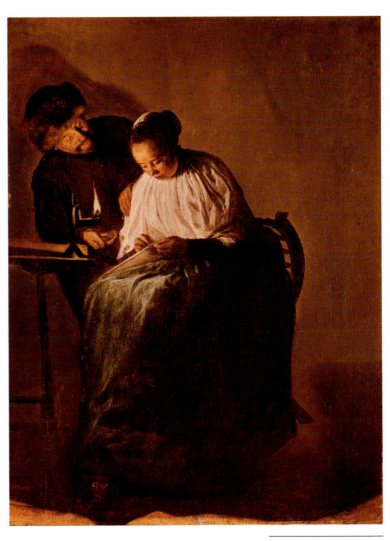

Figure B • Judith Leyster. *The Proposition.* 1631. Oil on panel. 11 11/16 × 9½". Mauritshuis, The Hague, The Netherlands.

The woman who is the recipient of a proposition or who is shown as an active member of a brothel is generally depicted as a more than willing participant. The subject already appears in fifteenth-century engravings and becomes even more popular in the sixteenth century. Especially popular are scenes of the Prodigal son "wasting his life with riotous living" (Luke 15:31) and "devouring [his] life with harlots" (Luke 15:30), as in the print of 1519 by Lucas van Leyden [Fig. C] where the young woman in the center is seducing the "son" at the right, while, at the same time and unbeknownst to him, she is picking his pocket.

Figure C • Lucas van Leyden. *The Prodigal Son.* 1519. Woodcut. Prints Division, The New York Public Library, Astor, Lenox and Tilden Foundations.

This view of the theme is similar to that of Quentin Metsys's *Ill-Matched Lovers* of about 1520 [Fig. D], and others of the same type, where money is used to compensate for the age of the elder participant (hence, an admission that they are ill-matched). The exchange of love, or sex, for money is quite clear, although the money is often being stolen by the woman rather than being given willingly by the man. . . .

The procuress theme was particularly popular in seventeenth-century Utrecht and is well illustrated by Baburen's *Procuress* of 1622 [Ap-

preciation 15, Fig. B]. The entire cast is present: the old procuress at the right, the customer in the center, and the prostitute on the left. Each is a stereotype for a clearly defined role, and all are shown as bold, jocular, and certainly willing participants in this exchange of services for money.

However, Leyster's attitude toward the subject and her treatment of it differ from those of the Utrecht masters and from those of her contemporaries in general. Her *Proposition,* painted just one and a half years after she left the Utrecht area (she lived in Vreeland,

near Utrecht, from 1628 to September 1629), recalls the Caravaggesque spirit in theme, time (a night scene), and light source (an oil lamp). But it is these similarities which serve to accent its differences. Leyster's work may, in fact, be considered a critical response to the painting of her predecessors. Her depiction of the scene is contrary to the accepted role assigned women in the painting from the fifteenth to the seventeenth centuries, previously mentioned, in which they "fleece" men, pick their pockets, steal their money, seduce them, abuse them, and generally make fools of them. The theme of prostitution exploits the idea of women using their wiles to degrade men and lead them to sin. Leyster's painting does not foster this image.

In her *Proposition,* the mood is not one of carousing but of quiet intimacy. The woman, usually depicted as a willing participant in the adventure if not its instigator, is not shown that way here. She is not entertaining the leering cavalier who offers her money; she is neither playing a lute, nor drinking, nor wearing a low-cut dress—nor is she accepting his offer. The embodiment of domestic virtue, she continues sewing. Rather than encouraging the man's intentions, she becomes the embarrassed victim. The room is silent as we wait for her response. Leyster's woman is no harlot: she is an ordinary woman being propositioned—not an extraordinary circumstance. The difference in approach is unprecedented: it surely represents, to some degree, Leyster's viewpoint as a woman in a world whose way of seeing and representing was dominated by men. ■

Figure D • QUENTIN METSYS. *Ill-Matched Lovers. ca* 1520–1525. Oil on oak. 17 × 24¾″. The National Gallery of Art, Washington, D.C. Ailsa Mellon Bruce Fund.

8.29 • REMBRANDT.
The Night Watch. 1642.
Oil on canvas. 12′ 2″ ×
14′ 7″. Rijksmuseum,
Amsterdam.

Profound Portraiture: Humanism and Individualism in the Art of Rembrandt. In the Dutch Netherlands, the patronage system of court and church, so dominant in Catholic Italy, Spain, and the adjacent Spanish Netherlands, played a lesser part. The hereditary nobility had been largely replaced by the commercial middle class as Dutch society's power brokers. Unlike Catholic churches with their "graven images," Protestant churches had largely done away with the commissioning of grand-scale paintings, sculpture, and architecture. For these reasons, an open art market came to dominate in the Dutch Republic, and large-scale commissions, such as those showered upon Bernini and Rubens, were few. The fabled *Night Watch* (8.29) of Rembrandt van Rijn (1606–1669) was one such large commission. But even this grand-scale commission was an exception. As was typical in seventeenth-century Holland, it was not paid for by a cardinal or prince. It was commissioned by a company of civil guardsmen. In true democratic-capitalistic spirit, each guardsman decided what he would contribute to the artist's fee. Commensurately, those who paid the

most were featured front and center, whereas those who contributed less found themselves on the sides or in the rear. Here was Dutch capitalism and democracy made visible. And where was such a work hung? Certainly not in a royal palace or private chapel. Its first place of residence was the social hall of the guardsmen; its second, Amsterdam's Town Hall. So it went in seventeenth-century Holland.

Like the paintings of Rubens, *The Night Watch* does exhibit certain qualities of the Italian baroque: grand scale, dramatic lighting, energetic activity, protagonists in substantial number. Rembrandt's painting, however, is much toned down in comparison to the supernormal spectacles (8.21–8.25) of Rubens or Bernini. Some of the same down-to-earth realism and humanism of Gentileschi's Judith have entered this picture. The expressions and gestures of the eighteen members of the company, and of the sixteen "extras" Rembrandt added free of charge, are more matter of fact than superhuman, more spontaneous than posed. Overall, it is a work far more Dutch than Italian in inspiration, one in keeping with the pragmatic Netherlandish temperament and its penchant for realism. Compared to the larger-than-life spectacles of so much Catholic baroque art, *The Night Watch* is, in fact, rather down to earth. The dog in the lower right barks as the men assemble; soldiers converse informally as they load or check their weapons. A guardsman on the extreme right, cut by the picture frame, beats out the call to assembly. No one strikes the customary noble pose, even though this is a group portrait. Spontaneity and informality are the rule, making *The Night Watch* a forerunner of such slice-of-life "modern portraits" as Delacroix's *Paganini* (2.6) or Degas's *Place de la Concorde (Vicomte Lepic and His Daughters)* (7.18), created a full two centuries later.

Coloristically, lights and darks predominate. We note blacks, browns, burnt yellows, and whites emboldened by a few areas of red. This restraint in color contrasts with the far more brilliant palette of Rubens and most Italian baroque painters. And although Rembrandt has accorded the painting a Rubenesque energy and variety—men readying themselves in a diversity of activities, with flags, pikes, and guns pointing in every direction—all the pieces hold together and are tempered by a classically stable composition. An equilateral triangle, in which with the two leading officers form the bottommost point, helps bring unity to the variety. Captain Cocq (in black) and his first lieutenant walk in the very front center, at the advance of their guard. They are the persons of most prestige and the largest contributors to Rembrandt's fee. A triangular phalanx of followers, including soldiers, a dwarf, a dog, and an angelic girl in golden tones, walks behind. The two commanders wear rich black-and-white clothes that make them stand out from the rest, and the captain's bright red sash is the central coloristic feature.

Frans Banning Cocq, a wealthy merchant, was the captain of this company, which half a century earlier had fought against the Spanish imperialists. Active fighting now a thing of the past, the company had largely become an honorary male drinking and eating club for upper-middle-class members of Amsterdam society, as the art historians Honour and Fleming point out.

> Militia companies kept alive memories of the heroic days of struggle against authoritarian Spain and some of the older men in the picture may well have been veterans. But it was, above all, the triumph of the Dutch republic with its loose (if by no means egalitarian) social structure and exaltation of private enterprise that is being celebrated. Rembrandt spared no pains to create as convincing an illusion of actuality as possible in this image of self-possessed and somewhat self-satisfied burghers walking out of the picture to meet us on their own terms.[5]

This emphasis on individualism, self-image, and actuality carries over to Rembrandt's other works. We observe these same qualities in his religious works (4.17, Appreciation 5) and especially his portraits, for which he was respected as one of the leading painters of the day. In no other painted or sculpted portraits prior to these is the particularized inner life of the individual so keenly felt. The subjects of these portraits included surgeons, guild leaders, burgomasters (mayors), and members of Amsterdam's Jewish community. Whether of individuals, couples, or groups, they revealed the human depths of his upper-middle-class patrons. Numerous portrait commissions made Rembrandt a wealthy man, though in

later years, his monies depleted from excessive spending, he had to sell or auction art works and belongings to save himself from paupery. At one point, he had to declare bankruptcy.

Ironically, some of the portraits that are most valuable today went unsold during Rembrandt's lifetime. These are from the astonishing series of over ninety self-portraits that he created during a period of some forty years. As portraiture, they are a crowning achievement and a harbinger of things to come hundreds of years later. Only in the late nineteenth-century self-portraits of painters such as van Gogh (1.13) and Gauguin (7.23), and in the twentieth-century self-portraits of photographers such as Cindy Sherman (7.62) do we once again meet artists who focus so intensively on themselves over an extended period. That Rembrandt could conceive of and execute such a series must be taken as a sign of how much social conditions had changed. A rising modern world founded on capitalism and democracy, not so different from our own, was beginning to take shape. It promoted a culture of individualism that paved the way for the development of increasingly personally oriented forms of art: the world as seen, felt, or imagined through the eyes of increasingly self-conscious individuals. In such a world, Rembrandt was on the artistic cutting edge.

From Rembrandt and individualistic forebears such as Michelangelo, the concept and myth of the struggling artist-hero evolved. True, there were artists who, like Raphael, Bernini, and Rubens, fit perfectly with the intentions of their wealthy and powerful patrons and were in their lifetimes economical, social, and artistic successes. But there were also those great artists since the Renaissance, far lesser in number, who challenged the status quo and the artistic conventions of their day. For the most part, their art was either not well accepted or went in and out of fashion. (Michelangelo is an exception; his art has been revered over the centuries.) They usually suffered poverty or hard times.

Rembrandt's life fits this general description. As his nonconforming art gradually went out of fashion, his immense professional success waned. The downward swing of Rembrandt's material fortune was aggravated by an uncompromising, even irascible personal-

ity: "extravagant manners" and a spendthrift "capricious way of living" that made him, as a well-informed contemporary put it, "very different in his person from other men." Moreover, he did not fit the role of the artist as courtly gentleman and liberally educated intellectual; "he read only Dutch and even that badly," according to a contemporary. For these reasons, Rembrandt came to epitomize the now-common conception of the embattled artist, a self-styled individualist alienated from his peers and society as a whole. The critic John Berger describes this type of "artist-hero" as follows:

> . . . a man whose life-time is consumed by struggle: partly against material circumstances, partly against incomprehension, partly against himself. He is imagined as a kind of Jacob wrestling with an Angel. (The examples extend from Michelangelo to van Gogh.) In no other culture [ancient, medieval, or tribal] has the artist been thought of in this way. Why then in this culture? We have already referred to the exigencies of the open art market. But the struggle was not only to live. Each time a painter realized that he was dissatisfied with the limited role of painting as a celebration of material property and of the status [whether of church, state, nobleman, or burgher] that accompanied it, he inevitably found himself struggling with the very language of his own art as understood by the tradition of his calling.[6]

The works of Rembrandt that deviate most decisively from the prevailing artistic language of the day were created during the complex maturity of his middle age. The subjects of these works are often his friends or himself, or they are creations of his imagination, scenes from the Bible, history, or mythology. These are subjects he is most interested in or knows best. In these works, such as *The Jewish Bride* (8.30) and *The Return of the Prodigal Son* (4.17), the emphasis is intensely psychological. Probing inward, Rembrandt reveals spiritual truths. He portrays something of the subject's inner core, the thoughts and feelings that motivate the outward expression and gesture. The material world, the external face of property, status, and middle-class values, becomes of secondary importance. These paintings, which seem to work emotionally from the inside out, represent a revolt against the great majority of paintings of Rembrandt's day and before. Compare, for example, his psycholog-

8.30 • REMBRANDT.
The Jewish Bride. ca 1665.
Oil on canvas. 48 ×
65½″. Rijksmuseum,
Amsterdam.

ically compelling *Jewish Bride* with Van Eyck's Arnolfini marriage portrait (4.34), that far more optically descriptive masterpiece of the early oil painting tradition. Or compare Rembrandt's later, almost expressionistic style with the intensely mimetic paintings of contemporary Dutch masters such as Vermeer (7.5) or Kalf (4.35). Rembrandt expanded conventional European realism to reveal what was customarily not revealed: the innermost hopes, dreams, joys, and fears of his subjects.

A comparison of an early and late self-portrait illumines the artist's struggle and breakthrough to a new language that defied the norm. In his *Self-Portrait with Saskia* (8.31), painted about 1635, we see the twenty-nine-year-old Rembrandt and his new bride, the beautiful and wealthy Saskia van Uylenburgh. He is clearly happy, toasting his beloved and showing off their combined good fortune. The painting is in the accepted artistic

languages of the Catholic baroque and Protestant Dutch realist traditions. Working in his native tradition, Rembrandt shows an abundance of naturalistic detail, that "art of describing" so pronounced in northern artists from Van Eyck and Dürer to Vermeer. In the *Self-Portrait with Saskia*, this fascination with the surface appearance of things is especially evident in the representation of textures, from feathers and pheasant plumes to woven table coverings and gilded sword hilts.

To this language of Dutch naturalism he would join the motion and emotion, drama and display characteristic of Rubens and the Catholic baroque tradition. Here in the early marriage portrait are the Baroque grand gesture and the overt emotional expression. Lighthearted and joyous, Rembrandt smiles out at us. He is the flamboyant cavalier in revels with his comely bride. Also baroque are those exciting compositional diagonals (note

8.31 • REMBRANDT.
Self-Portrait with Saskia.
ca 1635. Oil on canvas.
63⅜ × 51½".
Gemäldegalerie, Staatliche
Kunstsammlungen, Dresden,
Germany.

8.32 • REMBRANDT.
Self-Portrait. ca 1669. Oil
on canvas. 33⅞ × 27¾".
The National Gallery,
London.

the sweeps of sword and arms, and the twist-ing poses) and the painting's chromatic flour-ish. The sumptuous reds of Rembrandt's clothing join in complementary harmony with Saskia's greens, all within a color scheme warm and golden. Buoyant in form and spirit, the early *Self-Portrait with Saskia* seems a Dutch cousin of Rubens's painting of himself and his own young bride in *The Garden of Love* (8.25), painted just a year or two earlier. As art critic Berger puts it, "Rembrandt is here using the traditional methods for the traditional pur-poses. His individual style may be becoming recognizable. But it is no more than the style of a new performer playing a traditional role." As a virtuoso performance, the *Self-Portrait with Saskia* bypasses emotional depth and complexity, the qualities so apparent in Rem-brandt's later masterpieces, for masterful de-scription and the customary exaltation of the

sitter's good fortune, prestige, and wealth. A comparison between the *Self-Portrait with Sas-kia* and *The Jewish Bride*, that moving marriage portrait painted thirty years later, makes these differences clear.

A late self-portrait by Rembrandt (8.32) shows that the artist has turned away from both the Dutch art of description and the ba-roque notion of narrative drama. His works from the 1660s show a severe simplification in both composition and subject matter. Only the bare essentials are presented; the resulting simplicity increases the focus on the subject's facial expression or gesture. These works present tighter, more emotive close-ups, to borrow a concept from the cinema, than tra-ditional portraiture had previously allowed. Depths of feeling are revealed. The subject, whether Rembrandt or another, comes for-ward in the fullness of his or her emotions. Gone is the customary distance imposed by formality of pose or emphasis on cultural sta-tus, rank, clothing, possessions. Such a con-centrated "minimalism" contrasts with both the "maximal" story-dramas of so many ba-roque history paintings and the plenitude of detail packed into Dutch realistic paintings. As the foreground and background falls away, our focus intensifies. At the same time, Rem-brandt's use of a dramatic chiaroscuro guides us through the pregnant darkness to the light. The patterns of light and dark lead the eye to those select illuminated parts, usually the head and hands, that are most revealing.

In his mature works, Rembrandt refused to produce the transparent mirror of the world so eagerly pursued by his countrymen. In his earlier portraits, the artist had proved himself highly capable of rendering a convincing illu-sion of reality, but now he sought different means and ends. Art historian Svetlana Alpers writes that the thick surfaces of scumbled and layered paint in his later works distort the world to offer "a rare entry into invisible hu-man depths." Rembrandt, she tells us, rejected in his mature paintings the established practice of "good craftsmanship"—clear linear defini-tion of figures, accuracy of descriptive surfaces, smoothness of finish—to go beyond the visible world into a psychological one. The paint itself now comes to life. The materiality of the medium is emphasized. "His paint," Alpers

writes, "is something worked as with the bare hands—a material to grasp, perhaps, as much to see." It becomes "that common matter, like the very earth itself in the biblical phrase, out of which the figures emerge and to which they are bound to return." Rembrandt, the struggling artist, had indeed brought forth a new language, one capable of revealing human depths rarely before represented.

Vermeer of Delft: Innkeeper, Art Dealer, and Artist of Greatness.

Though Rembrandt's later years were plagued by struggle and bankruptcy, he obstinately refused to resort to a second (or third) job to pay for food or rent, as did many more pragmatic Dutch painters. Seventeenth-century Dutch artists whom we admire today might have earned much of their income by trading in tulips, collecting taxes, or working as innkeepers. Moreover, the painters who were tavern keepers often exhibited their art in their inns.

The case of Jan Vermeer (1632–1675), now considered one of the greatest artists of all time, is illuminating in this regard. In spite of being well known among his contemporaries, Vermeer never achieved sufficient financial success to support his family by painting alone. The seventeenth-century Dutch art market, like today's, was characterized by fluctuating prices, changing fashions, and an overabundance of artists. Then as now, it was a difficult place in which to earn one's way. Striving to carve out a successful niche in a highly competitive market, most Dutch painters came to specialize: in portraits, landscapes, seascapes, still lifes, and "genre" scenes of everyday life. They did this for two reasons: to increase their output (if they came up with a successful formula, they'd use it again and again) and to establish a personal identity ("name recognition") in an overpopulated art world. Vermeer specialized in indoor domestic scenes ("interiors"). Many, like *Woman in Blue* (8.33), possess moral overtones or secondary symbolic meanings. We cannot be certain, but some of these interiors may depict rooms of his own house in the city of Delft. Simultaneously, the house in Delft may have served as artistic subject, living quarters, inn, exhibition space, and art dealer's shop.

Vermeer produced very few paintings in his lifetime; no more than thirty-five pictures can be attributed to him. This was probably due to the limited time that he could devote to his art and his slow and meticulous working technique. In this regard, Vermeer's painting, *The Concert* (Appreciation 15), may reveal as much about Vermeer's socioeconomic status as his artistic life. On the wall behind the harpsichord are two oil paintings. The two may have been part of his personal inventory and, as an art dealer, he may have been prepared to sell them to supplement his income. Like the vast majority of fine artists today who support themselves and their families through other jobs—teaching, house painting, driving taxis, waiting on tables, working in art galleries—Vermeer was a "hyphenated artist"; in his case, an artist-innkeeper and/or artist-art dealer. Because he valued his painting as a "liberal art," a learned pursuit that combined art, science, morality, and poetry, Vermeer was willing to take up other occupations so as not to compromise the quality of his work as an artist. Having other sources of income, he could work as slowly and thoughtfully as he wished. Nonetheless, at the end of his life Vermeer found himself a proverbial struggling artist, having to sell off his pictures at auction to stay financially afloat.

If Vermeer had to struggle to make ends meet, he did not when it came to artistic style. Vermeer's art, unlike that of the rebellious Rembrandt, was comfortably in the mainstream of Dutch realism. His small pictures did not break new formal ground so much as expand or enrich the possibilities already present in the art of the Lowlands. To begin, Vermeer's paintings possess an exceptional objective accuracy, probably aided by the camera obscura (7.4) or other optical devices. In addition, the works feature a clear articulation of interior spaces and a remarkable sensitivity to the effects of light. His was "the art of describing" at its best, an art that succeeded in creating that smooth, transparent mirror of the world that was the goal of so many Dutch painters.

Vermeer's artistic achievements resonated with the larger sociocultural forces of his time. Undergirding a Vermeer painting like *The Concert* and *Woman in Blue* is the pragmatic realism of Dutch commercial culture, the objective materialist view of Dutch science, and the skeptical commonsense outlook of prom-

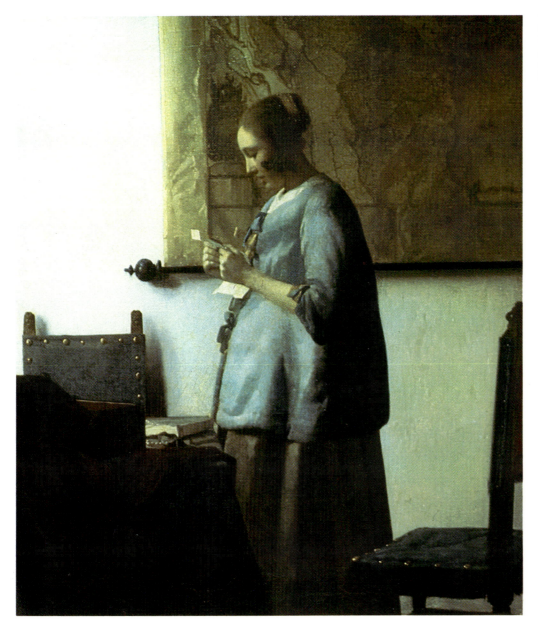

8.33 • JAN VERMEER. *Woman in Blue Reading a Letter. ca* 1662–1664. Oil on canvas. 18¼ × 15⅜″. Rijksmuseum, Amsterdam.

inent philosophers. The "light of reason" that characterizes Vermeer's pictures invites comparison with the rationalist philosophies articulated by his near contemporaries Descartes and Spinoza, both of whom published major works in Holland. His pictures chart space with the same passion that Dutch geographers mapped the earth and Dutch astronomers charted the heavens. As if to make the point, Vermeer created two paintings, *The Astronomer* and *The Geographer*, showing scientists engaged in their work. Several other works, including both *Woman in Blue* and *Young Woman with a Water Jug* (7.5), feature large maps hung proudly on an interior wall.

The artist's fascination with light and clear seeing finds yet another analogue in the ardent desire of his countrymen to perfect optical instruments that could help the eye to see acutely. The Dutch had been in the forefront of the development of lenses, telescopes, microscopes, and camera obscuras, instruments that influenced the way artists such as Vermeer saw and represented the world.

Jan Vermeer. *The Concert.*

MARY ANN SCOTT

Figure A • DIRCK VAN
BABUREN. *The Procuress.*
1622. Oil on canvas.
40 × 42⅜″. Museum
of Fine Arts, Boston.
M. Theresa B. Hopkins Fund.

Seventeenth-century Dutch painting provides images of the common lives of ordinary individuals in a subject category known as genre (Fig. A). During the so-called Golden Age of the Netherlands, an economically strong middle class supplied commissions for thousands of artists of various abilities. The cultural situation then resembled that in America today, where many artists support themselves with other work. One of the most gifted Dutch artists was Jan Vermeer, who was a picture dealer and possibly an innkeeper in the little town of Delft. Vermeer left few paintings and not a single drawing or etching. Fewer than thirty-five paintings are known today. Nevertheless, his small body of primarily genre paintings ranks among the most poetically beautiful of Netherlandish art.

Vermeer's *Concert* (Fig. B) appears on first viewing to be a simple, intimate domestic scene of figures practicing music together. One woman plays the harpsichord. She is accompanied by a man, seen from the back, who performs on a barely visible bent-necked theorbo. Another woman, standing, sings from a music sheet. That these individuals belong to the prosperous upper middle, or *burgher,* class is evident, for they enjoy leisure time to study complicated and expensive musical instruments. Notice that the artist has carefully positioned a beautiful viola da gamba on

the floor in the foreground and a small lute over a costly, imported tapestry on the table at left. The figures' fine clothing and the presence of two paintings (as well as the painted harpsichord lid itself) further attest to the musicians' comfortable circumstances. Characteristic of Vermeer are the refined handling of the brush, realistic figural representation, subtle gradations of color and light, double cast shadows, masterful textural effects, and intricate compositional balance (notice the spatial effect achieved by the juxtaposition of the table detail at left and the figural group at right).

Like so many seventeenth-century Dutch paintings, *The Concert* can be studied on a deeper level. Some scholars recognize subtle romantic undertones in works such as this. A clue to the possibly sensual secondary meaning might be read in the erotic painting on the back wall at right, a procuress scene representing a lute-playing prostitute, her merry

Mary Ann Scott (1946–1988) was a Fulbright scholar and a professor of Northern European art at the University of Denver. She wrote Dutch, Flemish, and German Paintings in the Cincinnati Art Museum: Fifteenth through Eighteenth Centuries *as well as a monograph on the Dutch artist Cornelis Bega.*

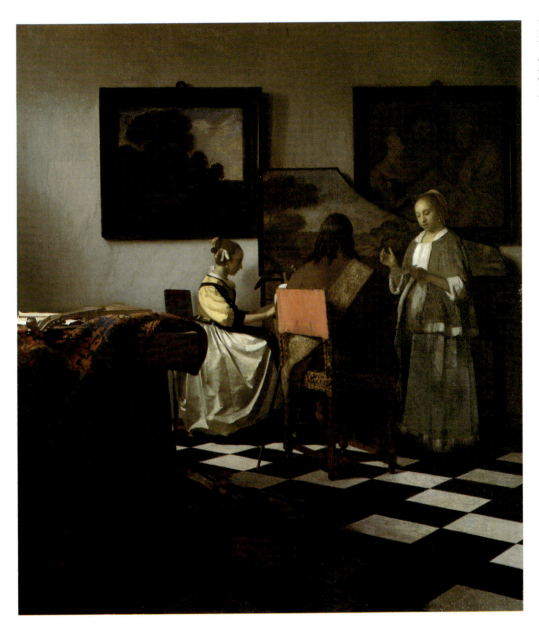

Figure B • JAN VERMEER. *The Concert. ca* 1665–1666. Oil on canvas. 28½ × 25½". The Isabella Stewart Gardner Museum, Boston.

customer, and a madam. The arrangement of two women and a man parallels that of the trio in the room. It may be that Vermeer meant the picture within the picture as a reference to the sensual association enjoyed by the music makers, whose precise relationship the artist otherwise leaves ambiguous.

Besides providing us with an object of exceptional beauty and rich meaning, *The Concert* further serves as an important visual document. The painting of *The Procuress* (Fig. A) on the wall is not mere fantasy but a known work by Vermeer's near contemporary, Dirck van Baburen (*ca* 1595–1624). We know from the surviving inventory of Vermeer's private collection that he owned this very painting. By incorporating it into his genre scene, Vermeer increased the sense of realism. Ironically, both paintings are located today in one American city, Boston. ∎

Vermeer and the History of Taste. The instructive case of Vermeer proves that the reputations of even the greatest artists rise and fall with changing times. The individualism and realism that were basic to seventeenth-century Dutch art continued to influence certain painters into the eighteenth century. But descriptive Netherlandish genre art, such as that of Vermeer, did not receive the highest accolades until a century and a half later. At that time, the artists and writers identified with the nineteenth-century realist and naturalist movements (7.6, 7.13) became its champions. Prior to the mid-nineteenth century, the most ambitious and celebrated artists, such as David (7.28) and Ingres (4.39), tended to look to the legacy of the Italian south rather than that of the Netherlandish north. Those seeking the heights of artistic fame and moral authority turned not to painters of commonplace Dutch interiors but to those artistic traditions and subjects considered far more noble: the classical art of ancient Greece and Rome, the "grand manner" tradition of the Italian high Renaissance, Rubens, and the Roman baroque. Relative to subject matter, the increasingly influential academies of art and design in eighteenth-century Italy, France, and England had made the determination that "history painting" of mythological, religious, and historical subjects was the artistic category of highest moral and cultural status. In contrast, humble genre scenes of interiors and everyday life were rated as being of only moderate cultural significance. Only paintings of animals, landscapes, and still lifes ranked lower. Out of step with elite eighteenth-century taste, Vermeer's art received only modest acclaim. Certain writers, somehow missing the subtle poetry with which the artist's tender silver-gray light invests every object and gesture, even criticized his paintings as "too objective" and naturalistic.

The rise of Vermeer's worldwide reputation required the arrival of a historical period whose values approximated those of his own. A major 1866 study of Vermeer by the French realist critic Théophile Thoré (1807–1869) set the stage for the painter's restoration to prominence. A radical democrat and socialist, Thoré fled abroad to escape the police of the French oligarchy. Traveling in Holland and experiencing its art, he came to equate seven-teenth-century Dutch "domestic and civic painting" with the art of a society emancipated from tyranny. In keeping with the values of mid-nineteenth century French realism and naturalism, Thoré praised Vermeer and his Dutch compatriots for their honest presentation of the daily life of the common people. Humble Dutch genre and landscape, Thoré asserted, and not the court- or church-sponsored art of the high Renaissance or Catholic baroque, was the cultural forebear of the nineteenth century's socially democratic "painting of modern life." As realist painters of modern life (such as Courbet, Millet, and Manet) and the impressionists rose to prominence, so did the reputation of Jan Vermeer.

In the twentieth century, with the rise of "abstract art," Vermeer's art continued to be rated highly, but more for its form than its subject matter. Educated to the values of formalist abstraction, the modernist sensibility savors the beauty of Vermeer's color, light, shape, and composition. Artistic meaning and value, as Vermeer's case reveals, will never remain static. They will always blow with the winds of cultural change.

The Academies and the Rising Status of Art. Common to seventeenth- and eighteenth-century artists, whether from northern or southern Europe, was the ongoing struggle for professional prestige. Aiding the artists in their quest for higher sociocultural status were the newly formed academies of art and design. The situation in France is a leading example. Founded in Paris in 1648, the French Royal Academy of Painting and Sculpture helped French painters and sculptors to raise their disciplines to the esteemed status of liberal arts. The French Royal Academy began the process by legally separating itself from the various guilds of artisans and craftspeople. Painting and sculpture were henceforth defined, in the law books and public mind, as liberal rather than mechanical arts. The Royal Academy subsequently sought to guarantee that all painters and sculptors associated with it demonstrated the good taste of gentlemen-intellectuals in their work. The academy accomplished this task by educating professional artists and interested "amateurs" in the values of "the fine" and "true" art. This is not to say

that the French Royal Academy was monolithic and static in its definition of what constituted the fine and true art. Quite the contrary. The definition of good art, like the definition of fine art itself, was ever subject to change. By the beginning of the eighteenth century, for example, the "Rubenists," those artists and connoisseurs who championed Peter Paul Rubens's colorful, painterly style, had substantially liberated the French Royal Academy from the earlier aesthetic dominance of the "Poussinists." The latter group was composed of classicists who favored a more intellectual art, one based on precise contour drawing and supposedly time-tested rules. These rules, it was argued, had been derived from the glorious art of the ancients and passed down to the present through the noble art of Raphael and their own most recent champion, the French history painter Nicolas Poussin (1615–1675) (9.22).

ART IN EIGHTEENTH-CENTURY FRANCE: FROM ROCOCO TO NEOCLASSICISM

Watteau's Pilgrimage to Cythera: *From Baroque to Rococo.* The interval between Rubens's *Garden of Love* (8.34), probably painted in 1634, and Jean-Antoine Watteau's *Pilgrimage to Cythera* (8.35), completed in Paris in 1717, saw the beginning of a new century and the rise of a new cultural sensibility and artistic style. In art historical terms, we leave the world of the baroque and enter that of the rococo. The two works and artists are clearly different, but there are also many similarities.

The commonalities begin with the artists themselves. Both Rubens and Watteau (1684–1721) were Flemish Catholics who painted for an international market. Both were closely connected to the French upper classes. Rubens, born of an Antwerp family, spent much

8.34 • PETER PAUL RUBENS. *The Garden of Love. ca* 1632–1634. Oil on canvas. 6′ 6″ × 9′ 3½″. The Prado, Madrid.

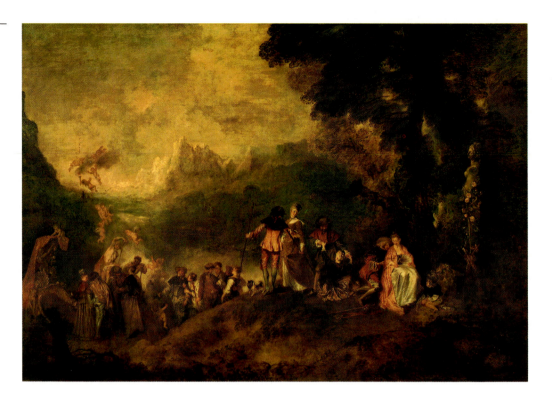

8.35 • JEAN-ANTOINE WATTEAU. *A Pilgrimage to Cythera.* 1717. Oil on canvas. 4′ 3″ × 6′ 4½″. The Louvre, Paris.

of his life working throughout Catholic Europe: in Italy, France, and the Spanish Netherlands. Watteau, brought up until the age of eighteen in an area of the Spanish Netherlands newly annexed by France, spent most of his adult years in Paris. Further, Watteau was a great admirer of Rubens, first seeing his works in Paris as engravings of original drawings or paintings. Later, he saw Rubens's cycle of paintings of the former French queen, Marie de' Medici (8.24), in their original setting in the Luxembourg Palace through the mediation of a highly placed friend, and he made many copies after them. Like Rubens, Watteau worked exclusively for society's elite. He was supported by a small circle of aristocrats and "bourgeois nobles" who patronized his art and housed him in their palaces and apartments.

Watteau was inspired by the imaginative designs, opulent coloring, and unabashed sensuousness of Rubens's paintings. In the ongoing battle between the Poussinists (who emphasized classical line and composition, and morally elevated subject matter) and the Rubenists (who emulated the more intuitive, colorful, painterly art of Rubens), Watteau's art, and its ultimate public success, was a victory for the Rubenists. The Rubenists rejoiced when in 1717 Watteau's *Pilgrimage to Cythera* earned the painter official entry into Paris's Royal Academy of Painting and Sculpture. The painting was further honored by having a new artistic category, the **fête galante** (elegant entertainment) invented for it. In the academy's hierarchy of artistic categories, the fête galante gained an intermediate place between history painting at the top and genre and still life at the bottom.

In its way, Rubens's 1635 *Garden of Love* is a baroque fête galante, an upper-class party in the countryside, that sets the stage for Watteau's rococo *Pilgrimage to Cythera*. Both show elegant open-air entertainments and have a common theme: the courtly worship of love. The island of Cythera, from which (or to which) Watteau's gentlemen and ladies are traveling in a gilded boat, was reputed to be the home of an ancient cult that worshiped the mythological love goddess. Rubens's gentleman and ladies, in slight contrast, are not at the beginning or end of their revels. They are fully engaged in the pleasures of their love garden. The two paintings are similar in that they show a comparable number of lovers, urged along by airborne cupids. In both, a

little dog, symbolic of loyalty, is at the foot of a man in red. In addition, each work shows us the various stages of the relationship between lovers: from the inviting opening conversations to the consummation of couples pairing off (in Rubens's own case, in holy matrimony). Observation alone would certainly lead to the hypothesis that Watteau drew inspiration from Rubens's work, and a reading of historical documents proves this to be the case.

But for all their similarities, these are very different works. These differences reflect dissimilarities in the two men and their worlds. The differences begin with the settings. Rubens's *Garden of Love* was improvised from the garden-park of the artist's own country estate. This garden-park is dominated by hard, heavy stone, massive baroque architecture, and solid, full-bodied sculptures. Watteau's *Pilgrimage to Cythera* is likewise set in a garden-park, probably based loosely on the pastoral estate of one of his wealthy benefactors, but the light and airy surroundings are a bit more informal and "natural," an environment later writers would describe as picturesque. In this parkland of the privileged, we encounter a soft backdrop of trees and misty mountains and statuary that is far more understated and attenuated. Witness the slender, garlanded figure of Venus, the goddess of love, on the right. Compared to the hefty baroque statues pictured in the Rubens painting, this rococo Venus appears tall and thin, a wistful nature spirit.

Rubens's *Garden of Love* is a place of grandeur and dynamism where love is being energetically pursued. The figures are big-bodied and dominate the foreground. Compositionally, they are joined in a compact, physically interrelated group. One receives a sense of confidence and solidarity. These are people of weight, health, and strength. Watteau's figures, in contrast, are slender and elongated. They move with a slower, more calculated grace. They have been compared to actors and actresses, men and women who play their roles with consummate skill on life's stage. (Watteau was a great lover of theater.) Small in scale compared to their Arcadian surroundings, these rococo lovers do not dominate their natural setting but seem to exist in harmonious relationship with it. They spread out languidly over a gently curving slope and proceed separately as couples or small groups. Figures split off from their fellows. Space opens between and around them.

The Pilgrimage to Cythera *in its Social Context.*

In contrast to baroque art (8.22–8.24, 6.24), which tends to direct the eye to the object of greatest importance, Watteau's painting seems more open, decentralized, and diffused. These spatial characteristics of *The Pilgrimage to Cythera* have interesting parallels in Watteau's own life and times. The French court had recently been decentralized, and the nobility moved to townhouses ("hôtels") throughout Paris. For the previous half century, the French nobility had been under the centralized control of Louis XIV (1643–1715). To control the disruptive nobles, the "Sun King" required them to reside at his country court at Versailles. But with the gradual ebb of the king's power and his death in 1715, the nobles chose once again to go their own ways. They promptly scattered, many moving to Paris, where they mixed with the upper class of the wealthy bourgeoisie. In the capital city, this social elite entertained in their hôtels and pursued life freely and individualistically. The control and focus of the Sun King's autocratic court, manifested in the sternly rational order and imperial feeling of his architecture (6.28), gave way to the more unbounded flow of urban living and carefree, fête galante entertaining. Both in its form and subject matter, Watteau's painting seems to reflect something of this social change.

The Pilgrimage to Cythera also gives visual form to what social historian of art Arnold Hauser calls "rococo epicureanism." This new pleasure-loving attitude, Hauser argues, represents a change in ideals of the noble upper class. "Under Louis XIV," writes Hauser, "the court nobility still extolled an ideal of heroic and ideal perfection, even though in reality it mostly lived for its own pleasure." "Under Louis XV" [1715–1774], Hauser continues, "the same nobility professes a hedonism which is also in harmony with the outlook and the way of life of the rich bourgeoisie" with whom they intermingle. It is an epicureanism—sophisticated, charming, precious, playful, and, at its extreme, decadent—partly inspired by Watteau, that came to be known as "the style

of Louis XV." Later, this style was called **rococo,** its present name.

Two Paintings: Two Personalities. In addition to larger sociocultural factors that distinguish the rococo child from its baroque parent, personal differences between Rubens and Watteau differentiate *The Garden of Love* from *The Pilgrimage to Cythera*. Rubens had been a vigorous participant—diplomat, artist, husband and family man—on the stage of life. Ever the major actor, he even participates in *The Garden of Love*. (He is the cavalier on the far left.) Watteau, in contrast, was an introspective outsider and keen observer from a distance. He was a tender man, sensitive and shy, a bachelor of solitary disposition. In several of his paintings, he pictures himself as the odd man out, the sad-eyed clown or background musician. His pleasures are passive and imaginative rather than active and physical; more those of the voyeur than the lover.

Watteau seems more comfortable viewing his protagonists from afar, as if through a wide-angle or telephoto lens. Weakened by tuberculosis and dying from it at the age of thirty-seven, he necessarily saw love and life as precious but transient, passing before his eyes just as the idyllic landscape in the background of his painting fades into the mists. In this respect, Watteau anticipates the impressionists and modernist consciousness. He captures fleeting words and glances, moments of happiness and anxiety, ultimately making for a view of the world far less idealized, grandiose, and melodramatic than that of his Catholic baroque predecessors. Cupids, statues of Venus, and Arcadian garden-parks may be the backdrops for Watteau's scenes of high society, but their primary subject is the real world of lovers, actors, musicians, and clowns. Watteau's contemporaries considered his art far more realistic than fantastical. No artist, rococo or otherwise, had ever observed and pictured the life of French high society more accurately.

From Fine Art to Fine Decoration: The Rococo as Total Style. The formal characteristics of *The Pilgrimage to Cythera* incorporate key elements of the style of Louis XV. Coloristically, Watteau's palette is more delicate and muted than its vigorous baroque parent. Rubens's primary reds become Watteau's plums or pinks. Brilliant baroque blues are toned down to rococo pastels, and bright yellows turn toward yellow-browns and mellow golds. Observing differences in the painterly surfaces, art historian Steven Jones notes that "the strong impasto [**impasto** is heavily textured paint] painting often used by Watteau's master, Rubens, is here diluted to a liquefied freedom of paint, vital but fragile in the artist's hands, evoking the play of light on satin and foliage. The evaporation of the scene in mist might almost be the final liquefaction of Watteau's palette of colour in the mists and the water." Such coloration, softer, sweeter, more delicate, found its way into rococo interior design and other forms of decorative art.

Similarly, Watteau's vocabulary of shapes found counterparts in contemporary decorative and applied arts. Historian Steven Jones comments on the elaborate decoration of the pilgrimage bark at the waterside: "Its stern is dominated by the shell, or *rocaille* motif [from which the name *rococo* was derived]. The cherubs who hang in the air on their cloud are curling and decorative elements." The same ornamental flair and vocabulary of visual forms that appear in this painting—the *rocaille* motif, leaves, branches, flowers, clouds, and other natural forms—appeared in the style of Louis XV interiors of Paris townhouse hôtels such as the Princess's Salon of the Hotel de Soubise (8.36). Light plum in color with golden decorative effects (curling shells and clouds, curvaceous cherubs, stylized plant motifs) on walls and ceiling, the oval room seems conjured up rather than constructed. With its mirrors, light color, loosely curving shape, inset paintings, and tall arched windows that manipulate the natural lighting, the room seems almost insubstantial. Chairs, tables, fireplaces, clocks, chandeliers, silverware, porcelain figurines—even the fashionable apparel of the upper classes—reflected this generalizable style. For several decades, the rococo would be the total style of the French upper classes, pervading every visible aspect of their lives.

In the context of a total style, rococo paintings were seen as part of the overall decor, an essential ingredient in the interior decorator's composition. As such, paintings were often

8.36 • GERMAIN BOFFRAND. Salon de la Princesse in the Hotel de Soubise, Paris. Begun 1732. Archives Nationales, Paris.

commissioned with a particular interior space, at times unusually shaped, in mind. Created for such urban interiors, French rococo period paintings tended to be smaller and more intimate than their baroque counterparts. In comparison to the large-scale paintings of the baroque, *The Pilgrimage to Cythera* measures a modest fifty-one inches by seventy-six inches. Baroque power and grandeur had given way to rococo intimacy and elegance. Though baroque in its lineage, the rococo style had achieved an identity very much its own.

Chardin: Painter of French Middle-Class Life. If Watteau is one of the premier painters of French high society, then Jean-Baptiste-Siméon Chardin (1699–1779) is one of France's preeminent painters of middle-class life. As a commentator on the Salon of 1741 wrote about Chardin's painting, *The Morning Toilet* (8.37), "It is always the *Bourgeoisie* he brings into play.... There is not a single woman of the Third estate, who does not think it an image of her figure, who does not see there her own domestic establishment, her polished manners, her countenance, her daily

occupations, her morals, the moods of her children, her furniture, her wardrobe." For the Parisian middle class of his day, Chardin presented realistic images of daily life shown at its ideal best. This was the "real and ideal" image to which they aspired.

Chardin was born two months before the beginning of the eighteenth century into the large family of a skilled cabinetmaker. Artistically, his inspiration came not from the elegant rococo but from the naturalistic genre and still life art of seventeenth-century Flanders and Holland. He, in fact, gained admittance to the French Royal Academy as a still life painter of "animals and fruit." From this most humble of artistic categories, rated lowest in the academic hierarchy because it did not concern itself with human beings and their actions, Chardin proceeded to the painting of genre scenes, especially interiors, in the Flemish and Dutch tradition (8.33, 7.5). The academies rated genre paintings slightly higher than still lifes because they dealt with the human world, albeit the one of common people and activities. These early genre paintings, rather than the still lifes that dominated his later years,

8.37 • JEAN-BAPTISTE SIMÉON CHARDIN. *The Morning Toilet*. 1741. Oil on canvas. 49 × 39 cm. Nationalmuseum, Stockholm.

would bring Chardin success in the salons, making for a solid if unspectacular reputation. In the art world of the eighteenth century, the highest honors were still reserved for those who depicted great religious, mythological, or historical events or painted idealized portraits of distinguished persons.

Like the genre paintings of his Dutch and Flemish predecessors, Chardin's pictures portray reality and convey moral messages. Chardin's messages concern the highest ideals of middle-class morality: simplicity, honesty, and industry. This moral idealism pervades the full range of middle-class life shown in Chardin's pictures: in subjects dealing with personal hygiene, food preparation, homemaking, and education of the young. This moral idealism is reflected in pictures with fitting titles, such as *The Morning Toilet, Saying Grace, The In-*

dustrious Mother, The Governess, The Young Schoolmistress, The Kitchen Maid, and *The Cellar-Boy*. Blending pictorial naturalism and ethical idealism, such representations of bourgeois life were appreciated and purchased by middle- and upper-class persons alike, perhaps reflecting the growing prominence of the bourgeois world view in eighteenth-century French society. *The Governess*, as but one example, was bought by a Parisian banker, a successful bourgeois, who later sold it to the Prince of Liechtenstein, an enthusiastic collector of Chardin's art.

The creations of an industrious, self-effacing bourgeois, Chardin's unassuming little paintings represent a split from the more refined and elevated history and portrait painting preferred by the upper classes. Whereas many of his more honored contemporaries flattered their sitters or idealized their subjects, Chardin painted as he saw, and not as academic tradition dictated or upper-class patrons preferred. A discerning viewer of the day noted that Chardin's little genre paintings and still lifes differed substantially from the more decorative, outwardly sophisticated work of most of his contemporaries. They possessed values of "simplicity and truth, which are so rare, so difficult to grasp in a century when art of every kind is so close to [rococo] mannerism and affectation."

A similar evaluation of Chardin's work was made by the eminent natural philosopher, social reformer, and art critic Denis Diderot (1713–1784), the principal contributor to the *Encyclopédie*, the first modern encyclopedia. For this genius-activist of the liberal French Enlightenment, Chardin's art embodied all those commendable values so lacking in the more elegant, ethically frivolous paintings of contemporary rococo masters. The son of an accomplished artisan, the morally upright Diderot reserved some of his harshest criticism for the fabulously successful rococo painter Francois Boucher (1703–1770), famous for his stylish portraits of the nobility and playful mythological scenes that brim with sensual pleasure. Whether we agree with Diderot's harsh assessment of Boucher or not, the latter's *Toilet of Venus* (8.38) is world's apart from Chardin's matter-of-fact, morally proper *Morning Toilet*. Especially sympathetic with

Chardin's realism, Diderot wrote glowingly of the artist's still lifes (8.39) at the Salon of 1763. A materialist in his world view, Diderot was impressed by Chardin's truthfulness to nature, the magical power of his illusionism, and the honest but dignified way he treated his humble subject matter. With the misguided, libertine talent of the rococo master Boucher in mind, Diderot exclaims of Chardin: "Here is the real painter; here is the true colorist." He continues:

> There are several small paintings by Chardin at the Salon. Nearly all represent fruits and the accessories of a meal. They are nature itself; the objects seem to come forward from the canvas and have a look of reality which deceives the eye. . . .
>
> For the porcelain vase is truly of porcelain; those olives are really separated from the eye by the water in which they float; you have only to take those biscuits and eat them, to cut and squeeze that orange, to drink that glass of wine, peel those fruits and put the knife to the pie.
>
> Here is the man who truly understands the harmony of colors and reflection. Oh, Chardin! What you mix on your palette is not white, red, or black pigment, but the very substance of things; it is the air and light itself which you take on the tip of your brush and place on the canvas. . . .
>
> This magic is beyond comprehension. There are thick layers of paint, laid one on top of the other, which interpenetrate from the bottom to the top layer. In other places, it is as if a vapor had been breathed on the canvas; in others still,

8.38 • FRANÇOIS BOUCHER. *The Toilet of Venus.* 1751. Oil on canvas. 42⅝ × 33½". The Metropolitan Museum of Art, New York. Bequest of William K. Vanderbilt, 1920.

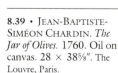

8.39 • JEAN-BAPTISTE-SIMÉON CHARDIN. *The Jar of Olives.* 1760. Oil on canvas. 28 × 38⅝". The Louvre, Paris.

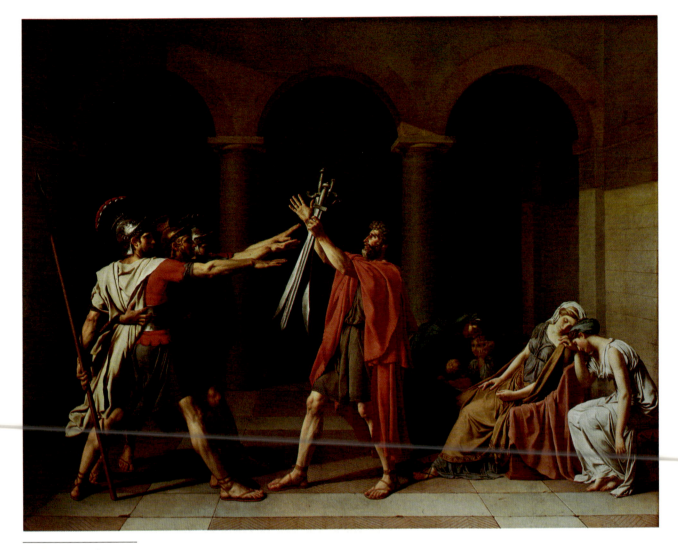

8.41 • JACQUES-LOUIS DAVID. *The Oath of the Horatii.* 1784. Oil on canvas. 10′ 10″ × 14′. The Louvre, Paris.

vius. The impressive architecture and art works that were excavated quickened imaginations. Interests beyond the archeological and antiquarian made their presence felt. In men of political reformist bent such as Diderot and David, the "classical revival" motivated passionate thoughts of a new society that might match the greatness of ancient Rome or Greece.

The young David's embrace of the classical revival and the progressive values of the French Enlightenment ultimately led him to take up an increasingly classicist style of painting. His principal goal was moral instruction, and he chose morally uplifting subjects from the ancient world for this purpose. In this regard, two key Enlightenment precepts of

Diderot served him well: to think and act like a Spartan (heroically, selflessly, stoically) and to place greatest value on art that is socially useful, morally instructive, and ethically elevating. Such an art, as David saw it, strove to imitate "nature in her most beautiful and perfect form," subsequently stirring in the viewer "a feeling natural to man [that] attracts him to the same end. . . ." In this glorious way art could help the forces of progress to accomplish the highest of all purposes: the perfection of human beings and society.

Selected as "first artist" to the French Revolution, as others had once been chosen "first painter" to the king or queen, David attempted to put these Enlightenment ideals into effect. Appointed in 1793 as the member

in charge of art on the Committee on Public Education, he argued for an art education on the most democratic scale. "Who will deny," he wrote, "that until now the French people had been a stranger to the arts, and had lived in their midst without participating in them? Any fine piece of painting or sculpture was immediately bought by a rich man, often very cheaply; and jealous of exclusive ownership, he allowed it to be seen by only a few friends, and barred it from the rest of society." Hereafter, David asserted, the collections, commissioned works, and art education facilities of the state should be available to all. As but one action, the palace of the Louvre, filled with the art collections of the French kings, was opened to the general public free of charge. Supported by such a democratization of art appreciation, painting and sculpture, David maintained, might pursue "their true destiny, which is to serve morality and elevate men's souls!"

Painted five years before the French Revolution, but seeming to prophesy it, David's *Oath of the Horatii* (8.41) perfectly embodies the artist's fervent statements. Even without knowing the specific story of the Horatii, we are stirred to feelings of duty, sacrifice, and moral earnestness. An older man holds up three swords before three young soldiers in ancient Roman battle dress. The women respond with a sense of tragic expectation. The men's expressions are of the utmost seriousness. They fix their eyes on the swords, fierce symbols of the bloody mission they are about to undertake. They seem to be swearing to fight for some noble cause and, if necessary, die for it.

All the formal elements in this very large painting, approximately eleven feet high and fourteen feet wide, work to express these general feelings and thoughts. The composition turns to the classically simple and emphatic one-point perspective of the Renaissance: the crossed swords are at the visual and psychological center of the design. Something of the pyramidal arrangement and one-point perspective system of Leonardo's *Last Supper* (8.5) and Raphael's *School of Athens* (8.6) are used here to dramatic effect, but in a more rigorously simplified, concentrated way. The story is told with a vivid economy of means.

The outstretched arms and parallel poses of the three men communicate a feeling of human solidarity: "all for one and one for all." The young men will give their lives rather than fail.

The women respond to the danger their men will soon face. Two of them swoon while a third shields two small children in fearsome anticipation. A formal and spiritual contrast is thus set up between the men and the women. This contrast today appears overtly stereotypic—men as strong and active, women weak and passive—but for centuries it seemed "natural" to all (4.38, 4.39). David's men are dominant forces: powerful in body, and stern and selfless in mind. They keep their feelings under tight control. The women, in their secondary, reactive roles, are emotional; their gestures convey their anguish and fear. To express their mental state, David has made their poses softer, transforming their bodies into wilting curves. The colors of the clothing they wear are muted, "weakened" to match their physical and mental condition. In virile contrast, the men are clothed in stronger reds, whites, and blues. Their gestures are bold and straight-lined, their postures angular and erect.

The way David draws, paints, and arranges his figures reinforces the effectiveness of the storytelling. The three groups are neatly divided by the three classical style architectural niches that frame the background. The balance is symmetrical. All is clear, ordered, and unequivocal, like the unfolding action itself. There are no moral blurs, shadowy doubts, or mixed meanings in this tragic drama. The crisp precision of the drawing, especially in the finely cut outlines and contours of the figures, reinforces the clarity of story and composition. It is as if David has sculpted these figures rather than painted them. One wonders what the sculptor Houdon would have said about these figures brought to such full-bodied life.

The story of the Horatii is a good match for the formal qualities just noted. Three brothers from Rome, the Horatii, are off to battle three brothers from the neighboring city of Alba for the purpose of settling a political dispute. Commanded by their father, they are ready to give their lives for the honor of family and city. And they do. The Albans are de-

APPRECIATION 16

The Portraiture of Elisabeth Vigée-Lebrun

WENDY SLATKIN

Elisabeth Vigée-Lebrun (1755–1842) was among the most talented and successful aristocratic portrait painters of the late eighteenth and early nineteenth centuries. As official portraitist for the Queen of France, Marie Antoinette, she achieved one of the highest positions in her society. After the French Revolution, as she traveled around Europe, she continued to experience a series of international triumphs. Her output was prodigious: she produced about 800 paintings during her lifetime. Like [the early eighteenth century portraitist Rosalba] Carriera, to whom she was frequently compared by her contemporaries, Vigée-Lebrun had the capacity both to reflect and to formulate the esthetic tastes of her aristocratic clientele.

The daughter of a pastel portrait painter, Vigée-Lebrun recalled in her memoirs that her father and his colleagues gave her instruction and encouraged her talents. She also studied the paintings in the Louvre, especially Rubens's Marie de' Medici cycle [8.24]. In this active, supportive environment, her talents developed precociously. When she was twenty, she commanded higher prices for her portraits than any of her contemporaries.

In 1778, Vigée-Lebrun was summoned to court to paint her first portrait of Marie Antoinette. Thus began a relationship that would dominate the career and reputation of the artist. An ardent royalist until her death at the age of 87, Vigée-Lebrun was called upon to create the official image of the queen. The painting that best exemplifies Vigée-Lebrun's role as political propagandist is the monumental and complex *Marie Antoinette and Her Children* [Fig. A]. This work was commissioned directly from the funds of the state to defuse the violent attacks on the queen's moral character then circulating in France. It was painted only two years before the cataclysm of the French Revolution, the imprisonment of the royal family, and their subsequent execution. This official image was designed as an aggressive, if ultimately ineffective, counterattack to the political opponents of the monarchy. Vigée-Lebrun placed the queen in the imposing and easily recognizable setting of the Salon de la Paix at Versailles. The famous Hall of Mirrors is visible on the left side of the painting. The royal crown sits on top of the cabinet on the right, the ultimate symbol of the power and authority of the kings. The figure of the queen herself dominates the composition. Her features have been ennobled and beautified, while the enormous hat and full, voluminous skirts create an impression of superhuman monumentality. Her luxuriant costume, the immense blue velvet robe and hat convey . . . the grandeur of the French monarchy. Vigée-Lebrun wanted her painting to express not only the sanctity of divine right monarchy but also the bourgeois, Enlightenment concept of "Maternal Love." The triangular composition is derived from High Renaissance images of the Madonna and Child

Wendy Slatkin is a professor of art history at the University of Redlands, Redlands, California. She is the author of the book, Women Artists in History: From Antiquity to the Twentieth Century *(Prentice-Hall, 1990), from which this appreciation is taken.*

by Leonardo and Raphael. . . . Marie Antoinette displays her children as her jewels. The Dauphin stands on the right, slightly apart from the group, as is only appropriate for the future king of France (although events were to alter the dynastic succession). The eldest daughter gazes up at the queen with filial adoration. The empty cradle to which the young Dauphin points originally contained the queen's fourth child, an infant girl, who died two months before the painting was to be exhibited at the Salon opening. On that day, August 25, 1787, anti-monarchist feelings were running so high that Vigée-Lebrun refused to display the painting for fear that it might be damaged.

There is a strong contrast between the opulent formality of *Marie Antoinette and Her Children* and Vigée-Lebrun's *Portrait of Hubert Robert* [Fig. B]. Robert, a close friend of the artist, was a painter who specialized in the creation of picturesque classical ruins. . . . As opposed to the formal reserve of Marie Antoinette, Robert leans casually on one arm. The relaxed pose contrasts with a tense, alert gaze. Robert seems to be receiving inspiration from some undetermined source. The sharp turn of the head, strong lighting, and a sense of barely controlled energy convey a vivid sense of tangible presence. The face is painted realistically, which underscores the immediacy of the image. The barely restrained, proto-Romantic energy of Hubert Robert anticipates subsequent developments in romantic portraiture in the early nineteenth century.

Vigée-Lebrun positioned Robert against an undetailed, neutral background in which brushstrokes are visible. This plain ground is similar to those used by her colleague, Jacques Louis David, for portraits [Appreciation 2, Fig. C] and other types of painting (see *Death of Marat*). However, the neutral background is in marked contrast to the bright, ruddy complexion of Robert and the three primary colors employed in his costume: a yellow vest, blue jacket, and red collar. The primary colors are echoed in the paint brushes, also tipped with red, yellow, and blue. The white cravat, which

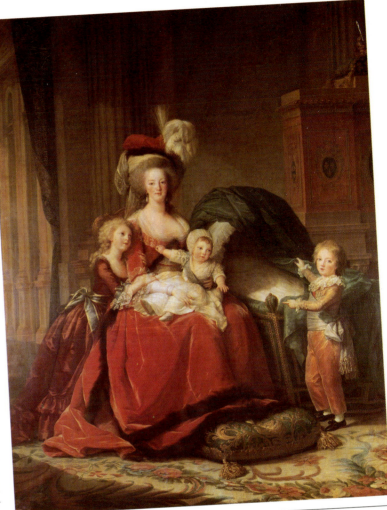

Figure A • ELISABETH-LOUISE VIGÉE-LEBRUN. *Marie Antoinette and Her Children*. 1787. Oil on canvas. 9' ¼" × 7' ⅝". Musée National du Chateau de Versailles.

(continued)

Fro
T

In the seven decades from the America laration of Independence in 1776 to merous revolutions that convulsed Eu 1848, the modern world was born. It world born of radical changes in every life. Citizens in America and France re for political rights: individual free democratic governance, and property In 1808, Spain began its bloody strugg national liberation from Napoleon's o ing forces, and in 1821 Greece rose up a Turkey for its own national freedom. In and 1849, the various Italian states rel against their Austrian rulers for indepen and ultimate nationhood. In the first months of 1848, almost fifty revolut ranging from struggles for statehood an litical rights to uprisings against grievous nomic and working conditions, eru throughout continental Europe.

The birth of the modern period saw middle classes across Europe continuing t drive for equality with, and eventual sup ority over, the aristocracy. Concurrently, Industrial Revolution swept both the

Figure B • ELISABETH-
LOUISE VIGÉE-LEBRUN.
Hubert Robert. 1788. Oil
on canvas. 41¼ × 33".
The Louvre, Paris.

groups—fixed social classes, powerful professional and crafts guilds, hereditary orders, tradition-bound communities—was giving way increasingly to a world that pulsed with freely moving individuals. The "atomization" of society into small units of free-floating individuals and families, all fending for themselves, has already been discussed in respect to the industrialization and urbanization of nineteenth-century England. These same processes of individualization and atomization soon made themselves felt in France and elsewhere in Europe. Propelled by the emphases of the rising democratic and capitalistic systems on individual rights and self-interest, the centuries-old social fabric of Western society was unraveling. The old social order had been characterized by the strict and lifelong confinement of individuals to respective social classes, guilds, and communities. In the new social order, by contrast, the class, occupation, and life-style of individuals could change fluidly over the course of a lifetime. In brief, a new world was emerging. Its primary shapers were democracy and capitalism, industrialism, science, and urbanism. Freedom and individualism were its rallying cries.

In this revolutionary sociocultural context, **romanticism,** the first certifiably modern art movement, was born. Like all revolutions, the so-called romantic rebellion built on and reacted against the world that produced it. It grew from earlier art movements and schools, but it infused these with unprecedented freedom, individuality, and originality. It maintained ties with the past while striving idealistically for a brave new future. In these regards, it is perhaps most accurate to see romanticism as a transitional movement that bridges two worlds, one dying and the other struggling to be born.

THE ARTIST AS ROMANTIC REBEL: GOYA & GÉRICAULT

Emerging at the end of the eighteenth and the beginning of the nineteenth century, romanticism started as a hybrid. It initially incorporated small pieces or large chunks of previous schools or styles: baroque, rococo, neoclassicism, naturalism. In the early work of the

Spanish artist Francisco Goya (1746–1828), for example, the artist blends the playful subject matter, dainty coloration, and melodious painterly style of the rococo with his naturalistic sense of the social scene and a firm understanding of academic neoclassicism. The younger French painter, Théodore Géricault (1791–1824), who lived his entire adult life in the nineteenth century, was inspired by the dramatic baroque style of Rubens, the revolutionary neoclassicism of David, and the naturalistic painting of English animal and landscape painters, Constable among them.

But although romantic art was of mixed parentage, it soon became a unique offspring. To begin, romantic art was characterized by a more intense expression of the artist's individuality—his or her *personal* feeling, thought, imagination—than any previous movement. According to the contemporary German philosopher Georg Wilhelm Friedrich Hegel (1770–1831), the ruling principle in society and art was fast becoming "free subjectivity," the unlimited right of each person to make personal development and interest the key motive of his or her activity. Consider Géricault's portrait of a young artist friend (9.1). The most noticeable quality of this portrait is the subject's self-absorption. He seems lost in his own thoughts and feelings. The outer world fades away like the nebulous background on which he hangs his palette. As the writer Edmund Feldman observes, one senses in this dreamy bohemian a mixture of sensitivity and languorous boredom, a world-weariness that might be overcome only by exceptional effort. Rightly called "the classical image of the romantic artist," the youth must take up the role of the great-souled person, the genius, the individual who expresses personal thoughts and feelings and makes his or her own rules. What we today call "self-expression"—in art, fashion, or life-style—begins most emphatically with the romantics.

In the sphere of fine art, such self-expression often took on a rebellious social or psychological cast; thus, the twentieth-century references to these artists as "romantic rebels" and to their movement as the "romantic rebellion." In the Spaniard Goya, for instance, this rebelliousness manifested itself as an emotional outcry against inner demons and a pas-

sionate denunciation of social injustice. In addition, Goya's outcry was often attended by an explosion of imagination, producing troubled visions and fantastical revelations of the inner self unlike any seen before. With the Frenchman Géricault, emotion and rebellion likewise seethed on canvas or paper, but the work was more consistently naturalistic in style. A true romantic rebel, Géricault explored subject matter that most artists had previously avoided: a horrible shipwreck, mentally disturbed persons, the industrial underclass.

The individualistic spirit of the works of certain artists of previous centuries—Michelangelo, the mannerists, Rembrandt—was fully unleashed by the romantics. For Goya and Géricault, individualism had indeed become a paramount value. Never before had works of art been so subjective and self-expressive as Goya's two print series, *Los Caprichos* (*The Caprices*) and *Deparatos* (*Follies*), or the "black paintings" of his final years. For his part, Géricault, in an attempt to develop a thoroughly individualistic way of seeing and representing, purposely defied the time-honored academic approach to art education. Believing that academies of fine art ruined rather than fostered great and original talents, he argued that artists should be "self-taught"; that is, they should freely seek their own models and masters. Naturally, such a self-taught, "self-made" artist would tend to develop an original, individualistic vision and style. Herein lie the roots of our conception of the "modern artist." Géricault wrote:

> Supposing that all the young people admitted to our schools were endowed with all the qualities needed to make a painter, isn't it dangerous to have them study together for years, copying the same models and treading approximately the same path? After that, how can one hope to have them still keep any originality? Haven't they in spite of themselves exchanged any particular qualities they may have had, and sunk the individual manner of conceiving nature's beauties that each one of them possessed in a single uniform style?[1]

Such liberal, self-oriented schooling, Géricault maintained, would foster those qualities—individual genius, original talent, creative imagination, subjective expression—most often associated with romanticism. And, in

9.1 • THÉODORE GÉRICAULT. *Portrait of an Artist in His Studio.* 1818. Oil on canvas. 4′ 9⅛″ × 3′ 8⅛″ . The Louvre, Paris.

fact, this seemed to be the case. Following their own instincts about art education, artists as diverse as Constable, Turner, and Delacroix developed singular styles that suited and reflected their interests and temperaments. Committed to individualism in art and life, the romantic spirit naturally cultivated differences as well as commonalities between artists. Constable, for example, was more committed to a scientific naturalism (7.6) than his fellow Englishman J. M. W. Turner (1775–1851). Meanwhile, Turner's work itself is given to difference and variability. His early work adhered to an idealizing "sublime" style much praised in academic circles, but in some of his later work, far less accepted, he gave remarkably free rein to bold imagination. The latter paintings, which passionately evoke the

9.2 • JOSEPH MALLORD WILLIAM TURNER. *Rain, Steam, and Speed.* 1844. Oil on canvas. 90.8 × 121.9 cm. The National Gallery, London.

cosmic forces of nature, are colorful, boldly brushed works of semi-abstraction that look like twentieth-century abstract paintings decades before their time. *Rain, Steam, and Speed—The Great Western Railway* (9.2) is such a work, juxtaposing nature's mighty wind and rain with the awesome force of a steam-driven passenger train speeding across a giant new railroad bridge. Like many romantic masterpieces, *Rain, Steam, and Speed* was inspired by a deeply felt personal experience: in this case, the artist putting his head out a train window during a rainstorm. And, like much of the great art of past and present, the finest romantic art is complex and defies easy definition. In the work of Constable, Turner, Goya, and Géricault, we experience such art at its multifaceted best.

From Court Painter to Social Critic: The Art of Francisco Goya. The first five decades of Francisco Goya's long life were spent in a steady climb toward social and economic success as well as critical acclaim. The son of an artisan father and a mother descended from minor nobility, Goya lived from 1746 to 1828, making him an almost exact contemporary of the revolutionary French neoclassical painter David. But whereas David, in his early career, went hard against the grain, denouncing both the monarchy and the Royal Art Academy, Goya began by sticking to the tried-and-true path. For the first forty years of his life, Goya sought success through the Spanish Academy and through commissions awarded by the royal court. Like the vast majority of his fellow artists, he desired the patronage of the upper classes. Ultimately, he made his way to the top, gaining appointment as court painter to Charles IV in 1799.

As a painter of high society, Goya was a huge success, but we probably would not recognize him as one of history's greatest artists had not two traumatic events redirected his

life. The first was the permanent loss of his hearing. Caused by a life-threatening illness in 1792, his sudden deafness seems to have transformed Goya, making him bolder, willing to risk more. An unflinching realism came increasingly to characterize his portraits of the aristocracy. Even his group portrait of the royal family in 1800 abstained from the customary idealization, showing certain family members as unattractive or even mean-spirited. At the same time, Goya began to unleash a surreal imagination in self-expressive drawings and engravings. This direction, a prelude to modern expressionism and surrealism, is seen in Goya's print series, *Los Caprichos,* or *Caprices,* first seen by the public in the final year of the century. The plate entitled *The Sleep of Reason Produces Monsters* (9.3) is representative of the series. A sleeping figure is engulfed by a nightmare. A first level of meaning is that irrational, frightening dreams can fly up and overcome the individual while the conscious mind sleeps. But what the artist is really trying to represent is a partnership between reason and imagination, the rational and irrational faculties. This interpretation is validated by Goya's caption, which reads, "Imagination abandoned by reason produces impossible monsters: united with her, she is the mother of the arts and the source of their wonders."

If we extend the meaning of the print from the individual to the social level, we might conclude that the artist was also indicting Spanish society for its failure to make reason its guiding light. Imagination so abandoned produces monsters. As reason sleeps, Goya asserts, Spain has been transformed into a dark realm of monstrous folly reigned over by political corruption, religious superstition, lechery, prostitution, stupidity, and greed. In all eighty plates of the *Caprichos,* Goya hammers home this message. The sunlit goals of the Enlightenment—reason, justice, order, harmony—have been eclipsed. The artist, as rebel, must cry out for their return.

The second traumatic event that shook Goya's life was the occupation of Spain by the forces of Napoleon in 1808. It would bring further horrors. Many Spanish intellectuals, Goya included, initially had much sympathy with Napoleon's general program. It promised a shift toward the liberal Enlightenment values that the American and French Revolutions had tried to put into effect. Spanish intellectuals were more than ready to do away with the corrupt, reactionary monarchy that had imprisoned those who stood for reform. But instead of bringing reform, the occupation of their country by Napoleon's armies led to disaster. Inspired by patriotic nationalism, the citizens of Madrid revolted against their foreign rulers. On May 3, French firing squads executed scores of Madrileños. Years later, Goya portrayed the event with chilling realism

9.3 • FRANCISCO GOYA. *The Sleep of Reason Produces Monsters.* 1799. Etching and aquatint. 215 × 150 mm. Museum of Fine Arts, Boston. Gift of Mr. and Mrs. Burton S. Stern, Mr. and Mrs. Bernard Shapiro, and the M. and M. Karolik Fund.

9.4 • FRANCISCO GOYA. *The Third of May, 1808.* 1814–1815. Oil on canvas. 8′ 9″ × 13′ 4″. The Prado, Madrid.

9.4 • FRANCISCO GOYA. *The Third of May, 1808.* 1814–1815. Oil on canvas. 8′ 9″ × 13′ 4″. The Prado, Madrid.

(9.4). Reason has disappeared altogether to be replaced by the forces of death and destruction. The modern military machine lines up the motley resisters and mows them down. The mighty gesture of David's *Oath of the Horatii* (8.41), unified and heroic, has here gone astray. The three Horatii have turned into a cold-blooded French firing squad, a well-ordered but cruel machine for exterminating the enemy. The executioners are portrayed as faceless troops just following orders. Losing their humanity, they have become a well-oiled, bureaucratic machine. Only the hopeless Spaniards, about to die, are capable of individualized responses; they retain the bewildered and frightened expressions of humanity. With arms spread apart and upward, face and body ablaze with light, the central figure is like a dying Christ. The distortion of reason by injustice has wrought the most horrifying of nightmares.

"Little wars" or *guerillas,* were initiated by Spanish bands throughout the country.

(These were the first so-called guerilla actions.) Violent atrocities were committed by both sides, and Goya depicted them with graphic ferocity in a print series called *The Disasters of War* (10.10). Acting almost as a journalist, he shows us the everyday occurrences of this vicious guerilla war. Corpses are mutilated. The heads and arms of the dead are hung on the limbs of trees. The modern colossus of war, with its accompanying plague of terror, chaos, and suffering, ravaged Spain for six years while Goya etched and painted its cruel image. His art of social conscience would serve as inspiration for scores of humanitarian artists to come.

Goya's later paintings and prints shrieked out against inner demons: fear, depression, alienation. Not until the arrival of modern expressionism did artists express their internal turmoil so boldly. Not until the symbolists and surrealists did artists reveal their dreams and fantasies so forcefully. Goya's art would be a deep spring from which many later artists drank.

Portraying the Victims: The Art of Géricault.
Like Goya, Théodore Géricault was committed to portraying life's victims. His subjects included the torn and tattered "street people" of the British underclass (5.16) and the mentally disturbed people confined in French asylums. Géricault didn't care that government censors and the state-sponsored art academies frowned on such subject matter. He was a new type of artist, a rebel who pursued an independent and original vision, whatever the cost. Financial support from his well-to-do bourgeois family made his independence possible. Géricault did not have to starve to maintain his artistic freedom, nor did he have to seek commissions or work an outside job. Bourgeois wealth made it much easier for Géricault and other well-to-do nineteenth-century innovators, such as Delacroix, Manet, and Courbet, to pursue an independent, personally chosen course. The artists themselves, not a particular patron or the academies, in most cases determined the subject matter and style of the work.

Perhaps with David's *Oath of the Horatii* in mind, Géricault chose a stirring subject for the painting he hoped would make his public reputation. Like David, he sought his major triumph at the annual exhibition of the government-sponsored Salon. And like the master he so admired, he submitted a work (9.5) with strong political and moral overtones. Its subject was the controversial shipwreck of the *Medusa,* a government vessel. Captained by an aristocratic official appointed by the restored Bourbon monarchy, the ship had sunk off the western coast of Africa in 1816. Provisions for the passengers' safety seem to have been minimal. One hundred forty-nine passengers were assigned to a hastily assembled raft that was to be towed by the ship's lifeboats. Shortly thereafter, the ropes between the vessels

9.5 • THÉODORE GÉRICAULT. *The Raft of the Medusa.* 1818–1819. Oil on canvas. 16′ 1″ × 23′ 6″. The Louvre, Paris.

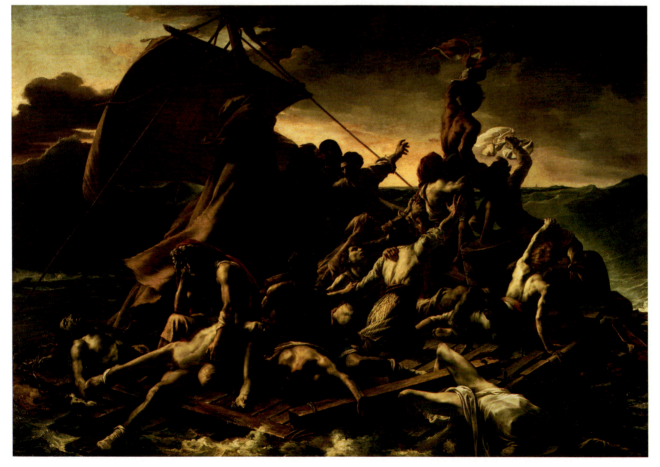

broke, or were purposely cut, and the raft drifted off. The result was disaster for those on the raft. Tortured by hunger and thirst, they fought among themselves. Only fifteen survived, many near death. The disaster inflamed the liberal opposition, to which Géricault belonged, against the conservative monarchy. In the spirit of protest, the artist created lithographic prints to accompany a pamphlet in which two of the survivors accused the government of criminal negligence. The artist then committed himself to illustrating the disaster for the world to see. His goal was to create a modern history painting of a contemporary tragedy.

Personally, Géricault was impetuous and lived a freewheeling, even violent life; he loved to ride wild horses and ultimately died at thirty-three from a riding injury. But in the creation of art, Géricault was the most painstaking seeker of truth. Working like an investigative journalist, he interviewed the survivors of the *Medusa* and studied dead and dying persons in hospitals. He had the ship's carpenter build a facsimile of the original raft and examined its response to rolling waves at sea. He observed the types of clouds that form over the ocean. Géricault's intense romantic sympathy with suffering, cruelty, and death coincided with a rigorous commitment to scientific truth. The molding of feeling and fact by genius would bring forth a masterpiece.

In the spirit of high romantic drama, Géricault chose to portray the most impassioned moment, the one that combined the greatest anguish and hope. He also chose to work on a huge scale: a canvas sixteen feet high by twenty-three wide. The larger-than-life dimensions of the work amplify its emotional impact. On the horizon is a tiny sail. Those survivors with remaining strength struggle forward and upward. A crescendo builds. We feel it coursing upward through the dead and dying to those above who strain toward their potential rescuers. Formally, we feel the stress of intersecting diagonals: the men, for example, pull in one direction; the mast leans in another. The triangular formation of central figures, with the black sailor waving his shirt at the top, creates an upward thrust. (As a subtext, the issue of Negro emancipation had arisen, and the liberal Géricault was naturally a supporter.)

From an art historical perspective, elements of Michelangelo (the writhing, powerful nude male bodies), Rembrandt (the dramatic light-dark contrasts), and Rubens (the propulsive energy and theatricality of the "baroque" composition) coexist in *The Raft of the Medusa*. But most striking to Géricault's contemporaries was the emotional and empirical truth of the painting. So convincing was the work that most viewers overlooked its defiance of the traditional content of history painting. An ignoble contemporary event was the subject of a painting whose genre was previously reserved for the most noble and elevated subjects. No gods, saints, emperors, or Horatii are pictured here; only the nameless, brutalized survivors of a disaster. History painting was on its way to being democratized, its subject matter opened up to the full range of human experience.

THE ART OF DELACROIX: A ROMANTIC MARRIAGE OF FORM & CONTENT

Empathizing with the suffering, the cruelly treated, and those battling for liberty, many of the romantics were drawn to the various national movements for freedom and independence. Eugène Delacroix (1798–1863), France's romantic painter par excellence, had created a stirring symbol for his own nation in *Liberty Leading the People* (9.6, 4.21). The painting eulogized the successful uprising of middle- and working-class French citizens against a repressive, reactionary monarchy in the Revolution of 1830. Dominated by the colors of the French flag, the work focuses on the allegorical figure of Liberty, "this strong woman with powerful breasts, rough voice, and robust charm," as a contemporary ode described her.

For a foreign neighbor, Delacroix created an international rallying cry, *Greece Expiring on the Ruins of Missolonghi* (9.7), which took up the cause of the Greek struggle for independence from the Ottoman Turks. This painting shows the symbolic figure of the Greek nation, a kind of "Liberty Enchained," kneeling on the ruins of a decimated town. Noble but vulnerable, the figure of Greece spreads her arms as if to ask why. The large

9.6 • EUGÈNE DELACROIX. *Liberty Leading the People*. 1830. Oil on canvas. 8′ 6″ × 10′ 8″. The Louvre, Paris.

painting was first shown in 1826 at a huge public benefit for Greek relief at a Paris gallery. Almost two hundred works by the foremost painters in France were exhibited, the first time so many artists had united behind a humanitarian cause. In the end, Greece, with the military aid of Britain, France, and Russia, gained her independence.

Color, a central element in romantic painting, helps tell the story. Complements of bluish purple in Greece's cloak and yellow-orange in her golden sash and braids interact in a smoldering incandescence. Simultaneously, the creamy whites of the woman's dress pick up and are animated by these complementary hues. The reds of Greece's sandal, lower cape, and headpiece further intensify the complementarity while serving as visual links to the other figures. In the background, a stormy purple-blue sky angles downward. It echoes the color, directional line, and sentiments of the nation on her knees. Crushed beneath broken slabs of heavy stone, a Greek fighter's hand and arm reach out lifelessly. He is clothed in a garment of lurid red and green, another emotive complementary exchange. In the upper right stands a victorious Ottoman Turk soldier armed to the teeth. The red, gold, and black of his clothes relate the victor cyclically to the two victims at his feet. In this way, Delacroix uses color both to evoke emotion and unify the composition. In the words of the art historian Walter Friedlaender, "what Delacroix's technique creates is a painterly

unity so constituted that each touch of color is dependent on, and reflected in, all the others, so that instead of many separate local tones [as typical of the classical academic approach] a synthetic color harmony is achieved."

Like many of Delacroix's paintings, *Greece Expiring on the Ruins of Missolonghi* was based on a literary source. It was inspired by the writings and stirring personal example of the romantic English poet Byron (1788–1824), who died at Missolonghi fighting for Greek freedom. Much romantic art was, in fact, broadly illustrative, interpreting literary sub-

9.7 • EUGÈNE DELACROIX. *Greece Expiring on the Ruins of Missolonghi.* 1826. Oil on canvas. 6′ 11½″ × 4′ 8¼″. Musée des Beaux-Arts, Bordeaux.

jects drawn from past and present sources: classical mythology, Dante, Shakespeare, Sir Walter Scott, Byron. By basing his paintings on such masterworks, Delacroix felt he was collaborating with the giants of literature. He cherished "communicating with other souls," especially ones of sensitivity, passion, and imagination, that is, of genius. Although the subject matter was of primary importance, the artist also focused on formal considerations—line, color, composition—to bring imaginative life to the chosen content.

The significance of subject matter notwithstanding, we begin to note in Delacroix's work a tendency toward an equal weighting of form and content. Recall the analysis of *Greece Expiring on the Ruins of Missolonghi* while considering Delacroix's goal as a painter, stated in his own words: "If, to a composition that is already interesting by virtue of the choice of subject, you add an arrangement of lines that reinforces the impression, a chiaroscuro that arrests the imagination, and color that fits the character of the work . . . the result is harmony, with all its combinations, adapted to a single song. . . ." Through his expressive subject matter, combined with his interactive color, energetic brushwork, and harmonious compositions, Delacroix inspired the young lions of the coming generation. They appreciated him for his balance of form and content. And they respected his artistic independence and originality.

Delacroix's admirers among the upcoming generation included the American expatriate James McNeill Whistler (5.11, 5.12), and the Frenchmen Edouard Manet and Henri Fantin-Latour (1836–1904). So great was Fantin-Latour's admiration of Delacroix that he painted *Homage to Delacroix* (9.8) in 1864, a year after the master's death. The *Homage to Delacroix* is art history brought to life. It affirms the continuity between generations. It is about roots and development. Here are Manet, Whistler, Fantin-Latour, and such prominent young writers as Baudelaire, Champfleury, and Duranty admiring a portrait of the recently deceased Delacroix. Each man in his own way loved Delacroix's art, but, perhaps equally, they loved his romantic example of what it meant to be an artist. They admired Delacroix's emphasis on "genuine feeling" and "great audacity to dare to be oneself," his com-

9.8 • HENRI FANTIN-LATOUR. *Homage to Delacroix.* 1864. (Seated: Fantin-Latour, coatless; Baudelaire, far right. Standing: Whistler, left side of portrait; Manet, right side of portrait.) Oil on canvas. 5′ 3½″ × 8′ 2½″. Musée d'Orsay, Paris.

mitment to developing an "absolutely personal way of seeing things" and an artistic language of one's own to express it. "If you cultivate your soul," Delacroix had written, "it will find the means to express itself." Artistic style, he argued, the means by which one expresses oneself, grows organically from the soul like a flower from a vine. Style cannot be grafted artificially by an academy or other outside force. This passionate concern of Delacroix and the romantics for individuality of seeing and expressing made a deep impression on the independent-minded men and women of the younger generation. Along with the marriage of form and content, the emphasis on individualism and stylistic independence was romanticism's chief gift to the modernist movement.

THE EMERGENCE OF THE MODERN ART WORLD

Modern Art in Its Social Context. Romanticism's cultural emphasis upon the individual's feelings, imagination, and originality was a primary force motivating the independent modern art movements and individualistic styles. But other less obvious social forces were also promoting the freedom and individualism so basic to modern art. In the preceding century, liberal Enlightenment thinkers and partisans of political democracy had made the case for individual rights and had fought to guarantee freedoms of personal expression. The political and cultural climate now partially supported and did not completely oppose a free and self-determined art. In the economic sphere, competitive capitalism, now dominant in much of Europe, stood for "free" enterprise and the "self-made" individual. In this societal context, it is not surprising that independent-minded artists, whether romantics, naturalists, or realists, marched to their own drummer and rebelled against bureaucratic schools, academies, and salons that promoted conformity. Increasingly, artists sought to create paintings and sculptures that were original and personally meaningful. Being "genuine" or "sincere" (that is, true to one's own feelings) became a central value of the independents. At mid-century, most artists, to be sure, still adhered to the traditional academic ways, but the cultural dominance of the old art establishment was being challenged. New directions, independent and individualistic, were being charted.

elevation in the cultural status of art. After three long centuries, painting and sculpture were finally embraced as "liberal" and "fine" art forms of major significance. Prominent literary men such as Ruskin in England and Baudelaire in France now actually looked up to painters such as Turner and Delacroix. With deference, they wrote scores of pages in explication and praise of their favorite artist's work. Just a century before, the situation had been quite different. Painting and sculpture were still striving for equality with the "liberal" literary arts. The writer Diderot, for example, would never have regarded his contemporary Chardin as an equal, even though he showered praise on his paintings. Literary intellectuals of the eighteenth century still looked on painting and sculpture much as Renaissance poets had looked on the art of Leonardo da Vinci and his colleagues. Because painting and sculpture required manual labor and handicraft, they could never attain the highest status, which, writers of the past had argued, was

reserved for poetry, prose, and music, the most fully intellectual of the arts.

By the mid-nineteenth century, however, all this had changed. Painting and sculpture were finally judged to be equals to the other arts. The academic painting *Charles X Awarding Prizes at the Salon of 1824* (9.11) proves the point. It shows famous musicians, writers, and socialites honoring painters and sculptors, with the king himself handing out the awards. At this Salon, Ingres would win membership to the Academy, Delacroix a second-class medal, and Constable a gold medal for his *Haywain* (Appreciation 17). The years of struggle by various painters and sculptors, the growing prestige of the official art academies, and the expansion of the art world and its public had brought painting and sculpture full-fledged liberal arts status. The deep-rooted stigma that painting and sculpture were mere "mechanical arts" was consigned to the past. (After 1840, it would be the photographers who had to overcome the old argu-

9.11 • FRANÇOIS-JOSEPH HEIM. *Charles X Awarding Prizes at the Salon of 1824.* Oil on canvas. 5′ 8″ × 8′ 5″. The Louvre, Paris.

ment that visual art was inferior due to its mechanical nature. Ironically, painters, sculptors, and their supporters now sought to deny full fine art status to the new "industry" of mechanical reproduction.)

Looking to the Present and Future: The Influence of Progress. Another cultural force propelling the evolution of modern art was the notion of "progress." During the Renaissance, and even into the nineteenth century, many among the elite looked back to ancient Greece and Rome as the models of culture and society most worthy of emulation. For centuries, educated persons had sought a "rebirth" or "revival" of the values of the classical world. For greatness, they looked to the past. But a "progressive" consciousness was also taking root. Renaissance artists such as Brunelleschi and Michelangelo spoke of themselves as "moderns" who would outdo "the ancients" in the size, beauty, or excellence of their accomplishments. In the eighteenth and nineteenth centuries, major artists and intellects likewise looked forward as well as back. Both Thomas Jefferson and the painter David called for a return to the greatness of classical Greece and Rome while simultaneously leading the revolt for radically new societies. In Victorian England, Ruskin and Morris called for a revival of the Middle Ages while militating for a progressive new social order.

Paradoxically, all such calls for a return to the past took place in societies that were moving forward at increasing speeds. The eighteenth-century Enlightenment, with its scientists, encyclopedists, and philosophers, had succeeded in shifting the engine of progress into high gear. The engineers and entrepreneurs of the Industrial Revolution had stoked the fire until the idea of progress had begun to move with the speed and power of a locomotive. Progress was well on its way to becoming the central metaphor in our lives. (Over the last hundred years, we have been extraordinarily focused on progress as it manifests itself in personal growth, science, industry, medicine, education, and every other area of life.) Modern art, for its part, has followed this progressive ethic. Its orientation is ever to the present or the future. "Live for and show your own time," the realists and naturalists asserted, a credo the French artist Rosa Bon-

heur (1822–1899) followed in both her life and art (Appreciation 18). For Bonheur and her fellow "painters of modern life," the goal was to capture the spirit and appearance of their era. Their art, they believed, would be on the cutting edge of modernity. As individuals and artists, they saw themselves as important members of society's vanguard.

The Rise of the Avant-Garde. Meaning the "advanced guard" or "vanguard," the **avant-garde** stood for an entirely new relationship between the artist and society. Up to this time, artists had looked to the past as the source of their subject matter and style; avant-garde artists looked to the present and future. The dynamically changing modern world was their model and muse. True, the advanced guard might build on the accomplishments of the past, but what really mattered was being on the cutting edge of the present, being "children of their age" whether in terms of politics, ideas, science, fashion, music, or poetry. What the twentieth-century critic Harold Rosenberg called "the tradition of the new," the all-out modernist commitment to originality and innovation, was taking root. Not just the art world but all the sectors of society were participating. With increasing speed, the free-market system introduced new products and fashions. Scientists brought forth new inventions; medical researchers, new cures; engineers, new and bigger bridges and tunnels. Within this progressive context, avant-garde artists, joined by vanguard poets, critics, and historians, launched a multitude of movements or schools. New "isms" emerged at an accelerating rate as the century proceeded onward: naturalism, realism, impressionism, neo-impressionism, and symbolism were a few of the most prominent. This proliferation of movements mirrored the core modernist values: individualism, originality, pluralism, and a commitment to present-tense "modernity" and future-oriented "progress."

Goya, Géricault, Delacroix, Constable, and Turner had anticipated the emergence of modern art and were its forebears. Two mid-century painters, Gustave Courbet and Edouard Manet, were its founding members. More than any other artists, Courbet and Manet would originate our conception of the avant-garde artist and modernist art.

APPRECIATION 17

John Constable. *The Haywain.*

ROBERT BERSSON

Born in a year auspicious for revolutionary developments, the British artist John Constable (1776–1837) would become the most profound of the early nineteenth-century "natural" painters, combining an empathic feeling for nature with a scientific penetration into physical phenomena. A comparison of his *Haywain* of 1821 with the idealized landscapes that dominated previous centuries—Poussin's classicist *Burial of Phocion* (9.22), Rubens's baroque *Garden of Love* (8.34), Watteau's rococo *Pilgrimage to Cythera* (8.35), Sandby's picturesque *Landscape with Bridge and Castle* (3.10)—provides insights into the revolutionary aspects of the new "naturalist" or "realist" way of seeing. Admittedly, *The Haywain* looks only mildly realistic to our twentieth-century eyes, conditioned as we are to the extreme realism of the camera. But to art lovers of a prephotographic era, accustomed to intentionally beautified portrayals of nature, Constable's naturalism was jarring. To many of his fellow countrymen, his art appeared too plain and too blunt in its truthfulness. The eminent critic Ruskin found paintings like *The Haywain* "artless"; that is, without charm or imagination. Ruskin preferred the romantically Sublime landscapes and seascapes of Turner, with their passionate portrayal of nature at its most untamed and dramatic (3.17, 9.2). Although Ruskin responded with enthusiasm to the genius of Turner, his particular way of seeing blinded him to a different kind of greatness in Turner's contemporary, Constable.

Passions as profound as Turner's, but far less tumultuous, resonate in Constable's art. He may not have chosen Turner's Alpine heights, violent storms, or spectacular sunsets as his subject matter. He may not have employed his contemporary's swirling brushwork or brilliant color in his treatment. His more modest, down-to-earth temperament was uncomfortable with what he saw as high romantic "bravura" and "attempts to go beyond the truth." Yet a romantic emotion, quieter in tone, does pulse in his sensitive renderings of gentle lowland scenes (7.6). "Painting," Constable wrote, "is but another word for feeling." To commonplace scenes he could bring a profound sensuous love. Nature, straightforward and unadorned—the actual color of trees and clouds, texture of wood and brick, motion of wind and water—was more than enough to engage his artistic energies.

Constable's landscape paintings are animated by the mobile sunlight and rustling breezes of the days on which he painted. In *The Haywain* one senses that Constable actually felt and saw those rippling reflections on the water and those alternating patterns of light and shadow that color the fields. He knew those fleeting clouds, so particularized in shape, value, and texture. It has been said that Constable went so far as to "bottle" clouds to study their true appearance. We know that he made hundreds of cloud studies, noting on the back the type of cloud, the month, time of day, and sometimes even the direction of the wind. For this artist, landscape painting was the result of firsthand viewing and long study. When he entered his studio to elaborate a more "finished," academically polished painting from his full-sized, out-of-doors oil sketch, the freshness of the original impression and his years of careful observation served to keep his vision truthful. Can there be any doubt

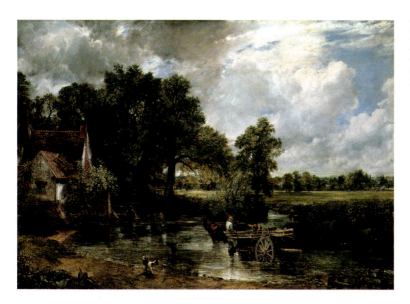

JOHN CONSTABLE. *The Haywain*. 1821. Oil on canvas. 130.2 × 185.4 cm. The National Gallery, London.

that this same fascination with actuality, this naturalist vision, led to the invention of photography, that supreme form of realistic reproduction? It comes as no surprise that photography (7.7) was, in fact, developed in the 1830s and was popularly received in England and France at the height of the naturalist movement in the 1840s and 1850s.

The social context that gave rise to Constable's naturalistic landscape painting also saw the disappearance of large portions of the rural landscape. Factories, mines, railroads, and an expanding population would soon overrun a quiet, largely agricultural countryside. A centuries-old way of life, centered on nature's rhythms, would soon give way to the mechanical operations and accelerated pace of an urban, industrial society. With this disturbing prospect before him, Constable, the son of a wealthy rural miller, set out to paint, and thereby preserve, what he knew and loved best: "the sound of water escaping from mill-dams [as in *The Haywain*] . . . willows, old rotten planks, slimy posts, and brickwork." "Those scenes," he wrote, "made me a painter and I am grateful." In response to the description of a new "bright, brick, modern, im-proved, patent monster" to replace an old wooden mill that had burned down, Constable shuddered that "there will soon be an end of the picturesque in the kingdom." Understandably, modern industrial machinery, in spite of its growing presence in the countryside, is never pictured in his art. In the context of the Industrial Revolution, Constable's painting can be seen as a personal statement in defense of the simple joys of a rural life swiftly retreating before what he saw as a brutalizing world of machines.

Although Constable's painting did not find immediate popular acceptance in England, it did receive a very warm welcome in France, a society beginning to experience an industrial and urban revolution of its own. Exhibited in the French national Salon of 1824, *The Haywain* was honored with a prestigious gold medal. More importantly, it gave impetus to the development of French "open air" painting, which was then still in its infancy. There is a direct line from Constable to the French naturalists and impressionists of the upcoming decades. Spanning the nineteenth century, all of these artists can be seen as "natural" landscape painters of the modern era. ∎

Rosa Bonheur. *The Horse Fair*.

ROBERT BERSSON

The artist Rosa Bonheur (1822–1899) and her large, enormously popular painting of 1853, *The Horse Fair*, have proved provocative subjects for contemporary scholars. Art historians, especially those of feminist commitment, find the most important issues of life and art embodied in Bonheur's biography and paintings. As Linda Nochlin puts it, "Rosa Bonheur is a woman artist in whom, partly because of the magnitude of her reputation, all the various conflicts, all the internal and external contradictions and struggles typical of her sex and profession, stand out in sharp relief."

What were these struggles, conflicts, and contradictions? To begin, we learn from Rozsika Parker and Griselda Pollock that women artists from the sixteenth through the nineteenth centuries were compelled to enter such fields as animal, portrait, landscape, and still life painting because academic practice forbade them from studying the nude. Because history painting (4.39, 9.19), the most esteemed of the academic categories, was based on the accurate representation of the human figure, this was a difficult field for women artists to enter. In such a sociocultural setting, it was quite natural for an aspiring young artist like Rosa Bonheur to turn to landscape and animal painting.

However, to Bonheur's good fortune, the "lesser" artistic categories, those beneath history painting in prestige, were gaining in importance during the first part of the nineteenth century because of the rise of democratic and socialist values, the impact of contemporary romantic and naturalist landscape painting (3.17, Appreciation 17), and the subsequent revaluation of seventeenth-century naturalistic Dutch landscape and genre art (8.28). The reputation of Vermeer (8.33) was restored at this time. This larger shift in artistic ideology gave legitimacy to those subjects women artists were already pursuing. Moreover, the newly dominant middle class, gaining in influence in the art world as elsewhere, tended to purchase for their homes paintings of everyday subjects rather than grandiose mythological or religious scenes. The moment was right for Bonheur to step onto the stage. Her unique family background and personal sensibility paved the way for her artistic development and ultimate success.

Like most women artists who had achieved success in the previous centuries—for example, Gentileschi, Kauffmann, and Vigée-LeBrun—Bonheur was born into an artist's family and received her initial training from her father. Her father was a painter, her mother had been his pupil, and all four children pursued artistic careers, each specializing in animal subjects. Following a thorough education in drawing and painting, Bonheur, in fact, proved so excellent an artist that in 1849 she took over her father's post as director of a drawing school. Art historians Parker and Pollock write that Rosa adopted her father's politics in addition to his position. Raymond Bonheur, the two tell us, "was a Utopian socialist of the school of Saint-Simon whose doctrines not only espoused equal rights for women but placed a special social responsibil-

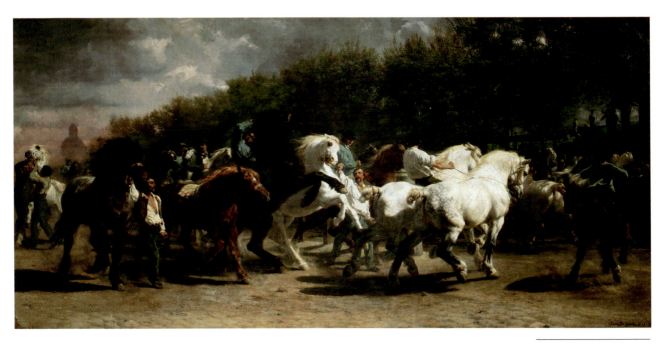

ROSA BONHEUR. *The Horse Fair*. 1853. Oil on canvas. 8′ ¼″ × 16′ 7½″. The Metropolitan Museum of Art, New York. Gift of Cornelius Vanderbilt, 1887.

ity upon the artist as part of the elite that would lead society to a new world."

Saint-Simonism thus provided Bonheur with a model of activity both as a woman and as an artist. Bonheur won considerable success as a professional artist—she was made a member of the coveted Legion of Honor. The award was given for her paintings, drawings and sculptures of animals, whose anatomy, unlike that of the human figure, she was able to study. She dissected carcasses in slaughterhouses and observed animals at work in the fields and in her own private menagerie.

In art historical terms, Bonheur's work as an animal and landscape painter fits broadly within the development of naturalism and realism in French painting in the first half of the nineteenth century. Realist-naturalist artists such as Courbet (9.13), Millet (7.13), and Daubigny (9.23) might be considered her ideological and stylistic relatives, although the working-class stone-breakers and peasant laborers of Courbet and Millet gave to their work a radical political content absent from Bonheur's realistically portrayed beasts of burden.

But this is not to say that *The Horse Fair* is without its revolutionary aspects. For one, *The Horse Fair* was enormous in size, eight feet high and over sixteen feet wide, the largest animal painting yet created. Here was a painting of work animals, humble subject matter in a minor academic category, that was being presented on a grand heroic scale customarily reserved for prestigious history paintings of mythological or religious scenes. Furthermore, Bonheur, as a woman artist, had to employ a revolutionary method to study and sketch the animals that were the subjects of the work. In order to proceed with her work, she had to get around the notions of bourgeois propriety that confined women solely to the domestic sphere. To visit Paris horse markets without the accompanying harassment or danger, she was forced to disguise her sex. To sketch at the markets and at the slaughterhouses where she studied animal anatomy, Bonheur had to dress like a man—a complicated state of affairs that required permission from the authorities.

(continued)

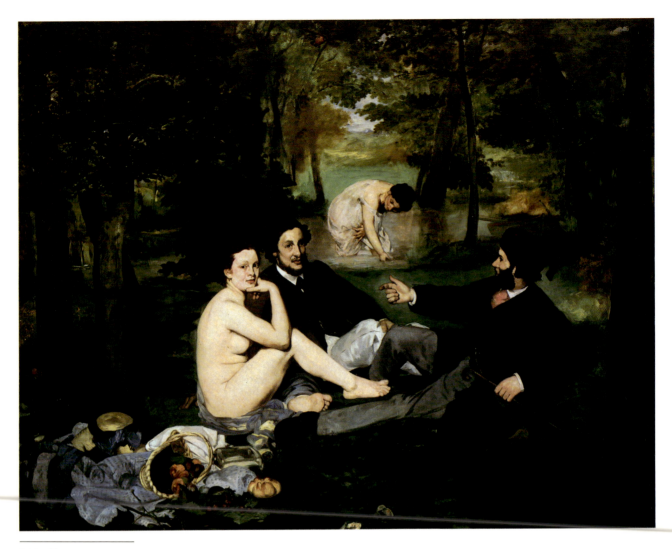

9.14 • EDOUARD MANET. *Luncheon on the Grass.* 1863. Oil on canvas. 7′ × 8′ 10″. The Louvre, Paris.

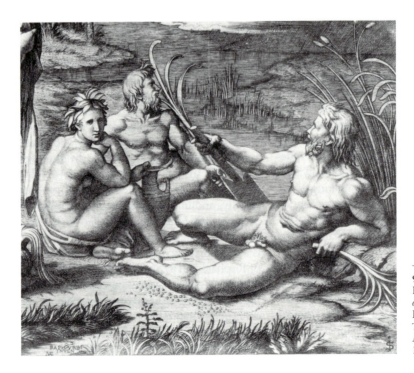

9.15 • MARCANTONIO RAIMONDI. *The Judgment of Paris* (detail). *ca* 1520. Engraving after Raphael. The Metropolitan Museum of Art, New York. Rogers Fund, 1919.

9.16 • GIORGIONE. *Pastoral Concert. ca* 1510. Oil on canvas. 43¼ × 54⅜". The Louvre, Paris.

Paris? Here was a woman, all too recognizable as a contemporary personage, sitting stark naked at a picnic with two men in modern middle-class dress. And if her brazen nakedness were not enough, the woman had the gall to stare at the viewer with a very unfeminine boldness. It is true that three centuries before, Giorgione, the Venetian Renaissance master, had placed two nude nymphs in a pastoral setting with two clothed men who are playing musical instruments. But the two were symbolic mythological figures, and the *Concert Champêtre* (*Pastoral Concert*) was a poetic allegory, not a threatening, oddball translation of contemporary life.

Manet's *Luncheon on the Grass* was simply too modern and realistic for the public and too unconventional for the conservative jurors of the 1863 Salon. The painting was thus relegated with other work rejected by the jury to a "Salon des Refusés," a special salon of the rejected. So great was the outcry against the severe decisions of the jury that year—three-fifths of approximately five thousand paintings

and sculptures had been rejected—that the government conceded alternative exhibition space in the Palace of Industry to the refused artists. Prominent critics unleashed their scorn on this "picture of the realist school" as indecent, vulgar, or immoral. The Emperor Napoleon III himself joined the critical chorus, calling Manet's *Luncheon on the Grass* "immodest."

The writer Emile Zola (1840–1902) came to the artist's defense, directing viewers away from the painting's unusual subject matter and urging them instead to consider its formal brilliance, which he argued, was Manet's central concern.

> Painters, especially Manet who is an analytical painter, do not share this preoccupation with subject matter which frets the public above everything else; for them the subject is only a pretext for painting, but for the public it is all there is. So undoubtedly, a nude woman in the *Déjeuner sur l'herbe* is only there to provide the artist with an opportunity to paint a bit of flesh. What should be noticed in this painting is not the picnic but the landscape as a whole, its

CLAUDE MONET: IMPRESSIONIST PAR EXCELLENCE

Of the younger generation of *plein air* artists, no individual was more concerned with capturing the ever changing face of nature (1.1) than Claude Monet (1840–1926). He worked with a frenetic, on-the-spot intensity to seize the "fleeting impressions" that passed before his eyes (9.24). The writer Guy de Maupassant (1850–1893), while on vacation at the seashore in 1885, had the opportunity to observe Monet "hunting" for his impressions. De Maupassant wrote that Monet was followed by children who carried "five or six canvases representing the same subject at different times of day with different [atmospheric] effects."

He took them up and put them aside in turn, following the change in the sky. And the painter, before his subject, lay in wait for the sun and shadows, capturing in a few brush strokes the ray that fell or the cloud that passed. . . . I have seen him thus seize a glittering shower of light on the white cliff and fix it in a flood of yellow tones that, strangely, rendered the surprising and fugitive effect of that unseizable and dazzling brilliance. On another occasion he took in his hands a downpour beating on the sea and dashed it on the canvas—and indeed it was the rain that he had thus painted. . . .[9]

Not all of Monet's contemporaries viewed such impressions of nature with the same excitement as de Maupassant. To most critics and art lovers of the day, the paintings of the younger "impressionist" artists such as Monet, Renoir, and Morisot looked even more sketchy and unfinished than those of their naturalist elders. For most viewers, the rapid-fire brushwork, divided patches of brilliant color, and blurred outlines of objects distorted landscapes, seascapes, and cityscapes almost beyond recognition. One satiric reviewer quipped that the broadly brushed figures of people in Monet's 1873 cityscape, *Boulevard des Capucines* (9.25) looked like "black tongue-lickings." They were simply unrecognizable! Quivering with indignation, the critic blasted Monet's "slap-dash" painting method as "unheard-of, appalling." "I'll get a stroke from it, for sure," he concluded.

Other reviewers lambasted the young *plein air* painters for being everything from "criminals" and "communists" to malicious "enemies of beauty." It was joked that they painted by loading a pistol with several tubes of paint and firing at a canvas, then finishing off the work with a signature. Only the so-called abstract expressionist artists of our own century have endured equal ridicule.

9.24 • PIERRE-AUGUSTE RENOIR. *Monet Painting in His Garden at Argenteuil.* 1873. Oil on canvas. 18⅜ × 23½". The Wadsworth Atheneum, Hartford, Conn. Bequest of Anne Parrish Titzell.

Certain perceptive critics, however, appear to have understood the controversial way of seeing and representing from the beginning. Writing about the first impressionist group show in 1874, a number of reviewers commented on the intense concern of the younger *plein air* painters with capturing the fleeting effects of light and atmosphere on the color of objects, and the consequent forgoing of careful modeling of three-dimensional form in favor of a painterly recording of an object and its coloristic "tone." Such painters, one critic noted, were concerned not with a detailed, objectively accurate representation of reality, but with "a certain general aspect," an overall coloristic impression of a motif at one particular moment (Appreciation 19). Impressionism began to be distinguishable from its parent, naturalism.

From the 1870s onward, the objective, mimetic truth so passionately sought by the naturalists begins gradually to give way to the more subjective truth of each artist's personal vision and style. Faithfulness to nature's actual appearances was abandoned in favor of each individual's idiosyncratic way of seeing and representing. The particular vision of each artist, and not a broad criterion such as objective imitation, increasingly became the determining factor in the perceptual and artistic processes. Artists such as Monet, Renoir, and the independent-minded sculptor Auguste Rodin made decisions that were completely arbitrary and, in certain ways, contradictory to their heartfelt naturalist tendencies. The impressionist painters, for example, made the decision to focus on one specific aspect of nature— color—above all others. In addition, they resolved to render their impressions of the world in styles that were highly original and individualistic, thus laying the groundwork for the evermore subjective and abstract post-impressionist art of the coming decades. In retrospect, it is not hard to see why impressionism was so controversial and so baffling when it came under official view in the 1870s.

In a related vein, the sculptor Auguste Rodin (1840–1917), born the same year as Monet, forged a personal style that encom-

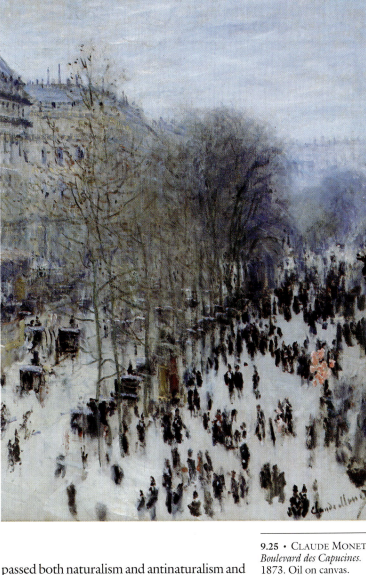

9.25 • CLAUDE MONET. *Boulevard des Capucines.* 1873. Oil on canvas. 31¾″ × 23¹³⁄₁₆″. The Nelson-Atkins Museum of Art, Kansas City. Acquired through the Kenneth A. and Helen F. Spencer Foundation Acquisition Fund.

passed both naturalism and antinaturalism and also paved the way for the free interpretation of the human figure in twentieth-century sculpture. In his *Walking Man* (Appreciation 20), Rodin arbitrarily decided to represent a fragment—a headless body—rather than an entire figure, as was customary. A headless walker, realistic in form and movement, surges through space. A riveting synthesis of naturalism and antinaturalist abstraction, the *Walking Man* strides like a human locomotive between the more objective realism of the nineteenth century and the more subjective abstraction of the twentieth.

Claude Monet. *Branch of the Seine Near Giverny.*

ROBERT BERSSON

For this appreciation, I asked a longtime friend who is a high school art teacher to write about the work of a favorite impressionist artist. My friend, who asked to remain anonymous, chose Claude Monet's *Branch of the Seine near Giverny,* painted in 1897. His deeply personal response brings this Monet painting to vivid life while also making clear how works of art can transform our lives. He writes:

As a teenage boy I had always been fascinated by the Impressionists, particularly Monet. I recall seeing his *Branch of the Seine near Giverny* (Fig. A) at the Museum of Fine Arts in Boston in 1962. I was fifteen years old. I had never seen a painting before that looked both real and unreal at the same time. I could recognize that the masses of blue, green, and purple surrounding the river were trees, but what kind—willow, oak, or maple—I couldn't tell. I couldn't tell where most of the trees ended and their reflections in the river began. But somehow the lack of realism didn't bother me because the scene itself, and the way it was painted, were fascinating. Up close the painting looked blurry, out of focus, a patchwork of brushstrokes: inch-long dabs and dashes of blues, greens, purples, and grays. Unlike most of the paintings I had seen previously, this painting had bold brushwork, building up into rough, layered textures you could actually feel. Yet, when you stepped back to a certain distance, the magic began. What seemed to be a blurry patchwork coalesced into a crystalline image of a river in the early morning hours. I felt as if I were really there. It was quiet, still, not a person in sight. Mist rose silently. An almost invisible haze filled the air. It was as if I had wandered all alone into a magical place that no one, except myself and the artist, had seen before. The trees and their reflections drew me in. My eye traveled down the river, searching for some mystery yet unseen. The fuzziness of the forms invited my imagination, stimulated my involvement.

My parents bought me a large picture book filled with Monet's paintings. The brilliance and variety of the color were breathtaking. His paintings of the same subject—haystacks, cathedrals, lily ponds, the river Seine—at different seasons of the year and hours of the day awoke my senses to the beauty and excitement of light and atmosphere. From then on, the way I saw the world changed. My love of solitary early morning walks, late afternoon light, the effects of snow and fog, and watery reflections is due in great part to Monet and his fellow impressionists.

I feel a special kinship with these painters. To them, more than any others, I owe a feeling of closeness to nature. To this day, when I can interrupt my busy routine for even five minutes, I will look out the window or walk down the street to contemplate nature's life force as it manifests itself in the play of light and shadow, the whisper of the trees, the procession of the clouds. Such experiences provide a deep pleasure and lift the spirits. I can feel a rare sense of communion with forces greater than myself, a timeless connection to a larger whole beyond the frenetic chatter of our modern world.

Monet was not a religious man in the traditional sense of the word. He believed only in what he could see and touch with his hands. Yet his experience of nature—and that of his fellow impressionists who painted the land, the water, and the sky—was spiritual in qual-

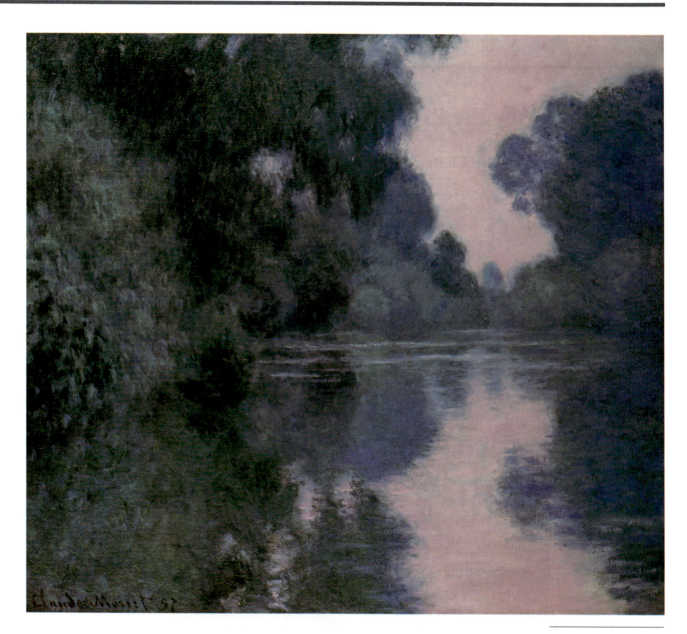

ity. In effect, it was a form of worship. When Monet wrote, "I have no other wish than a close fusion with nature, and I desire no other fate than to live in harmony with her laws," he was echoing a spiritual conviction held by many landscape painters, and lovers of nature, in the modern era. ∎

CLAUDE MONET. *Branch of the Seine near Giverny.* 1897. Oil on canvas. 32 × 36½". Museum of Fine Arts, Boston. Gift of Mrs. W. Scott Fitz.

9.27 • MARY CASSATT.
The Bath. 1891–1892. Oil
on canvas. 39½ × 26″.
The Art Institute of Chicago.
Robert A. Woller Collection.

negative reviews, implored Morisot to break with "the so-called school of the future." Courageously, she refused.

Morisot helped to expand the emotional range and subject matter of the impressionist group. Intimate scenes of family life and of women engaged in work or play, seen from the unique perspective of mother, aunt, sister, or friend, are especially important contributions of Morisot and Mary Cassatt. These works broadened and deepened the impressionist cultural landscape. Some of the representations of mothers and children by Morisot and Cassatt are among the most humanly touching ever created, in spite of the growing emphasis of most impressionists on form over subject matter: "treating a subject in terms of the tone and not the subject itself," as one partisan put it.

Of the impressionists, Cassatt and her friend Degas perhaps struck the most equal balance between form and subject matter. We can admire the color, line, and compositions of Cassatt and Degas (7.14, 7.18) for their own sake while at the same time appreciating the inner life of their particular human subjects. Cassatt's *The Bath* (9.27) can be savored for its formal qualities: its bold use of flat color and design, reflecting the influence of Japanese prints (7.15); its unusual, tilted "seen-from-above" perspective; its strong contours; and the rich decorative patterns in the flowered wallpaper, painted chest, geometric rug, and broadly striped dress. But *The Bath* must also be appreciated for the special human relationship it portrays between mother and child. In a period that emphasized bourgeois domestic values, Cassatt's unique treatment of this subject nonetheless stood out from most others, and only Morisot and Renoir qualified as near-equals. The French writer Joris-Karl Huysmans (1848–1907) singled out Cassatt's work in this genre, exclaiming that only a woman could truly capture the physical and emotional relationship between mother and child. For the first time, thanks to Cassatt, Huysmans wrote, "I have seen the effigies of ravishing youngsters, quiet bourgeois scenes painted with a delicate and charming tenderness. Furthermore, one must repeat, only a woman can paint infancy." In her works Huysmans

saw "a special feeling that a man cannot achieve. . . ." (But a man who, like Renoir, had realized some of his female and maternal qualities might come close.)

In visual terms, perhaps the "special feeling" Huysman sensed in *The Bath* comes from the total absorption of both mother and child in their mutual, reciprocal activity. In "close-up" depictions, which have been interpreted as reflecting the restricted social spaces of bourgeois feminity, they hold, touch, and glance as one. A Cassatt mother and child are never two separate beings but are interconnected in a profound unity. Furthermore, they neither look out at, nor are they posed for, the viewer outside the picture frame, the traditional way artists of the past had seen and represented the theme of mother and child. We, the viewers, simply do not exist for them. The mother and her child devote their attention exclusively to the other, thereby promoting a feeling of great intimacy. Perhaps all this adds up to the unique feeling that Huysmans discerned, coming as it did from a revolutionary modern, realist way of seeing and representing. Like the work of Morisot, Renoir, and Monet, the paintings and pastels of Cassatt possess an impressionist delicacy and charm, but they also express a very real female "force"; the vast power of the physical and spiritual bond between mother and child. In art of the modern period, perhaps only the drawings and prints of Kathe Kollwitz have achieved such a profoundly powerful maternal feeling (4.26).

Within the larger context of the woman's emancipation movement—which Cassatt, an outspoken political progressive, actively supported—the specific successes of artists such as Morisot and Cassatt were inspirational. Their public achievements helped to draw increasing numbers of women to careers in painting and sculpture, especially in the independent circles of the avant-garde. And although the fine arts were still very much a man's world—women artists remained in secondary positions relative to leadership and public recognition—many women artists contributed significantly to the emergence of the avant-garde at the end of the nineteenth and beginning of the twentieth century.

THE TRIUMPH OF IMPRESSIONISM: AN ART FOR OUR TIME

Why has impressionism, which was so controversial at first, become so popular in our own time? No art movement today has a larger following. Is it simply the result of years of public exposure and art education? No, it is more than that. To begin, impressionist art speaks directly to us. It is the product of a world, largely middle class and metropolitan, and a world view, materialist and individualist, that the majority of us know well. Impressionism embodies a way of seeing and representing grounded in change and material sensation, an art of the senses and the most subtle physical effects. The creation of a society that has fostered unprecedented degrees of individualism, impressionism is a style peculiarly appropriate to democratic capitalism: an art of the most intimate subjectivity and solitary individuality. The work of predominantly middle-class men and women educated in metropolitan centers, it is an art of, by, and for city dwellers and suburbanites. At first sight, writes social historian of art Arnold Hauser, it may seem surprising that the metropolis, with its herding together of people, should produce an intimate impressionistic art rooted in the feeling of individuality and solitude. "But," he continues, "the two basic feelings which life in such an environment produces, the feeling of being alone and unobserved, on the one hand, and the impression of roaring traffic, incessant movement and constant variety, on the other, breed the impressionist outlook on life in which the most subtle moods are combined with the most rapid alternation of sensations."

But feeling "at home" with the impressionist way of seeing and representing is only part of this style's allure. For the modern viewer, impressionist subject matter is frankly seductive. For people caught in the bureaucratic entanglements and propulsive pace of modern life, impressionism offers the most refreshing subjects. In the welcoming presence of a Monet, Renoir, or Morisot, one can escape to a simpler life of heartwarming sights and pleasurable sensations: country roads, verdant meadows (9.26), seaside cliffs (1.1), gardens

ing, or portray the eternal, that which is greater than the self. In portraits or scenes from nature (9.33), the painter might bring forth creative life force in the manner of God Himself. Yet for all his nobility of purpose and original genius, van Gogh, unrecognized and disparaged in his time, lived an anguished life. Like other struggling vanguard artists, van Gogh had developed a visual language so personal that it was incomprehensible to all but a sympathetic few. His art, to establishment critics, seemed even more laughable than that of the impressionists who, only a decade earlier, had been jokingly accused of "loading a pistol with several tubes of paint and firing at a canvas, then finishing off the work with a signature." Unable to understand such art, the aver-

age critic and viewer dismissed work like van Gogh's as a joke or insult. Given such an antagonistic relationship, in which neither side sought reconciliation, a cultural gulf opened between the creators of unconventional art and the public. In his entire lifetime, van Gogh could sell but a single work, and that for a pittance. In 1888, van Gogh offered paintings, today worth many millions, to his landlord in the place of rent money. Were it not for the financial support from the strained pockets of his ever-supportive brother, Theo, few paintings by van Gogh would be in existence today.

By the last quarter of the nineteenth century, vanguard artists had indeed become aware that they were completely on their own, free-floating molecules in a world more self-oriented and "atomized" than any previously. European society, van Gogh lamented, was no longer "obeliscal" and "solidly framed" like past societies, such as those of the Middle Ages. In a world where change had become the rule, where people seemed to care only for themselves, van Gogh complained that all was "in the midst of downright *laisser-aller* [state of negligence or letting go] and anarchy." In earlier societies, in contrast, each individual, including the painter and sculptor, had been "a stone, and all the stones clung together, forming a monumental society." But this type of "architecturally constructed" society, in which the artist was a securely integrated part, was no more.

Vanguard artists had become outsiders alienated from a powerful bourgeois establishment committed to material wealth, social status, and respectability. It is therefore not surprising that the comfortable middle classes, a relatively new and extremely important segment of the art-buying public, preferred traditional academic art to avant-garde art. Academic art tended to be literary in content and stylishly realistic in style. Created by accomplished painters such as Cabanel (9.19) and Jean-Léon Gérôme (1824–1904), such academic art has been described by the contemporary art historian Linda Nochlin as technically slick and showy, specializing in titillating nudes and saccharine religious scenes. It was the painting that the *nouveau riche* preferred. Such work, writes Nochlin, fulfilled "the secret dreams and more overt demands for moral

9.30 • JEAN-LÉON GÉRÔME. *The Slave Market. ca* 1867. Oil on canvas. 33³⁄₁₆ × 24¹³⁄₁₆". Sterling and Francine Clark Art Institute, Williamstown, Mass.

probity and a recognizable story" of these newly rich citizens. In Gérôme's attention-grabbing stories (9.30), with their exotic settings and sexual overtones, Nochlin even notes a stylish prototype for the popular films, television programs, and commercials of the future. "Works like Gérôme's," she claims, "are valuable and well worth investigating not because they share the aesthetic values of great art on a slightly lower level, but because as visual imagery they anticipate and predict the qualities of incipient mass culture."

Naturally, vanguard artists and critics rejected such conventional "bourgeois art," with its popular mass appeal, denouncing those who appreciated a Cabanel or Gérôme as "callous" or "philistine." Their own art, they were sure, was superior: far more experimental, abstract, and self-expressive. So antagonistic was the relationship between the avant-garde artist and the mainstream public that, by the turn of the century, many in the vanguard actually hoped that their art would "shock the bourgeoisie." The secret desire or public goal of many modernists was to prompt outrage in the comfortable middle class. The cultural chasm between artist and mainstream society had never been wider.

Their status as outsiders caused progressive artists to fluctuate between community and aloneness. On the one hand, painters such as van Gogh, Gauguin, and Cézanne had committed themselves to individual struggle: solitary artists working for and by themselves. They doggedly maintained their independence from the social elites that in the past had commissioned and largely determined the style and subject matter of art. As Christlike figures who had taken up the cross of art—Gauguin actually painted himself as a tormented Christ in Gethsemane and a conflicted Adam (7.23) in the Garden of Eden—avant-garde artists were apostles of the new. With the birth of the avant-garde, modern art, in fact, became something of religious crusade, grounded in faith and belief, characterized by immense sacrifice, and resulting, for a chosen few, in spiritual revelation and societal rewards.

The artists had to be spiritually committed. They usually faced hard lives, filled with poverty, loneliness, and psychological struggle.

Even for the most Christlike, it was impossible to go it completely alone. The formation of communities of mutual support was a natural response. Invariably, vanguard artists would try to form art colonies, guilds, brotherhoods, associations, movements, schools, or groups. Manet's Batignolles group and the impressionist group were such communities of mutual support. In England, the Pre-Raphaelite Brotherhood and the guilds and associations of the Arts and Crafts movement arose for similar reasons. The various European art nouveau and secessionist movements at the turn of the twentieth century were related developments. Such communal endeavors bolstered individual resolve while also supporting the general cause of modern art through the sharing of ideas, exhibition space, living quarters, and so forth. Along this line, van Gogh dreamed of establishing an artist's colony, a brotherhood of the isolated, in the south of France. He invited Gauguin to participate in this enterprise. Gauguin himself had earlier gravitated to the villages and inns of coastal Brittany, where artists resided in informal communities. From this supportive environment emerged his groundbreaking symbolist art. Well into the twentieth century, vanguard artists would alternate, in ever-shifting balance, between community and solitude, collective solidarity and solitary journey.

The role of the progressive artist in Western society had indeed become problematic, and artists' groups only partly overcame the problems. Because of their alienation from the mainstream of life, independent seekers such as van Gogh, Gauguin, and Cézanne might achieve masterpieces, but they almost always suffered grievously to do so. Gauguin exiled himself from Europe to the tropics and experienced both joys and terrible sorrows along the way. Cézanne lived the last decades of his life as an austere, lonely hermit. Vincent van Gogh went mad and committed suicide. "We artists," van Gogh wrote, "who love order and symmetry, isolate ourselves and are working to define *only one thing*." Only in our individual art works, he might have added, can we create the order, balance, and wholeness that is so lacking in our own lives.

These three great founders of twentieth-century modern art all pursued single-minded

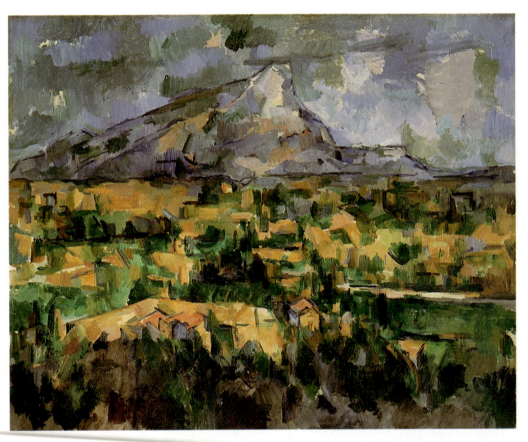

9.32 • PAUL CÉZANNE. *Mont Sainte-Victoire.* 1904–1906. Oil on canvas. 28⅞ × 36¼″. The Philadelphia Museum of Art. The George W. Elkins Collection.

ciation come his way. Three young artists separately sought him out, treating the suspicious old man respectfully, calling him "master," and embracing him as their mentor.

Cézanne channeled all his thought and feeling into his art. Like Gauguin and van Gogh, he was totally committed to art, believing, like them, that it was the most elevated of pursuits. A deeply religious Catholic, Cézanne believed that the act of drawing and painting nature, whether landscape, still life, or figure, brought the artist into contact with God through His manifold creations. He spoke of nature in its many forms as "the spectacle that the Pater Omnipotens Aeterne Deus [The All-powerful Father, Eternal God] spreads out before our eyes." Cézanne further believed that his own painting should reflect the godlike qualities of the land, people, and everyday objects. Cézanne sought to give to his paintings the order and harmony—the permanence behind the fleeting impression, the eternal beyond the momentary—that the Creator had invested in nature. "I simply must produce after nature,"

wrote Cézanne. "My works," he emphasized, are simply "constructions after [nature], based on method, sensations, and developments suggested by the model." Because God, for Cézanne, was the great architect and geometer, he perceived nature itself as harmonious, orderly, and geometrical. In the holistic weave that was nature, geometrical forms, permanent and ideal, took precedence over the ever-changing appearances that had so entranced the impressionists.

The Movement toward Abstraction: From Cézanne to Van Gogh and Gauguin. "Treat nature," Cézanne wrote, "by the cylinder, the sphere, the cone," advice that the early twentieth-century cubist artists took to heart. In this way, the artist's intellectual, "geometrical" concept of nature would be perfectly integrated with his perceptual experience of it. The artist, Cézanne insisted, must first experience the sensations of nature to render the subject with intensity. Then the artist used intellect to create the finished work of art. Perception and

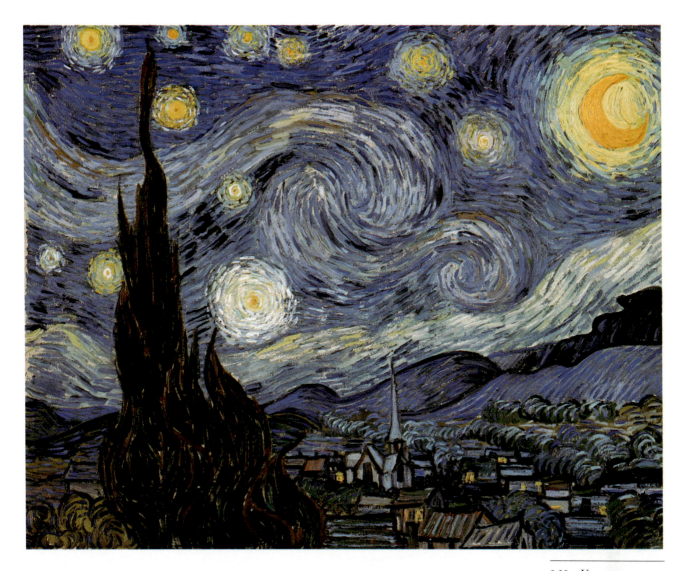

9.33 • Vincent van Gogh. *The Starry Night*. 1889. Oil on canvas. 29 × 36½″. Collection, The Museum of Modern Art, New York. Acquired through the Lillie P. Bliss Bequest.

conception had to proceed hand in hand. "For if the strong experience of nature—and assuredly I have it—is the necessary basis for all conception of art on which rests the grandeur and beauty of all future work, the knowledge of the means of expressing our emotion is no less essential, and is only to be acquired through very long experience." Because he valued the perceptual and conceptual side of art making equally, Cézanne would have been disappointed to learn that future abstractionists inspired by his work ignored his emphasis on the direct sensory experience of nature. For these abstract artists, Cézanne's "naturalism" was old-fashioned. It was Cézanne's formal, constructivist "intelligence" that pointed the way to the abstract art of the future.

Cézanne's dual emphasis on naturalism and orderly intelligence caused him to look askance at the more abstract, freely subjective works of van Gogh and Gauguin. For Gau-guin's tendency to decorative abstraction, Cézanne derided that artist as "just a maker of Chinese images." His judgment of van Gogh's paintings was even more harsh; he asserted that the Dutchman painted "like a madman." Although Cézanne strove for strong sensations before nature, he also fought in his art to tame his instincts and emotions. (His own early work had actually been boldly romantic and emotional.) Rational intelligence should, Cézanne believed, modulate intense feeling. The carefully constructed paintings of his final thirty years aspire to a classical quality of order, calm, and balance.

In the work of van Gogh, in contrast, intense feelings often burst the traditional bounds of naturalism, classicism, and rationality. Nature's colors and shapes are exaggerated or distorted for the sake of emotional expression. Vincent van Gogh's ecstatic vision, *Starry Night* (9.33), rolls with the infinite

9.34 • PAUL GAUGUIN.
*The Spirit of the Dead
Watching.* 1892. Oil on
burlap mounted on
canvas. 28½ × 36⅜".
The Albright-Knox Art
Gallery, Buffalo, N.Y.
A. Conger Goodyear
Collection, 1965.

power of the nocturnal cosmos, the primeval earth, and a human psyche on fire. The same subjectivity, although less feverish, characterizes the many-sided art of Gauguin. To the more classically oriented Cézanne, the work of these two artists looked frankly irrational: images from a strange, alien world. More than Cézanne, van Gogh and especially Gauguin made a radical break with objective nature and the sensory-based art of the naturalists and impressionists.

Probing inward instead of outward, Gauguin sought to move completely beyond external nature. Increasingly, he created from memory, imagination, or the dream. Beginning as an impressionist and exhibiting in their group shows from 1879, Gauguin, by the late 1880s, was becoming a bona fide post-impressionist. The impressionists, the pioneering Gauguin argued, remained overly concerned with the colorful external appearance of nature, "retaining the shackles of verisimilitude." They remained too tied to the past in their perceptual commitment to the physical landscape, whereas he and his symbolist friends, sought to paint "the dream landscape, created from many different entities." The impressionists, Gauguin protested, were imprisoned by the outer optical sensation, whereas he and his symbolist colleagues sought the inner world. "They heed only the eye and neglect the mysterious center of thought, so falling into merely scientific reasoning." The result, to Gauguin, was a kind of decorative realism, but

a realism just the same. To escape the shackles of external reality—recall his criticism of photography as a mechanical, mimetic art—Gauguin believed that it was "better to paint from memory" without the model always before one. The resulting work would be more "artistic" and "individualistic." If the artist works subjectively and not objectively, he asserted, "your work will be your own; your sensation, your intelligence and your soul will then survive." An artist's technique should come from within and be developed by that person alone. It should not come from outside, either from the study of nature or the old masters.

Gauguin described his own technique as "very fugitive, very flexible, according to my disposition when I arise in the morning; a technique which I apply in my own manner to express my own thought without any concern for the truth of the common, exterior aspects of Nature." In this regard, *Self-Portrait, Les Miserables* (9.31) qualifies as one of Gauguin's first post-impressionist works. In this painting he moved beyond the perceptual realism of impressionism to an art more subjective, decorative, and stylized: "a complete abstraction," in the artist's words, that began to leave the objective world behind.

Gauguin's *Manao Tupapau—The Spirit of the Dead Watching* (9.34), painted four years later in Tahiti, represented a further step toward an art of abstraction and imagination. In a letter to his family in Europe, the artist sheds light on his invention of imaginary forms and figures in this painting, noting an abstract or "musical" use of color, line, and composition to convey mysterious moods.

> A young Tahitian girl is lying on her stomach, showing part of her frightened face. She rests on a bed covered by a blue *pareu* and a light chrome yellow sheet. A violet purple background, sown with flowers glowing like electric sparks; a strange figure sits beside the bed.
> . . . The *pareu* being intimately connected with the life of a Tahitian, I use it as a bedspread. The bark cloth sheet must be yellow, because in this color it arouses something unexpected for the spectator. . . I need a background of terror; purple is clearly indicated. And now the musical part of the picture is laid out.
> . . . I see here only fear. What kind of fear?
> . . . The *tupapau* (Spirit of the Dead) is clearly indicated. For the natives it is a constant dread.
> . . . My decorative sense leads me to strew the background with flowers. These flowers are the phosphorescent flowers of the *tupapau*; they are the sign that the spirit nears you. Tahitian beliefs.
> . . . To sum up: The musical part: undulating horizontal lines; harmonies of orange and blue, united by the yellows and purples (their derivatives) lit by greenish sparks. The literary part: the spirit of a living person linked to the spirit of the dead. Night and day.[12]

In these paragraphs, Gauguin articulates some of the central tenets of **symbolist** aesthetics. He speaks of the power of color and line, "the musical part of the picture," to evoke feelings. Independent of the literary or descriptive aspects of the painting, undulating lines and color harmonies, like melodic lines and chordal harmonies in music, engage the emotions. Line, shape, and color, arranged according to the artist's "decorative sense," possess a mysterious abstract force. The emotion or "idea" of fear is elicited "by means of forms" as much as by the figure of the tupapau. Gauguin and the symbolists looked on such formal power as magical and honored it as spiritual.

Symbolist art and values subsequently influenced the vanguard art nouveau artists working at the turn of the century throughout Europe. Increasingly, these artists, working in both the fine and applied arts (4.24, 4.25, 5.26–5.28), used organic abstract form and decoration to convey emotional and mental states. Not satisfied with realist conceptions of art, including impressionism, these early modernists sought to create a beauty of spiritual, psychological, and aesthetic essences that went beyond reproductions or optical impressions of the physical world. The many-sided edifice of twentieth-century modern art would be built upon the innovative groundwork laid by Gauguin and the symbolists, van Gogh, Cézanne, and other turn-of-the-century avant-garde artists.

Paul Cézanne. *The Blue Vase.*

ROBERT STUART

Paul Cézanne would have to be the last artist I would remove from the roll call of modern masters. Coming upon a few of his painted apples and pears, and a stray dish or two in a museum is always an exhilarating experience.

Cézanne was grandly successful in his goal of bridging the light, color, and experiential realism of impressionism with the weighty form, clear structure, fully realized space, and well-ordered compositions of the classical museum masterpieces he so respected in the Louvre museum in Paris. What Cézanne strikes so well is a balance between the real and the ideal. It is a fusion of the real world of perception, light, and color that Monet brilliantly captured and the ideal soundness of classical composition and stability of form that has proved enduring since the early Renaissance.

We sense a kindred spirit in early Renaissance works and those of Cézanne. One could call it the spirit of the beginner. Cézanne is a beginner because he ventured in a new direction and a beginner because he is innocent in the sense valued so highly by Zen Buddhism. This sense of the beginner brings with it a certain hesitancy and awkwardness at times, a searching for the right location, the right color, or perhaps the right contour. It also brings an innocence that is unassuming and refreshing, that allows us to identify with the artist as a fellow human being in awe before a

Robert Stuart is a painter whose landscapes and still lifes have been exhibited throughout the United States. He lives in the Shenandoah Valley of Virginia.

divine or natural mystery. I sense this in a painting like Giotto's *Joachim Takes Refuge in the Wilderness* [3.6]. This is not yet a full-fledged Renaissance work of art. Giotto, like Cézanne, is on the way to something, and there is a disarming, spirited clumsiness in his stylized figures and architectonic compositions.

The Blue Vase of 1883–1887 is a quintessential Cézanne, but for me it is much more. In a large Paris retrospective of the artist's works, that painting stood out like a giant among giants and stopped me cold in my tracks. Like medieval stained glass with its flickering blue light, the blue vase in the painting radiates a bluish light that tinges the other objects and colors the cast shadows. That same blue permeates the background and informs the entire painting, endowing commonplace objects with a majestic transcending mystery. A tabletop with a blue vase, three ripe apples, an ink bottle, a dish, and a half-visible flask becomes an altar where we commune with the sublime.

The Blue Vase bears traces of Cézanne's search for form. We see in the two apples on the right his stray or floating contour lines. A Louvre Museum master such as Chardin would never have allowed such drawing lines to remain visible in his still lifes [8.39]. The tracks of Cézanne's struggle for balance and order remain for us to see. Behind the blue vase, the two split halves of the dish don't quite connect. The right half is slightly higher, and the same is true of the back horizon line of the table edge. These discrepancies, along with the tilt of the table's front edge, the upward-

pointing ink bottle resting on the top edge of the table, and the long yellow ochre vertical on the right side of the canvas give a distinct upward movement to the right side of the vase and a counterbalancing downward push to the left side.

It's quite a balancing act between weights and counterweights, movements and counter-movements; a brilliant, stirring translation of the still life objects perceived through the senses and rendered by the intellect into a classically ordered aesthetic composition. This "redoing of Poussin according to nature," which Cézanne described as his task, represents not only a bridge between impressionism and the classicism of Poussin [9.22] but also a direction for painting into the modern world. This formalist, constructivist side of Cézanne led directly to Picasso's cubism, was a great inspiration to Matisse, and no doubt motivated many other twentieth-century painters.

It never ceases to amaze me how fresh and contemporary Cézanne paintings look a century after he stood at his easel before Mont Sainte-Victoire [9.32] or before one of those immortal vase-and-fruit combinations. By himself, Cézanne carved out a path for twentieth-century art, a path that leaves room for realism and abstraction, for direct observation of nature as well as the intuited order of the mind. His art was seminal to the early modernists and leaves much fertile territory for artists of the present to explore. ∎

10.1 • PAUL GAUGUIN. *And the Gold of Their Bodies*. 1901. Oil on canvas. 26½ × 30″. Musée d'Orsay, Paris.

10.2 • HENRI MATISSE. *Pink Nude (Seated Nude)*. 1909. Oil on canvas. 33 × 41 cm. Musée de Grenoble, Grenoble, France.

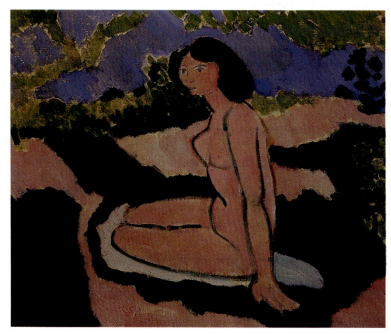

Polynesian women (10.1) and Matisse's *Pink Nude* (10.2) of 1909. The subject of Matisse's piece has undergone a radical metamorphosis. She has been transformed from a particular human being into a flat abstract design of arbitrary color and decorative pattern. What the woman truly looks like, what her personality or life is like, is of little concern to the artist. Here is "pure painting," painting increasingly freed from the constraints of subject matter. In comparison, Gauguin's painting of two Polynesian women looks almost realistic. That is how far Matisse and the fauves had liberated form from subject matter.

In 1890, the vanguard artist Maurice Denis issued a now-famous statement that emphasized the primacy of form over subject matter in modern art: "It is well to remember that a picture—before being a battle horse, a nude woman, or some anecdote—is essentially a

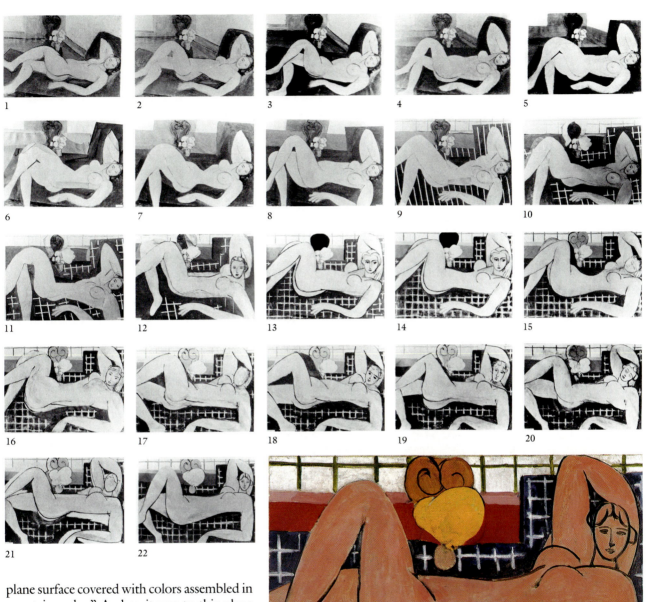

plane surface covered with colors assembled in a certain order." And so it was to this plane surface covered with colors assembled in a certain order, rather than to the nude woman or horse in the picture, that Matisse devoted his feelings and long career.

The artist's love affair with expressive form is readily seen in the twenty-two photographs (10.3) Matisse had taken of one of his later works in progress. The finished painting was the *Pink Nude* (10.4) of 1935. Observing the many versions in sequence, we note how Matisse's original, somewhat naturalistic portrayal of the nude model changes over half a year's time. We witness a shift in concern from subject to form, from naturalistic depiction to

10.3 • HENRI MATISSE. *Pink Nude (Large Reclining Nude)*. 1935. Twenty-two black and white photographic versions of the painting. The Baltimore Museum of Art. The Cone Archives.

10.4 • HENRI MATISSE. *Pink Nude (Large Reclining Nude)*. 1935. Oil on canvas. 66 × 92 cm. The Baltimore Museum of Art. The Cone Collection.

interpretive abstraction. As the artist put it, "I cannot copy nature in a servile way; I must interpret nature and submit it to the spirit of the picture." In the twenty-two versions, we see an evolution: Matisse has flattened the voluptuous figure and flower vase into curvaceous abstract shapes and transformed the bed and walls into rectilinear planes. The background and foreground have been integrated into a single, flattened picture surface. During the six months, Matisse has continually changed the size and position, or altered the shape of the figure and surrounding objects, to create a compelling composition in which "the various elements I use will be so balanced that they do not destroy each other." After much effort, the painter finally achieved what he wanted: a picture that to him was balanced, harmonious, and, most importantly, "expressive."

But what did he mean by "expressive"? Matisse tells us.

> Expression to my way of thinking does not consist of the passion mirrored upon a human face or betrayed by a violent gesture. The whole arrangement of my picture is expressive. The place occupied by figures or objects, the empty spaces around them, the proportions, everything plays a part. Composition is the art of arranging in a decorative manner the various elements at the painter's disposal for the expression of his feelings.[1]

And these feelings, Matisse insists, will come through more completely if the artist captures the true essence of the things he or she portrays. Relative to the female nude, Matisse's goal was to make an equivalent for the human body that would be more "true to life" than any painstaking representation from daily life—more accurate and meaningful because it captures the nude's "enduring character and content" and because it is a pure product of the artist's creativity.

An equivalent for the human body that would be more true to life? More an embodiment of the essence of life than any detailed realistic portrayal? Paradoxical as this might seem, Matisse, often attained this "true-to-life" quality in highly abstract works of art. His *Blue Nude* (Appreciation 22) of 1952, created in the medium of cut paper, embodies such a combined pictorial and human expressiveness. The *Blue Nude* conveys the human essence, though not the naturalistic appearance, of the nude female body in joyous motion. Turning to the medium of cut paper at the end of his long career, Matisse believed that his *découpages* continued the evolution of his paintings but achieved even more "completely and abstractly a form reduced to the essential."

For his entire life Matisse strove to create a life-affirming abstract art. His commitment was ever to an "art of balance, of purity and serenity" and to uplifting subject matter that was never "troubling or depressing." There can be no doubt that works such as the *Blue Nude* and *The Thousand and One Nights* (2.34) have brought an enduring pleasure into an often troubled world. For such a significant accomplishment, Matisse well deserves his place as a giant of the "art of expression." But pain as well as pleasure dwells in the world, and many artists came forth to portray the darker aspects of modern life. Of these, none was more expressive than Edvard Munch (1863–1944).

Munch and German Expressionism: An Art of Alienation. Matisse and most of the fauves looked beyond daily life to the somewhat autonomous formal realm of color, shape, and composition as the locus of their personal expression. In contrast, the source of expression of the **German expressionist** artists was the highly emotional experience of daily living itself. The almost methodical process of abstraction, a union of intellect and intuition, that Matisse enacted in the *Pink Nude* of 1935 would have been unthinkable to them. The expression of raw feelings demanded more urgent execution. Emotions seething within had to be transmitted with immediacy while the feelings were still strong. The swirling shapes, unnatural colors, and distorted figures of these artists were an expression of the intensified way they experienced the world. They did not invent their abstract paintings or sculptures while in a state of conscious aesthetic remove or "psychical distance" from life; their creations were the products of direct confrontations with existence. Pictorial concerns were not to be wrestled with in an autonomous artistic realm of pristine freshness. For the German expressionists, pictorial form was inseparable from the storm and stress of life itself. Moreover, their art often dealt precisely

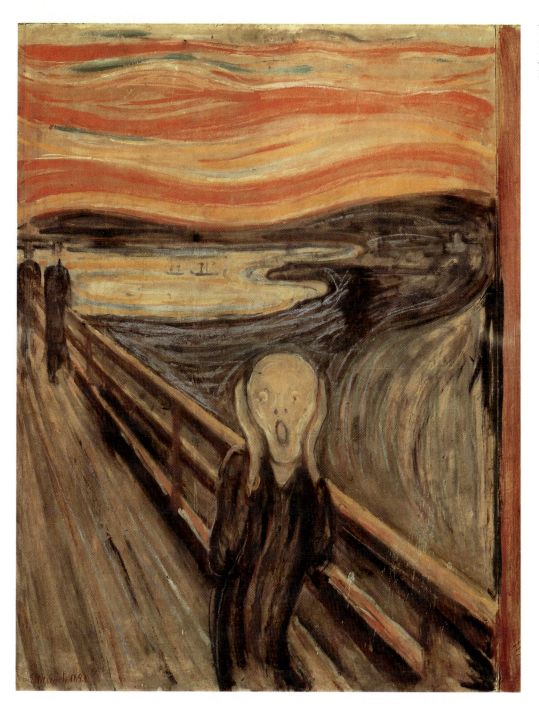

10.5 • EDVARD MUNCH. *The Scream.* 1893. Oil on canvas. 36 × 29″. Nasjonalgalleriet, Oslo.

with those depressing subjects and troubling states of mind that Matisse so studiously avoided. If Matisse stands at one end of the spectrum of modern expressionist art, then assuredly the Norwegian Edvard Munch and most of the German expressionists stand at the other.

The titles of some of Munch's greatest paintings from the final decade of the nine-teenth century—*Death in the Sick Room, Anxiety, Melancholy, Jealousy*—imply a journey into a dark realm where Matissean balance, serenity, and pleasure could not possibly exist. Consider the frightening *Scream* (10.5) of 1893. A shriek wells up inside a ghostlike figure on a bridge. The scream is internal. It crashes back and forth within the walls of a paranoiac mind. The two persons walking off into the distance

are oblivious to the silent cry. Unthreatened by the world, they have no sense of what the protagonist, Munch himself, is experiencing. Munch's scream is completely unheard, making the situation even more upsetting.

Anyone who has ever experienced phobias or witnessed an attack of anxiety or panic knows what Munch is expressing here. The world has suddenly become a frightening place, a nightmare. All that once seemed solid has become fragile. Stability and self-control are threatened by a sense of "losing one's mind." For fear that he is going out of control, the horror-stricken figure cries out in anguish. Facial expression and bodily gesture communicate part of the experience. The background tells the rest: the swirling, blood-red sky; the water, land, and atmosphere undulating in a dizzying rhythm; the bridge, in unnerving perspective, rushing off at an impossible speed and tilt. Extremes of hot and cold colors, reds and red-oranges, blues and bluish purples, fight against each other. Munch tells us why he painted *The Scream* the way he did:

> I was tired and ill—I stood looking out across the fjord—the sun was setting—the clouds were coloured red—like blood—I felt as though a scream went through nature—I thought I heard a scream—I painted this picture—painted the clouds like real blood. The colours were screaming.[2]

Matisse had painted his subjects at a calm aesthetic and psychical distance, his goal being a tranquil, harmonious art that might bring comfort and relief to the modern viewer. Munch couldn't possibly have created his art at such a serene, intellectual remove. He worked from his inner turmoil. The fire of the moment brought forth his form and suffused every aspect of his work. He had suffered terribly as a child: his father was a gloomy, ranting religious bigot; his mother was a submissive wreck; his beloved sister, along with his mother, died of tuberculosis. "Disease and insanity," as he later put it, "were the black angels on guard at my cradle. In my childhood I felt always that I was treated in an unjust way, without a mother, sick, and with threatened punishment in Hell hanging over my head." The pain of this unsettling upbringing was exacerbated by the alienation of the avant-garde artist from bourgeois society and the general sense of estrangement that many sensitive souls felt in an increasingly urban, industrial society. For many persons, the city had indeed become a place of lonely crowds and destructive allurements, a "devourer of souls." Both *The Scream* and van Gogh's *Night Cafe* (1.8) were visual manifestations of this lonely despair.

By the turn of the century, many avant-garde artists had rejected all aspects of bourgeois society, including its moral system and life-style. In a development that hit full stride in the mid-nineteenth century, avant-garde artists often pursued vanguard life styles, "bohemian" or otherwise countercultural, along with vanguard, antibourgeois art. Munch, like the bohemian Gauguin before him, struggled to free himself from what he saw as repressive bourgeois behavior. In art and etiquette shocking to the bourgeoisie he sought open expression of his sexual drives and the irrational forces of his mind. Many of Munch's strongest works, created between 1892 and 1902, unleash his psychic demons, including his intensely conflicted feelings of love and hate, desire and fear toward women. Is his striking *Madonna* (10.6) a Virgin Mary, pagan love goddess, earth mother, devil, or, as is probable, all of these? The answer is as multifaceted as Munch's contradictory attitudes

toward women, especially emancipated ones who now demanded equality with men. If such an image of woman was threatening to countercultural men, imagine how it must have frightened and scandalized proper middle-class gentlemen.

In retrospect, one can see how the social and cultural tensions of the turn of the century might have ultimately manifested themselves as personal psychological tensions. In the Germanic countries, vanguard artists often expressed such psychic tensions in their art. The inner psychological life of the person was fast becoming a central concern of the German intelligentsia. Many of the most prominent psychological theorists of the early twentieth century were men of Germanic background. For example, Freud's first studies of hysteria and his pioneering *Interpretation of Dreams* (1899) were published at the turn of the century. At the grassroots level, troubled individuals, Munch among them, could now see fit to enlist the help of psychotherapists to uncover and heal their internal wounds.

Like Munch, van Gogh, and Gauguin, many Germanic artists in the early twentieth century responded with psychic intensity to reality's more disturbing aspects. These younger German artists likewise distorted natural appearances to convey emotional depths. With realistic detail pared away to intensify facial expression and gesture, the works of Käthe Kollwitz (1867–1945) literally cry out against communal pain and social injustice. Social evils—poverty, unemployment, war—rather than inner neuroses motivated her personal turmoil and powerful artistic forms (Appreciation 6, 4.26). *Outbreak* (10.7), part of her print series, *Peasants' War*, is an explosive communal eruption, a social counterpart to Munch's individual psychological outpouring in *The Scream*. A mix of the social and psychological, Ernst Ludwig Kirchner's street scenes (7.29), with their acidic color, sharp, pointed shapes, and claustrophic space, convey a feeling of personal unease and urban dis-ease. Influenced by Kirchner (1880–1938) and other northern expressionist artists, German filmmakers of the late teens and twenties directed their cinematographers, editors, and designers to distort natural appearances to convey states of mental turbulence and even madness (7.30, 7.31). Rooted in the potent expression of psychological and social states of mind, expressionism became a major direction of German theater, dance, music, and literature as well as painting and sculpture.

10.7 • KÄTHE
KOLLWITZ. *Outbreak.*
1903. Mixed media.
20 × 23¼". The Library of
Congress, Washington, D.C.

Expressionism Explained: Worringer's Theory of Abstraction and Alienation. The existence of German expressionism as an art historical construct and major cultural phenomenon is due largely to the writings of Wilhelm Worringer (1881–1965). In the early twentieth century, this young German art historian proposed the idea that an expressionist "drive to abstraction" was a central tendency in Germanic art, both of the past and present. He argued his case in books, articles, and lectures. His provocative treatises, *Abstraction and Empathy* (1908) and *Form in Gothic* (1911), stimulated both Germanic artists and their public to perceive northern European art as a distinct artistic phenomenon, proudly different from the more famous art of the Mediterranean south. The southern European artistic tradition, wrote Worringer, was born in the Greco-Roman world, and the Italian Renaissance represented its second flowering. From Raphael to Poussin to Ingres, and thereafter on to Cézanne and Matisse, this "classical" approach to art was defined by a formal orientation to harmonious proportions, noble simplicity, and calm grandeur. In its premodern incarnations (for instance, classical Greek sculpture, the neoclassical sculpture of Hou-

don, and the classical tradition paintings of Raphael, Poussin, Ingres), an idealized realism had also characterized this tradition. Germanic art, in contrast, was frequently anticlassical and antirealistic. Vincent van Gogh's painting *Starry Night* (9.33) and Edvard Munch's lithograph of *The Scream* (10.8), for example, exhibit a restless urge for abstraction; their forms are characterized by linear intensity and complexity. Such Germanic art, Worringer believed, had its greatest flowering prior to the modern period in the Gothic Middle Ages (6.18), a period northern European artists and intellectuals of the early twentieth century looked to with pride as a fountainhead of their culture.

Aesthetic differences between Germanic and Mediterranean art aside, Worringer's most interesting idea is that different cultural outlooks or spirits underlay and motivated the northern and southern traditions. At the root of the classical and Gothic ways of seeing and representing were the different ways the northern and southern cultures related to the world and, more specifically, to nature. Mediterranean people, Worringer wrote, lived in comfortable natural surroundings, in a land that was warm, sunny, and fertile. Their relationship with nature was characterized by ease and harmony, by a sympathetic identification or "empathy." This supportive, life-affirming relationship with nature led Mediterranean cultures to an empathic, realistic, and often idealized art characterized by the classical qualities of harmony, order, and serenity. The soul and art of northern people, by contrast, were formed by the discomfort and alienation they sensed in the world around him. This alienation had its roots in the harsh physical surroundings of the north: a cold, dark, and storm-filled climate, a grudging landscape resistant to human attempts to secure food and shelter. Such an environment promoted not empathy but estrangement. (Building on Worringer's basic theory of alienation, other thinkers asserted that the atomization of life in urban-industrial society, social injustice, upward-striving religions, and repressive moral systems further contributed to Germanic estrangement.)

Because alienation, Worringer argued, was the basic condition of northern artists, their

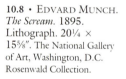

10.8 • EDVARD MUNCH. *The Scream.* 1895. Lithograph. 20¼ × 15⅝". The National Gallery of Art, Washington, D.C. Rosenwald Collection.

natural tendency was to distance themselves from a discomforting world. Rejecting the outer world, they increasingly turned to their inner selves. For motive and inspiration, they relied on their own heightened subjectivity and introspection. Incapable of an empathic relationship with nature and society, German artists felt compelled to forsake naturalness and tranquillity for a personal "play of fantasy" and "drive to abstraction."

> Actuality, which Gothic man could not transform into naturalness by means of clear-sighted knowledge, was overpowered by this intensified play of fantasy and transformed into a spectrally heightened and distorted actuality. Everything becomes weird and fantastic. Behind the visible appearance of a thing lurks its caricature, behind the lifelessness of a thing an uncanny, ghostly life, and so all actual things become grotesque. . . .[3]

This passage might well be describing many of the paintings of van Gogh, Munch, and Kirchner; German expressionist films, such as *The Cabinet of Dr. Caligari* and *The Last Laugh*; and the work of some of the most powerful Germanic early twentieth-century modernist painters and sculptors. For example, consider the large painting *Night* (10.9), completed in 1918–1919 by Max Beckmann (1884–1950). An emotional by-product of the horrors of World War I and its aftermath, this painting has as its theme the nocturnal invasion of a slum dwelling by a gang of thugs. In a jammed-in, claustrophobically shallow space, a nightmarish scene of torture and violation is taking place. The mind and body of the artist have assimilated real-life wartime and postwar experiences and reinterpreted them as the "distorted actuality," "weird and fantastic"

10.10 • Francisco Goya. *No Quieren* (*They Do Not Want To*). From *The Disasters of War. ca* 1810–1815. Etching and aquatint. 15.5 × 20.9 cm.

caricature, and "spectrally heightened" expression of which Worringer spoke.

The reader might protest that certain works of Mediterranean artists also fit Worringer's description of expressionist art. This, in fact, is true. Worringer, and others before him, overgeneralized the dichotomy between northern and southern art. For example, various works by Michelangelo (8.13) and the Italian mannerists (8.20) might qualify as "alienated" in spirit and distorted, fantastical, spectrally heightened, or abstract-expressionistic in form. The same holds true of the Spaniard Goya's *Caprichos* (9.3) and *Disasters of War* (10.10), a Mediterranean predecessor and variant of Beckmann's painting, *Night*. To be sure, psychic anxiety and its various manifestations in art—abstraction, expressionism, and fantasy—have never been solely the property of the Germanic countries. Today, more than ever, anxiety and anxious abstract art are worldwide phenomena. But these qualifications aside, Worringer's general theory of abstraction and alienation remains provocative and potent. In the early twentieth century, it was especially exciting and influential, offering northern artists a stirring explanation and rationale for their controversial new work.

From Alienation to Spiritualized Abstraction: The Art of Kandinsky and Klee.

The writings of many early twentieth-century modernists tended to support Worringer's idea that alienation promoted an abstract and expressionistic art. As the painter Paul Klee expressed it, "The more horrifying this world becomes (as it is in these days) the more art becomes abstract; while a world at peace produces realistic art." Numerous artists felt alienation was a principal reason for the distortion, abstraction, and fantasy in their art. But this alienation, they believed, had a positive as well as a negative side. To be estranged was to be motivated to break free from the worldly bonds of realism, to defy bourgeois conventions, to liberate oneself for higher experiences. For northern artists of the early twentieth century, the process of abstraction meant an unleashing of the individual's "spirit" or "soul." Munch had spoken proudly of his art as showing "the inner images of the soul." The artist, he wrote, begins with nature and then transforms it to express "the interior of man." Kirchner and the **Brucke** (Bridge) artists saw their movement as a "spiritual" bridge to a future life more free, creative, and expressive, more fully "human." Dissatisfaction with external reality had led these "humanist" artists to create an art that forcefully distorted actuality to express the powerful feelings of their souls. But athough van Gogh, Munch, and the Brucke artists transformed the outward appearance of reality, sometimes to fantastic degrees, their art always retained a direct connection to the physical, human world.

Estrangement from the world led other artists to create works of imaginative fantasy or complete abstraction that transcended the natural world altogether. Artists who pursued such directions almost always attached a "higher" spiritual or religious significance to their abstract art. The chief proponent of this general tendency was Wassily Kandinsky (1866–1944), an artist who was born in Russia but lived much of his life in Germany. Kandinsky's role in pioneering twentieth-century abstraction was great. He created a transcendental abstract art, wrote influential books and essays, and founded a major movement. Living in Munich between 1908 and 1914, Kandinsky met the art historian Worringer and found that they held many ideas in common. Each believed that alienation prompted the tendency to abstraction and that the resultant abstract art was the most spiritual type of art. Kandinsky must have found inspiring

Worringer's assertion, in 1908, that the northern "impulse to self-alienation . . . seeks after pure abstraction as the only possibility of repose within the confusion and obscurity of the world-picture, and creates out of itself, with instinctive necessity, geometrical abstraction." In his own widely read treatise, *Concerning the Spiritual in Art,* published in 1912, Kandinsky wrote that in a world "choked by materialist lack of belief" the mission of abstract art, which pierces the dense outer surface of things, is to direct "the development and refinement of the human soul, to raising the triangle of the spirit. . . ." Such beautiful, spiritualizing abstract art was a direct expression of the artist's inner spirit and need. It was "produced by internal necessity, which springs from the soul."

In 1912, the year in which Kandinsky published *Concerning the Spiritual in Art* and helped to found the **Blaue Reiter** (Blue Rider) movement, he had not yet arrived at the modern "geometrical abstraction" he and Worringer had envisioned. But his art was highly abstract and involved several exploratory approaches. One approach the artist called his "impressions," which he described as fauvist-type interpretations of outward natural subjects ranging from mountains and buildings to horses with riders. More abstract, and at times nonfigurative altogether, was the approach Kandinsky categorized as "improvisations." These the artist defined as "largely unconscious, spontaneous expression[s] of inner character, of non-material [i.e., spiritual] nature." Created in 1912, *Improvisation 28* (10.11) pulsates with the ecstatic energy that characterizes so many of the artist's paintings from the pre–World War I period. If this is "painting of the soul," as Kandinsky maintined, it expresses a passionate soul vibrating with excitement. Black lines, straight or curv-

10.11 • WASSILY KANDINSKY. *Improvisation 28 (Second Version).* 1912. Oil on canvas. 43⅞ × 63⅞". Collection, The Solomon R. Guggenheim Museum, New York.

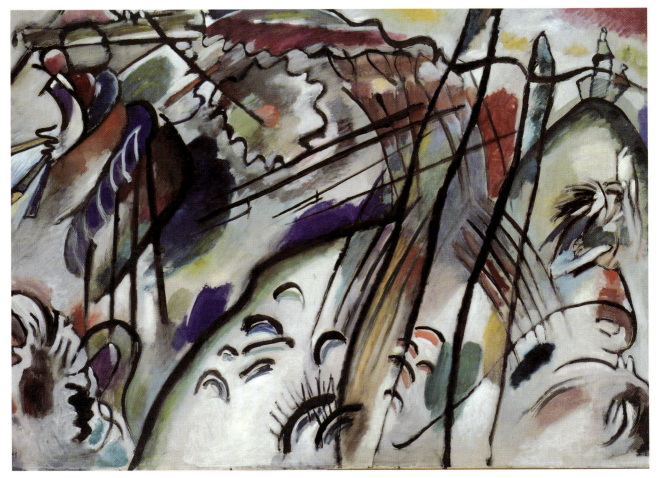

10.12 • Wassily Kandinsky. *Composition VIII.* 1923. Oil on canvas. 4′ 7⅛″ × 6′ 7⅛″. Collection, The Solomon R. Guggenheim Museum, New York.

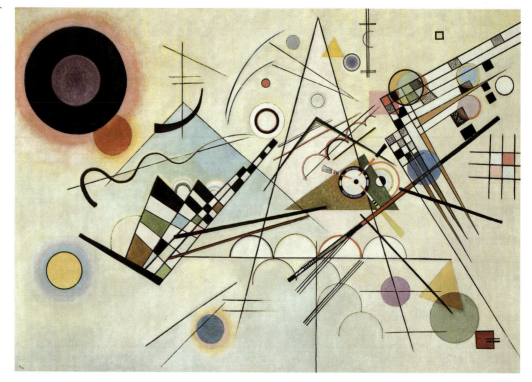

ing, crisscross and dash here and there. A cornucopia of primary and secondary hues—red, yellow, blue, green, brown, orange, purple—pulsate within and around the lines. Some of the shapes vaguely resemble mountains and tops of buildings, but the material world is left behind. Space is flattened; foreground and background meld together in a swirling mix. Transformed by the artist's "largely unconscious, spontaneous expression of inner character," lines, colors, and shapes now intertwine dynamically in an outpouring of Kandinsky's highly charged soul. Such painting anticipated by thirty years the improvisational abstract expressionist "action painting" that began full force after World War II.

After 1921, Kandinsky broke through to the art of pure geometrical abstraction that both he and Worringer had earlier envisioned. *Composition VIII* (10.12), an oil painting he created in 1921 while a teacher at the Bauhaus, exemplifies this breakthrough. In this painting, writes art historian Werner Haftmann, Kandinsky has subjected "his Abstract Expressionism to a discipline, fitting his powerfully surging forms into a rigorous scaffolding . . .

the turbulent streams of dynamic colour giving way to clear luminous forms, of mathematical precision." With the development of these geometrical abstractions, to which he would devote the rest of his life, Kandinsky had arrived at an art completely removed from everyday reality. In such "absolute" art, writes art historian Werner Haftmann, human "passions and natural data had ceased to be important; the essential, as in music, was to evoke and create a higher state of feeling which would illumine the darkness surrounding us with a reflection of universal harmony." Over the course of a lifetime, Kandinsky explored the full range of "abstract" and "nonfigurative" painting, pointing to scores of directions future artists could take.

Kandinsky's three closest friends in the Blaue Reiter movement were the painters Franz Marc (1880–1916), August Macke (1887–1914), and Paul Klee. Like Kandinsky, each man was committed to the search for the spiritual behind the material, for a higher reality within or above the physical plane. These artists looked to the imaginative art of primitive peoples and children, naive folk art, and

10.13 • PAUL KLEE. *Red and White Domes.* 1914, Watercolor. 14 × 13.7 cm. Kunstsammlung Nordrhein-Westfalen, Düsseldorf.

the innocent lives of animals and plants for imagery, soulful and wise, that would break the conventional bonds of academic painting. Macke framed the issue this way: "Are not the children who construct directly from the secrets of their emotions more creative than the imitators of Greek form? Are not the savage artists, who have their own form, strong as the form of thunder?"

The Swiss-German Paul Klee (1879–1940) held children's art in especially high esteem. He loved its spontaneous expressiveness and uninhibited inventiveness. He himself longed to see and represent as a child or primitive might, to paint "as though newborn, knowing absolutely nothing about Europe; ignoring facts and fashions, to be almost primitive." Yet no child or tribal person could have created Klee's work. His little pieces blend

whimsical fantasy with continental sophistication and studious technique.

In 1914, Klee spent twelve days in the North African country of Tunisia. He was overwhelmed by the brilliant color of this Mediterranean land. "Color has taken hold of me," he exclaimed. "I am [now] a painter." Stimulated by African color, architecture, and art and influenced by the colorful orphic cubism of his French friend Robert Delaunay (10.21), Klee arrived at an art at once luminous and structured, representational and abstract. The watercolor *Red and White Domes* (10.13), only five inches high by five wide, is an abstraction of a Tunisian town with its Moorish domes. Dating from the Blaue Reiter period, *Red and White Domes* shows the artist's "childlike" but highly cultivated style and anticipates the even more abstract and imagina-

10.16 • GEORGES BRAQUE. *Houses at L'Estaque.* 1908. Oil on canvas. 28½ × 23″. Kunstmuseum, Berne. Hermann and Margrit Rupf Foundation.

(10.17), a classic example of analytic cubism, bits and pieces of objects meet the eye. It is as if the objects, geometrized and abstracted from life, had been taken apart, "analyzed," and creatively reassembled according to the artist's imagination. In *The Portuguese,* a musician, highly abstracted, stands or sits before us, a guitar under his arm. "Where is the guitar?" a confused viewer might ask. Looking hard, we locate the guitar's sound hole, crossed by four strings, in the center of the painting, about three quarters of the way down. Curving black lines that do not meet suggest the guitar's body, while a barely discernible rectangular shape to the left hints at the instrument's neck. Additional curving lines and forms around this central image seem to echo the basic guitar shape. Is Braque showing us the instrument as seen from different angles, as many writers maintain? Is he presenting a multiplicity or simultaneity of views?

Such a painting makes demands of the viewer. We are required to put the pieces together, to bring closure to a multifaceted image. We must search for the head and body of the Portuguese guitarist because they, too, are composed of geometrical fragments. After some effort, we discover the head and torso centrally located in the upper half of the painting. The face of the musician appears in silhouette looking left; it fits neatly within the borders of a larger triangular form that expands outward and downward from the painting's top edge.

An analytic cubist painting such as *The Portuguese,* with its fractured shapes, flattened space, and monochrome color, leaves perceptual reality far behind. Still greater abstraction, total abstraction, might have been attained, but Braque and Picasso were not interested. They desired to remain in touch, even if barely, with the real world. And so they used words, numbers, letters, and signs in their paintings to anchor both themselves and the viewer to reality. In *The Portuguese,* the stenciled word "Bal" (dance) and the numbers "10.40," the total of a bar bill, are a link to the reality of the dance hall where the Portuguese musician played and customers danced, drank, and paid their tabs. The inclusion of such signs and symbols was Braque's original contribution to the cubist movement.

Braque and Picasso completed their most abstract paintings by 1912. From that year onward, the fragmented forms of analytic cubism began to combine and coalesce—to "synthesize"—into objects that were more clearly delineated and recognizable. The analyzed fragments were reassembled into synthetic wholes, as in Picasso's *Three Musicians* (2.27) of 1921. The basic objective was to "rehumanize" the picture, synthesizing the abstract and the real into a visual poetry. The resulting **synthetic cubist** style, with its more unified representations, was the second great phase of the cubist movement. Ultimately, it would become the dominant cubist style of the century, and its influence extended throughout the fine and popular arts (2.28). Picasso's giant painting, *Guernica,* painted in 1937 as an outcry against the bombing by fascists of a Spanish town, is probably the most famous example of this style as well as one of the most powerful political works of art in the modernist tradition (Appreciation 23).

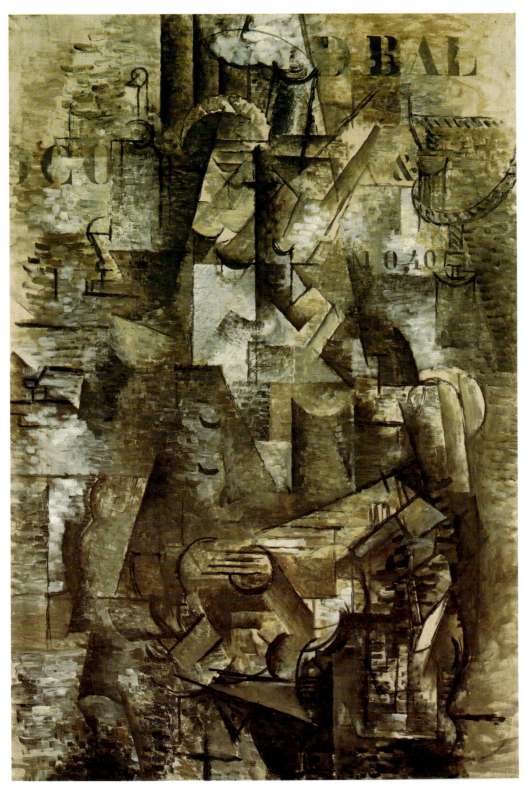

10.17 • GEORGES
BRAQUE. *The Portuguese.*
1911. Oil on canvas. 46¼
× 32¼″. Oeffentliche
Kunstsammlung,
Kunstmuseum, Basel.

10.18 • PABLO PICASSO.
Guitar and Wineglass.
1912. Collage and
charcoal. 24⅝ × 18½″.
Marion Koogler McNay Art
Museum, San Antonio,
Texas. Bequest of Marion
Koogler McNay.

The introduction of collage into Braque's and Picasso's easel paintings around 1912, an innovation credited to Picasso, helped to bring about the synthetic style by reintroducing identifiable imagery. Picasso's engaging *Guitar and Wineglass* (10.18), made mainly of pasted paper, shows how the technique of collage was initially employed. This early example of synthetic cubism exemplifies the greater integrity and wholeness that were now granted to objects. Only the wineglass in the lower right is drawn in charcoal in the earlier analytic style. The guitar, easily seen, is composed of four cut pieces of paper, and the wallpaper pattern of the background completes the body. Compared to the highly abstract paintings of the analytic period, so difficult to comprehend and enjoy, this collage is charming in its simplicity. *Guitar and Wineglass* is a lighthearted, sensuous work, with Picasso playing the jester. A torn piece of sheet music is comically attached to the neck of the guitar as if to say, "This pasted-down guitar makes, and is made of, music!" A piece of handpainted paper simulating commercial, mass-produced woodgrain veneer ironically makes up part of the instrument's body. "Ah," the viewer might think, "here is an imaginary guitar made of imaginary wood that is supposed to suggest the real material." Here is visual tongue-in-cheek humor in action. Picasso has brought forth from his fertile imagination a world that synthesizes the abstract and the real, that does not imitate but, with human warmth, evokes the shapes, textures, words, melodies, and collagelike character of daily life.

Collage was to become a tremendously popular medium in the twentieth century, serving diverse artists in numerous ways. But collage was not Picasso's only major innovation from the period around 1912. Ceaselessly creative, Picasso made a revolutionary breakthrough in the medium of sculpture, opening up immense realms of possibility. His *Guitar* (10.19) of 1912 would make a threefold contribution to the evolution of three-dimensional art. Sculpture, many in the avant-garde argued, lagged far behind painting in its "modernity." Picasso's *Guitar* helped to modernize the medium in three important ways. The Spaniard's sculpture pointed the way to new materials, new methods of construction,

stone or wood, or modeled it in clay and then cast it into bronze. He had invented a new way of bringing sculpture into being, one that was taken up in short order by the Russian constructivists, the dadaists, and many others. Finally, *Guitar* proclaimed a new conception of what sculpture could be. By emphasizing open spaces within its thin metal walls, *Guitar* promoted "space" or "spatiality" as a new basis for modern sculpture. Traditionally, sculpture had been defined by the convention of solid form or "mass." All sculptures prior to Picasso's *Guitar,* from those of the ancient Egyptians and Greeks to those of the twentieth century, had been based on the concept of mass. Artists now began to look on space, both within and around the object, as a principal consideration.

Exhibited in private galleries and public exhibitions, cubist art naturally aroused a storm of controversy. Like the avant-garde movements that had preceded it, cubism was hotly denounced by the majority and strenuously defended by a coterie of artists, literary people, and art dealers. To fight back against a critical populace who called the artists everything from "villains" to "anarchists," cubism's defenders offered explanatory theories as well as historical accounts of the movement. Attempting to show that cubism was as much evolution as revolution, the movement's supporters located its roots in the painting of Cézanne and, before him, in the achievements of Manet and Courbet. Cubism, they argued, was an amazing achievement: simultaneously abstract and realistic. Formally, it broke apart and reassembled, or constructed creative counterparts to, the things in the artist's immediate world. The form was abstract, but the subject matter was rooted in the real world. Portraits of friends and musicians joined with common still lifes of bottles and glasses on cafe tables. The surrounding industrial, mass media society suggested images and materials. Stenciled letters and numbers, newspaper and sheet-music fragments, commercial wallpaper and artificial woodgrain were fixtures of the cubist iconography.

Cubism, its proponents asserted, was as profound and complex as modern society itself. It mirrored in diverse ways the society that had produced it. The fractured imagery

10.19 • PABLO PICASSO. *Guitar.* Paris, 1912–1913. Sheet metal and wire. 30½ × 13⅛ × 7⅝". Collection, The Museum of Modern Art, New York. Gift of the artist.

and a whole new conceptual definition of the art form.

These were three groundbreaking contributions. Picasso's use of "industrial" sheet metal and wire in his *Guitar,* as opposed to traditional artistic materials such as marble, bronze, clay, and wood, directed artists to the materials, such as metal, iron, glass, and plastic, most reflective of their time. These were materials suited to modern men and women living in "the machine age." The making of *Guitar* was equally revolutionary. Picasso had assembled or "constructed" his sculpture from separate pieces of cut metal. He hadn't used the customary methods of execution of past centuries. He hadn't carved his subject from

of the cubists could be viewed as a metaphor of the fragmented, disruptive quality of urban life. The "simultaneous" views of objects found in analytic cubist works (for instance, the multiple views of the guitar in Braque's *The Portuguese*) might mirror the modern individual's common experience of "simultaneity." The modern metropolis with its sensory bombardment, mass media, and information overload not only produced but also demanded simultaneity of perception and thought. Metaphors of relativity and connection have similarly been attributed to analytic paintings. In an analytic cubist painting such as Braque's *The Portuguese,* the critic Robert Hughes sees "the world . . . imagined as a network of fleeting events, a twitching of skin surfaces." Such works of art are the products of big city life, nervous and fast-moving. In addition, Hughes sees in analytic cubism a "molecular view of the world" traceable to impressionism. Made up of little molecules or atoms, analytic paintings have been seen as visual analogues of the atomic theory of the period. Others have associated this molecular or atomic view with the "atomized" social fabric of urban industrial society. In collage, other creative thinkers found one of the most relevant metaphors for our modern lives. Collage integrated the most disparate elements into a single unity. As in a collage, the modern individual synthesizes enormous amounts of contrasting information, images, and feelings into one meaningfully integrated existence. What a boatload of interpretations cubism launched!

Are some of these interpretations way off target? Have others hit the mark dead center? Each thoughtful viewer must decide. Cubism's explicators did believe strongly that their movement, like every other in history, reflected its time. The gallery director Daniel-Henry Kahnweiler (1884–1976) wrote of the "free, mobile perspective" of Picasso and Braque. So different from the fixed, linear perspective of the Renaissance, might not cubist perspective reflect the far greater freedom and mobility of early twentieth-century life? Might not the "relativity" of views common in analytic cubist paintings relate, in some intuitive or synchronous way, to Einstein's contemporary theory of the relativity of space and time?

This theory was becoming known to advanced thinkers right about the time the cubists were pursuing their own researches. A relativity of views? In an international sense, a relativity of cultural views had certainly entered the world of modern art. Western and non-Western, industrial and tribal ways of seeing and representing intermingled in the artistic vanguard. The influence of non-Western art on the European moderns had already been substantial: Japanese art on the Impressionists and post-impressionists; Oceanic and Oriental art on Gauguin and the symbolists; African and Melanesian art on the fauves, German expressionists, and cubists. Picasso and Braque especially

valued African and Oceanic tribal art (10.20) for its formal, abstract qualities and its conceptual way of representing reality. In a social context marked by individualism, multiculturalism, simultaneity, and relativity, vanguard artists were stimulated by new and unconventional ways of seeing and representing the world. According to the poet and critic Guillaume Apollinaire (1880–1918), many of the young cubist artists "contemplate Egyptian, Negro, and Oceanic sculptures, meditate on various scientific works, and live in anticipation of a sublime art."

The cubist movement had definitely hit on something important in respect to both European art and society. Related movements into geometrical abstraction appeared almost simultaneously in other countries. A few of these evolved independently from French influence, but most were directly stimulated by it. As the contemporary art historian Herschel Chipp writes, "Cubism is, in fact, the immediate source of the formalist stream of abstract and non-figurative painting that has dominated the art of the twentieth century. The movements of this stream—Constructivism, Neoplasticism, De Stijl, and Orphism—arose very soon after the development of Cubism itself, owing part of their impetus to the prevailing sentiment for formalism, but receiving a vital fertilization from Cubist formal devices and Cubist ideas." Cubism for artists throughout Europe was rarely an end in itself. Rather, it was a means to many different ends. Diverse vanguard artists borrowed from cubism its revolutionary methods of abstracting or "formalizing" images. These they then employed to their own unique purposes.

The Orphic Cubism of Robert and Sonia Delaunay. Robert Delaunay (1885–1941), his wife, Sonia Terk-Delaunay (1885–1979), and the artists associated with orphic cubism were consumed by the poetic expression embodied in color and light. Robert Delaunay, who had exhibited with the Paris cubists, made that city the starting point of his abstractions. He was thrilled by the energy, light, and structure of modern life. He used as the subjects of his otherwise abstract paintings some of its most impressive technological creations: the Eiffel tower, the airplane, the urban sky-

line. Over time, these once recognizable subjects became increasingly abstract, submerged in colorful, geometric shapes. By 1912, pushing his art to the limits of abstraction, Delaunay departed ecstatically, if only briefly, from subject matter. "Everyone," he said, "has sensitive eyes to see that there are colours, that colours produce modulations, monumental forms, depths, vibrations, playful combinations, that colours breathe goodbye to Eiffel Towers, views of streets, the outside world. . . . We no longer want apples in a fruit bowl, we want the [poetic, spiritual] heartbeat of man himself." Placing color relationships above all, color alone being "form and subject," Delaunay created a series of *Window* paintings that are totally or almost totally abstract.

The painting *Window* (10.21) of 1912–1913 is nearly but not entirely nonobjective.

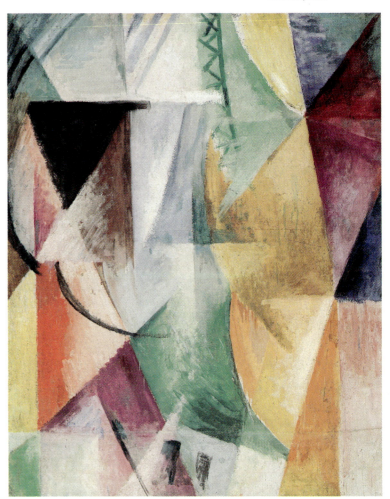

10.21 • ROBERT DELAUNAY. *Window.* 1912–1913. Oil on canvas. 111 × 90 cm. Musée National d'Art Moderne, Paris.

At first glance, we experience it as a rainbow of luminous colors, with each chromatic area woven into a loosely geometric cubist grid. No contour lines or "Old Master" *chiaroscuro* shading techniques are employed to delineate shapes or bring forth depths. Color, as Delaunay insisted, plays all the main roles, operating as shape, space, and subject matter. The color is vibrant; complementary areas of orange and blue, pink and green, and yellow and purple energize their neighbors. Implied lines, formed only by the borders of color areas, play off each other, diagonals, verticals, horizontals, and curves. Do these "color-forms" hint at buildings or streets seen from a window? If so, they do so indirectly, at best. At the top center is the barest schematic rendering of the Eiffel Tower. It alone calls forth line as an element above color. Now that we see it, we note the Eiffel Tower's dematerialized form rising up from the very center of the painting.

Here was painting moving toward complete abstraction. Classifying such art as "orphic" (that is, in the tradition of the mythological Orpheus, the most poetic and inspirational of musicians), the critic Apollinaire defined this offshoot of cubism (**orphic cubism**) as painting whose elements and structures came not from the outside world but from within the artist himself. "The works of the orphic artist," he wrote, "must simultaneously give a pure aesthetic pleasure, a structure which is self-evident, and a sublime meaning, that is, the subject. This is pure art."

All seems alive and moving in the *Window* paintings. One feels the excited touch of Delaunay's brushstrokes, but the most emphatic motions or rhythms come from the interactions of the bold color areas. These, the artist believed, are the rhythms of the modern world pulsating through both individual and society, for "nature is pervaded by all manner of rhythms" that art should imitate "in order to become equally pure and sublime, to rise to visions of a complex harmony, a harmony of colours which separate and at the same time join together again to form a whole." This connection between spiritual purity and sublimity and harmonic combinations of color and rhythm likewise inspired Delaunay's northern neighbors and friends in the Blaue Reiter movement: the Russian Kandinsky (10.11), the German Marc, and the Swiss-German Klee (10.13). As of 1911, Delaunay began to exhibit with his Blue Rider colleagues in Munich, and Klee translated Delaunay's essay, entitled "Light," into German.

The Mechanical Paradise of the Italian Futurists.

All over Europe, modern artists seemed to be manifesting the spirit of the industrial age in their work. The Delaunays, with their emphasis on rhythm and movement, and their earlier explicit interpretations of modern life, metropolitan Paris, (see cover) the Eiffel Tower, and the airplane, found southern relations in the **futurists** of Italy. The futurists, true to their name, had given themselves body and soul to the brave new world of technological innovation. Violent in their likes and dislikes, these militant young men hated what they saw as Italy's stagnant social and cultural past. They longed to destroy all those obsolete paintings and sculptures that stank of nature and classical calm and order, all those museum "cemeteries" that housed worthless, outdated, "dead" art. The past only imprisoned. They associated it with "poison," "weariness," "decay," and "death." Past values and beliefs only "exhausted, lessened, and trampled" the potentiality of modern "living" humanity. The old books, art works, and museums, the vessels and repositories of past culture, had to be burned. The ancient slate had to be wiped clean. In this way, the new world and generation, "nourished on fire, hatred, and speed," might be born.

The poet F. T. Marinetti (1876–1944), the futurist leader and propagandist extraordinaire, called for a world of dynamism and fearless technological adventure with a vibrant modern art to match. Poetry, painting, and sculpture should reflect the energy and excitement of the urban industrial society rising around them: "factories hanging from the clouds by the threads of their smoke; bridges like giant gymnasts stepping over sunny rivers sparkling like diabolical cutlery; adventurous steamers scenting the horizon; large-breasted locomotives bridled with long tubes, and the slippery flight of airplanes whose propellers have flaglike flutterings and applauses of enthusiastic crowds." Worringer's theory of

10.22 • GIACOMO
BALLA. *Speeding
Automobile*. 1913. Oil on
card. 23½ × 38¼". Civica
Galleria d'Arte Moderna,
Milan.

Mediterranean art as calm, classical, and realistic was being stood on its head. The futurists were throwing the old Italian love of nature, realism, and classicism out the window. In place of espousing the perennial southern values, the futurists pursued a wild love affair with the emerging mechanical paradise. Their violent art was expressive of the new machine-god. "We declare," wrote Marinetti in the "Futurist Manifesto" of 1909, "that the splendor of the world has been enriched with a new form of beauty, the beauty of speed. A race-automobile adorned with great pipes like serpents with explosive breath . . . a race-automobile which seems to rush over exploding powder is more beautiful than the Victory of Samothrace" (one of the most revered of ancient classical sculptures). The new "shapes" of industry, which the poet Walt Whitman had marveled at a half century before, had risen.

They had captured the imagination of the avant-garde in general and the futurists in particular.

The *Speeding Automobile* (10.22) of Giacomo Balla (1871–1958) makes Marinetti's exultant words visible. One's immediate feeling is of dynamism and speed. The powerful automobile is moving so fast that it has become a blur. Propulsive lines of force and energetic triangular shapes radiate from its center; the vehicle is speeding toward and beyond the picture's left edge. The limited palette of burnt orange, black, and white and the fragmented imagery remind one of analytic cubist paintings such as Braque's *The Portuguese*, but cubist paintings were never so fast-moving. Rather, the quality of blurred motion in *Speeding Automobile* is probably rooted in early cinema and, more specifically, in sequential photographs (7.20, 7.21), which capture, in

superimposed stages, the movement of people or objects through space.

Today's viewers must find Balla's 1913 perception and representation of speed interesting. He was obviously impressed with the speeds that automobiles, only recently mass-marketed, could attain. Even to those of us who have watched race cars travel at two hundred miles per hour or more, Balla's car looks fast. It literally shoots across the picture. It is a car that, as Marinetti exclaimed, hurls driver and spectator through the streets, tires scorching, at a death-defying clip, "break[ing] away from rationality as out of a horrible husk" so that "we give ourselves up" to the furious ecstasies of the mechanical "unknown." Yet Balla's automobile is a square, boxlike affair, with wooden-spoked wheels

10.23 • UMBERTO BOCCIONI. *Unique Forms of Continuity in Space.* 1913. Bronze (cast 1931). 43⅞ × 34⅞ × 15¾″. Collection, The Museum of Modern Art, New York. Acquired through the Lillie P. Bliss Bequest.

and big bug-eyed headlights. It probably went no faster than forty miles an hour! This irony aside, the futurists were in touch, prophetically so, with the essential nature of the new urban, industrial society in which "all things move, all things run, all things are rapidly changing." And as artists, they succeeded admirably in making the formal breakthroughs necessary to convey this technological world.

For Marinetti and his compatriots, the man for the times, futurist man, had to be fearless, violent, and, as we put it today, "macho." He had to be ready to destroy all that was old, weak, feminine, and conventional to clear the way for the new. With destruction seen in such a positive light, it was only natural that Marinetti glorified "war—the only true hygiene of the world—militarism, patriotism, the destructive gesture of the anarchist. . . ." (These are wild words from the founder of futurism, but ones that did not entirely overstate his real-life position; he later became minister of culture under the fascist dictator Mussolini.) Futurist man had to embody the power, force, and dynamism of the present. He was now a driver or passenger in speeding automobiles and planes. On foot, he was a fast-moving pedestrian energized by the sights, smells, and sounds of the street. Futurist man, young, strong, and unstoppable, marched only forward, the embodiment of "our whirling life of steel, of pride, of fever and of speed." So wrote the futurist painters, led by Umberto Boccioni (1882–1916), in their "Technical Manifesto" of 1910.

While speeding cyclists and motorists, dynamic soccer players and laborers, violent soldiers and rioters were the subjects of abstract futurist paintings, it would be a sculpture by Boccioni that provided the most memorable image of futurist man. *Unique Forms of Continuity in Space* (10.23) is a powerfully striding figure: part man, part machine, all energy. The figure's right leg and left arm surge forward; its mighty sinews both push through and open out into the surrounding space. The blur of motion seen in futurist paintings such as *Speeding Automobile* is here replaced by winglike forms that seem to grow out of and flow behind the figure. Atop the massive, mobile torso is the control center of the "unique forms." The cranial lobe of the head is swept

back but still organic in shape. The rest is all machine. The face of futurist man evokes the image of a steam locomotive, armored car, or tank. The features are enginelike, with geometrical spaces opening into or out of the core. The "marvelous mathematical and geometrical elements," Boccioni wrote, "that make up the objects of our time" must characterize futurist sculpture. Futurist man would increasingly have to give up human personality (face) for mechanical impersonality (force), thereby appropriating for himself the abstract essences of the machine age: energy, dynamism, exhilarating movement through space. In his influential "Technical Manifesto of Futurist Sculpture" of 1912, Boccioni, speaking like an artist-engineer, called for a new sculpture based on "force-lines," "plastic zones," "directional curves," and "rhythmic continuity." The shape of such sculpture would be characterized by a "bare, fundamental severity [that] will symbolize the severity of steel that determines the lines of modern machinery." Disdaining the static nature of traditional sculpture, futurist sculptors would attempt to convey "rhythmical movement" because, as Boccioni put it, "objects never end"; they are forever in motion and interaction with their surrounding environment, in "infinite combinations of sympathetic harmonies and clashing aversions." The "closed," clearly defined volumes of traditional sculpture had to be abolished to "break open the figure and enclose it in environment."

FROM FUTURISM & CUBISM TO RUSSIAN CONSTRUCTIVISM: THE SCULPTURE OF GABO

Within a year, Boccioni's joyous vision of futurist sculpture and futurist "machine-man" was dashed by the crushing devastation of World War I. Machines operated by men killed combatants and civilians in the millions. Europe was ravaged, and the sculptor, a soldier in the Italian forces, was killed during the conflict. But the influence of Boccioni's tradition-smashing sculptures, paintings, and writings outlasted the catastrophe. His works and those of his futurist colleagues inspired many, among them the artists of revolutionary Russia. The Russian avant-garde artists, in alliance with the communist vanguard led by their political leaders Lenin and Trotsky, sought to build from the ruins of the war and the Bolshevik Revolution an ideal, classless society based on the marriage of humanity and industry. Many Russian artists in graphic design, painting, sculpture, architecture, and film were as excited as their futurist predecessors about creating an art appropriate to the industrial age. The Russian **constructivist** artists of the teens and early twenties looked on the abstract language of the futurists and cubists with much favor. In sculpture, the boundary-breaking works and ideas of Boccioni and Picasso found a most receptive audience among the Russians. In particular, two young brothers, Naum Gabo (1890–1977) and Anton Pevsner (1886–1962), built on the futurist and cubist legacy.

In his "Technical Manifesto of Futurist Sculpture," Boccioni had called for the use of modern materials: "transparent planes, glass, sheets of metal, wires . . . cardboard, iron, cement . . . cloth, mirrors, electric lights, etc., etc." Picasso had made his *Guitar* from sheet metal and wire. Gabo and Pevsner assembled or "constructed" their works from the materials of industry—plastics, glass, steel, nylon thread—and used them more extensively than any previous sculptor. Boccioni had written defiantly that the traditional criteria by which sculpture was defined, notably enclosed form (mass) and stillness (stasis), had to be thrown on the garbage heap of the past. The Italian imagined a sculpture of open space, of "atmospheric planes that link and intersect things." Picasso's *Guitar* certainly moved in this direction of spatiality. Gabo, in his *First Constructed Head* (10.24) of 1915, extended Picasso's achievement. He realized in spatial form what for Boccioni had remained a dream. Volumes of open space, evoked by thin planar forms, define head, face, and neck. These, in turn, open the figure up to fluid spatial interaction with the environment around it. The space of the figure and its airy surroundings are truly coextensive. Gabo put into practice what Boccioni only envisioned. The Italian also had written of sculptures that might physically move. By 1920, Gabo realized this idea,

and graphic design, should play an integral part in daily life. For example, El Lissitzky created the abstract poster *Beat the Whites with the Red Wedge* (2.31) to inspire public support for the communist "red" armies in their effort to defeat the counter-revolutionary "white" forces. Unfortunately for the Russian avant-garde, abstract painting, sculpture, and graphic design were soon discouraged by the revolutionary political councils who favored art works that were more conventional in style and subject matter (for instance, realistic portraits of idealized worker heroes and communist leaders) and directly functional (geared to communication and propaganda needs). Without jobs or commissions, prominent members of the Russian avant-garde, including Gabo, Pevsner, Kandinsky, and Lissitzky, began to leave the Soviet Union for the freer, more supportive climate of Western Europe. A sizeable group settled in Germany. From 1922 until the rise of the nazis, Gabo, a Jew, lived in Berlin. His art and ideas were warmly received in various vanguard circles, including Germany's Bauhaus. Adding to the substantial Russian influence in postwar Germany, Gabo's fellow emigre, Kandinsky, taught at the Bauhaus for over a decade, from 1922 to 1933.

With the exception of early representational works such as the "constructed heads," almost all of Gabo's mature sculptures are nonrepresentational, and many have an architectonic quality. Made of transparent plastic, wood, and metal, his *Column* (10.25), for example, has the lightness, transparency, and geometrical lucidity that Bauhaus architects and designers admired. About the *Column,* created in 1923, he said: "My works of this time, up to 1924 . . . are all in the search for an image which would fuse the sculptural element and the architectural element into one unit. I consider the *Column* the culmination of that search." Gabo's sculpture looks rather like an early model of a glass skyscraper (10.26) by the pioneering German architect Ludwig Mies van der Rohe. This is not surprising because Gabo indeed thought like an architect and engineer. He wrote: "The plumb-line in hand, eyes as precise as a ruler, in a spirit as taut as a compass . . . we construct our work as the universe constructs its own, as the engineer

10.24 • NAUM GABO. *First Constructed Head.* 1915. Wood. Height, 28″. Courtesy and © Graham and Nina Williams.

creating a "kinetic construction" made from a vertical metal rod, eighteen inches high, that vibrated by means of a motor.

Both Gabo and Pevsner, and fellow countrymen such as Kandinsky and El Lissitzky (1890–1956), had returned to revolutionary Russia with the hope that their modern art might contribute to the building of the ideal, classless society of the future. Modern abstract art, Gabo and Pevsner wrote in their "Realistic Manifesto" of 1920, was not to be isolated in museums or private collections but should be present throughout society, "in the squares and on the streets . . . at the bench, at the table, at work, at rest, at play; on working days and holidays . . . at home and on the road . . . in order that the flame to live should not extinguish in mankind." Modern art, in the form of public sculpture, architecture, and product

constructs his bridges, as the mathematician his formula of the orbits." Like Bauhaus director Walter Gropius, who saw architecture as the leading art that could incorporate all the others, Gabo wrote that his constructive sculpture should keep pace with modern architecture, "the queen of all the arts," and guide it. He found it encouraging that modern architecture and product design, as evidenced in the creations of Mies van der Rohe, and Gropius and Breuer (5.33, 5.34) at the Bauhaus, embodied principles parallel to his own. Constructivist forms and ideas were finding a receptive home in what would become known, in architecture and design circles, as the **international style**, a worldwide movement that, Gabo believed, would powerfully energize "the whole edifice of our everyday existence."

Gabo left a rich legacy for future sculptors. Any sculptor who works in the newest industrial materials, emphasizes space over mass, works nonobjectively or architectonically, or creates large-scale outdoor sculptures for public spaces owes a substantial debt to Gabo's pioneering efforts and to Russian constructivism in general.

10.25 • NAUM GABO. *Column. ca* 1923. Plastic, wood, metal, and glass. 41½ × 29 × 29". Collection, The Solomon R. Guggenheim Museum, New York.

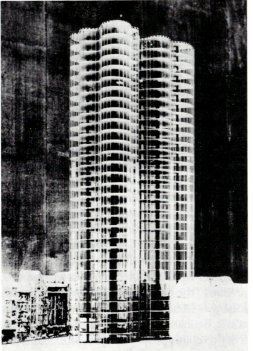

10.26 • LUDWIG MIES VAN DER ROHE. Model of a glass skyscraper. 1922. Photograph courtesy Mies van der Rohe Archive, The Museum of Modern Art, New York.

ART OF THE IRRATIONAL: FROM DADA TO SURREALISM

Just as there are diverse streams within expressionism and formalist abstraction, so, too, are a variety of directions apparent within **dada,** the anarchic international movement that arose in response to World War I. With a name fittingly derived from a nonsense word, dada was a countercultural movement that stood for freedom, "non-rational" creativity, and rebellious nonconformity. Committed to absolute freedom and everything that was anti-bourgeois, dada art and activities tended to follow discrete tendencies in different countries and cities. For example, the creations of Marcel Duchamp (1887–1968), the premier figure of Paris and New York dada, emphasized the movement's intellectual and aesthetic side. In contrast, the output of the Berlin dadaists was emotional in tone and political in intent.

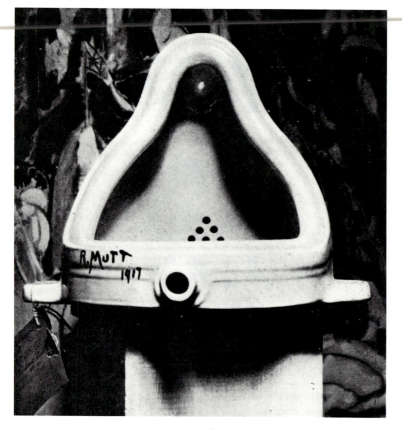

10.28 • MARCEL DUCHAMP. *Fountain.* 1917. Readymade. 14 × 19 × 24″. The Philadelphia Museum of Art. Arensberg Archives. Original lost.

Duchamp and Intellectual Dada. By 1917, Marcel Duchamp, a successful vanguard painter in the cubist and futurist styles, had begun to devote much of his energy to aesthetic rebellion and provocation of the art establishment. One infamous example was the showing of a common urinal in an art gallery exhibition. He titled it *Fountain* and signed it "R. Mutt" (10.28). Intellectually, Duchamp was challenging the art establishment to battle. Placing a readymade object in the art gallery raised all kinds of aesthetic issues. Viewers were aghast. Nothing like Duchamp's *Fountain* had even been shown in an art exhibit. Was the urinal to be taken seriously and considered "art" because of its visual form? Or was R. Mutt's urinal non-art? Or anti-art? Or all a big joke? Duchamp certainly had everybody guessing or riled up.

Intellectual dada at its best, the work continues to provoke debate right up to the present. Is *Fountain* "art" simply because Duchamp, an established artist, selected it and put it in the show? Does it continue to be art because art historians and museum curators say it's art? Is it the bold originality of Duchamp's thinking that makes *Fountain* art? Was Duchamp saying that mass-produced industrial products possessed a beauty equal or superior to that of fine art? Was he saying that the distinction between fine and applied art should be eliminated? Ever enigmatic, Duchamp refused to supply specific answers to these questions.

Relative to the artist's intentions, we know that Duchamp espoused art that stimulated thought, an art in the "service of the mind." His call was for art to turn to "an intellectual expression, rather than to an animal [physical, sensuous] expression." The belief that artists created simply from instinct and emotion disturbed him. He loathed the phrase "stupid as a painter" and thought the artist's true role was to be an aesthetic challenger and cultural provocateur. He preferred art that functioned as a "cerebral pistol shot," a dadaist phrase that aptly describes his own *L.H.O.O.Q.* (10.29), a color reproduction of Leonardo da Vinci's *Mona Lisa*, with mustache and goatee penciled in. Here is a work that defies artistic tradition and actually defaces an icon, an in-

tellectual "anti-art" of multiple meanings, bristling with irreverent puns and satire. The critic Robert Hughes deciphers it:

> The coarse title—*L.H.O.O.Q.*, pronounced letter by letter in French, means: "She's got a hot ass"—combines with the schoolboy graffito of the moustache and goatee; but then a further level of anxiety reveals itself, since giving male attributes to the most famous and highly fetishized female portrait ever painted is also a subtler joke on Leonardo's own homosexuality (then a forbidden subject) and on Duchamp's own interest in the confusion of sexual roles.[9]

For Duchamp, dada was a most appealing "sort of nihilism." It was, as he put it, "a way to get out of a state of mind—to avoid being influenced by one's immediate environment, or by the past: to get away from clichés—to get free." In works like *Fountain* and *L.H.O.O.Q.*, Duchamp not only got free, defying cliché and convention but also infinitely expanded the boundaries of what art might be. For this, innumerable artists would thank him.

The Political Dada of Berlin. With Duchamp and his friend Man Ray (7.35) in the forefront, Paris and New York dada had been characterized by intellectual iconoclasm and irreverent wit. In contrast, Berlin dada was hotly emotional and political. Its anticultural nihilism was more desperate, its anarchy more urgent. By the end of World War I, its intentions were socially activist, even revolutionary. Berlin dada was more of a bitter cry in the wilderness than a playful protest against art establishment conventions. "Dada," as one of its founders, the Rumanian poet Tristan Tzara had asserted, was not born "of art, but of disgust."

The German dadaists were disgusted with the bourgeois society whose nationalism, materialism, and misguided rationalism had brought the countries of the world into a brutal, senseless world war. Millions were being killed or maimed by the machines of industry and the military men who wielded them. This bloodiest of wars smashed the once great promise of the Industrial Revolution and the notion of scientific progress. Hundreds of thousands of civilians were homeless or starving. Despising bourgeois culture, especially its vaunted "logic" and "rationality," dada's foun-

10.29 • MARCEL DUCHAMP. *L.H.O.O.Q.* 1919. Pencil on print of Leonardo's *Mona Lisa.* 7¾ × 4¾". Private Collection.

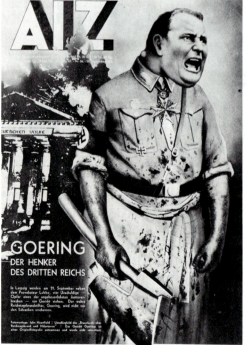

10.31 • GEORGE GROSZ. *Fit for Active Service*. 1916–1917. Pen, brush, and india ink. Sheet, 20 × 24⅜″. Collection, The Museum of Modern Art, New York. A. Conger Goodyear Fund.

10.32 • JOHN HEARTFIELD. *Goering the Executioner of the Third Reich*. From *AIZ*, XII: 36, 1933. Rotogravure on newsprint from original photomontage. 15⅛ × 11⅛″. The Museum of Fine Arts, Houston. Museum purchase with funds provided by Isabell and Max Herzstein.

attention was a dummy of a German officer, fitted with the head of a pig, hanging absurdly from the ceiling (10.33).

Although the dada movement disintegrated during the early 1920s, the dada spirit, in both its political and intellectual forms, resurfaced throughout the century under various guises. By 1924, many of dada's ideas, approaches, and participants had been absorbed into a new countercultural movement, surrealism. The leader of the Surrealist movement, the French poet André Breton (1896–1966), was himself a former dadaist. And like dadaism, surrealism's appeal and influence were worldwide.

Surrealism: Liberating the Unconscious. Many of the dadaists had previously spoken of the importance of the unconscious in the transformation of art and society. According to the dadaist Jean Arp, who subsequently exhibited with the surrealists, "The law of chance, which embraces all other laws and is as unfathomable to us as the depths from which all life arises, can only be comprehended by complete surrender to the Unconscious. I maintain that whoever submits to this law attains perfect life."

Surrealism's official founder, André Breton, likewise called for a liberating "surrender to the Unconscious" and made it the central principle of the new movement. By integrating the unconscious and conscious life-worlds, Breton believed, a wondrous super-reality or "sur-reality" might be attained. All of the arts, literary, visual, dramatic, and cinematic, might serve as instruments of exploration and revelation in this grand quest. In his "Surrealist Manifesto" of 1924 Breton wrote, "I believe in the future transformation of those two seemingly contradictory states, dream and reality, into a sort of absolute reality, or sur-reality, so to speak." **Surrealism** he officially defined as "the belief in the superior reality of certain forms of association neglected heretofore; in the omnipotence of the dream and in the disinterested play of thought."

The pursuit of the dream and the free play of thought, rather than any specific aesthetic considerations, were the primary goals of the movement and preconditions for all art-making activities. Thus freed from any precon-

ceived aesthetic strictures, surrealist artists created an outpouring of work so diverse in style and media as to defy categorization. Some paintings, for example those by the Frenchman André Masson (1896–1987), were highly abstract. Masson's art was spurred by what the surrealists called "psychic automatism," the guiding of the creative process by an unchecked stream of consciousness and unconsciousness that encompassed dream imagery, instinctive impulse, and spontaneous thought. Art historian William Rubin writes that Masson's creative process in *Meditation on an Oak Leaf* (10.34) might be likened to that of a receptive "spectator at the unfolding of his own chain of associations." Masson allowed the deepest impulses of his psyche— "subterranean forces," he called them—to inspire his imagery. In *Meditation on an Oak*

10.34 • ANDRÉ MASSON. *Meditation on an Oak Leaf.* 1942. Tempera, pastel, and sand on canvas. 40 × 33". Collection, The Museum of Modern Art, New York. Given anonymously.

10.33 • *First International Dada Fair.* Berlin, 1920. Photograph of dada artists taken in the gallery of Dr. Otto Burchard. Bildarchiv Preussischer Kulturbesitz, Berlin.

Frida Kahlo. *The Broken Column.*

GEORGINA VALVERDE

I was introduced to the art of Frida Kahlo by one of my art professors in college. "Surely you have heard of her. After all, weren't you born and raised in Mexico?" Well, yes, part of my life. I knew of Diego Rivera, Frida Kahlo's husband and one of the most famous twentieth-century Latin American artists. He painted colossal murals [1.3] depicting the plight of the struggling poor, important subject matter with social conscience. For the first time, I conceded to being slightly prejudiced. I didn't know of too many Mexican women artists, and I certainly didn't admire any.

I rushed to the library and checked out Frida Kahlo's biography. As I poured over the pages, I was soon revisiting Mexico, my country of birth, during the 1920s, the years of the Mexican Revolution and the time of my grandparents. Kahlo's life unfolded before me like a story from a morbid, trashy magazine: shocking, painful, scandalous, glamourous, heroic, and tragic at the same time. The title of the article might have been "Woman impaled by metal railing in bus accident spends the rest of her life painting strange self-portraits." But there is more than plain goriness to Kahlo's story, and although it is a challenge to condense my admiration for her and her work to a few words, I hope to convey a sense of the qualities and achievements that make her an exceptional human being.

Georgina Valverde is an artist and language instructor. She lives in Chicago, where she works with Hispanic-American children.

Frida Kahlo was born July 6, 1907, in Coyoacán, a suburb of Mexico City. Her father was a photographer of German descent, and her mother was a *mestiza,* (part Spanish, part Indian), a good beginning to an interesting history. In 1925, her life took a tragic and disastrous turn when a trolley crashed into the bus she was riding back from school. A metal rod practically skewered her, piercing her upper spine and emerging through her vagina, crushing and tearing her right leg and foot along the way and causing a triple fracture of the pelvis. Although I use the word *tragic,* in no way do I feel pity for Kahlo. She was a strong character who made the best of her situation. In fact, if she hadn't been so severely wounded, she may never have painted at all. As she lay convalescing at the Red Cross Hospital in Mexico City, she began recording on canvas a personal martyrdom of many operations and hospital stays, the sorrow of not being able to carry a pregnancy to full term, and, finally, the amputation of her right leg. Art must have been therapy for Kahlo, certainly one of the few things she could do while bedridden, and eventually, a powerful reason to carry on. In her own words, "I paint my own reality. . . . The only thing I know is that I paint because I need to, and I paint whatever passes through my head, without any other consideration."

A strong-willed individualist in a society that taught women to be passive, Kahlo was also somewhat of a daredevil, as the following story illustrates. As soon as she was able to walk, she decided to consult the famous mu-

ralist Diego Rivera to see "whether her paintings were worth anything." She went to the site where he was working on a mural, summoned him down from the scaffolding, and asked him point blank to judge her work. His response: "Go home, paint a painting, and next Sunday I will come and see it and tell you what I think." Three years later, in 1929, they were married.

Kahlo's paintings are small, jewel-like, meticulously rendered, and shocking because of their content. She was strongly influenced by the style of Mexican folk *retablos,* small narrative paintings that tell a story, usually of an accident or illness overcome miraculously through the intervention of Christ, the Virgin, or a patron Saint. The event is described literally in all its goriness, both pictorally and through text, which also includes a dedication to the intercessor. Kahlo's treatment and themes, although of a secular nature, make her paintings personal *retablos.*

A poignant example of this type of personal narrative is *The Broken Column* (Fig. A), which she painted in 1944 after spinal surgery. (She underwent thirty-two operations during the course of her life.) In this painting, we see a suffering Frida commanding the picture plane. She delicately holds a white drape, which gives her an air of martyrdom. Her body cracks open below the chin to reveal a crumbling Ionic column in place of the spine. Sharp nails of different sizes pierce her flesh, penetrating just enough to stay in place but having no other apparent purpose than to exacerbate the torture. It is hard to say how much longer the orthopedic corset will hold Frida together. The body is bursting at the seams with unbearable pain. Behind her, nature echoes her desolation in craters and cracks of dusty landscape where no living thing would dare grow. But Frida's stare makes us aware of a powerful sense of balance, perhaps even well-being, an otherworldy stoicism in the face of suffering. Her tears stream down freely, but her expression is unmoved. She seems to be saying, "I am this decaying body. My suffering is as in-

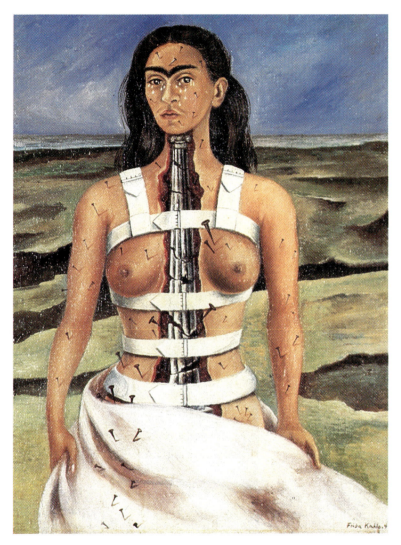

finite as the horizon line. But I am something more, something enduring and strong."

I am afraid I have said too much about Kahlo's suffering and not enough about her *joie de vivre,* a life-loving quality that nourished and sustained her until her death in 1954. She enjoyed the bizarre and unconventional and surrounded herself with some of the world's most fascinating personalities, whom she drew to her like a magnet. At the same time, she felt a deep appreciation of and reverence for the

Figure A • FRIDA KAHLO. *The Broken Column.* 1944. Oil on masonite. 15¾ × 12¼″. Courtesy Sra. Dolores Olmedo, Mexico City.

10.41 • JOHN SLOAN.
McSorley's Bar. 1912.
Oil on canvas. 26 × 32".
The Detroit Institute of Arts.
Founders Society Purchase.

John Sloan (1871–1951) was an artist of the Henri circle also committed to democracy in both his art and politics. Born in Pennsylvania, Sloan worked as a newspaper illustrator in Philadelphia and New York City before becoming a painter; in this way, he continued in the tradition of his great nineteenth-century predecessors, Daumier and Homer, who had also worked as visual journalists. Some of Sloan's finest drawings, created for the prominent socialist magazine, *The Masses,* are lively, hard-hitting political commentaries. But when it came to the medium of painting, overt protest gave way to seemingly straightforward pictures of modern life. Yet there is more to these paintings than simple documentation. Sloan invests the commonplace with a warmth and poetic tenderness that ennoble his subjects. He depicts the lower classes and their environs with the same high respect that earlier painters had accorded to mythological figures and regal subjects. It is in his love of everyday subject matter that Sloan's democratic and socialist principles shine through. His friend Henri put it best, observing that in Sloan's paintings of tenements, street scenes, and dusky saloons (10.41), one experiences the artist's "demand for the rights of man, and

his love of the people; his keen observation of the people's folly, his knowledge of their virtues. . . ."

Formally, many of Sloan's works, like Henri's, employ the broad, summarizing brushwork of Manet and the impressionists; the paint is applied with spontaneity and gusto. Yet unlike the French artists, Sloan uses dark and smoky colors in his city scenes. His palette reflects the actual colors of American big city life and the influence of Rembrandt, Daumier, and Courbet, the realist-humanist artists he so admired. Compositionally, like his forebear Degas, Sloan tends to show informal and asymmetrical scenes, actual "slices of life." While he bristled against the camera, which eventually put newspaper illustrators like himself out of work, Sloan, again like Degas, was probably influenced by photography's instantaneous images of city life. In *McSorley's Bar,* which he called a "favorite out of the way retreat for appreciative ale drinkers," he captures a fleeting second in the life of the bar. Having taken visual notes, like the good newspaper reporter he was, Sloan returned to his studio to record his vivid memories with painterly flourish. The result was the kind of rough-hewn painting conservative jurors of the New York Academy of Design tended to reject from their annual exhibition on the grounds of ugliness or indecency.

Determined to reach the larger public on their own terms, Sloan, Henri, and their friends originated the idea of a group show of their own, a North American first. In the best democratic tradition, Sloan and Henri stood for "the giving of an opportunity for greater freedom in exhibitions." It was unfair, they maintained, for the academies and their conservative juries to decide for the entire public which art was praiseworthy and which unacceptable. This modernist stance of artistic independence was the springboard for the independent New York City exhibitions of "the Eight" in 1908 and the New York Exhibition of Independent Artists in 1910.

Coordinated by the artists of the Henri circle, both shows represented aesthetic democracy in action. For the first time, artists of diverse styles, from realism to impressionism to post-impressionism, exhibited together in the same room. For one critic, accustomed to

the general unity of style in the New York Academy's exhibitions, the two-week show of "the Eight" was nothing less than pictorial anarchy. "When fairly within the Macbeth Galleries," he wrote, "you are appalled by the clashing dissonances, by the jangling and booming of eight differently tuned orchestras. . . ." In addition to decrying the show's stylistic diversity, critics and onlookers were disturbed by either the undignified subject matter or the artists' freewheeling techniques. Epithets like those hurled at Courbet, Manet, and the impressionists decades earlier were leveled at "the Eight." Maurice Prendergast's abstract translations of beach scenes, the most modern-looking paintings in the show by European standards, were satirized as "a jumble of riotous pigment . . . like an explosion in a color factory." Henri's vigorous, boldly stroked portraits were likened to "a collection of masks," and Sloan was denounced for the "vulgarity" of his subjects. But a substantial number of critics sided with "the Eight," one praising them as "so excellent a group" that their paintings "escaped the blight of imitation." And support came from the public as well. The Macbeth Galleries were packed with eager viewers from nine in the morning to six at night for the show's entire two-week run.

Buoyed by the success of the 1908 show, many of the same artists organized a major independent exhibition without juries and prizes in 1910. Excitement ran high in New York City, the rising capital of North American art. The academy's dominion over American art and taste was beginning to crumble. One newspaper headline read, "Rival Exhibition, Artists in Revolt Against Academy Verdicts." A sympathetic critic wrote that the independent exhibit would hopefully "make art history in New York as the Salon des Refusés [of 1863] did in Paris. . . ." In fact, it did. On opening night, one thousand people crammed inside the building. Another fifteen hundred outside struggled to get in. Police had to regulate the movements of the art exhibition visitors, a first in the city's history. The power of the academy had been broken. Henceforth "anarchic individualism," which today we call pluralism, would reign. The two independent shows had created a new cultural climate supportive of experimentation, and both realists

10.43 • EDWARD HOPPER. *Early Sunday Morning.* 1930. Oil on canvas. 35 × 60″. The Whitney Museum of American Art, New York. Purchase, with funds from Gertrude Vanderbilt Whitney.

Between Realism and Abstraction: Three American Originals. The Henri and Stieglitz circles and the Armory Show laid a strong foundation for the rapid growth of American art. At the same time, the United States was emerging as a leading world power. With growing confidence, many Americans were now eager to push forward toward cultural as well as political and economic greatness. Learning from Europe's masters but also building on indigenous traditions, some of the finest North American artists who emerged in the first half of the century—Hopper, O'Keeffe, Shahn, Lawrence, Woodruff, and Bearden—brought forth original syntheses of realism, expressionism, and formalist abstraction. Artists such as these were ready to reject the notion of American culture as provincial or "colonial," to break the tradition of looking to Europe for their models.

Edward Hopper (1882–1967), who had been educated both in the Henri circle and in Paris, emphasized the need for American independence from French art.

If an apprenticeship to a master has been necessary, I think we have served it. Any further relation of such a character can only mean humiliation to us. After all we are not French and never can be and any attempt to be so is to deny our inheritance and to try to impose upon ourselves a character that can be nothing but a veneer upon the surface.[12]

Without ever denying the importance of European art, Hopper believed in the value of an honest "native art" rooted in the rich soil of the American landscape and soul. Hopper's own stone-silent townscapes and cityscapes (10.43) reflect a sensitivity to a peculiarly Northeast American light, shape, texture, and subject matter. At the same time, his formal compositional sense would have pleased Degas and Cézanne, two of his favorite painters. But European influences notwithstanding, Hopper's paintings possess a distinctly American look and feel. This national flavor stems, in part, from the artist's choice of subjects. Hopper's favorite subject, Northeast American architecture, was already stamped, he noted, with "something native and distinct."

His aim was to bring out those distinctive qualities. He did so by conveying a personal interpretation of "my most intimate impressions of nature." It was a grave mistake, Hopper asserted, to go too far in the European modernist direction of "invention of arbitrary and stylized design" at the expense of the realistic look and feel of the scene, that which made it truly "American." In this sense, Hopper stood as a proud proponent of the realist tradition that had begun with Henri and "the Eight." Instead of striving for arbitrary abstract design, he affirmed, it was better to "attempt to grasp again the surprise and accidents of nature, and a more intimate and sympathetic study of its moods, together with a renewed wonder and humility on the part of such as are still capable of these basic reactions."

This is not to say that Hopper's realistic paintings are without their modernist side. A pronounced subjective element of personality always colors his work. For example, in comparison to Sloan's city scenes, which bustle with people and hum with social relationships, in part an expression of Sloan's own outgoing personality and "socialism," Hopper's urban places tend to architectural silence. Even when he includes a figure or two, the mood remains one of solitude. The person is isolated in his or her thoughts and feelings. The feeling of loneliness in Hopper's paintings may be, in large part, a reflection of the artist's own reclusive nature. He may not have consciously intended what he called "the loneliness thing," but it was definitely there, and he admitted it.

In *Early Sunday Morning,* Hopper combines his realist commitment with a modernist expressiveness and feeling for abstract design to create an intimate portrayal of Manhattan storefronts. The result is a masterpiece of international appeal that, at the same time, communicates "something native and distinct" about North America. In the early 1980s, the painting became a cultural icon. Used on the cover of telephone directories throughout the United States, it became part of the collective consciousness of millions of Americans. The stores are closed; the people in the upstairs apartments are asleep. The street is deserted, a favorite Hopper state of affairs. But with the

human beings removed, the buildings, flooded in early morning sunlight, come to life. Hopper's sympathy, his "wonder and humility" before the scene, animates the inanimate. The striped barber's pole and squat fire hydrant speak out as main characters. Areas of light and shade converse. Vibrant in the silence are Hopper's beloved "surprise[s] and accidents of nature": long morning shadows that streak across the pavement and building; sections of awnings that warm to the light while others recede into shade. Like musical variations on a theme, the large and small, vertical and horizontal rectangles of windows, doorways, buildings, and sky play off each other in a formalist "dynamic equilibrium." Here was painting with roots both in the New and Old Worlds but whose identity was uniquely North American. Here was "nature seen through a temperament," a realism as complex and modern as the individual who created it.

The art of Jacob Lawrence (born 1917) shows this same rich complexity. Personality, racial background, and indigenous African-American traditions conjoin to determine the subject matter and artistic style of this proud black man. Lawrence was a Depression era teenager in Harlem, the black cultural center of New York City and America. Like Hopper, he was committed to portraying meaningful native subject matter. In Lawrence's case, this meant the streets and tenements of the black ghetto as well as scenes from African-American history. A man of progressive humanist sentiments, Lawrence portrayed both the present life and past history of blacks with unflinching directness. He had important stories to tell about slavery and the struggle for freedom, the recent migration from the South, and the experience of daily life in the big cities of the North (**10.44**). Such an art of human concern aligned him with the powerful art movement of "social realism" that swept the United States during the bitter times of the thirties and early forties. His early paintings depicting ghetto poverty and oppression made him something of an urban biographer. He was a big city counterpart to the Farm Securities Administration painters, graphic artists, and photographers, artists such as Ben Shahn and Dorothea Lange, who documented

10.44 • JACOB LAWRENCE. *Tombstones.* 1942. Gouache on paper. 28¾ × 20½". The Whitney Museum of American Art, New York. Purchase.

black experience. Correlatively, Lawrence's interest in these two native art forms helped him to develop an indigenous, non-European artistic style: a kind of sophisticated North American "neo-primitivism."

A third stylistic influence, more subtle and indirect, was the "New Negro Movement," today known as "the Harlem Renaissance." In full swing in the twenties, the Harlem Renaissance saw a great flourishing of black consciousness ("the New Negro") accompanied by an emphasis on black cultural heritage ("Negritude"), African as well as American. Rising young black artists such as Lawrence and Romare Bearden (Appreciation 26) looked up to New Negro painters such as Aaron Douglas (1899–1979), whose grand-scale mural series, *Aspects of Negro Life* (10.45), dramatically told the story of black America, from African origins to the Depression. On the walls inside a Harlem public library for all to see, Douglas's mural was executed in stylized abstract forms and flat, hard-edged color that reflect both European modernist and African art influences. To be sure, Douglas had been inspired by both West African art and the African-influenced abstract paintings of modernists such as Picasso and Matisse. Lawrence's realistic art, with its two-dimensional patterning, flat areas of emotive color, and neo-primitive cubistic look, is the product of an extraordinary multicultural heritage, North American, European, and African.

In synthesizing cultures, Lawrence also managed a synthesis of modernism and realism. Paintings such as his *Cabinet Makers* of 1946 (10.46) are true "fusion art": a blend of social realism and formalist abstraction. The social content of *Cabinet Makers* resides in the five black artisans, skilled workers who measure, drill, and plane their boards with energy and confidence. They seem model workers thoroughly committed to making the best product for the public. A man who long believed that equal opportunity, integration, and hard work are the keys to black success in white America, the artist is also implying that the future of black Americans lies in education and constructive creative labor. From a formal standpoint, the overall design of the work was of paramount importance to Lawrence; he val-

the hard times of the "dust bowl" prairie (7.41–7.43).

But for all the social realism of Lawrence's subject matter, his formal style was never mimetic. His paintings shun optical imitation in favor of flat, abstract forms that tell true stories. These schematic, stylized forms seem to have arisen from Lawrence's immediate visual world: from the simplified shapes and bold colors of Negro folk art and American popular illustration. As the writer Jack Hobbs tells us, Lawrence "intentionally adopted some of the characteristics of folk art and comic strips in order to endow his own art with a greater power and directness" to comment on the

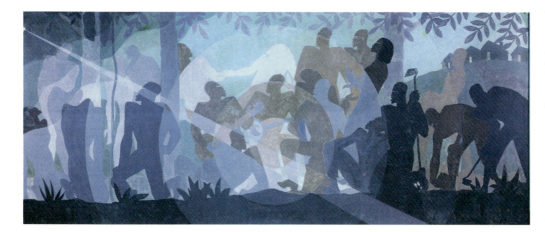

10.45 • AARON DOUGLAS. *Aspects of Negro Life: An Idyll of the Deep South.* 1934. Oil on canvas. 5′ × 11′ 7″. Schomburg Center for Research in Black Culture, The New York Public Library, Art and Artifacts Division. Gift of the artist.

10.46 • JACOB LAWRENCE. *Cabinet Makers.* 1946. Gouache with pencil underdrawing on paper. 21¾ × 30″. The Hirshhorn Museum and Sculpture Garden, Smithsonian Institution, Washington, D.C. Gift of Joseph H. Hirshhorn, 1966.

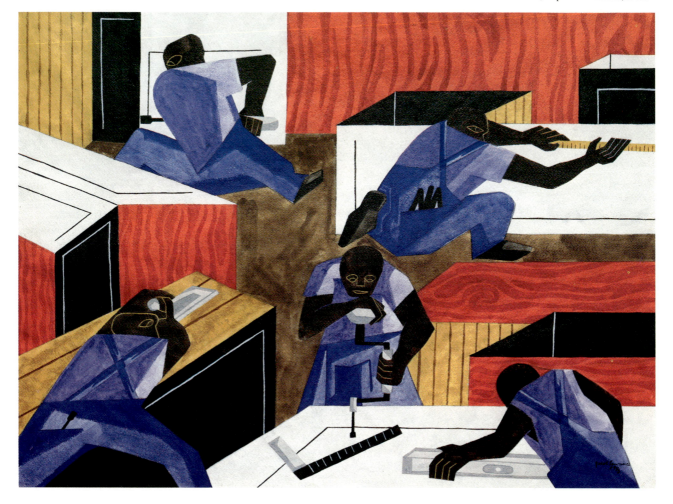

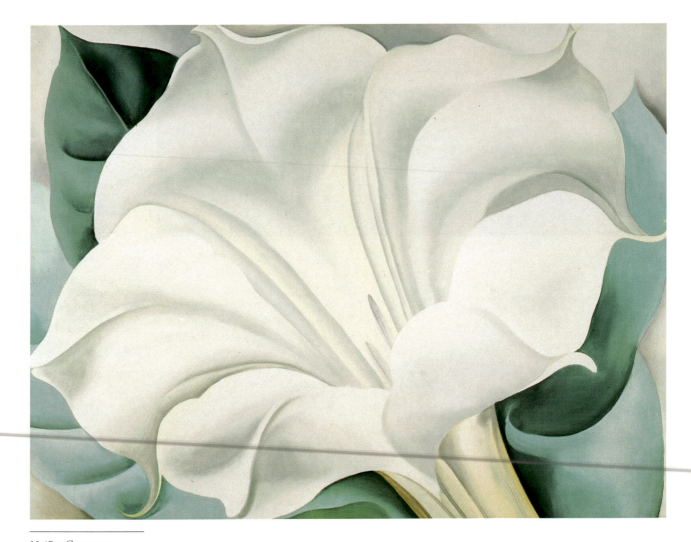

10.47 • GEORGIA
O'KEEFE. *The White
Trumpet Flower.* 1932. Oil
on canvas. 29¾ × 39¾".
The San Diego Museum of
Art. Gift of Mrs. Inez Grant
Parker in memory of Earle W.
Grant.

ued design not only for the sake of effective storytelling but also for its own sake. For Lawrence, the modernist beauty of significant form was not to be overlooked. Commenting on *Cabinet Makers,* the artist said, "The tools that MAN has developed over the centuries are, to me, most beautiful and exciting in their forms and shapes. In developing their forms in a painting, I try to arrange them in a dynamic and plastic composition." Formalistic and humanistic, North American, African-American, and European, Lawrence's art attests to the complexity and originality of realism in the twentieth century.

Another great American original and unsurpassed synthesizer of styles was Georgia O'Keeffe (1887–1986). Reared in rural Wisconsin and Virginia, she decided early to take responsibility for her own art education. A woman of strength and independence, O'Keeffe believed that she had to march to her own drummer. "School and things that painters have taught me . . . keep me from painting as I want to do." To depict the world as she saw it, she felt she had to originate a style of her own. This is not to say that O'Keeffe was unaware of the most advanced European and North American art of the day. A member from 1916 of the vanguard circle around the photographer Alfred Stieglitz, later to become his wife, O'Keeffe was exposed to the revolutionary innovations of Picasso, Matisse, Kandinsky, and the photographic avant-garde. Yet by that time her own sense of personal and artistic identity was so well developed that she absorbed cubist, expres-

sionist, and (later) surrealist influences and integrated them seamlessly into her distinctive style.

O'Keeffe's work covers a lot of territory. Her subject matter ranges from cityscapes to landscapes, from glittering skyscrapers to pastoral sunrises. Her focus extends from broad vistas of mountains, desert, and sky to intense close-ups of cow skulls and flowers (10.47), the latter possibly inspired by the still life close-ups of vanguard photographers. Formally, she moves fluidly between realism, semi-abstraction, and complete abstraction. At times the work stems from physical reality; at other times, from her imagination. On other occasions, it is a mixture of both (Appreciation 27). A sensibility of subtlety and strength unites all these variables. The art historian Lloyd Goodrich has succeeded in capturing some of the essential characteristics of O'Keeffe's sensibility and her richly varied and inclusive art.

> Absolute clarity marks her style; there is nothing vague about it. The element of mystery which does exist in some works is due not to obscurity but to their clear-cut but enigmatic images and forms. Her lucidity never becomes a mannerism; it is an innate characteristic of her personal vision. Edges are precise but not hard; they round the forms into depth. Her art has an essential refinement that involves no loss of strength; it is capable of both delicacy and power. There is often a degree of severity in her style. Everything is simplified to essentials; there are no unnecessary details. This simplification sometimes produces works of minimal forms and colors, but of maximum impact. Again there can be a profusion of elements, but always selective. Her art presents a rare combination of austerity and a deep sensuousness.[13]

For "all her wide range in content and artistic language," Goodrich concludes, "Georgia O'Keeffe's evolution has been marked by a fundamental consistency. She has been herself from the first."

From first to last, O'Keeffe was an American original. Like Hopper and Lawrence, her art asserted a "native" independence from Europe. Great modern art, realistic and abstract, was now being produced on North American soil. No longer did it slavishly look across the ocean for its models. And O'Keeffe, Lawrence, and Hopper were but three of the many who had liberated their art from European domination. North American art, however, would not achieve full recognition until the second half of the century. By that time, the locus of cultural as well as political and economic dominance was shifting. Fleeing the nazis, many of Europe's most important artists (10.36), designers, and architects had come to the New World. By the late 1940s, New York City was beginning to wrest from Paris the mantle of world cultural dominance, and a group of North American artists, the abstract expressionists, had launched the first internationally prominent art movement to originate outside the European continent. The former cultural colony was on its way to becoming the ruling power.

APPRECIATION 26

Romare Bearden. *Patchwork Quilt.*

JOANNE GABBIN

Romare Bearden will be remembered as an American artist who immortalized the rich cultural heritage and the jubilant and painful past of black people. Born in 1914, Romare Bearden grew up in Harlem in the midst of the Harlem Renaissance. The sights, sounds, and colors of this era later emerged in his paintings. Jazz musicians Duke Ellington, Fats Waller, Earl Hines, Count Basie, Ella Fitzgerald, and Cab Calloway strongly influenced the stylistic rhythms and improvisation in several of his works, which are visual representations of remembered performances. In his collages, he distilled the writings of contemporary poets and novelists—Garcia Lorca, T. S. Eliot, Hemingway, Langston Hughes, Richard Wright, and Ralph Ellison—in response to their humanistic vision. Childhood sojourns to Charlotte, North Carolina, and connections with the people of surrounding Mecklenburg County firmly rooted him in a culture ripe for revelation. There he learned the rituals and mysteries that informed and transformed southern black culture.

By 1961, Bearden began to experiment with collage, which became his signature medium. His method reflected the catholicity and spirited originality of a man who studied

Joanne Gabbin is a professor of English and the director of the Honors Program at James Madison University, Harrisonburg, Virginia. She is a scholar of African-American literature and is the author of Sterling A. Brown: Building the Black Aesthetic Tradition.

with the German-born George Grosz [10.31] at New York's Art Students League and formed associations with the Rumanian sculptor Constantin Brancusi and Frenchman Georges Braque [10.16] while he studied at the Sorbonne, the University of Paris. Eclectic in his study, he explored French impressionism, traditional Chinese painting, and seventeenth-century Dutch genre painting, from which he learned about the representation of interior space. He studied African tribal sculpture, from which he learned the freedom to conceptualize his figures as abstract forms. Bearden was also in turn influenced by cubism, surrealism, and the social realism of contemporary Mexican painters such as Diego Rivera [1.3]. The catholicity of his artistic influences was echoed in the range of materials he used in his collages. These included photostated pictures, cutouts, photographs, pieces of cloth, and anything else that could enhance the reality of his work. In *Patchwork Quilt,* the quilt is actually fashioned of strips of fabric to create the textural reality. The woman's body is composed of paper cutouts adorned by cloth remnants.

Visually, *Patchwork Quilt* is a superb study of structure, what Bearden calls the "anatomy of space." His figure of a black woman dominates the space, rivaled only to a degree by the strength of the patches of cloth draped over a couch that bears her weight. His technique draws us in. His use of flat, opaque paper, his way of giving the bare outline of the form, and his sparseness of detail make demands on us as viewers. By distilling the

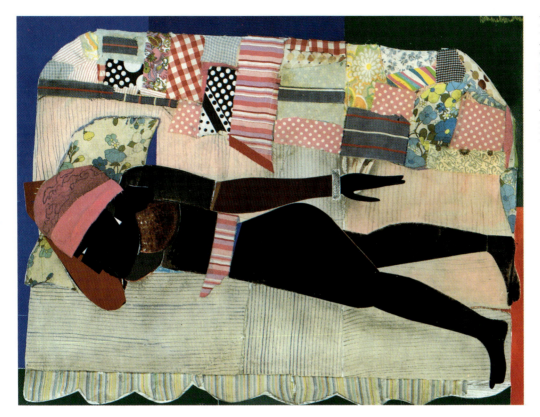

ROMARE BEARDEN.
Patchwork Quilt. 1970.
Cut and pasted cloth and
paper with synthetic
polymer paint on
composition board. 35¾
× 47⅞". Collection,
The Museum of Modern Art,
New York. Blanchette
Rockefeller Fund.

very essence of the woman, he demands that we fill in the details. We add texture, we add complexity, we make her human by our prolonged interest.

Patchwork Quilt is strikingly simple visually yet revelatory of many human undercurrents and nuances. The variegated colors and textures of the quilt bespeak the familiarity of the heavy quilt stored in the closet, roughly patched together by a grandmother's arthritic fingers and meant "for comfort and not for show." Against the backdrop of the quilt is the woman, strangely regal and expectant. This figure is emphatically abstract, yet she has a complexity that defies the static nature of her outline. She represents continuity. Her figure dominates the collage with bold darkness. Shades of black, brown, tan, and red suggest her diverse heritage and her beauty. She is

Africa, rooted in the fertile soil of Egypt and Ethiopia, her feet replicating those that graced the burial vaults of the great pyramids. Her torso is stiff and shapely like that of a Ghanaian fertility doll. She is Antilles with her breast ripe to suckle generations of slaves who would endure ocean passage, slavery, and repressive conditions. She is the intense, blues-tinged elegance of America, bowed yet unbent. Her face resembles an African mask in its angularity, softened only by the rose bandanna that circles her head. She is in the past and the present.

The collage says a great deal to me about survival, continuity, dignity, and diversity. In it, as in much of Bearden's work, the artist reaches for the heroic that resides even in the ordinary and the uncommon elegance that emerges from the familiar. ∎

Georgia O'Keeffe. *Cow's Skull with Calico Roses.*

BARBARA WOLANIN

Georgia O'Keeffe created a compelling image from a surprising combination of objects: an animal skull and two fabric roses. The composition is symmetrical, with the crack down the skull corresponding to the center of the canvas. The horns, which almost touch the edges, create an opposing horizontal line. The vertical axis is accentuated by the dark crevice that runs behind the skull and by two parallel wavy vertical edges to the right. Part of the skull is broken, revealing the jagged interior forms. The angular contours of the skull contrast with the rounded petals of the roses, which are also shown frontally. The stem on the lower flower points to the right, opposing the placement of the upper flower and the movement of the dark crevice to the left and thus creating a balance of forces.

The palette is limited to neutral shades, ranging from black to white, with subtle variations. The skull is creamy; the calico roses are silvery gray against the black stripe. The warm golden tone inside the skull is a focal point. There is some shading to define contours but no real illusion of light falling on the forms, since there are no cast shadows. The space and the gray shapes in the background are ambiguous. The objects seem frozen in time and space. They are smoothly painted, and the colors are carefully blended. One imagines the artist painting slowly, with deep concentration, almost as if in a trance.

Barbara Wolanin is an art historian whose area of expertise is early twentieth-century American modernism. She lives and works in Washington, D.C.

The objects are enlarged from life size, compelling the viewer to concentrate on their forms. This painting, with its almost cruciform design, attracts us almost like a religious icon; it is something on which to meditate. O'Keeffe often presented objects this way. The main object is presented frontally and centrally, often with a crevice or passageway running vertically through the center of the composition, suggesting that something lies beyond the facade.

Although the artist denied the morbid implications of the skull and flowers, through them she created a personal iconography. Her choice of objects was directly related to the summers she spent in New Mexico, starting in 1929, two years before she created this painting. She would bring back barrels of bones to New York to paint. She loved the colors and shapes of the desert, and to her, the bones were more beautiful and strangely more alive than the animals had been. They offered her endless possibilities of forms to paint. One day, she happened to put the cloth flowers in her studio, with the skull.

Many of the important influences on O'Keeffe can be traced in this painting. Her early study with Arthur Wesley Dow taught her to appreciate Japanese design, to experiment with "filling space in a beautiful way," and to balance light and dark. O'Keeffe was an important member of the circle of artists, writers, and photographers around Alfred Stieglitz, who first showed her work at his 291 Gallery in 1917. They later married, and he showed her work every year at his galleries. Several of his photographer friends created close-up views of flowers or fruit that may have

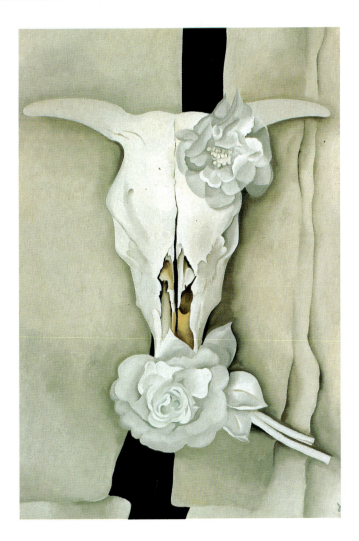

unconsciously molded her vision. Stieglitz championed a number of painters who, like O'Keeffe, created abstract statements of their experience of nature. When O'Keeffe first showed paintings of skulls, critics called her a surrealist, despite her lack of connection with the official surrealist movement. For her own part, she saw herself and her paintings as unique.

The spareness of the color and imagery in *Cow's Skull with Calico Roses* reflects O'Keeffe's personality and her almost monastic way of living. She usually dressed in black and lived in rooms with bare white or gray walls, often in solitude. After Stieglitz's death in 1946, she lived in the stark landscape of New Mexico, which inspired her art until her own death at ninety-nine in 1986. O'Keeffe was a strong-willed person who had clear ideas about her art and who disliked being asked to explain her paintings with words. Her intensity of concentration on her art is reflected in this painting. She would become so absorbed in the subjects she painted that her painting process seemed to become a mystical or spiritual experience. Through her art, she was able to convey a sense of the spiritual in nature to her viewers. ∎

Chapter 11

The Visual Arts in the Second Half of the Twentieth Century

FROM PARIS TO NEW YORK: A TALE OF TWO CITIES

With the decimation of continental Europe by the Second World War and the rise of the United States to the position of world leader, the center of the modern art activity began to shift to North America. Having risen to the forefront militarily, politically, and economically, the United States now proceeded to do the same on the cultural front. National wealth and power, coupled with quality artistic production and persuasive art writing, soon resulted in American cultural dominance. For vanguard artists, New York City steadily took on the role previously played by Paris. The most nationalistic of the American vanguard critics, Clement Greenberg (born 1909), declared in 1948 that the quality of American art had risen so dramatically in the mid-forties as to overtake the modernist art of Europe, which he judged to be in grievous decline. The first upstart voice to declare American superiority, Greenberg asserted that "with the emergence of new talents so full of energy and

content . . . the conclusion forces itself, much to our own surprise, that the main premises of Western art have at last migrated to the United States, along with the center of gravity of industrial production and political power."

With increasing numbers of gallery and museum exhibitions, magazine and newspaper articles devoted to homegrown modern art, New York City soon became the capital of the international art world. Spurred by polemical critics, wealthy collectors, and enterprising dealers centered in the New York City area, the first internationally prominent art movements to originate outside of Europe inscribed themselves in the Western art history books. Rising to prominence in the late 1940s and early 1950s, the so-called **abstract expressionists** of the "New York School" made a name for themselves around the world. Even those in the European vanguard acknowledged the strength of the new American art: so "powerful, serious, and disturbing," as one young artist in Paris put it. "American artists," wrote the New York–based art historian Meyer Schapiro, "are very much aware of a

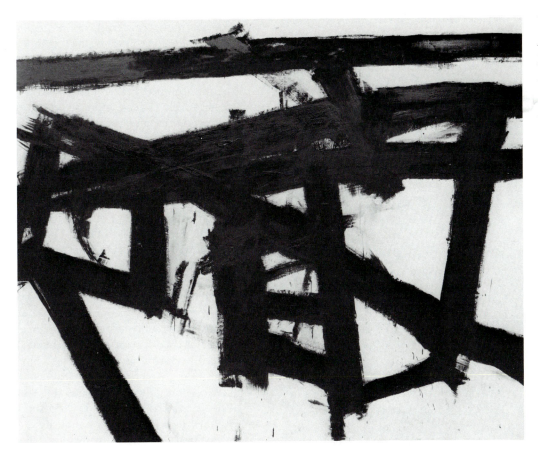

11.1 • FRANZ KLINE. *Mahoning.* 1956. Oil on canvas. 6′ 8″ × 8′ 4″. The Whitney Museum of American Art, New York. Purchased with funds from the Friends of the Whitney Museum of American Art.

change in atmosphere since the war: they feel more self-reliant and often say that the center of art has shifted from Paris to New York, not simply because New York has become the chief art market for modern art, but because they believe that the newest ideas and energies are there and that America shows the way."

To be sure, the artistic production of the older masters of the "School of Paris" did not die with the war. Giants such as Picasso, Braque, Giacometti, and Matisse continued to produce masterpieces in their studios in France. But the issue, as ever, for the modernist vanguard was not the past but the present and, by implication, the future. The issue in vanguard circles was not where the best old art came from but where the best new art was coming from. The younger School of Paris modernists, the most militant Americans argued, were not creating art of comparable quality to that of their New York School counterparts. One American critic went so far as to claim that the vitality of the French avant-garde had "dried up." It wasn't that the younger French artists lacked technical virtuosity or support from the art world, wrote New York art critic Thomas Hess (1920–1978). And it wasn't that the younger French modernists lacked talent or knowledge. What the art of the post-war School of Paris lacked, Hess asserted, was moral force and aesthetic urgency, what today might be called "soul."

In painting, this moral force and aesthetic urgency was evidenced in works that tended to be big and bold, virile and violent. The French art, in contrast, featured a different spirit and style: more subtle, delicate, and refined. Compare a large black-and-white painting (11.1) by the American Franz Kline (1910–1962) to a large black-and-white abstraction (11.2) by the Frenchman Pierre Soulages (born 1919). Painting such as Kline's ("American-type" painting, to use critic Clement Greenberg's phrase) was perceived by its

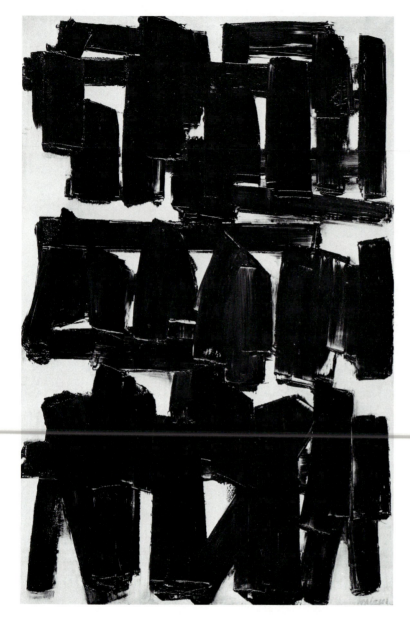

11.2 • PIERRE SOULAGES. *Painting, November 20, 1956.* 1956. Oil on canvas. 6′ 4¾″ × 4′ 3⅛″. Collection, The Solomon R. Guggenheim Museum, New York.

supporters as more "powerful," more "vigorous," "rougher and more brutal" than its French counterparts. It took more "risks," was more "adventurous" and "original." In comparison, the art of the French modernists was judged negatively to have more stylistic flair but less existential and pictorial punch. In 1947, Greenberg compared the work of Jackson Pollock (1912–1956), a rising young American painter, to that of Jean Dubuffet (1901–1985), a vanguard counterpart among the younger French artists. Greenberg affirmed his preference for Pollock's tougher, more brutal "American" art (11.3). The critic judged Dubuffet's art (11.4) to be sophisticated, skillfully done, charming in a childlike way; in sum, a pleasing "package." But, as painting, it simply didn't have as much to say, formally or expressively, as the American's art. Pollock's painting, with its "astounding force" and ability "to work with riskier elements," was "less conservative" and "completer." Similarly, the young American vanguard painter Robert Motherwell (born 1915) described the art of his French counterparts as "too suave and skillfully done," tradition-bound objects that were too "beautifully made" and "finished." These Americans judged French modernism to be more tame, style conscious, and conservative than its raw, hard-hitting, risk-taking American counterpart. In retrospect, we see in such judgments two different aesthetic value systems at work, a twentieth-century replay of such earlier cultural clashes as those between Italian Renaissance (6.17) and German Gothic art (6.18) and nineteenth-century classic (2.5) and romantic art (2.6).

By the 1950s, American vanguard critics and artists clearly believed that the best new art, the most aesthetically innovative and existentially expressive, was being produced in the United States. But how did they explain this rapid rise of the New York School and sudden decline of the School of Paris? After all, North America had long been considered a cultural "colony," a mere backwater in comparison to the shining modernity of Parisian culture. What contextual factors promoted New York and America's momentous takeover of the leadership of vanguard painting and sculpture? One of the more provocative explanations was put forward by critic Thomas

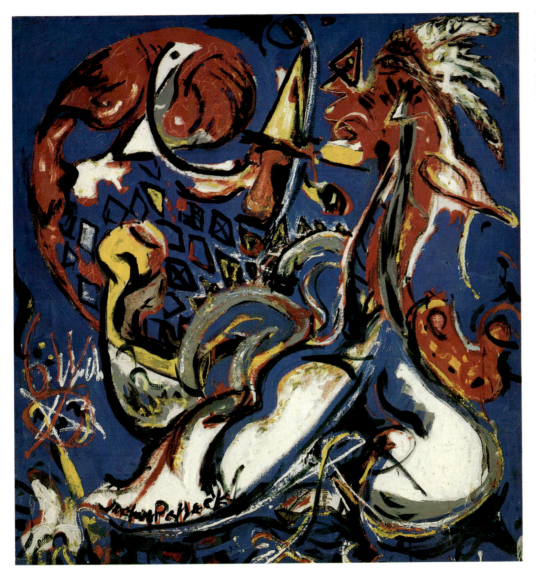

11.3 • JACKSON POLLOCK. *Moon Woman Cuts the Circle.* 1943. Oil on canvas. 42 × 40″. Musée National d'Art Moderne, Paris. Gift of Frank Lloyd.

Hess, editor of the influential magazine, *ARTnews*, which passionately supported vanguard American art during the crucial period of the 1950s. In a controversial essay entitled "A Tale of Two Cities," Hess proposed a two-part hypothesis to explain the transfer of cultural power. The first part of the hypothesis went like this: The younger French modernists had been co-opted by the establishment. They had, in effect, surrendered their independence and foresaken their vanguard roots. They were no longer free and independent rebels like their staunch forebears: Delacroix, Courbet, Manet, the impressionists, post-impressionists, fauvists, and cubists. The younger mem-

bers of the French avant-garde had been won over by the Paris art establishment. They had become part of the status quo. (By the 1960s, Hess and others would lament that many younger American artists were likewise caving in to the art establishment.)

The mark of the modernist avant-garde, Hess insisted, had always been its independence. The naturalists, realists, impressionists, and post-impressionists of the nineteenth century had all proudly called themselves independents. They had exhibited in their own independent shows. Independence had meant freedom from the influence of the French Academy, the Salon jurors, the opinions of the

the liberal intelligentsia argued that abstract expressionist painting exemplified the American democratic tradition at its best: freedom of thought and expression in action, and this in an age of totalitarianism and social conformity. With liberal politicians, intellectuals, museum directors, and corporate heads—the Rockefellers, for example, were founders and board members of New York's tremendously influential Museum of Modern Art—behind them, the New York School eventually carried the day and were embraced by the international world of high culture. What a bubbling caldron of response Pollock and his friends had stirred up! Just consider the highly varied appraisals that one of Pollock's most famous drip paintings, *Number 1, 1948*, elicited (Appreciation 28).

Tragically, Pollock died young. His life ended in what may well have been a suicidal automobile accident. The year was 1956. He was forty-four years old. His many demons, among them depression, alcoholism, and the fear that he had little more to say as an artist, had come to haunt and perhaps overwhelm him. In a passage that might serve as an epitaph, the critic-historian Sam Hunter wrote:

> Pollock's sudden passing only served to make him more of a heroic figure for a younger generation of artists, and dramatized his impressive role as an innovator.
> . . . For fellow artists, his committed search for pictorial liberties and his aggressive spirit of revolt made Pollock into something of a creative demiurge. He supplied perhaps the conclusive example in his generation of painting as a *total act*. His expressive freedom, implemented by the spatializing powers of his brushwork and of his later cursive "writing" in paint, helped give the contemporary American artist a new *modus operandi*: it identified passion with an abstract means and gave these means the power to express directly certain phases of human consciousness.[4]

Fellow painter Willem de Kooning (born 1904) had once praised Pollock for "breaking the ice" to the freest art ever created. But if

11.8 • WILLEM DE KOONING. *Dark Pond*. 1946. Oil on composition board. 46½ × 55½". Courtesy of Frederick R. Weisman Art Foundation, Los Angeles.

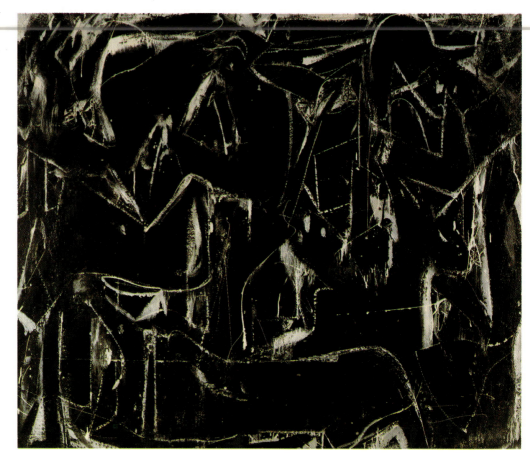

Pollock was the most spontaneous, de Kooning was a close second. Arriving in the United States in 1926, this academically trained Dutchman, who could paint a realistic still life with ease, turned out to be one of the wildest of "the wild ones": a freewheeling gesture painter of promethean energy. His black-and-white *Dark Pond* (11.8), done in 1946, reveals much about the action painter and his art.

The picture surface or ground of *Dark Pond* is entirely black with white marks, dots, and lines of differing length and thickness. Almost every white line interconnects in some way to form an irregular shape—plus a few geometric ones—against the black ground. Although de Kooning has, at the picture's upper edge, sketchily painted in several of these shapes with white, all of the others remain white outlines against the black ground. Shading is not attempted, and a flat, friezelike effect is produced—figure-ground distinctions are blurred—although one might perceive the white markings to be up against or slightly raised above the black ground. Emphasized more or less equally, these many varied shapes interweave to create an "all-over" effect with no single focal point.

These same formal qualities reveal the artist's fiery way of putting paint on canvas. De Kooning's line is intense, highly charged, and emotional, much like the pulsating, electrical lines of a rock guitarist. His lines are not the precise contours of a classicist but the passionate outpourings of a romantic. The artist is powerfully involved in the actual physical process of creation. One feels the speed, force, and gesture of each brushstroke. Every line, shape, and mark is infused with de Kooning's manic excitement, his urgent desire to paint, to get it all down and said.

One can envision de Kooning struggling, wrestling with the canvas, stepping back, looking with fixed concentration at the evolving work, making sure all is right, in place. Setting passionately back to work, painting over lines and shapes, he ceaselessly destroys in order to create an image of ever greater vitality. He paints boldly on until the painting finally seems to have a life of its own.

Like Pollock in his range, de Kooning did not adhere to a consistent form and content. Both artists moved fluidly between complete abstraction and full-scale figuration. There are

relatively small de Kooning pantings in spare black and white, such as *Dark Pond,* and huge canvases, abstract or figurative, with immense swaths of singing color. After the series of black-and-white paintings of 1946–1951, which included *Dark Pond,* the expressionistic *Women* series burst forth. Best known for their presentation of monstrous, distorted women of colossal size, these paintings showed that abstract expressionism was not closed to figurative representation. Following the *Women* series, de Kooning returned to seemingly nonfigurative abstractions, such as *Gotham News* (11.9) and *Easter Monday.* But these abstractions, like many of the artist's works, maintained relations to the outside world. They were named for particular places or things. *Gotham News,* for example, incorporates pages torn from a New York City ("Gotham") newspaper. Almost seamlessly integrated into the painting, these torn pages appear as ragged white shapes along the picture's top and lower left edges. De Kooning was strongly affected by his surroundings, and *Gotham News* illustrates how the real world indirectly entered his nonrepresentational work. Such "crowded cityscapes of the mid-fifties," Harold Rosenberg observes, "belong, as their titles indicate, to news and the calendar, to the flow of events in time, rather than to [actual] objects situated in space." That is, the paintings are connected to the artist's day-to-day experience of New York City, his general "abstract" feelings about urban life, and not to any specific object, event, or place. "The compressed composition," Rosenberg writes, "thick, ragged edges, gritty surfaces, and uncertain, nondescript colors of *Gotham News* and *Easter Monday* are siphoned from de Kooning's grim years in his Fourth Avenue and East Tenth Street lofts, from the decaying doors of the buildings, the rubbish-piled areaways, the Bowery cafeteria, the drunks on the stoops."

Confirming the effect of place on de Kooning's more abstract works, Rosenberg notes that when the artist moved from New York City to "the Springs" in rural eastern Long Island, "his compositions open out as if with a sigh into lyrical panoramas keyed to drives in the countryside." Thomas Hess, another de Kooning expert, agrees, observing that by the 1960s the artist's colors and abstract imagery—as, for example, in his paintings, *Rosy-*

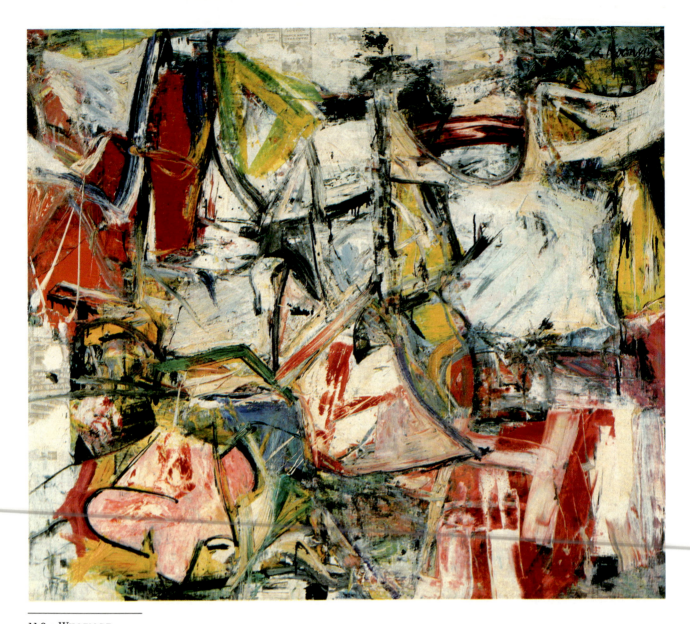

Fingered Dawn at Louse Point and *Pastorale*—
bear the growing imprint of his surrounding
environment: "the summer Long Island coun-
try: very flat and sunny—green grass, yellow
beach, green water, blue sky, powdery brown
earth." For all the apparent abstraction of his
nonrepresentational paintings, the content of
the outer world—city, countryside, highway
drives, women—almost always makes itself
felt, even if, in the artist's own words, such
content is but "a glimpse of something, an
encounter like a flash."

Abstract Expressionist Color Field Painting:
Rothko and Newman.
By the early 1950s it
had become clear that there were not one but
two types of abstract expressionism (and their
variations). Art historian Meyer Schapiro

quickly detected and wrote about these con-
trasting tendencies. After identifying the ac-
tion painting of Pollock and de Kooning as
"an art of impulse and chance," Schapiro de-
scribed the "opposite approach." He saw
this trend in the paintings (11.10) of Mark
Rothko (1903–1970), but the tendency ap-
plied equally to the work of Barnett Newman
(1905–1970) and their mutual friend Clyf-
ford Still (1904–1980) (2.13).

The year was 1956. Schapiro wrote that
Rothko

. . . builds large canvases of a few big areas of
colour in solemn contrast; his bands or rectan-
gles are finely softened at the edges and have the
air of filmy spectres, or after-effects of colour;
generally three or four tones make up the scheme
of the whole, so that beside the restless com-

plexity of Pollock or de Kooning, Rothko's painting seems inert and bare. Each seeks an absolute in which the receptive viewer can lose himself, the one in compulsive movement, the other in an all-pervading, as if internalised, sensation of a dominant colour.

. . . And possessing an extraordinary tangibility and force, often being so large that it covers the space of a wall and therefore competing boldly with the environment, the canvas can command our attention fully like monumental painting in the past.[5]

Particularly drawn to the Rothko-Newman-Still stream of abstract expressionism, the formalist critic Greenberg reserved his highest praise for its accomplishments. Here was painting that for Greenberg truly pushed beyond the bounds of French cubism, painting that made the next essential leap forward in the historical march of artistic styles. Here, Greenberg exclaimed, was painting that moved beyond all of cubism's by now old-fashioned naturalistic tendencies, for example, its figurative shapes (abstractions of bottles, guitars, and the like) and figure-ground distinctions (foreground objects that stand out from shallow backgrounds). Greenberg wrote in delight that "a new kind of flatness, one that breathes and pulsates"—one that transcends the bounds of cubism—inhabits "the darkened, value-muffling warmth of color of Newman, Rothko, and Still." In addition, here was painting that seemed to transcend the category of easel painting itself. Featuring enormous areas of color, these works functioned more like environments or fields than pictures within confining frames (easel paintings). "Broken by relatively few incidents of drawing or design," Greenberg wrote, "their surfaces exhale color with an enveloping effect that is enhanced by size itself. One reacts to an environment as much as to a picture hung on a wall." Such works, the critic continued, destroy the "Cubist, and immemorial, notion and feeling of the picture edge as a confine. . . ." and "have to be called, finally, 'fields.'" Soon **color field painting** became the name most frequently associated with this general approach.

Relative to method and intention, gesture and color field painting have their differences but also certain similarities. In color field painting, immediacy of gesture was replaced

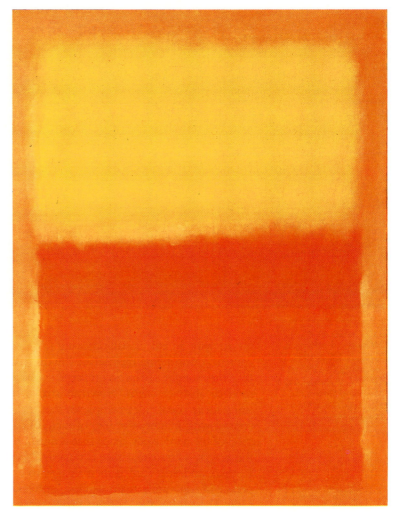

11.10 • MARK ROTHKO. *Orange and Yellow.* 1956. Oil on canvas. 7' 7" × 5' 11". The Albright-Knox Art Gallery, Buffalo, N.Y. Gift of Seymour H. Knox, 1956.

by a painting process that was relatively slow-moving, but nonetheless a kind of intuitive "action." In this process, enormous color areas were brought together in elemental encounters. Improvisational fervor was banished in favor of impassioned meditation. But, in the end, each work was considered successful only if it directly expressed the individual artist's most profound feelings. A high moral seriousness characterized the feeling tone of all abstract expressionist art.

So great was the moral seriousness of the color field artists, and so elevated the visions of Rothko, Newman, and Still, that they came to be recognized as the "theological" side of the abstract expressionist movement. This religious connotation is, in fact, appropriate for these men and their work. Each tried to infuse

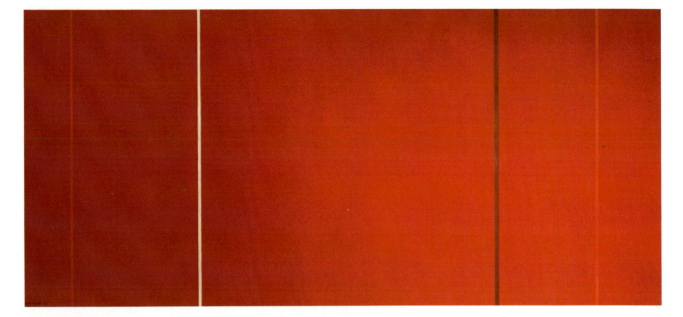

11.11 • BARNETT NEWMAN. *Vir Heroicus Sublimis.* 1950–1951. Oil on canvas. 7′ 11⅜″ × 17′ 9¼″. Collection, The Museum of Modern Art, New York. Gift of Mr. and Mrs. Ben Heller.

his art with an emotionally moving spiritual content. Considering themselves "myth-makers," they sought to express universal truths in modern abstract terms. Newman strove to bring forth visual "idea-complexes that make contact with mystery—of life, of men, of nature, of the hard, black chaos that is death, or the grayer, softer chaos that is tragedy." He, Rothko, and Still wanted their images to express and communicate on a grand, universal scale. Their form, the shape of their content, had to be sublime, tragic, and timeless. Not surprisingly, their paintings became gigantic, rejecting any reference to the everyday world in favor of vast spaces and elemental colors (11.11). Articulating the three men's intentions, Newman spoke of "reasserting man's natural desire for the exalted, for a concern with our relationship to the absolute emotions." The theologically oriented titles of many of Newman's works, drawn from the Old and New Testaments and Greek mythology, explicitly confirm these goals. Rothko protested that his art was not about formal innovation but spiritual content.

> I am not interested in relationships of color or form. . . . I am interested only in expressing the basic human emotions—tragedy, ecstasy, doom, and so on—and the fact that lots of people break down and cry when confronted with my pictures show that I *communicate* with those basic human emotions. The people who weep before my pictures are having the same religious experience I had when I painted them. And if you, as you say, are moved only by their color relationships, then you miss the point![6]

Such spiritual content obviously communicated itself to critic-historian Sam Hunter, who wrote that the art of Rothko, Newman, and Still seeks a priestly style "that stands above fatality, chance, and the laws of the world: a more controlled, starkly simplified, and stable art, exempt from the contingent and the accidental."

> Playing on resonant color sensations, which induce associations with symbolist color reveries, these artists seem to wish to make contact with a transcendental reality, a sphere of Otherness beyond the self. Indeed, the painting even threatens to become an instrument of occult knowledge, or at least an instrument of revelation. [Their art] . . . presents a single magnified sensation, and an undifferentiated continuum, suggesting the unity of Being. Matter is refined into a luminous suspension which becomes a sign of some inner harmony; the painting defines itself as a phase in the effort to cultivate a permanent openness of the spirit to mystery. Exalted through splendid color, the senses develop strange powers and mysterious antennae which reach beyond the self into the regions of the Ideal.[7]

Confirming Hunter's response, two private patrons were so impressed by the spiritual

power of Rothko's and Newman's art that they financed the building of a house of worship, currently a nondenominational chapel at Rice University in Houston, Texas, in which the two men's works are objects of religious contemplation. For the interior walls of the chapel, Rothko created a series of darkly mysterious monochromatic paintings (11.12), enormous in size. Before them, individuals of diverse faiths, Christian, Jewish, Zen Buddhist, Islamic, have come to meditate or pray. Newman's contribution to the "Rothko Chapel" was a large metal outdoor sculpture. Twenty-six feet high, his *Broken Obelisk* (11.13) is a pillar balanced on the point of a pyramid. These heaven-ascending abstract forms are fertile with religious symbolism. According to one common interpretation, the obelisk, broken at its crest, represents imper-

11.13 • BARNETT NEWMAN. *Broken Obelisk.* 1963–1967. Height, 26'. Cor-Ten steel. The Rothko Chapel, Houston.

11.12 • MARK ROTHKO. North, northeast, and east wall paintings from the Rothko Chapel. 1961–1965. Oil on canvas. The Rothko Chapel, Houston.

fect humankind standing erect and striving upward for spiritual completion. Of his *Broken Obelisk,* Newman wrote, "it is concerned with life and I hope I have transformed its tragic content into a glimpse of the sublime."

This is pretty heady stuff, the sublime, tragic, and transcendental. A puzzled first-time viewer might respond, "Aren't the artists and critics reading a bit too much into these spare, simple works? Spiritual intentions aside, all I see in Newman's pieces are simple geometric shapes, whereas Rothko's works appear to be no more than fuzzy bands of color floating in colored space." Relative to first encounters with difficult twentieth-century art, whether by Picasso, Oppenheim, Pollock, Rothko, or Newman, even art critics, historians, and educators sometimes have to admit that their initial responses are far from fully appreciative. Some are puzzled; others are exasperated. Inevitably, much of our century's art is going to take a lot of looking, thinking, and studying before it is understood and appreciated. And even then, not all educated viewers will appreciate all works of modern art equally. While this writer, after a long "getting-acquainted" period, has come to find Rothko's paintings very moving, certain thoughtful critics, such as John Canaday, formerly of the *New York Times,* are stirred very little. Responses to twentieth-century painting and sculpture will naturally be as individualistic and varied as the art itself.

Abstract Expressionist Sculpture: The Art of David Smith. Although it is possible to speak of the New York School of abstract expressionist painting, it is more difficult to identify a New York School of abstract expressionist sculpture. Yet certain sculptors did share strong affinities, in background, influences, methods, and intentions, with their painter counterparts. Some, such as David Smith (1906–1965), even started out as painters. Like the abstract expressionist painters with whom he was friendly, Smith was initially influenced by the major European art movements of the day, cubism, constructivism, and surrealism. A 1945 work, fittingly titled *Reliquary House,* is a miniature surrealist world: an open, houselike structure whose shelves or floors contain voluptuous forms that suggest childhood memories and adult sexual fantasies. True to its surrealist lineage, this reliquary sculpture by Smith is somewhat reminiscent of Giacometti's *Palace at 4 A.M.* (10.37). Like the psychologically motivated work of Pollock (11.3) and other New York School painters during this same period, much of David Smith's early work might be called abstract surrealism. But Smith was not to be tied to any single movement, style, or subject matter. In the spirit of Pollock's statement, "Every good artist paints what he is," Smith bent all styles and subjects to his own individualistic vision, creating a diversity of works as wide-ranging as his sensibility. Over three decades, his subject matter and sources of inspiration stretched from surrealist fantasy to political protest to landscapes and the shapes of geometry. His style ranged from linear "drawings in space" composed of thin scrap metal rods, shafts, and fragments (11.14) to dynamic arrangements of large geometric volumes: stainless steel cubes, cylinders, and slabs (11.15).

Reading Smith's own words, one senses his filial connection to the New York School abstract expressionists. We sense this connection in his attitude toward art as total self-expression and self-discovery, and in his commitment to an improvisational method of creating art. This commentary by Smith reminds one of Pollock:

> When I begin a sculpture I am not always sure how it is going to end.
> . . . If I have a strong feeling about its start, I do not need to know its end, the battle for solution is the most important. . . . Sometimes when I start a sculpture, I begin with only a realized part, the rest is travel to be unfolded much in the order of a dream.[8]

For Smith, preconception in sculpture played little part. He rarely used "previously conceived drawings" and was totally opposed to "preconceived laws or ideals." His sculpture grew organically from the flow of his changing identity and the evolving "stream" of his own sculptures, past, present, and projected. In other words, his work arose "in process" or "in action." The sculptor noted that he often started with a single part and let the improvisational process take over from there. "When I work, there is no consciousness of ideals—but intuition and impulse." "The truly creative

11.14 • DAVID SMITH. *Hudson River Landscape.* 1951. Welded steel. 4′ 1½″ × 6′ 3″ × 1′ 4¾″. The Whitney Museum of American Art, New York. Purchase.

artist," Smith stated, "is projecting towards what he has not seen, and can only take the company of his identity." In contemporary work "force, power, ecstasy, structure, intuitive accident, statements of action dominated the object." His way of working strongly related to the action painting of Pollock and Smith's good friend de Kooning. "The adventure is alone," Smith relates, "and the process itself becomes actuality." The creative artist, in his fertile loneliness, brings forth a truthful image that expresses himself and his creativity. "His act in art," wrote Smith, "is an act of personal conviction and identity. If there is a truth in art it is his own truth." Ultimately, the artist is the main subject of the work.

The process by which Smith's *Hudson River Landscape* (11.14) came into being reveals the deeply abstract expressionist nature of his work. Improvised action, the imaginative manipulation of accident and chance, the employment of surrealist-based "free association"—the unconscious and conscious minds in open interplay—are all abundantly evident. *Hudson River Landscape,* Smith said, "started from drawings made on a train between Albany and Poughkeepsie, a synthesis of drawings from 10 trips going and coming over this 75 mile stretch" along New York's Hudson River.

> On this basis I started a drawing for a sculpture. As I began, I shook a quart bottle of India ink, it flew over my hand, it looked like my landscape. I placed my hand on paper and from the image this left I travelled with the landscape to other landscapes and their objects, with additions, deductions, directives which flashed past too fast to tabulate, but whose elements are in the finished sculpture.[9]

11.15 • DAVID SMITH. *Cubi XII*. 1963. Stainless steel. 9′ 1⅝″ × 4′ 1¼″ × 2′ 8¼″. The Hirshhorn Museum and Sculpture Garden, Smithsonian Institution, Washington, D.C. Gift of The Joseph H. Hirshhorn Foundation, 1972.

A whole range of "realities" had bolted into the creative process, contributions from the real world and the imagination, from intuition, conscious decision, and chance. All would ultimately be welded together: the imaginative unification of multiple realities in the final piece. Although traces of it remained, the Hudson River landscape, the artist's point of departure, had been powerfully transformed.

Two art experts, John Russell and Rosalind Krauss, see *Hudson River Landscape* in very different ways. Rich in meanings, the work evokes decidedly different responses from the two individuals. Each viewer, as the sculptor would have liked it, "projected" his or her personal meanings onto the work, thereby "bringing it to completion." Critic John Russell focuses on the sculpture's landscapelike qualities, thus bringing the work to final completion in a somewhat literal, naturalistic way. Russell observes that the artist "took note of the rocky banks, the staircaselike steps of land that led down to the water, the meandering movement of the river when its level was low toward the end of winter, and the slow circling of the huge clouds above." Smith then "synthesized all these things in two-dimensional form [the sculpture being conceived in a frontal, planar way] with the effect of a man drawing in the air, bending the steel to his will as freely as a landscape draftsman bends the penciled line, and calling upon the memory of natural phenomena to help him to articulate space."

Looking at the work more formally, and in terms of the evolution of modern art styles, Rosalind Krauss describes the articulated planar space of *Hudson River Landscape* and another 1951 piece as "shallow, weblike, their flat facades knifing across the viewer's line of sight. . . ." The result, she observes, is something of a sculpture-painting, a piece reflective of the emphasis in modern sculpture on open space and in modernist painting on antinaturalistic flatness. Krauss then makes this observation:

> . . . these sculptures were radically unlike the human body [sculpture's traditional subject] with its density and its upright verticality. In that sense they seemed to his critics to represent Smith's breakthrough; it was as though his

originality, his claim to modernism, could be identified with the rejection of the human figure. Cleaving to the idea of landscape, Smith was seen as entering into modernism by means of a format that was horizontal rather than vertical and referred to continuous space rather than mass or volume.[10]

Ever the explorer, Smith soon passed beyond the frontal, horizontal landscape format. His finest sculptures of the next fifteen years moved fluidly between solid mass and open space, vertical and horizontal, frontal and "in-the-round" orientations. His works incorporate found objects and invented shapes, abstract and representational forms, sometimes all welded together in the same piece. In his final years, geometric forms largely took over. A long series of stainless-steel sculptures, the *Cubi* (11.15), created between 1961 and 1965, were built from combinations of cubes, cylinders, lozenges, circles, and flat rectangular or square slabs. Earlier connections to surrealist fantasy or landscape imagery were exorcised for a freely geometrical abstract expressionism that could be read—and "completed" by the viewer—in diverse ways.

The critic Russell was impressed by the anthropomorphic and "American" qualities of these late works. To begin, he saw them as abstract metaphors of "vertical man." "Though not organized in expressly human terms," Russell writes, "they stand for a certain idea of American manhood: one that is free, open, outgoing, erect, and not overly complicated." "The glint and sparkle of the stainless steel," the critic observes, "is fundamental to them. So is their [human] scale, which dominates but does not dwarf us." For Russell, Smith's work was a powerful statement of humanism and optimism. It was art that "stands for a large-heartedness [and] a freedom from corruption and a breadth of ambition which have largely ceased to characterize the world of art," fitting words by a humanist critic about a humanist-existentialist sculptor.

More formally and historically minded, Rosalind Kraus again offers a different perspective. She judges the *Cubi* to be unrivaled in American sculpture in regard to their aesthetic qualities. At the same time, she acknowledges that the *Cubi* are elusive in their formal meaning. They are a bundle of seeming con-

tradictions: objects that equivocate between flatness and bulk, volume and line, monochrome and color, frontality and multiple views. It is therefore not surprising to her that sculptors and critics look at the *Cubi* differently. (As the sculptor himself often emphasized, the meaning of modern art is open-ended rather than neatly precise.) Some viewers, Krauss notes, "treat the *Cubis* as abstract gestures, or rhythms—as allusions to the stretching, striding, turning movements of a heroically scaled figure." Others, in complete contrast, "think of them as colossal [nonfigurative] constructions—the first wave of sculpture's migration into the realm of architecture."

Those in the first group generally describe their formal experience of the works as colored by a sense of antimateriality; they speak of the illusion of masslessness and weightlessness, of light so captured and reflected that the sculptures dissolve into "dazzling emblems" and create "an energy that is purely optical." As we would expect, the second group's perception of the works is the absolute reverse of this. For them the excitement of the *Cubis* reside in the unalloyed massiveness of the individual elements, in the sculptures' presentation of corporealized solid geometries.[11]

Smith's own statements on the *Cubi* tend to support both critical positions. On the one hand, he spoke of the mass and power of the stainless steel: "sometimes you make it appear with all its force in whatever shape it is." On the other hand, he often ground and polished the surfaces of the *Cubi* in a rough way, thus giving them a coloristic, "painterly" quality. Gestural, high-energy strokes reminiscent of those of Pollock and de Kooning have been scored into the steel surfaces. "I make them and I polish them in such a way," he noted, "that on a full day, they take on the dull blue, or the color of the sky in the late afternoon sun, the glow, golden like the rays, the colors of nature. And in a particular sense, I have used atmosphere in a reflective way on the surfaces." The sculptures, intended for the outdoors, thus take on the coloristic qualities of their surroundings, whether blue sky or green grass, bright sun or city lights. In delicious paradox, the solidity of steel merges with the weightlessness of atmosphere.

APPRECIATION 28

Jackson Pollock. *Number 1, 1948* from Four Different Perspectives

ROBERT BERSSON

Considering Jackson Pollock's *Number 1, 1948* from four different perspectives—that of an American formalist critic, a Jungian psychological theorist, a British Marxist art critic, and a German art historian—shows how very provocative the artist's drip paintings were for different viewers. First we hear from art historian and critic Michael Fried, a follower of the formalist aesthetics of Clement Greenberg.

The Museum of Modern Art's *Number One* (1948), roughly typical of Pollock's best work during these years, was made by spilling and dripping skeins of paint onto a length of unsized canvas stretched on the floor which the artist worked on from all sides. The skeins of paint appear on the canvas as a continuous, all-over line which loops and snarls time and again upon itself until almost the entire surface of the canvas is covered by it. It is a kind of space-filling curve of immense complexity, responsive to the slightest impulse of the painter and responsive as well, one almost feels, to one's own act of looking. There are other elements in the painting besides Pollock's line: for example there are hovering spots of bright color, which provide momentary points of focus for one's attention, and in this and other paintings made during these years there are even handprints put there by the painter in the course of his work. But all these are woven together, chiefly by Pollock's line, to create an opulent and, in spite of their diversity, homogeneous visual fabric which both invites the act of seeing on the part of the spectator and yet gives his eye nowhere to rest once and for all. That is, Pollock's all-over drip paintings refuse to bring one's attention to a focus anywhere. This is important. Because it was only in the context of a style entirely homogeneous, all-over in nature and resistant to ultimate focus that the different elements in the painting—

most important, line and color—could be made, for the first time in Western painting, to function as wholly autonomous pictorial elements.

At the same time, such a style could be achieved only if line itself could somehow be pried loose from figuration. Thus an examination of *Number One*, or of any of Pollock's finest paintings of these years, reveals that his all-over line does not give rise to positive and negative areas: we are not made to feel that one part of the canvas demands to be read as figure, whether abstract or representational, against another part of the canvas read as ground. . . . Pollock has managed to free line not only from its function of representing objects in the world, but also from its task of describing or bounding shapes or figures, whether abstract or representational, on the surface of the canvas. In a painting such as *Number One* there is only a pictorial field so homogeneous, overall and devoid both of recognizable objects and of abstract shapes that I want to call it *optical*, to distinguish it from the structured, essentially tactile pictorial field of previous modernist painting from Cubism to de Kooning. . . .

In contrast to the formalist critic, with his commitment to pictorial and stylistic analysis of the art object itself, a Jungian interpreter sees a painting such as *Number 1, 1948* as an exploration of inner depths and a revelation of the artist's unconscious. It seems fitting to interpret Pollock's work in this way because the artist was consciously influenced by both Jungian and Freudian psychology. The artist used the surrealist practice of psychic automatism—based on the Freudian technique of "free association"—as a starting point for his action-oriented painting procedure. Likewise, he had been drawn to Jungian ideas of the

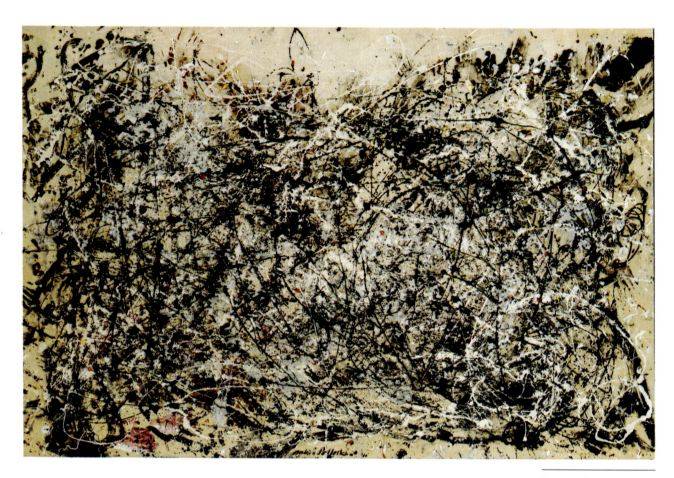

JACKSON POLLOCK. *Number 1, 1948.* 1948. Oil and enamel on unprimed canvas. 5′ 8″ × 8′ 8″. Collection, The Museum of Modern Art, New York. Purchase.

collective unconscious and subconscious archetypes as the creative center and source of his art. Our appreciation of *Number 1, 1948* is certainly enriched by psychoanalytic interpretation. This interpretation is by Jungian theorist Aniela Jaffe:

Pollock's pictures, which were painted practically unconsciously, are charged with boundless emotional vehemence. In their lack of structure they are almost chaotic, a glowing lava stream of color, lines, planes, and points. They may be regarded as a parallel to what the alchemist called the *massa confusa,* the *prima materia,* or chaos—all ways of defining the precious prime matter of the alchemical process, the starting point of the quest for the essence of being. Pollock's pictures represent the nothing that is everything—that is, the unconscious itself. They seem to live in a time before the emergence of consciousness and being, or to be fantastic land-scapes of a time after the extinction of consciousness and being.

. . . On the other hand, these paintings reveal an unexpected background, a hidden sense. They often turn out to be more or less exact images of nature itself, showing an astounding similarity with the molecular structure of organic and inorganic elements of nature.

The Jungian theorist then concludes that a Pollock painting such as *Number 1, 1948* strangely resembles hitherto hidden forms of matter as revealed in microphotographs. It is similar in configuration, for example, to a vibration pattern made by sound waves in glycerine.

Expanding the focus from Pollock the individual to Pollock the product of Western society, Marxist critic John Berger views the

(continued)

mainstream art of our times, achieving an honored place in museums and galleries, college classrooms, and corporate boardrooms. Widespread education in modern art history, appreciation, and studio practice has certainly helped to foster understanding and popular acceptance of this century's vanguard art. With the penetration of modern art to the heart of academe itself—most practicing artists now have college degrees in "studio art" and earn their livelihood by teaching art at colleges and universities—we might even conclude that visual art has achieved its longtime cultural goal of becoming an honored discipline on equal footing with the other liberal arts of the academy. Twentieth-century artists had achieved the cultural ideal expressed in Raphael's *School of Athens* (8.6). It was into this rapidly changing cultural and social situation, with New York City fast becoming the capital of the international art world, that the next generations of artists stepped.

AFTER ABSTRACT EXPRESSIONISM: FROM PAINTERLY TO POST-PAINTERLY ABSTRACTION TO MINIMALISM

As the North American art establishment and the world at large changed, so did the concerns of younger American artists. One major shift was from "extra-artistic" psychological, social, or spiritual concerns, so important to the first generation of the New York School, to more strictly "artistic" concerns. The almost overwhelming preoccupation of the abstract expressionists with self—self-expression, self-discovery, self-transcendence—gave way to more impersonal, "self"-less, and external concerns. One group of younger artists focused on formal concerns: new ways of working with color, surface, and the shape of the canvas. Another group was concerned with innovations in content, incorporating in their work recognizable subject matter and found objects from the everyday world. The artistic pioneers of the next generations seemed to be trying to extend the boundaries or pass beyond the strictures of the triumphant abstract expressionist movement. Many felt they had to shake off the vise grip of abstract expressionism to realize an original art of their own.

Helen Frankenthaler: Between Painterly and Post-Painterly Abstraction. Formal innovation—in color, the handling of paint, and surface design—was one way beyond the influential hold of the first generation. As might have been expected, Clement Greenberg, partisan critic of formalist invention, was there to help lead the way for those American abstractionists whose pictorial innovations he admired. Writing magazine articles and organizing gallery and museum shows, Greenberg ultimately named the new movement he helped to build. He called it **post-painterly abstraction.** By "post-painterly" Greenberg meant painting that had evolved past the gestural abstraction typified by the work of Kline (11.1), de Kooning (11.9), and hundreds of enthusiastic younger painters who, perhaps too slavishly, had taken up de Kooning's general style. (Greenberg likewise saw Pollock's early and late paintings, although not his drip paintings, as gestural and painterly.) All such "painterly" work was based on the hand-driven gesture of painted strokes. Greenberg did not like the fact that "the stroke left by the loaded brush or knife . . . frays out, when the stroke is long enough, into streaks, ripples, and specks of paint." Instead, the critic favored a nongestural, postcubist approach, anticipated by the broad color fields of Rothko, Newman, and Still, that tended toward clearly defined, flat areas of color. Little or no personal gesture or "autobiographical" brushwork was to be discerned in such paintings. The artists Greenberg praised as "post-painterly" tended to be concerned with "the high keying, as well as lucidity, of their color . . . contrasts of pure hue rather than contrasts of light and dark . . . relatively anonymous execution."

To be sure, the journey from gestural abstract expressionism to post-painterly abstraction was not made overnight, but it was not many years before the new formally oriented post-painterly abstraction made its public and art historical presence felt. At the forefront of the new direction in the early 1950s was Helen Frankenthaler (born 1928). With her roots in gestural abstraction but her sensibility oriented to color and space, this young artist was a pioneer for her generation, opening the field of painting to new possibilities. Of liberal upper middle-class background, Frankenthaler

10/28/52

was reared in New York city and educated in progressive private schools. At the end of the 1940s, she was at arts-oriented Bennington College, where she received a strong grounding in cubism. In 1950, she became a friend of Clement Greenberg. She says, "Through Clem I met everybody, the whole cast. I was terrified. I was just coming out of a Cubist academe [Bennington College]. But seeing the pictures of de Kooning . . . Gorky . . . Pollock . . . it was thrilling." In 1951, aided by the influential Greenberg, Frankenthaler had her first one-person show at a New York City gallery. That same year, she visited Pollock's studio in rural eastern Long Island and saw fifteen of his drip paintings up close. Key links between painterly and post-painterly abstraction were about to be forged.

A 1952 painting, *Mountains and Sea* (11.16), was the breakthrough work, a transitional piece or bridge between the painterly works of Pollock, de Kooning, and the early abstract expressionist Arshile Gorky and the formalist, "post-painterly" abstraction to come. (Her own work for the next four de-

cades would be a successful synthesis of the two directions.) Justly honored as a "seminal" work, *Mountains and Sea* did for post-painterly abstractionists such as Morris Louis and Kenneth Noland what Pollock's drip paintings had done for the gestural action painters. It liberated them. It opened up new possibilities for them to explore. It specifically helped Louis and Noland, both based in Washington, D.C., to break the potent grip of their immediate abstract expressionist heritage.

At the insistence of Greenberg, Louis and Noland paid a visit in 1953 to Frankenthaler's New York City studio to see *Mountains and Sea.* "It was," Noland later said, "as if Morris [Louis] had been waiting all his life for this information." Noland was also much moved by the work. Here was a unique painting that employed Pollock's revolutionary methods, the dripping and staining of paint into raw canvas tacked to the floor, but used them to achieve formal as opposed to expressionist or surrealist ends. What artists such as Louis and Noland saw in *Mountains and Sea,* in the words of one writer, was "a way to convey the

weightless bloom of color without any apparent thickness of paint: light without texture." Here was an art that grew from but pointed beyond the emotive personal gestures of the abstract expressionist action painters. Here was an "action-oriented" painting that emphasized the "abstract" rather than the "expressionist" side of the movement. Weighty existential concerns gave way to concerns about formal innovation in color, light, and space. *Mountains and Sea* showed a way beyond the storm-tossed content of the first-generation painters. It heralded an art of largely "visual" or "optical" considerations.

Frankenthaler's own statements make clear this change in focus and intention from one generation to the next. She saw her best paintings not as an expression of psychological forces but as "an intense play and drama of space, movements, light, illusion, different perspectives, elements in space." The expression of personal feelings, myths, or spiritual states mattered far less than the physical manipulation of paint and canvas. The primary goal for Frankenthaler was the creation of "successful," "aesthetically meaningful" pictures. A successful painting was a visually pleasurable "moment caught." In the life-affirming spirit of Matisse, Frankenthaler believed that good paintings embodied that deeply satisfying moment when certain elements of space, light, and scale come together in harmony. In addition to recalling the decorative, pleasure-giving art of Matisse (2.34), Frankenthaler's words and works bring to mind the paintings of the impressionists and their similar preoccupation with light, color, space, and movement. With a sense of relief at escaping the powerful sway of the first generation of the New York School, Noland, Louis, and others acknowledged Frankenthaler's work, especially *Mountains and Sky*, as a bright star pointing the way to evermore exciting possibilities.

Let us look more closely at Frankenthaler's most influential painting, aided by the insights of *Time* art critic, Robert Hughes. Hughes praises *Mountains and Sea* as an "exquisite painting" of "rapid blots and veil-like washes . . . dashed down as though the canvas were a page in a sketchbook." Of ambitious abstract expressionist proportions, a full seven feet high by ten wide, the work was painted by the twenty-four-year-old Frankenthaler "after a

trip to Nova Scotia, whose coast is plainly visible in it: the pine-forested mountains and humpy boulder, the dramatic horizontal blue." As to method, "It was made flat on the floor, like a Pollock, and records the influence of Cézanne's [late, semi-abstract] watercolors, as well as abstract expressionist painters [Pollock, Gorky, de Kooning] whom Frankenthaler had studied. . . ." Despite the painting's great size, writes Hughes, Frankenthaler succeeded in making *Mountains and Sea* "an agreeably spontaneous image (and was painted in one day), pale and subtle, with a surprising snap to its trails and vaporous blots of blue, pink and malachite green." Because the thin pigment has soaked into the weave of the canvas, the painting is "in effect, a very large watercolor."

Paintings such as *Mountain and Sea*, based on the spontaneous gesture of "action painting," show Frankenthaler to be, in one sense, an heir of the abstract expressionist tradition of Pollock and de Kooning. For decades she has remained in love with the spontaneous gesture and the unforeseen imagery that emerges from improvised action. In her work, Hughes writes, "one sees traces of the surrealist ideas that had formed Pollock—an openness to the kind of unsought private image that was generally barred from [post-painterly] color-field painting" (for instance, that of Louis and Noland). But if she is partly an abstract expressionist of painterly gesture, she is also partly a post-painterly abstractionist in the Greenbergian sense. Her main focus has always been color and the pleasurable sensations that can rise from it. "Frankenthaler's forte," Hughes asserts, "has always been controlling space with color, vigilantly monitoring the exact recession of a blue or the jump of a yellow, the imbricated [overlapped, as tiles] weight of a dark area against the open glare of unpainted canvas." Another critic, who calls Frankenthaler "one of our best painters," describes her work as "abstract landscapes" narrowed down to the essentials: "mainly color—vibrant, limpid, often elegantly transparent—in the service of a highly simplified design." Hers, the critic continues, is a lyrical, at times astonishingly beautiful painting that eliminates "the bravura rhetoric of [abstract] Expressionism while maintaining its sense of physical immediacy."

11.17 • MORRIS LOUIS. *Tet.* 1958. Synthetic polymer on canvas. 7′ 11″ × 12′ 9″. The Whitney Museum of American Art, New York. Purchase, with funds from the Friends of the Whitney Museum of American Art.

Post-Painterly Abstraction: The "Color Painting" of Louis and Noland. Inspired by their 1953 visit to Frankenthaler's studio, Morris Louis (1912–1962) and Kenneth Noland (born 1924) began to explore the potentialities they saw in *Mountains and Sea.* Their journeys took them in the direction of an impersonal, optically oriented art in which personal gesture was jettisoned for the triumphant expansion of pure fields of color. Both men had been excited by the method and appearance of Frankenthaler's painting with its "weightless bloom of color without any apparent thickness of paint: light without texture." Stimulated by Frankenthaler's staining technique of thinned pigment—at first diluted oil paint, later water-based **acrylic**—into large expanses of unprimed canvas, Louis began to experiment in earnest. He unrolled huge stretches of canvas on the floor, and then lifted or lowered different sections of the canvas, pouring, scrubbing, or blotting paint into the raw cloth. As the paint quickly soaked into the folds and pleats he had made, a number of basic configurations emerged. Working in series based on a single pictorial idea, Louis created numerous variations on these basic formal themes. His major themes or visual configurations have been categorized, in their sequential order of development, as "veils" (11.17), "unfurleds" (11.18), and "stripes" (11.19). Over the course of eight years, from the first "veils" of 1954 to the final "stripes" of 1962, he moved away from first-generation abstract expressionism, especially its gestural, painterly side, to a post-painterly abstraction that has been called by such names as "color field," and "color" painting, and "Washington color school." (Washington, D.C. was the base of operation for Louis, Noland, and several similarly minded colleagues.)

As Greenberg saw it, Louis's work was proceeding in the right direction. It evolved gradually from the veils (interpenetrating fields of color that create a somewhat misty, atmospheric effect) to the unfurleds (rivulets of separate and distinct colors that flow diagonally down toward the center of the canvas from the sides) to the stripes (bands of pure, unsaturated color placed adjacent to each other in parallel vertical, horizontal, or diagonal arrangement). Supported by Greenberg, now a close friend, Louis had reduced the "expressionist" side of abstract expressionism so that the "abstract" side of color and surface might breathe with a resplendent life of its own. A comparison of a veil painting such as *Tet,* 1958 and an unfurled such as *Alpha-Pi* of

11.20 • KENNETH
NOLAND. *Turnsole*. 1961.
Synthetic polymer paint
on unprimed canvas.
7′ 10⅛″ × 7′ 10⅛″.
Collection, The Museum of
Modern Art, New York.
Blanchette Rockefeller Fund.

and Louis as equal in aesthetic quality and art historical importance to that of the "first-wave pioneers" of abstract expressionism, other major writers voiced far different opinions. Harold Rosenberg, still an arch-supporter of the abstract expressionists and a tough-minded humanist, expressed strong reservations about Noland and the post-painterly direction in general. Aggravating matters, Rosenberg never much liked his rival Greenberg on a personal level. Rosenberg likened Noland's work to good "wall decoration" and "interior design" as opposed to real art. In a 1977 review of a major Noland show at New York City's Guggenheim Museum, Rosenberg decried the loss of individuality and the poverty of content of post-painterly art. He called Noland's color paintings "collective art, bound by rules and principles rather than by an effort toward the realization of individuality." In words that remind one of the romantic individualist Baudelaire, Rosenberg laid out his critique of Noland's post-painterly formalism. By centering on a set of predefined formal problems (color and surface), and "firmly repulsing chance, whim, accident, dream, and the irrational, American formalism achieved a conscious group purposefulness that had not been evident in art since the functional [social realist] aesthetics of the nineteen-thirties."

In a related response, the critic-historian Leo Steinberg observed that Noland's thirty-foot-long stripe paintings, consisting of parallel color bands "embody, beyond the subtlety of their color, principles of efficiency, speed, and machine-tooled precision which, in the imagination to which they appeal, tend to associate themselves with the output of industry more than art." Perhaps because industry and corporations appreciated clean lines, smooth finish, and streamlined design, post-painterly art was eagerly bought up by corporate collectors in the sixties and seventies. So flat and streamlined in meaning were Noland's canvases that the sharp-tongued writer Tom Wolfe exclaimed satirically, "Noland was known as the *fastest* painter alive: i.e., one could see his pictures faster than anybody else's. The explanation of why that was important took considerably longer."

Offering a more balanced review of Noland's art and post-painterly abstraction in general was *Time* magazine critic Robert Hughes. Hughes judged Noland to be an outstanding, though limited painter. His target series, the critic wrote, possess "an airy energy that few American painters (and no European ones at the time) could equal." They "bloom and pulsate with light. They offer a pure, uncluttered hedonism to the eye." But such art, however optically appealing, had also to be seen for its limits; that is, for what it left out. Hughes observed, "The paintings Frankenthaler, Noland, Louis, and Jules Olitski did in the 1960s were, as a whole, the most openly decorative, anxiety-free, socially indifferent canvases in the history of American art." And this was the decade of civil rights struggle, the Vietnam War, the anti-war movement, the pop culture explosion, and widespread countercultural revolt.

A work of art cannot, of course, speak to all issues. By narrowing their issues to color and surface, post-painterly abstractionists such as Louis and Noland had willingly sacrificed complex, anxiety-ridden life considerations for relatively anxiety-free, aesthetic ones. The resulting paintings, at their best, were masterpieces of life-affirming optical grandeur. The torment and weighty moral seriousness projected by so much abstract expressionist art were not present in Noland's targets or Louis's unfurleds. Post-painterly color field painting had realized the Matissean goal of a pleasure-giving, decorative art: an art "like an appeasing influence, like a mental soother, something like a comfortable arm chair in which to rest from physical fatigue." For leading cultural and economic institutions, struggling to maintain their hold during the tumultuous times of the sixties and early seventies, post-painterly abstraction was a desirable style indeed: cool and refined, pleasant to the eye, and sometimes very beautiful indeed.

Minimalist Art: The Continuing Evolution Toward Pure Visibility. Like its post-painterly relative and forebear, **minimalist art** tended to be cool and conceptually refined, but it also tended to upset viewers. It was just too simple. Their radical simplicity, lack of human feeling, and absence of conventional artistic qualities made minimalist works disturbing. Minimalist paintings might consist of no more than a large monotone canvas like the aptly named *Blue Monochrome* of 1961 by Frenchman Yves

11.22 • FRANK STELLA.
Ileana Sonnabend. 1963.
Metallic paint on canvas.
6′ ¾″ × 10′ 8″. Courtesy
Gagosian Gallery, New York.

expressionist paintings, especially those in the popular gestural style of de Kooning. Stella's paintings looked so simple and spare that many didn't even think of them as art. They consisted of just a simple and symmetrical geometric pattern of repeating white lines on a surface painted uniformly in one color: black, silver, or copper.

Serious reviewers accustomed to the highly emotional, often busy, improvised canvases of gestural abstract expressionism were puzzled. Was Stella "trying to destroy painting?" a reviewer asked during an interview. Replying that he wasn't out to destroy anything, the artist asserted, "It's just that you can't go back. . . . If something's used up, something's done, something's over with, what's the point of getting involved with it?" In effect, Stella didn't want to get involved with what he called "the old values in painting—the humanistic values," by which he meant sentiment, painterly brushwork, and detail. Rather, he sought to create art so visually "lean" and "accurate" that the viewer would simply want to look at his work as a visual "object." His goal was an art pared down to pure visibility, with no references to the artist's hand, personality, or the outside world. "All I want anyone to get out of my paintings, and all I ever get out of them, is the fact that you can see the whole idea without any confusion. . . . What you see is what you see."

What do we see in the Stella piece entitled *Ileana Sonnabend* (11.22)? To begin, we see a very large monochromatic work, almost six

and a half feet high by eleven feet long. (From their abstract expressionist forebears, Stella, and most minimalists, adopted grandeur of scale along with the idea of "all-over" composition.) The work is purple; the darker "lines" are formed by the unpainted spaces between the painted purple bands. The overall configuration is symmetrical. Stella liked symmetrical composition because it was "non-relational": beyond the need to "balance . . . to jockey everything around." He put it this way: "In the newer American painting we strive to get the thing in the middle, and symmetrical, but just to get a kind of force, just to get the thing on the canvas." Kenneth Noland had been doing the same thing, Stella noted, with his concentric circles, "getting them in the middle because it's the easiest way to get them there . . . in front on the surface" to stress the surface qualities of the work. Paring away troublesome extras (for instance, detail, painterliness, and the need to balance) allowed Noland and Stella to concentrate on, and realize the potential of, their particular formal concerns: color in Noland's case, shape (or "structure") in Stella's.

In *Ileana Sonnabend* we are aware of Stella's concern with shape. The "shaped canvas," in fact, was one of Stella's principal contributions to the art of painting and object making. Stella's main concern had been generating a painting from the "idea" of a certain shape or configuration. That shape or configuration then provided the defining structure for the entire work. In *Ileana Sonnabend,* the defining structure dictates the "positive" shape of the canvas, the repeating linear pattern on the surface of the canvas, and the inner, open-space "negative" image as well. And true to the idea of absolute symmetry and balance, the inner negative shape in *Ileana Sonnabend* has the same basic proportions as the outer positive structure.

Such works were obviously not created by improvisation or chance. They look almost mathematical or scientific compared to most abstract expressionist works. Like an architect or product designer, Stella carefully developed his visual ideas on paper or in small three-dimensional models. But like a traditional artist, he then executed these plans by his own hand. Because he valued control over chance, and deliberation over spontaneity, Stella, like

11.23 • FRANK STELLA. *Giufà, la Luna, i Ladri e le Guardie* from the Cones and Pillars series. 1984. Synthetic polymer paint, oil, urethane enamel, fluorescent alkyd, and printing ink on canvas, and etched magnesium, aluminum, and fiberglass. 9′ 7¼″ × 16′ 3¼″ × 24″. Collection, The Museum of Modern Art, New York. Acquired through the James Thrall Soby Bequest.

most post-painterly and minimalist artists, worked in thematic series (targets, stripes, grids, polygons) in more or less systematic ways. He developed visual ideas over a period of a year or more, with the rigorous devotion that characterizes scientific research. In this respect, works such as *Ileana Sonnabend* are cerebral and conceptual ("idea art") as well as visual and optical. The names of the series of Stella's early shaped canvases, such as *Irregular Polygon Series* and *Protractor Series*, give a sense of both the serial and systematic nature of his art.

In *Ileana Sonnabend,* the principal visual idea certainly comes across with clarity and force. Stella "wanted something direct—right to your eye . . . something that you didn't have to look around—you got the whole thing right away." But, one interviewer asked, were clarity and immediacy of a visual idea enough? Shouldn't there be more to see in the work than just that? Stella's reply was that the enjoyment of seeing visual form, or ideas in visual form, should be enough. If he could invest in his works enough rightness of form and "presence," then viewers would find them "worth looking at, or enjoyable;" they would receive "a visual sensation that is pleasurable."

As the maker of boundary-breaking "objects," Frank Stella, for over thirty years, has been a prolific inventor: of shaped canvases; of geometric wooden reliefs; of giant, multi-layered aluminum reliefs that project so far off the wall that they completely blur the lines between painting and sculpture. "I'm moti-

vated," he says, "by the desire to make something, and I go about it in the way that seems best." In the late fifties and early sixties, his way of making art actually helped to launch a movement, minimalism. But the irrepressible Stella was never content with past successes. He kept seeking out new formal and conceptual challenges, new ways of making art. By the seventies, he had left the values of his minimalist past—geometrical simplicity, nonrelational symmetry, repetition, monochromy—far behind. Objects of great variety and complexity, such as *Giufà, la Luna, i Ladri e le Guardie* (11.23) poured forth from his studio. These works might be characterized by brilliant color, ever-changing shape (geometrical or free form), complicated composition, and diverse materials. From the mid-seventies, he even employed the painterly brushwork and detail he once defiantly rejected. His mixed-media reliefs became so profusely detailed, dynamic in energy, and theatrical in presence that critics described them as "baroque." No matter how baroque these expansive reliefs become, however, they remain minimal in one important sense: their strict emphasis on the visual or optical quality of the work. No symbolism, literary association, or overt reference to the artist's life or the outside world is apparent. These reliefs, like Stella's early paintings and shaped canvases, are to be appreciated for their own visual sake or not at all. After three decades of inventive object making, Stella is beginning to find a large audience that finds his works, as he hoped, well "worth looking at."

11.24 • ROBERT RAUSCHENBERG. *Bed*. 1955. Combine painting. Oil and pencil on pillow, quilt, sheet, on wood supports. 6′ 3¼″ × 31½″ × 8″. Fractional gift of Leo Castelli in honor of Alfred H. Barr, Jr., to The Museum of Modern Art, New York.

FROM ART TO LIFE: THE CREATIONS OF RAUSCHENBERG, JOHNS, AND KAPROW

From the possibilities inherent in abstract expressionism, two almost diametrically opposed artistic directions emerged. One can observe the birth of these two directions in the 1950s and follow their progress right up to the present. One tendency, epitomized by post-painterly and minimalist art, emphasized innovations in form. The other tendency featured innovations in subject matter. So opposite do the two directions seem that one might think of them dialectically as minimalist thesis and maximalist antithesis. Consider this: at the same time that post-painterly and minimalist artists were paring away "extraneous" form and content (realist subject matter, naturalistic associations, psychological or spiritual meanings, painterly detail, and so on) so as to amplify the power of two or three formal elements (for instance, color, surface, shape), artists of the opposite maximalist tendency were violently expanding both the range of subject matter and the number of formal elements that the work might contain. As the formalists concerned themselves with the simplification of painting and sculpture to their essentials by purging all unnecessary extras, so-called **neo-dadaists** such as Robert Rauschenberg (born 1925), Jasper Johns (born 1930), and Allan Kaprow (born 1927), were pushing their work to extremes in the opposite direction. In the true spirit of dada and surrealism, these three men were bursting the boundaries between art and life, pulling more and more of the world into their work until the demarcation between art and life became truly blurred. In 1955, the thirty-year-old Rauschenberg took his own pillow, bedsheet, and quilt, boldly painted on them in an abstract expressionist gestural style, and then hung the finished "combine," part painting, part real-life object, on the wall. Titled *Bed* (11.24), the work remained notorious and controversial in the art world for years. Was *Bed* a serious painting or a dada gesture? Was it art or life? Or was it something in between, a synthesis of all of these? If the formalist tendency could be called "minimalist" in its reductive pursuit of pure form and clear definition, the Rauschenberg-Johns-Kaprow

tendency was its "maximalist" opposite: impure, messy, expansive, all-encompassing. Confining definitions and limitations on form or subject matter were to be thrown out the window.

Whereas the formalist artists and critics argued that the best modern art was always concerned with solving strictly visual problems—art in dialogue with itself, art as a closed system—artists such as Rauschenberg, Johns, and Kaprow stood for an incredibly open-ended art. They were for art in dialogue with everything: all of life, all of art, all of form and

subject matter; and all at the same time. There were no distinctions or separations: just one big, bubbling stew where different art forms, subjects, styles, media, and elements simmered in the same pot. Naturally, viewers were puzzled. They couldn't understand what the works of Rauschenberg, Johns, and Kaprow were. Were they painting? sculpture? art? anti-art? or what? A whole battery of new names—combines, assemblages, mixed media, events, performances, happenings—had to be invented to describe these novel works. What, for example, was Rauschenberg's image, *Automobile Tire Print*? The image was made in 1951 by inking a car tire and driving the car over a twenty-two-foot length of paper. Was Rauschenberg's tire track a print? A document of an event? A performance? Art or life? Or all of the above? According to Rauschenberg, works such as *Automobile Tire Track* and *Bed* defied the conventional (and limiting) aesthetic classifications; instead, they took place and existed in what he termed "the gap" between art and life.

For all their radicalism, such boundary-breaking works were not without significant antecedents. The primary artistic grandparents of Rauschenberg and his compatriot Johns were the dadaists of the teens and early twenties with their two-dimensional collages (10.30) and photomontages (10.32), found-object readymades, and three-dimensional assemblages constructed from the throwaway items and refuse of everyday life (11.25). Like their American "neo-dada" grandchildren, the original dadaists sought to destroy all distinctions between high art and daily life. Marcel Duchamp's infamous *Fountain* (10.28), essentially a urinal exhibited in an art gallery, is a prime example. The debate continues as to whether Duchamp's "readymade" is art or life, "non-art" or "anti-art."

The European dadaists were not the only influence on this group. An important older friend and forebear of both Johns and Rauschenberg was the North American composer and philosopher John Cage (born 1912). Cage was a born dadaist with strong ties to Zen Buddhist thought. (He, in fact, was the driver of the car that made Rauschenberg's *Automobile Tire Print*.) Cage's commitment to chance and the breaking of boundaries—between the arts, between the arts and

life—were central to his philosophy. A clear expression of these values in his own work as a composer is the now famous "musical" piece (event or gesture) entitled *4'33"*, during which the concert audience listens to four minutes and thirty-three seconds of silence. But they do not hear only silence. If the audience members listen attentively, they hear four and a half minutes of what Cage considered "music," all composed by chance: the creaking of chairs, coughs, or, if the concert is outside, wind, the patter of rain, and so forth. Each performance of this "silent piece" is as prone to chance and change as life itself. Are the listeners experiencing art? Or a slice of life? Cage liked to think of it as life and art made coextensive, one a continuation of the other.

If dada was the grandparent of Rauschenberg and Johns and Cage was an older uncle, then abstract expressionism was their imme-

11.25 • KURT SCHWITTERS. *Construction for Noble Ladies.* 1919. Cardboard, wood, metal, and paint. 40½ × 33″. The Los Angeles County Museum of Art. Purchased with funds provided by Mr. and Mrs. Norton Simon, the Junior Arts Council, Mr. and Mrs. Frederick R. Weisman, Mr. and Mrs. Taft Schreiber, Hans de Schulthess, Mr. and Mrs. Edwin Janss, and Mr. and Mrs. Gifford Phillips.

diate parent. Abstract expressionism's painterly brushwork, its commitment to unbounded freedom and individualistic choice, and its sense of open-ended experimentation and "action" all found their way into the art of Rauschenberg, Johns, and Allan Kaprow. Even the incorporation of common matter from daily life had roots in abstract expressionism, for example, Pollock's use of sand, small pieces of glass, and his own handprints in certain drip paintings (11.7) and de Kooning's use of newspaper or magazine fragments in a number of paintings (11.9).

Such art historical background might foster an intellectual grasp of these unusual works, but it doesn't necessarily bring about appreciation. After all, these are difficult works. When the art critic and historian Leo Steinberg examined the pieces in Jasper Johns's first

one-man show (1958) in a New York City gallery, he was admittedly flabbergasted. He left the show unsettled, but, as he wrote, "the pictures remained with me—working on me and depressing me."

The thought of them gave me a distinct sense of threatening loss or privation. One in particular there was, called *Target with Four Faces* [11.26]. It was a fairly large canvas consisting of nothing but one three-colored target—red, yellow, and blue; and above it, boxed behind a hinged wooden flap, four life casts of one face—or rather, of the lower part of a face, since the upper portion, including the eyes, had been sheared away. The picture seemed strangely rigid for a work of art and recalled Baudelaire's objection to Ingres: "No more imagination; therefore no more movement." Could any meaning be wrung from it? I thought how the human face in this picture seemed desecrated, being brutally thingified—and not in any acceptable spirit of social protest, but gratuitously, at random. At one point, I wanted the picture to give me a sickening suggestion of human sacrifice, of heads pickled or mounted as trophies. Then, I hoped, the whole thing would come to seem hypnotic and repellent, like a primitive sign of power. But when I looked again, all this romance disappeared. These faces—four of the same—were gathered there for no triumph; they were chopped up, cut away just under the eyes, but with no suggestion of cruelty, merely to make them fit into their boxes; and they were stacked on that upper shelf as a standard commodity. But was this reason enough to get so depressed? If I dislike these things, why not ignore them?

. . . The pictures, then, kept me pondering, and I kept going back to them. And gradually something came through to me, a solitude more intense than anything I had seen in pictures of mere desolation. In *Target with Faces,* I became aware of an uncanny inversion of values. With mindless inhumanity or indifference, the organic and the inorganic had been leveled. A dismembered face, multiplied, blinded, repeats four times above the impersonal stare of a bull's-eye. Bull's-eye and blind faces—but juxtaposed as if by habit or accident, without any expressive intent.[13]

Learning a bit about Jasper Johns's personality and that of his colleague Rauschenberg further enriches our experience of their works. At one time, the two men were intimate friends and struggling young artists sharing the same studio space. Like some of the great artists—Monet and Renoir, van Gogh and Gauguin, Picasso and Braque—who, worked closely and productively together, Johns and Rauschenberg influenced each other, but

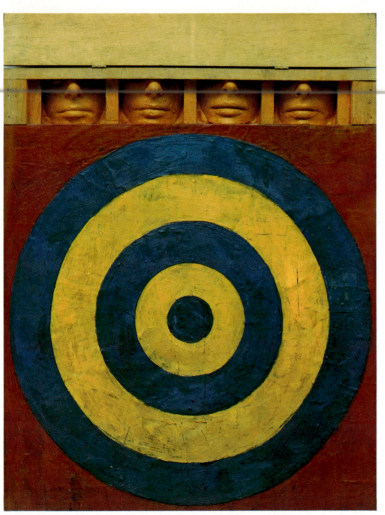

11.26 • JASPER JOHNS. *Target with Four Faces.* 1955. Assemblage. Encaustic on newspaper and cloth over canvas, 26 × 26″, surmounted by four tinted plaster faces in wood box with hinged front. Box, closed, 3¾ × 26 × 3½″. Overall dimensions with box open, 33⅝ × 26 × 3″. Collection, The Museum of Modern Art, New York. Gift of Mr. and Mrs. Robert C. Scull.

never to the point of disguising their potent differences in personality and approach. Whereas Johns is reclusive, meditative, and introverted, Rauschenberg is amiable, impulsive, and extroverted. In working method, Johns is painstaking and deliberate; Rauschenberg, freewheeling and spontaneous. Johns is all control and contraction; Rauschenberg is anarchic and expansive. When Johns breathes in, wrote one critic, Rauschenberg breathes out. And their art works reflect these differences in temperament and method. Johns's works are cool and terse, as the critic Steinberg observed of *Target with Four Faces*. The piece seems resonant with meaning but tells very little. Compared to Johns's works, introspective and almost silent, Rauschenberg's are passionate and verbose.

For Rauschenberg, all the world represents subject matter to act upon. Everything delights or fascinates him. Like a sponge, he is ready to drink it all up. He is ready to throw together anything, try anything in an art of endless combinations. Reflecting both his personality and art-making philosophy, Rauschenberg wrote that he had "a kind of house rule" when it came to making his combines. "If I walked completely around the block [in New York City] and didn't find enough to work with, I could take one other block and walk around it—but that was it." The final assemblage, he concluded, "had to look at least as interesting as anything that was going on outside the window."

Between 1955 and 1960, a remarkable range of objects found on those walks around the block made their way into his assembled combines. Rauschenberg used stuffed animals, car tires, roller skates, electric clocks, wooden ladders and chairs, street signs, and ventilation ducts. In comparison to most of his object-studded combines, Rauschenberg's early combine, *Bed,* looks like a bare-bones minimalist abstraction.

Entering the early sixties, Rauschenberg continued to collect pieces of the world and incorporate them into his art, but his focus changed. Instead of employing the physical objects of his immediate urban surroundings as his subject matter, he now collected and mixed together the images of the international mass media. He appropriated his subjects and forms from print, photographic, and tele-

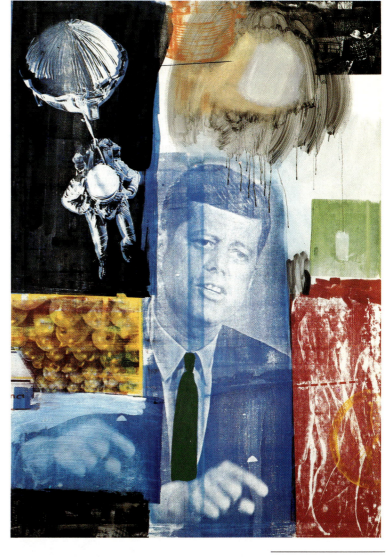

11.27 • ROBERT RAUSCHENBERG. *Retroactive I.* 1964. Oil and silkscreen on canvas. 7′ × 5′. The Wadsworth Atheneum, Hartford, Conn. Gift of Susan Morse Hilles.

vision images. The artist had turned his attention from an object-filled city to the glut of media images. "I was bombarded with TV sets and magazines, by the refuse, by the excess of the world. . . . I thought that if I could paint or make an honest work, it should incorporate all of these elements, which were and are a reality."

Rauschenberg had come to the recognition that the most influential reality of the present is not one of physical objects but of media images. He had realized that the mass-media environment was gradually eclipsing both the natural and built environment in its power over us. In a 1964 silkscreen print, *Retroactive I* (11.27), print and television images

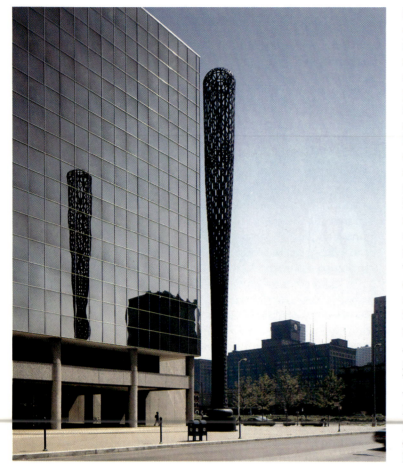

11.31 • CLAES
OLDENBURG. *Batcolumn*.
1977. Welded steel bars
painted gray. Height,
100′. U.S. Social Security
Administration, Chicago.

its quick success, among other reasons, various established critics railed against the pop art incursion. They heartily disliked Oldenburg's soft sculptures for their bigness, brashness, and vulgarity. Clement Greenberg, pushing post-painterly art at the time, scorned the movement as merely fashionable, "a new episode in the history of taste." Harold Rosenberg denounced pop art, with its fetish for consumer commodities, as a sinister product of a materialistic, philistine culture. Art historian Peter Selz found in pop art a "want of imagination" and "passive acceptance of things as they are," qualities that demonstrated a "profound cowardice . . . limpness and fearfulness of people who cannot come to grips with the times they live in." With the success of pop art, the century-long tradition of the avant-garde, committed to independence from and opposition to the status quo, seemed to have caved in to the bourgeois mainstream. At least, that is how these three senior vanguard writers saw the pop art phenomenon. "A critical examination of ourselves and the world we inhabit," Selz wrote, "is no longer hip: let us, rather rejoice in the Great American Dream." Key avant-garde values of independence and criticality were being surrendered. In cutting fashion, Selz continued his attack.

> The striking abundance of food offered us by this art is suggestive. Pies, ice cream sodas, coke, hamburger . . .—often triple life size—would seem to cater to infantile personalities capable only of ingesting, not of digesting or interpreting. Moreover, the blatant Americanism of the subject matter . . . may be seen as a willful regression to parochial sources just when American painting [abstract expressionism] had at last entered the mainstream of world art. . . . [Pop art] is as easy to consume as it is to produce and, better yet, is easy to market, because it is loud, it is clean, and you can be fashionable and at the same time know what you're looking at. Eager collectors, shrewd dealers, clever publicists, and jazzy museum curators, fearful of being left with the rear guard, have introduced the great American device of obsolescence into the art world.[16]

dicted the inflation in scale and more refined, immaculate finish of Oldenburg sculptures, both soft and hard, in the future. Some of the artist's works became so large that they had to move out of galleries and museums and into the public domain. One example among many is Oldenburg's twenty-ton *Batcolumn* (11.31) in downtown Chicago. A "public art" monument to America's favorite sport, the hundred-foot *Batcolumn* is a tongue-in-cheek competitor to the modern skyscrapers around it.

The huge commercial success of Oldenburg's 1962 Green Gallery show was one of the first indicators of pop art's appeal. It predicted the meteoric rise of pop art to international acclaim. No longer an underground downtown movement of artists involved in happenings and rough-hewn object making, the "new realist" art quickly became a chic uptown commodity eagerly bought and sold by dealers, collectors, and consumed by the affluent "jet set" crowd and mass media. For

Perhaps with pop art, American painting and sculpture had reached a dividing line between "modern" and "post-modern" art: that is, between the old, anti-establishment avant-garde, which was concerned with the critical examination of self, art, and the world, and a post-modernism more accepting of the artistic past and societal status quo. More traditionally

representational and realistic styles and commonplace commercial subject matter and form were no longer out of the question. Older writers such as Selz, Greenberg, and Rosenburg bemoaned this shift in artistic attitude and direction. But, one might ask these critics, what was the new generation of artists to do? Avoid representing the commodities and commercial images that glutted daily life? Avoid the all-pervasive imagery of the mass media? In post-war America, the world of popular culture was everpresent. Nature, once the dominant setting of human activity, had been almost completely replaced by mass culture. The landscape of the present was no longer one of rural fields and village greens but of skyscrapers, billboards, supermarket aisles, and television screens. True to the credo of the nineteenth-century realist Courbet, the "new realists" were interpreting the appearances and customs of their time in their own individual ways. And, like Courbet and his colleagues, they were representing only the "real and existing": actual, concrete reality.

Among the new pop realists, Oldenburg was the master jester, playing with the overlooked everyday forms and drawing fun from them: blowing them up to vast sizes, deflating hard surfaces into softness, mining the gap between art and the everyday and bringing forth astonishing gems of comic and aesthetic delight. In comparison, Roy Lichtenstein (born 1923) appeared at first to be the cool stylist. He worked in a straightforward commercial mode: clean, precise, and to the point. But soon he, too, established himself as something of a wit. Around 1961, Lichtenstein, who had been painting in both abstract expressionist and figurative styles, turned to the graphic art of the cartoon strip for his basic form and subject matter (11.32, 2.15). This is not to say that he liked everything about comic strips. Personally, he found many of the subjects of cartoons (for instance, violence, militaristic and fascist-type characters) disturbing. He noted that the subjects of pop art in general were among the "most brazen and threatening characteristics of our culture, things we hate, but which are also powerful in their impingement upon us." But such disagreeable subjects, he believed, were not to be shunned, as many modern abstract artists had done. They should be accepted head on. Art since Cézanne, Lichtenstein affirmed, had "become extremely romantic and unrealistic [that is, abstract], feeding on art. . . . It has had less and less to do with the world, it looks inward. . . . Pop Art looks out into the world; it appears to accept its environment, which is not good or bad but different—another state of mind." Anticipated in the work of Rauschenberg, Johns, and Kaprow, this divergent "state of mind," outward-looking, accepting of the environment, realistic, seemed to herald the coming or return of an "antimodern" or "anti-avant-garde" direction. In this sense, pop artists such as Lich-

11.32 • Roy Lichtenstein. *As I Opened Fire . . .* 1964. Magna on canvas. Three panels, 68 × 56″ each. Stedelijk Museum, Amsterdam.

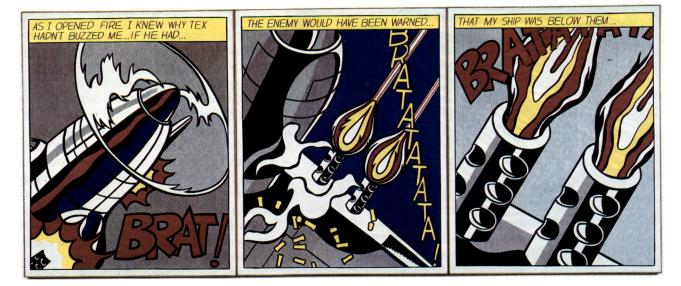

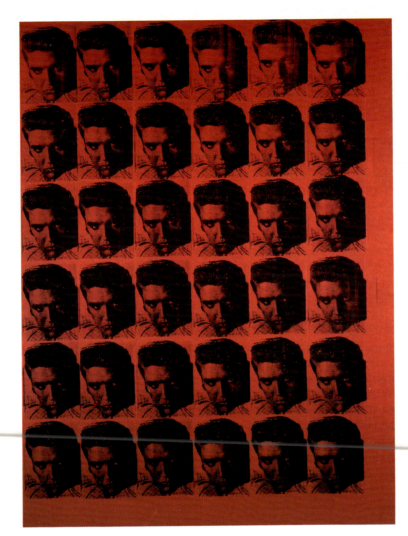

11.35 • ANDY WARHOL. *Red Elvis*. 1962. Acrylic and silkscreen on linen. 69½ × 52″. © The Estate and Foundation of Andy Warhol, New York.

President John F. Kennedy's grieving widow Jacqueline in *Twenty Jackies* of 1964, thirty-six repeated head shots of Elvis Presley in *Red Elvis* (11.35) of 1962, and so on.

The result of this repetition in Warhol's pictures of celebrities and products was to overload the viewer's mental circuits. Excessive repetition reduced the meaning of the person or product to the lowest common denominator. A famous celebrity such as singer Elvis Presley ceased to be a unique person. Endless repetition drained the guts from him. Converted to a superficial media image, the once soulful singer turned into little more than an instantly recognizable sign. Warhol's potent use of repetition made us only too conscious of how the unending stream of media images blunts our sensibilities. No image of a real human being, however striking, could stand up under the pressure of endless duplication. To repeat an image was to empty it, dehumanize it, reduce its intensity and complexity to the zero point. Were such works simply mirroring society, or were they implicitly criticizing it? Warhol, ever noncommittal, never told.

As to critical response to his work, Warhol had his ups and downs. Having made his way to New York from Pittsburgh in 1949, the painfully shy young man succeeded grandly in the area of commercial illustration. Through the fifties, he created whimsical drawings and watercolors that were used as illustrations for magazine articles, book jackets, record album covers, and advertisements. Major clients, such as RCA Victor, CBS Radio, and *Glamour* magazine, contracted his services. His commercial art work received prestigious awards from the eminent Art Directors Club. But, in the early 1960s, when he tried to find a New York gallery to show his "serious" art, none would have him. No one wanted to take a chance on an artist who painted "crass" subject matter (Dick Tracy and Popeye cartoon characters, Campbell's soup cans) in a bold commercial art style. When Warhol finally did get to show a series of his Campbell's soup cans across the country in a Los Angeles gallery, a nearby art dealer scornfully put a stack of actual soup cans in the window along with a sign that read, "Get the real thing for 29 cents." (If older vanguard critics thought pop artists such as Oldenburg and Lichtenstein were "sell-

actual product. At first, he handpainted each soup can in paintings that contained as many as two-hundred cans! Later, he employed a photo-silkscreen process by which he could mechanically repeat the soup can image, in grid formation, in whatever denominations he preferred. Here was a quintessential visual expression of mass reproduction, like the display a shopper would find on the shelves of the local supermarket: soup can after soup can, row after row. Shifting his attention between mass-produced products and mass-produced media images—were the two interchangeable?—Warhol selected well-known photographs of celebrities such as Marilyn Monroe and Elvis Presley, modified them to varying degrees, and then printed them, in grid pattern, over and over again: twenty close-ups of

outs" to the status quo, they must have judged Warhol to be the establishment's very own marketing machine!) But Warhol's impersonal pop realism soon began to catch on. The film-maker Emile de Antonio kept pressuring New York dealers to show his friend, telling them that Warhol's hard-edged imagery represented "our society, it's who we are, it's absolutely beautiful and naked." It was the wave of the future. And, in terms of art world and popular success, he was right. Lichtenstein, Oldenburg, and Warhol all received shows between 1962 and 1963. Critical response was heated, but the shows sold well. The popular press, in love with controversy, soon joined in with splashy publicity.

The pop art movement was launched, and it was soon accompanied by the vast "pop music explosion" that hit full stride in Europe and America around 1964. Of all the pop artists, Warhol was the most influential on the pop music scene. His grid format directly influenced the cover design of the Beatle's 1964 breakthrough album *A Hard Day's Night* (2.17). Like a whirlwind, the sixties pop music explosion carried Warhol into numerous pop counterculture activities, ranging from management of rock groups to album cover design for the Velvet Underground and Rolling Stones (2.19). Fluidly crossing media boundaries, the artist became involved with other collaborative projects, most notably alternative filmmaking. Typical productions, in which Warholian repetition and impersonality were taken to new lengths, were *Eat* (forty-five minutes of pop artist Robert Indiana eating a mushroom) and *Empire* (eight straight hours of New York City's Empire State Building filmed from a single unchanging camera position). Between these art pursuits and his numerous appearances before a mass media now insatiable for pop culture and counterculture news and gossip, Warhol's career as an artist and celebrity was launched.

In the 1960s, fine and popular art were blending as they had never done before. The old modernist avant-garde notion of the artist as lonely creator, working in the solitude of the studio, was under all-out attack. The whole direction of the new movement—pop, new realist, post-modern—seemed outward: fine art and the fine artist were venturing out into the nitty-gritty of the everyday world. New

roles, previously taboo, now became acceptable: the artist as documenter of external reality; the artist as "commercial" in subject matter, style, and business goals; the artist as media star. To most of the artists and critics of the old avant-garde, from Rothko and Newman to Greenberg and Rosenberg, pop art, and new realist art in general, looked like a "sell-out." The pop artists had been "co-opted" by the system. But to pop artists such as Warhol and Lichtenstein, the older modernist vanguard overemphasized subjective emotion, individuality, and personal creativity. These younger artists were looking around and appropriating things—media images, mass-market products, commercial and industrial art styles—that their abstract expressionist elders had scorned. They were men and women from different worlds. Whereas the abstract expressionists were shaped by the turbulent decades of depression and war, the pop artists were largely products of the post-war society—affluent, materialistic, and relatively peaceful—and the mass-media, mass-market culture of the fifties and early sixties. It is perhaps not surprising that, with backgrounds so very different from their abstract expressionist predecessors, the new realists broke with the values of the old, anti-establishment vanguard. If, in retrospect, abstract expressionism can be seen as the last major modernist avant-garde movement in North America and Europe, then new realism, more mainstream, popular, and "contextual," might well qualify as the first full-fledged post-modern one.

Other Forms of New Realism: Superrealist Sculpture and Photorealist Painting. Two forms of the new realism that soon became distinguishable from pop art but shared many of its values were **superrealism** and **photorealism.** So strong were some of the connections between pop and the two new currents that one superrealist sculptor, George Segal (born 1924), was, and often still is, identified as a pop artist. This is not surprising in one sense. His friendship in the late fifties and early sixties with artists concerned with the stuff of everyday life, including Kaprow, Oldenburg, and Lichtenstein, linked him personally with those who helped to found pop art. More to the point, Segal's plaster-cast sculptures in their environmental settings, which he showed

11.36 • GEORGE SEGAL.
The Diner. 1964–1966.
Plaster, wood, chrome,
Formica, masonite,
fluorescent lamp. 8′ 6″ ×
9′ × 7′ 3″. The Walker Art
Center, Minneapolis. Gift of
the T. B. Walker Foundation.
1966.

in New York from 1960 onward, resemble pop in their direct, impersonal representation of everyday reality. Segal's early environmental works even contained real-life props that recall pop art iconography: a movie marquee, common kitchen and bathroom furnishings, a counter and cooking equipment from an actual diner (11.36). A confirmed people-watcher, Segal often saw his human subjects "against garish light, illuminated signs . . .

visually vivid objects that were considered low class, anti-art, un-art, kitsch, disreputable. . . ." It was essential to include these "pop" objects in his work. Moreover, he was trying to look as "bluntly" as he could at these objects and the people involved with them. His was very much a pop way of seeing.

Yet as one pays more attention to Segal's art, the differences from pop art make themselves felt. To begin, Segal was representing

real people and things, not "secondary" media images of people or things. His plaster sculptures were cast from "live" human beings, and the settings he built for them were constructed from the actual objects of daily life. The work thus had a human immediacy that the "mediated" images of pop art lacked. Seeing a Warhol portrait was like viewing a person through the filtering devices of television or photography. Seeing a Segal portrait was almost like encountering the person in the flesh, but with several crucial exceptions. In Segal's people, naturalistic color was left out, and the details of the person's physiognomy were absent. The figures were stark white, the color of their plaster material, or painted in monochrome blue, black, or red to evoke a mood. Segal's situational figures always evoke a feeling state. Most apparent is a feeling of aloneness, isolation, and absorption in separate activities not unlike that in Edward Hopper's earlier paintings of American people and places (10.43). But other feelings also come through in Segal's work, not the artist's personal emotions but the feelings communicated by the individuals enmeshed in their specific situations.

Consider, for instance, the sculptor's "situational" sculpture, *The Diner*. It might bring to mind another late-night spot, van Gogh's *Night Cafe* (1.8). Some of the feelings van Gogh's *Night Cafe* embodies are similar, but the tone of Segal's work is cooler and more impersonal. Segal noted that the piece "is the essence of every New Jersey diner." Living forty miles from New York City, the sculptor frequently returned to his New Jersey home late at night, taking a much-needed coffee break on the way. He recalls the electricity of those late-night visits.

Walking into a diner after midnight when you're the only customer, there's both fatigue and electricity. The waitress behind the counter is always sizing you up, either wondering if you're going to rob her or rape her, if you're going to be dangerous or sexually attracted. There is a careful avoidance of eye contact with two people alone in a diner after midnight, but there's electricity—it's always present. My figures seem to be standing still, but I am interested in some kind of electricity or tension or ferment that's implied in the stillness.[17]

To capture this feeling of inner tension, Segal carefully chose the people and poses,

organized the props, and manipulated the spatial relations between figure and figure, figure and prop.

With *The Diner*, the obvious fact is that the waitress and the fellow drinking coffee are not psychically connecting. In my original version, I had something like eight feet of bare, empty counter between them, and something wasn't clicking in the piece. When I clustered the two figures together, I had a huge expanse of emptiness and the two figures were presumably huddling together for warmth, and to me ... I increased the psychic distance between them by making them one big lump. Two figures combine to make one big lump against all the emptiness. The power of the form is very real to me, the shape of the counter, the color of the bulk.[18]

For all their literal or psychological content, the new realist artists, pop artists included, always made certain to emphasize the formal content of their art. Of *The Diner*, Segal said that "the white figure, the waitress, is against the pure intense red of a wall; the bottom half of the seated man is against the dark, black/green linoleum of the counter. And they are austere, abstract, dark, light, vivid—every kind of thing."

For the artist, creating such a work was "like walking a tightrope and doing a juggling act" because there were so many choices to make and variables to balance: choosing the most expressive gestures for the persons, making the right combinations of shapes and empty voids, selecting and organizing the coffee urn, cups, counter, and fluorescent lighting to evoke the necessary mood. In van Gogh's *Night Cafe*, one is impressed by how far apart people can feel even when they are in close physical proximity. Segal's *Diner* is a similar kind of place, but the sense of alienation comes across more quietly, through a chilly realism.

Warmer in feeling tone and far more naturalistic, the sculptures of Duane Hanson (born 1925) qualify as full-fledged superrealism. Like Segal, Hanson places his figures in commonplace and lifelike situations. But unlike Segal, Hanson strives for extreme naturalism in his figures as well as his settings. He makes his figures by pouring a synthetic liquid plastic into plaster molds cast from actual persons. He then paints the hardened plastic figures in infinite detail, dresses them in actual clothing, and even implants real hair, strand by strand, into their scalps. The final product

can be so lifelike that many viewers have gone up to Hanson's sculptures to ask them questions. When they receive no answer, they do a startled double-take.

Yet for Hanson fooling the eye is only a means to a more important end. Like George Segal, Hanson is concerned with communicating social truths about everyday people and situations. But whereas Segal tends to subtlety and mystery—the number of meanings that viewers can bring to the relationship between the man and woman in *The Diner* are many—Hanson tends to be more socially and psychologically specific in his meanings. In his early works of the late sixties, such as *Race Riot* and *War,* the meanings are emphatically sociological and crystal clear. The tension in such works arises from conflict between specifically recognizable social groups and are directly related to specific historical events: the Vietnam War and the race riots in Harlem and Watts in the late 1960s.

In the early seventies, Hanson's sculptures gained in naturalism and shifted toward a balance between social and psychological meanings. Giving the sculptures greater psychological weight was Hanson's use of single figures, in contrast to his earlier group ensembles. The sculptures also became increasingly lifelike. Whereas before the figures looked somewhat stereotypical—"generic" cops, rioters, soldiers—the sculptures now took on highly individualized presences. The works became portraits of individual, mostly working-class people: art museum and security guards; tourists; cleaning women and waitresses; construction workers, tired shoppers, struggling old people. Even a few artists (paint-spattered artist-laborers?) joined the roll call of blue-collar workers (7.57).

This focus on ordinary people in their ordinary surroundings relates Hanson to the larger new realist movement, but it was soon clear that his aims are quite different from those of his pop art predecessors. Hanson, like Segal, is concerned with actual life versus media versions of it. Like Segal, he is also a determined social realist. But, more than any other new realist, he is an explicit social critic. He wants his art to express his "feelings of dissatisfaction" with the world. He is a politically motivated artist concerned with "lost

causes, revolutions," and society's forgotten people. His portraits reveal to the privileged persons who view and collect his fine art a completely different social circle: the men and women who work the menial jobs, receive the low wages, live the "low-brow" life-styles. As a contemporary German art critic put it, "His figures portray individuals on the edge of nice society, the losers, people who have given up. They are people at work, bored, dull and tired, and their empty faces reveal their troubled empty lives." *Woman Cleaning Rug, Dishwasher, Repairman, Woman Derelict, Man with Hand Cart:* these are Hanson's people.

Over the years, Hanson's figures have taken on more complex meanings, exuding what the artist likes to call "the bittersweet mixture of life." Speaking about his *Dishwasher* (11.37), the artist asks us to put ourselves

. . . in the place of a guy who washes dishes day in and day out, one who doesn't have many aspirations except to have a color television set. That was one of the things the model was planning to save his money for. . . . He does his job well. He could wash dishes faster than any guy I ever saw.[19]

Such a man's life is indeed bittersweet. His work is esteemed by very few, yet he does it well and probably takes some pride in it. The less pleasant side is that he is overweight and tired. Eyes downcast, shoulders sagging, he is beginning to look old and misshapen before his time. High blood pressure and a heart attack may be on the way. Is this dishwasher not a twentieth-century counterpart of the faltering young man in Courbet's *Stone-Breakers* (9.13)? Is he not an inevitable victim of a commercial-industrial society where only some can really succeed? The dishwasher may indeed be able to buy that color television someday and stock his refrigerator with beer, soft drinks, and junk food. But is this truly "the good life"? "Do we really want our citizens to live this way?" These are the questions that Hanson's sculptures ask. They are meant to jog our social consciences. Because they are so real in every way, they will not let us forget.

The superrealist sculpture of artists such as Hanson is usually seen as the three-dimensional counterpart to the work of photorealist painters such as Chuck Close (born 1940) and Richard Estes (born 1936). The painted images of these artists look so real that viewers often mistake them for large-scale black-and-white or color photographs instead of oil or acrylic paintings (7.56). In fact, they are paintings based on photographs. Working from color prints or photographic slide projections, photorealist artists meticulously select from and imitate the visual reality captured by the camera. Their reasons for turning to photographs were essentially twofold. In practical terms, it was far easier to work from photographs in the controlled comfort of the studio than to return to a particular location day after day, in all kinds of weather, or pay a model to hold the same pose for weeks and months. In addition, in a culture dominated by photographic images, it was inevitable that certain painters would ultimately attune their works to a photographic way of seeing and representing. The pop artists, after all, had already been mining magazine and newspaper photographs for their subject matter and style. The photorealists turned photography to a rather different end: the construction of the most illusionistic *trompe-l'oeil* (fool the eye) paint-ings of commonplace scenes and people ever seen by twentieth-century eyes.

Like the superrealistic sculptures of Hanson, photorealist paintings received mixed reviews when they made their debut in the early 1970s. Many viewers and critics saw little more than copying in such art. All who beheld them admitted that the paintings and sculptures were extraordinary technical accomplishments. Being so large, Chuck Close's portraits were particularly impressive; *Phil* (11.38), a black-and-white portrait of composer Philip Glass, is nine feet high by seven feet long. "How was that done?" nearly everyone asked in astonishment. But, in the end, viewers and reviewers often judged photorealists' technical tour de forces to be more imitation than art.

11.38 • CHUCK CLOSE. *Phil.* 1969. Synthetic polymer on canvas. 9' × 7'. The Whitney Museum of American Art, New York. Purchase, with funds from Mrs. Robert M. Benjamin.

11.39 • RICHARD ESTES. *Downtown.* 1978. Oil on canvas. 122 × 152 cm. Museum Moderner Kunst, Vienna. On loan from the Ludwig Collection, Aachen, Germany.

Modern art had long ago cast off imitation and copying for expression, imagination, and abstract form. Were superrealist sculpture and photorealist painting turning back the clock of art history?

In the absolute mimesis of photorealist paintings, the originality, individuality, and passion that characterized so much earlier modernist art—abstract expressionism, surrealism, cubism—were utterly absent. Even when photorealist paintings were compared to their nearest artistic neighbors, the pictures of earlier twentieth-realists such as Edward Hopper (10.43), the initial responses were not favorable. (Most realist paintings of the past were based on a different way of seeing: the human looking at a scene rather than photographic reproduction.) Compared to a Hopper, a streetscape by Richard Estes (11.39, 7.56) looked strangely mechanical, impersonal, and feelingless. And, to be sure, photorealism is all of these things. Without apology,

photorealist painting is as cool, exacting, and revealing as the all-seeing machine eye of the camera. Herein lay its exciting strengths and, for certain critics, its serious limitations.

Harold Rosenberg, while admitting the illusionistic prowess of these new "sharp-focus realists," lamented that they, like their pop art predecessors, had cast off the modern movements "avant-garde principle of transforming the self and society." While the old vanguard critic found Estes's "photographic" paintings "the most consistently satisfying" in an early new realist group show, he lamented that photorealism had taken up pop art's "cool neutralism as an antidote to the emotional heat of abstract expressionism." "This frame of mind," wrote Rosenberg, "has been inherited by photo-realism, but without the counter-awareness of the Expressionist subjectivity; the new coolness [of photorealism] came in from the cold." Such painting seemed a conscious rejection of the most important modern

art of the previous decades, lacking completely "any tension aroused by the art of the past." Along with pop, photorealism seemed to be striking out in an opposing path, one that was soon called "post-modernism." "In copying in paint its photocopies of nature," Rosenberg concluded, "the present generation of realists seems to feel freer of the demands of [modern avant-garde] art than any of its predecessors. By all evidence, a new stage has been reached in merging painting and sculpture into the mass media." For Rosenberg, new realist art did not challenge society but rather reflected it, just as the photographic, cinematic, and video images of the mass media did. In the opinion of older avant-garde critics and artists, such straightforward reproduction of reality was a grave limitation and weakness. Yet, even its opponents had to agree that photorealism's reflection of the world was a stunning one.

"We see things photographically," says painter Richard Estes with characteristic conciseness. "We accept the photograph as real." Like the photographs from which he selects his visual "information," an Estes painting is characterized by immense detail, infinitely subtle values, fleeting reflections, and the lighting of the moment. Formally, his paintings feature precision, smoothness of surface, and clarity of shape and color. Only up close can one discern the human touch of the paintbrush. (Certain photorealist painters, such as Chuck Close, strive for even greater realism and impersonality by using airbrush tools that spray the paint onto the canvas, thus eliminating all traces of the human hand in the work.)

Their meticulous realism notwithstanding, Estes and his photo-realist colleagues are more interested in formal than human concerns. They care more about "making a painting" than making social comments about the places or people they record. They speak, for the most part, of surface and depth, clarity and sparkle, order and balance, and compositional organization. They also frequently discuss materials and techniques: underpainting, overpainting, refinement, and "finish." Given such strong formal concerns, it is understandable that they have excluded storytelling, narrative, and emotion from their work. In many ways, they treat their scenes or people as still lifes,

frozen objects to be rendered in paint. Estes, for example, examines buildings as abstract objects of color, shape, and texture rather than as containers that reflect and shape the lives of their human occupants. People are rarely presented. The urban environment, as a visual structure, is generally the subject and object of the work. (A thoughtful viewer might nonetheless learn a great deal about our urban culture from an Estes painting; the amount of objective visual data provided is enormous.)

In an interview, Estes revealed that he doesn't even like most of the places he paints. Given a chance, he would have torn down most of the subjects of his works. He chose them for formal and technical reasons. In the flashing lights, bold signs, and expanses of window glass filled with "rich and exciting" reflections he found a variegated world of color, shape, and design to exploit. Disregarding social or psychological considerations, he looked at his city motifs coldly, abstractly, "without comment or commitment." By so doing, he could manipulate the scene strictly for its visual potential.

Why did he paint pictures of these particular scenes? Estes answered that these were the surroundings in which he lives. He simply wanted to paint them, just as artists for centuries have chosen to reproduce their immediate surroundings. In Chicago, where he had gone to art school, and in New York City, his adopted home, nature had been replaced by the manufactured environment of culture. "It's funny," he observed, "all the things I was trained to paint—people and trees, landscapes and all that—I can't paint. We're living in an urban culture that never existed even fifty years ago." Shaped by the imperatives of this urban environment, by photography, and by the formal requirements of painting a good realist picture, Estes produced paintings of city scenes that not only "fool the eye" but also help the eye to see more of the real world than it has ever seen before.

Into the Eighties and Nineties: Varieties of Figurative Art.

By the 1980s, art of a primarily representational or figurative character had returned to a place of dominance in the world of fine art. So-called abstract art, nonfigurative or highly abstract in form, which had been

such a powerful force for most of the century, no longer reigned supreme, although it was still a very significant area of creativity in the hand of such artists as Joan Mitchell and Sylvia Lark (Appreciation 29). The tremendous popular success of pop art, photorealist painting, and superrealist sculpture in the art world and public arena opened the floodgates for figurative artists of all kinds. Critics and historians began to discuss, and galleries and museums began to show, numerous artists who focused on the human figure, the architectural or natural landscape, and still lifes. The traditional centuries-old categories of painting and sculpture—history, portraiture, genre, the nude, still life—experienced a remarkable rebirth of popularity, something of a public renaissance. "Cooler" approaches to realism, such as those of Warhol, Estes, and Segal, were joined by "hotter" forms of expressionistic and surrealistic figuration, which often simmered with psychological or social content. Long-time masters of figurative art, overlooked or undervalued by modern art museums during the "age of abstraction," were awarded major one-person shows at the world's most important museums in the 1980s and 1990s. For example, in 1987 the Berlin-born British painter, Lucian Freud (born 1922), grandson of the psychoanalytic theorist Sigmund Freud, had a major one-person retrospective show at the prestigious Hirshhorn Museum of Art in Washington, D.C. There reviewer Dave Luljak, and thousands of others, experienced Freud's powerfully expressive portraits for the first time (Appreciation 30).

Along with "significant form," the rallying cry of those who championed formalist abstraction, one began to hear increasingly of the importance of "significant content." Psychological and social content began to rival and even surpass abstract visual form in terms of critical attention. Older American artists who probed psyche and society—individuals such as May Stevens (Appreciation 31), born in 1924, and Leon Golub, born in 1922— were "discovered" by the art establishment.

Younger figurative artists gained international renown as leaders of the worldwide **neo-expressionist** movement. Among these were the Italians Francesco Clemente (born 1952) and Enzo Cucchi (born 1950) and the Germans Georg Baselitz (born 1938), Jörg Immendorff (born 1945), and Anselm Kiefer (born 1945), the latter's mighty works moving fluidly between figuration and abstraction. This important movement emerged to critical acclaim and commercial success in the late seventies and early eighties. (Among the forebears of the new expressionism, especially respected by the German artists, were van Gogh, Munch, Kirchner and the Die Brucke group, and Max Beckmann.) Figurative artists working in the United States whose art was closely identified with the new expressionism were Robert Longo (7.58), Julian Schnabel (born 1951), and David Salle (born 1952) and the British-born artists Sue Coe (born 1951) and John Ahearn (born 1951). Almost all of these artists were born after World War II, and the European artists, perhaps even more than American artists, initiated the neo-expressionist movement. Although New York City and North America remained the capital of the international art world, in keeping with American economic, political, and cultural superpower status, the international nature of neo-expressionist movement showed that other countries and centers were beginning to gain clout in the art world. Moving beyond what some called the "cultural imperialism" of New York, the art world was becoming steadily more internationalized and regionalized. Important art might now originate from almost anywhere: Berlin and the Black Forest in Germany, the hill towns and cities of Italy, the American Midwest and rural South.

Two Neo-Expressionist Artists: Leon Golub and Eric Fischl. Of all the figurative artists, young and old, associated with the new expressionism, Leon Golub stands out as an emotional powerhouse. Born in Chicago in 1922, Golub belongs to the generation of artists who followed close on the heels of the first-generation abstract expressionists. Touched by the Depression, the Holocaust, and the Cold War, Golub shares something of the alienated existential sensibility of the first-generation New York School. But instead of shifting his aim away from a disturbing world and toward psychological or metaphysical concerns, as Pollock and Rothko did, Golub focuses on the most unsettling aspects of modern civilization

11.40 • LEON GOLUB. *Interrogation II*. 1981. Acrylic on canvas. 304.8 × 426.7 cm. The Art Institute of Chicago. Gift of the Society for Contemporary Art, 1983.

itself (11.40). Violence between people and between nations is strongly reflected in his work of the 1960s. The Vietnam War looms large. Works are titled *Combat, Napalm,* and *Vietnam*. Gigantic, primitive figures run, battle, and fall. Violence reigns. In all the artist's works of the last two decades, two harsh questions confront the viewer: Is it possible to lead a meaningful existence in a world governed by power and violence? How does one live morally in an amoral world? Golub's works are uncomfortable ones. They never let us off the hook. They ask only the toughest existential and ethical questions, and ominously stare out at us and demand answers.

Since the mid-1970s, Golub has focused on the civil wars of the third world, especially those in Central America and Africa. His huge expressionistic paintings bring us face to face with prisoners and torturers, third-world death squad killers and their victims. True to their content, the works are charged with a disturbing malevolence. They are intentionally ugly, seething with evil, shocking the viewer into specific moral questions and concerns: Does our government support such activities? Do we aid third-world nations who torture and murder their opponents in these gruesome ways? Golub, the political activist-artist, thinks so, and his paintings cry out against American involvement in countries such as El Salvador, the cruel model for many of his *White Squad* (i.e., that is, death squad), *Mercenaries,* and *Interrogation* series. Such "activist pictures," writes critic Donald Kuspit, "are not simply war pictures but concern the sadomasochistic interaction between alien groups of people. . . . These groups experience each other as foreign, almost nonhuman, and so feel free to victimize each other, to treat each

other inhumanly." Placing the artist in historical context, Kuspit sees Golub as sharing Gauguin's and van Gogh's "tragic view" of life while at the same time, like Courbet, facing up to the tragedy through an activist social commitment.

It is Golub's greatness, Kuspit writes, to have recaptured the original purpose of the cultural avant-garde: to reveal "the most advanced social tendencies"; to agitate for a better world even if it means laying "bare with a brutal brush all the brutalities, all the filth, which are at the base of our society." And like the realist Courbet, painting worn-down stone-breakers and ragged peasants, Golub might justifiably be called "an apostle of ugliness." As Kuspit sees it, Golub's restoration of the traditional sense of the avant-garde—in the radical, oppositional tradition of Courbet, van Gogh, Gauguin, the German *Die Brucke* expressionists, the Berlin dadaists, Max Beckmann, the Picasso of *Guernica,* and the abstract expressionists—is crucial to the progress of art in the late twentieth century. In comparison to art of such social weight and criticality, filled with an immense "tragic sense of life," mere formalist innovation, however artful, appears lifeless. As Kuspit puts it, "The newly naked appearance of the tragic perspective in Golub's work not only shows his continuity with the greatest modern art but also the bankruptcy, the increasing absurdity, of pure [formalist] painting, and the impossibility of practicing it authentically today." For both critic and painter, significant content is the heart and soul of any art that has something truly important to say.

Eric Fischl (born 1948) is another, much younger "painter of modern life" who has a great deal to say. His content, like Golub's, is significant morally, psychologically, and socially, and his style is a similarly disturbing mix of realism and expressionism. Raised in the suburbs of New York City, Fischl sets his sights on the social and sexual life of affluent America and the international jet set. In the 1960s and 1970s, certain pop artists had taken as their subject the sex-saturated images of the American mass media. In bold frontal embrace, they played with the media's exploitive images. One pop artist portrayed women as sex objects, faceless beings whose breasts, gen-

itals, and lips were emphasized above all else. Mimicking the media, another pop artist presented women in an equally pornographic way, as seductive nude salespersons of commercial products. In contrast, the younger Fischl chose to portray sexually charged North American and European life firsthand, especially among its well-to-do members. His representations of contemporary sexual activities (masturbation, intercourse) and sex-role relationships (between mother and son, father and daughter, black man and white woman, Western tourists and third-world natives) are characterized by a complex ambivalence. The paintings seethe with mixed emotions: guilt and excitement, affection and aggression, attraction and repulsion. In addition, they tell complex stories with varying clarity. As Fischl himself tells it, modern existence is difficult and trying. Traditions and rituals that once taught people their social and sexual roles and gave life meaning have been wiped out. Each person must struggle and find his or her own way, and that is not easy to do.

Fischl's 1985 painting *A Brief History of North Africa* (11.41) is filled with social conflict and sexual ambivalence. A clothed, dark-skinned North African, a boy on his shoulders, walks toward a group of Western tourists on a sandy ocean beach. The hot, high-pitched yellows of the sand shout with intensity against the brilliant complementary purple-blues of the sky. The man has come to sell the Westerners "tourist art" to make his living. A young white-skinned boy runs eagerly toward the North Africans. Broad, bold brushwork animates his body and the entire scene. He seems excited by the sight of the exotic objects, especially the strange, many-armed, white-faced doll. The white boy's body melds into that of the African who walks toward him. At the same time, a bored jet-setter looks away; she appears in the same reclining nude pose in other Fischl paintings with vacation spot titles (*The Black Sea, Costa del Sol*). Her dark glasses, hard look, and body language tell us she couldn't care less about native culture or tourist art. Yet her leg lies between the eager boy and the North Africans. Will she stop the boy from making contact with the Africans or simply ignore their interaction? Is she the boy's mother or a stranger? The artist leaves this,

11.41 • ERIC FISCHL. *A Brief History of North Africa*. 1985. Oil on linen. 7′ 4″ × 10′. Private collection. Courtesy of Mary Boone Gallery, New York.

and the resolution of other little stories in his paintings, to the viewer's imagination. In a Fischl work, ambivalence and open-endedness always confront us. We, the viewers, have to "complete" his pieces.

On the right half of the painting, another story is unfolding. Made up of revealing little incidents, a "brief history of North Africa" is passing before our eyes. A North African woman, primly covered from head to foot in traditional garb, appears to walk steadfastly past us. She is the old Africa. We look up at her from beach level. She does not look back. She will soon walk out of our sight. As viewers, we see her as the other Western tourists, reclining nude on the brilliant sunlit beach, see her. Is Fischl implying that we and the tourists are one and the same? Are we, like the central figure, fixated on our own thoughts or sights? Or are we like the brown-skinned young woman in the black bathing suit who gazes at the tradition-bound African woman? Do we take off our suits and join in the nude sun-bathing? Or do we respect the traditional North African ways by keeping our swimsuits on? Do we buy tourist art and trinkets from the native person who depends on us for his livelihood? What do we do? How do we act? What is right?

A Brief History of North Africa asks many questions, and many of these questions are moral ones. They concern the conduct of our lives and the effect of our lives on others. The issues are large, and the answers are not easy. Perhaps that is why Fischl paintings often make us uneasy. They touch a lot of nerves. "One is forever on such brinks with Fischl," writes author Peter Schjeldahl, "gazing into deep waters and debating whether to take a plunge." "He is a witness," Schjeldahl continues, "giving testimony that must be taken . . . point by point and word by word." The stories that expressive realists such as Fischl, Golub, and Stevens tell us bear serious listening. In work like theirs, fine art returns to the arena of morality and ethical conduct with a vengeance.

revealed a concern with an expanded set of issues—light, boundlessness, and the subtler side of the emotions—in succeeding decades.

Mitchell's labors are a quiet and concrete reminder that the concerns of abstract painting have disappeared only to the extent that we say they have and are alive to the extent that we practice them. Although an abstractionist, Mitchell is concerned above all with nature and the emotions. Proceeding less from concept than from feeling, she paints paintings—of fields, streams, and sunflowers—that are at once purely abstract and purely representational. A lifelong love of poetry vitalizes the work with the patterns of emotions, patterns in tune with her own life crises. Her mature work speaks of homages to friends, of mortality, of loss. Psyche and paint are linked in ways more subtle and more exploratory than the link of psyche to "psychoanalytic" imagery of the 1930s. Mitchell herself describes this link:

> What makes me want to squeeze the paint in the first place, so that the brush is out, is a memory of a feeling. It might be of a dead dog,

Figure B • SYLVIA LARK. *Chanting.* 1987. Oil on canvas. 6′ 4″ × 8′. University Art Museum, University of California at Berkeley. Gift of Jeremy Stone.

it might be of a lake, but once I start painting, I'm painting a picture.

Mitchell speaks for the tradition of painterly painting. Always seeking light in her work, she looks to the light in Goya [9.4], Delacroix [9.7], or Bonnard with the same intensity that she looks to her memories; both are the content of the work. Mitchell's great gift may be to remind the art world that content in abstract painting is made of both memory and light, metaphor and paint. Mitchell's path has been a quiet one. She has taken the time to do the labors required to extend the range of abstract painting's meanings and painterly means.

A second generation of abstract painters has continued this work. Elizabeth Murray, Susan Rothenberg, Sylvia Lark, Louisa Chase, Mary O'Neal, Gregory Amenoff, Terry Winters, and Katherine Porter are representative of artists who have widened the thematic scope of abstraction. It is not accidental that among this group there is a higher proportion of women and a greater ethnic diversity than characterized the New York School. As an alternative to the scenario where painting loses its credibility, this story demonstrates the extension of painting to a wider range of human experience.

Sylvia Lark (born 1947) exemplifies several kinds of extensions that have occurred in the current generation: she alludes to the icons of diverse cultures; she challenges the dominant male formal structures of painting; and she is self-aware of the dangers of cooptation. Richard Wollheim says this of her work:

> Critics, rightly, have stressed Lark's visits to Africa and the Far East and her experience with alien shrines and cults. But what impresses me most about these paintings is the return journey they record. Amulets, archaic rocks, scraps of veil and silk, passages of half-erased script, lie side by side with her father's bric-a-brac, with vestiges of the body, and now, most recently with lumps of paint exploding onto the palette . . . Lark's art is, amongst other things, an art of equivalences. It equates, by means visible to us, affections and feelings we would have thought irreconcilable.

As in Mitchell's work, the painterly means of Lark's work keep pace with the extension of content. In *Chanting* (Fig. B), a painting ostensibly about a Tibetan prayer ceremony, thin pastel glazes give the work a structure that depends neither on Renaissance illusions of depth nor on the dynamics of the flat "picture plane." Instead, the space floods off the canvas and exists in a vibrant atmosphere between viewer and canvas. Lark borrows the freedom of abstract expressionism, but, like Mitchell, extends it. For Lark, paint is pain and sexuality, a sense of touch and a sense of what cannot be touched. The work extends painting's expression of spirituality both by its inner motives and by the painterly inventiveness on the surface of the canvas.

In Lark's work, as in the art of many of the abstractionists noted here, paint precedes concept, and the painting is less receptive to quick historical categorization than are conceptual, minimal, or neo-expressionist genres.

By one view, abstract painting "died" for this very reason. But from another, all art is dying because its deeper levels are lost through facile art historical interpretation and by cooptation to art market commodity or pop-cultural status. We are approaching a situation where many avant-garde works are not distinguishable from MTV; they are fast, pulsating, and shallow. The deeper levels of human experience still need subtle and ambiguous means to be expressed fully. Ann Gibson has written of the abstract expressionists' refusal to make their artistic intentions explicit. Donald Kuspit calls abstraction the final taboo, the refusal to make complex meanings clear in precise verbal terms. In Mitchell, Lark, and other contemporary abstract painters, meaning is taken seriously, but the form of its conveyance is kept beyond the range of any simplistic or reductive translation. Abstract painting defeats its own communicative power in small ways so that it can survive in larger ways, and with that survival it preserves the chance to speak to the broadest range of human emotions. ■

Lucian Freud. *John Minton*.

DAVE LULJAK

All art reflects what it is to be human, but the portrait confronts this question directly. For the past century, the portrait has played a slight role in the history of art. Not only have artists of this period generally satisfied their artistic concerns through other subject matter, but it seems that our philosophical self-understanding has been stunted as well by the presence of various forms of materialism and technology that encourage us, for example, to think of human happiness in terms of manufactured products and human capability in terms of the behavior of machinery. The portraits of Lucian Freud represent a striking exception to this general situation.

Unlike many twentieth-century figure paintings, in which the figure is little more than an excuse for making a nice modernist painting, Freud's portraits present a profound view of the human condition. Freud's view is consonant with the twentieth-century philosophy collectively called existentialism. Unlike portraits from the Renaissance through the romantic period, his do not portray an ideal of human dignity, social rank, spiritual depth, or inner turmoil. Instead, Freud presents his sitters as mere objects stripped of any obvious distinguishing human trait. All that separates them from other forms of matter is the anxiety brought by their consciousness of this fragile existence as a thing among other things.

John Minton (Fig. A) is representative of a number of Freud's portraits painted in the late 1940s and early 1950s. What is most striking to me is that Freud presents a view neither of the social, conventional persona nor of the inner life of the sitter. Instead, Freud reveals to us the surface of the human being, stripped of its comforting customs and habits and emptied of its significant thoughts and emotions. Considered as an object among objects, the significant human feature becomes the skin, the highly charged point of contact of thing with thing and the arbiter of interior and exterior worlds.

Two features of Freud's portraits are central in revealing this view of the human being. First are the eyes. Conventionally, eyes have been considered "the windows on the soul," providing a key to divining the human psyche. In Freud's portraits of the 1940s and 1950s, the eyes are large with a surface something like a translucent egg shell. The size of the eyes seems to promise vision, both inward and outward, but they are impenetrable, preventing us from gazing into the soul of the sitter. They are glazed, indicating no focused attention on the part of the sitter. They seem equally hard and brittle, as if they could easily be made to expose what Shakepeare's King Lear called the "vile jelly," the mere matter that makes up the sophisticated instrument of the eye. Also noticeable is the spread-out gaze of the two eyes,

Dave Luljak is an artist and philosopher who has published in the journal, Art Criticism. He lives in Stony Brook, New York.

each wandering away from the direction of its partner. Psychologically, this creates a mood of disturbance in the figure, as if the sitter is on guard against an attack that might come from some unknown direction.

Physiologically, this spreading gaze is part of a second significant element of these portraits, a stretching of the sitter's features. Distortions in perspective give an elastic aspect to the skin of these figures, expanding the surface area and focusing our attention on the taut membrane of the flesh. All significance is concentrated at this surface, at the point of contact of the human matter with other matter. The flesh, and by extension the human being itself, is rendered as simultaneously shell-like and visceral.

What keeps these paintings from being depictions of pure, soulless materialism is the sitter's awareness of the uneasy condition of his or her humanity. The condition is uneasy because it is not explicable through the laws of cause and effect or instinct by which we understand the material or animal worlds, nor is it illuminated by the faith in the power and benevolence of reason found in the previous three centuries.

This view of the human being as essentially a thing, caught up in a whirl of surface appearances and sensations, informs such diverse mid-century works as the existential philosopher Jean-Paul Sartre's novel *Nausea*, the artist Alberto Giacometti's *Walking Man* [Appreciation 20, Fig. B], and the detective writer Dashiell Hammett's *The Maltese Falcon*. Lucian Freud paints this view of human existence, stripping his sitters of both the inner and outer trappings that we regard as constituting our humanity, rendering the human as an anxious and fragile membrane of sensation. In the paintings of Freud, the skin becomes the concrete representation of the perilous sliver of space between fatalism and self-determination that existentialism regards as the home of the human being. ■

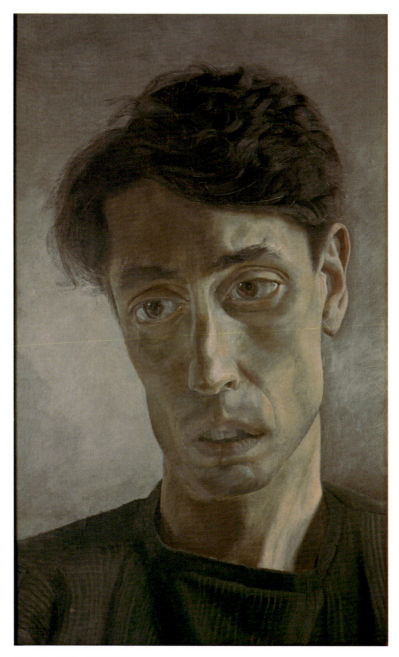

LUCIAN FREUD. *John Minton*. 1952. Oil on canvas. 15¾″ × 10″. Collection of the Royal College of Art, London.

The Painting of May Stevens

JOSEPHINE WITHERS

May Stevens's odyssey with Rosa Luxemburg (1871–1919), "Polish/German revolutionary leader and theoretician, murder victim" and her mother, Alice Stevens [1895–1985], "housewife, mother, washer and ironer, inmate of hospitals and nursing homes," began modestly with a two-page spread of collages in the first issue of *Heresies* magazine. This 1976 "Tribute to Rosa Luxemburg" and "Two Women" fitted well with *Heresies'* avowed goal of examining art and politics from a feminist perspective.

. . . This was the beginning of a complex exploration of the relationships between herself and Rosa Luxemburg—her adopted "ideal" mother—and her own mother, Alice Stevens, and ultimately between Rosa Luxemburg and Alice Stevens. . . .

After Stevens introduced Alice Stevens and Rosa Luxemburg in *Heresies,* she presented them as the presiding spirits in *Mysteries and Politics* (1978) [Fig. A], an imaginary gathering of thirteen women. Their realms were still divided. On our left Alice Stevens holds her baby daughter, May Stevens; on this side is the wisdom of the body, of intuition, and unconsciousness—represented by performance artists Betsy Damon, Mary Beth Edelson, and painter Pat Steir. In the apparent center, the Madonna-like figure of artist Poppy Johnson holding her twins echoes Alice Stevens's cradling gesture. To the right looms Luxemburg's spectral head, presiding over the

realm of the intellect of words, of concrete knowledge—represented by art historians Pat Hills (visibly pregnant) and Carol Duncan; artists Suzanne Harris, Joan Snyder, Amy Sillman, and anthropologist Elizabeth Weatherford. At the actual center of the painting stands the artist herself, looking back, and pointing toward the Madonna figure. Once again [as in a number of earlier paintings], Stevens used a triptych arrangement but now with a fluid, cinematic space and stretched wide-angle perspective. This painting set the stage for the development of a dialectical and shifting relationship between Rosa Luxemburg and Alice Stevens which May Stevens explored in other paintings. And by now it was clear that Stevens's own version of the imaginary gathering . . . was to be articulated in terms of her women's community—actual, historical, and mythic. It is well to keep in mind that many other feminist artists were engaged in similar work at this time: among others, Mary Beth Edelson (*Some Living American Women Artists*—a collage remake of da Vinci's *Last Supper*), Faith Ringgold (*Family of Women*), and Judy Chicago (*The Dinner Party*) [Appreciation 32].

At the time Stevens did *Mysteries and Politics,* she had been reading Adrienne Rich's *Of Woman Born: Motherhood as Experience and Institution* (1976), one of the early books to reevaluate the institution of motherhood from a feminist perspective. *Of Woman Born* clearly influenced the development of Stevens's own thinking. In fact, she appears to have responded directly to some of Rich's observations, as when Rich writes: "Many women have been caught—have split themselves—be-

Josephine Withers is a professor of art history and has served as Director of the Women's Studies Program at the University of Maryland, College Park.

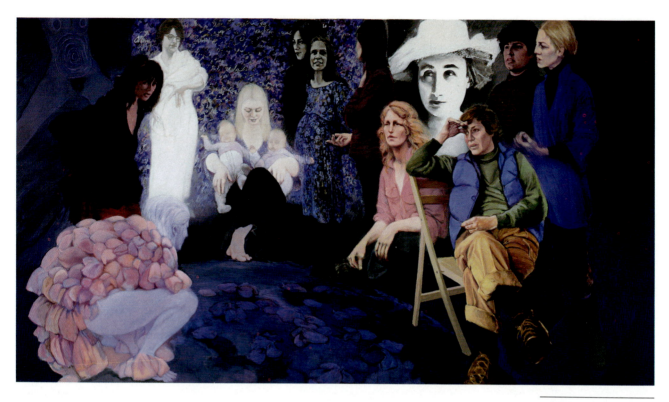

Figure A • MAY
STEVENS. *Mysteries and
Politics*. 1978. Acrylic on
canvas. 6′ 6″ × 11′ 10″.
San Francisco Museum of
Modern Art. Gift of Mr. and
Mrs. Anthony Grippa.

tween two mothers: one usually the biological one, who represents the culture of domesticity, of male-centeredness, of conventional expectations, and another, perhaps a woman artist or teacher, who becomes a countervailing figure." Rich argued that "this splitting may allow the young woman to fantasize alternately living as one or the other 'mother,' . . . But it can also lead to a life in which she never consciously resolves the choices. . . ."

Stevens first used the title "Ordinary. Extraordinary" in her artist's book, published in 1980; at the time she began to explore a way through or around this splitting that Rich described. The photo and Xerox collages in the book [featuring images of Rosa Luxemburg and her mother] were "written on, painted on, added to, subtracted from, desiccated and destroyed by repeated reproduction and loss of intermediate values and detail." The intention was to erode, break apart, and confound the divisive and polarized notion that the one woman's life was special, exemplary, extraor-

dinary, and the other was banal, forgettable, and ordinary. Stevens's particular treatment of her theme responds to and challenges Rich's implicit argument that one must choose the one or the other. She does not, however, seek to flatten out the extreme contrasts and differences implicit in these women's lives with an easy resolution. "I don't want a false resolution, in my work or in my theory. I will rather have it not fit than force it, or cut off something, or deny something I believe in."

. . . The painting *Forming the Fifth International,* in the "Ordinary. Extraordinary" series, was completed in 1985 [Fig. B]. Here Rosa Luxemburg and Alice Stevens are conversing in a garden, presumably speaking of the revolution which will "be once again," and which, Stevens implies in the title, must include women's voices if it is to succeed. Pictorially, however, the painting is more problematic than this description indicates. Although the depicted space is unified, the

(continued)

521

Figure B • May Stevens. *Forming the Fifth International.* 1985. Acrylic on canvas. 6′ 6″ × 9′ 7″. Collection of the artist.

figures are not. Alice Stevens is both palpable and luminous, her body boldly modeled. Rosa Luxemburg, however, is flatly painted . . . and so appears to sink back into the painting and to remain just beyond our touch. The incongruities and the dis-ease of this picture are not unintentional, and can be understood as part of Stevens's strategy to deepen her understanding of her own mental mapping by giving visual form to the fluctuating, uneven, and imperfectly remembered way in which she— and we—apprehend the world.

. . . At first view, the oppositional character of the "ordinary/extraordinary" conjunction seems paramount; both the words themselves and our dichotomous habits of thought easily prompt such a reading. But on longer reflection, it appears that Stevens has used this ten-sion to explore and question what our relationships are, will, and can be to our mothers, our foremothers, and to our past. The generative tension embedded in Stevens's "ordinary/extraordinary" theme echoes other, more familiar oppositions—the private and public, the personal and political. The notion that the personal is political has long been central to Stevens's own work, as it has been to feminist thinking of the past twenty years. Stevens has made an important and complex contribution to this discourse. The issues and oppositions she presents are clarified but not resolved; the work raises as many questions as it answers. It is not easy to look at these paintings. But, then, neither is it easy to live in the social and political situation in which we find ourselves today. ■

Beyond Painting & Sculpture:
Expanding the Boundaries of Art

BEYOND PAINTING & SCULPTURE: A HOST OF NEW ART FORMS

As illustrated by the work of so many artists, a major direction of the last four decades has been the "opening up" of artistic subject matter to include more of "life"; more of life's content in physical, moral, spiritual, psychological, sociological, and political terms. As part of this expansionistic "maximalist" tendency, many artists have moved beyond the traditional forms of painting and sculpture altogether. To realize enormously wide-ranging goals, post–World War II artists have created totally new forms—beginning with the mixed media works and combines of the fifties and the happenings and situational sculptures of the sixties—that go far beyond the conventional boundaries of painting and sculpture.

In this chapter, we will meet a number of the important artists working in these new, nontraditional art forms. To begin, let us look at works that break with convention but that still, like paintings and sculptures, are made to be seen in art gallery or museum settings. Thereafter, we will proceed to works of art that break out of the gallery-museum context and take place in the "real world" of our city streets and country fields.

The "Story Quilts" of Faith Ringgold: A Coming Together of Art, Craft, and Storytelling. The mixed media "story quilts" of Faith Ringgold (born 1934) are boundary breaking in several important ways. First, they reintroduce narrative or storytelling to the realm of fine art. For over a hundred years, since the time of the impressionists, modernist artists and critics have tended to shun storytelling, condemning it as "literary art"; only old-fashioned art (for instance, Renaissance art, nineteenth-century academic art) told stories, they argued. What, then, were the modernists to make of artists such as Faith Ringgold, whose works are so blatantly committed to narrative? Such artists were definitely breaking one of modernism's cardinal rules. In the context of modernism, Ringgold's illustrative graphic art, featuring pictures complete with text, could only be seen

12.1 • FAITH
RINGGOLD. *The Street
Story Quilt.* Part I: *The
Accident.* Part II: *The Fire.*
Part III: *The Homecoming.*
1985. Acrylic on canvas,
dyed and pieced fabrics.
7′ 6″ × 12′. The
Metropolitan Museum of Art,
New York. Courtesy Bernice
Steinbaum Gallery,
New York.

as "anti-modern" or "post-modern." Lichten-
stein's pop art cartoon-paintings with their
captions had been bad enough; now complete
stories were being offered!

As if breaking the modern art taboo against
storytelling were not enough, Ringgold and
others, especially feminist artists, began inte-
grating traditional women's handicrafts into
their work. Judy Chicago (born 1934) in-
cluded ceramics, china painting, and needle-
work in her grand-scale *Dinner Party* of
1973–1979 (Appreciation 32). Ringgold,
whose mother was an accomplished seam-
stress, included quilting and tie-dying in her
art. Moreover, both artists' emphasis on col-
laboration challenged the ingrained myth of
the artist as an isolated, individualist genius.
Collaboration, as we shall see, is an essential
ingredient in a variety of post-modern art
forms. Ringgold always gives public credit to
the individual who dyes or sews the fabric on
which she paints, and Chicago likewise ac-
knowledges and honors the numerous artists
and craftspersons who make epic works like
The Dinner Party possible.

Craft media, which since the Renaissance
had been considered on a cultural rung far

below painting and sculpture, were being em-
ployed creatively toward fine art ends. For
Ringgold and Chicago, the vision of the artist
is what really counts. If quilting or ceramics
works better than painting or sculpture to ac-
complish their ends, then those are the mate-
rials and techniques of choice. No medium is
a priori better than any other. If the artist has
important ideas, stories, or feelings to share
and can do so with formal power, then it mat-
ters little whether the medium is sewn fabric
or oil on canvas.

Here is arts reviewer Phyllis Quillen de-
scribing a quilt by Ringgold:

For artist Faith Ringgold, the outrage of social
injustice and the beauty of the human spirit can't
be captured with mere paint and canvas.

She began as a painter in the 1950's, but by
the early 1960's, Ms. Ringgold was feeling
cramped. The stretched, prepared canvas was
'too European, too intellectual' for this Ameri-
can black, feminist painter.

Painting gave way to masks, then to soft
sculptures and, finally, to her story quilts, with
their soft surfaces and long, fascinating written
tales of injustice, violence, poverty, love, self-
sacrifice, endurance and survival.

. . . The derelict, burned-out shells of tene-
ments in her hometown, New York's Harlem,

form the basis of three of her story quilts. . . . New York's abandoned and half-abandoned buildings are 'devastation like you've never seen,' but Ms. Ringgold looked at them with the dual vision of a painter and a storyteller.

. . . The first panel [12.1] of the quilt shows the front of an intact building, filled with neatly curtained windows and the horrified faces of the neighbors, peering down at the tragic traffic accident that provides the narrative impetus for the story.

'Ain nobody on this street gonna ever forget that accident. All them cars piled up right outside this door? An everybody in 'em dead but Big Al. It wasn't real. They were just going to Coney Island for some corn on the cob,' her narrator laments.[1]

The remaining quilts in the three-part *Street Story Quilt* tell of the fall of Big Al into drunkenness and the decline of the building itself—windows bricked-up, graffiti and black power slogans covering its walls—toward abandoned ruin. *The Street Story Quilt's* numerous rectangular story blocks, each accompanied by a caption like the one above, communicate ideas that could not be told through visual images alone. For Ringgold, the quilts are a "platform for mixing art and ideas so that neither suffers." Critic Lucy Lippard observes that Ringgold's visual imagery has "flair, authenticity, and a clean, sure, ebullient sense of design." Firmly rooted in Africa's heritage, the inhabitants "stare straight out at the viewer, resembling African carvings, Ethiopian saint paintings, Egyptian mummy cases." The tie-dyed cloth that simulates the color and texture of the tenement buildings smolders in variations of warm reddish purples and browns. With or without captions, these images would stand forth as potent art. But the words add another level of meaning to the images. As novelist Alice Walker puts it, the folk language in Ringgold's quilts is "rich and sure." As narratives, the quilts "have life, surprise, heart." "One feels the marriage of the stories and the quilts is also true, is inevitable, is justice." In Faith Ringgold's narrative quilts, form and content, story and image walk hand in hand.

Installations: Environmental Art for Interior Spaces. Faith Ringgold's story quilts break many of modern art's cardinal principles, but, in one sense, they remain traditional. Like paintings, they are made to hang on museum or gallery walls. In contrast, the creations of

artists such as Judy Chicago, who create **installations,** usually take up whole rooms—floor, walls, even ceiling—in museums or galleries. The total-environment happenings created by artists such as Allan Kaprow and the situational or environmental works of sculptors such as George Segal qualify as early examples of the installation. In Segal's *The Diner* (11.36), a portion of a museum room is transformed into a full-scale portrayal of a late-night New Jersey diner. In another installation piece of the mid-1960s, Los Angeles artist Ed Kienholz (born 1927) created one of the most horrific and unforgettable images in the history of twentieth-century art. Art historian H. H. Arnason describes it.

The State Hospital [12.2] is a construction of a cell with a mental patient and his self-image,

12.2 • ED KIENHOLZ. *The State Hospital.* 1966. Mixed media. 8 × 12 × 10′. Moderna Museet, Stockholm.

modeled with revolting realism—the living dead. Strapped to their bunks, the two effigies of the same creature—one with a goldfish swimming in his glass bowl head—make one of the most horrifying concepts created by any modern artist.[2]

In installation works such as *State Hospital,* writes Arnason, Kienholz is expressing his concern "with the stupidity or the misery that is hidden just behind the facade of modern, commercial civilization." Behind the glossy advertisements and the myth of the American dream, the artist seems to be saying, lies an American nightmare of mental hospitals, prisons, and other institutions reeking of human devastation. Having worked in a mental institution, Kienholz felt it imperative to bring the shocking conditions he experienced there to the attention of the public through his art.

Installation pieces range as broadly in style, subject matter, and feeling tone as traditional art forms do. Some are highly abstract, some realistic, others expressionistic or surrealistic. In contrast to Kienholz's critical and pessimistic *State Hospital,* others are optimistic and uplifting. Some focus on the present, whereas others evoke the past. Many installation pieces, with their emphasis on three-dimensional forms, are the creations of artists with a background in sculpture. Yet painters have also turned their talents to the installation as an alternative art form. Because of their previous orientation to two-dimensional work, painters tend to emphasize the flat surfaces of the installation space. When creating a total environment, they often paint their images on wall, floor, and ceiling surfaces and weave them together formally and thematically into one all-encompassing work.

For her 1989 installation piece *Initiation,* painter Judy Jashinsky (born 1947) covered the bare walls and floors of several gallery rooms with painted images that simulate the walls and architectural setting of the Villa of the Mysteries (12.3) in the ancient southern Italian city of Pompeii. Jashinsky created furniture in ancient Greco-Roman style to place in the rooms. The result is a total environment, unified by style and subject matter. The centerpiece of Jashinsky's installation is a large nine-by-sixteen-foot painting that covers the entire rear wall of the final room (12.4). The

12.3 · Villa of the Mysteries. Wall painting. *ca* 60 B.C. Pompeii, Italy.

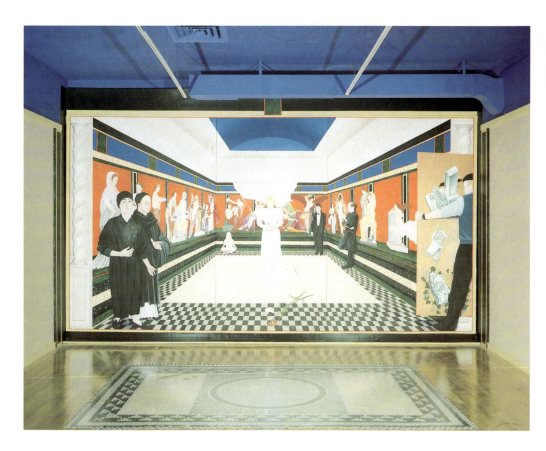

12.4 • JUDY JASHINSKY. *Initiation.* 1989. Wall painting frieze. Oil on linen. 9 × 16′. Courtesy the artist.

viewer does not, however, read this huge image as a painting, that is, as a separate and distinct object. Rather, the painted surface seems a continuation of the architectural interior, indivisible from it. Fooling the eye, the painted image evokes the central room of the ancient Villa of the Mysteries. In that room, a human drama is unfolding. Persons from the present and recent past have arrived for an important event. Just as in ancient days, an initiation ceremony is taking place. (The Villa of Mysteries was a sacred place in which individuals were initiated into the religious cult of the Greek god Dionysus.) This contemporary initiation involves Jashinsky's own rite of passage as a woman and artist. In the center of the illusionistic room, we meet the artist's imaginary daughter (holding a mask of the artist's own face in her hands), the artist's niece (rear left), and several artists who influenced her life. To the right are two "bad boys" of the world of modern art: Jackson Pollock, his foot propped up against the wall, and, in the corner, Edvard Munch. To Jashinsky, they represent her male art teachers but also have "something to do with women trying to understand maleness and sexuality." In the front left corner stands the most prominent figure in her ceremony, Georgia O'Keeffe, a woman and artist she greatly admires.

Why did Jashinsky, a painter, decide to weave her paintings seamlessly into the overall architectural structure of an illusionistic environment occupying several rooms? Why not simply mount the paintings on the walls? Her answer was that she created a total interior environment "in order to create an unbroken illusion." A painting alone on a bare wall would have been viewed as a separate, discrete object. But paintings that were integrated seamlessly into a total environmental scheme became part of a greater whole, a powerful, overarching illusion. Jashinsky's goal was to make her installation an all-encompassing experience in which viewers might totally immerse themselves, just as the initiate gives herself over completely to her initiation ceremony.

12.5 • TIM DAULTON. *Civilization.* 1989. Mixed media (wood, styrofoam, paper, and cardboard). 8 × 13', with 20' fabric spread. Courtesy the artist.

Confrontational rather than ritualistic, *Civilization* (12.5), an installation piece by Tim Daulton (born 1953), aggressively challenges viewers. As soon as they enter the darkened gallery space, viewers are confronted by Daulton's larger-than-life "military toy," a tank whose gun is aimed directly at their heads. Moreover, this tank-toy is alive. Engine noises grumble and voices come from within. Wheels and treads turn. Lights flash off and on. Tribal peoples are crushed beneath the tread of the monster's forward-moving bulk. Noxious waste pours from exhaust pipes, befouling the environment. Politicians and corporate executives, distant from the scenes of their crime, steer the ship of state from its topmost deck. Beneath the top deck all the different classes of society are pictured, in descending order of wealth and power. They are the little cogs that enable this fortress "civilization" to run smoothly and efficiently. Daulton has presented us with a disturbing vision of society and culture as a vast hierarchical machine run by a military-industrial-political complex. Whether the viewer agrees with his view of Western civilization or not, the formal and expressive power of the piece pulls one in. It hits, visually and intellectually, like a lightning

bolt. The piece entices you to examine every visual detail and to think about the numerous critical ideas put forth.

As Daulton's *Civilization,* Jashinsky's *Initiation,* and Judy Chicago's *Dinner Party* show, a major strength of installation pieces is their potential for dealing with expansive themes and complex issues. Mixing art forms and media (painting, sculpture, crafts, found objects, sound, lighting, and so on) and utilizing large interior spaces for the final work, artists have greatly expanded their possibilities. Whereas a painting, photograph, or sculpture presents an image of a world, an installation, in three-dimensional space, presents the world itself. In this world, a dinner party, initiation, or confrontation with a tank might actually take place.

For centuries, museums have been exclusively oriented to the showing of objects hung on walls or placed on pedestals. Can our museums adapt to the requirements of the new, nontraditional, multimedia art forms? Installation artists need flexible space, financial assistance, and staff support to exhibit their important work. As Sally Hagaman observes in her essay on Judy Chicago's *Dinner Party* (Appreciation 32), that significant installation

piece has hardly ever been seen "live" since its three-month showing at the San Francisco Museum of Modern Art in 1978. One reason is the expense and difficulty of mounting such large installations; museums, with their limited space and resources, are not eager to give up whole rooms in which many paintings and sculptures might be shown. Unless we develop new types of flexible, open spaces in our current museums and the museums and art centers of the future, installation art, and other forms of nontraditional art, will not receive the support and exhibition area they deserve.

Performance Art: The Artist as Performer. Installations occasionally spill over into another new form, **performance art.** In the 1970s, various artists sought to move beyond the physical art object-commodity. These artists included the "conceptualists" of the 1970s, who valued the artist's creative concepts, ideas, and processes over the final, permanent product. Exhibits by conceptualists often consisted of nothing more than the artist's handwritten ideas, typed thoughts, or photographs documenting a project or process. By encouraging artists to think about creative possibilities that went beyond the static art object, conceptual artists played a leading part in the general 1970s tendency to expand the boundaries of art. For the conceptualists, the "idea art" of Marcel Duchamp (10.28, 10.29), which had constantly challenged art establishment boundaries in the century's first half, was a potent inspiration. Many considered his works the first **conceptual art.**

Sharing strong affinities with the conceptual artists but also taking their lead from the action-oriented happenings and paintings of abstract expressionism—the idea of the work of art as an event or process—performance artists began to stage events or perform activities as their art work. Fittingly enough, the pioneering German performance artist Joseph Beuys (1921–1986) actually called his pieces "actions." Performing alone or in collaboration with others, performance artists, in effect, became their works of art. For instance, in his piece entitled *I Like America and America Likes Me* (12.6), Beuys lived for three days in a gallery space with a live coyote. There was no longer a permanent object to be bought or

12.6 • JOSEPH BEUYS. *I Like America and America Likes Me.* 1974. Week-long action with coyote at the René Block Gallery, New York. Courtesy Ronald Feldman Fine Arts, New York.

sold, hung on a wall, or placed on a pedestal. But this didn't mean that performance artists forsook the art world. Their performances might take place in a museum or gallery, as did Beuys's *I Like America and America Likes Me,* or in some personally chosen space to which the art world public is usually invited. Wherever the performance took place, it was almost always recorded on photograph, film, or videotape, as in Bill Viola's *Reasons for Knocking at an Empty House* (7.61). Art institutions could then rent or buy the piece, and interested viewers could see it.

Relative to form and content, performance pieces are as individualistic as their creators. Some pieces are symbolic and ritualistic. In Beuys's *I Like America and America Likes Me,* for instance, the coyote represents North America before European colonization, when the Indians lived in respectful harmony with the world of nature. Through his peaceful interaction and attempt at intimate relationship with the coyote over the three-day period, Beuys felt that he "made contact with the psychological trauma point of the United States' energy constellation: the whole American trauma with the Indian, the Red Man."

In utter contrast to Beuys's symbolic attempt to heal wounds across historical time,

to overcome long-term alienation between cultures and species, the pieces of Chris Burden (born 1946) are self-oriented, deeply disturbing, and rooted in the violent present. Burden's works of the 1970s turned out to be as frightening and nerve-racking as any work of art has ever been. Many performance artists of the 1970s placed themselves in personally challenging situations, but Burden pushed his situations to extremes. Time and again, he placed himself in dangerous situations that might result in bodily injury. These situations, he observed, reflected elements he found in North American culture, and he wanted to experience them firsthand. Here is Burden's terse description of *Shoot* (12.7), his most notorious piece:

Shoot, November 19, 1971, F Space, Santa Ana, California
 At 7:45 pm I was shot in the left arm by a friend. The bullet was from a copper-jacketed 22 long rifle. My friend was standing about 12 feet away.[3]

Why, an interviewer asked Burden, did he have himself shot in the arm? "Well," Burden answered, "it's something to experience. How can you know what it feels like to be shot if you don't get shot? It seems interesting enough to be worth doing it."

12.7 • CHRIS BURDEN. *Shoot.* November 19, 1971. Performance at F Space, Santa Ana, Calif. Courtesy the artist.

12.8 • LAURIE ANDERSON. "Let x = x" from *United States* (Part II). 1980. Performance presented by The Kitchen at the Orpheum Theatre, New York.

Shoot was performed in a gallery space with an audience looking on. It was documented in photographs and on film, as were other death-defying Burden performance pieces during the seventies. The reader might ask whether Burden's pieces are art or exhibitionism. Or whether Beuys is an artist, shaman, adventurer, or prophet. In many a performance, the boundaries between art and other areas of life have indeed become quite blurry.

Compared to the simple, riveting drama of a brief Burden piece such as *Shoot,* the performance pieces of Laurie Anderson (born 1947) are long, complicated, multimedia productions (12.8). Within a total environment created by slide projections, film images, and theatrical lighting effects, Anderson talks, sings, and plays her violin or keyboard through an elaborate electronic sound system. An extraordinary range of effects, reflecting her familiarity with both classical and "art rock" music, is called forth. Almost invariably her pieces require the participation of a large technical crew. At certain concerts and on her recorded albums, musicians and other artists from across the cultural landscape contribute their talents. Collaborators from the world of progressive rock music include virtuoso guitarist Adrian Belew and singer-songwriter Peter Gabriel, who has cowritten songs with Anderson and sung back-up vocals. Noted novelist William Burroughs has performed on a number of Anderson monologues.

Characterized by potent visual and verbal imagery and musical inventiveness, Anderson performance pieces have been acclaimed in various art magazines. Music and theater journals also write about them. Anderson's performance art has expanded beyond the art world and the gallery spaces where many of her original pieces were performed. In 1983,

she began to take her pieces, beginning with *The United States Tour,* to concert halls around North America and Europe. Still earlier, she recorded songs and albums that achieved varying degrees of popular success. Her most commercially successful song, "O Superman," was second on the British Pop-Singles Chart in 1981; not long afterward, Warner Brothers, a major pop music company, recorded a double-album set based on *The United States Tour.*

Here is Janet Kardon's assessment of *The United States Tour* and its multisensory assembling of verbal, musical, and visual images:

> The recurrent themes are the road, flight, a moving flag, symbols of transience that characterize our culture. This ambitious work is an impressive anthology of Anderson's narratives and songs. This musical assemblage includes demonstrations of classical violin virtuosity as well as rock quotations, appropriations from the conventions of the movies, popular music and slang.[4]

Is an Anderson performance piece such as *The United States Tour* related to a rock concert experience? In many ways, it is. Similarities include the emphasis on a single magnetic performer, the use of multimedia forms of expression, and the attendance of a large, enthusiastic, paying audience. Anderson's music furthermore overlaps with rock music, particularly "progressive" rock music, in its basic sounds and rhythms. But it is similarly related to classical opera, music, theater, and art. One doesn't go to an Anderson performance to dance and party but rather to sit, concentrate, and be powerfully moved by the images, sounds, and narratives.

In Anderson's performance pieces, the boundaries between fine and popular art have been at least partially dissolved. In effect, her performances operate at the intersection of the pop and fine art worlds. On the one hand, her pieces build on the achievements of several generations of vanguard artists operating in the domain of high culture, from the mixed media assemblages of Robert Rauschenberg to the intermedia sensory bombardments of Kaprow's happenings, to the video artworks of Nam June Paik and others. On the other hand, Anderson's work shares qualities with rock concert performances as well as the virtuoso audiovisual effects of commercial film and video; for example, the visualizing of sound and surreal narratives that characterize MTV. Relative to the world of popular culture, her work has affinities with that of the most creative and thoughtful rock musicians, artists of similar complexity and richness of invention, such as David Byrne.

Like Laurie Anderson, David Byrne (born 1952) is one of an increasing number of multitalented "crossover" artists. An art school dropout, Byrne is best known since the late seventies as the lead singer-songwriter for the critically acclaimed "new wave" rock group, Talking Heads. As a performing artist, Byrne doesn't think twice about weaving together the different arts or crossing over old boundaries between popular and high culture, Western and non-Western culture. His performances, like Anderson's, draw strongly from North American black as well as white culture and take him into almost all the other arts, including, in the visual sphere, album cover design, concert lighting and imagery, and film production. In the gap between popular and high culture, Talking Heads' album covers (2.22) are a match for their intriguing music as works of art. Byrne has helped design several of these covers, and his expansive fellow spirit, artist Robert Rauschenberg, has designed one as well (2.20).

Byrne's most ambitious work of visual art is his 1984 concert film *Stop Making Sense* (12.9). In the best Anderson performance art tradition, the film melds diverse cultures and media. In triumphant synthesis, pop music, with its roots in black soul and rhythm and blues, joins forces with visual imagery and lyrics that come right out of dada, expressionism, and neo-expressionism. A true multimedia artist, Byrne made visual-theatrical decisions on lighting effects, costumes, and props and choreographic decisions on the movements of the musicians and supporting cast. He played a substantial role in making directorial decisions on camera angles, editing, and the general "look" of the film. Writing for *Artforum* magazine, critic Carter Ratliff likens Byrne to a contemporary neo-expressionist painter who struggles to find a fit between his three-dimensional self and the two-dimensional

12.9 • JONATHAN DEMME. David Byrne in *Stop Making Sense*. 1984. Island Alive Releasing/ Cinecom International Films. The British Film Institute, London.

picture surface. In Byrne's form and content, Ratliff observes a direct link between the artist's nervous, twitching stage presence and the unsettling, alienated figures who inhabit contemporary neo-expressionist paintings, such as Robert Longo's *Untitled (White Riot Series)* (7.58). Toward the end of *Stop Making Sense,* the critic notes, "Byrne encases himself in the literal, boxy flatness of a white suit a couple of feet too wide for his frame. Throughout, severe lighting reduces his face to a play of light and dark planes against a field of darkness." Such distorted, ironic images of the self— Byrne both fits and doesn't fit into his outfit and public persona—reveal an edgy discomfort with the outer world and the inner self. Such outlandish but deadly serious images, Ratliff writes, embody existential "confronta-

tions with the terror of the self and its life as a patched-together artifice." Byrne's imagery and music both entertain and unsettle. His multimedia performance art expresses his battle to make sense out of a world that often stops making sense.

Multimedia performing artists such as Byrne and Anderson now take for granted the experimental joining of the arts that musician John Cage, artist Robert Rauschenberg, and dancer Merce Cunningham together explored in the late 1950s. Within the expansive, maximalist direction of post-war art, performance artists, more than any others, have opened the art establishment's doors to vast worlds of intermedia and intercultural possibility. In a society that values openness and pluralism, such a direction is indeed a healthy one.

APPRECIATION 32

Judy Chicago. *The Dinner Party.*

SALLY HAGAMAN

When Linda Nochlin posed the question "Why Have There Been No Great Women Artists?" in the January 1971 issue of *ARTnews,* feminist inquiry in art history really began. This inquiry has since focused on many important issues. These include the inequitably small number of women artists represented in museums, galleries, exhibitions, art periodicals, and historical texts; the exclusion of expressive forms traditionally produced by women (needlework, quilts, other crafts) from "fine art" categories; and the restrictive model of the artist as a solitary (usually male) genius rather than a person influenced by and often working collectively with other people. This scholarship of feminist art historians has resulted in numerous studies of women artists past and present and has helped these artists gradually gain entry into our art museums and literature.

However, these historians have not been the only people interested in rewriting the history of art in order to shed light on these "lost" women. Artist Judy Chicago's massive *The Dinner Party* (Fig. A), created between 1973 and 1979, was intended to represent both the oppression and achievement of women throughout history. The room-sized work is composed of an open triangular table, equi-

lateral in structure, that holds place settings representing thirty-nine important women (artists and others) from myth and history. Each setting at the table has a goblet and a large porcelain plate, some with raised and carved areas. These ceramic plates, boldly painted with a traditional china-painting technique, symbolize individual women. Each setting rests on an intricately embroidered runner that gives the woman's name and has visual designs expressing her accomplishments. The table rests on a large triangular porcelain floor, embellished with 999 names of women of achievement, thus suggesting that the women at the table were supported by the accomplishments of many others.

The piece was a major undertaking. It involved extensive research in women's history, china painting, needlework, and ceramic techniques in addition to thousands of hours of actual construction time. Chicago used a collaborative approach, engaging some four hundred people (mostly volunteers) in the work's execution. She hoped *The Dinner Party* would be an example of a new art that would express women's experiences, reach a wide audience, and bring new respect for women's artistic achievements. However, the work met with mixed reviews and has been exhibited only rarely, in part because of its large size. (In spite of this, *The Dinner Party* has found its way into many recent art historical and appreciation texts).

One of the thirty-nine women at Chicago's table is Hatshepsut, one of the four known women pharaohs of ancient Egypt. The traditional art history or appreciation text focuses

Sally Hagaman is a professor in the Department of Creative Arts, Purdue University, Lafayette, Indiana. She is active as a writer on aesthetics and is a member of the Women's Caucus and Social Theory Caucus of the National Art Education Association.

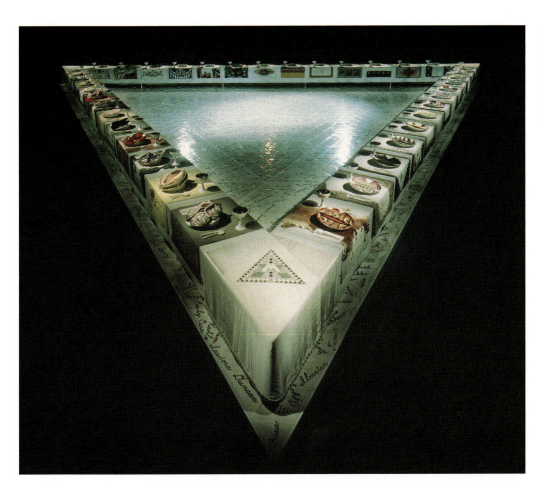

on the importance of the male pharaoh as god incarnate in ancient Egypt and on the various works produced for these god-kings. But feminist art historian Nancy Luomala points out that because of the matrilineal system of descent and inheritance in that culture, the king owed all his power and position to the queen. The throne was inherited by the oldest daughter, who became a king-maker in two ways: (1) while she was unmarried or separated from her husband, her brother or maternal uncle could co-rule with her as regent; and (2) when she married, her husband ruled as pharaoh. The husband was king only as long as the marriage lasted, and he was deposed if the marriage was terminated by the queen.

Chicago's choice of Hatshepsut is a natural one. During the Eighteenth Dynasty, she ruled Egypt for twenty-one years and through two marriages. She ruled because, though married, she did not let her husbands rule. Her first husband was a son of her father by a minor wife. After his death, she married a much younger half-brother who had no real power until after her death. In fact, it is speculated that he had her murdered. As Egypt's ruler, Hatshepsut completed many building projects (including her own massive mortuary temple), strengthened the economy through trade, and maintained peace throughout her reign.

The Hatshepsut plate (Fig. B) is set on a runner embroidered with hieroglyphs that

roughly symbolize the events of her life. It is the first of the thirty-nine plates to have raised and carved areas. The sculptural approach creates an unfolding of forms from the raised center of the plate. Chicago's dramatic use of lights and darks in the reds, yellows, and blues of those shapes reinforces this effect. The outermost blue shapes are reminiscent of the ceremonial heavy wig worn by Egyptian pharaohs, male or female. Clearly, the design of Hatshepsut's plate is a variation of the butterfly image used by Chicago to symbolize liberation on most of the thirty-nine plates. At the same time, this image visually refers to the female genitals. This "blatant female imagery" alienated many male critics and museum cu-

rators and may be a factor in the infrequency of exhibition of *The Dinner Party.*

Like other feminist artists and art historians, Chicago asks, through this work, that the viewer look at the world in a different way: through the eyes and deeds of women. The work presents a powerful message about the importance of individual achievement within the context of group collaboration. It questions the traditional limits of how art may be made. It pushes the boundaries of what visual subject matter and what kinds of objects may even be considered art. Finally, *The Dinner Party* gives symbolic voice to the important and diverse roles that women have played throughout history. ∎

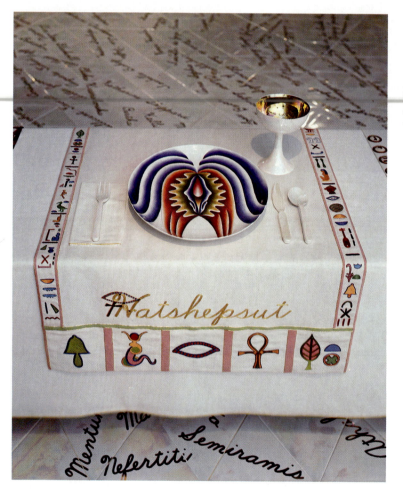

Figure B • JUDY CHICAGO. "Hatshepsut," plate and place setting from *The Dinner Party.* 1979. Multimedia, china painting on porcelain, needlework. 48 × 48 × 48′ installed.
© Judy Chicago.

Beyond the Museum's Walls: Activist, Public, and Environmental Art. Since the 1970s certain artists have felt it necessary to move beyond the bounds of the art world and art public altogether. To reach a broader public, or to connect their art to the larger society or natural environment, they have moved outside the museum's walls and constraints of fixed exhibition spaces. City streets, tenement walls, and the world of nature have become locations for their art. Social, political, environmental, and spiritual concerns in addition to aesthetic impulse have led them into these domains of real life. Some works by these artists are meant, like museum pieces, to be permanent. Examples are murals (1.3) and sculptures (11.13, 11.31) made for specific public places. But many others are events or experiences rather than permanent art objects. As events or experiences, they might last for a few minutes, several days, or weeks. Then they are gone, but not without being preserved in films, videotapes, or photographs. Our age of media reproduction has made possible the ongoing public existence of nonpermanent art objects, performances, and events. Today, such ephemeral art can truly flourish. The most transient art works and experiences can be saved on videocassettes or photographs and seen by interested viewers at any time in any place. And if the media documentation is effective, the viewer can feel that he or she is experiencing the event or work firsthand.

The Shadow Project is an example of a powerful but ephemeral art event that has retained its power thanks to media documentation. On August 6, 1985, citizens in over two hundred communities around the world woke up to discover gripping human images on the streets and sidewalks of their towns (12.10). These

12.10 • ALAN GUSSOW. Poster from *The Shadow Project.* August 6, 1985. Courtesy the artist.

images were grim visual reminders of the first nuclear tragedy that took place on that day forty years earlier in Hiroshima. Over ten thousand volunteers had painted silhouettes of townspeople on the streets and sidewalks. The silhouettes signified all that would remain of a human being caught near ground zero in a nuclear war. People from the United States to Canada, Brazil to Iceland, and Great Britain to Malaysia experienced the painted human shadows firsthand, and many thousands more experienced the event and the haunting images through news coverage.

The founder of *The Shadow Project,* Alan Gussow (born 1931), stated the purpose: "By scattering images across the face of the earth, we hope to nourish the collective imagination. It is possible, indeed it is our expectation, that people seeing for themselves what will be left after nuclear war will not only act to preserve their own lives, but to continue all life on earth." Gussow, a highly respected, award-winning painter of landscapes ("very traditional with a touch of impressionism") in the 1950s and 1960s, felt it necessary, by 1980, to leave conventional easel painting in order to deal with his passionate environmental concerns. Through various "projects" that coupled art and people (students, political activists, the larger public), he hoped to "stir people's imaginations" so that they would care more deeply about nature and the preservation of the planet. From this general impulse, the international *Shadow Project* was born. New York City was the scene of the first public action. "On August 6, 1982, 125 volunteers worked through the night to put down 2,000 shadows on streets and sidewalks in Manhattan." The images were created in nonpermanent paints that were later cleaned or washed away. *The Shadow Project* was reenacted in Portland, Oregon, in August 1983 and then spread worldwide, culminating in the 1985 *Shadow Project,* with ten thousand participants around the world. Since then, *The Shadow Project* has been reenacted annually on a smaller scale, and photographic, film, and video images of the event continue to reach thousands of persons. *The Shadow Project* was an image and idea whose time had come.

To put on and record an event such as *The Shadow Project,* the artist must leave the confines of his or her studio and interact out in the world with volunteer workers, a paid project staff, media people, government officials, and funding agencies. The artist must become a team leader, community organizer, fund-raiser, negotiator, and all-purpose trouble shooter. Although activist artists such as Alan Gussow have focused on saving humanity and nature, most environmental artists approach the natural and built environmental without set aims for major political or ecological change. Their goals may be social, aesthetic, spiritual, scientific, political, ecological, or various combinations thereof.

Of all contemporary environmental artists, the most famous is probably the Bulgarian-born Christo (born 1935), who has lived in the United States since 1964 but works worldwide. With a love of packaging or clothing the environment, Christo has wrapped a mile and a half of the Australian coastline in white woven fabric, has spanned a mammoth 1368-foot opening between two mountains with his 365-foot-high *Valley Curtain* of bright orange nylon, and surrounded eleven islands in Miami's Biscayne Bay with pink fabric. He works in urban areas as well. He completely wrapped the ancient Pont-Neuf Bridge in Paris and entire modern art museums in Berne, Switzerland, and Chicago. Although it may take years to bring these projects to completion, they remain in place only for weeks or months before they are removed and the site is returned to its original condition.

Of all Christo's projects, the largest and most socially, politically, and artistically complicated to date is his *Running Fence* (12.11). The 1976 press release for the project summarizes in impressive detail the extraordinary effort that went into the creation of *Running Fence.*

Running Fence, 18 ft. high, 24½ miles long, extending East-West near Freeway 101, north of San Francisco, on the private property of 59 ranchers, following the rolling hills and dropping down to the Pacific Ocean at Bodega Bay, was completed on September 10th, 1976.

The project consisted of: 42 months of collaborative efforts, the ranchers' participation, 18 Public Hearings, 3 sessions at the Supreme Courts of California, the drafting of a 450 page Environmental Impact Report and the temporary use of the hills, the sky and the ocean.

12.11 • CHRISTO. *Running Fence.* 1972–1976. Sonoma and Marin counties, Calif. Woven nylon fabric, steel cables, and steel poles. Height, 18′; length, 24½ miles. © Christo. 1976 Photograph: Jeanne-Claude.

Conceived and financed by Christo, "Running Fence" was made of 165,000 yards of heavy woven white nylon fabric, hung from a steel cable strung between 2,050 steel poles (each: 21 ft. long, 3½ inch diameter) embedded 3 ft. into the ground, using no concrete and braced laterally with guy wires (90 miles of steel cable) and 14,000 earth anchors. The top and bottom edges of the 2,050 fabric panels were secured to the upper and lower cables by 350,000 hooks. All parts of Running Fence's structure were designed for complete removal. Running Fence crossed 14 roads and the town of Valley Ford, leaving passage for cars, cattle and wildlife and was designed to be viewed by following 40 miles of public roads, in Sonoma and Marin Counties.

The removal of the Running Fence started 14 days after its completion and all materials were given to the Ranchers.[5]

The press release does not mention that Christo had to raise three million dollars through the sale of his own art works—

sketches, collages, drawings, and lithographs—to pay the astronomical costs of the project.

The question most people ask about enormous projects such as *Running Fence* is "Why?" Why did Christo do it, especially if all his pieces, like *Running Fence,* are to be disassembled in weeks or months? First, Christo loves the challenges of seeing his complex projects through to completion. He is excited by the process of wrestling with the hundreds of real-life elements—ranchers, government officials, environmentalists, townspeople, financiers, student assistants, and workstaff—required by the construction of his giant environmental pieces. Just as visual elements such as line, shape, and color make up traditional art works, the human elements of people and social interaction are key ingredients in any Christo work. The artist affirms that "people are the elements" of his art. But, he adds, they are not the "subject matter" of the pieces.

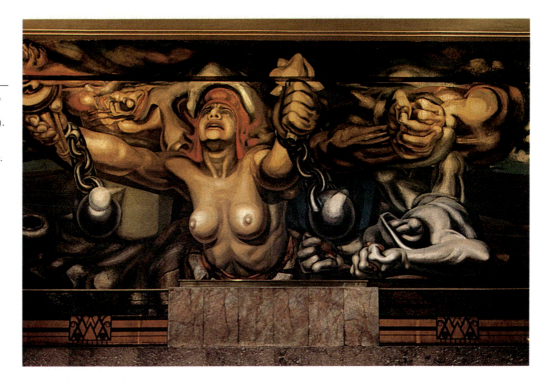

12.13 • DAVID ALFARO SIQUEIROS. *New Democracy* (central panel). 1944. Mural. 52 square meters. Instituto Nacional de Bellas Artes, Mexico City.

content, will endure as artistic masterpieces. Growing up in a culture in which the museum is often thought of as the sole repository of great art, we need to open our eyes to the numerous twentieth-century masterworks in squares and parks, on government buildings and neighborhood walls.

Beyond European and North American Culture: Appreciating the Art of Non-Western Peoples. Over the past century and a half, the art of non-western peoples has come to be increasingly appreciated in Europe and North America. The second half of the nineteenth century witnessed the discovery of Asian (3.13–16) and especially Japanese art (3.18, 7.15) by sophisticated Westerners. Between 1860 and 1900, the influence of Japanese art was very substantial on the impressionist and post-impressionist artists and Arts and Crafts and art nouveau artist-designers. Around the turn of the century, rising interest in Egyptian (Appreciation 20, Fig. C), African (Appreciation 35), Islamic (4.2), and Oceanic (10.20) art helped to sow the seeds of modern abstract art. Leading members of the symbolists, fauves, German expressionists, and cubists were stimulated by the aesthetic and spiritual qualities they perceived in these non-Western art forms. Mexican mural art (1.3, 12.13) with its strong roots in native Aztec and Mayan

Indian culture (Appreciation 37, Fig. D), exerted a potent influence on Western art from the 1930s. Artists as diverse as Ben Shahn and Jackson Pollock were affected. In 1933, Shahn assisted Diego Rivera on his murals for New York City's Radio City, and Pollock, in 1936, worked in David Alfaro Siqueiros's "experimental workshop," also in New York City. In addition to being influenced by Mexican mural art, Pollock always noted his debt to the imagery and methods of the Indian sandpainters of the Southwest United States. Similarly, Janet Saad-Cook has been inspired by the cultural achievements of the Indians of the American Southwest (Appreciation 9, 33). Twentieth-century art must be seen as international not only because of its worldwide outreach but also because of intercultural form and content.

As the rapid development of international commerce and instantaneous communication has transformed the world into a global village, we in the West have come into increasing contact with a diversity of once foreign cultures. We now see high-quality reproductions of ancient or contemporary works from Africa, Asia, or Latin America at the turn of a page or touch of a button. At the same time, we are beginning to appreciate the multicultural makeup of our polyglot societies. In the United States, for example, we have discovered that we are not so much a melting pot as

a tapestry made up of diverse ethnic, racial, and cultural strands. We are African, Asian, Hispanic, Caucasian, and Native American in our heritage. Within these broad categories, we are Nigerian, Vietnamese, Puerto Rican, Polish, Navajo, and much more. In the last quarter of this century, we have begun to integrate the cultural and artistic diversity within and outside of our societies into our art books and art courses. This development of a multicultural or intercultural art education is long overdue. Conditioned for so long to a narrowly ethnocentric Western view of the world, we are gradually realizing that our view is one among many, and that there is an enormous amount to be learned from views and works that are different from our own. In their appreciations of contemporary African sculpture, Indian graphic art of the Pacific Northwest, and the works of our "compañeras" in Latin America, Sharon Mayes, Jack Greer, and Betty LaDuke introduce us to worlds of art we may never have encountered before (Appreciations 35–37).

Worlds of Art: Into a Period of Pluralism. The second half of the twentieth century has seen art expand in every way. In addition to the intercontinental and intercultural nature of so much of our art, we have seen minimalist and maximalist directions, paintings reduced to all-black canvases side by side with mixed media works and performance pieces that take in the subject matter of the whole world. Following the international triumph of abstract expressionism in the 1950s, we have seen figurative art storm back onto center stage, from 1960s pop to 1970s superrealism to 1980s neo-expressionism. As we enter the 1990s, all possible works and artistic directions—modernism and post-modernism, realism, surrealism, expressionism, formalist abstraction, and their hybrids—seem to exist simultaneously. An all-embracing, nonhierarchical value system—traditionalists would call it "anarchic"—appears to be in effect. In contrast to periods during which a particular style (classicism, romanticism, abstract expressionism) or subject matter (religion, mythology, history) ruled over the rest in hierarchical fashion, a period of democratic pluralism in form, medium, and subject has arrived.

In the present pluralist decades, all art forms, media, mixed media, and new media seem to be valued equally. Painting and sculpture no longer reign as the supreme art forms. Art created from traditional handicrafts might be shown in one museum room, and high-tech video works in another. Traditional subjects—history, religion, mythology, portraiture, genre, landscape, and still life—long banished from the halls of art, have returned. Gradually, the art of minority, ethnic, and national groups from outside the North American-European mainstream is finding its way into our galleries and museums. The handicrafts and decorative arts, graphic and product design, all previously considered "minor" arts, are beginning to be granted more equal status. Sexual barriers are falling too; art by women is achieving more equal recognition with art by men. Art with overtly homosexual or controversial political subject matter is still shunned by the art establishment, but even that may change. In general, a democratic pluralism reigns.

In such an open-ended, pluralistic art world, fixed rules and governing principles do not exist, at least not for very long. We, the viewers, must set our own standards. If we had lived in an earlier time, when a clear-cut system of aesthetic values dictated the way, art appreciation would be an easy matter. We would feel secure in our responses and comfortable in our judgments. But we don't live in such a simple, hierarchical world. Late twentieth-century society is complex, contradictory, and ever-changing, with an art to match.

As viewers, we are sorely challenged by the new pluralism. With so much and so many types of art before us, and so little in the way of fixed standards to guide us, we must largely find our own way. Fortunately, we are not completely rudderless. The time-tested principles of formalism and contextualism will help guide us. So will the knowledge we have gained by studying the worlds of art of diverse times and cultures. A growing awareness of the different ways people have seen and represented the world, and responded to art, should encourage us to be more open-minded, tolerant, and thoughtful in our processes of appreciation.

Janet Saad-Cook. *Sun Drawing*.

M. E. WARLICK

Janet Saad-Cook (born 1946) creates art out of sunlight. In a darkened room with sunlight streaming through a window, she begins by arranging highly reflective materials within the path of the sun's transit. When direct sunlight strikes these materials, brilliant forms of light are refracted onto the surrounding walls and ceiling (Fig. A). Then, as the earth rotates and the angle of sunlight changes, these forms slowly and subtly change. They are ephemeral, amorphous, spinning into webs and arcs of silver, gold, and the pure prismatic colors of the rainbow. These forms coalesce and then dissolve again until the transit of sunlight is complete. While experiencing the beauty and evolution of these light forms, the viewer becomes keenly aware of the earth's rotation and the resulting transit of sunlight.

She calls this process *Sun Drawing*. Her art combines nature and science as she creates a visible connection between the daily path of the sun and the advanced technical processes that produced her reflective materials. When she first began the *Sun Drawing* process, she collected materials that would refract light, such as iridescent plastic films and fibers. These materials, such as a gold, transparent polyimide film that insulates spacecraft, are normally used for industrial purposes. More recently, she has developed permanent materials to replace the flexible films—dielectrically

M. E. Warlick is an assistant professor, School of Art, University of Denver, Colorado. Her areas of expertise are surrealism and twentieth-century women artists.

coated glass and mirrored bronze and stainless steel. The glass is heated until it begins to bend or slump, forming a slightly curved surface. The surface is then coated dielectrically with a multilayer interference material similar to that used on telescope lenses. The coated glass, combined with the highly polished and mirrored surfaces of the metals, casts pure prismatic light onto the walls of the surrounding environment. By carefully bending, folding, and superimposing the materials, she controls both the shapes and colors of this continuously evolving mural of light.

During her early experiments with this process in her Washington, D.C. studio, she became increasingly curious about the sun's cycle. Wanting to learn more about the yearly cycle of the sun, she began to research and visit many sacred sites around the world built by ancient cultures who tracked the path of the sun. In 1983–1984, she visited several prehistoric sites of the Anasazi Indians in the American Southwest [Appreciation 9], including those at Chaco Canyon (New Mexico) and Hovenweep (Utah and Colorado). These ancient cultures observed the passage of sunlight on the significant dates of the year, the solstices and the equinoxes. Saad-Cook studied how these ancient astronomers marked the passage of the sun. Some tribes simply watched the horizon, observing the rising and setting of the sun at different points throughout the year. Others found natural formations in nature, such as rocks over which the sunlight passed. Several of these natural formations are marked with Indian petroglyphs (rock drawings) that often symbolize the sun.

In some areas, the Indians built structures with such precise orientation that sunlight enters small windows or openings in a deliberate way on significant solar days. At several of these sites, Saad-Cook set up a number of temporary *Sun Drawing* installations, placing her reflective materials within the path of direct sunlight so that light forms were reflected within the Indian structures. In other installations, the *Sun Drawing* passed over the ancient rock petroglyphs. During the summer solstice of 1984, she worked at the Anasazi site of Hovenweep in a ruin called Twin Towers (Fig. B). Attaching her reflective materials along a vertical ledge, she formed a *Sun Drawing* using the noon sun. This elegant petroglyph of light plunged deep into the three-story circular chamber, with silvery diamond

shapes and golden stars connected by arcs of light and shimmering touches of pink, orange, and green hovering along the ancient wall.

The body of work from her visits is called the *Southwest Portfolio,* which contains photographs of the sacred sites as well as photographs of her *Sun Drawing* installations. She did not want to intrude on these sites in any way but rather to add a contemporary homage to the works of these ancient Native Americans. She said, "I wanted to reach across time, to connect my art to the beauty they had created, still marking and completing the same cycle and return of the sun."

Since 1985, she has been working on the *Sun Drawing Project,* a permanent structure that will house a *Sun Drawing* activated for

(*continued*)

Figure A • JANET SAAD-COOK. *Sun Drawing.* Installation view. 1988. Sunlight, mirrored steel, mirrored bronze, and optically coated glass. 11 × 16 × 20′.

Figure B • Janet Saad-Cook. *Sun Drawing, Twin Towers, Hovenweep.* 1984. Sunlight, iridescent plastic film, metalized polyester, Kapton. Created on site at Hovenweep National Monument, Utah.

the full yearly cycle of the sun. For the site of this project, she selected a modern astronomical observatory, the National Radio Astronomy Observatory's VLA (Very Large Array), located on the Plains of San Agustin, near Socorro, New Mexico. At this observatory, twenty-seven antennae, each eighty-two feet in diameter, receive radio waves from deep space. Interference phenomena are used to create color images of the radio sky, much as colors are produced in a *Sun Drawing*. Throughout the year, visitors will be able to observe on the interior walls and dome of a hemisphere-shaped building a *Sun Drawing* constantly changing in harmony with the sun's cycle. The National Science Foundation has approved construction of the project, indicating its support for this innovative connection between art and science. Many scientists, in-

cluding archaeo-astronomers who study the astronomy of ancient cultures as well as physicists who first developed the dielectric coatings she uses, have been drawn to Saad-Cook's work.

Saad-Cook finds a spiritual connection to the sacred sites of ancient cultures while using the materials of modern science. In the midst of this brilliant and elegant dance of light the viewer experiences the interaction between the sun and the earth and an awareness of a constant cosmological dynamic that is often lost or ignored in our modern world. She makes the cycle of the sun a human experience. With her art, she hopes to express "the visible manifestation of continuous change that occurs through time, with the absolute certainty of what is constant—of return." ■

APPRECIATION 34

Ascension. A Community Mural.

TOM ANDERSON

Obviously instrumental in nature, the mural called *Ascension* fits into the contemporary street mural tradition in its content and to a lesser extent in its style. Directed and painted by Wadsworth Jarrell with Elizabeth Furbish, Elissa Melaragno, and a neighborhood team, this mural exists in and is supported by a predominantly black neighborhood in Athens, Georgia. The mural urges blacks to rise up and be proud of black culture and its contribution to American society in the context of an African genesis and heritage.

The thematic content, from the upper left, clockwise, consists of sports achievements, women's achievements, the construction industry, music, and education. Embedded in the thematic content are significant African symbols such as the hornbill bird and the chameleon lizard. The content is unlike that of most black pride murals in being generic rather than specific. The usual renderings of Harriet Tubman, Frederick Douglass, Muhammed Ali, and so on, have been bypassed in favor of nonspecific, generalized character types. This is consistent with the mural's intent in exhorting everyone to reach for his or her best. We can't all be Muhammad Ali, but we can all project ourselves into one of the mural's characters.

Tom Anderson is an art educator at Florida State University and an artist who has painted numerous community murals. His doctoral dissertation was a critical analysis of street murals in the United States.

It is the style of the mural, however, that really gives it its power. The consensus among community-oriented street muralists of all persuasions is that naturalism or modified naturalism is the most appropriate stylistic mode. The reasoning is that the masses, with little or no art education, are most likely to understand naturalistic imagery. Instrumental art, which defines a work's excellence by its ability to stimulate the observer to action, requires that the observer easily understand the imagery presented. In *Ascension,* Jarrell and his team use the concept of ascension not only thematically but stylistically, demanding that the audience stretch a bit, that they rise to the content of this mural by attending to a more difficult, more highly abstracted style. And it is in the mural's style that the African roots of black American culture are most clearly defined. The patterns come from African masks and Nigerian Senufo carvings. The mortarboard hats of the school graduates on the lower left appear first as pure decorative pattern. The music section on the lower right swings and moves like the jazz it obviously depicts. Ironically, this music section, which is most removed from naturalistic imagery, is the one most expressive of the human qualities it depicts. The liberties taken with the human form exude a sensuality visually expressive of the music's form. The gestures, elongation, implied movement, and fluidly connective pattern make for an inspired passage. This looks like the sounds great jazz saxophonists have made.

548

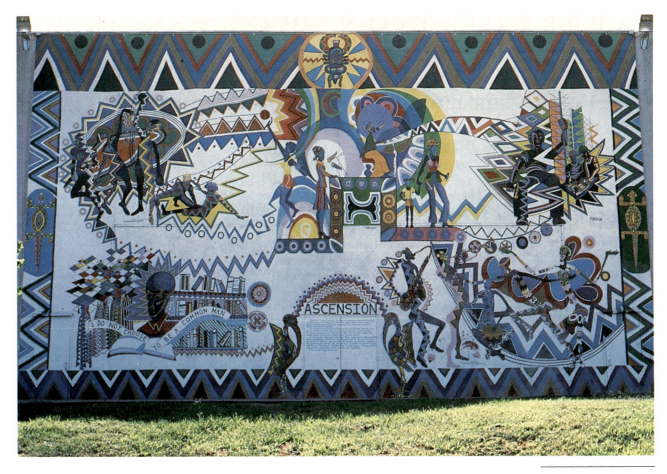

Ascension. A community mural in Athens, Ga. 1979. Acrylic, latex, and Hyplar scaler on wall. 32 × 52′.

Overall, it is significant that this mural uses the abstract language of the African tradition rather than the visual language of the naturalistic European tradition to carry a content as American as jazz and basketball. *Ascension* is a mural that exhorts black people to be proud of their heritage and to use it as a platform to rise to their future potential. The mural refuses to "talk down" to its audience, instead educating them through its style as well as its content, encouraging them to reach for meaning and join in the ascension. If it is successful in communicating to its audience, it has performed not only an act of perceptual and aesthetic elevation but also one of cultural elevation. ∎

Tim Paul. *Wolf.*

JACK GREER

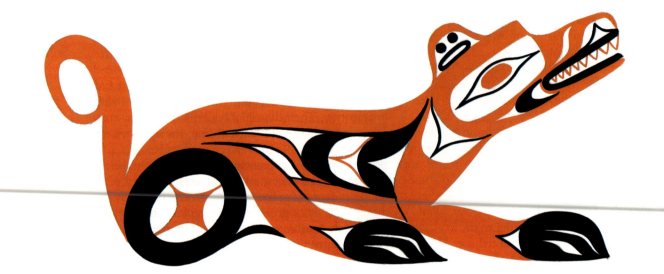

Figure A • TIM PAUL. *Wolf.* 1990. Watercolor. 4 × 9¾".

I came to North American Indian art late in life. Perhaps that is why it strikes me now as so fresh, new, like another look at creation.

The *Wolf* (Fig. A) by Tim Paul of the Northwest coast Nootka people. Look at its eye, gazing from another world, the world of myth, the world of a different culture, a separate way of seeing things. The lines are geometric, stylized, but swirl into organic folds, the form of a living thing reduced not to its bones but to its electric essence. This is no simple geometry: the wolf is forever on the verge of transformation.

In the wolf's ear the face of a child begins to take shape. The wolf's front paw takes the form of a bird's beak. The hindquarters, tail, and back leg all suggest change. In the wolf lies the possibility of all creatures. What are we to make of this changing icon?

Look at the set of the jaw. There is power here, the force of the wolf as it moves through change. It seems to say that being does not favor the fainthearted. The eye glares this same message and becomes the very center of the design, just as a person's consciousness forms the center of the galaxy of being and thought.

The wolf is not attacking. The pose is alert, ready, but relaxed. The animal's body will adapt to this posture for a long time: eternity. In the wolf we see how art arrests a fresh sense of being into a fixed expression. The lines are dynamic and swirling, but the design is balanced and poised. The wolf is changing but never changes.

For the Indians of the Pacific Northwest the wolf served as a sign of transformation. In the traditions of the Nootka people, dancers dressed in the costume of the wolf and swept into the longhouses of the tribe. There they ran off with the children, taking them to the woods for days to teach them the arts of dance, song, and fasting and to teach them their place in the hierarchy of nature and man.

This design by Tim Paul, with the child's face skillfully incorporated into the wolf's ear, clearly shows the possibility of transformation. Paul himself was attuned to this vision of transformation. He was initiated into the wolf dance at a young age in his home village of Zeballos on the west coast of Canada's Vancouver Island.

There is nothing dull about this vision. In the wolf, as in the totem poles and designs of many tribes in the Pacific Northwest (Fig. B), we see a spiritual reality that is almost frightening in its intensity. The set of the wolf's jaw, the sharpness of the paws, and the unrelenting eye all point to the potential danger of perception. Like the fantastic gargoyle animals of European cathedrals, these totems warn off the unknown entities of the spirit world.

The love of nature inherent in these frightening creatures derives not from gentleness but from respect and awe. One cleaves to the natural and the supernatural alike not out of a sentimental fondness but out of a spiritual urgency. The wolf will have his way. Change will come. Being will take form.

Some may find the design of the wolf unsettling. The challenge, then, is not to feel fear. The challenge is to let in a new vision of being, of the world, and to give it space to live. The wolf threatens us with its jaw, stares us down with its eye, intimidates us with its claws, but in the striking beauty of its pose it invites us to join it: we too can *become* with the wolf, following its bold lines into time. ■

Jack Greer is a poet, novelist, and writer on environmental issues. He works for the Maryland Sea Grant, a joint state and federal program concerned with the ecological well-being of the Chesapeake Bay.

Rabel says of the
I paint, I am an a
I'm a man or a wo

The universal
guishes Rabel's ea
her own two chil
often been her s
portraits of *indit*
ways popular and
has also explored
environmental, an

Speaking abou
Planners (Fig. A).
"Mexico plans ar
money from the p
thing." In this lar
roles of rich and p
in a flower-trim
down on the hea
brown robe.

In contrast to
murals, aligned w
bel's freer, more p

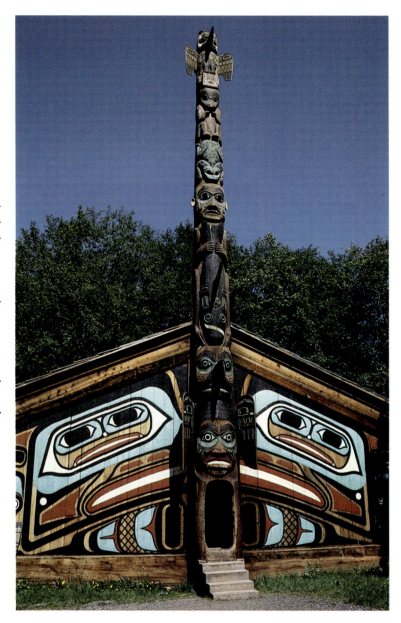

Figure B • Tlingit Indian Tribal House. Near Ketchikan, Alaska.

Figure A • FANNY
RABEL. *Planners.* 1981.
Oil on canvas.

Figure C • MARIA
GALLO. *Earth Mother.*
1981. Oil on canvas.

of the few women whose work is represented in national art exhibits, she is unique in a male-dominated profession. The theme of her work is woman, and she paints from a feminist perspective.

To reach Maria Gallo's small house and patio-studio, where she lives with her father and sister, one has to pass streets filled with the stalls of the sprawling Mercado Orientale, Managua's largest market, which never closes. The market vendors, mostly women, come before dawn, carrying enormous bamboo baskets of fruits and vegetables that they set up in wood stalls or on the stone-paved street. Women "carrying baskets as an extension of their round, strong bodies, as symbolic of the market women, the women of life": these are the images Maria Gallo uses in her work.

In her paintings she achieves the rough feel of stone by preparing the canvas surface with a thick textural base of sand and other materials applied with a spatula. Her painting *Earth Mother* (Fig. C) is an example. Here the curved form of the mother, holding ears of corn in her lap, is simplified as if carved from a solid piece of stone.

Maria Gallo has never been able to paint full time. Her parents did not encourage her to pursue art as a career; her father, who drives a taxi, felt that school should prepare her to earn a living. For several years she worked as a secretary; but in 1972, when she was 21, she determined to study art at the National Fine Arts School, where she was the only woman student. She recalls that the faculty demanded the same quality of work from her as from the men.

Immediately after the revolution, in 1978–1979, Maria began to work with the Ministry of Culture, first as an art teacher in Sandino City, a district of Managua, and, after 1981, as coordinator of all ministry art centers. However, she is often not at her desk in the ministry, but visiting the sixteen centers all over the country to "see and know what is being done, to offer workshops, mount exhibits and promote art so that it is accessible

Figure D · Western sky-bearer or "Bacab" from the Temple of Meditation, Copan, Honduras. Tenoned mosaic stone sculpture of andesite tuff. Kneeling figure about one meter high.

to all levels of the population, including housewives, peasants and factory workers." She also brings exhibitions by professional artists to rural areas. Travel and meeting all kinds of people, she says, have given her a better understanding of "the beauty of the pueblo [society]" and a new consciousness of her pre-European Mayan roots (Fig. D). Participation in the National Artists Union gives her a sense of professionalism and solidarity with other artists.

Maria Gallo says, "I am learning now about my pueblo, an extraordinary land that has suffered much, one that is not too well developed but is in the process of creating its own new future. . . . We are rediscovering our own feelings and giving them importance. Artists are no longer interested in producing bright, superficial or, picturesque paintings for tourists, as in former years, but are seeking to work with a true depth of feeling, an authentic Nicaraguan spirit." ∎

down of an in-depth analytic description, it's time to push on. The real excitement is about to begin. It starts as you develop your own personal responses, understandings, meanings, or explanations of the work: that is, your "interpretation." If the analytic description is the soil from which appreciation grows, then the personal interpretation is the emerging flower. And the flowers that blossom forth will vary widely. The range of interpretations viewers give to de Kooning's *Dark Pond* or van Gogh's *Night Cafe* will be quite varied because each viewer brings his or her unique personality, background, purposes, and interests to the piece. In this regard, interpretation is simultaneously a contextualizing and individualizing process. When we interpret a work, we bring to it the personal "context" of our ideas, emotions, and knowledge and, in so doing, give individual meaning(s) to the work. We make art works such as *The Night Cafe* or *Dark Pond* our own; we put our personal stamp on them. No one else's interpretation of these paintings will be exactly the same as ours. In this sense, interpretation can be seen as a highly creative process in which we project onto the work our original thoughts, subjective feelings, and unique backgrounds. The twentieth-century sculptor David Smith perhaps put it best, stating that the artist provides us with the work of art and then we, the viewers, creatively "complete" the work by interpreting it and giving it meaning in our own special ways. For example, this interpretation of *Dark Pond* from Chapter 11, endows the painting with subjective meanings:

> de Kooning's line is intense, highly charged, and emotional, much like the pulsating lines of a rock guitarist. His lines are not the precise contours of a classicist but the passionate outpourings of a romantic. The artist is powerfully involved in the actual physical process of creation. One feels the speed, force, and gesture of each brushstroke. Every line, shape, and mark is infused with de Kooning's manic excitement, his urgent desire to paint, to get it all down and said.
>
> One can envision de Kooning struggling, wrestling with the canvas, stepping back, looking with fixed concentration at the evolving work, making sure all is right, in place. Setting passionately back to work painting over lines and shapes, he ceaselessly destroys in order to create an image of ever greater vitality.

During the process of personal interpretation, viewers can project themselves into the work in large or small ways. The previous interpretation evidences an interest in artistic and musical processes that are improvisational and emotionally expressive. At the same time, it emphasizes and places a high value on the artist as a solitary, individualistic creator.

Other persons' interpretations of *Dark Pond*, even though based on the same objective visual information, would naturally differ. People with strong interests in politics, sociology, or abnormal psychology probably would not have based their interpretations on de Kooning's artistic process or bold expression of emotion. Instead of interpreting *Dark Pond* as the passionate improvisational work of a romantic individualist, others might find it an unsettling expression of personal disorder, societal disintegration, or political anarchy, and they might make highly convincing cases, based on the visual evidence, to this effect.

Recall Appreciation 28 of Jackson Pollock's abstract expressionist painting, *Number 1, 1948*, and the wide-ranging interpretations it prompted. The formalist critic interpreted *Number 1, 1948* as a visual first in Western painting, a work in which Pollock's "all-over" approach to composition enabled line and color to function as "wholly autonomous pictorial elements." The Jungian psychoanalytic theorist, for her part, interpreted Pollock's *Number 1, 1948* as a revelation of the artist's mind at its deepest levels: "the unconscious itself." At the same time, the Marxist newspaper reviewer interpreted the work as an expression of "the disintegration of our culture." Each interpretive response, so remarkably different, nonetheless sheds light on some important aspect of the work, ourselves, and our society. Exposure to a variety of interpretations helps the viewer realize that other points of view are valid and that his or her interpretation can be challenged, expanded, deepened, and ultimately enriched. In this regard, writing an interpretive paper can be a broadly educational experience, leading to both a deeper appreciation of a work of art and an enlarged understanding of the values and interests that shape our own individual interpretations of art and the world.

To summarize, one excellent way to write an interpretive paper is to: (1) describe and analyze the art work in objective detail and (2) interpret the work subjectively in accordance with one's own thoughts, feelings, experiences, interests, or viewpoints. This can be done in a sequential step-by-step method, as in the previous response to de Kooning's *Dark Pond*. Or the two steps can be seamlessly interwoven. A wonderful example of this interweaving of analytic description and interpretation is the interpretation in the first pages of *Worlds of Art*. The essay was written by an undergraduate student in response to Claude Monet's *On the Cliffs, Dieppe* (1.1). Starting from the first two lines, the writer joins subjective, interpretative response with objective, analytic description.

> When my glance fell upon the painting I was suddenly transformed into the mist and coolness and silent secret that is the sea. The ocean is calm—blue and green with touches of pink and purple. The sky is pale, paler than the ocean, and there is a hint of pink and yellow on the horizon. Perhaps in an hour the sky will be ablaze with sunset.
>
> There is a oneness, a unity among sky, rocks, and ocean. It all flows with the same rhythm; the strokes are even, graceful, and free. The cliffs in the background have almost merged with the ocean. Only at their summit is a contrast between earth and sky discernable. In the foreground are cliffs of more distinctive purple and green hues and on the ocean side, there is an outcropping of clay-colored rock or sand.
>
> . . . Just as drops of water make the sea, and grains of sand form the shore, so each tiny stroke of color forms this limitless painting which is only a glance.

Artist Jerry Coulter does the same as he reacts to the formal elements of van Gogh's *Night Cafe*. Note how he speaks objectively of the painting's texture and then, almost simultaneously, interprets how the texture makes him feel.

> When one looks at the material itself—the way the paint is put on in rough, heavy textures—there's a kind of anxiety in it. There's a scratching, almost flailing in some places as opposed to a fluid, tender touching of brush to canvas. And although there is control, there seems to be a psychotic intensity behind it. It's all put down so excitably, scratched into or thrust onto the picture surface.

Thus, the interpretive paper can proceed sequentially from objective analytic description to subjective interpretation, or it can weave together description, analysis, and interpretation from the start. Viewers might experiment with each approach, or mixtures and variations of the two, and then decide which are most effective for them.

FROM INTERPRETIVE PAPER TO RESEARCH PAPER

A second major approach centers on factual research. The writer consults books and articles for specific information or seeks expert opinions about the work, artist, and his or her society and culture. The writer might interview an artist, designer, craftsperson, psychologist, sociologist, anthropologist, or art historian first hand. The goal is a scholarly essay or research paper on the given work and its creator. Consider, for example, art historian Werner Haftmann's scholarly writing on Vincent van Gogh's *Night Cafe* (1.8). Haftmann focuses on van Gogh's personal history and the history of the painting itself. He provides us with information about the artist's personality and background, and cites van Gogh's own statements about *The Night Cafe*. He tells us about the artist's relationship to the people pictured in the painting. In effect, Haftmann tells us where, when, how, and why the painting was created. To begin, he introduces us to the artist. We are given facts.

> In February, 1886, Vincent van Gogh came to his brother Theo's shop. Gaunt, awkward, red-headed, highly-strung, he took everyone but himself for a genius. Given to dreams of universal brotherhood and love he met with indifference everywhere.
>
> What brought him to painting in the first place was his overflowing love of things and his fellow men. He had been an unsuccessful salesman in an art gallery, and then a lay preacher in the Belgian coal mining area. . . .

After telling us about van Gogh the person, Haftmann speaks of various art works, including *The Night Cafe*. He includes the artist's own comments about the work. "In painting the cafe at Arles at night," Haftmann writes, "Vincent again enhanced and modified the colours, 'in order to show [in the artist's

words] that this is a place where a man can lose his mind and commit crimes . . . an atmosphere of a flowing inferno, pale suffering, the dark powers that rule over a man in his sleep.' " "Colour," Haftmann concludes, "became for van Gogh a bridge to the realm where objects are signs, conveying messages from man's inner world."

In terms of writing style, Haftmann tells his historical story well. Although the research-based style of writing demands factual accuracy, clarity, and logical development, it need not, as Haftmann proves, be dry or ponderous. Haftmann's style is lively and filled with his own humanist values and empathic feelings for van Gogh and his paintings.

Each author's approach to the research paper is, in fact, as unique as the person who writes it. Relative to essays in *Worlds of Art* that are essentially art historical—that concentrate on facts and expert opinions about the work, the artist, and his or her times—the reader might, for a start, consider Appreciations 14–18. In each of these essays, the author marshals facts and learned opinions to different ends. A unique purpose and point of view are embodied in each essay. Mary Ann Scott's paper on Vermeer's *The Concert* (Appreciation 15) is primarily descriptive and informative. She presents factual information about the artist, work, genre paintings, and middle-class life in mid-seventeenth century Holland. One senses that Professor Scott wanted to keep her own opinions and beliefs out of this brief but instructive paper. She strives for good, solid, nonargumentative scholarship. In contrast, Frima Fox Hofrichter, writing about another Dutch seventeenth-century painter, Judith Leyster (Appreciation 14), lets her own strong opinions be known. Her paper is essentially a scholarly argument that makes a convincing case for a particular, somewhat controversial position. Her goal was to prove that Judith Leyster, as a woman artist, represented a common subject of the day (the sexual propositioning of women by men) in a far different way than contemporary male painters did. A feminist way of analyzing and interpreting the world underlies Hofrichter's argument.

Research and writing in art history, the psychology and sociology of art, and other scholarly areas are never value neutral. Even with the same factual materials available to them, Hofrichter and Scott would probably view and interpret the same seventeenth-century Dutch paintings in quite different ways. All writers of research papers are committed to their own values and beliefs, however obvious or subtle, conscious or unconscious. And, of course, these values and beliefs enter into their research and writing. All art historians select and organize facts according to their value and belief systems. Recognizing that all art historical research and writing are slanted one way or another in no way diminishes the import of this writing. Art history that is value-based, and thus diversified in its views of art, is the art history of a democracy. (The art history of a dictatorship, in contrast, would be repressively one-sided, allowing for only the one "true," government-sanctioned view of art.) Diversified, value-based art history makes for a democratic interchange of competing ideas and information, and a subsequent understanding of art that is richer for its multiple views and more truthful for its complexity.

Consider some of the points of view represented in art historical essays in *Worlds of Art*. Appreciations 14 and 31 are art historical essays written from a feminist perspective. Appreciation 13, on photographer Edward Weston's nudes, in contrast, is written from a formal and historical position that might make certain feminist writers cringe. Relative to political values reflected in the art historical essay, Appreciation 6 provides a left-oriented view of Käthe Kollwitz's *Hamm*. It stresses socialist or social democratic themes, such as the oppression of the working class, especially working-class women. Appreciation 25 on Frida Kahlo emphasizes the personal over the political; it underplays Kahlo's own outspoken socialist politics in favor of her personal physical and psychological struggles. Clearly, the writer was more concerned with Kahlo's private side than with her public one. In each example cited, factual information is shaped in accordance with the interests, beliefs, and worldview of the individual writer.

Some critics have asserted that writers of research papers look too much at books and not enough at works of art. The best writers

of research essays, however, scrutinize the works of art they are studying as closely as the documents they are consulting. As an integral part of their research, they necessarily engage in probing analytic description. Appreciation 1 is an example of art historical writing that interweaves careful analytic description with scholarly research. Artist Eugene Grigsby's essay on Hale Woodruff's murals *Interchange* and *Dissipation* typifies this mix of sensitive observation and historical scholarship.

> Visually, *Dissipation* gains strength and tension from dynamic diagonals, rippling with rhythmic movements. African masks and sculptures crisscross in and above the hands of the European destroyers. Rich colors animate the patterns of design. Whereas the quiet and composure of *Interchange* evoke calm reflection, the composition and content of *Dissipation* angrily admonish the Europeans for trying to destroy a culture, suggesting that the masks and sculpture of Africa will survive the looting and outlive the flames.

Research-based writing can be as exciting and meaningful as interpretive writing. In addition to presenting factual research, it can shed light on the writer's thoughts, feelings, values, and beliefs.

One final note. Research-based writing does require citations, that is, notes or footnotes that give the sources of specific facts or quotations. The rule for all beginning writers is "When in doubt, cite your sources!" In academic contexts, failure to cite sources can even be considered plagiarism, a serious charge. Don't risk plagiarism charges. Cite your sources!

Relative to the form of your end notes or footnotes, use a standard, officially accepted form of citation. Two good guides are *The Chicago Manual of Style* or Kate L. Turabian's *A Manual for Writers of Term Papers, Theses, and Dissertations*.

Appendix II
Time Line of Artists and Art

ANCIENT EGYPT
3000 B.C.–1000 B.C.

Historical Events

ca 3000–2500 B.C.
Dynasties of pharaohs, or god-kings, begin their rule over Egypt

ca 1360 B.C.
Restoration of the old polytheistic religions by the Pharaoh Tutankhamen

Artistic Events

ca 2660 B.C.
Portrait Panel of Hesy-ra

ca 1360 B.C.
Scene of Tutankhamen Hunting on a painted chest

ANCIENT GREECE
1000 B. C.–100 B.C.

Historical Events

499–478 B.C.
Wars between Greeks and Persians

460–429 B.C.
Athens at the height of its power

Artistic Events

530 B.C.
Black Figure Amphora by Exekias

447–438 B.C
Parthenon by Ictinus and Callicrates

ca 447–405 B.C.
Acropolis, Athens

ANCIENT ROME
100 B.C.–500 A.D.

Historical Events

45 B.C.
Reign of the emperors beginning with Julius Caesar

ca 3 B.C.–30 A.D.
Life of Jesus Christ

Artistic Events

Late first century B.C.
Pont du Gard

72–80 A.D.
Colosseum

81 A.D.
Arch of Titus

100–112 A.D.
Markets of Trajan

ca 120–127 A.D
Pantheon

244–249 A.D.
Portrait Bust of *Philippus the Arab*

307–312 A.D.
Basilica of Maxentius by Apollodorus of Damascus

EARLY MEDIEVAL EUROPE
500–1100

Historical Events

771–814
Reign of Charlemagne, King of the Franks; spread of Christianity throughout Europe

from ca 1000
Rise of towns and city-states throughout Europe

Artistic Events

834–843
Genesis Scenes from Moutier-Grandval Bible, France

1015
Adam and Eve Reproached by the Lord, bronze cathedral doors, Germany

ca 1100
Mosaic, Cappella Palatina, Italy

ca 1150–1200
Book of Jeremiah from Winchester Bible, England

ca 1200
Genesis Scenes from Mosaic Ceiling of St. Mark's, Venice

LATE MEDIEVAL EUROPE
1100–1400

Historical Events

1096–1291
The Crusades

1337–1453
The Hundred Years' War between France and England

Artistic Events

1140–1144
Choir of St. Denis, France

1140–1260
Chartres Cathedral, France

Begun 1296
Florence Cathedral by Arnolfo di Cambio, Italy

Begun 1439
Choir of St. Lorenz by Heinzelmann and Roriczer, Germany

1443–1451
House of Jacques Coeur

Giotto • di Paolo • Lorenzetti Brothers • Limbourg Brothers

ANCIENT AMERICA
100 B.C.–1300 A.D.

Historical Events

400–1000 A.D.
The Mayans develop an advanced civilization in Central America

100 B.C–1300 A.D.
The Anasazi culture of the American Southwest flouishes

Artistic Events

ca 700 A.D.
Seated Figure, Mayan Temple of Meditation, Copán, Honduras

ca 1000 A.D
Anasazi "Kayenta Olla"

SUNG AND MING DYNASTY CHINA
900–1650

Historical Events

907–1279
Sung Dynasty; advent of modern Chinese culture

1368-1644
Ming Dynasty

Artistic Events

ca 1000
Travelers amid Mountains and Streams by Fan Kuan

Late fourteenth century
Autumn Landscape by unknown artist

1400–1490	1490–1525	1525–1600	1600–1700	1700–1800

THE EARLY RENAISSANCE IN ITALY 1400–1490

Historical Events

1434–1492
Florence at the height of its cultural and political power under Cosimo and Lorenzo de'Medici

Artistic Events

Brunelleschi • Ghiberti • Masaccio

Bellini • Botticelli

THE EARLY RENAISSANCE IN NORTHERN EUROPE 1400–1490

Historical Events

Rise of commercial society and international trade

Artistic Events

Hubert and Jan van Eyck

ROYAL PERSIA

Historical Events

Between thirteenth and fifteenth centuries Mongol invasions bring Chinese culture and artists to the Near East

Artistic Events

ca 1450
The Persian Prince Humay Meets the Chinese Princess Humayun in Her Garden, Illuminated Manuscript

THE HIGH RENAISSANCE IN ITALY 1490–1525

Historical Events

1492
The Italian Columbus claims New World for Spain
1503–1513
Papal Rome rises to power under Julius II
1513–1521
Leo X rules papal Rome

Artistic Events

Leonardo • Raphael • Michelangelo

RENAISSANCE AND REFORMATION IN NORTHERN EUROPE 1490–1525

Historical Events

1454
Gutenberg's invention of printing from movable type
1517
Protestant Reformation begins

Artistic Events

Dürer

COUNTER-REFORMATION IN ITALY, 1525–1600

Historical Events

1540s
Founding of Jesuits and Inquisition
1550s
Counter-Reformation fully operative

Artistic Events

Mannerism
Michelangelo • Pontormo • Parmigianino

Venetian High Renaissance
Palladio • Titian

SEVENTEENTH-CENTURY CATHOLIC EUROPE

Historical Events

Italy and Catholic countries of France and Spain at height of their powers

France, under the "Sun King" Louis XIV, and Spain create colonies worldwide

Artistic Events

Baroque
Bernini • Gentileschi • Rubens

Baroque Classicism
Perrault • Poussin

SEVENTEENTH-CENTURY PROTESTANT EUROPE

Historical Events

1609
Dutch republics gain their independence from Spain

Seventeenth century "Golden Age" of Holland based on international trade and colonization

Artistic Events

Rembrandt • Leyster • Vermeer

EIGHTEENTH-CENTURY FRANCE

Historical Events

1715–1774
Reign of Louis XV
1789
French Revolution
1799
Napoleon's rise to power

Artistic Events

Rococo
Watteau • Boucher
Chardin • Vigée-Lebrun

Neoclassicism
David • Houdon

EIGHTEENTH-CENTURY ENGLAND

Historical Events

Rise of England as a worldwide power

Artistic Events

Gibbs • Gainsborough • Kauffmann • Sandby

EIGHTEENTH-CENTURY NORTH AMERICA

Historical Events

1776
Declaration of Independence of American colonies

Artistic Events

Neoclassicism
Jefferson • Houdon

1800–1825	1825–1850	1850–1875	1875–1900	1900–1920

EUROPE
1800–1825

Historical Events

1800–1815
Napoleon conquers Spain and most of Europe and North Africa

1815
Defeat of Napoleon at Waterloo

Artistic Events

Romanticism
Goya • Géricault

Classicism
David • Ingres

JAPAN
1800–1850

Historical Events

1793–1853
Gradual breakdown of isolation and centuries-old rule of the shoguns

Artistic Events

Hokusai • Hiroshige

UNITED STATES
1800–1850

Historical Events

Westward expansion
Development of slave states in rural South and free states in industrial North

Artistic Events

Neoclassicism
Jefferson • Latrobe

Product Design
Shakers

EUROPE
1825–1850

Historical Events

1839
Introduction of photography by Daguerre
Revolutions of 1848 throughout Europe

Artistic Events

Romanticism
Delacroix • Turner

Classicism
Ingres

Realism
Daumier

Gothic Revival
Pugin • Barry • Adams

EUROPE
1850–1875

Historical Events

Industrialization and urbanization of England and France

First World's Fairs in England (1851) and France (1855)

Artistic Events

Realism
Courbet • Manet • Nadar • Brown

Naturalism
Daubigny • Monet

Arts and Crafts Movement
Morris • Webb

Anglo-Japanese Art
Godwin • Jeckyll • Whistler

Furniture Design
Thonet

UNITED STATES
1850–1900

Historical Events

1861–1865
The Civil War

Industrialization and urbanization

1890s
Invention of cinematography

Artistic Events

Romanticism
Church

Naturalism
Homer • Muybridge

Art Nouveau
Tiffany • Bradley

Early Modern Architecture
Richardson • Sullivan

EUROPE
1875–1900

Historical Events

1875
Democratically elected French Republic

Urban industrial revolution

Invention of sequential photography and cinematography

Artistic Events

Impressionism
Monet • Morisot • Degas • Cassatt

Post-Impressionism
Cézanne • Gauguin • van Gogh • Munch

Art Nouveau
Toulouse-Lautrec • Beardsley • Guimard • Gaudí • Horta

Rodin

Photography and FIlm
Marey • Lumiere Brothers

EUROPE
1900–1920

Historical Events

1914–1918
World War I

1917 Russian Revolution

Artistic Events

Fauvism
Matisse • Derain

German Expressionsim
Kirchner • Kollwitz

Cubism
Picasso • Delaunay

Futurism
Balla • Boccioni

Der Blaue Reiter
Kandinsky • Klee

Dadaism
Duchamp • Höch

Early Modern Design
Hoffmann • Behrens

UNITED STATES
1900–1940

Historical Events

1917
Entry into World War I
1929–1940
Depression

Artistic Events

Social Realism
Henri • Sloan • Lange

Modernism
O'Keeffe • Hopper • Douglas • Lawrence

Photographic Modernism
Stieglitz • Steichen Weston • Sheeler

Modern Architecture
Wright

Silent Film
Griffith

1920–1940	1940–1960	1960–1990	1960–1990	1960–1990

EUROPE
1920–1940

Historical Events

1930s
Worldwide depression

1920s and 1930s
Rise of fascism in Germany, Italy, and Spain

Artistic Events

German Expressionism
Beckmann • Murnau

Bauhaus
Gropius • Albers • Breuer

Russian Constructivism
Gabo • Pevsner • Lissitzky

De Stijl
Mondrian • Van Doesburg

Surrealism
Breton • Buñuel • Dalí • Giacometti • Oppenheim • Magritte • Masson • Calder

Fascist Realism
Riefenstahl

Modern Architecture
Mies van der Rohe • Le Corbusier

MEXICO
1900–1940

Historical Events

1911
Mexican Revolution begins for democracy, social justice, and nationhood

1917
Mexican Constitution

Artistic Events

Social Realism
Rivera • Siqueiros • Orozco

Surrealism
Kahlo

EUROPE
1940–1960

Historical Events

1939–1945
World War II

1945
Division of Europe into communist and capitalist blocs begins

Artistic Events

School of Paris
Picasso • Matisse • Giacometti • Dubuffet • Soulages

Freud

Neo-Realist Film
Zavattini • De Sica

Modern Architecture
Le Corbusier

UNITED STATES
1940–1960

Historical Events

1941–1945
World War II

Cold War begins by 1946

Artistic Events

Abstract Expressionism
Pollock • de Kooning • Kline • Rothko • Smith • Newman • Mitchell

Rauschenberg • Johns

Post-Painterly Abstraction
Frankenthaler • Louis • Noland

Photographic Modernism
Adams • Siskind

Modern Architecture and Design
Mies van der Rohe • Wright • Yamasaki • Saarinen • Pei • Eames • Knoll

UNITED STATES
1960–1990

Historical Events

1964–1973
Vietnam War

1990
End of Cold War

Artistic Events

Happenings
Kaprow

Pop Art
Lichtenstein • Oldenburg • Warhol

Minimal Art
Stella • Judd

Superrealism
Segal • Hanson

Photorealism
Estes • Close

Performance Art
Burden • Anderson • Byrne

Installation Art
Kienholz • Chicago • Jashinsky

Environmental Art
Christo • Tacha • Saad-Cook

Neo-Expressionism
Golub • Fischl • Stevens • Longo

Social Realism
Costa-Gavras • Gussow • Ringgold

Photographic Modernism
Arbus • Uelsmann

Photographic Post-Modernism
Kruger • Sherman • Brodsky

Architectural Post-Modernism
Venturi • Moore

EUROPE
1960–1990

Historical Events

1980s
Democratization of Eastern European countries begins

1990
End of Cold War

Artistic Events

Social Realist Film
Pontecorvo • Costa-Gavras • Guney

Fellini • Antonioni • Bergman

Performance
Beuys

Neo-Expressionism
Baselitz • Immendorff • Kiefer • Clemente • Cucchi

AFRICA
1980–1990

Artistic Developments

Zimbabwean Sculpture
Munyaradzi • Matamera

CANADA
1980–1990

Artistic Developments

Northwest Indian Art
Paul

LATIN AMERICA
1980–1990

Artistic Developments

Mexican Art
Rabel

Nicaraguan Art
Gallo

Glossary

abstract expressionism A worldwide art movement, primarily in painting, that originated in the United States after World War II. Employing bold, gestural brushwork or broad fields of color, the abstract expressionists sought to express deeply personal feelings or symbolic thoughts through highly abstract or nonrepresentational forms.

Acropolis The physical and spiritual top (*akros*) of the city (*polis*) in an ancient Greek town. Specifically, the fortified hill on which Athens built its spiritual center in the fifth century B.C.

acrylic paint A type of quick-drying paint, increasingly popular after 1950, in which the colored pigment is bound together by a synthetic plastic medium.

action painting Within the **abstract expressionist** movement of the 1940s and 1950s, the highly improvisational, spontaneous approach to artistic creation pursued by such painters as Pollock, de Kooning, and Kline. The term *action painting* denoted that the work of art arose "in process" (that is, in action) as opposed to being planned beforehand.

aerial perspective The creation of an illusion of three-dimensional space in a painting through the use of increasingly muted colors and less distinct outlines to depict increasingly distant objects. See also **one-point perspective.**

analytic cubism The stage of **cubism,** especially as practiced by Picasso and Braque from *ca* 1909 to 1912, wherein objects are geometrized and abstracted from life, taken apart or "analyzed," and then creatively reassembled according to the artist's personal conception.

apse The semicircular or polygonal space generally situated at the east end of a church and housing the choir, sanctuary, and altar.

arcade A series of **arches** raised on columns or piers, or any covered passageway having an arched roof.

arch A curved structure that spans an opening. Arches come in many shapes and variations.

art nouveau A movement in the applied arts at the turn of the twentieth century that rejected the old, traditional styles and emphasized the development of "new" (*nouveau*) functional and decorative art works. Art nouveau graphic and architectural design, jewelry, and glassware features sinuous lines and organic shapes abstracted from natural subjects.

Arts and Crafts A movement in Europe and North America from the last quarter of the nineteenth to the beginning of the twentieth century

that sought to raise all product design and decoration to the level of art. Founded by William Morris and others, the movement championed handcraftsmanship and well-made, functional, and simply but attractively designed products.

avant-garde Meaning the "advanced guard" in French, a term applied to independent artists or groups of artists who are on the cutting edge of the art and culture of their society. In opposition to traditional mainstream art and culture, the avant-garde arose in mid-nineteenth century France with Courbet, Manet, and the **impressionists** and continues to the present day wherever progressive, independent-minded artists challenge the status quo.

baroque A style of art and architecture especially popular in the Catholic European countries and their colonies in the seventeenth century. Baroque art is characterized by enormous scale, curvilinear movement, dynamic energy, and emotional drama. With its original emphasis on religious subjects and the propagation of the Catholic faith, it is often thought of as the style brought into being by the Catholic Counter-Reformation.

baroque classicism A severe, toned-down variant of the exuberant Catholic **baroque** style, especially prevalent in architecture created during the reign of the seventeenth-century French king Louis XIV. Buildings in this style employ grandiose scale tempered by a sober **classical** design featuring symmetry and decorative restraint.

Bauhaus Active from 1919 to 1933, a famous school of art and design in Germany that sought a union of artists, designers, and craftspersons for the purpose of creating excellent works of design—products, graphics, decorative art, architecture—that might be mass-produced for the good of all persons in society.

bay An opening or spatial element demarcated by pillars, columns, or other architectural supports.

Blaue Reiter From the German for "Blue Rider," a school of artists that rose to prominence in Munich, Germany, before World War I. This avant-garde group was committed to highly abstract art expressive of the artist's innermost feelings and spiritual aspirations. Leading members of the group were Kandinsky, Klee, Marc, and Macke.

broken pediment In Roman, **mannerist,** or **baroque** architecture, a pediment that has been split apart at its topmost part or at the center of its base. See **pediment.**

Brucke Founded in Dresden, Germany, in 1905 by Kirchner and others, a group of artists who saw themselves as a much-needed "bridge to the future" in art and culture. Expressing their emotions and inner psychological states through the abstraction of human and landscape subjects, the artists of Die Brucke ("the Bridge") were pioneers of the style that came to be associated with **German expressionism.**

calligraphy The art of beautiful handwriting, practiced from ancient times to the present day.

camera obscura From the Italian for "dark" (*obscura*) and "room" (*camera*), a lightproof box with a small opening or lens for projecting an image of an object or scene onto a surface from which the image could be copied.

chiaroscuro From the Italian for "light-dark" (*chiaro-oscuro*), the use of light and dark values in a drawing, painting, or graphic image to create an illusion of three-dimensional form and spatial depth.

classical A descriptive word referring generally to any style in art that features calm grandeur, emotional restraint, and formal and intellectual clarity. Specifically, *classical* refers to that ancient Greek and Roman art and architecture, such as the Parthenon and Pantheon, that are prototypes for this style of noble simplicity and visual clarity.

classicism Any style characterized by the aesthetic principles and forms of the **classical** art and architecture of ancient Greece and Rome.

clerestory An upper zone of a wall, usually in a church or cathedral, pierced with windows that admit light to the central part of the structure.

colonnade A series of regularly spaced columns that support an **entablature** and often one side of a roof.

color field painting Within the **abstract expressionist** movement, the nonrepresentational approach to painting in which broad bands of flat, luminous color are applied to large mural-sized canvases for the purpose of conveying basic human emotions and universal spiritual states. Exponents of this approach are Rothko, Newman, and Still.

columnar orders Various arrangements of columns with **entablatures.** In classical Greek architecture, the three orders were **Doric, Ionic,** and **Corinthian;** the Romans later added **Tuscan Doric** and Composite, variants of the original Greek orders.

conceptual art Anticipated by the "idea art" of Duchamp and rising to worldwide prominence by the early 1970s, a movement emphasizing the primacy of the artist's ideas and concepts over the finished, physical art object-commodity. Conceptual art works often take the form of written notes, essays, or photographs documenting the artist's thought processes or creative projects.

constructivism The approach to art developed by Russian **avant-garde** sculptors, painters, and graphic artists (for example, Gabo, Pevsner, Lissitzky) in the late 1910s and early 1920s. These artists worked in a largely nonrepresentational style featuring freely arranged abstract geometric forms; often referred to as *Russian constructivism*.

contextualism An approach to the understanding art that centers on the study of art "in context"; that is, in relation to the rest of life. Contextualism emphasizes the study of everything that surrounds and relates to the work of art: the viewer; the artist; the physical setting of the work; and the art, culture, and society that gave birth to it.

Corinthian After the Doric and Ionic, the third columnar order developed in ancient Greece. Employed in many ancient Roman and Italian Renaissance buildings, the Corinthian order is characterized by a tall, slender column and an elaborate capital composed of leaf-like decorative forms.

cornice 1. A horizontal molding that projects along the top part of a building or wall. 2. The third or uppermost section of an **entablature**.

cubism Originated by Picasso, Braque, Delaunay, and others in Paris in the years before World War I, a multifaceted approach to art characterized by flat, loosely geometric forms abstracted from life. Relative to the work of Picasso and Braque, cubist art is usually divided into two major styles or stages, **analytic cubism** (*ca* 1909–1912) and **synthetic cubism** (after 1912).

dada An anarchic international movement in art and culture, lasting from approximately 1914 to 1920, that arose largely in response to World War I. Derived from a nonsense word, dada stood for freedom, nonrational creativity, and rebellious nonconformity. Two types of dada artists stand out: those, like Duchamp and Man Ray, who focused on intellectual and aesthetic issues, and those, like Hoch, Heartfield, and Grosz, who emphasized social and political content.

daguerreotype Named after Louis Daguerre, the French artist and inventor who developed photography in the 1830s, a photograph made on a plate of chemically treated metal or glass.

De Stijl From the Dutch for "the style," a movement in the fine and applied arts that originated in neutral Holland during World War I. Its leaders were van Doesburg and Mondrian. It is characterized by dynamically asymmetrical compositions created from simple geometric shapes painted in flat colors.

Doric The earliest and simplest columnar style developed in ancient Greece. Employed in the Parthenon, it is characterized by sturdy proportions and a minimum of decoration in columns and **entablature**.

duomo Meaning "cathedral" in Italian, a term also referring specifically to Florence's cathedral, whose immense dome was completed by Brunelleschi in the first half of the fifteenth century.

engraving 1. A printmaking process whereby a design is cut by means of a handheld instrument into metal plates or wooden blocks. The cut areas are inked for printing. A dampened paper is then placed on the surface of the plate or block and run through the rollers of a printing press with enough pressure to force the softened paper into the inked areas below the surface of the plate or block. 2. The finished print resulting from the process of engraving.

entablature In classical architecture, the horizontal beam structure supported by columns and divided horizontally into three sections, the architrave (bottom), frieze (middle), and cornice (top).

etching 1. A printmaking process wherein a design is produced by scratching lines on the surface of a metal plate covered with an acid-resistant material. The plate is then placed in acid, which "etches" the lines into the surface of the metal. The lines are inked, and a dampened paper is placed on the surface of the plate and run through the rollers of a printing press with enough pressure to force the softened paper into the inked areas below the surface of the plate. 2. The finished print resulting from the process of etching.

expressionism The approach to creating art that focuses on the exaggeration or distortion of natural forms for the purpose of expressing the artist's subjective feelings.

fauvism Associated with the early work of Matisse and the group known as the *fauves* (French for "wild beasts") around the year 1905, a style featuring bold distortions of natural shapes and colors resulting in brilliantly colored abstractions from life.

formalism The approach to art that focuses on the sensuous appreciation of the visual or "formal" qualities of the art work, for instance, its line, shape, color, texture, and composition.

formalist abstraction A major current within modern twentieth-century art that primarily emphasizes the formal or "abstract" qualities (for instance, line, shape, color, and composition) of the work of art. Artists committed to formalist abstraction might work in representational (Weston, Sheeler, Estes), abstract (Siskind,

Braque), or nonrepresentational (Mondrian, Gabo, Stella) styles.

fresco From the Italian for "fresh" or "cool," a technique involving the brushing of water-based paints onto wet ("cool," "fresh") plaster. As the plaster dries, the paint becomes a permanent part of the plaster wall or ceiling. Leonardo's *Last Supper,* Raphael's *School of Athens,* and Michelangelo's Sistine Chapel ceiling are frescos.

functionalist (machine) style A style in product and architectural design that, taking its cue from the beauty and efficiency of machines, embodies the principle "form follows function." Designed primarily with functional or practical concerns in mind, the resulting products and buildings featured simple, streamlined geometric forms and little or no decoration. Arising at the beginning of the twentieth century, this style is usually associated with the **modern** style of design.

futurism A movement in art arising in Italy in the years before World War I. Futurists sought to communicate the dynamism, power, and glory of the new urban industrial "machine" world. Employing the general forms of **analytic cubism,** futurist painters, sculptors, and photographers imbued their abstractions of city scenes and mechanical experiences with a sense of movement or vibration.

German expressionism The various schools of early twentieth-century German painters and sculptors (Die **Brucke,** Der **Blaue Reiter**) who distorted or abstracted natural forms for the sake of expressing the artists' intense personal feelings about the world. Germanic artists working in music, literature, theater, and film (*The Cabinet of Dr. Caligari, The Last Laugh*) also adopted this emotionally expressive, psychologically charged approach.

gesture painting Within the **abstract expressionist** movement, the style of painting characterized by bold, hand-driven gestures of the brush or other painting tools. The painters de Kooning, Pollock, and Kline are exponents of this general approach.

Gothic A style of architecture developed in Western Europe between the twelfth and sixteenth centuries. Gothic buildings are characterized by pointed arches, luminous stained glass, and soaring vertical shapes and spaces. The Gothic style is especially evident in the cathedrals of France, England, and Germany and influenced all the other arts as well.

Gothic revival A term applied to those styles of architecture and product design that in nineteenth-century England and North America reintroduced the shapes, proportions, and decoration of the medieval **Gothic** style. Numerous churches and college buildings as well as the British Houses of Parliament are built in the Gothic revival style.

grand manner Art created in the general heroic style of such Renaissance masters as Michaelangelo and especially Raphael; art that in subject matter, principles, and techniques followed in the lofty tradition of these grand masters.

graphic arts In the centuries following the Renaissance, any form of visual representation, especially such two-dimensional media as drawing, painting, etching, and engraving. In the modern period, the term *graphic arts* has come to be specifically associated with the various printmaking arts, such as **etching, engraving, and lithography.**

graphic design The systematic organization of visual information, usually encompassing both imagery and text, for the purpose of communication or persuasion. Magazine advertisements and covers, corporate brochures, and publicity posters are examples of graphic design.

happenings Arising worldwide around 1960, a mixed-media environmental art form that features theaterlike activities in which persons and/or objects interact in improvisational ways.

illuminated manuscript A hand-illustrated (illuminated) manuscript or book with pictures or motifs that relate to the accompanying text. The most famous medieval European examples feature, in addition to illustrations, exquisite **calligraphy** and elaborately decorated initial letters.

impasto The application of paint to a surface in thick, heavy textures; that is, in a pastelike way.

impressionism Rising to prominence in France in the 1870s, a movement of artists, such as Monet, Renoir, and Morisot, who painted general, colorful impressions of everyday scenes with the intent of capturing a fleeting moment in time. Employing divided brushwork, fuzzy outlines, and brilliant color, the impressionists used a mix of **naturalism** and abstraction, and were particularly sensitive to the changing effects of light and atmosphere on their subjects.

installation Rising to prominence in the 1970s, an art form featuring the creation of total, "environmental" works of art installed in entire rooms or other interior spaces. Such installation works can involve a wide range or mixture of media. Chicago's *The Dinner Party* is an example.

international style A worldwide **modern** style of architecture and product design that rose to prominence by the middle of the twentieth century. It embodies the functionalist ethic "form

follows function" and is characterized by abstract geometric shapes with little or no decoration and the absence of reference to regional styles or traditional styles of the past.

Ionic After the **Doric,** the second columnar order developed in ancient Greece. Its elegantly detailed elements and columns with scroll-like capitals make the order less heavy than the sturdy Doric though less elaborate than the later **Corinthian** order.

lithography 1. The process of printmaking wherein a greasy material is used to draw or brush a design onto the surface of a flat stone or metal plate. The surface is then chemically treated and dampened so that printer's ink is absorbed only by the greasy areas that make up the design. The surface is then covered with paper, which is rolled through a printing press under great pressure. 2. The finished print resulting from the process of lithography.

machine style Inspired by the functionalist aesthetic of machines, an artistic style, especially evident in modern product and architectural design, that emphasizes simple, clear geometric forms with little or no added decoration.

mannerism A style in art and architecture arising in the first half of the sixteenth century in Italy. It emphasized the personal "manner" or style of the artist. In the case of artists such as Michelangelo, Pontormo, and Parmigianino, these personally distinctive styles are characterized by arbitrary distortions or exaggerations of the rational, classically idealized Renaissance forms of the day.

mimesis From the Greek for "imitation," a striving for realism that dominates much of the art of the Western tradition, both in the ancient Greco-Roman world and post-Renaissance Europe and North America.

minimalism A movement in art that arose in the 1960s and is characterized by a reductive focus on the most basic formal elements (color, shape, structure) of a work. The sculpture of Judd and the paintings and shaped canvases of Stella are examples of this minimalist approach and style.

mobile Developed by Calder in the 1930s, a type of kinetic sculpture that features moving forms suspended in mid-air by wires.

modernism Any style characterized by the aesthetic principles, forms, and subjects of the **modern style** of fine and applied art. Modernist styles tend to reject references to the past and embrace the forms and subjects of the present. In the period from approximately 1860 to 1960, modernism has emphasized artistic individualism and varying degrees and types of abstraction.

modern style In art historical terms, a term usually referring to those styles of nineteenth- and twentieth-century art, beginning with **romanticism** and culminating with **abstract expressionism,** that emphasize artistic individuality, contemporary subject matter or content, and varying degrees and types of abstraction.

naturalism Anticipated in the painting of Constable, the mid-nineteenth century style or school of art that emphasized fidelity to nature's actual appearances and a democratic range of subject matter, including scenes of everyday life and commonplace landscape views. Painting out of doors so as to capture with honesty the freshness and light of everyday scenes, Daubigny and such young future impressionists as Monet, Renoir, and Morisot worked within this naturalist approach.

neoclassical Rising to prominence in the second half of the eighteenth and first half of the nineteenth centuries, a style of art and architecture that built on the ideals, forms, subject matter, and symbolism of the **classical** art and architecture of ancient Greece and Rome. Across the arts, the neoclassical ("new classical") style is broadly characterized by heroic grandeur, formal clarity, and emotional restraint.

neo-dada The term applied to artists who work in the general spirit of the anarchic, rebellious **dada** movement of the early twentieth century. Emphasizing freedom, nonrational creativity, and the breaking down of barriers between art and life, the art of Rauschenberg, Johns, and Kaprow in the 1950s and 1960s was described by certain writers as "neo-dada."

neo-expressionism Rising to prominence in the 1980s, a style of art pioneered by figurative artists in Germany (Baselitz, Immendorff, Kiefer), Italy (Clemente, Cucchi), and the United States (Longo, Fischl, Golub). In the service of subjective expression, neo-expressionists ("new expressionists") distort natural form, space, color, and composition in a style reminiscent of early twentieth-century **German expressionism.**

neo-Gothic Arising in the mid-nineteenth century, a style of architecture and product design in England and the United States that revived the use of the forms, principles, and decorative effects of the medieval Gothic style. See also **Gothic revival.**

neorealism A term used to describe the Italian films of the decade after World War II that employed a social documentary style, real-life settings, and straightforward stories revealing the difficult lives of the common people. In a broader sense, *neorealism* simply means "new realism" and denotes the revival or return of a realist style.

new realism A general term applied by various

critics to the return around 1960 of full-fledged figurative styles of art (**pop, photorealism, superrealism, neo-expressionism**) following more than half a century in which abstract styles of art (**cubism, surrealism, abstract expressionism,** and their variants) dominated the modern art world.

oil painting The application of oil-based pigments to a flat surface, most often canvas, stretched over a wooden frame. More than any other medium prior to photography, oil paint enabled artists to render real-life objects or imaginative subjects in a highly realistic three-dimensional manner.

one-point perspective Perfected during the Renaissance, a geometrical system by which artists create an illusion of receding space on a two-dimensional surface. Figures or objects grow or diminish in size with mathematical precision according to how near or far from the viewer they are intended to seem. Paintings employing this system of "sight lines" that recede from the edges of the picture to a single vanishing point within often possess a convincing physical realism and psychological drama. Examples are Leonardo da Vinci's *The Last Supper,* Raphael's *The School of Athens,* and David's *The Oath of the Horatii.*

orphic cubism A type of early twentieth-century cubist painting characterized by the interaction of areas of flat, luminous color in highly abstract compositions. Its main exponents were Robert Delaunay and his wife, Sonia Terk-Delaunay. Critics defined this offshoot of **cubism** as a "pure art" whose elements and structures came not from the outside world but from within the artist and, through abstract color and structure, gave a pure aesthetic pleasure and sublime meaning.

pediment In **classical** and **neoclassical** architecture, the triangular gable end of the roof above the columns and entablature.

performance art Any work of art constituted by the observable activity of the artist. Performance art rose to prominence in the 1970s. Examples are the shooting of the artist Burden in the arm by a friend before a small gallery of viewers and Anderson's huge multimedia productions performed in packed concert halls.

perspective The depiction of the illusion of three-dimensional space on a two-dimensional surface; the picturing of objects or figures as they appear to the eye in keeping with a sense of realistic distance and depth. Two types of perspective or perspectival techniques are **one-point** and **aerial perspective.**

photomontage A composite photographic picture made up of different photographic images.

photorealism Rising to prominence in the 1970s, a style of realistic painting based on photographs of a person, object, or scene. In keeping with the photographic way of seeing and picturing, the paintings of photorealist artists such as Estes and Close are characterized by extraordinary detail, a tremendously subtle range of values, and objective physical accuracy.

photo-secessionists A term describing photographers who publicly seceded from the mainstream photographic movements of the late nineteenth and early twentieth centuries. The photo-secessionists stood for the idea of photography as a fine **pictorial** art concerned with truth, feeling, and beauty. Rebelling against nonartistic documentary photography, commercial photography, and the traditional, highly artificial academic photography of the day, the major photo-secession group was established by Stieglitz in New York in 1902.

pictorialism A movement in vanguard photography that reflected the **symbolist** aesthetics of the late nineteenth century. Pictorialism emphasized the artistic (that is, pictorial) possibilities of the camera's imagery. Photographers such as Stieglitz, Steichen, and Kasebier, later identified as **photo-secessionists,** considered themselves pictorialists and strove for formal beauty, suggestive moods, and poetic truths in their work.

picturesque In general terms, a way of seeing and representing nature as if it were a pleasing picture; more specifically, the aesthetic movement in England and North America in the late eighteenth and nineteenth centuries that sought to create landscape art and design characterized by charming subjects, playful variety, and pleasing asymmetrical arrangements.

pilaster In architecture, a rectangular, columnlike projection from a wall. Pilasters form part of the wall and are used for support or decoration.

pop art Rising to prominence in the 1960s, a style of figurative art whose form and content derive from the imagery of the mass media and the products of consumer society. Oldenburg, Lichtenstein, and Warhol are leading pop artists.

portico A porch or covered walk consisting of a roof supported by columns.

post-impressionism The movement in art in the last two decades of the nineteenth century that sought to move beyond naturalistic **impressionism** to an art of greater subjective and aesthetic concerns. Among these concerns were the expression of inner emotion, the suggestion of **symbolist** feeling and thought, and **formalist abstraction.** Vincent van Gogh, Gauguin, and Cézanne are considered three pioneers of post-impressionism.

post-modernism A movement in reaction against **modernism's** rejection of the past and emphasis on artistic individualism and abstraction. Post-modernist artists and architects value the past (its styles, subjects, symbols), art that is socially and contextually sensitive, and imagery that is figurative (portraits, still lifes, landscapes) and sometimes narrative.

post-painterly abstraction Rising to prominence in the late 1950s and early 1960s, and growing from abstract expressionist **color field painting,** a style of **formalist abstraction** that emphasizes flat and luminous color as an end in itself. The colorful "targets" of Noland and brilliant "stripes" of Louis are examples of this approach, which rejected the gestural "painterly" brushwork and emotional expressionism of the earlier **abstract expressionist** artists.

realism In general terms, any artistic style concerned with an accurate portrayal of the external world; more specifically, a style of painting popularized in mid-nineteenth century France by Courbet. Realist painters strived for accurate portrayal of a democratic range of contemporary subjects, including lowly stone-breakers and peasants, in accordance with the artist's own individual style and point of view.

rococo A style of eighteenth century fine and applied art known in France as "the style of Louis XV." Commissioned primarily by the aristocracy and upper middle class, rococo art is characterized by intimate scale, graceful curvilinear movement, ornate decorative effects, and pleasure-loving subject matter.

romantic Any style in art that emphasizes feeling, imagination, and individuality. Formal characteristics of romantic painting include bold brushwork, colorful expression, sensuous textures, and dramatic movement.

romanticism In art historical terms, a movement in early nineteenth-century Europe and North America that reacted against the academy and the classical styles of the day. Identified with such artists as Goya, Géricault, Delacroix, and Turner, romanticism valued freedom from authority, emotional inspiration, poetic imagination, and individualistic genius.

social realism A term used in the twentieth century to describe a realistic style of art that portrays, often from a leftist political perspective, the life of the common person in society. In the United States social realism in painting, sculpture, photography, and the graphic arts was the dominant style of the Depression years of the 1930s.

subjective camera A cinematographic technique whose purpose is to make the viewer feel that he or she is looking at the world through the eyes of one of the characters in the film.

Sublime A state of mind, valued by nineteenth-century romantics, wherein nature at its most passionate and powerful is experienced as awesome and terrifying but simultaneously inspiring and exalting. This **romantic** way of seeing and representing nature as Sublime is epitomized in Turner's painting, *Snowstorm, Avalanche, and Inundation—A Scene in the Upper Part of the Val d'Aosta,* and Church's huge painting, *Niagara.*

superrealism A style of sculpture characterized by extreme fidelity to realistic detail. The 1970s figures of Hanson and Andrea, two superrealists, are sufficiently lifelike that they are sometimes mistaken for actual people.

surrealism The movement in the literary and visual arts from the mid-1920s to the mid-1940s that sought to reveal the contents of the unconscious mind and dream world, joining together the conscious and unconscious realms of existence in a super-reality, or "surreality." In the visual arts, surrealist artists pursued two general stylistic directions, one representational (Dalí, Magritte) and the other highly abstract (Masson, Miró).

symbolism An antinaturalist movement in poetry and the visual arts in the last two decades of the nineteenth century that sought to portray spiritual realities. In painting, artists such as Gauguin pursued a symbolist aesthetic in using line, color, and shape abstractly (that is, "musically" or "decoratively") to suggest or evoke subjective thoughts and feeling states.

synthetic cubism The style of **cubism** developed by Picasso and Braque after 1912 wherein the fractured, highly abstract forms of **analytic cubism** are reconstituted into synthetic wholes that are clearly recognizable as figures, still lifes, and so forth. This final stage of cubism features flat, loosely geometric figures against a shallow background.

tempera A type of paint and process of painting, much used in the medieval period and early Renaissance, in which colored pigments are mixed with water and a binder of egg yolk.

trompe l'oeil From the French for "fool the eye," any form of illusionism in the visual arts that is so convincing that the viewer believes he or she is looking at the actual object.

Tuscan Doric A simplified version of the Roman **Doric** order with a minimum of decoration in the columns and **entablature.** Michelangelo employed this order for the Laurentian Library vestibule.

vanishing point The point in the **one-point perspective** system where all the sight lines come together and vanish in infinity. In Leonardo da Vinci's *Last Supper,* the vanishing point is lo-

cated immediately behind the head of Christ so that the lines of the walls and ceiling all angle in to focus the viewer's attention on the central figure of Jesus.

vault In architecture, an arched roof, ceiling, or other covering of brick or stone.

Victorian design Characterized by profuse decoration and eclectic historical styling; the type of applied art that dominated the period of Queen Victoria's reign from 1837–1901.

woodblock print 1. A process of printmaking, one of the oldest, in which lines or shapes are cut into a block of wood so that the design to be printed protrudes from the block. The protruding sections are then inked and pressed onto paper manually or by means of a mechanical press. 2. The print that results from the process of woodblock printmaking.

Notes

CHAPTER 1

1. Jerry Coulter, interview by author, tape recording, Summer 1985.

2. Herschel Chipp, *Theories of Modern Art,* Berkeley and Los Angeles: University of California Press, 1968, pp. 36–37.

3. Herschel Chipp, *Theories of Modern Art,* p. 37.

4. Werner Haftmann, *Painting in the Twentieth Century,* vol. 1, New York: Praeger, 1960, p. 24.

CHAPTER 2

1. Jim Miller, ed., *Rolling Stone History of Rock & Roll,* New York: Random House, 1980, pp. 181–82.

CHAPTER 3

1. Eve Borsook, *The Companion Guide to Florence,* Englewood Cliffs, N.J.: Prentice-Hall, 1983, p. 233.

2. Jane Austen, *Northanger Abbey,* New York: New American Library, 1965, p. 93.

3. Jane Austen, *Northanger Abbey,* p. 94.

4. Immanuel Kant, *Critique of Judgment* (1790), in Lorenz Eitner, ed., *Neoclassicism and Romanticism 1750–1850,* vol. 1, Englewood Cliffs, N.J.: Prentice-Hall, 1970, p. 98.

CHAPTER 4

1. Calvin Coolidge, quoted in Frank Presbey, *The History and Development of Advertising,* Westport, Conn.: Greenwood Press, 1961, p. 619.

2. General Motors advertisement, quoted in Jane Stern and Michael Stern, *Auto Ads,* New York: David Obst Books, Random House, 1978, p. 21.

CHAPTER 5

1. Walt Whitman, "Song of the Broad-Axe," in *Walt Whitman: Complete Poetry and Collected Prose,* New York: The Library of America, 1982, p. 339.

2. Nikolaus Pevsner, *Studies in Art, Architecture, and Design,* vol. 2, New York: Walker and Company, 1968, p. 41.

3. Nikolaus Pevsner, *Studies in Art, Architecture, and Design,* p. 78.

4. William Wordsworth, "The Excursion," in Ernest de Selincourt, ed., *The Poetical Works of Wordsworth,* Book VIII, London: Oxford University Press, 1951, p. 683.

5. Nikolaus Pevsner, *Studies in Art, Architecture, and Design,* p. 23.

6. Oscar L. Triggs, *Chapters in the History of the Arts and Crafts Movement,* New York: Benjamin Blom, 1971, p. 43.

7. Herbert Bayer, Walter Gropius, and Ise Gropius, eds., *Bauhaus. 1919–1928,* Boston: Charles T. Branford Company, 1952, p. 16.

8. Henry Dreyfuss, *Designing for People,* New York: Simon & Schuster, 1955, pp. 23, 24.

CHAPTER 6

1. Louis Sullivan, quoted in James Marston Fitch,

American Building: The Historical Forces That Shaped It, Boston: Houghton Mifflin Co., 1972, p. 206.

2. Spiro Kostof, *A History of Architecture,* New York: Oxford University Press, 1985, p. 410.

3. Vincent Scully, *Modern Architecture,* New York: George Braziller, 1971, p. 11.

4. Philip C. Johnson, *Mies van der Rohe,* New York: Museum of Modern Art, 1953, p. 195.

5. Robert Hughes, *The Shock of the New,* New York: Alfred A. Knopf, 1981, p. 190.

6. Ricardo Bofill and Leon Krier, *Architecture, Urbanism, and History,* New York: The Museum of Modern Art, 1985, p. 15.

7. Robert A. M. Stern, quoted in Patricia H. Werhane, *Philosophical Issues in Art,* Englewood Cliffs, N.J.: Prentice-Hall, 1984, p. 123.

8. Robert A. M. Stern, quoted in Patricia H. Werhane, *Philosophical Issues in Art,* pp. 122–23.

CHAPTER 7

1. Elton Davies, *Arts and Cultures of Man,* San Francisco: International Textbook Co., 1972, p. 370.

2. Jose Arguelles, *The Transformative Vision,* Boulder, Colo.: Shambhala, 1975, p. 116.

3. Charles Baudelaire quoted in Aaron Scharf, *Art and Photography,* New York: Penguin, 1974, pp. 145–46.

4. Edmond Duranty quoted in Linda Nochlin, *Impressionism and Post-Impressionism, 1874–1904,* Englewood Cliffs, N.J.: Prentice-Hall, 1966, p. 6.

5. Edmond Duranty quoted in Linda Nochlin, *Impressionism and Post-Impressionism 1874–1904,* p. 6.

6. Edmond Duranty quoted in Linda Nochlin, *Impressionism and Post-Impressionism 1874–1904,* p. 6.

7. *The Complete Letters of Vincent Van Gogh,* vol. 2, Greenwich, Conn.: New York Graphic Society, 1959, p. 590.

8. Maurice Denis quoted in Aaron Scharf, *Art and Photography,* p. 252.

9. Maurice Maeterlink quoted in Jonathan Green, *Camera Work: A Critical Anthology,* Millerton, N.Y.: Aperture, Inc., 1973, p. 62.

10. *Diane Arbus,* Millerton, N.Y.: Aperture Monograph, 1972, p. 10.

11. Gerald Mast, *A Short History of the Movies,* Indianapolis: Bobbs-Merrill, 1981, p. 195.

12. *Dorothea Lange: Photographs of a Lifetime,* Millerton, N.Y.: Aperture, Inc., 1982, p. 76.

13. Florence Thompson quoted in Paul Berger, Leroy Searle, and Douglas Wadden, *Radical Rational/ Space, Time: Idea Networks in Photography,* Seattle: University of Washington, 1983, p. 25.

14. Alfred Stieglitz quoted in Dorothy Norman, *Alfred Stieglitz: An American Seer,* New York: Random House, 1973, p. 76.

15. H. H. Arnason, *History of Modern Art,* New York: Harry N. Abrams, 1986, pp. 648–49.

CHAPTER 8

1. Michelangelo, quoted in Anthony Blunt, *Artistic Theory in Italy, 1450–1600,* London: Oxford Press, p. 62.

2. Michelangelo, quoted in Anthony Blunt, *Artistic Theory in Italy, 1450–1600,* pp. 79, 80.

3. Arnold Hauser, *The Social History of Art,* vol. 2, New York: Vintage Books, 1957, p. 88.

4. Kenneth Clark, *Civilisation,* New York: Harper & Row, 1969, p. 191.

5. Hugh Honour and John Fleming, *The Visual Arts: A History,* Englewood Cliffs, N.J.: Prentice-Hall, 1982, p. 468.

6. John Berger, *Ways of Seeing,* New York: Penguin, 1982, p. 110.

7. Denis Diderot, quoted in Lorenz Eitner, *Neoclassicism and Romanticism, 1750–1850,* Englewood Cliffs, N.J.: Prentice-Hall, 1970, p. 58.

8. Thomas E. Crow, *Painters and Public Life in Eighteenth-Century Paris,* New Haven, Conn.: Yale University Press, 1985, p. 214.

CHAPTER 9

1. Robert Goldwater and Marco Treves, eds., *Artists on Art from the XIV to the XX Century,* New York: Pantheon, 1972, p. 226.

2. Linda Nochlin, *Realism and Tradition in Art, 1848–1900,* Englewood Cliffs, New Jersey: Prentice-Hall, 1966, p. 52.

3. Linda Nochlin, *Realism and Tradition in Art, 1848–1900,* pp. 75–76.

4. Linda Nochlin, *Realism and Tradition in Art, 1848–1900,* p. 77.

5. Linda Nochlin, *Realism and Tradition in Art, 1848–1900,* p. 76.

6. Linda Nochlin, *Realism and Tradition in Art, 1848–1900,* p. 76.

7. Madeleine Fidell-Beaufort and Janine Bailly-Herzberg, *Daubigny,* Paris: Editions Geoffroy-Dechaume, 1975, p. 45.

8. Madeleine Fidel-Beaufort and Janine Bailly-Herzberg, *Daubigny,* pp. 49–50.

9. William C. Seitz, *Claude Monet,* New York: Harry N. Abrams, 1960, p. 118.

10. Rozsika Parker and Griselda Pollock, *Old Mistresses: Women, Art and Ideology,* New York: Pantheon, 1981, p. 43.

11. Herschel Chipp, *Theories of Modern Art,* Berkeley: University of California Press, 1968, p. 67.

12. Herschel Chipp, *Theories of Modern Art,* pp. 67–69.

CHAPTER 10

1. Herschel B. Chipp, *Theories of Modern Art,* Berkeley: University of California Press, 1968, p. 132.

2. Robert Hughes, *The Shock of the New,* New York: Alfred A. Knopf, 1981, p. 285.

3. Herbert Read, *A Concise History of Modern Painting,* New York: Praeger, 1966, p. 54.

4. Werner Schmalenbach, *Paul Klee,* Munich: Prestel-Verlag, 1986, p. 18.

5. Herbert Read, *A Concise History of Modern Painting,* p. 187.

6. Herschel B. Chipp, *Theories of Modern Art,* p. 180.

7. Herschel B. Chipp, *Theories of Modern Art,* p. 206.

8. Johannes Itten, *The Art of Color,* New York: Reinhold, 1961, p. 44.

9. Robert Hughes, *The Shock of the New,* p. 66.

10. Jose Arguelles, *The Transformative Vision,* Boulder, Colo.: Shambhala Publications, 1975, p. 208.

11. William S. Rubin, *Dada, Surrealism, and Their Heritage,* New York: Museum of Modern Art, 1967, p. 195.

12. Edward Hopper, *Edward Hopper,* New York: American Artists Group, Inc., 1945, p. 2.

13. Lloyd Goodrich and Doris Bry, *Georgia O'Keeffe,* New York: Praeger, 1970, pp. 15–16.

CHAPTER 11

1. Francis V. O'Connor, *Jackson Pollock,* New York: Museum of Modern Art, 1967, p. 40.

2. Francis V. O'Connor, *Jackson Pollock,* p. 55.

3. Harold Rosenberg, *The Tradition of the New,* New York: McGraw-Hill, 1965, pp. 25–28.

4. Sam Hunter, *Art Since 1945,* New York: Washington Square Press, 1962, p. 279.

5. Maurice Tuchman, *New York School: The First Generation,* Los Angeles: Los Angeles County Museum of Art, 1965, p. 51.

6. Robert Rosenblum, *Modern Painting and the Northern Romantic Tradition: Friedrich to Rothko,* New York: Harper & Row, 1975, p. 215.

7. Sam Hunter, *Art Since 1945,* p. 312.

8. David Smith, *David Smith,* New York: Holt, Rinehart and Winston, 1968, p. 56.

9. David Smith, *David Smith,* p. 71.

10. Rosalind Krauss, *Terminal Iron Works: The Sculpture of David Smith,* Cambridge, Mass.: MIT Press, 1971, p. 58.

11. Rosalind Krauss, *Terminal Iron Works: The Sculpture of David Smith,* p. 175.

12. David Smith, *David Smith,* p. 133.

13. Leo Steinberg, *Other Criteria: Confrontations with Twentieth-Century Art,* London: Oxford University Press, 1972, pp. 12–13.

14. Ellen Johnson, ed., *American Artists on Art: From 1940 to 1980,* New York: Harper & Row, 1982, pp. 59–60.

15. Ellen Johnson, ed., *American Artists on Art: From 1940 to 1980,* p. 58.

16. Barbara Rose, *Claes Oldenburg,* New York: Museum of Modern Art, 1969, p. 91.

17. Martin Friedman and Graham W. J. Beal, *George Segal: Sculptures,* Minneapolis: Walker Art Center, 1978, p. 37.

18. Martin Friedman and Graham W. J. Beal, *George Segal: Sculptures,* p. 37.

19. Martin H. Bush, *Duane Hanson,* Wichita, Kansas: Edwin A. Ulrich Museum of Art, 1976, p. 61.

CHAPTER 12

1. Phyllis Quillen, "Soft to the Touch, Striking to the Eye, Hard on the Heart: Artist Tells Stories on Quilts," *Daily News-Record,* Harrisonburg, Virginia, January 19, 1989.

2. H. H. Arnason, *History of Modern Art,* Englewood Cliffs, N.J.: Prentice-Hall, 1986, p. 474.

3. Ellen H. Johnson, ed., *American Artists on Art: From 1940 to 1980,* New York: Harper & Row, p. 236.

4. Janet Kardon, *Laurie Anderson: Works from 1969 to 1983,* University of Pennsylvania: Institute of Contemporary Art, 1983, p. 24.

5. Per Hovdenakk, *Christo: Complete Editions 1964–1982,* New York: New York University Press, 1982, p. 55.

6. Albert E. Elsen, *Purposes of Art,* New York: Holt, Rinehart and Winston, 1981, p. 295.

7. Beth Cofflet, "Running Fence: A Drama in Wind and Light," *Artnews,* November 1976, p. 85.

TEXT CREDITS

Appreciation 16: Wendy Slakin, *Women Artist in History: From Antiquity to the 20th Century,* 2e, ©1990, pp. 82–87. Reprinted by permission of Prentice Hall, Inc., Englewood Cliffs, New Jersey; *Appreciation 31:* Reprinted from *Feminist Studies,* Volume 13, Number 3 (Fall 1987), by permission of the publisher, FEMINIST STUDIES, Inc., c/o Women's Studies Program, University of Maryland, College Park, MD 20742; *Appreciation 37:* Selections from Companeras: Women, Art, and Social Change in Latin America by Betty LaDuke. Reprinted by permission of City Lights Books, San Francisco, California.

PHOTO CREDITS

Chapter 1 1.3, Mark Rogovin
Chapter 2 2.3, © Baron Wolman; 2.4, © Charles Ledford; 2.5, 2.8, Giraudon/Art Resource, New York; 2.9, Frank Johnston/The Washington Post; Appreciation 2, Figure C, Scala/Art Resource, New York; Appreciation 2, Figure D, Giraudon/Art Resource, New York; 2.15, Tate Gallery/Art Resource, New York © Roy Lichtenstein/VAGA New York, 1990; 2.25, Scala/Art Resource, New York; 2.27, Copyright 1990 ARS, New York/SPADEM; 2.34, Copyright 1991 Succession H. Matisse/ARS, New York
Chapter 3 3.2–3.6, Scala/Art Resource, New York; 3.9, Giraudon/Art Resource, New York
Chapter 4 4.1, Art Resource, New York; 4.2, Photo M. A. D./Sully-Jaulmes; 4.4–4.6, Alinari/Art Resource, New York; 4.8–4.9, Giraudon/Art Resource, New York; 4.10, The Bridgeman Art Library, London; 4.11, 4.13, 4.17, 4.21, Scala/Art Resource, New York; 4.26, © Käthe Kollwitz/VAGA New York 1990; Appreciation 6, © Käthe Kollwitz/VAGA New York 1990; 4.29, Copyright 1990 ARS, New York/SPADEM; 4.30, photo: George Roos; 4.38, K. E. Kraft/Sun Dog Productions; 4.39, Giraudon/Art Resource, New York; 4.40, K. E. Kraft/Sun Dog Productions
Chapter 5 5.5, The Granger Collection, New York; 5.6, The Mansell Collection, London; 5.7, The Granger Collection, New York; 5.13, Giraudon/Art Resource, New York; 5.17, The Bettmann Archive; 5.23, 5.24, © Martin Charles; 5.28, A. G. E. Fotostock, Barcelona; Appreciation 8, Christine Bastin and Jacques Evrard; 5.35, © Robert Damora; 5.43, *God's Own Junkyard,* renewed and updated by Peter Blake. Photograph copyright © 1964, 1979 by Peter Blake. Reprinted by permission of Henry Holt and Co., Inc.; Appreciation 9, © David Muench; 5.45, 5.46, Robert Bersson
Chapter 6 6.3, Bauhaus-archiv, Berlin; 6.4, Hirmer Fotoarchiv, Munich; 6.5, Gilbert Garcia/The Image Bank; 6.6, 6.7, Copyright 1990 ARS, New York/SPADEM; 6.9, Courtesy Ernst Wasmuth Verlag, Töbingen; 6.10, Lionel Isy-Schwart/The Image Bank; 6.11, Leonard Von Matt, Buochs, Switzerland; 6.12, 6.13, 6.15, 6.16 (top and bottom), 6.17, Alinari/Art Resource, New York; 6.18, A. Hamber, Architectural Association, London; 6.19, Scala/Art Resource, New York; 6.20–6.24, Alinari/Art Resource, New York; 6.26, 6.27, Scala/Art Resource, New York; 6.28, Giraudon/Art Resource, New York; 6.29, 6.30, Virginia State Library and Archives, Richmond; 6.31, Courtesy University of Virginia Library, Special Collections; 6.32, The Bettmann Archive; 6.33, © Robert Llewellyn; 6.34, Monticello, Thomas Jefferson Memorial Foundation, Inc.; 6.35, J. Ramey/The Image Bank; 6.36, Courtesy District of Columbia Commission of Fine Arts; 6.38, Washington Stock Photo;

6.39, Hirmer Fotoarchiv, Munich; 6.40, © Photri, Inc., Falls Church, Virginia; 6.41, 6.42, Giraudon/Art Resource, New York; 6.43, Marburg/Art Resource, New York; 6.44, Art Resource, New York; 6.45, Giraudon/Art Resource, New York; 6.46, Scala/Art Resource, New York; 6.47, Alinari/Art Resource, New York; 6.48, Ronald Sheridan/The Ancient Art and Architecture Collection, London; 6.49, Courtesy National Buildings Record, London; 6.50, Allen Litton; 6.51, Chicago Historical Society; 6.52, © Thomas Payne; 6.53, © Peter Mauss/ ESTO; 6.54, Ezra Stoller © ESTO; 6.56, Courtesy Illinois Institute of Technology; 6.57, *God's Own Junkyard,* renewed and updated by Peter Blake. Photograph copyright © 1964, 1979 by Peter Blake. Reprinted by permission of Henry Holt and Co., Inc.; 6.58, Giraudon/Art Resource, New York Copyright 1990 ARS, New York/SPADEM; 6.59, Copyright 1990 ARS, New York, SPADEM; 6.60, Fondation Le Corbusier, Paris. Copyright 1990 ARS, New York/SPADEM; 6.61, Lucien Hervè, Paris. Copyright 1990 ARS, New York/SPADEM; 6.62, Copyright 1990 ARS, New York/SPADEM; 6.63, Courtesy British Cement Association, Slough, England; 6.64, Bettmann Newsphotos; 6.65 (both figures), Courtesy Davis, Brody and Associates, New York; 6.66, Hedrich-Blessing, Chicago; 6.67, © 1984, 1985 The Frank Lloyd Wright Foundation; 6.68, © The Frank Lloyd Wright Foundation; 6.69, © Robert Llewellyn; 6.70; Hedrich-Blessing, Chicago; 6.71, Henry Fuermann/University Archives, State University of New York at Buffalo; 6.72, © Marc Treib; 6.73, © Christopher Little; 6.74–6.76, Robert Bersson; Appreciation 11, Figure A, Courtesy Salk Institute for Biological Studies, La Jolla, California; Appreciation 11, Figure B, Courtesy Princeton University; Appreciation 11, Figures D, E, F, Hood Museum of Art, Dartmouth College, Hanover, New Hampshire, photography by Jeffery Nintzel; Appreciation 11, Figure C, Christopher Noll
Chapter 7 7.1, 7.2, Alinari/Art Resource, New York; 7.13, Scala/Art Resource, New York; 7.28, Alinari/Art Resource, New York; 7.29, © Ernst Ludwig Kirchner/VAGA New York 1990; 7.34, Copyright 1991 C. Herscovici/ARS New York; 7.35, Copyright 1991 ARS New York/ADAGP; 7.36, Giraudon/Art Resource, New York; 7.37, © Herbert Bayer/VAGA New York 1990; Appreciation 12, Orson Welles, *Citizen Kane,* 1941. A Mercury Production/RKO Radio; Appreciation 12, Figures A, C, D, H, The British Film Institute, London; Appreciation 12, Figures B, F, G, I, The Museum of Modern Art/Film Stills Archive; Appreciation 12, Figure E, The Bettmann Film Archive; 7.50, Art Resource, New York Copyright 1991 ARS New York/ADAGP
Chapter 8 8.1–8.4, Alinari/Art Resource, New York; 8.5–8.10, Scala/Art Resource, New York; 8.11–8.13, Alinari/Art Resource, New York; 8.15, Giraudon/Art Resource, New York; 8.16, Marburg/Art Resource, New York; 8.21, Alinari/Art Resource, New York; 8.22, Courtesy Irving Lavin, Institute for Advanced Study, Princeton; 8.23, The Bridgeman Art Library, London; 8.24, 8.25, Giraudon/Art Resource, New York; Appreciation 14, Figure B, Scala/Art Resource, New York; 8.29, 8.30, Scala/Art Resource, New York; 8.31, Giraudon/Art Resource, New York; 8.33, Kavaler/Art Resource, New York; Appreciation 15, Figure B, Isabella Stewart Gardner Museum/Art Resource, New York; 8.34, 8.35, Scala/Art Resource, New York; 8.36, Bulloz, Paris; 8.39, Scala/Art Resource, New York; 8.41, Giraudon/Art Resource, New York; Appreciation 16, Figure A,

Giraudon/Art Resource, New York; Appreciation 16, Figure B, Scala/Art Resource, New York
Chapter 9 9.1, Giraudon/Art Resource, New York; 9.4–9.6, Scala/Art Resource, New York; 9.7, 9.8, 9.11, Giraudon/Art Resource, New York; 9.12, The Mansell Collection, London; 9.13, The Bridgeman Art Library, London; 9.14, 9.16, Giraudon/Art Resource, New York; 9.17, Scala/Art Resource, New York; 9.18–9.20, Giraudon/Art Resource, New York; 9.22, Scala/Art Resource, New York; Appreciation 20, Figure A, Copyright 1990 ARS, New York/SPADEM; Appreciation 20, Figure B, Copyright 1991 ARS New York/ADAGP; Appreciation 20, Figure C, Hirmer Fotoarchiv, Munich; Appreciation 21, Scala/Art Resource, New York
Chapter 10 10.1, Giraudon/Art Resource, New York; 10.2–10.4, Copyright 1991 Succession H. Matisse, New York; 10.7, © Käthe Kollwitz/ VAGA New York 1990; Appreciation 22, Copyright 1991 Succession H. Matisse/ARS New York; 10.9, © Max Beckmann/VAGA New York 1990, 10.11, 10.12, Copyright 1991 ARS New York/ADAGP; 10.13, 10.14, Copyright 1991 ARS New York/Cosmopress; 10.16, Art Resource, New York Copyright 1991 ARS New York/ADAGP; 10.17, Copyright 1991 ARS New York/ADAGP; Appreciation 23, Scala/Art Resource, New York. Copyright 1990 ARS, New York/SPADEM; 10.18, 10.19, Copyright 1990 ARS, New York/ADAGP; 10.20 © Photo R. M. N., Paris; 10.21, 10.28, 10.29, Copyright 1991 ARS New York/ADAGP; 10.30, © Hannah Höch/VAGA New York 1990; 10.31 © George Grosz/VAGA New York 1990; 10.34, Copyright 1990 ARS, New York/SPADEM; 10.35, Copyright 1990 Demart Pro Arte/ARS, New York; Appreciation 25, Figures A and B, Courtesy Dr. Salomon Grimberg, Dallas, Texas; 10.37, 10.39, 10.42, Copyright 1991 ARS New York/ADAGP
Chapter 11 11.2, Copyright 1991 ARS New York/ADAGP; 11.3, Copyright 1991 The Pollock-Krasner Foundation/ARS New York; 11.4, Copyright 1991 ARS New York/ADAGP; 11.6, Nina Leen, *Life* Magazine. © Time Warner Inc.; 11.7, © Hans Namuth; 11.8, 11.9, Willem de Kooning/VAGA New York 1990; 11.10, 11.12, Copyright 1991 Kate Rothko-Prizel and Christopher Rothko/ARS New York; 11.14, 11.15, © David Smith/VAGA New York 1990; 11.20, © Kenneth Noland/VAGA New York 1990; 11.22, 11.23, Copyright 1991 Frank Stella/ARS New York; 11.24, © Robert Rauschenberg/VAGA New York 1990; 11.25, Copyright 1991 ARS New York/Cosmopress; 11.26, © Jasper Johns/VAGA New York 1990; 11.27, © Robert Rauschenberg/VAGA New York 1990; 11.28, photo: Robert McElroy; 11.29, © Martha Holmes; 11.30, photo: Rudolph Burckhardt; 11.31, Hedrich-Blessing, Chicago; 11.32, 11.33, © Roy Lichtenstein/VAGA New York 1990; 11.34, 11.35, Copyright 1991 The Estate and Foundation of Andy Warhol/ARS New York; 11.36, © George Segal/VAGA New York 1990; Appreciation 28, Copyright 1991, The Pollock-Krasner Foundation/ARS New York; Appreciation 29, Figure A, photo: J. Hyde, Paris; Appreciation 29, Figure B, photo: Benjamin Blackwell; Appreciation 30, Figure A, photo: Lee Fatheree; Appreciation 30, Figure B, photo: David Heinlein
Chapter 12 12.3, Alinari/Art Resource, New York; 12.8, © Paula Court; Appreciation 34, photo: Tom Anderson; Appreciation 36, Figure B, Steve McCutcheon/Alaska Pictorial Service; Appreciation 37, Figure D, photo: William L. Fash, Northern Illinois University